DATE DUE

DE 2/02			
MY 28 0			

DEMCO 38-296

Historical and Philosophical Issues in the Conservation of Cultural Heritage

Readings in Conservation

Historical and Philosophical Issues in the Conservation of Cultural Heritage

Edited by

Nicholas Stanley Price

M. Kirby Talley Jr.

Alessandra Melucco Vaccaro

THE GETTY CONSERVATION INSTITUTE

LOS ANGELES

Historical and philosophical
 issues in the conservation

nation: Dinah Berland
Design: Sandy Bell
Production Coordination: Anita Keys
Typesetting: G & S Typesetters, Inc.

Printed in the United States of America by Science Press,
 Division of The Mack Printing Group

ISBN 0-89236-250-2 (cloth)
ISBN 0-89236-398-3 (paper)

The Getty Conservation Institute is committed to the preservation of cultural heritage
worldwide, seeking to further scientific knowledge and professional practice in the field of
conservation and to raise public awareness of conservation's importance. Through field
work, research, training, and the exchange of information, the Institute addresses the
conservation needs of museum objects and archival collections, archaeological
monuments and sites, and historic buildings and cities.

COVER ILLUSTRATION:
Honoré Daumier, *Advice to a Young Artist,*
probably after 1860, oil on canvas,
16⅛ × 12⅞ in. Gift of Duncan Phillips
© 1995 Board of Trustees,
National Gallery of Art, Washington, D.C.

Library of Congress Cataloging-in-Publication Data

Historical and philosophical issues in the conservation of cultural
 heritage / edited by Nicholas Stanley Price, M. Kirby Talley, Jr.,
 Alessandra Melucco Vaccaro.
 p. cm. — (Readings in conservation)
 Includes bibliographical references and index.
 ISBN 0-89236-250-2. — ISBN 0-89236-398-3
 1. Art—Conservation and restoration. 2. Architecture—
 Conservation and restoration. I. Stanley Price, Nicholas, 1947–
 II. Talley, Mansfield Kirby. III. Melucco Vaccaro, Alessandra.
 IV. Series.
 N8555.H57 1996
 702′.8′8—dc20
 95-44736
 CIP

Contents

Foreword

The Getty Conservation Institute produces a range of publications that address issues of interest to the conservation community and other audiences. This book is one such example. Emerging from a perceived need by conservators, connoisseurs, collectors, and museum professionals, this first volume in the Readings in Conservation series is the result of an effort to make available to the general public, students, specialists, and scholars some of the most significant texts on conservation that have come to light in the past.

As with any such collection, the choice of individual texts was difficult, as was the decision concerning the volume's scope. Ultimately, the editors decided on a historical approach that spoke to the origins of thinking in conservation practice to set the groundwork for a clearer understanding of conservation issues today. Thus this set of readings took shape, reflecting the Western tradition of conservation with a strong emphasis on connoisseurship. The editors also wanted to address the enormous corpus of written materials on Western conservation practices before tackling those of other parts of the world. Future volumes in this series will add to this perspective to form a solid compendium of readings on the subject.

We hope that all who use these texts will explore, discover, and enjoy the diverse thoughts of the distinguished authors who have long reflected on the basic issues of conservation from scholarly, spiritual, and often passionate points of view. We also hope that professionals and students alike will benefit from this heritage, which we proudly present to all those who share in our respect and commitment to conservation of the cultural heritage.

Miguel Angel Corzo
Director
The Getty Conservation Institute

Preface

Aim of This Volume

The main aim of this volume has been to compile a number of writings that have proved to be influential in the development of thinking about the conservation of cultural heritage. While the concept of "cultural heritage" is a relatively modern one, many of the contemporary debates about conservation have their roots in the Western intellectual tradition of past centuries. At a time when cultural heritage is increasingly promoted as being of universal value (or as "world heritage"), it is particularly opportune to reexamine the historical and philosophical antecedents of current issues; hence the title of this book.

The present volume of readings presents texts and commentary relevant to the appreciation and conservation of all works of art. Future volumes are planned that will be devoted to specific topics, such as architecture and paintings.

The principal audience envisaged for this book is the ever-increasing population of students entering formal education and training programs in conservation. The volume is therefore designed to be used, first and foremost, as teaching material. It should join the relatively few texts deliberately produced as didactic material for conservation students in providing relevant and fundamental sources for the historical and philosophical issues that underlie the discipline they have decided to study.

In making available a number of texts that have not been previously assembled in one place, and that individually are sometimes hard to locate, this volume should also prove of value to conservation professionals. The same should be true for those working in other disciplines, such as art and architectural history, archaeology, anthropology, and the sciences. Special-

ists in these disciplines often need to understand the historical context of earlier restorations of the material that they are studying—if, indeed, the restorations have been recognized for what they are. In turn, conservators have long advocated the inclusion of conservation concepts in the teaching of other relevant disciplines. This compilation of readings may therefore help to promote a more fruitful exchange of ideas concerning the importance of conservation to the appreciation and study of the arts.

Selection of the Readings

The main criterion for the selection of texts represented here is well expressed by Alessandra Melucco Vaccaro in her introduction to Part VI (pages 326–31), when she writes, "[T]he guiding principle of these readings is the search for the roots of contemporary problems and the rereading of texts that have become classics but that are still rich in suggestions and useful for putting our everyday problems into perspective."

Those roots are generally to be found in the Western intellectual tradition of writing about the fine arts, their appreciation and their study through connoisseurship and scholarly research. The readings collected here are drawn principally from that tradition. The value of the tradition itself is at present the subject of continuing debate, and certain influential strands within it are currently out of favor; connoisseurship is a case in point. Nevertheless, the present compilation of readings, organized with the aim of identifying the roots of contemporary debates in conservation, deliberately emphasizes the tradition of aesthetic appreciation and connoisseurship in the fine arts (see especially Parts I and II). It is within this tradition that conservation philosophy has developed, even if the range of material culture that is today the object of conservation actions is much broader than the fine arts alone (Melucco Vaccaro, introduction to Part III, pages 202–11). A further aim for including the readings found in Part I—many of which will be generally familiar to the student of the history of art—is to reassert the continuing importance of aesthetic appreciation and connoisseurship (however temporarily unfashionable in art historical studies) for making judgments concerning conservation.

The readings in this book were chosen, regardless of their original language, because the ideas they express have proved over time to have been influential. Many of them demonstrate the recognition long ago of issues in conservation that are currently enjoying renewed attention—for example, the original intention of the artist, the de-restoration of restored monuments, and the treatment of sacred or ritual objects. It is important to understand Western approaches to conservation within a historical perspective before evaluating their relevance to the conservation of non-Western material culture.

The emergence of the concept of universal or world heritage has brought these issues to the fore, for example with respect to the idea of authenticity, and they are certain to provide stimulating debate for the student of conservation and the arts.

If the search for the roots of contemporary problems in conservation has been a principal criterion in the selection of texts, another has been an emphasis on the importance of fully understanding the object to be conserved before any intervention, whether preventive or remedial, is considered. As Philippot has summarized it, the three questions to be asked are: "(1) What is to be considered the whole of the object, to which all operations must be referred? (2) What is the context of the object? and (3) What has been the history of the object?" (Reading 26, page 271)

A thorough assessment of both aesthetic and historic significance is considered by the editors of these readings to be fundamental in guiding decisions about conservation policy. Some prominence has therefore been given to the writings of Cesare Brandi and of Paul Philippot, who have been influential in establishing a conservation philosophy that stresses respect for the object itself and the understanding of its aesthetic and historic values. References to their work are rare in the North American conservation literature. It is hoped that this volume will help to make their philosophies better known.

To realize the aim of the book, the Getty Conservation Institute invited the submission of preliminary lists of fundamental texts, in accordance with the guidelines established for the project, from three specialists in the discipline: Joyce Hill Stoner, conservator, director of the Art Conservation Program at the University of Delaware, Winterthur Museum; Catheline Périer d'Ieteren, art historian, Université Libre de Bruxelles, Belgium; and Alessandra Melucco Vaccaro, archaeologist, Istituto Centrale del Restauro, Rome, Italy. A master list of the three individual submissions was then sent for review and comment to some fifteen conservators, conservation scientists, and teachers, the majority of them working in the United States.

In the light of the reviewers' comments, a provisional final list of texts was drawn up. At the same time, M. Kirby Talley Jr., art historian, Ministry of Culture, the Netherlands, was invited to propose a list of texts on art history and connoisseurship. The final list of texts was established with the advice of Kirby Talley and Alessandra Melucco Vaccaro, who were then invited to write the introductions to their respective sections.

To amplify the range of texts selected, and to increase the value of the volume as teaching material, annotated bibliographies have been added to each section. The bibliography in Part I is the work of Kirby Talley; the others have been compiled by Alessandra Melucco Vaccaro, Cristina Iamandi, and myself, often drawing on suggestions made by earlier reviewers.

Terminology

The process of assembling these texts and, especially, that of editing those translated for the first time into English, has led to certain decisions about terminology that require a brief explanation. Two apparently problematic pairs of terms are, on the one hand, *conservation* and *restoration* and, on the other hand, *work of art* and *object*.

The simplest, if not the most elegant, solution to the problem of distinguishing between the terms conservation and restoration is to avoid the problem by juxtaposing them in the form conservation/restoration. As Melucco Vaccaro proposes in her introduction to Part VI (pages 326–31): "Juxtaposing the two terms is an attempt at recovering the sense of a historic tradition, at gathering together the best from the two movements that were so ferociously opposed to one another in the nineteenth century." In other words, it should be possible to "show that a single process can ensure the survival of cultural heritage" (page 327), one that sees a continuum of procedures involving both conservation and restoration.

The term conservation-restoration has already been adopted in certain areas—in much French literature, for example—though it is cumbersome for regular usage. Moreover, *restauro* in Italian and *restauration* in French have broad denotations encompassing much of what is meant by conservation alone in English (though *conservazione* and *conservation* are increasingly used in Italian and French, respectively, as if equivalent to their English cognate). On the other hand, the word restoration in North American usage, if employed at all, has come to be used in a more restricted sense, usually denoting an intervention aimed at integrating the losses in a work of art or at re-creating a period style.[1]

The solution adopted in this volume has been to use the word conservation (and its related terms, conservator, etc.) when modern practice is being described, and to retain the word restoration (and its related terms) when used in texts referring to earlier practice or whenever the context particularly requires it.

The apparent problem of the other pair of terms, work of art and object, arises because of the increasing tendency to distinguish, in terminology and even in approach, between fine arts conservation and objects conservation. This distinction reflects, in a general way, the relative weight being attached to the aesthetic and historic (or documentary) values of the material under discussion. Kirby Talley, for instance, in his introduction to Part I (pages 2–41), refers usually (though not exclusively) to "works of art" in emphasizing the aesthetic value of paintings and other fine arts. It has long been pointed out that many objects and buildings were created primarily to serve functional ends, but that some have come to be viewed also as works of

art (compare the title of H. J. Plenderleith's classic work, *The Conservation of Antiquities and Works of Art,* London, 1956). Rather than introduce the cumbersome phrasing of work of art/object, the editors have decided instead to retain whichever of the two terms is more appropriate to its context.

How to Use This Volume

The texts included here are intended to stand on their own. Nevertheless, the rationale for their inclusion, and for their particular location in the volume, will be clearer if the introduction to each part of the book is read in advance of the readings that follow it. This is especially true of the selection and sequence of the various extracts from Cesare Brandi's *Teoria del restauro,* a collection of articles and lectures by Brandi that together demonstrate his thinking.

The sequence of chapters in the volume is designed to lead from the roots of appreciation and studies of works of art during the nineteenth and first part of the twentieth centuries (Parts I and II) to the emergence of a modern conservation philosophy (Part III). Modern theory is put into historical perspective in Part IV by considering earlier approaches to restoration following the development of a historical consciousness, and the restoration and anti-restoration debate concerning architecture in the middle of the nineteenth century in Part V. Several important issues in that debate are elaborated further in Part VI on the reintegration of losses, often considered the key question in restoration theory, and in Part VII on the idea of patina in regard to works of art. The discussions of patina can profitably be read with those on the artist's intent in Part II.

Finally, Part VIII, on the role of science and technology, introduces the third member of the interdisciplinary team often considered essential for successful conservation practice: the scientist, who now joins the art historian (along with the archaeologist and architect, as appropriate) and the conservator. The achievements of early pioneers—such as Friedrich Rathgen, Alexander Scott, Harold Plenderleith, E. W. Forbes, Rutherford Gettens, George Stout, and Paul Coremans—established the important role that science could play in decisions about conservation and restoration policy for a work of art. The impact of science on methods of technical examination helped transform what had been principally an artisan tradition into a discipline with a demonstrable methodology. When it comes to the success of science and technology in developing conservation treatments, however, Melucco Vaccaro adopts a more cautious view in her introduction to this section. Here again is a rich topic for discussion among students of art, conservation, and the sciences.

To avoid overburdening the texts with notes, the number of editorial interpolations has been deliberately limited. Technical terms—as well as the names of artists, authors, and works of art—can readily be found in standard reference sources. Moreover, given the aims of this book, the complexity of key terms such as restoration, patina, and reintegration is better conveyed through reading the selected texts and the editors' introductions than through the limitations of a glossary.

At the back of the book, we have provided biographical notes on the authors whose writings are represented here (pages 472–82). These are intended to convey an idea of the cultural and chronological context in which the authors were or are working. We have also provided an annotated bibliography (pages 451–71) to encourage further study. A certain number of cross-references have been provided within the introductions to each part of the book to connect interrelated ideas. Many more connections remain to be discovered by the reader, connections that will help identify the common strands and divergent currents within the development of ideas about the conservation of cultural heritage. I hope the readings collected here will help promote and enrich debate over these fundamental ideas in the years to come.

Acknowledgments

The preparation of a book of this scope and complexity would not have been possible without the help and advice of many people. For preliminary suggestions of titles as potential readings and for reviewing the entire volume in draft, I extend special thanks to Catheline Périer-D'Ieteran, Université Libre de Bruxelles; and Joyce Hill Stoner, University of Delaware. In addition, Charles S. Rhyne, Reed College, Portland, Oregon; and Martha Simpson, National Gallery of Art, Washington, D.C., provided helpful comments on the draft manuscript. Preliminary lists of readings were reviewed by Arthur Beale, Boston Museum of Fine Arts; W. T. Chase, Freer Gallery of Art, Smithsonian Institution; Brian Considine, the J. Paul Getty Museum; Margaret Holben Ellis, New York University; Lilian Masschelein Kleiner, Institut Royal du Patrimoine Artistique, Brussels; Mark Leonard, the J. Paul Getty Museum; Ian McClure, Hamilton Kerr Institute, Cambridge, United Kingdom; Paul Perrot, Santa Barbara Museum of Art; Frank Preusser, while at the Getty Conservation Institute; Andrea Rothe, the J. Paul Getty Museum; David Scott, the Getty Conservation Institute; and Christopher Tahk, State University College at Buffalo.

For undertaking translations into English, thanks are due to Karin Bruckner, Barbara Harshav, Elizabeth Maggio, Gianni Ponti, Brent Sverdloff, Alexandra Trone, and Garrett White, who are credited where their respective

contributions occur. Special appreciation is due to Gianni Ponti for agreeing to undertake the task of translating excerpts from Cesare Brandi's writings.

Finally, I wish to thank my colleagues at the Getty Conservation Institute: Marta de la Torre, director of the Training Program, who guided the project's development throughout; Sheri Saperstein, who helped coordinate the project from the start; and Cristina Iamandi for her research of the annotated bibliography and the authors' biographical notes. I would also like to thank the staff of the Institute's Publications department, especially Dinah Berland for coordinating the editorial production of the book and former staff assistants Colette Muse and Kimberly Kostas for obtaining permissions to reprint the readings and illustrations. I also acknowledge gratefully the many independent consultants who contributed to the project at various stages, including Nomi Kleinmuntz for preliminary copyediting, Sylvia Tidwell for picture research, Savage Information Services and Deanna DeMayo for bibliographic verification, Karen Lang for copyediting the translation of Riegl's text, and Joy Hartnett for extensive editorial assistance in preparing the texts for publication. To all those mentioned, and to many other colleagues who have helped with advice and suggestions, I extend my warmest thanks.

<div style="text-align: right">

Nicholas Stanley Price
Former Deputy Director, Training Program
The Getty Conservation Institute

</div>

Note

1. In the title of the paper given by PAUL PHILIPPOT on "Restoration: Philosophy, Criteria, Guidelines" at the 1972 Williamsburg conference, the author's term "restoration" was changed to "historic preservation" for publication of the paper in the United States (see Philippot, Readings 26 and 38). In the revised (1994) *Code of Ethics* and *Guidelines for Practice* of the American Institute for Conservation of Historic and Artistic Works (AIC), the word restoration is not used at all.

Note to the Reader

The readings in this volume were excerpted from a wide variety of sources, ranging from lectures published in journals of limited circulation to parts of chapters from well-known and frequently reprinted texts. Some of these readings were translated expressly for this volume. Some of the English texts were originally published in the United Kingdom, while others are from American editions. (Full source information is given at the bottom of the first page of each reading.) To produce a clear and consistent style for the volume as a whole while retaining, insofar as possible, the integrity of the original material, the following conventions have been adopted: All readings have been edited for American English spelling and punctuation. Omissions made by the editors within and at the beginnings and ends of paragraphs are indicated by equally spaced ellipsis dots; the authors' deletions in the original texts are indicated by ellipsis dots with no spaces. Omissions of one or more paragraphs are indicated by a symbol between paragraphs. Editorial notes and other additions to the original texts are set in brackets.

Notes and note numbers have also been made consistent. Note numbers are sequential within each reading, and notes are set as endnotes throughout. The original number for each note, if different, is set in brackets at the beginning of each endnote. If notes were identified by page number in the original, these page numbers are also given. Publication information has been provided to complete missing bibliographic data whenever possible.

The editors and publishers welcome your comments and suggestions for future printings and subsequent volumes in this series.

PART I

The Eye's Caress:
Looking, Appreciation,
and Connoisseurship

Pieter Christoph Wonder, *Patrons
and Lovers of Art*, 1826.
Oil on canvas.

The Eye's Caress:
Looking, Appreciation,
and Connoisseurship

Thou, silent form, dost tease us out of thought
As doth eternity.
—John Keats, "Ode on a Grecian Urn"

The Aesthetic Imperative: The Importance of Looking and Appreciation

Erwin Panofsky's injunction that a work of art "demands . . . to be experienced aesthetically" may at first sound strange to our ears since the emphasis today is often placed on the documentary rather than the aesthetic aspects of works of art (see Reading 5, page 60). Works of art do provide, in varying degrees, valuable information on technique, materials, stylistic development, aspects of social, political, or personal (the maker's and/or the owner's) history. They should still be considered, first and foremost, however, in relation to their original intention as works of art. Alois Riegl terms the aesthetic significance of a work of art its *artistic value* and the documentary importance its *historical value* (see Reading 6, page 69).

Both of these values are important, but it is necessary to reorder priorities and place the horse before the cart again. Concentration on the documentary relevance of a work of art eventually reduces it almost solely to the status of purveyor of information. When Rubens painted his vibrant sketches, such as the *Study of Lioness for Daniel in the Lion's Den* shown in Figure 1, he did so to provide his patrons with an idea of how the finished work would look. These sketches also frequently served as working drafts—blueprints, as it were—for his studio assistants. Rubens did not paint the sketches to provide future generations of art historians, restorers, and artists with lessons on materials and technique. An artist's intent is intrinsically bound up with aesthetic considerations and how we are meant to look at and appreciate works

Figure 1
Peter Paul Rubens, *Study of Lioness
for Daniel in the Lion's Den,*
ca. 1681. Chalk, gouache.

of art. Because works of art acquire other values, especially historical ones, a documentary dimension is inevitable. These added values are bonuses, but no matter how important they may be, or we may consider them to be, they will always be secondary to art value or aesthetic significance.

Why is it so important to look at works of art, to appreciate them as aesthetic objects, to learn to discriminate quality and "hand," to experience what Bernard Berenson and other writers chosen for this volume would call "aesthetic reverie"? Can one even learn to do all of this? To begin with the second question, the answer is yes, provided, as Berenson noted, one has a natural aptitude that can be trained. No right way, or wrong way, of looking exists, but the method used by Kenneth Clark contains all the steps involved and is excellent as a general guideline of procedure (see Reading 4, pages 57–58). While looking and appreciating can be very intensive, hard work, it can also be highly pleasurable and rewarding, what Berenson terms "life-enhancing" (Reading 8, page 104). By its very nature, our way of looking and appreciating, our decisions as to quality and hand will be individual, hence subjective. What, then, is the relative worth of the exercise? Why bother?

When we look at a work of art, a dialogue is opened between the work of art as an aesthetic object and our eye; that is, our ability to distinguish quality, hand, and, to whatever extent possible, original intent; which includes the artist's image-intent and how the artist's choice and use of form, color, materials, techniques, and surface finish contributed to the realization of it. This, in essence, is what is meant by *aesthetics*, whether we think of it as a science of beauty, as having a sense of love for the beautiful, or as having to do with the rules, principles, and practice of the fine arts.[1] The extent of our historical, technical, and material knowledge will determine our ability to evaluate—as an artist might—what we see with what we know.

If we look at works of art primarily—or even worse, exclusively—as carriers of information rather than as aesthetic objects, we have begun our examination with a prejudice that limits the value of the information gathered. Since time is merciless in the changes it causes, original intent, which is so bound up with aesthetic value, is often hard, if not downright impossible, to determine with any degree of absolute certainty. Sources can provide much important information, but even the information they contain is not always clear and definitive. Therefore, a seemingly legitimate excuse has been provided to neglect looking and appreciation and to concentrate on a nuts-and-bolts approach focusing on materials, technique, and condition. These are aspects of any work of art that can be studied and analyzed and that can provide objective, scientific information. The extent to which scientific information is truly objective is a subject deserving more attention, perhaps, but here it will be sufficient to caution that all information contains both subjective and objective elements. Concentration on the material aspects over the artistic or aesthetic ones tends to reduce works of art to objects. Dealing with objects appears easier than dealing with works of art, since objects are tangible and works of art have something intangible, something immaterial about them. Instead of being the pleasurable and rewarding jumping-off point in our appreciation and study, this "otherness" of works of art is often perceived as threatening by people who either do not sufficiently comprehend this immaterial quality, or have been denied the opportunity to become familiar with its existence and importance.

When engaging in a dialogue between our eye and a work of art, Panofsky, among others, encourages us to use our intuition and re-create the works aesthetically. This involves, insofar as possible, determining the artist's intent. Aesthetic appreciation, which is subjective, is the other half of aesthetic re-creation. Being certain of the artist's intent, or perceiving it adequately based on our aptitude for and experience of looking—coupled with our knowledge of history, materials, and techniques—enriches our aesthetic appreciation, but it also limits our compass for subjective judgments. This helps to prevent what Panofsky terms *appreciationism* (Reading 5, page 65).

Because professionals, whether art historians or restorers, have a justified reserve with regard to subjective opinions, emphasis has been, and still is, placed on historical value over art value.

What are the results of a "practical," object-oriented approach to works of art and their conservation and/or restoration? Picture varnishes and their historical use is a subject that has only recently begun to receive the scholarly attention it deserves. Conservators who concentrate solely on the problem of the protection that varnishes provide and/or on the problem of the longevity of varnishes, may be far less concerned with the original visual intent. Since Impressionism, most artists have had a preference for matte surfaces. Their way of seeing surface finish has affected our way of seeing surface finish, and conservators who have been responsible for putting matte, synthetic varnishes with a supposed extra life span on old masters have tampered in a most essential manner with original intent and aesthetic value. These conservators are also guilty of having acted in a highly subjective manner, since they neglected the evidence supplied by both the sources and objects themselves. What at first sight appears to be a highly objective, scientific, no-nonsense, material-and-condition-oriented approach turns out to be as subjective as appreciationism.

If materials can influence aesthetics, so can conservation techniques. Since works of art have increasingly come to be considered as objects bearing information of documentary worth, and since historical value is often prized above artistic value, honesty has become a battle cry among many conservators. How far one goes in reconstructing losses, how far one goes in disguising worn or poor condition are topics with which to start a war. Many people in the conservation community attempt to dismiss the importance of an aesthetic approach to conservation and restoration by referring to it as "cosmetics," the implication being that it is a frill that can just as well be eliminated. No historical work of art, regardless of how good its present condition, has come down to us in an absolutely pristine state. Most works have suffered to a greater or lesser degree the ravages of time and, in many instances, the ravages of unfortunate interventions over the years. What has become the historical value—for better or worse—of a work of art often conflicts with the artistic value and artist's intent.

In general, what is still original in any work of art is of the ultimate importance, whether to the connoisseur, art historian, conservator, or lover of art. When a connoisseur is confronted with the problem of attributing a work of art, what constitutes the original is crucial for his or her decision. Just how far any treatment should go in brushing up a work of art is something that has to be discussed in concert with all parties concerned each time one embarks on conservation. Today, no one would recommend an extensive re-creation of a major portion of a missing image, as was carried out by Luigi

Figure 2
Rembrandt van Rijn,
The Jewish Bride,
ca. 1665. Oil on canvas.

Cavenaghi, a famous paintings restorer, on Carlo Crivelli's *Pietà* during the first quarter of the twentieth century.[2] Cavenaghi's reconstruction, which constitutes about 35 percent of the painting's surface, although weak in comparison to the original Crivelli, is still sufficiently good to fool the untrained eye at first sight, perhaps even some professional eyes, as well.

The importance of connoisseurship to conservators should therefore be obvious since many decisions that have to be made as to what is original, or what has been added (hence what eventually may be removed during conservation), can only be made on the basis of what the eye tells one about style and hand. Conservators should not expect art historians—who are connoisseurs neither by definition nor by training—always to be able to supply this essential service. Technical examination and analyses, like all methods, have their limitations. A case in point is the beretlike hat worn by the man in Rembrandt's *Jewish Bride* in the Rijksmuseum (Fig. 2). During its recent conservation, much discussion centered around this hat. Was it original or a later addition? Scientific methods could provide no definitive answer, nor could documentary evidence, and opinion among the experts, who examined the picture with great care, was divided. The potential shortcomings of both objective and subjective methods of analysis and diagnosis are made quite obvious by this example. The hat, reconstructed after this latest cleaning, is still very much in place.

No one who truly loves art underestimates the value of the original elements in any work of art. The problem is, however, that the original component is frequently accompanied by later additions. Removing all later

additions—provided they can be determined beyond the shadow of a doubt—and leaving the original parts in splendid isolation is perhaps the most honest approach to conservation, if the concept of original intention is completely neglected. Even if we do not know the specific intent of a work of art, we can be fairly certain that its maker did not set out to create a document flawed by time and interventions. But how does one address the problem of striking a balance between what is actually left (i.e., historical value and historical condition) and a known or surmised intent? To remove all overpaintings on a picture and then to exhibit it might be honest as far as a document is concerned—the work would be nothing else—but such an approach would do violence to the aesthetic value and intent. Techniques such as *tratteggio*, when well handled, can offer a compromise solution between "honest" and "deceitful" aesthetic reintegration. However, any restoration technique that ends by dominating the original work of art, such as the so-called chromatic selection applied to Cimabue's great *Crucifix* (Fig. 3a, b), cannot be accepted.[3] This is an example of what Albert Albano has noticed of the conservator imposing his or her norms on a work of art (see Albano, Reading 17, pages 176–84).

Figure 3a, b
Giovanni Cimabue, *Crucifix*, ca. 1288, (a) before 1966 flood and (b) after 1966 flood damage and subsequent restoration.

(a)

(b)

Such supposedly honest approaches to restoration techniques are only possible when looking, appreciation, and aesthetic reverie are considered to be of less importance than "knowing" about a work of art, and then considering it primarily as a historical document. Conservators are, in the final instance, often responsible for other people's ability to appreciate works of art; they should never forget that when viewers look at a work of art they do so to see the artist's creation, insofar as possible, and not the conservator's handiwork.

Perhaps the most complicated of all the conservator's tasks is achieving the acceptable balance between protecting the documentary information provided by a work of art's accrued historical value and ensuring that its aesthetic imperative, its demand to be appreciated aesthetically as a work of art, will be respected. The object—Keats's "silent form"—is always there before us, but coming to a proper understanding of a work's many values and the intentions behind it is fraught with immense problems, as is our understanding of an even greater mystery: eternity. Time inevitably insinuates itself between the work of art and its audience; and as each day passes something more is lost, perhaps imperceptible at any given moment, until "we who delve in beauty's lore / Know all that we have known before / Of what inexorable cause / Makes Time so vicious in his reaping."[4]

Time and the Past: A Voiceful Echo

Like Circe, the past is both intriguing and deceptive. It easily arouses our curiosity to "see through a glass darkly" and look backward into time. Our pursuit, however, will soon be frustrated; for the past, with all its myriad and subtle bygone realities, can no more be pinned down than quicksilver. And no matter how objective, how methodically historical we attempt to be, our perception of the past will always remain, to a greater than lesser degree, colored by our own times. The past will always have a contemporary tint to it, for as Goethe wrote, "What Spirit of the Times you call / Good Sirs, is but your spirit after all / In which the times are seen reflected." Our perceptions will also be far more personal or subjective than we usually like to admit. Does this mean then that the past, and a meaningful understanding of it, is beyond our grasp? Even when dealing with our own past, we sooner or later discover that our memories start playing tricks on us, and we are all selective about what we choose to remember and forget.

While we cannot go back in time and keep everything we might like, the past does, as it were, speak to us. John Ruskin, man of letters, critic, apologist for Turner, champion of the British working classes, accomplished draftsman and watercolorist, and Slade Professor at Oxford, was one of the most perceptive writers on art and architecture who ever put pen to paper.

Writing in 1948, Berenson still considered Ruskin "the greatest writer on art up to date."[5] Today, Ruskin is out of fashion for a variety of reasons. His eloquent style arouses distrust in people who have been brought up to write prosaically; his obtrusive religious beliefs are off-putting; his thought, especially in his later years, when madness got the upper hand, is often rambling and disjointed; his ideas (such as a cityscape with uniform shop fronts and uniform lettering) frequently place him in the limbo of "nutter country." And yet, none of this can detract one iota from the immense value of his trenchant critical insights. In "The Lamp of Memory," chapter 6 of his *Seven Lamps of Architecture,* written in 1848, Ruskin remarks that "the greatest glory of a building . . . is in its Age, and in that deep sense of voicefulness, of stern watching, of mysterious sympathy, nay, even of approval or condemnation, which we feel in walls that have long been washed by the passing waves of humanity" (Ruskin, Reading 1, page 42).

Buildings achieve such "voicefulness" from the succeeding generations that use them; for each person, each generation, leaves some mark behind, however slight or considerable. This sense of accumulated voicefulness is given the term *age value* by Riegl (Reading 6, pages 72–75). When Ruskin looks at the past, he does so not as a romantic longing for days and things long gone, but as a realist who sees the past in the context of continuity with the present and future. The past is there to inspire us. We can learn from the past, and we should respect what is left of it. One thing we cannot do with the past is replicate it. We can only destroy it, and that is why Ruskin is so violently opposed to restoration and unsympathetic additions to old buildings. Furthermore, according to Ruskin, when we build, we should do so for the future and it should "be such work as our descendants will thank us for" (Ruskin, Reading 1, page 42). By this, he does not mean that what we build must be "traditional"—say a shopping mall in English Tudor style—but that it takes into account the unfolding continuity and development of human productions through time. And, most important, we must always do our best because "old work" was always the result of their builders' "utmost."[6] And, like all human works, our productions, too, will gradually acquire voicefulness.

Is the past really out there speaking to us like some entity forever frozen in time? While the past does speak, the past itself is forever changing. Time is simultaneously all-inclusive and selective. At one given moment in time, the past is one thing; at the next given moment, it is another. In that space between any two moments, things have been added to and deleted from the past. At some given moment, the last traces of a ruin will finally disappear and thereby bow out of the past, at least as a physical object. The past, then, has many movable voices, like a symphony orchestra. However, before we will ever be able to hear the music of the past, its voicefulness, we will have to familiarize ourselves as thoroughly as possible with its instruments.

No matter how well we do this, we will never succeed in hearing absolutely authentic music. Like the music produced on period instruments for so-called authentic performances, the past's voicefulness will always sound, to varying degrees, somewhat false, somewhat shrill.

Preparation for a Journey into Time: Aptitude and Education

If the past speaks, do people listen, and—perhaps even more important—are people capable of listening? In these fast-moving times in which we live, do people even want to listen to the past anymore? If popular educational programs and documentaries on television are any indication of general interest, then it is probably safe to assume that the past still holds a fascination. But how do we get close to it and still remain as free as possible from romanticized notions, or worse, from a clinically archaeological, fragmented approach?

In the introduction to his *Aesthetics and History in the Visual Arts*, 1948,[7] Bernard Berenson, the renowned connoisseur of Italian Renaissance painting, explains his approach to art and art history. This book was intended to be a summing-up of his thought on aesthetics, art criticism, humanism, history, and art history. Despite the fact that it is at times a bit rambling, *Aesthetics and History* provides a synthesis of his approach to art and life, which to him were intimately related, and which he was busy adjusting and refining up to the time of his death in 1959. For Berenson, anyone who wants to understand about historic artistic productions (his primary concern in regard to the past) must have a broad classical, humanistic education, a knowledge of various languages, be well read, have a love for music—or, in other words, be a highly educated, cultivated human being. Equally important, the person must also have an aptitude for seeing and appreciating, what can be termed *visual discrimination*. Writing in his ninety-first year, Berenson noted, "Only now do I realize how gifted I was for seeing and feeling. No wonder I was eager to find out why I felt works of art, why they meant so much to me, why I lived them!"[8] Such an ability to see, however, cannot simply be drawn upon like a magic wand; it must be trained. The process is lengthy. Writing in 1948, he asked, "Has it not taken me sixty years to learn to feel, to analyze, and to understand the intimate spirit of a work of art, and to realize what differentiates it from another?"[9]

Undoubtedly, this sounds very personal, very subjective, especially in a period when so much weighty effort has been expended to make art history "objective" and "scientific." Max J. Friedländer, former director general of the Kaiser Friedrich Museum in Berlin and the greatest connoisseur of Northern European painting to date, astutely remarked, "Art history, which

is frequently described as young, or even as still in the nursery, appears to the typical university mind as a playful child in need of education, who must first of all learn seriousness from the grown-up branches of learning" (Friedländer, Reading 14, page 145). Berenson's affirmation that "there are many approaches to the history of art—as many, perhaps, as there are individual students," may cause many a professor to shake his or her head in despair. What Berenson is saying, however, is not that everyone's emotive impression is of equal value, or that *de gustibus non est disputandum* (there is no use arguing about taste). Because he believed the history of art's primary concern should be "with the work of art as it affects the spectator, the listener, the enjoyer," Berenson never denied that our personal response to a work of art is of utmost importance. To be significant, however, such a response had to come from a highly cultivated individual with an aptitude for visual appreciation that has been thoroughly trained and well exercised. As he emphasized in the introduction to *Aesthetics and History,* "It has been my life's work to 'live' the work of art, to turn it over and over on my mental palate, to brood, to dream over it; and then in the hope of getting to understand it better I have written about it" (Berenson, Reading 2, page 46).

Like Berenson, Friedländer acknowledges the role erudition plays in our response to art but, along with Berenson, emphasizes that true appreciation, or meaningful comprehension, of art depends upon the receptive powers of the beholder. One does not have to be an artist to understand art, but one must, like the artist, possess imagination. Such people are called the "artistically gifted" by Friedländer, and, while they are incapable of producing art, they do possess artistic insight and are able to grasp the full significance of a work of art. Such a talent is platonic, and Friedländer dubs the insightful lover of art a "Raphael without hands" (Reading 14, page 141). Berenson also emphasizes that one must see as the artist sees. A good visual memory is also a requisite, as Friedländer asserts, "Emotion and the senses have a much better memory than the intellect." Since the lover of art becomes excited by looking at works of art and has an "emotional sympathy" for them, the person will experience "delight in contemplation" (Reading 14, page 141). Pure enjoyment, for both Friedländer and Berenson, comes very close to being the *summum bonum* of our interest in art. Berenson even went so far as to posit that "the *raison d'être* of a work of art is the ideated [10] pleasure it can give us, and the way it feeds and enlarges our capacity for feeling it." [11]

Clive Bell: Sensibility and the Perception of Significant Form

Clive Bell, art critic and a member of the Bloomsbury group, published a book titled *Art,* 1914, in which he first expounded his theory of "significant

form" (Reading 3, page 48). It has had far-reaching consequences on how we have come to see form and construction in all the arts. Bell is in full agreement with Berenson and Friedländer concerning the essential "equipment" necessary to appreciate art. He opens his chapter, "The Aesthetic Hypothesis," by clearly stating that "without sensibility a man can have no aesthetic experience." He further affirms that "any system of aesthetics which pretends to be based on some objective truth is so palpably ridiculous as not to be worth discussing. We have no other means of recognizing a work of art than our feeling for it" (Reading 3, page 48). While such an unequivocal dismissal of an objective aesthetic will undoubtedly upset some writers on aesthetics, Bell's stance is comparable to that of Friedländer and Berenson. The latter also criticized "most so-called aesthetics and treatises on art in the abstract," because "they seldom if ever betray that the author 'lived' the work of art. They are the outcome of reading and cogitation."[12]

Bell, however, almost makes it too easy for the potential art lover. According to Bell, all one needs to appreciate or comprehend a work of art is "a sense of form and color and a knowledge of three-dimensional space" (Reading 3, page 50). As important as these abilities are, they are not enough. They may, however, be sufficient for people who agree with Bell that "Art" is exclusively "significant form," that is, a combination of lines and colors that produces "certain forms and relations of forms." Here, of course, Bell does not so much part company with Berenson and Friedländer as ostracize himself by using his concept of significant form almost exclusively in the context of abstract art. Bell expresses his antipathy for what he termed "descriptive painting," which includes most of Western painting up to Cézanne; though he did, somewhat grudgingly, admit that some descriptive pictures have "formal significance." Although he limited the relevance of his own theory by insisting it was especially pertinent to painting other than descriptive, Bell did manage to underscore the importance of the more abstract elements in the composition of a painting—line, color, and the handling of space. Despite his emphasis on abstract art, Bell's approach is basically in agreement with that of Berenson and Friedländer (see Bell, Reading 3, page 50).

For Bell, as for Berenson, the work of art is always of primary importance; all else—the artist, the times in which the artist lived, materials, and techniques—are secondary. Succinct as ever, Bell summed up the work of art's unique significance: "We cannot know exactly what the artist feels. We only know what he creates" (Reading 3, page 52). This emphasis on the work of art as the only relevant piece of "evidence" is the cornerstone of Berenson's approach to connoisseurship and aesthetics. Whether one is looking at a work of art for pleasure—and for Berenson, study was equivalent to pleasure—or for the purpose of attributing it to a particular artist, it is with the

work that one begins and ends. Of course, Berenson was aware of the pertinence of historical information. "As for a historical interest in a work of art, I deny that it can be disassociated from the aesthetic one; paintings carry with them so much of the environment from which they were produced. But by expanding its particular historical interest one arrives at a better understanding of the beauty of a work of art, and thus from contact with new forms of beauty one's taste is expanded."[13] Berenson's "environment" is akin to Ruskin's "voicefulness," and the more one understands of the environment, the more one appreciates the work of art.

Kenneth Clark: A Way of Looking as the Gateway to Comprehension

Ultimate comprehension, though, depends upon our ability to look. "To develop a taste for painting, only one form of teaching is possible: looking at them until the painting has penetrated into you and constitutes part of your soul."[14] We must not allow Berenson's somewhat mystical terminology to distract us from the accuracy of his observation. How do you go about making a painting part of your soul or imprinting it upon your visual memory? Kenneth Clark, a Berenson protégé who became one of this century's greatest writers on art, offered a "method" in the introduction to a series of essays written for the *Sunday Times* of London and later published as *Looking at Pictures* (see Reading 4, pages 56–59). Sixteen paintings, all of them masterpieces, are looked at and commented upon, and the method shows how the subjective and objective approaches must blend if our appreciation is to be meaningful.

Clark begins by saying there is no one way, no "right way" of looking at works of art. Again, pleasure figures prominently as the reason for looking, but Clark clearly states that "art must do something more than give pleasure." Exactly what that *more* is, he explains as an "increase [to] our energy of spirit" (Reading 4, page 57). This derives from Berenson and is what he meant, in part, by the terms "House of Life" and "life-enhancing." In his *Aesthetics and History in the Visual Arts*, Berenson offers a definition of life-enhancement: "I mean the ideated identification of ourselves with a person, the ideated participation in an action, the ideated plunging into a state of being, or a state of mind, that makes one feel more hopefully, more zestfully alive; living more intense, more radiant a life not only physically but morally and spiritually as well; reaching out to the topmost peak of our capacities, contented with no satisfaction lower than the highest. The impulse to this ideated identification possesses everyone."[15] For that matter, so does the tendency to daydream, but ideated or imagined participation is far more than daydreaming. Great art has the ability to provide the "artistically gifted"

observer with an uplifting experience. Bell put it directly: "The characteristic of a work of art is its power of provoking aesthetic emotion; the expression of emotion is possibly what gives it that power" (Reading 3, page 53).

Berenson's "ideated identification" is a bit more complicated than this: The idea that results in our mind is correlative to the work of art before us. An interplay occurs between the work of art, which provides, and the spectator, who accepts and transforms the experience into one that increases "our energy of spirit." A similar interaction occurs for Bell, but it is more abstract, more removed from any content in a painting, and is solely preoccupied with form. "The contemplation of pure form leads to a state of extraordinary exaltation and complete detachment from the concerns of life" (Bell, Reading 3, page 54).

Clark believes that the ability to look can and must be trained, and he explains how he looks at pictures. There are four steps: "impact, scrutiny, recollection, and renewal." Impact is the first impression, which scans the painting, taking in "tone and area, shape and color." For Clark it is "immediate" (Reading 4, page 57). Friedländer reckoned that "[t]he first impression is deeper than all subsequent ones, of different kind and of decisive importance. The first contact with a work of art leaves a profound imprint, if only because it is connected with excitement. The receptiveness of the eye is heightened by that which is new, strange, unexpected, different" (Friedländer, Reading 14, page 152). First impressions are equally important for Bell, who believed that they were usually more cerebral than emotional. One first critically judges, even hastily or almost intuitively, the correctness of form. This, Bell asserts, "would explain the fact that passing rapidly through a room we recognize a picture to be good, although we cannot say that it has provoked much emotion" (Reading 3, pages 49–50).

From impact, which concerns the general or abstract pictorial qualities of significant form, Clark proceeds to the specific (e.g., a passage where the drawing has captured especially well what is represented, or an area of exceptionally fortuitous color). During both phases—impact and scrutiny—the viewer experiences what Clark terms a *pure aesthetic sensation*. This can be a strong excitation, an emotion comparable to a sense of reverie. Berenson's writings are filled with references to aesthetic reverie. The intensity of such abstract ravishment is considerable, as witnessed by Berenson's account of his reaction to "disembodied color" in the Upper Church at Assisi. "It did not belong to any shape. It was in the air, produced by reflections, from the stained glass, the frescoed walls and ceiling. I neither saw nor felt either. I was bathed in color. It was a revelation almost as rejuvenating as the one I had years before with regard to form and movement while facing the facade of San Pietro at Spoleto. I say rejuvenating, because I felt as if born to a new kingdom, to an enlarged life. Since then I have got to enjoy color as much as

smell, almost as much as taste, and as sensuously."[16] As with lovemaking, such intensity of feeling cannot be maintained *in extenso*. Even an experienced lover of art like Clark was only able to indulge such reverie for about two minutes before alleviating the tension by recollection.

By "recollection" Clark meant drawing upon accumulated erudition (i.e., knowledge of history, the development of styles, iconography, the artist's biography, familiarity with materials and techniques, and recognition of the restorer's hand). All of this he somewhat dismissingly refers to as "nips of information," and it is at this stage that historical analysis takes place. While the intellect is occupied, the eye, like a boxer during a break in a prizefight, is allowed to recoup energy before the next onslaught of aesthetic reverie. During this final stage of visual communing—renewal—an ideated synthesis occurs in Clark's imagination between what he sees in the painting and what surrounds him in his daily environment. "I find myself looking at my room as if it were a Vermeer, I see the milkman as a donor by Rogier van der Weyden, and the logs on the fire crumble into the forms of Titian's *Entombment*" (Clark, Reading 4, page 58).

Widely drawn comparisons, which must, however, be incisive to be meaningful, help relate art directly to our lives, intimately to what we see and experience each day. Berenson constantly drew such analogies between what he saw in works of art—whether paintings, statues, buildings, or whatever—and what he observed in his environment. His ability for making uniquely quintessential comparisons between paintings, artists, landscapes, objects, and so on, that at first sight seem unrelated, allowed Berenson to capture the intrinsic elements of a work of art's individual character and power and to express them in a few sentences, thereby concisely revealing an integral part of its relevance to our lives. In Portofino in 1947 he observed "the foliage exactly as in Giorgione, feathery yet exquisitely massed and each mass delicately drawn."[17] Anyone familiar with Giorgione's manner of creating foliage will appreciate the vivid accuracy of this description and the use of the word *feathery* (see Fig. 4). Art makes us see our surroundings in a different way; it teaches us to see things as the artist saw them.

Erwin Panofsky: History, Aesthetic Significance, Intent, and Meaning

Before proceeding to some of the ways of looking at what Bell would term "significant form," in other words, at the more purely abstract or constructive elements in a work of art, it must be underscored that the type of pleasure to be derived from looking at art as emphasized by Berenson, Friedländer, Bell, and Clark is not what Erwin Panofsky would label *appreciationism*. As a young man, Panofsky, the expert on iconography, was influenced by Heinrich Wölfflin and Alois Riegl (both of whom are discussed on the following

Figure 4
Giorgione, *The Tempest,*
ca. 1505–10. Oil on canvas.

pages). Panofsky can be termed the art historian's art historian. Like Berenson, he was a polyglot, immensely well read, and his interest in his subject was catholic. Whereas both were scholars, Berenson was more the connoisseur than historian, and Panofsky was almost exclusively the historian. In the nineteenth century, the philological approach to art history arose, which reduced works of art to the status of documents. They have a message for us, whether it be iconographic, technical, stylistic, historical, social, political, religious, et cetera; "everything," as Lionello Venturi said, "except their artistic imagination." Art historians of this ilk—and Panofsky was one of them—seem to be content with erudition for erudition's sake. Venturi, who before World War II was professor of art history at the University of Turin, believed that one had to move beyond art history to art criticism in order to understand fully any work of art. For him, art was far more than a document; it was "something nearer certainly to what Hegel saw [art expresses the ideal] than to what is seen by the philologist. So that, looked at in retrospect, the enormous philological labor on art of almost a century and a half appears to us very much more like an imposing mound of stones than an architecture in stone."[18]

While this criticism applies to many art historians, it would be unfair to imply here that it fits Panofsky to a tee. He erected some mighty "architec-

ture in stone" in his always elucidating books and articles, and he was fully "aware of the dangers inherent in what has been decried as 'Teutonic' methods in the history of art."[19] In his essay, "The History of Art as a Humanistic Discipline" (see Reading 5, pages 60–68), he warns that our understanding of art must go beyond indiscriminate or ill-informed appreciationism. For Panofsky, works of art were "not always created exclusively for the purpose of being enjoyed," but they always have "aesthetic significance," and, most important, "demand . . . to be experienced aesthetically." Like Berenson, Friedländer, Bell, and Clark, Panofsky also believes that "[o]nly he who simply and wholly abandons himself to the object of his perception will experience it aesthetically" (Reading 5, page 61). Why do works of art "demand" to be experienced aesthetically? In comparison to practical objects, works of art—which may also serve a practical purpose—have an "intention" given them by their creators. Some objects that were never intended as works of art—Panofsky uses African household utensils as an example—have been turned into art objects by our own (Western cultural) "intentions."

Before the art historian can properly study a work of art, he or she must both "re-enact the actions [of the creators] and . . . re-create the creations" (Panofsky, Reading 5, page 62). This by now sounds familiar, for it is more or less Berenson's exhortation to "live" the work of art. Although Panofsky and Berenson basically go through the same process of re-creation, they do so to achieve different goals. Berenson wanted to achieve life-enhancement, an enriching of both his soul and his understanding of a work of art as a work of art (i.e., by comprehension of form and movement). This understanding of a painting goes much further than a mere intellectual comprehension of its formal pictorial elements, an approach favored by Panofsky and Wölfflin, as will be discussed. If the artist has mastered these, he will achieve movement and tactile values and the spectator must be able to perceive them if he is to succeed in his quest for pleasure (see Berenson, Reading 8, pages 101–3). This realization on the part of the art lover, the result of an interaction between observer and the observed, is what provides enjoyment. Or, as Berenson put it, "to suppose that we love pictures merely because they are well painted, is as if we said that we like a dinner because it is well cooked, whereas, in fact, we like it only because it *tastes* good" (Reading 8, page 104).

Panofsky wanted to achieve a more scholarly and less aesthetic understanding, and he reveals his tendency toward the philological approach. What really interests him about a work of art is not its material presence, but its meaning. To get to that meaning we have to carry out a "rational archaeological analysis," by which Panofsky means thorough scholarly research. This, however, is not all. We must also subject works of art to "an intuitive aesthetic re-creation," which takes the matter of quality into consideration. Aesthetic re-creation, however, is not as simple as it may sound, and the

process is dual. "[W]e build up our aesthetic object both by re-creating the work of art according to the 'intention' of its maker, and by freely creating a set of aesthetic values comparable to those with which we endow a tree or a sunset" (Panofsky, Reading 5, note 4, page 66; and the introduction to Part II, pages 162–75). Panofsky freely admits, therefore, that it is always difficult to determine precisely what the creator's intention was.

What Panofsky seems to understand by aesthetic values is a romantic immersion into a golden glow and the defects brought on by age. This is what Riegl basically means by age value. At this point, a surprising dichotomy becomes glaringly apparent between Panofsky's and Berenson's approaches to works of art. For Berenson, the primary meaning of a work of art is contained quite simply in its physical or material presence. That is why Berenson's analysis of works of art concentrates on formal qualities. His aesthetic reverie results from his perception of the "abstract" disposition of pictorial elements (i.e., "significant form"). For Panofsky, the primary meaning of a work of art comes from its message as a document. Formal qualities, what Riegl calls *artistic value,* were of secondary if not lower importance to Panofsky. This is why when he, the consummate scholar, actually looks at an object—the sculptures on Chartres cathedral, for instance—he sees it subjectively and almost exclusively in terms of its age value—in other words, romantically.

Despite their differences, Berenson and Panofsky realized that comprehension, and therefore meaningful appreciation, of a work of art depended on an amalgam between scholarship and what Panofsky called *intuitive aesthetic re-creation* and Berenson termed *aesthetic reverie.* When we study a work of art, both processes are at work simultaneously and interact with one another. This is, in effect, the interplay between what Clark terms *scrutiny* and *recollection.* Like Berenson, Friedländer, and Clark, Panofsky believed that "[t]he re-creative experience of a work of art depends, therefore, not only on the natural sensitivity and the visual training of the spectator, but also on his cultural equipment" (Panofsky, Reading 5, page 63). If the individual's preferences lie essentially with aesthetic enjoyment, the art lover will have to achieve a balance between it and scholarship to avoid appreciationism.

Alois Riegl: Ruskin's "Voicefulness" Interpreted as "Values"

An approach that at first sight appears to a large degree removed from aesthetic appreciation, meaningful or otherwise, was systematized by Alois Riegl, an Austrian art historian with a bent for a rigidly intellectual categorization of works of art. Coldly scholastic to the utmost, his system of view-

ing works of art as possessors of various "values" reveals nonetheless an inter-play between beholder and beheld in which aesthetic considerations do play a role. Exactly how this reciprocity affects our perceptions can have far-reaching consequences with regard to conservation and restoration.

Works of art have values—in fact, several values simultaneously—that interact with one another and ultimately influence how we see a work of art, especially, but not exclusively, in the context of time. Riegl's "The Modern Cult of Monuments: Its Essence and Its Development" was originally published in 1903. By "monuments" we do not have to think solely in terms of buildings, for Riegl's "values" can be applied to all works of art. Regardless of quality or importance, all works of art are "historical monuments" and at the same time "monuments of art." Aesthetic characteristics are called "artistic value" and are properties of a work that have "specifically artistic properties, such as concept, form, and color" (Reading 6, page 71). Here again we have Bell's "significant form." Raising the question as to whether or not artistic value in the past was "just as objectively present as historical value" in any particular monument, Riegl addresses the problem of intention (Reading 6, page 71). Was the intention we see in a work of art put there by its maker or by our subjective interpretation? Riegl believes we have turned many works into "monuments" that were never intended as such by their creators, who were primarily concerned with practical rather than artistic goals.

Age value is easy to recognize and it has a strong emotional appeal (Reading 6, pages 72–83). It is what Ruskin meant by "voicefulness" and is the product of the accumulated effects of time. Panofsky's romantic appreciation of the weathered statues on the cathedral at Chartres is the result of a preference, by no means exclusive, for age value. As Riegl observes, the twentieth-century viewer is as disturbed by "[s]igns of decay (premature aging) in new works . . . as much as signs of new production (conspicuous restorations) in old works," and "particularly enjoys . . . the purely natural cycle of growth and decay" (Reading 6, page 73). This regard for age value is not, as Riegl suggests, unique to the twentieth century, as shown by the fondness for ruins, even artificial ones, in the eighteenth century. Those who place primary importance on age value believe that preservation of monuments should allow for a gradual, but nonetheless final, decay. Works of art are allowed to die with dignity, as it were.

Age value, which can easily be seen and understood by all, ultimately comes from the recognition of historical value. Awareness of historical value is the result of study and reflection and is the specialist's turf. Historical value, as Riegl argues, emphasizes the importance of original condition and is dependent upon it for the degree of its significance. Since the original condition enjoys the highest priority, works must be maintained in as pristine a

condition as possible. Riegl's emphasis is firmly on the thorough conservation of all original elements that are still intact. Any additions to the original condition will have to be removed to maintain the work's integrity.

Historical value asserts the importance of information about the past and the knowledge it can provide us about styles and their development. When Riegl says that "historical knowledge becomes an aesthetic source in addition to and aside from a feeling for age value" (Reading 6, page 76), he seems to mean that recognition of styles—for example, through accumulated knowledge of and familiarity with them—provides aesthetic insights. These in turn become pleasurable through our awareness of and emotional response to age value. There is no aesthetic reverie here, nor any intuitive aesthetic re-creation. Riegl was too cerebral, too noetic (literally, intellectual to the exclusion of emotion) in his approach to works of art to admit much of an emotional response into his system. Almost for good measure, just in case anyone might ever accuse him of propagating aesthetic reverie, he adds that "[t]his satisfaction is certainly not immediate (that is to say, artistic); but one of intellectual reflection, for it requires art-historical knowledge" (Reading 6, page 76). Berenson, Friedländer, Clark, Bell, and even Panofsky would have said that the satisfaction is *enhanced* by art-historical knowledge.

Throughout history certain monuments have been created to do honor to a specific event, person, place, et cetera. Riegl gives such a monument "deliberate commemorative value" because it aims "to keep it perpetually alive and present in the consciousness of future generations" (Reading 6, page 77). Deliberate commemorative value therefore demands restoration. As for "use value," many buildings, which are also monuments, deliberate or historical, continue to be used. Such monuments cannot be abandoned to the slow deterioration inherent in the concept of age value. According to Riegl, they will require rigorous maintenance, or conservation, and, when necessary, restoration. Optimum condition is the objective of *use value* (Reading 6, pages 79–80), as it is of *newness value* (Reading 6, pages 80–81).

Newness value, like age value, can be recognized and valued by everyone, but Riegl says the masses have a preference for it. Diametrically opposed to age value, newness value demands restoration. In the nineteenth century, much restoration work was carried out—especially on buildings—that attempted to obliterate the effects of age and achieve what was considered a historical integrity by revealing the "original condition." This was done by removing later additions and/or reconstructing lost elements. Such an approach is a synthesis of the newness and historical values and is best illustrated by the work of French restoration architect Eugène-Emmanuel Viollet-le-Duc (see Reading 30, pages 314–18).

Riegl isolated what he termed "relative artistic value," which, he suggested, can only be assessed by people who are "aesthetically educated." Exactly what is meant by relative artistic value is never made absolutely clear by Riegl. Artistic value depends either on a historical concept of an objective aesthetic, which Riegl says has never been satisfactorily defined, or on the requirements of the modern *Kunstwollen* (will for art, or artistic intentions). He concludes that "If there is no such thing as eternal artistic value but only a relative, modern one, then the artistic value of a monument is no longer commemorative, but a contemporary value instead" (Reading 6, page 71). What he seems to be saying here is that an objective aesthetic implies an intention and results in an eternal art value, thereby producing a monument with deliberate commemorative value. Looking through modern eyes we no longer look objectively or historically, but rather subjectively at monuments. Our standards reflect the requirements of the modern *Kunstwollen*; or, in other words, our standards reflect how we see, and want to see, monuments in the context of the here and now. This is "contemporary value," and it is opposed to historical and commemorative values.

Riegl's "values" are in constant interaction: newness and historical, historical and age, commemorative and age, age and use, use and historical. The constellations can be constantly reshuffled, and will be, as succeeding generations consider these values through the optics of their way of seeing (i.e., their contemporary value and *Kunstwollen*). When Riegl wrote "The Modern Cult of Monuments," he confidently stated that as far as the masses were concerned, "only the new and complete is beautiful; the old, fragmentary, and discolored is considered ugly" (Reading 6, pages 80–81). While people still do, in general, have a preference for the "new" look, a far more subtle appreciation of age value by the public has been achieved, thanks, to a large extent, to the conservation profession. This, in turn, will undoubtedly change again in the future. Riegl's values will therefore remain in permanent flux as one generation's contemporary value gets added to the following generation's historical value, and so on.

Heinrich Wölfflin: A Methodology of Visual Analysis

It is easier to categorize concepts such as values, which belong, are given, or accrue to monuments, than to establish a methodology of visual analysis of the formal elements in a work of art. Heinrich Wölfflin, a Swiss art historian and pupil of the legendary Jacob Burckhardt and Adolf von Hildebrand, wrote his *Principles of Art History: The Problem of the Development of Style in Later Art* in 1915.[20] Wölfflin first addressed the problem of how we should look at works of art and analyze their formal characteristics in his *Classic Art,*

1899. His *Principles,* one of the "classic" texts on comprehending the development of style, attempts to analyze "the mode of representation as such," which, of course, depends upon "the mode of perception."[21] In other words, how artists see determines how they portray, and Wölfflin reminds us that "we only see what we look for, but we only look for what we can see" (Reading 7, page 98). Each age, each people, each individual sees differently, and how we see at any given moment in time or place determines period, national, and individual style. Wölfflin cautions that "not everything is possible at all times. Vision itself has its history, and the revelation of these visual strata must be regarded as the primary task of art history."[22] The corollary for restoration, especially reconstruction of missing elements—whether on paintings, statues, buildings, et cetera—is obvious.

Wölfflin chose to illustrate the validity of his classifications of style by establishing a schema of five antipodal ways of "imaginative beholding," or seeing.[23] Even though his system is exclusively devoted to demonstrating the differences between Classic (or High Renaissance) and Baroque art, he believes it valid, with adjustments, for other periods and other types of art. The five antithetical concepts are: linear and painterly, plane and recession, closed and open form, multiplicity and unity, and absolute and relative clarity. *Linear* achieves form by line, by giving objects a sense of a tangible reality that is bounded. They are consequently set off against their background. *Painterly* relaxes line and creates form by merging objects and their background. It realizes a sense of visual reality. *Plane* results from line, and the greatest clarity of form is in one plane. With the relaxing of line, contours and plane are discounted, and objects are now seen primarily in terms of spatial *recession.* While every work of art, if it is to be successful, must be a self-contained entity, one can speak of a *closed* composition in Classic art and an *open* or loose composition in Baroque art. Open form creates the impression that the composition goes beyond the limits of what is actually seen. In a Classic composition, the individual elements, while integrated into the whole, always maintain a degree of independence. Baroque art makes all individual elements subservient to a single theme or overriding principle of pictorial *unity.* However, there is unity in Classic art, but the parts that compose it are more articulated than in Baroque art. Classic art strives for perfect or *absolute* clarity, which gives objects a plastic feeling or tangible reality. *Relative* clarity does not sacrifice artistic form for effect, but the clarity of an object is treated equally with overall composition, color, and light. An object becomes part of an entire effect rather than an individual element contributing to an entire effect.[24]

The essence of Wölfflin's five pairs of concepts is contained in the antitheses linear and painterly, and he admits that these five pairs "to a certain

extent . . . involve each other and, provided we do not take the expression lit-
erally, we could call them five different views of one and the same thing."[25]
Wölfflin applied his schema to drawings, paintings, sculpture, and archi-
tecture, and while no arbitrary system, no matter how relevant, can ever
work equally well for such divergent material, his does succeed in showing
how imaginative beholding manifested itself during various periods in stylistic
similarities common to various art forms, which at first sight might not be
apparent. What Wölfflin offers us is a method of analysis that concentrates
solely on determining and classifying significant form. Like Berenson, he has
a preoccupation with the abstract building blocks in a work of art. Unlike
Berenson, Friedländer, Bell, Clark, and Panofsky, he does not derive any aes-
thetic reverie from his perceptions. Even Riegl admitted that people derive
pleasure from their awareness of age value and newness value. Wölfflin
approached his subject with a scientist's rather than an aesthetician's eye,
but the results of his research are only relevant in the context of aesthetics,
or how we look.

Linear and Painterly: Form Defined and Tactility
versus Form Unified and Visual Effect

In the linear style, line defines form, and forms are legibly distinguished from
one another. Line, of course, still exists in the painterly, but its edges or its
boundaries are unstressed. Through this and the use of lights and shadows,
which are also used in the linear, a semblance of movement is created. This,
in turn, results in unity. In the painterly, "not the separate form but the total
picture is the thing that counts, for it is only in the whole that that mysteri-
ous interflow of form and light and color can take effect" (Wölfflin, Read-
ing 7, page 86). This is why, for example, a technique like *tratteggio* could
never be used successfully for in-paintings on Baroque pictures.

 The linear style is tactile and provides a "distinctness plastically felt.
The evenly firm and clear boundaries of solid objects give the spectator a
feeling of security, as if he could move along them with his fingers, and all
the modeling shadows follow the form so completely that the sense of touch
is actually challenged." An artist's eye "feels along the body" and his drawing
has "an element of physical grasping" (Reading 7, page 87). When looking at
a linear or tactile work of art, our eye repeats the operation and "feels" its way
over it. As Joseph Addison said in "The Pleasures of the Imagination," 1712,
which may be the first treatise on aesthetics, "our Sight . . . may be considered
as a more delicate and diffusive kind of Touch."[26] For Berenson, one of the
most important pictorial elements was tactile values. Wölfflin's influence on
the young Berenson was immense, and at the age of eighty-three Berenson

had not forgotten it. He noted in his diary that "Wölfflin's *Prolegomena zu einer Psychologie der Architektur* [Introduction to a psychology of architecture] presented for [his] doctoral thesis in 1886 (a year before my graduation), contains in essence and more than in essence my entire philosophy of art."[27] This and Wölfflin's *Classic Art*, 1899, were of seminal importance to Berenson when he wrote the four essays between 1894 and 1907 that were later published as *The Italian Painters of the Renaissance.*

Bernard Berenson: Tactile Values and Aesthetic Appreciation

Whereas Wölfflin recognized and analyzed the sense of the tactile, Berenson went further and demonstrated how an artist's successful creation of plastic form influences our psychological response to a work of art. A well-defined rendering of form, whereby objects are given body and are articulated in space, gives them artistic existence. "This intimate realization of an object comes to us only when we unconsciously translate our retinal impressions of it into ideated sensations of touch, pressure, and grasp—hence the phrase 'tactile values'" (Berenson, Reading 8, page 104). (*Tactile*, a term frequently used by Berenson, refers to the creation of the illusion of the third dimension in a picture, the sense of space surrounding a figure. This stimulates our desire to touch an object "appearing" in the round.) While this sense of touch is ideated or imagined, our desire to actually touch is, as Berenson reminds us, instinctive. It is an obvious way of bridging the gap between beholder and beheld, of crossing the chasm between the intellectual and the physical appreciation of a work of art. Actual touching provides "immediate and 'material' communication," and Berenson expresses his sympathy for the desire to do so. "Contact is a desire for joining, love for the 'thing in itself,' of 'itness' as I call it" (see Morra, Reading 9, page 106). Since touching works of art is not encouraged by most owners, we will have to confine our appreciation to the ideated sort. But Berenson's point is well taken. Recognizing and defining linear form was sufficient for Wölfflin. For Berenson, that was the first step to aesthetic pleasure. The extent that a painting provides life-enhancement is in proportion to the extent that an artist succeeds in giving that painting artistic existence through tactile values.

Painterly Style: Form Unified and Visual Effect

With the Baroque came the visual rather than tactile painting, and Wölfflin found this to be "the most decisive revolution which art history knows" (Wölfflin, Reading 7, page 87). In the painterly, figures and backgrounds become a totality. Things are related to one another and to their surroundings by an emphasis on movement and changing appearances. A sense of the

tactile is, of course, still present, but it has been transferred from the sense of touch to the sense of sight. Our eyes "feel" the surface of paintings and delight in that. With the Baroque, more painterly effects, such as heavier impastos, were used to achieve the visual sense of unity and motion. John Brealey, former chairman of the Paintings Conservation Department of the Metropolitan Museum of Art, termed such surfaces *low-relief sculpture*. Of course, they appeal strongly to our tactile sense, our desire to touch, but the paintings themselves, as pictorial representations, appeal primarily to our visual sense.

Since sculpture is corporeal mass in the third dimension, line, as such, seems irrelevant. Yet Classic sculpture conveys a sense of line, since such statues are conceived from one principal point of view. Other views obviously exist, but the Classic freestanding statue demands to be viewed from one standpoint. As with painting, Baroque sculpture negates outline, since it is primarily concerned with movement. View leads to view. Surface treatment is also different: "Classic art loves quiet and Baroque restless surfaces," Wölfflin writes (see Reading 7, page 89), which in turn agitate and are agitated by lights and shadows. Ruskin observed how subtle such an interaction between surface and light and shadow could be. He said it was the sculptor's task to achieve "an abstract beauty of surface rendered definite by increase and decline of light—(for every curve of surface has its own luminous law, and the light and shade on a parabolic solid differs, specifically, from that on an elliptical or spherical one)."[28] The decor or setting of Baroque sculpture is especially important since it contributes to the sense of movement and unity as envisioned by the artist and/or architect. Wölfflin mentions "Northern Baroque altars, where the figures combine to such an extent with the structure that they look like the foam on the tossing wave of the architecture. Torn out of their context, they lose all their meaning, as is proved by some unfortunate exhibitions in modern museums" (Wölfflin, Reading 7, page 90).

In architecture, linear and painterly are pure conceptions of decoration since architecture does not have to imitate things. Again, quiescence and movement are contrasted, but Wölfflin cautions that all architecture and all decoration have some movement. Nevertheless, Classic decoration, no matter how lively, presents a static appearance, whereas Rococo ornament, like a kaleidoscope, appears to change constantly. Classic architecture has a basic structural form that, like Classic statuary, demands to be seen from one standpoint. Even if we move around a Classic building, this basic structural form will assert itself. Should a view distort it, we will move to another position, where it is corrected. Painterly architecture wishes to alter the basic form as much as possible, and the architect decides the standpoint(s) from which the spectator must view it. Architectural elements maintain their independence in the Classic style; they are perfectly articulated within the

overall. In the Baroque, architectural elements lose their articulation and are merged to create an overall effect of undulating movement. Light and shade accent details in the Classic and help to give a building structural definition. In the Baroque, structure or plastic form "can at times be quite submerged in the total movement [of light and shade] which plays over the surfaces" (Wölfflin, Reading 7, page 93).

Wölfflin's system of five antipodal ways of seeing was never intended to solve every question of style. Exceptions exist for any rule, but what he did was to sharpen our awareness so that we can distill the basic elements of style by careful visual analysis. He drew our attention to an obvious but often forgotten fact: "Every epoch perceives with its own eyes, and nobody will contest its right to do so, but the historian must ask in each case how a thing demands to be seen in itself" (Wölfflin, Reading 7, page 94). Berenson, too, studied works in a scientifically analytical manner, a method in part learned from Wölfflin, but he went a step further to aesthetic appreciation. Perhaps Wölfflin was incapable of admitting emotion into his response to art. Without it, however, the exercise—no matter how enlightening as to style or other issues—remains hollow. George Santayana, the philosopher and fellow student of Berenson's at Harvard in the 1880s, insisted in his *Sense of Beauty*, 1896, that "we have still to recognize in practice the truth that from these despised feelings [imagination and emotion] of ours the great world of perception derives all its value, if not also its existence. Things are interesting because we care about them, and important because we need them. Had our perceptions no connection with our pleasures, we should soon close our eyes on this world; if our intelligence were of no service to our passions, we should come to doubt, in the lazy freedom of reverie, whether two and two make four."[29]

Ernst Gombrich: Changing Ways of Seeing

How each epoch sees and how a work of art demands to be seen are themes explored in *Art and Illusion*, 1960, by Ernst Gombrich, former director of the Warburg Institute and professor of the history of the Classical tradition at the University of London. An amalgam of art history, science, and psychology, *Art and Illusion* analyzes how "what they know" and "what they see" affects how artists create a visual representation. As Wölfflin cogently noted, "we only look for what we can see" (Reading 7, page 98), and over the ages it has been the artists who have extended the borders of our vision. Imitation is not literal; it is a suggestion, and each advance in artistic vision is a struggle to manage or manipulate relationships between light, local color, and tonal gradations. Sir Winston Churchill, a talented amateur artist, summed up the process of imitation: The artist looks at what he wishes to paint, and what he

eventually puts on the canvas is a "coded message." Light is turned into paint, but it only becomes intelligible when all relationships between light, local color, and tonal gradations are clearly in balance. When this is achieved, paint is transformed into light, but "the light this time is not of Nature but of Art."[30]

To demonstrate how an artist deals with these relationships, Gombrich takes John Constable's *Wivenhoe Park, Essex,* 1816–17 (Reading 11, page 110), as an example. In traditional landscape painting before Constable, gradations ran from a pale blue at the horizon to a mellow brown in the foreground. Constable wanted to be more faithful to the local color of grass, but in order to do this he needed to adjust this local color—bright green—to harmonize "with the range of tonal gradations which the landscape painter needs to suggest depth" (Gombrich, Reading 11, page 115). His innovation was not a radical departure from tradition, but rather a widening of possibilities by an adjustment of tone. By seeing what he was looking for, to use the other half of Wölfflin's dictum, Constable in turn taught artists how to see differently. They soon followed his lead as did art lovers.

Tonal relationships in paintings are delicate and can be influenced by several factors. As time passes, pigments can and do change in intensity, some becoming darker, others lighter, some fading, others becoming transparent. Old varnish layers turn yellow, if not darker, and new varnish layers often produce an oversaturation of color that exaggerates the changes certain pigments have undergone. Since tonal relationships are responsible for the creation of depth in a painting, any disturbance of them results in a correlative alteration of spatial focus. When we look at paintings we are always aware of lights and shades and the resultant effect of depth. Ruskin believed that our interest in the handling of light was paramount to our concern with other aspects of a painting. "In painting, [the] progress of the eye is marked always by one consistent sign—its sensibility, namely, to effects of *gradation* in light and color, and habit of looking for them, rather even than for the signs of the essence of the subject" (Ruskin, Reading 12, page 129).

When it becomes necessary to clean paintings, those responsible for doing so are confronted with a double-barreled problem. Dirty varnish obscures tonal relationships; a cleaned picture will reveal tonal relationships that have been altered by changes in various pigments. Quite rightly, Gombrich says that restorers should be aware of more than technical matters. They must also take the "psychology of perception" into serious consideration. Their primary concern should be with the "light of Art" and the preservation of tonal relationships. "It is particularly the impression of light, as we know, that rests exclusively on gradients and not, as one might expect, on the objective brightness of the colors" (Gombrich, Reading 11, page 121).

Here the importance of aesthetic perceptions to the conservation profession becomes crystal clear. Conservators, or as Gombrich terms them,

"those invisible ghosts, the tone engineers," have a tremendous responsibility both to the artist and the art lover (Reading 11, page 122). They must carry out research on the aesthetics of presentation in former epochs, especially in the period in which a painting was created. What was considered to be a painting's proper look? How should it be varnished? Did artists really use tinted varnishes? Was there ever a general norm during any period? But most important, conservators must possess the aesthetic sensitivity to stay on balance and do, as John Brealey always said, "the right thing by the picture." Different approaches to cleaning exist and can be the cause of acrimonious debate. What no conservator can deny, however, is that, as Hedley insisted, "a restoration policy towards cleaning must embody a system of aesthetics."[31] The approach advocated by Gombrich is known as selective cleaning and attempts to restore balance to tonal relationships that have been changed by the ravages of time. His choice of this method is the result of a subjective aesthetic preference. But as Berenson, Friedländer, Bell, and Clark have all argued, aesthetic sensitivity will always, to a greater more than a lesser degree, be subjective. Consequently, it will be the conservator's task to achieve equilibrium between historical and technical knowledge and theories of aesthetics and aesthetic perceptions. (For a further discussion of these issues, see Part VII, "The Idea of Patina," pages 365–421.)

Connoisseurship: The Perception of "Hand" and Quality

A more "scientific" way of looking at works of art goes by the name of connoisseurship. Connoisseurship is primarily concerned with identifying an artist's "hand," what came from the artist and no one else, hence "original." It depends on a well-defined notion of the individual personality, and furthermore on the belief that this concept is of importance. Awareness and comprehension of the uniqueness of the work of a given individual is the cornerstone of connoisseurship. Interest in the artist's hand coincided with the reawakened concept of the individual during the Renaissance. Giorgio Vasari was very careful to tell his readers in his *Lives of the Painters, Sculptors, and Architects*, 1550, that he did not set out to "make a mere list of the artists with an inventory . . . of their works." Beyond the biographical account, he "tried to distinguish the good from the better, and the best from the medium work, to note somewhat carefully the methods, manners, processes, behaviour and ideas of the painters and sculptors."[32] If then, during the fifteenth and sixteenth centuries, people became aware of such concepts as originality, manner, and style, it would not be before the seventeenth century that theorists would attempt to work out a system that not only defined these concepts but also allowed lovers of art to apply them in their study and appreciation of art.

In England, the first person to address the problems of connoisseurship without using that term, however, was Franciscus Junius the Younger, Lord Arundel's learned librarian. In 1638 he published his *Painting of the Ancients*, which includes some material that touches on the basic precepts behind connoisseurship. The first short manual on connoisseurship to provide guidelines for new collectors when purchasing works of art was published in 1666 by André Félibien, seventeenth-century historiographer of the Academy of Painting and secretary to the Academy of Architecture in France. This appeared as a chapter titled "De la connoissance des tableaux" in his *Entretiens sur les vies et sur les ouvrages des plus excellents peintres anciens et modernes*. According to Félibien, there are three types of *connoissance*: (1) how to distinguish between good and bad in a picture, (2) how to determine the name of the author, and (3) how to know an original from a copy. Between 1666 and 1725 Félibien's *Entretiens* was reprinted six times. Its influence was considerable and far-reaching. When Roger de Piles published his *Abrégé de la vie des peintres* in 1699, he included Félibien's chapter on *connoissance* in its entirety.

Perhaps what can be called the first real book on the subject was published in England. Jonathan Richardson Sr., the early-seventeenth-century portrait painter and one of the greatest theorists on art, published *The Connoisseur: An Essay on the Whole Art of Criticism As It Relates to Painting* in 1719, followed in the same year by *An Argument in Behalf of the Science of a Connoisseur*. On the subject of distinguishing hands, Richardson goes much further than Félibien toward offering a method. When studying a picture, we can never be certain how far the artist either fell short of or exceeded the idea he or she had in mind, "but the Work like the Corporeal, and Material part of Man is apparent, and to be seen to the utmost."[33] The picture, then, offers us the best evidence for judging whose hand made it. Each person thinks and acts individually and differently. Richardson mentions handwriting: "If in forming an A, or a B no two Men are exactly alike, neither will they agree in the manner of Drawing a Finger, or a Toe, less in the whole Hand, or Foot, less still in a Face, and so on."[34] This anticipates Giovanni Morelli and Berenson. Differences in manner can be recognized by careful study and comparison of a large number of works. When we attempt an attribution, Richardson advises us to "compare the work under consideration with the Idea we have of the Manner of such a Master, and perceive the Similitude."[35] This is exactly how Max Friedländer made his attributions (see Friedländer, Reading 14, pages 139–53). Regardless of the help offered by secondary information, what we call sources, Richardson stresses that it is "on the Works Themselves we must Chiefly and Ultimately depend."[36]

This injunction became the foundation of connoisseurship during the nineteenth century, and a methodology was slowly developed that emphasized

a "scientific" or morphological approach. One of the great humanist connoisseurs, the type described by Richardson, was Sir Charles Eastlake. A polymath, Eastlake was both scholar and painter. His talents as collector came to good use when he became the first director of the National Gallery, London. In 1835 he wrote an essay titled "How to Observe," which was "Intended to Assist the Intelligent Observation of Works of Art." The connoisseur is defined as "he who more especially professes to *know*." He must be able to recognize the "characteristics of epochs, schools, and individual works" and to distinguish between originals and copies. Quality is the best criterion for judgment. However, this type of study forces connoisseurs to concern themselves with secondary issues—"with facts rather than truths, with appearances and results rather than with their causes." Eastlake makes an important distinction between the connoisseur and the amateur, or lover of art. The connoisseur's knowledge is used for practical purposes, to help exercise judgment, whereas the amateur's knowledge "kindles the imagination." Both aspects, combined in one person, produce the ideal judge.[37]

One of the first of the so-called scientific connoisseurs was Joseph Archer Crowe. In 1847, at the age of twenty-two, he met Giovanni Battista Cavalcaselle in a post carriage on his way to Berlin. This was the beginning of a lifelong collaboration. In 1856 their *Flemish Painters* was published, followed by *A New History of Painting in Italy*, 1864–66; and then, in 1871, *A History of Painting in North Italy*. Monographs on Titian and Raphael completed their work together. They made copious notes, with thousands of drawings by Cavalcaselle, whose penetration into stylistic characteristics went further than that of any of his predecessors. Crowe and Cavalcaselle's example served as a guideline to Morelli and Berenson.

Giovanni Morelli: The Morphological Method

Like Cavalcaselle, Giovanni Morelli was an Italian patriot. As a student of medicine in Munich he specialized in comparative anatomy. It was only in 1874 that he first published a series of essays that appeared under the pseudonym of Ivan Lermolieff. In 1881 he published a critical work on the Italian masters in the museums at Munich, Dresden, and Berlin, in which he exposed several German museum directors who had been taken in by spurious works or copies. They reacted with understandable wrath. His *Kunstkritische Studien* of 1890 and 1891 were translated into English as *Italian Painters: Critical Studies of Their Works*. In the opening chapter, titled "Principles and Method," Morelli chose the dialogue form between a Russian, Ivan Lermolieff (Morelli himself), and an Italian gentleman to present his ideas. His method rests upon one simple tenet, namely that to understand pictures "we must go to the works of art themselves, and, what is more, to the

country itself, tread the same soil and breathe the same air, where they were produced and developed."[38]

At the opening of his chapter "Principles and Method," Morelli categorically states that the professors of art history are the enemies of connoisseurs. The connoisseur understands art, while the art historian describes the development and decay of art throughout history. A teacher's "first duty [is] to point out to his pupils the characteristic features in a work of art."[39] Obviously, it is hard work to appreciate a picture, but "we cannot possibly hope to understand a work of art unless we have first succeeded in analyzing it, and from the analysis have passed to the synthesis."[40] The art historian, however, is almost exclusively interested in the culture behind a work of art rather than the work itself. Morelli admits that a historical study of culture can in some instances provide insights into stylistic change, but he finds the emphasis on the value of this approach overexaggerated. If students deal exclusively in historical theories, they will view a work of art with "preconceived notions" and fail to allow "it to speak for itself."[41]

In order to study pictures effectively, one has to pose the right questions. Form and technique are "the basis of all art study," and the would-be connoisseur must learn to look at the world with an artist's eye.[42] An artist can never be studied in isolation; his oeuvre must be compared to the works of his predecessors, contemporaries, and immediate followers. Although Morelli is highly critical of art historians, he does admit the importance of the knowledge of history. However, one must learn to look at pictures before reading about them. "All that I wish to contend is that the germ of the art-historian, if it exist at all, can only develop and ripen in the brain of the connoisseur; in other words, it is absolutely necessary for a man to be a connoisseur before he can become an art-historian, and to lay the foundations of his history in the gallery and not in the library."[43]

Morelli's method, while accepting intuition, depends upon a thorough comprehension of "the surer testimony of the forms peculiar to each great master with which observation and experience have made us master."[44] According to Morelli, who promotes his method, all decisions of authorship from Vasari to the time he was writing were based on a combination of intuition and documentary evidence. Now, however, it was possible to be more accurate and systematic by carefully analyzing the way in which artists created form, the way in which they painted, for example, a finger, an eye, a mouth, or an ear. "Every great artist sees and represents these forms in his own distinctive manner; hence, for him they become characteristic."[45] While Vasari originally made the analogy between individual style and handwriting, Junius noted the importance of *parerga* (those passages in a picture that are put in quickly, almost as an afterthought, and consequently reveal the true "handwriting" of the artist), and Richardson later reemphasized the concept

of the individuality of "handwriting." What Morelli did was to apply this concept of the uniqueness of form systematically to the study of pictures in search of an author. He repeatedly stresses the importance of being familiar with the artist's place of origin. "Like the language of a nation, the phraseology of form and color can only be properly learnt and understood in the land of its birth."[46] Anyone familiar with the variety of Dutch skies, both in reality and in the paintings of such artists as Meindert Hobbema, Jacob van Ruisdael, Philips Koninck (Fig. 5), and Willem van de Velde the Younger, will understand the accuracy and importance of this observation.

Although Morelli firmly believed that the precise perception of individual form is the most important tool of the connoisseur, he was not unaware of the importance of documentary evidence. However, he warns that all documents must be carefully studied as to authenticity and accuracy. Even when documents give the name of the artist for a specific commission, caution is necessary. A document in the Strozzi Library in Florence stated that Neri di Bicci was commissioned in 1461 to paint a Last Supper for the convent of San Onofrio. Morelli says, however, that the work was painted by Perugino's assistant, Giannicola Manni. Johann David Passavant, who first studied painting in Paris with Baron Gros before becoming a distinguished connoisseur in the early nineteenth century, thought it was by Giovanni Spagna, and Cavalcaselle gave it to Gerino da Pistoia. Since there is little agreement among three renowned connoisseurs, the document in this case may be more relevant than Morelli thought. However, the point on the value of the written word is well taken. Another matter that can complicate and hamper the connoisseur's task is the material condition of a painting. Due to restorations, it can be difficult to study the artist's methods and materials.

In the introduction to the Borghese Gallery,[47] Morelli develops his theory that an artist's hand can be determined by concentrating on the characteristic way in which he painted certain parts of the human anatomy, as, for example, hands and ears.

> Let me endeavor by an example to render my imperfectly expressed ideas more intelligible to my readers. I have already observed that, after the head, the hand is the most characteristic and expressive part of the human body. Now most painters, and rightly enough, put all the strength of their art into the delineations of the features, which they endeavor to make as striking as possible, and pupils, for this part of their work, often appropriated ideas from their masters. This is rarely the case in the representation of the hands and ears; yet they also have a different form in every individual. The type of Saints and the mode of treating drapery are usually common to a school, having been transmitted through the master's works to his pupils and imitators; while, on the other hand, every independent master has his own special conception and treatment of

Figure 5
Philips Koninck,
Panoramic Landscape,
ca. 1665. Oil on canvas.

landscape, and what is more, of the form of the hand and ear. For every important painter has, so to speak, a type of hand and ear peculiar to himself.[48]

Form is always individual but manifests itself more distinctly in the less important areas of a painting, where the painter relaxes his hand, thereby giving full play to his own unique calligraphy. Pupils and imitators are not likely to copy or imitate such minor areas, and they remain therefore the clearest evidence of a particular hand. Morelli's method works best with pictures in which the anatomy is well defined, but the principle can be applied to paintings of any school or period, provided emphasis is always placed on those parts of the composition where the artist has allowed his hand to move freely, thereby slipping into a typically unique manner.

Bernard Berenson and Max Friedländer: The Science of Intuition

Just as Mussorgsky had Ravel, Morelli had Berenson. At the age of twenty-five, Berenson made a lasting commitment to connoisseurship. Sitting at a café in Bergamo, the town where Morelli grew up, Berenson said to his companion, Enrico Costa, "We shall give ourselves up to learning, to distinguish between the authentic works of an Italian painter of the fifteenth and six-teenth century, and those commonly ascribed to him. . . . We must not stop

till we are sure that every Lotto is a Lotto, every Cariani a Cariani, every Prevatali a Prevatali, every Santacroce a Santacroce."[49] In 1920 Berenson wrote a short piece entitled *Rudiments of Connoisseurship*, which provides a detailed explanation of his method. There are three things necessary for the historical study of art: contemporary documents, tradition, and the works of art themselves. Documents and tradition have to be carefully examined before one lends them any credence. The work itself "is the event, and the only adequate source of information about the event." From Junius onward every writer has emphasized this by-now overly obvious truth. Berenson's general method of placing an unknown picture within a school and then with a given master is basically Richardson's. What distinguishes one artist from another are those characteristics particular to each. The connoisseur must isolate these characteristics and compare them with works in search of an author. Berenson calls this scientific research. Central to Berenson's method is the contention that "the less necessary the detail in question is for purposes of obvious expression, the less consciously will it be executed, the more by rote, the more likely to be stereotyped, and therefore characteristic" (Berenson, Reading 13, page 134).

At the end of his essay, he sums up the tests to be used, placing them in order of importance: (1) most applicable: ears, hands, folds, landscape; (2) less applicable: hair, eyes, nose, mouth; (3) least applicable: cranium, chin, structure and movement in the human figure, architecture, color, and chiaroscuro. Berenson warns his readers that this is no mechanical system. If we are searching for the identity between two works, we must not forget that the identity lies in the way artists have habitually visualized the world. "Rather than ask, 'Is this Leonardo's ear or hand?' we should ask, 'Is this the ear or hand Leonardo, with all his habits of visualization and execution, would have painted?'" The tests work inversely to the greatness of the artist; when dealing with great masters the matter of quality becomes of utmost importance in our attempts to attribute works to them. Berenson affirms, "The Sense of Quality is indubitably the most essential equipment of a would-be connoisseur" (Berenson, Reading 13, page 138).

The man who did for Northern painting what Berenson did for the Italian school was Max Friedländer. His fourteen-volume *Altniederländische Malerei* is the major contribution to date to the connoisseurship of early Netherlandish painting, as Berenson's *Italian Pictures of the Renaissance: A List of the Principal Artists and Their Works with an Index of Places* is for Italian Renaissance painting. *On Art and Connoisseurship* was published in English in 1944 and is one of the basic "textbooks" on the subjects of appreciation, looking, and connoisseurship. Friedländer's approach is a mixture of visual aptitude, erudition, and common sense. While critical of both

Berenson and Morelli, Friedländer recognized in Morelli someone who loved art so intensely that he was capable of reconstructing a painter's oeuvre.

As for Berenson, Friedländer agreed in general with the tests that he advocated, but remarked that Berenson's method might be less effective with schools other than the Italian Quattrocento. For example, Netherlandish sixteenth-century painters treated landscape more particularly and architecture more generally; therefore, the architecture becomes more important for discovering the characteristics of a Northern painter. Friedländer believed that the "criterion of similarity of form is completely unavailing" in differentiating between an original and a copy (Friedländer, Reading 14, page 147). This is not necessarily true since the form depends on the type of copy involved, as Félibien pointed out. Workshop copies can present problems. It is always possible that the master touched them up a bit before they left his atelier. Friedländer asserts that the only way of telling originals from good copies is by determining the difference in quality. The connoisseur "recognizes the author on the strength of the sensually spiritualized impression that he receives."[50]

Friedländer admitted that the expert depends to a large extent on intuition, and he mentions that Morelli used his method as a means of providing evidence for what he knew intuitively. The would-be connoisseur is someone who is born with a talent for perceptive observation. "Now it should be remembered that the works of art do not speak—they sing, and can therefore only be understood by listeners upon whom the Muses have bestowed their gifts." While stylistic analysis rapidly moves into the area of intuition, Friedländer maintains a detached attitude toward it: "It is to be believed and disbelieved." If a hypothesis does not stand up in the face of facts, one must discard it immediately and go on to another. The connoisseur must also have an encyclopedic visual memory, which is of far more significance than books and photographs. Too great a reliance on photographs can distract us from original works. They must never serve as the basis for any judgment and are solely helpful as *aide-mémoire* (see Friedländer, Reading 14, page 152).

When confronted with a picture in search of an author, Friedländer had recourse to the following method: "A picture is shown to me. I glance at it, and declare it to be a work by Memling, without having proceeded to an examination of its full complexity of artistic form. This inner certainty can only be gained from the impression of the whole; never from an analysis of the visible forms." The decision as to authorship is taken by "an unconscious comparison of the picture to be ascribed with an ideal picture in my imagination" (Reading 14, page 150). What Friedländer meant by an "ideal picture" is nothing less than a synthesis of a master's oeuvre made after looking at and studying the best examples. At first glance, it would seem that Friedländer's

approach is at great variance with Morelli's. It is not. While Morelli emphasized the uniqueness of form, especially in details, he did not forget the overall impression of a picture. Friedländer merely concentrated first on the picture as a whole, allowing his immediate response to become the basis of his attribution before testing it against the form of details. Regardless of whatever aids the connoisseur may use, the first impression is always of greatest importance.

Although intelligent, erudite, and well-trained intuition is the foremost element of Friedländer's method, he was not unaware of the value of objective criteria. Signatures and monograms, so long as they are genuine, are of obvious importance. However, he cautions that masters often signed works of their pupils and studio assistants. Contracts, inventories, catalogues (especially those close in time to the work in question), and sources—such as Vasari and van Mander—can be of great assistance. Another objective criterion is those "[m]easurably similar forms which, familiar to us from authenticated, signed, or recognized works, reappear in those to be attributed, say, in the architecture or ornament" (Reading 14, page 146). The ear, hand, and fingernail are also mentioned, and this test clearly derives from Morelli. Obviously, attributions should never be made from attributed works. One must always go to the undisputed, certain work and proceed with the comparison from there. According to Friedländer, painting methods and materials should also be studied, as should X rays, ultraviolet fluorescence, and photographic enlargements. Major advances have been made in the technical examination of pictures since Friedländer wrote his book, and he would undoubtedly approve of them and encourage their use. A picture's condition has to be thoroughly comprehended by the connoisseur since restoration can be highly misleading (for Friedländer's views on restoration, see Reading 33, pages 332–34). He recommends regular visits to restoration studios. Much can be learned by closely observing an artist's technique, the way he handled the brush and paint: "Temperament, élan, or tiredness betray themselves in the manner—vehement, decisive or else cautiously feeling its way—in which the paint has been applied."[51]

Looking at the original work of art with sensitivity and comprehension is of primary importance to Friedländer. He castigates those who refuse to do so and points out the consequent danger of such an approach:

> But when it is a question of artistic effect, there exists the danger that the scholars, who busy themselves so intensely with that which is invisible to the naked eye, lose the capacity to receive an impression of that which is visible. Insensitive observers acquire the right to take part in a discussion about artistic matters: they take the watch to pieces in order to study the works. And the watch no longer goes.[52]

Without, then, a complete appreciation of the overall artistic effect of a work of art, connoisseurship is not possible.

John Pope-Hennessy: The Continued Relevance of Connoisseurship Despite Criticism of Its Methods

Appreciation of overall artistic effects is not a subject much taught these days, as John Pope-Hennessy reminds us in the introduction, "Connoisseurship," to his *Study and Criticism of Italian Sculpture*. Teachers feel more comfortable studying and interpreting documents, for instance, than "[cultivating] the gift of sight." Pope-Hennessy demonstrates the relevance of connoisseurship to the study of art, and his choice of title is an homage to Berenson's *Study and Criticism of Italian Art*. Connoisseurship was only lately applied, around 1935, to the study of Italian Renaissance sculpture. One of the problems in analyzing and comparing sculpture is presented by the obvious fact that we must deal with the third dimension, that is, "actual, not notional tactility." Sculpture offers more than ideated sensations. Again he reminds us that we must always go to the original works of art. This is especially relevant with regard to sculpture since there is no one right view, despite Wölfflin's correct observation that Classic sculpture is conceived for one standpoint. Thus, photographs will never succeed in capturing the image in its totality (see Wölfflin, Reading 7, page 89).

No matter how great our aptitude, no matter how well our eye has been trained and exercised, our comprehension of works will be slow, and Friedländer cautioned us that "it is in the nature of a work of art to speak ambiguously, like an oracle" (Friedländer, Reading 14, page 144). Along with Vasari, Richardson, Morelli, Berenson, and Friedländer, Pope-Hennessy insists that we must seek to understand the artist's mind, oeuvre, materials, and technique. We must maintain a critically skeptical attitude toward all attributions. Pope-Hennessy reminds us that while documents can be helpful, their worth as evidence remains relative. Gary Schwartz, publisher and Rembrandt scholar, believes that the document is the only thing that matters. Taking an academically ideal stance, Schwartz wants to study "*all* the artists and works known from sources and documents," believing that the "only way of ascertaining the authorship of an object is to establish the history of its production." One needs to hunt through archives and libraries and find information "embedded in the treatises, poetry, government records, contracts, inventories, testaments—in the lives—of the times which produced them, not in the museum world of today."[53]

Just because something has been written down does not necessarily mean, of course, that it is the truth, or the whole truth. Berenson warns us

about what documents can and what they can never provide. Using Greek painting as an example, he points out that while there is "considerable literary information," we only have a vague idea of what it must have looked like. What we do know, what visual image we have, we owe to our "acquaintance with Greek marbles, bronzes, coins, vases, and scanty fragments of paintings, such as those of Pompeii" (Berenson, Reading 13, page 131). Schwartz wants incontestable evidence about the authorship of paintings, and connoisseurs will certainly understand his desire for proof positive. What bothers Schwartz is the subjective element of connoisseurship. A connoisseur's judgment remains a personal attribution—nothing more and nothing less—and the value of any attribution depends on who is making it. Interpreting documents can be subjective too, and a fair amount of attribution goes on with literary sources as well. Let us not forget the debates and scholarly research concerning who wrote Shakespeare.

The question is not whether documents are important, but whether they can help us attribute a work of art with any degree of certainty beyond what our eye tells us. When the information they contain has been confirmed to be telling the truth, the whole truth, and nothing but the truth, and when that information can be clearly related to a specific work of art beyond even the slightest shadow of a doubt, then one can say that the sources prove (with a 5 percent margin of error) picture A to be by artist G. It is rarely, if ever, so direct, so apparently simple. Schwartz draws our attention to a fact that many museums and collectors prefer not to discuss—namely, "our uncertainty with regard to the authorship of the great majority of undocumented works."[54] That countless works of art are undocumented may be regrettable, but that is the way things are and are likely to remain. Most of them, as specific objects, were probably never documented with any detail of description that would be relevant to the purposes of attribution. Information, like anything else, can be incorrectly recorded, tampered with, falsified, destroyed, or misinterpreted.

What is really at issue here are two different approaches to art—one academic and philological, the other aesthetic and visual. Pope-Hennessy notes that "many historically minded people [are obsessed] with literary evidence" (Pope-Hennessy, Reading 15, page 155). Neither approach alone can ever hope to solve the basic problem of connoisseurship attribution with absolute certainty. Schwartz admits that connoisseurship is "of great benefit to our appreciation of art as individuals and to the scholarly study of the art work, which after all comes to us with an ahistorical dimension." He also adds that connoisseurship helps us articulate "our value judgments";[55] in other words, it can furnish a methodology for our assessment of quality. In a period in which the practice of connoisseurship is at an absolute nadir, Pope-Hennessy unequivocally states that it "is not a poor substitute for knowledge,

but provides the only means by which our limited stock of documented knowledge can be broadened and brought into conformity with what actually occurred" (Pope-Hennessy, Reading 15, page 156). But he warns that, for it to be a useful tool, it must be practiced by those whose talent for it goes beyond semantics. People have to have an eye for connoisseurship. It is only through our eyes that we will ever succeed in "reading a building [or any work of art] as we would read Milton or Dante"—to borrow Ruskin's felicitous phrase (Ruskin, Reading 16, page 158).

However thorough we are in our studies, however inclusive we are in our approach—the academic *and* aesthetic, the visual *and* philological— no matter how good our aptitude for looking, no matter how much visual experience we have, works of art will always remain illusive to a greater or lesser extent. They are all historical objects, and time erects a relentless barrier that constantly puts more space between us and them. Napoléon once wittily remarked that history is a fable agreed upon. To interpret that fable even slightly, we will need to use the tools at our disposal: looking, appreciation, connoisseurship, scholarship, and modern techniques of scientific examination. And we must always remain vigilantly humble before works of art.

—MKT

Notes

1. See under "esthetic, aesthetic" in *The Century Dictionary: An Encyclopedic Lexicon of the English Language,* vol. 3 (New York: The Century Co., 1902), 2011.

2. See "A Monument of Restoration," in *Edward Waldo Forbes: Yankee Visionary,* exhibition catalogue (Harvard University, Fogg Art Museum, 1971), 124–27.

3. See UMBERTO BALDINI and ORNELLA CASAZZA, *The Cimabue Crucifix* (Wiener Verlag, n.d.) for an explanation of Professor Baldini's theory and photographs of the restoration.

4. EDWARD ARLINGTON ROBINSON, "For a Dead Lady," in *A Little Treasury of Modern Poetry,* ed. Oscar Williams (New York: Charles Scribner's Sons, 1952), 106.

5. BERNARD BERENSON, *Sunset and Twilight: From the Diaries of 1947–1958* (New York: Harcourt, Brace and World, Inc., 1963), 86.

6. JOHN RUSKIN, *The Seven Lamps of Architecture* (New York: Farrar, Straus and Cudahy, 1961), 27.

7. BERNARD BERENSON, *Aesthetics and History in the Visual Arts* (1948; reprint, St. Clair Shores, Mich.: Scholarly Press, Inc., 1979).

8. BERENSON, *Sunset and Twilight,* 398.

9. Ibid., 60.

10. "Ideated," as used by Berenson, means that a work of art causes one to imagine or form an idea of what is represented and thereby experience it.

11. HANNA KIEL, ed., *The Bernard Berenson Treasury: A Selection from the Works, Unpublished Writings, Letters, Diaries, and Journals, 1887–1958* (London: Methuen and Co. Ltd., 1964), 280.

12. BERENSON, *Aesthetics and History,* 25.

13. UMBERTO MORRA, *Conversations with Berenson,* trans. Florence Hammond (Boston: Houghton Mifflin Company, 1965), 105–6.

14. Ibid., 110.

15. BERENSON, *Aesthetics and History,* 136–37.

16. BERNARD BERENSON, *Sketch for a Self-Portrait* (London: Constable, 1949), 127–28.

17. BERENSON, *Sunset and Twilight,* 41.

18. LIONELLO VENTURI, *History of Art Criticism,* trans. Charles Marriott (New York: E. P. Dutton, 1964), 200–1, 216–17.

19. ERWIN PANOFSKY, "The History of Art as a Humanistic Discipline," in *Meaning in the Visual Arts* (Harmondsworth: Penguin Books, 1970), 370.

20. Originally published as *Kunstgeschichtliche Grundbegriffe: Das Problem der Stilentwickelung in der neueren Kunst* (Munich: F. Bruckmann, 1915).

21. HEINRICH WÖLFFLIN, *Principles of Art History: The Problem of the Development of Style in Later Art,* trans. M. D. Hottinger (1932; reprint, New York: Dover Publications, 1950), 11, 13.

22. Ibid., 11.

23. Ibid., vii.

24. Ibid., 14–16.

25. Ibid., 227.

26. JOSEPH ADDISON, RICHARD STEELE, et al., *The Spectator,* vol. 3, ed. Gregory Smith (London: Dent, 1967), 276; and HAROLD OSBORNE, ed., *Aesthetics in the Modern World* (New York: Weybright and Talley, 1968), 18.

27. BERENSON, *Sunset and Twilight,* 22.

28. JOHN RUSKIN, "Of the Division of Arts," in *Lectures on Art and Aratra Pentelici with Lectures and Notes on Greek Art and Mythology 1870,* vol. 20 of *The Works of John Ruskin,* ed. E. T. Cook and Alexander Wedderburn, Library Edition (London: George Allen, 1905), 215.

29. GEORGE SANTAYANA, *The Sense of Beauty* (New York: Charles Scribner's Sons, 1896), 3.

30. WINSTON S. CHURCHILL, *Painting as a Pastime* (1932; New York: McGraw-Hill, 1950), 28–29; see also Gombrich, Reading 11, pages 112–13.

31. GERRY HEDLEY, "On Humanism, Aesthetics, and the Cleaning of Paintings," reprint of two lectures (London: Courtauld Institute of Art, 1985), 3; also published in a more recent collection of Hedley's work edited by Caroline Villers (see annotated bibliography, page 468).

32. GIORGIO VASARI, *The Lives of the Painters, Sculptors, and Architects,* vol. 1, ed. William Gaunt, Everyman's Library (London: Dent, 1963; reprint, 1970), 201.

33. JONATHAN RICHARDSON JR., *The Works of Mr. Jonathan Richardson Sr., Consisting of I. The Theory of Painting; II. Essay on the Art of Criticism, so far as it relates to Painting; III. The Science of a Connoisseur,* corrected and prepared by Jonathan Richardson Jr. (1773; reprint, Hildesheim: Georg Olms, 1969), 99; based, in part, on JONATHAN RICHARDSON SR., *The Connoisseur: An Essay on the Whole Art of Criticism as It Relates to Painting* (London, 1719).

34. Ibid., 102–3.

35. Ibid., 107–8.

36. Ibid., 110.

37. Sir Charles Lock Eastlake, "How to Observe," in *Contribution to the Literature of the Fine Arts* (London: John Murray, 1870), 212, 215.

38. Giovanni Morelli, *Italian Painters: Critical Studies of Their Works* (London: John Murray, 1900), 2:18.

39. Ibid., 7.

40. Ibid., 8.

41. Ibid., 10.

42. Ibid., 11.

43. Ibid., 15.

44. Ibid., 20.

45. Ibid., 23.

46. Ibid., 24.

47. Originally published as Giovanni Morelli, *Della pittura italiana: Le Gallerie Borghese e Doria Pamphili in Roma, studii storico critici* (Milan: Fratelli Treves, 1897).

48. Morelli, *Italian Painters,* 76–77.

49. Berenson, *Sketch for a Self-Portrait,* 51.

50. Max J. Friedländer, *On Art and Connoisseurship,* trans. Tancred Borenius (London: Bruno Cassirer, 1944), 231.

51. Ibid., 189.

52. Ibid.

53. Gary Schwartz, "Connoisseurship: The Penalty of Ahistoricism," *The International Journal of Museum Management and Curatorship* 7 (1988): 261–68.

54. Ibid., 266.

55. Ibid.

The Lamp of Memory, I

JOHN RUSKIN

§10

Every human action gains in honor, in grace, in all true magnificence, by its regard to things that are to come. It is the far sight, the quiet and confident patience, that, above all other attributes, separate man from man, and near him to his Maker; and there is no action nor art, whose majesty we may not measure by this test. Therefore, when we build, let us think that we build for ever. Let it not be for present delight, nor for present use alone; let it be such work as our descendants will thank us for, and let us think, as we lay stone on stone, that a time is to come when those stones will be held sacred because our hands have touched them, and that men will say as they look upon the labor and wrought substance of them, "See! this our fathers did for us." For, indeed, the greatest glory of a building is not in its stones, nor in its gold. Its glory is in its Age, and in that deep sense of voicefulness, of stern watching, of mysterious sympathy, nay, even of approval or condemnation, which we feel in walls that have long been washed by the passing waves of humanity. It is in their lasting witness against men, in their quiet contrast with the transitional character of all things, in the strength which, through the lapse of seasons and times, and the decline and birth of dynasties, and the changing of the face of the earth, and of the limits of the sea, maintains its sculptured shapeliness for a time insuperable, connects forgotten and following ages with each other, and half constitutes the identity, as it concentrates the sympathy, of nations; it is in that golden stain of time, that we are to look for the real light, and color, and preciousness of architecture; and it is not until a

From JOHN RUSKIN, "The Lamp of Memory," chap. 6 in *The Seven Lamps of Architecture* (London: Smith, Elder, 1849), no. 10.

building has assumed this character, till it has been entrusted with the fame, and hallowed by the deeds of men, till its walls have been witnesses of suffering, and its pillars rise out of the shadows of death, that its existence, more lasting as it is than that of the natural objects of the world around it, can be gifted with even so much as these possess, of language and of life.

Aesthetics and History in the Visual Arts

BERNARD BERENSON

The idea of this approach to art theory and art history in the field of visual representation is to restate certain notions which have lain behind a career of many years. I have published books and articles, but, except one on the rudiments of connoisseurship, dating from the beginning of my activities, I have written almost nothing about the assumptions and convictions that have shaped and directed my work.

There are many approaches to the history of art—as many, perhaps, as there are individual students. We are blessed with treatise after treatise on the subject: technical, metaphysical, mathematical, biographical, theological, psychoanalytical, etc., etc. After nearly sixty years of preparation I may venture to speak of my way of facing the subject.

When I was young I cherished the hope of writing about all the arts as a personal adventure, not only about the visual arts but of music and literature as well. It was a hope too glamorous to outlast the inexperience of youth. The visual arts absorbed me to the exclusion of the others. Even then I had to narrow down and concentrate on a couple of centuries of Italian painting. Yet as an amateur—I would prefer the word "lover"—I have lived in many other realms of visual art, in all times and all climes.

It is not the business of art theory or art history to teach the practice of an art. They are not called upon to give training in the craft of painting, of sculpture, or of architecture, although they may stimulate and inspire the artist who sometimes hides in the craftsman. The purpose of art theory

From BERNARD BERENSON, *Aesthetics and History in the Visual Arts* (New York: Pantheon Books, 1948; reprint, St. Clair Shores, Mich.: Scholarly Press, 1979), 15–18 (page citations are to the reprint edition). Used with permission of the President and Fellows of Harvard College.

and history should be to reveal the successive phases of what people in their time have been offered to enjoy and appreciate; and how this enjoyment, and appreciation, waxed and waned through intervening ages; then whether we still enjoy and appreciate the same works, and, if we do, whether for the same reason. Furthermore, the business of art history is to recount what were the aspirations and ideals to which art gave permanent as well as passing form.

The theory and history of art as I have tried to pursue them are concerned with the work of art as it affects the spectator, the listener, the enjoyer, and not its maker, unless he too becomes an enjoyer.

Creative genius is a fascinating subject for study or, to be more accurate, for meditation and guessing. I have nothing against genial guessing in any field. Indeed, I wonder at times whether the most suggestive translation of *In initio erat verbum* would not be "In the beginning was the guess." So I am not averse to fancies about the ultimate nature of art and its origin, or to speculations regarding the artist and his activities. I might even have guesses of my own to offer, if I had the leisure. I would, however, insist with myself, as I do with others, on keeping the artist and the work of art in separate compartments.

It could be argued that no little of the sterility of art theory, and the unsatisfactoriness of art history, from late antiquity to our own day, is due to the failure to state at the outset whether one is thinking from the point of view of the producer of the work of art, or of its consumer. If Benedetto Croce, the most authoritative of contemporary writers on aesthetics, had kept in mind this distinction would he say as he does in *Per una Poetica Moderna* (written in 1922 and reprinted in *Nuovi Saggi di Estetica*) that "l'opera d'arte è sempre un atto spirituale" [the work of art is always a spiritual act]? Perhaps not. The work of art is the product of the mind's activity, but not that activity itself.

From the creator's point of view copies, reproductions, and imitations may not count; although it is hard to imagine how, without them, his creations would get known to any but the few who could afford access to them; or how his style could become diffused so as to exert a wide influence. Not many masterpieces of Greek sculpture would be known today and none of Greek painting. Moreover, what is the finished statue that we enjoy? Is it its intuitive creator's spontaneous and instantaneous creation? In the case of bronze, the preferred Greek material, the statue was a cast, and where marble was concerned it was a copy, made probably, but not certainly, and seldom entirely, by the creator himself after his laboriously contrived model. In painting, the spontaneously created product is more often than not a scrawl that has no closer relation to the elaborated Sistine ceiling by Michelangelo or the Sistine Madonna by Raphael than the product of that

most intuitive and spontaneous of all creative acts, the human embryo, has to the grown man of genius.

I am free to inquire what a work of art means to me and has been to me. It has been my life's work to "live" the work of art, to turn it over and over on my mental palate, to brood, to dream over it; and then in the hope of getting to understand it better I have written about it. As consumer of the art product I have the right to do all that. As I am neither figure artist, nor architect, nor musician, I have no certain right to speak of the producer. I am in the position of most critics, philosophers, and scholars. We have enjoyed experiencing the creative process in the art of words only with the logical result that writers on art seldom have in mind any of the arts except the verbal ones.

To take more interest in the artist than in his art is an effect of our hero-worshipping tendency, and, through the hero, of our masked self-worshipping instincts. We must resist these, and I for my part have never thought of writing on art except as an experience, personal, individual, but not private, not capricious, not self-assertive. "I do not love thee, Dr. Fell, The reason why I cannot tell" is not criticism, no matter how many variations you play on the theme, how well you orchestrate it, how beguilingly you write about it.

There may be no absolute in art, but so long as we stand, grasp, breathe, and react to temperature, for so long will there be fixed although oscillating relations between these functions and the demands they make on the work of art, on painting particularly. There is in fact a relative absolute in art which is determined by our psycho-physiological condition and our mental preparation.

Everything we are aware of, every faintest change within us that reaches consciousness and affects it, is of the mind, is mental. The business of art, as of all creative activities, is to extend the horizons of consciousness not only in width and depth, but in height as well. Art lies in that mental region, for it is based on processes within us that manifest themselves in consciousness. What is under the threshold of consciousness belongs to physiology and not to aesthetics, art theory, or art history.

It will be my endeavor to make myself and my readers more aware, more conscious of the potentialities and qualities of this world of art, this realm of ideated satisfactions. I cannot insist too much on the proposition that it is the prevalence of ideated satisfactions over actual ones that is important for art as distinct from material, technique, and so-called natural shapes.

Art

C L I V E B E L L

§I. The Aesthetic Hypothesis

It is improbable that more nonsense has been written about aesthetics than
about anything else: the literature of the subject is not large enough for that.
It is certain, however, that about no subject with which I am acquainted has
so little been said that is at all to the purpose. The explanation is discover-
able. He who would elaborate a plausible theory of aesthetics must possess
two qualities—artistic sensibility and a turn for clear thinking. Without sen-
sibility a man can have no aesthetic experience, and, obviously, theories not
based on broad and deep aesthetic experience are worthless. Only those for
whom art is a constant source of passionate emotion can possess the data
from which profitable theories may be deduced; but to deduce profitable the-
ories even from accurate data involves a certain amount of brain work, and,
unfortunately, robust intellects and delicate sensibilities are not inseparable.

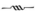

The starting point for all systems of aesthetics must be the personal
experience of a peculiar emotion. The objects that provoke this emotion we
call works of art. All sensitive people agree that there is a peculiar emotion
provoked by works of art. I do not mean, of course, that all works provoke the
same emotion. On the contrary, every work produces a different emotion.
But all these emotions are recognizably the same in kind; so far, at any rate,
the best opinion is on my side. That there is a particular kind of emotion pro-
voked by works of visual art, and that this emotion is provoked by every kind

From CLIVE BELL, *Art* (New York: Frederick A. Stokes, 1914; reprint, London: Chatto and
Windus, 1949), 3–4, 6–11, 16–17, 25–28, 36–37, 49–54, 56–64, 68–71 (page citations are
to the reprint edition). Used with permission of the Estate of Clive Bell.

of visual art, by pictures, sculptures, buildings, pots, carvings, textiles, etc., etc., is not disputed, I think, by anyone capable of feeling it. This emotion is called the aesthetic emotion; and if we can discover some quality common and peculiar to all the objects that provoke it, we shall have solved what I take to be the central problem of aesthetics. We shall have discovered the essential quality in a work of art, the quality that distinguishes works of art from all other classes of objects.

For either all works of visual art have some common quality, or when we speak of "works of art" we gibber. Everyone speaks of "art," making a mental classification by which he distinguishes the class "works of art" from all other classes. What is the justification of this classification? What is the quality common and peculiar to all members of this class? Whatever it be, no doubt it is often found in company with other qualities; but they are adventitious—it is essential. There must be some one quality without which a work of art cannot exist; possessing which, in the least degree, no work is altogether worthless. What is this quality? What quality is shared by all objects that provoke our aesthetic emotions? What quality is common to Sta. [Hagia] Sophia and the windows at Chartres, Mexican sculpture, a Persian bowl, Chinese carpets, Giotto's frescoes at Padua, and the masterpieces of Poussin, Piero della Francesca, and Cézanne? Only one answer seems possible—significant form. In each, lines and colors combined in a particular way, certain forms and relations of forms, stir our aesthetic emotions. These relations and combinations of lines and colors, these aesthetically moving forms, I call "Significant Form"; and "Significant Form" is the one quality common to all works of visual art.

At this point it may be objected that I am making aesthetics a purely subjective business, since my only data are personal experiences of a particular emotion. It will be said that the objects that provoke this emotion vary with each individual, and that therefore a system of aesthetics can have no objective validity. It must be replied that any system of aesthetics which pretends to be based on some objective truth is so palpably ridiculous as not to be worth discussing. We have no other means of recognizing a work of art than our feeling for it. The objects that provoke aesthetic emotion vary with each individual. Aesthetic judgments are, as the saying goes, matters of taste; and about tastes, as everyone is proud to admit, there is no disputing. A good critic may be able to make me see in a picture that had left me cold things that I had overlooked, until at last, receiving the aesthetic emotion, I recognize it as a work of art. To be continually pointing out those parts, the sum, or rather the combination, of which unite to produce significant form, is the function of criticism. But it is useless for a critic to tell me that something is a work of art; he must make me feel it for myself. This he can do only by

making me see; he must get at my emotions through my eyes. Unless he can make me see something that moves me, he cannot force my emotions. I have no right to consider anything a work of art to which I cannot react emotionally; and I have no right to look for the essential quality in anything that I have not *felt* to be a work of art. The critic can affect my aesthetic theories only by affecting my aesthetic experience. All systems of aesthetics must be based on personal experience—that is to say, they must be subjective.

—⚬⚬⚬—

For a discussion of aesthetics, it need be agreed only that forms arranged and combined according to certain unknown and mysterious laws do move us in a particular way, and that it is the business of an artist so to combine and arrange them that they shall move us. These moving combinations and arrangements I have called, for the sake of convenience and for a reason that will appear later, "Significant Form."

—⚬⚬⚬—

The hypothesis that significant form is the essential quality in a work of art has at least one merit denied to many more famous and more striking—it does help to explain things. We are all familiar with pictures that interest us and excite our admiration, but do not move us as works of art. To this class belongs what I call "Descriptive Painting"—that is, painting in which forms are used not as objects of emotion, but as means of suggesting emotion or conveying information. Portraits of psychological and historical value, topographical works, pictures that tell stories and suggest situations, illustrations of all sorts, belong to this class. That we all recognize the distinction is clear, for who has not said that such and such a drawing was excellent as illustration, but as a work of art worthless? Of course many descriptive pictures possess, amongst other qualities, formal significance, and are therefore works of art: but many more do not. They interest us; they may move us too in a hundred different ways, but they do not move us aesthetically. According to my hypothesis they are not works of art. They leave untouched our aesthetic emotions because it is not their forms but the ideas or information suggested or conveyed by their forms that affect us.

—⚬⚬⚬—

Let no one imagine that representation is bad in itself; a realistic form may be as significant, in its place as part of the design, as an abstract. But if a representative form has value, it is as form, not as representation. The representative element in a work of art may or may not be harmful; always it is irrelevant. . . . Before we feel an aesthetic emotion for a combination of forms, do we not perceive intellectually the rightness and necessity of the combination? If we do, it would explain the fact that passing rapidly through a room we recognize a picture to be good, although we cannot say that it has

provoked much emotion. We seem to have recognized intellectually the rightness of its forms without staying to fix our attention, and collect, as it were, their emotional significance. If this were so, it would be permissible to inquire whether it was the forms themselves or our perception of their rightness and necessity that caused aesthetic emotion. . . .

To appreciate a work of art we need bring with us nothing but a sense of form and color and a knowledge of three-dimensional space. That bit of knowledge, I admit, is essential to the appreciation of many great works, since many of the most moving forms ever created are in three dimensions. To see a cube or a rhomboid as a flat pattern is to lower its significance, and a sense of three-dimensional space is essential to the full appreciation of most architectural forms. Pictures which would be insignificant if we saw them as flat patterns are profoundly moving because, in fact, we see them as related planes. If the representation of three-dimensional space is to be called "representation," then I agree that there is one kind of representation which is not irrelevant. Also, I agree that along with our feeling for line and color we must bring with us our knowledge of space if we are to make the most of every kind of form. Nevertheless, there are magnificent designs to an appreciation of which this knowledge is not necessary: so, though it is not irrelevant to the appreciation of some works of art it is not essential to the appreciation of all. What we must say is that the representation of three-dimensional space is neither irrelevant nor essential to all art, and that every other sort of representation is irrelevant.

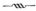

It is the mark of great art that its appeal is universal and eternal.[1] Significant form stands charged with the power to provoke aesthetic emotion in anyone capable of feeling it. The ideas of men go buzz and die like gnats; men change their institutions and their customs as they change their coats; the intellectual triumphs of one age are the follies of another; only great art remains stable and unobscure. Great art remains stable and unobscure because the feelings that it awakens are independent of time and place, because its kingdom is not of this world. To those who have and hold a sense of the significance of form what does it matter whether the forms that move them were created in Paris the day before yesterday or in Babylon fifty centuries ago? The forms of art are inexhaustible; but all lead by the same road of aesthetic emotion to the same world of aesthetic ecstasy.

§III. The Metaphysical Hypothesis

I want now to consider that metaphysical question—"Why do certain arrangements and combinations of form move us so strangely?" . . .

It seems to me possible, though by no means certain, that created form moves us so profoundly because it expresses the emotion of its creator. Perhaps the lines and colors of a work of art convey to us something that the artist felt. If this be so, it will explain that curious but undeniable fact, to which I have already referred, that what I call material beauty (e.g., the wing of a butterfly) does not move most of us in at all the same way as a work of art moves us. It is beautiful form, but it is not significant form. It moves us, but it does not move us aesthetically. It is tempting to explain the difference between "significant form" and "beauty"—that is to say, the difference between form that provokes our aesthetic emotions and form that does not—by saying that significant form conveys to us an emotion felt by its creator and that beauty conveys nothing.

For what, then, does the artist feel the emotion that he is supposed to express? Sometimes it certainly comes to him through material beauty. The contemplation of natural objects is often the immediate cause of the artist's emotion. Are we to suppose, then, that the artist feels, or sometimes feels, for material beauty what we feel for a work of art? Can it be that sometimes for the artist material beauty is somehow significant—that is, capable of provoking aesthetic emotion? . . .

Let us hear what the artists have got to say for themselves. We readily believe them when they tell us that, in fact, they do not create works of art in order to provoke our aesthetic emotions, but because only thus can they materialize a particular kind of feeling. What, precisely, this feeling is they find it hard to say. . . . Occasionally when an artist—a real artist—looks at objects (the contents of a room, for instance) he perceives them as pure forms in certain relations to each other, and feels emotion for them as such. These are his moments of inspiration: follows the desire to express what has been felt. The emotion that the artist felt in his moment of inspiration he did not feel for objects seen as means, but for objects seen as pure forms—that is, as ends in themselves. . . . [I]n the moment of aesthetic vision he sees objects, not as means shrouded in associations, but as pure forms. It is for, or at any rate through, pure form that he feels his inspired emotion.

Now to see objects as pure forms is to see them as ends in themselves. . . . All of us, I imagine, do, from time to time, get a vision of material objects as pure forms. . . . Who has not, once at least in his life, had a sudden vision of landscape as pure form? For once, instead of seeing it as fields and cottages, he has felt it as lines and colors. In that moment has he not won from material beauty a thrill indistinguishable from that which art gives? And, if this be so, is it not clear that he has won from material beauty the thrill that, generally, art alone can give, because he has contrived to see it as a pure formal combination of lines and colors? May we go on to say that, having seen it as pure form, having freed it from all casual and adventitious interest, from

all that it may have acquired from its commerce with human beings, from all its significance as a means, he has felt its significance as an end in itself?

What is the significance of anything as an end in itself? What is that which is left when we have stripped a thing of all its associations, of all its significance as a means? What is left to provoke our emotion? What but that which philosophers used to call "the thing in itself" and now call "ultimate reality"? Shall I be altogether fantastic in suggesting what some of the profoundest thinkers have believed, that the significance of the thing in itself is the significance of Reality? Is it possible that the answer to my question, "Why are we so profoundly moved by certain combinations of lines and colors?" should be, "Because artists can express in combinations of lines and colors an emotion felt for reality which reveals itself through line and color"?

—‴—

Certainly, in those moments of exaltation that art can give, it is easy to believe that we have been possessed by an emotion that comes from the world of reality. Those who take this view will have to say that there is in all things the stuff out of which art is made—reality; artists, even, can grasp it only when they have reduced things to their purest condition of being—to pure form—unless they be of those who come at it mysteriously unaided by externals; only in pure form can a sense of it be expressed. On this hypothesis the peculiarity of the artist would seem to be that he possesses the power of surely and frequently seizing reality (generally behind pure form), and the power of expressing his sense of it, in pure form always. . . .

[U]nless we assume that all artists are liars, I think we must suppose that they do feel an emotion which they can express in form—and form alone. And note well this further point; artists try to express emotion, not to make statements about its ultimate or immediate object. . . . In any case, the form in which he expresses his emotion bears no memorial of any external form that may have provoked it. Expression is no wise bound by the forms or emotions or ideas of life. We cannot know exactly what the artist feels. We only know what he creates. If reality be the goal of his emotion, the roads to reality are several. Some artists come at it through the appearance of things, some by a recollection of appearance, and some by sheer force of imagination.

To the question—"Why are we so profoundly moved by certain combinations of forms?" I am unwilling to return a positive answer. I am not obliged to, for it is not an aesthetic question. I do suggest, however, that it is because they express an emotion that the artist has felt, though I hesitate to make any pronouncement about the nature or object of that emotion. . . . Let me give one example. Of copies of pictures there are two classes; one class contains some works of art, the other none. A literal copy is seldom reckoned

even by its owner a work of art. It leaves us cold; its forms are not significant. Yet if it were an absolutely exact copy, clearly it would be as moving as the original, and a photographic reproduction of a drawing often is—almost. Evidently, it is impossible to imitate a work of art exactly; and the differences between the copy and the original, minute though they may be, exist and are felt immediately. So far the critic is on sure and by this time familiar ground. The copy does not move him, because its forms are not identical with those of the original; and just what made the original moving is what does not appear in the copy. But why is it impossible to make an absolutely exact copy? The explanation seems to be that the actual lines and colors and spaces in a work of art are caused by something in the mind of the artist which is not present in the mind of the imitator. The hand not only obeys the mind, it is impotent to make lines and colors in a particular way without the direction of a particular state of mind. The two visible objects, the original and the copy, differ because that which ordered the work of art does not preside at the manufacture of the copy. That which orders the work of art is, I suggest, the emotion which empowers artists to create significant form. The good copy, the copy that moves us, is always the work of one who is possessed by this mysterious emotion. Good copies are never attempts at exact imitation; on examination we find always enormous differences between them and their originals: they are the work of men or women who do not copy but can translate the art of others into their own language. The power of creating significant form depends, not on hawklike vision, but on some curious mental and emotional power. Even to copy a picture one needs, not to see as a trained observer, but to feel as an artist. To make the spectator feel, it seems that the creator must feel too. What is this that imitated forms lack and created forms possess? What is this mysterious thing that dominates the artist in the creation of forms? What is it that lurks behind forms and seems to be conveyed by them to us? What is it that distinguishes the creator from the copyist? What can it be but emotion? Is it not because the artist's forms express a particular kind of emotion that they are significant?—because they fit and envelop it, that they are coherent?—because they communicate it, that they exalt us to ecstasy?

One word of warning is necessary. Let no one imagine that the expression of emotion is the outward and visible sign of a work of art. The characteristic of a work of art is its power of provoking aesthetic emotion; the expression of emotion is possibly what gives it that power. It is useless to go to a picture gallery in search of expression; you must go in search of significant form. When you have been moved by form, you may begin to consider what makes it moving. If my theory be correct, rightness of form is invariably a consequence of rightness of emotion. Right form, I suggest, is

ordered and conditioned by a particular kind of emotion; but whether my theory be true or false, the form remains right. If the forms are satisfactory, the state of mind that ordained them must have been aesthetically right. If the forms are wrong, it does not follow that the state of mind was wrong; between the moment of inspiration and the finished work of art there is room for many a slip. . . .

. . . I have suggested that the task of the artist is either to create significant form or to express a sense of reality—whichever way you prefer to put it. But it is certain that few artists, if any, can sit down or stand up just to create nothing more definite than significant form, just to express nothing more definite than a sense of reality. Artists must canalize their emotion, they must concentrate their energies on some definite problem. The man who sets out with the whole world before him is unlikely to get anywhere. In that fact lies the explanation of the absolute necessity for artistic conventions. That is why it is easier to write good verse than good prose, why it is more difficult to write good blank verse than good rhyming couplets. That is the explanation of the sonnet, the ballade, and the rondeau; severe limitations concentrate and intensify the artist's energies.

—⁓—

What, then, is the conclusion of the whole matter? No more than this, I think. The contemplation of pure form leads to a state of extraordinary exaltation and complete detachment from the concerns of life: of so much, speaking for myself, I am sure. It is tempting to suppose that the emotion which exalts has been transmitted through the forms we contemplate by the artist who created them. If this be so, the transmitted emotion, whatever it may be, must be of such a kind that it can be expressed in any sort of form—in pictures, sculptures, buildings, pots, textiles, etc., etc. Now the emotion that artists express comes to some of them, so they tell us, from the apprehension of the formal significance of material things; and the formal significance of any material thing is the significance of that thing considered as an end in itself. . . .

. . . And of one other thing am I sure. Be they artists or lovers of art, mystics or mathematicians, those who achieve ecstasy are those who have freed themselves from the arrogance of humanity. He who would feel the significance of art must make himself humble before it. Those who find the chief importance of art or of philosophy in its relation to conduct or its practical utility—those who cannot value things as ends in themselves or, at any rate, as direct means to emotion—will never get from anything the best that it can give. Whatever the world of aesthetic contemplation may be, it is not the world of human business and passion; in it the chatter and tumult of material existence is unheard, or heard only as the echo of some more ultimate harmony.

Note

1. Mr. Roger Fry permits me to make use of an interesting story that will illustrate my view. When Mr. Okakura, the Government editor of *The Temple Treasures of Japan,* first came to Europe, he found no difficulty in appreciating the pictures of those who from want of will or want of skill did not create illusions but concentrated their energies on the creation of form. He understood immediately the Byzantine masters and the French and Italian Primitives. In the Renaissance painters, on the other hand, with their descriptive preoccupations, their literary and anecdotic interests, he could see nothing but vulgarity and muddle. The universal and essential quality of art, significant form, was missing, or rather had dwindled to a shallow stream, overlaid and hidden beneath weeds, so the universal response, aesthetic emotion, was not evoked. It was not until he came on to Henri Matisse that he again found himself in the familiar world of pure art. Similarly, sensitive Europeans who respond immediately to the significant forms of great Oriental art, are left cold by the trivial pieces of anecdote and social criticism so lovingly cherished by Chinese dilettanti. It would be easy to multiply instances did not decency forbid the laboring of so obvious a truth.

Looking at Pictures

KENNETH CLARK

No doubt there are many ways of looking at pictures, none of which can be called the right way. Those great artists of the past who have left us their opinions on painting—Leonardo da Vinci, Dürer, Poussin, Reynolds, Delacroix—often gave reasons for their preferences, with which no living artist would agree; and the same is true of the great critics—Vasari, Lomazzo, Ruskin, Baudelaire. Yet they lived at a time when the standard of painting was higher than it is today, and they thought of criticism as a more exacting profession than do most contemporary critics. They admired, more or less, the same works of art; but in their criteria of judgment they differed from each other even more than the painters, who at least had in common certain technical problems. The once fashionable phrase "he likes it for the wrong reasons" exposes not only arrogance, but ignorance of history.

But this is not to admit that the opposite character, the man who professes to "know what he likes" by the light of nature, is right in this, or any, field. No one says that about any subject to which they have devoted some thought and experienced the hazards of commitment. Long practice in any occupation produces a modicum of skill. One can learn to cook and play golf—not, perhaps, very well, but much better than if one had refused to learn at all. I believe one can learn to interrogate a picture in such a way as to intensify and prolong the pleasure it gives one; and if (as all those great men whose names I have just quoted would certainly have agreed) art must do

From KENNETH CLARK, *Looking at Pictures* (London: John Murray, 1960; reprint 1972), 15–18 (page citations are to the reprint edition). Used by permission of John Murray (Publishers) Ltd.

something more than give pleasure, then "knowing what one likes" will not get one very far. Art is not a lollipop, or even a glass of kümmel. The meaning of a great work of art, or the little of it that we can understand, must be related to our own life in such a way as to increase our energy of spirit. Looking at pictures requires active participation, and, in the early stages, a certain amount of discipline.

I do not suppose that there are any rules for this exercise; but perhaps the experiences of a confirmed lover of painting may be some guide, and this is what I offer in the essays that follow. I have set down, as accurately as I could, the course of my feelings and thoughts before sixteen great paintings. They have been chosen from as wide a range as possible, so that my responses have varied considerably. Sometimes, as in *Las Meniñas,* the subject comes first; sometimes, as with Delacroix, knowledge of the artist's character determines my attitude to his work. But on the whole I have found that my feelings fall into the same pattern of impact, scrutiny, recollection and renewal.

First I see the picture as a whole, and long before I can recognize the subject I am conscious of a general impression, which depends on the relationship of tone and area, shape and color. This impact is immediate, and I can truthfully say that I would experience it on a bus going at thirty miles an hour if a great picture were in a shop window.

I must also admit that the experience has sometimes been disappointing: I have jumped off the bus and walked back, only to find my first impression betrayed by a lack of skill or curiosity in the execution. So the first shock must be followed by a period of inspection in which I look from one part to another, enjoying those places where the color is harmonious and the drawing grips the things seen; and naturally I become aware of what the painter has intended to represent. If he has done so skillfully this adds to my enjoyment, and may, for a moment or two, deflect my attention from pictorial qualities to the subject. But quite soon my critical faculties begin to operate, and I find myself looking for some dominating motive, or root idea, from which the picture derives its overall effect.

In the middle of this exercise my senses will probably begin to tire, and if I am to go on looking responsively I must fortify myself with nips of information. I fancy that one cannot enjoy a pure aesthetic sensation (so-called) for longer than one can enjoy the smell of an orange, which in my case is less than two minutes; but one must look attentively at a great work of art for longer than that, and the value of historical criticism is that it keeps the attention fixed on the work while the senses have time to get a second wind. As I remember the facts of a painter's life and try to fit the picture in front of me into its place in his development, and speculate as to whether certain

parts were painted by an assistant or damaged by a restorer, my powers of receptivity are gradually renewing themselves, and suddenly make me aware of a beautiful passage of drawing or color which I should have overlooked had not an intellectual pretext kept my eye unconsciously engaged.

Finally I become saturated with the work, so that everything I see contributes to it, or is colored by it. I find myself looking at my room as if it were a Vermeer, I see the milkman as a donor by Rogier van der Weyden, and the logs on the fire crumble into the forms of Titian's *Entombment*. But these great works are deep. The more I try to penetrate them the more conscious I become that their central essences are hidden far further down. I have only scratched the surface with the worn-out instrument of words. For, quite apart from shortcomings of perception, there is the difficulty of turning visual experiences into language.

Some of the greatest masterpieces leave us with nothing to say. Raphael's *Sistine Madonna* is undoubtedly one of the most beautiful pictures in the world, and I have looked at it with what our grandparents would have called "elevated feelings" day after day for months; but the few banal thoughts it has aroused in my mind would not fill a postcard. In choosing subjects for these essays, therefore, I had to be sure that they were pictures about which something could be said without too much padding, rhetoric or whimsy. There were other limiting factors. I had to avoid painters—Piero della Francesca, for example—about whom I had written a good deal already; and for the same reason I have not included any pictures of the nude, although this has deprived me of the pleasure of writing about Rubens. Some pictures I greatly admire are inaccessible; and some, like Giotto's frescoes in the Arena Chapel, should not be considered out of their context. To choose pictures with a subject was perhaps inevitable: for what, after all, can one say, except in front of the original, about a Cézanne still life, which depends for its nobility on the exact tone and character of every touch. As a result I fear that illustration has been made to seem more important than it is, simply because it is easier to render in words.

[Author's note to the first edition]

All but one of these essays first appeared in the *Sunday Times* and my thanks are due to the Editor for allowing me to reprint them. They were designed to occupy one page and to be of a weight and consistency that would not be out of keeping with the rest of the paper. For some reason a piece which makes quite a substantial effect on the page of a newspaper seems to shrink when bound between boards. The essays which follow seem much shorter than they did when surrounded by advertisements; in fact they have nearly all been considerably lengthened.

The book is dedicated to the memory of Roger Fry. He would have disagreed with much that I say and would have been slightly shocked to find that I have

included works by Turner and Delacroix, painters to whom his mind was resolutely closed. But I remember that he listened eagerly to the most outrageous opinions; and it was in following his magical unfolding of Poussin's *Triumph of David* or Cézanne's *Compotier* that I first became aware of how much can be discovered in a picture after the moment of amateurish delight has passed.

The History of Art as a Humanistic Discipline

ERWIN PANOFSKY

§III

———

An art historian . . . is a humanist whose "primary material" consists of those records which have come down to us in the form of works of art. But what is a work of art?

A work of art is not always created exclusively for the purpose of being enjoyed, or, to use a more scholarly expression, of being experienced aesthetically. Poussin's statement that "la fin de l'art est la délectation" [the goal of art is enjoyment] was quite a revolutionary one,[1] for earlier writers had always insisted that art, however enjoyable, was also, in some manner, useful. But a work of art always *has* aesthetic significance (not to be confused with aesthetic value): whether or not it serves some practical purpose, and whether it is good or bad, it demands to be experienced aesthetically.

It is possible to experience every object, natural or man-made, aesthetically. We do this, to express it as simply as possible, when we just look at it (or listen to it) without relating it, intellectually or emotionally, to anything outside of itself. When a man looks at a tree from the point of view of a carpenter, he will associate it with the various uses to which he might put the wood; and when he looks at it from the point of view of an ornithologist he will associate it with the birds that might nest in it. When a man at a horse race watches the animal on which he has put his money, he will associate

From *Meaning in the Visual Arts* by ERWIN PANOFSKY (New York: Doubleday, 1955), 33–44; originally published in T. M. Greene, ed., *The Meaning of the Humanities* (Princeton, N.J.: Princeton University Press, 1940), 89–118. Copyright © 1955 by Erwin Panofsky. Used by permission of Doubleday, a division of Bantam Doubleday Dell Publishing Group, Inc.

its performance with his desire that it may win. Only he who simply and wholly abandons himself to the object of his perception will experience it aesthetically.[2]

Now, when confronted with a natural object, it is an exclusively personal matter whether or not we choose to experience it aesthetically. A man-made object, however, either demands or does not demand to be so experienced, for it has what the scholastics call an "intention." Should I choose, as I might well do, to experience the redness of a traffic light aesthetically, instead of associating it with the idea of stepping on my brakes, I should act against the "intention" of the traffic light.

Those man-made objects which do not demand to be experienced aesthetically, are commonly called "practical," and may be divided into two classes: vehicles of communication, and tools or apparatuses. A vehicle of communication is "intended" to transmit a concept. A tool or apparatus is "intended" to fulfill a function (which function, in turn, may be the production or transmission of communications, as is the case with a typewriter or with the previously mentioned traffic light).

Most of the objects which do demand to be experienced aesthetically, that is to say, works of art, also belong in one of these two classes. A poem or a historical painting is, in a sense, a vehicle of communication; the Pantheon and the Milan candlesticks are, in a sense, apparatuses; and Michelangelo's tombs of Lorenzo and Giuliano de' Medici are, in a sense, both. But I have to say "in a sense," because there is this difference: in the case of what might be called a "mere vehicle of communication" and a "mere apparatus," the intention is definitely fixed on the idea of the work, namely, on the meaning to be transmitted, or on the function to be fulfilled. In the case of a work of art, the interest in the idea is balanced, and may even be eclipsed, by an interest in form.

However, the element of "form" is present in every object without exception, for every object consists of matter and form; and there is no way of determining with scientific precision to what extent, in a given case, this element of form bears the emphasis. Therefore one cannot, and should not, attempt to define the precise moment at which a vehicle of communication or an apparatus begins to be a work of art. If I write to a friend to ask him to dinner, my letter is primarily a communication. But the more I shift the emphasis to the form of my script, the more nearly does it become a work of calligraphy; and the more I emphasize the form of my language (I could even go so far as to invite him by a sonnet), the more nearly does it become a work of literature or poetry.

Where the sphere of practical objects ends, and that of "art" begins, depends, then, on the "intention" of the creators. This "intention" cannot be absolutely determined. In the first place, "intentions" are, per se, incapable

of being defined with scientific precision. In the second place, the "intentions" of those who produce objects are conditioned by the standards of their period and environment. Classical taste demanded that private letters, legal speeches and the shields of heroes should be "artistic" (with the possible result of what might be called fake beauty), while modern taste demands that architecture and ash trays should be "functional" (with the possible result of what might be called fake efficiency).[3] Finally our estimate of those "intentions" is inevitably influenced by our own attitude, which in turn depends on our individual experiences as well as on our historical situation. We have all seen with our own eyes the transference of spoons and fetishes of African tribes from the museums of ethnology into art exhibitions.

One thing, however, is certain: the more the proportion of emphasis on "idea" and "form" approaches a state of equilibrium, the more eloquently will the work reveal what is called "content." Content, as opposed to subject matter, may be described in the words of Peirce as that which a work betrays but does not parade. It is the basic attitude of a nation, a period, a class, a religious or philosophical persuasion—all this unconsciously qualified by one personality, and condensed into one work. It is obvious that such an involuntary revelation will be obscured in proportion as either one of the two elements, idea or form, is voluntarily emphasized or suppressed. A spinning machine is perhaps the most impressive manifestation of a functional idea, and an "abstract" painting is perhaps the most expressive manifestation of pure form, but both have a minimum of content.

§IV

In defining a work of art as a "man-made object demanding to be experienced aesthetically" we encounter for the first time a basic difference between the humanities and natural science. The scientist, dealing as he does with natural phenomena, can at once proceed to analyze them. The humanist, dealing as he does with human actions and creations, has to engage in a mental process of a synthetic and subjective character: he has mentally to re-enact the actions and to re-create the creations. It is in fact by this process that the real objects of the humanities come into being. For it is obvious that historians of philosophy or sculpture are concerned with books and statues not insofar as these books and sculptures exist materially, but insofar as they have a meaning. And it is equally obvious that this meaning can only be apprehended by re-producing, and thereby, quite literally, "realizing," the thoughts that are expressed in the books and the artistic conceptions that manifest themselves in the statues.

Thus the art historian subjects his "material" to a rational archaeological analysis at times as meticulously exact, comprehensive and involved as

any physical or astronomical research. But he constitutes his "material" by means of an intuitive aesthetic re-creation,[4] including the perception and appraisal of "quality," just as any "ordinary" person does when he or she looks at a picture or listens to a symphony.

How, then, is it possible to build up art history as a respectable scholarly discipline, if its very objects come into being by an irrational and subjective process?

This question cannot be answered, of course, by referring to the scientific methods which have been, or may be, introduced into art history. Devices such as chemical analysis of materials, X rays, ultraviolet rays, infrared rays and macrophotography are very helpful, but their use has nothing to do with the basic methodical problem. A statement to the effect that the pigments used in an allegedly medieval miniature were not invented before the nineteenth century may settle an art-historical question, but it is not an art-historical statement. Based as it is on chemical analysis plus the history of chemistry, it refers to the miniature not *qua* work of art but *qua* physical object, and may just as well refer to a forged will. The use of X rays, macrophotographs, et cetera, on the other hand, is methodically not different from the use of spectacles or of a magnifying glass. These devices enable the art historian to see more than he could see without them, but *what* he sees has to be interpreted "stylistically," like that which he perceives with the naked eye.

The real answer lies in the fact that intuitive aesthetic re-creation and archaeological research are interconnected so as to form, again, what we have called an "organic situation." It is not true that the art historian first constitutes his object by means of re-creative synthesis and then begins his archaeological investigation—as though first buying a ticket and then boarding a train. In reality the two processes do not succeed each other, they interpenetrate; not only does the re-creative synthesis serve as a basis for the archaeological investigation, the archaeological investigation in turn serves as a basis for the re-creative process; both mutually qualify and rectify one another.

Anyone confronted with a work of art, whether aesthetically re-creating or rationally investigating it, is affected by its three constituents: materialized form, idea (that is, in the plastic arts, subject matter) and content. The pseudo-impressionistic theory according to which "form and color tell us of form and color, that is all," is simply not true. It is the unity of those three elements which is realized in the aesthetic experience, and all of them enter into what is called aesthetic enjoyment of art.

The re-creative experience of a work of art depends, therefore, not only on the natural sensitivity and the visual training of the spectator, but also on his cultural equipment. There is no such thing as an entirely "naive"

beholder. The "naive" beholder of the Middle Ages had a good deal to learn, and something to forget, before he could appreciate classical statuary and architecture, and the "naive" beholder of the post-Renaissance period had a good deal to forget, and something to learn, before he could appreciate medieval, to say nothing of primitive, art. Thus the "naive" beholder not only enjoys but also, unconsciously, appraises and interprets the work of art; and no one can blame him if he does this without caring whether his appraisal and interpretation are right or wrong, and without realizing that his own cultural equipment, such as it is, actually contributes to the object of his experience.

The "naive" beholder differs from the art historian in that the latter is conscious of the situation. He *knows* that his cultural equipment, such as it is, would not be in harmony with that of people in another land and of a different period. He tries, therefore, to make adjustments by learning as much as he possibly can of the circumstances under which the objects of his studies were created. Not only will he collect and verify all the available factual information as to medium, condition, age, authorship, destination, et cetera, but he will also compare the work with others of its class, and will examine such writings as reflect the aesthetic standards of its country and age, in order to achieve a more "objective" appraisal of its quality. He will read old books on theology or mythology in order to identify its subject matter, and he will further try to determine its historical locus, and to separate the individual contribution of its maker from that of forerunners and contemporaries. He will study the formal principles which control the rendering of the visible world, or, in architecture, the handling of what may be called the structural features, and thus build up a history of "motifs." He will observe the interplay between the influences of literary sources and the effect of self-dependent representational traditions, in order to establish a history of iconographic formulae or "types." And he will do his best to familiarize himself with the social, religious and philosophical attitudes of other periods and countries, in order to correct his own subjective feeling for content.[5] But when he does all this, his aesthetic perception as such will change accordingly, and will more and more adapt itself to the original "intention" of the works. Thus what the art historian, as opposed to the "naive" art lover, does, is not to erect a rational superstructure on an irrational foundation, but to develop his re-creative experiences so as to conform with the results of his archaeological research, while continually checking the results of his archaeological research against the evidence of his re-creative experiences.[6]

Leonardo da Vinci has said: "Two weaknesses leaning against one another add up to one strength."[7] The halves of an arch cannot even stand upright; the whole arch supports a weight. Similarly, archaeological research is blind and empty without aesthetic re-creation, and aesthetic re-creation is

irrational and often misguided without archaeological research. But, "leaning against one another," these two can support the "system that makes sense," that is, a historical synopsis.

As I have said before, no one can be blamed for enjoying works of art "naively"—for appraising and interpreting them according to his lights and not caring any further. But the humanist will look with suspicion upon what might be called "appreciationism." He who teaches innocent people to understand art without bothering about classical languages, boresome historical methods and dusty old documents deprives naïveté of its charm without correcting its errors.

"Appreciationism" is not to be confused with "connoisseurship" and "art theory." The connoisseur is the collector, museum curator or expert who deliberately limits his contribution to scholarship to identifying works of art with respect to date, provenance and authorship, and to evaluating them with respect to quality and condition. The difference between him and the art historian is not so much a matter of principle as a matter of emphasis and explicitness, comparable to the difference between a diagnostician and a researcher in medicine. The connoisseur tends to emphasize the re-creative aspect of the complex process which I have tried to describe, and considers the building up of a historical conception as secondary; the art historian in the narrower, or academic, sense is inclined to reverse these accents. But the simple diagnosis "cancer," if correct, implies everything which the research could tell us about cancer, and therefore claims to be verifiable by subsequent scientific analysis; similarly the simple diagnosis "Rembrandt around 1650," if correct, implies everything which the historian of art could tell us about the formal values of the picture, about the interpretation of the subject, about the way it reflects the cultural attitude of seventeenth-century Holland, and about the way it expresses Rembrandt's personality; and this diagnosis, too, claims to live up to the criticism of the art historian in the narrower sense. The connoisseur might thus be defined as a laconic art historian, and the art historian as a loquacious connoisseur. In point of fact the best representatives of both types have enormously contributed to what they themselves do not consider their proper business.[8]

Notes

1. [8] A. BLUNT, "Poussin's Notes on Painting," *Journal of the Warburg and Courtauld Institutes* (London) 1 (1937): 344 ff., claims (page 349) that Poussin's "La fin de l'art est la délectation" was more or less "medieval," because "the theory of *delectatio* as the sign by which beauty is recognized is the key of all St. Bonaventura's aesthetic, and it may well be from there, probably by means of some popularizer, that Poussin drew the definition." However, even if the wording of Poussin's phrase was influenced by a medieval source, there is a

great difference between the statement that *delectatio* is a *distinctive quality* of everything *beautiful,* whether man-made or natural, and the statement that *delectatio* is the *end* ("fin") of *art.*

2. [9] See M. GEIGER, "Beiträge zur Phänomenologie des aesthetischen Genusses," part 2, *Jahrbuch für Philosophie und phänomenologische Forschung* (Halle) 1 (1922), 567ff. Furthermore, E. WIND, *Aesthetischer und kunstwissenschaftlicher Gegenstand* (Ph.D. diss., University of Hamburg, 1923), partly reprinted as "Zur Systematik der künstlerischen Probleme," *Zeitschrift für Æsthetik und allgemeine Kunstwissenschaft* (Stuttgart) 18 (1925), 438ff.

3. [10] "Functionalism" means, strictly speaking, not the introduction of a new aesthetic principle, but a narrower delimitation of the aesthetic sphere. When we prefer the modern steel helmet to the shield of Achilles, or feel that the "intention" of a legal speech should be definitely focused on the subject matter and should not be shifted to the form ("more matter with less *art,*" as Queen Gertrude rightly puts it), we merely demand that arms and legal speeches should not be treated as works of art, that is, aesthetically, but as practical objects, that is, technically. However, we have come to think of "functionalism" as a postulate instead of an interdict. The Classical and Renaissance civilizations, in the belief that a merely useful thing could not be "beautiful" ("non può essere bellezza e utilità," as Leonardo da Vinci puts it; see JEAN PAUL RICHTER, *The Literary Works of Leonardo da Vinci 1445* [London: Sampson Low, Marston and Co., 1883]) are characterized by a tendency to extend the aesthetic attitude to such creations as are "naturally" practical; we have extended the technical attitude to such creations as are "naturally" artistic. This, too, is an infringement, and, in the case of "streamlining," art has taken its revenge. "Streamlining" was, originally, a genuine functional principle based on the results of scientific research on air resistance. Its legitimate sphere was therefore the field of fast-moving vehicles and of structures exposed to wind pressure of an extraordinary intensity. But when this special and truly technical device came to be interpreted as a general and aesthetic principle expressing the twentieth-century ideal of "efficiency" ("streamline your mind!"), and was applied to armchairs and cocktail shakers, it was felt that the original scientific streamline had to be "beautified"; and it was finally retransferred to where it rightfully belongs in a thoroughly non-functional form. As a result, we now less often have houses and furniture functionalized by engineers, than automobiles and railroad trains de-functionalized by designers.

4. [11] However, when speaking of "re-creation" it is important to emphasize the prefix "re." Works of art are both manifestations of artistic "intentions" and natural objects, sometimes difficult to isolate from their physical surroundings and always subject to the physical processes of aging. Thus, in experiencing a work of art aesthetically we perform two entirely different acts which, however, psychologically merge with each other into one *Erlebnis* [experience]: we build up our aesthetic object both by re-creating the work of art according to the "intention" of its maker, and by freely creating a set of aesthetic values comparable to those with which we endow a tree or a sunset. When abandoning ourselves to the impression of the weathered sculptures of Chartres, we cannot help enjoying their lovely mellowness and patina as an aesthetic value; but this value, which implies both the sensual pleasure in a

peculiar play of light and color and the more sentimental delight in "age" and "genuineness," has nothing to do with the objective, or artistic, value with which the sculptures were invested by their makers. From the point of view of the Gothic stone carvers the processes of aging were not merely irrelevant but positively undesirable; they tried to protect their statues by a coat of color which, had it been preserved in its original freshness, would probably spoil a good deal of our aesthetic enjoyment. As a private person, the art historian is entirely justified in not destroying the psychological unity of *Alters-und-Echtheits-Erlebnis* [age-and-genuineness experience] and *Kunst-Erlebnis* [art experience]. But as a "professional man" he has to separate, as far as possible, the re-creative experience of the intentional values imparted to the statue by the artist from the creative experience of the accidental values imparted to a piece of aged stone by the action of nature. And this separation is often not as easy as it might seem.

5. [12] For the technical terms used in this paragraph, see the introduction to ERWIN PANOFSKY, *Studies in Iconology: Humanistic Themes in the Art of the Renaissance*, Bryn Mawr College, the Mary Flexner Lectures on the Humanities no. 7 (New York: Oxford University Press, 1939); reprinted in T. M. GREENE, ed., *The Meaning of the Humanities* (Princeton, N.J.: Princeton University Press, 1940), 26–54.

6. [13] The same applies, of course, to the history of literature and of other forms of artistic expression. According to DIONYSIUS THRAX, *Ars Grammatica* 30, ed. P. Uhlig (Leipzig: B. G. Teubner, 1883), 5ff.; quoted in GILBERT MURRAY, *Religio Grammatici: The Religion of a "Man of Letters,"* Presidential Address to the Classical Association, 8 January 1918 (Boston and New York: Houghton Mifflin Company, 1918), 15, Γραμματική (history of literature, as we would say) is an ἐμπειρία (knowledge based on experience) of that which has been said by the poets and prose writers. He divides it into six parts, all of which can be paralleled in art history:

1) ἀνάγνωσις ἐντριβὴς κατὰ προσῳδίαν (expert reading aloud according to prosody): this is, in fact, the synthetic aesthetic re-creation of a work of literature and is comparable to the visual "realization" of a work of art.

2) ἐξήγησις κατὰ τοὺς ἐνυπάρχοντας ποιητικοὺς τρόπους (explanation of such figures of speech as may occur): this would be comparable to the history of iconographic formulae or "types."

3) γλωσσῶν τε καὶ ἱστοριῶν πρόχειρος ἀπόδοσις (offhand rendering of obsolete words and themes): identification of iconographic subject matter.

4) ἐτυμολογίας εὕρησις (discovery of etymologies): derivation of "motifs."

5) ἀναλογίας ἐκλογισμός (explanation of grammatical forms): analysis of compositional structure.

6) κρίσις ποιημάτων, ὅ δὴ κάλλιστόν ἐστι πάντων τῶν ἐν τῇ τέχνῃ (literary criticism, which is the most beautiful part of that which is comprised by Γραμματική): critical appraisal of works of art.

The expression "critical appraisal of works of art" raises an interesting question. If the history of art admits a scale of values, just as the history of literature or political history admits degrees of excellence or "greatness," how can we justify the fact that the methods here expounded do not seem to allow

for a differentiation between first-, second-, and third-rate works of art? Now a scale of values is partly a matter of personal reactions and partly a matter of tradition. Both these standards, of which the second is the comparatively more objective one, have continually to be revised, and every investigation, however specialized, contributes to this process. But just for this reason the art historian cannot make an a priori distinction between his approach to a "masterpiece" and his approach to a "mediocre" or "inferior" work of art— just as a student of classical literature cannot investigate the tragedies by Sophocles in any other manner than the tragedies by Seneca. It is true that the methods of art history, *qua* methods, will prove as effective when applied to Dürer's *Melancolia* as when applied to an anonymous and rather unimportant woodcut. But when a "masterpiece" is compared and connected with as many "less important" works of art as turn out, in the course of the investigation, to be comparable and connectable with it, the originality of its invention, the superiority of its composition and technique, and whatever other features make it "great," will automatically become evident—not in spite but because of the fact that the whole group of materials has been subjected to one and the same method of analysis and interpretation.

7. [14] G. PIUMATI, ed., *Il codice atlantico di Leonardo da Vinci nella Biblioteca Ambrosiana di Milano* (Milan: Ulrico Hoepli, 1894), fol. 244v.

8. [15] See MAX J. FRIEDLÄNDER, *Der Kunstkenner* (Berlin: B. Cassirer, 1919), and WIND, *Aesthetischer*. Friedländer justly states that a good art historian is, or at least develops into, a *Kenner wider Willen* [connoisseur against his will]. Conversely, a good connoisseur might be called an art historian *malgré lui* [in spite of himself].

The Modern Cult of Monuments: Its Essence and Its Development

ALOIS RIEGL

§1. Values of Monuments and Their Historical Development

In its oldest and most original sense a monument is a work of man erected for the specific purpose of keeping particular human deeds or destinies (or a complex accumulation thereof) alive and present in the consciousness of future generations. It may be a monument either of art or of writing, depending on whether the event to be eternalized is conveyed to the viewer solely through the expressive means of the fine arts or with the aid of inscription; most often both genres are combined in equal measure. The erection and maintenance of such "deliberate" monuments, which can be traced back to the earliest documented periods of human culture, have all but come to a halt today. When we speak of the modern cult of monuments or historic preservation, we rarely have "deliberate" monuments in mind. Rather, we think of "artistic and historical monuments," the official term to date, at least in Austria. This designation, which may have expressed quite a valid point of view from the sixteenth to the nineteenth centuries, may lead to misunderstandings today, due to the widespread contemporary conception of the essence of artistic value. Our primary task will therefore be to explore what was meant by "artistic and historical monuments" up until recently.

By common definition a work of art is any tangible, visible, or audible work of man of artistic value; a historical monument with any of the same properties will possess a historical value. In this context we may exclude

From ALOIS RIEGL, *Gesammelte Aufsätze* (Augsberg, Vienna: Dr. Benno Filser Verlag, G.m.b.H., 1928), 144–93; originally published as *Der moderne Denkmalkultus: Sein Wesen und seine Entstehung* (Vienna: W. Braumuller, 1903). Translated by Karin Bruckner with Karen Williams.

audible monuments (of musical art) from our consideration straightaway; for they, insofar as they are of any interest to us at all, are to be categorized simply as monuments of writing. The question that remains to be asked, therefore, refers solely to tangible and visible works of the fine arts (understood in the widest sense; that is, all creations formed by the hand of man): What is artistic and what is historical value?

Historical value is apparently the more comprehensive and may therefore be elaborated on first. We call historical all things that once were and are no longer. In keeping with the most modern conception, we include therein another view as well: that everything that once was can never be again, and that everything that once was forms an irreplaceable and inextricable link in a chain of development. Or, in other words: everything that succeeds was conditioned by what came before and would not have occurred in the manner in which it did if not for those precedents. The crux of every modern historical perception is precisely the idea of development. According to modern understanding, all human activity and all human fate of which we have evidence or knowledge may claim historical value: in principle, we consider every historical event to be irreplaceable. Since it is not possible, however, to take into consideration the vast number of events of which we have direct or indirect evidence, the number of which multiplies infinitely at every moment, one has no choice but to limit attention primarily and exclusively to such evidence that seems to represent especially striking stages in the development of a particular branch of human activity. This evidence may be a monument of writing, which, through reading, stirs images contained in our consciousness, or a monument of art, whose content is perceived directly through our senses. At this point it is important to realize that every monument of art is, without exception, a historical monument as well, since it represents a particular stage in the development of the fine arts for which no entirely equivalent replacement can be found. Conversely, every historical monument is also a monument of art, since even such a subordinate monument of writing as a torn-off slip of paper with a short, unimportant note contains, along with its historical value for the development of paper manufacturing, script, writing materials, et cetera, a whole series of artistic elements: the outward appearance of the slip of paper, the shape of the letters, and the manner of its composition. Certainly, these elements are so insignificant that we will not notice them in a thousand cases, since there are enough other monuments that will impart nearly the same content in a richer and more detailed manner. However, should the slip in question turn out to be the only preserved evidence of artistic creation of its time, we would be compelled, despite its scanty nature, to consider it an utterly indispensable monument of art. Art, as we encounter it in this example, is of interest to us

merely from a historical point of view: this monument appears to us as an indispensable link in the developmental chain of art history. The "monument of art" in this sense is really an "art-historical monument"; its value from this point of view is not "artistic value" but "historical value." As a result, the distinction between "monuments of art" and "historical monuments" is incorrect because the former are included in the latter and merge with them.

Is it only historical value, however, that we appreciate in monuments of art? If that were the case, then all works of art of former times, or at least of all periods of art, would have equal value in our eyes and would only achieve a relative increase in value by virtue of scarcity or age. In reality, we often hold later works in higher esteem than earlier ones; for example, a Tiepolo from the eighteenth century over a Mannerist work from the sixteenth century. There must be another kind of interest in an old work of art besides historical interest, something that can be found in specifically artistic properties, such as concept, form, and color. Apart from art-historical value, which all old works of art (monuments) possess without exception, there is also a purely artistic value that is independent of a work's rank within the developmental chain of history. Has this artistic value been just as objectively present as historical value, in the past, so that it may be said to represent, independent of the historical, an essential part of the definition of the monument? Or is it subjective, invented by a modern viewing subject in whose will it is formed and according to whose will it changes? If this were the case, would artistic value have no place in the definition of a monument as a work of commemorative value?

—⚉—

Consequently, "artistic value" has to be defined differently, depending on the earlier or more recent point of view. According to the older definition, a work of art was considered to possess artistic value if it corresponded to the requirements of an allegedly objective, but to date never clearly formulated, aesthetic. The more recent point of view assesses the artistic value of a monument according to the extent to which it meets the requirements of contemporary *Kunstwollen* (artistic volition), requirements that are even less clearly formulated and, strictly speaking, also never will be because they change incessantly from subject to subject and from moment to moment.

It is therefore of fundamental importance to our task that we fully clarify this difference in the perception of artistic value, since it influences the principal direction of all historic preservation in a decisive way. If there is no such thing as eternal artistic value but only a relative, modern one, then the artistic value of a monument is no longer commemorative, but a contemporary value instead. The preservation of monuments must certainly take this into account, since as a certain practical daily value it needs to be

considered along with a monument's historical past—commemorative value; this contemporary value must, however, be excluded from the definition of the "monument." If one adheres to the understanding of artistic value that emerged recently as the inevitable result of the immense art-historical research activity of the nineteenth century, then one may no longer speak in the future of "artistic and historical monuments," but only of "historical monuments." In the following we will use the term only in this sense.

Historical monuments are unintentional only in contrast to deliberate monuments; yet it is clear from the outset that deliberate monuments, which represent only a small fraction of all monuments, can at the same time be unintentional. Since the creators of these works, which we consider today as historical monuments, wanted primarily to satisfy certain practical or ideal needs of their own, of their contemporaries, and, at most, of their heirs, and certainly did not as a rule intend to leave evidence of their artistic and cultural life to future generations, then the term "monument," which we nevertheless use to define these works, can only be meant subjectively, not objectively. We modern viewers, rather than the works themselves by virtue of their original purpose, assign meaning and significance to a monument. In both cases—that of deliberate and of unintentional monuments—a commemorative value exists, and for that reason we think of both as "monuments." In both cases, we are interested furthermore in the original, uncorrupted form of the work as it left the hand of its maker, and this is the state in which we prefer to see it, or to which we prefer to restore it in thoughts, words, or images. In the case of deliberate monuments, the commemorative value is dictated to us by others (the former creators), while we define the value of unintentional monuments ourselves.

—⁂—

§2. The Relationship of Commemorative Values to the Cult of Monuments

—⁂—

In discussing commemorative value, naturally we have to begin with age value, not only because it is the most modern one and the one that will prevail in the future, but especially because it applies to the largest proportion of monuments.

A. Age Value

The age value of a monument reveals itself at first glance in the monument's outmoded appearance. That the monument appears outmoded is not so

much caused by an unfashionable stylistic form, since the style of the monument could be imitated and therefore its recognition and evaluation reserved for a relatively small circle of learned art historians, as by the fact that age value claims to appeal to the masses. Age value is revealed in imperfection, a lack of completeness, a tendency to dissolve shape and color, characteristics that are in complete contrast with those of modern, i.e., newly created, works.

—⁂—

The fundamental aesthetic principle of our time based on age value may be formulated as follows: From the hand of man we expect complete works as symbols of necessary and lawful production; from nature working over time, on the other hand, we expect the dissolution of completeness as a symbol of an equally necessary and lawful decay. Signs of decay (premature aging) in new works disturb us just as much as signs of new production (conspicuous restorations) in old works. Modern man at the beginning of the twentieth century particularly enjoys the perception of the purely natural cycle of growth and decay. Thus every work of man is perceived as a natural organism in whose development man may not interfere; the organism should live its life out freely, and man may, at most, prevent its premature demise. Thus modern man recognizes part of his own life in a monument and any interference with it disturbs him just as much as an intervention upon his own organism. The reign of nature, including those destructive and disintegrative elements considered part of the constant renewal of life, is granted equal standing with the creative rule of man.[1] It is considered displeasing, however, to break nature's law of the transition of growth into decay and vice versa. The obstruction of natural activity through the hand of man, which seems to us an almost impious sacrilege, as well as the premature destruction of human creation by the forces of nature, are to be strictly avoided. If the aesthetic effect of a monument, from the standpoint of age value, arises from signs of decay and the disintegration of the work's completeness through the mechanical and chemical forces of nature, the result would be that the cult of age value would not only find no interest in the preservation of the monument in its unaltered state, but it would even find such restoration contrary to its interests. The modern viewer of old monuments receives aesthetic satisfaction not from the stasis of preservation but from the continuous and unceasing cycle of change in nature. Thus the monument itself should not be withdrawn—not even if it were in human power to do so—from the disintegrating effects of nature's forces, provided these occur in calm, lawful continuity and not in sudden, violent destruction. From the standpoint of age value, one thing is to be avoided at all costs:

arbitrary human interference with the state in which the monument has developed. It may suffer neither addition nor subtraction; neither a restoration of what was disintegrated by the forces of nature in the course of time, nor the removal of whatever nature added to the monument during the same period of time, disfiguring its original discrete form. The pure, redeeming impression of natural, orderly decay may not be diminished by the admixture of arbitrary additions. The cult of age value condemns not only every violent destruction of monuments through the hand of man as a heinous interference with nature's lawful activity of disintegration, in which case the cult of age value operates on behalf of a monument's preservation; but in principle it condemns every effort at conservation, every restoration, as nothing less than an unauthorized interference with the reign of natural law. Therefore, the cult of age value works directly against the preservation of monuments. Without doubt, the unhampered activity of the forces of nature will ultimately lead to a monument's complete destruction. One can certainly say that ruins become more picturesque the more they are subject to decay: although the age value of ruins becomes less and less extensive as decay progresses—that is to say, as their age value is evoked by fewer and fewer elements—it also becomes more and more intensive, since the remaining elements have a much more forceful effect on the viewer. However, this process also has its limits, for if the extensive effect of age value is lost completely, no substance remains for intensive effect. A bare, shapeless pile of stones will not provide the viewer with a sense of age value. For that purpose, at least a distinct trace of the original form, of the former work of man—of the original production—must remain, since a pile of stones represents no more than a dead, formless fragment of the immensity of nature's force, without a trace of living growth.

—∞—

Age value, as indicated earlier, has one advantage over all other ideal values of the work of art: it claims to address everyone, to be valid for everyone without exception. It claims not only to be above all religious differences, but also to be above differences between the educated and the uneducated, art experts and laymen. Indeed, the criteria through which age value is perceived are, as a rule, so simple they can be appreciated even by people whose minds are otherwise absorbed completely with constant worries about their physical well-being and the material production of goods. Even the most limited peasant will be able to distinguish between an old church tower and a new one. In this sense, age value has a distinct advantage over historical value, which rests on a scientific basis and therefore can only be achieved through intellectual reflection. Age value, to the contrary, addresses the emotions directly; it reveals itself to the viewer through the most superficial, sensory (visual) perception. To be sure, age value has the same scientific root

as historical value; but age value will eventually signify the final scientific achievement for everyone; what the mind has honed will become accessible to the emotions. . . .

B. *Historical Value*

The historical value of a monument is based on the very specific yet individual stage the monument represents in the development of human creation in a particular field. From that perspective, what interests us in the monument are not the traces of nature's disintegrating force, which has brought its influence to bear through the course of time, but in the monument's original form as a work of man. A monument's historical value increases the more it remains uncorrupted and reveals its original state of creation: distortions and partial disintegrations are disturbing, unwelcome ingredients for historical value. This holds as equally true for art-historical value as for every value of cultural history, and also, naturally, for all chronological values. That the Parthenon, for example, survives for us merely as a ruin can only be regretted by the historian, whether he considers it as a monument of a particular stage in the development of Greek temple architecture, of the stonemason's craft, or of cult ideas and the worship of gods, and so on. It is the task of the historian to use all means available to correct the damage wrought by nature's power throughout the course of time. Symptoms of decay, which are crucial to age value, must by all means be removed according to the point of view of historical value. However, this must not happen with the monument itself but only with a copy or merely in thoughts or words. Thus even historical value considers the original monument fundamentally inviolable, but for an entirely different reason than age value. Historical value does not concern itself with preserving the traces of age or other changes caused by nature's impact since the time the monument was created; these do not matter or are just inconvenient. Rather, historical value is far more concerned with preserving the most genuine document possible for future restoration and art-historical research. Historical value knows that all human calculation and restoration is prone to individual error. For this reason, the original document must remain preserved whenever possible as an intact, available object, so future generations will be able to control our attempts at restoration and, if necessary, replace them with ones that are better and more well founded. The difference in interpretation between age value and historical value is most striking whenever questions arise as to the most suitable treatment of a monument by the standards of historical value. Prior disintegration by the forces of nature cannot be undone and should, therefore, not be removed even from the point of view of historical value. However, further disintegration from the present day into the future, as age value not only tolerates but

even postulates, is, from the standpoint of historical value, not only pointless but simply to be avoided, since any further disintegration hinders the scientific restoration of the original state of a work of man. Thus the cult of historical value must aim for the best possible preservation of a monument in its present state; this requires man to restrain the course of natural development and, to the extent that he is able, to bring the normal progress of disintegration to a halt. So we see that the interests of age value and historical value, although both commemorative values, diverge decisively on the critical issue of monument preservation.

—⁂—

First of all, even the most radical adherents of age value, which still to date belong predominately to the educated classes, will have to admit that the pleasure they experience from viewing a monument does not arise solely from age value, but to a large extent from the satisfaction derived from assigning the monument to one of the stylistic categories present in their minds, be it Antique, Gothic, or Baroque, and so on. Thus historical knowledge becomes an aesthetic source in addition to and aside from a feeling for age value. This satisfaction is certainly not immediate (that is to say, artistic); but one of intellectual reflection, for it requires art-historical knowledge. However, it is irrefutable that we have not become so independent of historical precedents of age value that we could entirely dispense with an interest in historical value. And when one turns today from people with higher education to people with average education, the latter of whom constitute the majority of those at all interested in ideal artistic values, one finds that even they divide monuments according to general periods such as medieval, early modern (Renaissance and Baroque), and modern. (In central Europe, ancient works are too rare to be generally recognized and evaluated as an individual class.) Such a division presupposes a basic orientation in art history and once again proves that we are not yet capable of separating age value from historical value as completely as some pioneers of the latest development may have in mind. This also explains why, for example, we find the ruinous state of a medieval castle more appropriate and more in accordance with our desire for atmosphere than that of a Baroque palace, which appears to us too new to be in such a state. We postulate, therefore, a certain relationship between the state of decay a monument displays and its age, which again presupposes a certain amount of art-historical knowledge.

From all of the above it may at least be said that commemorative value, one of the most important cultural forces today, has not achieved its absolute version as age value, so that we cannot fully dispense with its historical version completely. . . .

Today we still have every reason to do as much justice as we can to the requirements of historical research, that is, to satisfy the need for historical

value, rather than to simply treat it as a negligible quantity wherever it collides with the requirements of age value. Otherwise one would run the risk of impairing the higher interests that the preservation of age value is meant to serve.

—⁓—

It is not unusual for occasions to arise in which age value, while fundamentally opposed to interventions in the life cycle of the monument, must demand such measures. This is the case whenever the monument has suffered premature destruction by the forces of nature that threaten an abnormally rapid disintegration of its organism. If one observes, for instance, a segment of a previously well-preserved fresco on the exterior wall of a church being washed away by rain in such a way that the fresco itself threatens to perish before our eyes, then even an adherent of age value could certainly not oppose the installation of a protective awning, although this undoubtedly represents an intervention by the hand of modern man in the independent course of natural forces. . . .

In this particular case (the necessity of a protective awning over a fresco), we therefore see age value demanding the preservation of a monument through human intervention, something that typically only historical value, rather than age value, would strongly propose as in keeping with its intrinsic interests in protecting the original state of a work. To the proponents of the cult of age value, a gentle intervention by the hand of man seems the lesser of two evils when compared with the violence of nature. In such cases the interests of both values seem, at least on the surface, to go hand in hand, even though age value seeks merely to slow down disintegration, whereas historical value opts for a complete halt to the processes of decay altogether. The main issue for contemporary monument preservation is to avoid a conflict between both values.

—⁓—

C. Deliberate Commemorative Value

In contrast to age value, which appreciates the past for its own sake, historical value has had the tendency to select a particular moment from the developmental history of the past and to place it before our eyes as if it were part of the present. From the outset, that is from the erection of the monument itself, the purpose of deliberate commemorative value is to keep a moment from becoming history, to keep it perpetually alive and present in the consciousness of future generations. This third category of commemorative values forms the obvious transition to present-day values.

Whereas age value is based solely on decay, historical value seeks to stop the progression of future decay, even though its entire existence rests on

the decay that has occurred to the present day. Deliberate commemorative value simply makes a claim for immortality, an eternal present, an unceasing state of becoming. The disintegrating forces of nature, which work against the fulfillment of this claim, must therefore be fought ardently, their effects paralyzed again and again. A memorial column, for instance, with its inscription effaced, would cease to be a deliberate monument. Thus the fundamental requirement of deliberate monuments is restoration.

The character of deliberate commemorative value as a present-day value is furthermore expressed in the fact that there have always been laws to protect it against the destructive intervention of the hand of man.

In this category of monuments, the conflict with age value has naturally been constant. Without restoration, monuments would soon cease to be deliberate; age value is therefore a sworn enemy of deliberate commemorative value. As long as mankind does not abandon the yearning for immortality, the cult of age value will find an insurmountable opponent in the cult of deliberate commemorative value. Yet this irreconcilable conflict between age value and deliberate commemorative value has caused fewer difficulties for monument preservation than one would at first assume, since the number of "deliberate" monuments is relatively small compared to the vast quantity of nondeliberate ones.

§3. The Relationship between Present-Day Values and the Cult of Monuments

Most monuments are also able to satisfy those sensory and intellectual desires of man that could as well (if not better) be met by modern creations; and this potential, for which the monument was erected and on which its commemorative value is derived, is also the basis for its present-day value. From the standpoint of present-day value, one tends not to consider a monument as such but puts it on a par with a recently completed modern creation, thus requiring a monument (old) to display the same outer appearance as any work of man (new) in a state of becoming: that is, the appearance of absolute completeness and integrity unaffected by the destructive forces of nature. Depending on the nature of the particular present-day value considered, symptoms of natural decay may well be tolerated; sooner or later, however, a limit will be reached beyond which present-day value would become impossible and would strive to prevail over age value. A monument's treatment in accordance with age value, which wants to allow practically all things to run their natural course, ultimately comes into conflict with present-day value. . . .

—⁓—

A. *Use Value*

Physical life is a precondition for all psychic life and is therefore more important. The former can, at least, prosper just as well without the higher form of psychic life but not vice versa. Thus, for instance, an old building still in use must be maintained in good enough condition to accommodate people without endangering their lives or their health; any opening created in its walls or ceilings by the forces of nature must be repaired immediately. . . . In general, one could say that use value is basically indifferent to the kind of treatment a monument receives, as long as the monument's existence is not threatened. Beyond that, however, absolutely no concessions may be made to age value. . . .

The fact that innumerable secular and ecclesiastical monuments can still be put to practical use today and are actually being used does not need to be proved. If they were to go out of use, substitutions would be required in most cases. This demand is so compelling that age value's counterclaim to leave monuments to their natural fate could only be considered if one intended to produce substitutions of at least equal quality. However, the practical realization of this demand is only possible in relatively few exceptional cases. . . .

—⁓—

If we were to assume that it were actually possible to produce a modern substitution for all usable monuments, so that old originals could live out their lives without restoration, but as a result also without any practical use, would the requirements of age value be met completely? The question is not only justified, the answer to it is clearly no. Age value is based on the perception of the lively play of natural forces, an essential part of which would be irredeemably lost if a monument were not used by man. Who would want to view the dome of St. Peter's in Rome, for instance, without the lively entourage of modern visitors or religious ritual practices? Even the most radical adherent of age value would consider a residential building that was destroyed by lightning—even if remains indicated that the building had been built several centuries ago—or the ruins of a church on a well-traveled street more disturbing than evocative: we are used to seeing such structures used by man and find it disturbing when they have lost their familiar use and create an impression of violent destruction, unbearable even to the cult of age value. Age value reveals its full undiminished charm in the remains of those monuments that are no longer of practical use to us and in which we do not miss human activity as a force of nature, such as in the ruins of a medieval castle set in the wilderness of a steep mountain or in a Roman temple on one of Rome's busiest streets. We are still far from being able to

apply the pure standards of age value equally and indiscriminately to all monuments. We still distinguish more or less accurately between monuments that can and cannot be used, just as we distinguish between older and more recent ones. In the latter, we take historical value into consideration, in the former, we take use value along with age value. Only unusable works—that is to say, works with no use value—can be viewed and enjoyed exclusively from the standpoint of age value. Our viewing of usable works is always more or less impaired or disturbed should they fail to exhibit the present-day value we have come to expect from them. Here one encounters the same modern spirit that has given rise to the well-known agitation against *prisons d'art*.[2] Age value must oppose even more fervently than historical value the attempt to uproot a monument from its previous, so to speak, "organic" context and to imprison it in a museum, even though this setting would most effectively exempt it from the necessity for restoration.

Newness Value

Every monument, depending on its age and other favorable or unfavorable circumstances, must have experienced to a greater or lesser extent the disintegrating effect of natural forces. The monument will therefore simply never attain the completeness of form and color that newness value requires. This is the reason why strikingly aged works of art have always, even up to the present day, appeared more or less unsatisfactory in terms of the modern *Kunstwollen*. The conclusion is obvious: If a monument bearing signs of disintegration is to appeal to the modern *Kuntswollen*, the traces of age must be removed first of all, and through restoration of its form and color appear once again like a newly created work. Newness character can therefore only be preserved by means that are absolutely contradictory to the cult of age value.

At this point, the possibility of a conflict with age value arises that exceeds all aforementioned conflicts in terms of its severity and implacability. Newness value is indeed the most formidable opponent of age value.

The completeness of the newly created is expressed by the simple criteria of unbroken form and pure polychromy and can be judged by everyone, even those devoid of education. Thus newness value has always been the art value of the mass majority of the less educated or uneducated; whereas relative art value, at least since the beginning of more recent times, could only be evaluated by the aesthetically educated. The masses have always been pleased by everything that appeared new; in works of man they wished to see only the creatively triumphant effect of human power and not the destructive force of nature's power, which is hostile to the work of man. According to the masses, only the new and complete is beautiful; the old, fragmentary, and

discolored is considered ugly. This view of youth being undoubtedly prefer-able to age has become so deeply rooted over the past millennium that it will be impossible to eradicate in a couple of decades. For the majority of modern men, it is considered entirely self-evident that a chipped edge of a piece of furniture will be replaced by a new one or that sooty wall plaster will be taken down and replaced by fresh plaster. The great resistance that the apostles of age value encountered on their first appearance may be clearly explained by such a perspective. More than that, all of preservation of the nineteenth century was based essentially on this traditional point of view, or, to be more precise, on an intimate fusion of newness value and historical value: any striking trace of natural decay was to be removed, any loss or fragment was to be repaired, the work was to be restored to a complete, unified whole. The reinstatement of a document into its original state was the openly admit-ted and zealously propagated goal of all rational preservation of the nine-teenth century.

—⁂—

We seem to face a hopeless conflict here: on the one hand is an appre-ciation of the old for its own sake, a view that condemns any renovation of the old on principle; on the other hand is an appreciation of the new for its own sake, a view that seeks to remove all traces of age as disturbing and displeasing. The immediacy with which newness value may affect the masses far exceeds, at least today, the immediacy previously claimed for age value. Furthermore, the perpetual esteem newness value has enjoyed throughout the millennia, even as far back as we can look in human history, has under-standably yielded a claim to absolute and eternal validity for its adherents and, at least for now, has rendered its position close to irrefutable. The extent to which the cult of age value still requires the pioneering preparatory work of historical value becomes clear precisely from this point of view. Far wider classes of society will have to be won over to the cult of historical value before, with their help, the broad masses will be ready for the cult of age value. Wherever age value collides with newness value in a monument of continuous use, it will seek as much as possible to resign itself to newness value, not only for practical considerations (of use value, which was dis-cussed in the previous section), but also out of ideal (elementary artistic) considerations. . . .

Practical use value corresponds aesthetically to newness value as well; for its own sake, the cult of age value will, at least at its present stage of development, have to tolerate a certain degree of newness value in modern and usable works. If, for example, a Gothic town hall were to lose the crown of its baldachin in a highly visible place, the proponents of age value would certainly prefer to allow the trace of age to remain undisturbed. Today, how-ever, it does not cause any real controversy when, in the name of decorum,

the adherents of newness value advocate the restoration of the crown to its (indisputably verified) original form. The vehement controversy in which the proponents of both values engaged during the nineteenth century refer to another conclusion derived from newness value and in favor of historical value.

This controversy concerns monuments that have not been entirely preserved in their original form, but have, through the course of time, been subject to various stylistic additions through the hand of man. At a time when the cult of historical value for its own sake was still the most decisive and was based on the clear recognition of an original form, efforts were drawn toward the removal of all subsequent additions (cleaning, exposure) and the restoration of the original forms, whether these had been documented accurately or not. Even a mere modern approximation to the original seemed to be more satisfactory to the cult of historical value than an authentic, but stylistically foreign, earlier addition. The cult of newness value joins with historical value in this attempt insofar as the original to be restored also presents an intact appearance, since any addition that did not belong to the original style destroyed completeness and was considered a symptom of disintegration. The result of this was the postulate of stylistic unity, which advocated not only the removal of additions added to the work at a later stylistic period but also the renovation of the monument to a form in keeping with its original style. It is therefore correct to say that monument preservation of the nineteenth century was based essentially on the postulates of stylistic originality (historical value) and stylistic unity (newness value).

The strongest resistance to this system occurred when the cult of age value came into existence, since the latter concerned itself neither with stylistic originality nor with completeness but, on the contrary, sought to break with both of them. In this case, according to the cult of age value, what is required to keep a monument "alive," in use, is not necessarily concessions to either use value or its aesthetic counterpart, newness value, but rather a sacrifice of virtually everything that constitutes age value in a monument. To succumb would have been tantamount to a capitulation of age value; in order to avoid that, the adherents of age value began a fierce struggle against the previous system. Such struggles usually result in exaggerated claims against the opposing side, thereby obscuring clear insight into the matter at hand. As a result of these exaggerated claims, a reformer generally disputes in the heat of the battle some justifiable points of the old system that should not be sacrificed along with the truly untenable points. The impartial observer may feel compelled to unjustifiably support the truly untenable points of the old system endangered by reformist propaganda. However, the increasing change of opinion today has actually helped quite legitimate elements in the cult of age value to slowly establish themselves on their own. As one of many

examples: eight years ago a decision was made to demolish the Baroque choir of the Altmünster parish church, even though it was not yet in need of repair, and to replace it with a Gothic choir in order to achieve stylistic unity with the Gothic main building. Four years ago this plan to construct a Gothic choir of very dubious historical value but indisputable newness value was abandoned, primarily for financial reasons. Today, adherents of both the old and the new systems agree that it would have been an inexcusably sinful act against age value and historical value to remove the Herberstorf Choir, an artistic expression of the introduction of the Counter-Reformation in upper Austria. The postulate of stylistic unity appears to have been abandoned in this new, but widely shared point of view, which is even applicable to an ecclesiastical monument; the chasm between the thinkers among the adherents of the old system and the prudent among the reformers is actually bridged at the point where it earlier had been the widest.

Notes

1. Other characteristic traits of modern cultural life that refer back to the same origin as age value, especially in Germanic nations, are animal protection efforts and an appreciation for landscape in general. This appreciation has widened from the protection of individual plants or entire forests to the demand for the legal protection of "natural monuments," and thus to the inclusion of even inorganic matter into the scope of subjects requiring protection.
2. [Literally "prisons of art," used ironically to refer to art museums.]

Principles of Art History

HEINRICH WÖLFFLIN

LINEAR AND PAINTERLY
GENERAL OBSERVATIONS

§1. Linear (Draftsmanly, Plastic) and Painterly
Tactile and Visual Picture

If we wish to reduce the difference between the art of Dürer and the art of Rembrandt to its most general formulation, we say that Dürer is a draftsman and Rembrandt a painter. In speaking thus, we are aware of having gone beyond a personal judgment and characterized a difference of epoch. Occidental painting, which was draftsmanly in the sixteenth century, developed especially on the painterly side in the seventeenth. Even if there is only one Rembrandt, a decisive readjustment of the eye took place everywhere, and whoever has any interest in clearing up his relation to the world of visible forms must first get to grips with these radically different modes of vision. The painterly mode is the later, and cannot be conceived without the earlier, but it is not absolutely superior. The linear style developed values which the painterly style no longer possessed and no longer wanted to possess. They are two conceptions of the world, differently orientated in taste and in their interest in the world, and yet each capable of giving a perfect picture of visible things.

From HEINRICH WÖLFFLIN, *Principles of Art History: The Problem of the Development of Style in Later Art,* trans. M. D. Hottinger (New York: Dover, 1950), 18–21, 23, 27, 29, 54–56, 62–71, 229–31; originally published as *Kunstgeschichtliche Grundbegriffe: Das Problem der Stilentwickelung in der neueren Kunst* (Munich: F. Bruckmann, 1915). Used by permission of Dover Publications, Inc.

Although in the phenomenon of linear style, line signifies only part of the matter, and the outline cannot be detached from the form it encloses, we can still use the popular definition and say for once as a beginning—linear style sees in lines, painterly in masses. Linear vision, therefore, means that the sense and beauty of things is first sought in the outline—interior forms have their outline too—that the eye is led along the boundaries and induced to feel along the edges, while seeing in masses takes place where the attention withdraws from the edges, where the outline has become more or less indifferent to the eye as the path of vision, and the primary element of the impression is things seen as patches. It is here indifferent whether such patches speak as color or only as lights and darks.

The mere presence of light and shade, even if they play an important part, is still not the factor which decides as to the painterly character of the picture. Linear art, too, has to deal with bodies and space, and needs lights and shadows to obtain the impression of plasticity. But line as fixed boundary is assigned a superior or equal value to them. Leonardo is rightly regarded as the father of chiaroscuro, and his *Last Supper* in particular is the picture in which, for the first time in later art, light and shade are applied as a factor of composition on a large scale, yet what would these lights and darks be without the royally sure guidance which is exercised by the line? Everything depends on how far a preponderating significance is assigned to or withdrawn from the edges, whether they *must* be read as lines or not. In the one case, the line means a track moving evenly round the form, to which the spectator can confidently entrust himself; in the other, the picture is dominated by lights and shadows, not exactly indeterminate, yet without stress on the boundaries. Only here and there does a bit of palpable outline emerge: it has ceased to exist as a uniformly sure guide through the sum of the form. Therefore, what makes the difference between Dürer and Rembrandt is not a less or more in the exploitation of light and shade, but the fact that in the one case the masses appear with stressed, in the other with unstressed edges.

As soon as the depreciation of line as boundary takes place, painterly possibilities set in. Then it is as if at all points everything was enlivened by a mysterious movement. While the strongly stressed outline fixes the presentment, it lies in the essence of a painterly representation to give it an indeterminate character: form begins to play; lights and shadows become an independent element, they seek and hold each other from height to height, from depth to depth; the whole takes on the semblance of a movement ceaselessly emanating, never ending. Whether the movement be leaping and vehement, or only a gentle quiver and flicker, it remains for the spectator inexhaustible.

We can thus further define the difference between the styles by saying that linear vision sharply distinguishes form from form, while the painterly

eye on the other hand aims at that movement which passes over the sum of things. In the one case, uniformly clear lines which separate; in the other, unstressed boundaries which favor combination. Many elements go to produce the impression of a general movement—we shall speak of these—but the emancipation of the masses of light and shade until they pursue each other in independent interplay remains the basis of a painterly impression. And that means, too, that here not the separate form but the total picture is the thing that counts, for it is only in the whole that that mysterious interflow of form and light and color can take effect, and it is obvious that here the immaterial and incorporeal must mean as much as concrete objects.

—⁓—

But with all that the decisive word is not yet said. We must go back to the fundamental difference between draftsmanly and painterly representation as even antiquity understood it—the former represents things as they are, the latter as they seem to be. This definition sounds rather rough, and to philosophic ears, almost intolerable. For is not everything appearance? And what kind of a sense has it to speak of things as they are? In art, however, these notions have their permanent right of existence. There is a style which, essentially objective in outlook, aims at perceiving things and expressing them in their solid, tangible relations, and conversely, there is a style which, more subjective in attitude, bases the representation on the *picture*, in which the visual appearance of things looks real to the eye, and which has often retained so little resemblance to our conception of the real form of things.

Linear style is the style of distinctness plastically felt. The evenly firm and clear boundaries of solid objects give the spectator a feeling of security, as if he could move along them with his fingers, and all the modeling shadows follow the form so completely that the sense of touch is actually challenged. Representation and thing are, so to speak, identical. The painterly style, on the other hand, has more or less emancipated itself from things as they are. For it, there is no longer a continuous outline and the plastic surfaces are dissolved. Drawing and modeling no longer coincide in the geometric sense with the underlying plastic form, but give only the visual semblance of the thing.

Where nature shows a curve, we perhaps find here an angle, and instead of an evenly progressive increase and decrease of light, light and shade now appear fitfully, in ungraded masses. Only the *appearance* of reality is seized—something quite different from what linear art created with its plastically conditioned vision, and just for that reason, the signs which the painterly style uses can have no further direct relation to the real form. The pictorial form remains indeterminate, and must not settle into those lines and curves which correspond to the tangibility of real objects.

The tracing out of a figure with an evenly clear line has still an element of physical grasping. The operation which the eye performs resembles the operation of the hand which feels along the body, and the modeling which repeats reality in the gradation of light also appeals to the sense of touch. A painterly representation, on the other hand, excludes this analogy. It has its roots only in the eye and appeals only to the eye, and just as the child ceases to take hold of things in order to "grasp" them, so mankind has ceased to test the picture for its tactile values. A more developed art has learned to surrender itself to mere appearance.

With that, the whole notion of the pictorial has shifted. The tactile picture has become the visual picture—the most decisive revolution which art history knows.

—⚹—

A further point. Unified seeing, of course, involves a certain distance. But distance involves a progressive flattening of the appearance of the solid body. Where tactile sensations vanish, where only light and dark tones lying side by side are perceived, the way is paved for painterly presentment. Not that the impression of volumes and space is lacking; on the contrary, the illusion of solidity can be much stronger, but this illusion is obtained precisely by the fact that no more plasticity is introduced into the picture than the appearance of the whole really contains. That is what distinguishes an etching by Rembrandt from any of Dürer's engravings. In Dürer everywhere the endeavor to achieve tactile values, a mode of drawing which, as long as it is in any way possible, follows the form with its modeling lines; in Rembrandt, on the other hand, the tendency to withdraw the picture from the tactile zone and, in drawing, to drop everything which is based on immediate experiences of the organs of touch, so that there are cases in which a rounded form is drawn as a completely flat one with a layer of straight lines, though it does not look flat in the general impression of the whole. This style is not present from the beginning. Within Rembrandt's work, there is a distinct development. Thus the early *Diana Bathing* is still modeled throughout in a (relatively) plastic style with curved lines following the separate form: [in] the late female nudes, on the other hand, little is used but flat lines. In the first case, the figure stands out; in the later compositions, on the other hand, it is embedded in the totality of the space-creating tones. But what comes clearly to light in the pencil work of the drawing is, of course, also the foundation of the painted picture, although in the latter case it is perhaps more difficult for the layman to realize it.

In establishing such facts, however, which are peculiar to the art of representation on flat surfaces, we must not forget that we are aiming at a notion of the painterly which is binding beyond the special domain of

painting and means as much for architecture as for the arts of the imitation of nature.

The great contrast between linear and painterly style corresponds to radically different interests in the world. In the former case, it is the solid figure, in the latter, the changing appearance: in the former, the enduring form, measurable, finite; in the latter, the movement, the form in function; in the former, the thing in itself; in the latter, the thing in its relations. And if we can say that in the linear style the hand has felt out the corporeal world essentially according to its plastic content, the eye in the painterly stage has become sensitive to the most various textures, and it is no contradiction if even here the visual sense seems nourished by the tactile sense—that other tactile sense which relishes the kind of surface, the different skin of things. Sensation now penetrates beyond the solid object into the realm of the immaterial. The painterly style alone knows a beauty of the incorporeal. From differently orientated interests in the world, each time a new beauty comes to birth.

As even the most perfect imitation of the natural appearance is still infinitely different from reality, it can imply no essential inferiority if linearism creates the tactile rather than the visual picture. The purely visual apprehension of the world is *one* possibility, but no more. By the side of this there will always arise the need for a type of art which does not merely catch the moving appearance of the world, but tries to do justice to being as revealed by tactile experiences. It would be well if in all teaching representation in both types were practiced.

Sculpture
General Remarks

Winckelmann, criticizing Baroque sculpture, exclaims scornfully, "What a contour!" He regards the self-contained expressive contour line as an essential element of all sculpture and loses interest when the outline yields him nothing. Yet, beside sculpture with a stressed, significant outline, we can imagine sculpture with depreciated outline, where the expression is not formed in the line, and the Baroque possessed such an art.

In the literal sense, sculpture as the art of corporeal masses knows no line, but the contrast between linear and painterly sculpture exists for all that, and the effect of the two types of style is hardly less different than in painting. Classic art aims at boundaries: there is no form that does not express itself within a definite line-motive, no figure of which we could not

say with an eye to what view it is conceived. The Baroque negates the out-line: not in the sense that silhouette effects are excluded altogether, but the figure evades consolidation within a definite silhouette. It cannot be tied down to a particular view. It at once eludes the spectator who tries to grasp it. Of course, Classic sculpture can be viewed from different standpoints, but other views are clearly *secondary* with reference to the principal view. There is a jerk when we return to the principal motive, and it is obvious that the sil-houette is here more than the fortuitous cessation of the visibility of the form: it asserts, beside the figure, a kind of independence, just because it represents something self-sufficing. Conversely, the essence of a Baroque silhouette is that it does not possess this independence. No line-motive is intended to set up an existence of its own. No view completely exhausts the form. We can even go further—only the form-alienated outline is the painterly outline.

And the surfaces are handled in the same way. There is not only the objective difference that Classic art loves quiet and Baroque restless sur-faces: the handling of the form is different. In the one case, only definite, tangible values; in the other, transition and change: the representation reck-ons with effects which no longer exist for the hand but only for the eye. While in Classic art, lights and darks are subordinated to the plastic form, the lights here seem to have awakened to an independent life. In apparently free movement, they play over the surfaces, and it can even happen now that the form is completely submerged in the darkness of the shadows. Nay, even without possessing the possibilities which painting on surfaces, by definition the art of semblance, has at its disposal, sculpture in its turn has recourse to indications of form which no longer have anything to do with the form of the object and cannot be called anything but Impressionist.

While sculpture thus allies itself with mere visual appearance and ceases to set up the palpable and real as the essential, it enters upon quite new territory. It rivals painting in the representation of the transitory and stone is made to subserve the illusion of every kind of texture. The bright glance of the eye can be rendered just as well as the shimmer of silk or the softness of flesh. Every time since then that a Classic tendency has revived and defended the rights of line, it has considered it necessary to protest against this illusionism in texture in the name of the purity of style.

Painterly figures are never isolated figures. The movement must re-echo, and must not coagulate in a motionless atmosphere. Even the shadow in the niche is now far more important for the figure than formerly. It is no longer a mere foil, but springs into the play of movement: the darkness of the recess unites with the shadow of the figure. For the most part, architecture must collaborate with sculpture, preparing or prolonging movement. If, then, great objective movement is added, there arise those wonderful total effects,

such as are to be found especially in Northern Baroque altars, where the figures combine to such an extent with the structure that they look like the foam on the tossing wave of the architecture. Torn out of their context, they lose all their meaning, as is proved by some unfortunate exhibitions in modern museums.

As regards terminology, the history of sculpture offers the same difficulties as the history of painting. Where does linear cease and painterly begin? Even within Classicism, we shall have to distinguish varying degrees of the painterly, and when then light and dark increase in importance and the determinate form yields more and more to the indeterminate, we can denote the process in general as a development into the painterly, but it is absolutely impossible to lay one's finger on the point at which movement in light and form has reached so great a freedom that the notion painterly in the real sense of the word must be applied.

It is, however, not unnecessary to state here clearly that the character of definite linearity and plastic limitation was only attained after a long development. It is only in the course of the fifteenth century that Italian sculpture develops a clearer sensitiveness to line, and without certain painterly effects of movement being eliminated, the form-boundaries begin to acquire independence. It is certainly one of the most delicate tasks of the history of style to estimate correctly the degree of silhouette effect or, conversely, to appreciate the shimmer of a relief by Antonio Rossellino according to its original painterly content. Here the way lies open to the dilettante. Everyone imagines that, as he sees things, they are well seen, and the more painterly effects he can blink out of the thing, the better. Instead of losing time in individual criticism, let us refer to the painful subject of reproductions in books of our time in which, according to perception and standpoint, the essential character is so often missed.

—ɯ—

Architecture
General Remarks

The examination of painterly and unpainterly in the tectonic arts is especially interesting in that the concept, here for the first time liberated from confusion with the demands of imitation, can be appreciated as a pure concept of decoration. Of course, for painting and architecture, the position is not quite the same. Architecture of its very nature cannot become an art of semblance to the same degree as painting, yet the difference is only one of degree and the essential elements of the definition of the painterly can be applied as they stand.

The elementary phenomenon is this—that two totally different architectural effects are produced according to whether we are obliged to perceive the architectural form as something definite, solid, enduring, or as something over which, for all its stability, there plays an apparent, constant movement, that is, change. But let there be no misunderstanding. Of course, all architecture and decoration reckons with certain suggestions of movement; the column rises, in the wall, living forces are at work, the dome swells upwards, and the humblest curve in the decoration has its share of movement, now more languid, now more lively. But in spite of that movement, the picture in Classic art is constant, while post-Classic art makes it look as though it must change under our eyes. That is the difference between a Rococo decoration and a Renaissance ornament. A Renaissance panel may be designed with as much life as you like, its appearance stays as it is, while ornamentation such as Rococo art strew[n] over its surfaces produces the impression that it is in constant change. And the effect in major architecture is the same. Buildings do not run away and a wall remains a wall, but there subsists a very palpable difference between the finished look of Classic architecture and the never quite assimilable picture of later art; it is as though the Baroque had feared ever to speak the last word.

—ᴍ—

It has rightly been said that the effect of a beautifully proportioned room would make itself felt if we were led through it blindfold. Space, being physical, can only be apprehended by physical organs. This spatial effect is a property of all architecture. If painterly interest is added, it is a purely visual element—pictorial, and hence no longer accessible to that most general type of tactile feeling. The perspective of a flight of rooms is painterly not by the architectonic quality of the single room, but by the picture, the visual picture which is yielded by the superimposed forms: the separate form in itself can be felt, but the picture which is born of the sequence of receding forms can only be seen. So that, whenever "views" are to be reckoned with, we stand on painterly ground.

It goes without saying that Classic architecture must be *seen*, and that its tangibility has only an imagined significance. And in the same way we can, of course, look at the building in many ways, foreshortened or not, with or without intersection of the forms, and so on, yet from all standpoints, the tectonic basic form will penetrate as the decisive element, and where this basic form is distorted, we shall feel the fortuitousness of a merely secondary aspect and not be ready to tolerate it long. Conversely, painterly architecture is particularly interested in making its basic form appear in as many and as various pictures as possible. While in the Classic style the permanent form is emphasized and the variation of the appearance has beside it no independent

value, the composition in the other case is from the outset laid out in "pictures." The more manifold they are, the more they diverge from the objective form, the more painterly the building is considered to be.

In the staircase of a rich Rococo chateau, we do not look for the solid, enduring, concrete form of the layout, but surrender to the rhythm of the changing views, convinced that these are not fortuitous by-products, but that, in this spectacle of never-ending movement, the true life of the building is expressed.

Bramante's St. Peter's as a circular building with cupolas would also have yielded many views, but those which were painterly in our sense would have been, for the architect and his contemporaries, the meaningless ones. Being was the essential, not the pictures shifted this way or that. In the strict sense, architectonic architecture could acknowledge either no standpoint of the spectator—certain distortions of the form always being present—or all: painterly architecture, on the other hand, always reckons with the beholding subject, and hence does not in the least desire to create buildings which may be viewed from all standpoints, such as Bramante worked out for his St. Peter's; it restricts the space at the spectator's disposal so that it may the more certainly achieve the effects it has at heart.

—⁓—

We know that the Baroque enriched the form. Figures become more intricate, motives entwine, the order of the parts is more difficult to grasp. Insofar as this is connected with the principle of the avoidance of absolute lucidity, we shall have to consider these points later: here the phenomenon will only be treated insofar as the specifically painterly transformation of purely tangible into purely visual values is illustrated. Classic taste works throughout with clear-cut, tangible boundaries; every surface has a definite edge, every solid speaks as a perfectly tangible form; there is nothing there that could not be perfectly apprehended as a body. The Baroque neutralizes line as boundary, it multiplies edges, and while the form in itself grows intricate and the order more involved, it becomes increasingly difficult for the individual parts to assert their validity as plastic values; a (purely visual) movement is set going over the sum of the forms, independently of the particular viewpoint. The wall vibrates, the space quivers in every corner.

—⁓—

But the impression of movement is only attained when visual appearance supplants concrete reality. That is, as has already been observed, not possible to the same degree in the tectonic arts as in painting: we shall, perhaps, speak of Impressionist decoration, but not of Impressionist architecture. But, all the same, architecture has means enough at its disposal to provide the painterly contrast to the Classic type. It always depends on how much the individual form complies with the (painterly) total movement.

Depreciated line enters more easily into the great play of forms than plastically significant, form-defining contour. Light and shade, which cling to every form, become a painterly element at the moment at which they seem to have an independent import apart from the form. In Classic style, they are bound to the form; in the painterly style, they appear unbound and quicken to free life. It is no longer the shadows of the separate pilaster or window pediment of which we become aware, or, at any rate, not of these only. The shadows link up among themselves, and the plastic form can at times be quite submerged in the total movement which plays over the surfaces. In interiors, this movement of light can be carried on in oppositions of dazzling light and pitch dark, or tremble in merely light tones—the principle remains unchanged. In the one case, we must think of the vigorous plastic movement of Italian church interiors; in the other, of the flickering lightness of a very softly modeled Rococo room. If the Rococo liked wall mirrors, that does not only mean that it liked light, but also that it wished to discount the wall as concrete surface by what is apparently impalpable not-surface—the reflecting glass.

The deadly enemy of the painterly is the isolation of the single form. In order that the illusion of movement may be brought about, the forms must approach, entwine, fuse. A piece of furniture of painterly design always requires atmosphere: you cannot set a Rococo chest of drawers against any wall—the movement must re-echo. It is the peculiar charm of Rococo churches that every altar, every confessional, is merged into the whole. The astonishing extent to which tectonic barriers are broken down in the consistent development of this demand can be realized in supreme examples of painterly movement, as, for instance, the St. John Nepomuk Church by the brothers Asam in Munich.

As soon as Classicism reappears, the forms temporarily separate. In the facade of the palace, we can again see window beside window, each separately apprehensible. Semblance has evaporated. The concrete form, solid, enduring, must speak, and that means that the elements of the tangible world again take the lead—line, plane, geometric body. All Classic architecture seeks beauty in what is, Baroque beauty is the beauty of movement. In the former, "pure" forms have their home, and architects seek to give visible form to the perfection of eternally valid proportions. In the latter, the value of perfected being sinks into insignificance beside the idea of breathing life. The constitution of the body is not indifferent, but the primary demand is that it should have movement; in movement, above all, lies the stimulus of life.

These are radically different conceptions of the world. What has here been set forth on the subject of painterly and unpainterly forms one part of the expression in which the conception of the world manifested itself. The spirit of the style, however, is equally present in major as in minor arts. A

Figure 1
Hans Holbein the Younger,
tankard. Etching by
Wenceslaus Hollar.

Figure 2
Rococo vase, Schwarzenberg
Garden, Vienna.

mere vase is enough to illustrate the universal historical opposition. When Holbein designs a tankard [Fig. 1], it is the plastically determinate figure in absolute perfection, a Rococo vase [Fig. 2] is a painterly, indeterminate work: it settles into no tangible outline, and over the surfaces there plays a movement of light which makes their tangibility illusory; the form is not exhausted in *one* aspect, but contains for the spectator something inexhaustible. . . .

―――

Every epoch perceives with its own eyes, and nobody will contest its right to do so, but the historian must ask in each case how a thing demands to be seen in itself. In painting this is easier than in architecture, where there are no limits to arbitrary perception. The stock of reproductions at the disposal of art history is rife with false views and false interpretations of effects. The only thing that can help here is verification by contemporary pictures.

A multiform late Gothic building such as the Town Hall of Louvain must not be so drawn as a modern eye, trained on Impressionist lines, sees it (in any case, that gives no scientifically serviceable reproduction), and a late Gothic chest in low relief must not be looked at in the same way as a Rococo chest of drawers: both objects are painterly, but the store of contemporary

pictures gives the historian plenty of clear indications as to how one type of the painterly is to be distinguished from the other.

The distinction between painterly and unpainterly (or strict) architecture comes out most clearly when painterly taste has had to grapple with a building of the old style, that is, where we have an alteration into the painterly style.

The SS. Apostoli church in Rome [Fig. 3] possesses a fore part which was worked out in early Renaissance style in two stories of arcades with pillars below and slim columns above. In the eighteenth century the upper story was closed in. Though the system was not destroyed, a wall was created which, envisaging throughout the impression of movement, stands in characteristic contrast to the strict character of the ground floor. Insofar as this impression of movement is achieved by atectonic means (raising of the window pediments above the line of the springing of the arches), or is produced by the motive of the rhythmic articulation (unequal accentuation of the bays by the statues on the balustrade—the central and corner bays are stressed) we leave the matter to itself; nor must the peculiar conformation of the middle window, which projects from the surface—at the edge of our reproduction—preoccupy us here. What is radically painterly is that the forms have here lost throughout their separateness and tangible concreteness, so that, beside them, the pillars and arches of the lower story appear as something totally disparate, as the only real plastic values. That does not lie in the

Figure 3
SS. Apostoli Church, Rome.

stylistic detail—the creating spirit is different. Not the restless movement of the line in itself is the decisive factor (in the breaking of the pediment corners) nor the multiplication of the line itself (in the arches and lintels), but that a movement is created which quivers over the whole. This effect presumes that the spectator is able to disregard the merely tangible character of the architectonic form and is capable of surrendering to the visual spectacle, where semblance interweaves with semblance. The treatment of form assists this reading in every way possible. It is difficult, even impossible, to seize the old column as a plastic form, and the originally simple archivolt is not less withdrawn from immediate tangibility. By the telescoping of the motives—arches and pediments—the building becomes so intricate in appearance that one is always impelled to apprehend the total movement rather than the single form.

In strict architecture every line looks like an edge and every volume a solid body: in painterly architecture the impression of mass does not cease, but with the notion of tangibility there is combined that illusion of all-pervading movement which is derived just from the nontangible elements of the impression.

A balustrade in the strict style is the sum of so many balusters which assert themselves as tangible separate bodies in the impression: with a painterly balustrade, on the other hand, it is the shimmer of the total form which is the main factor in the effect.

—✳︎—

Foreshortening adds its quotum. The effect of painterly movement will make itself felt the more easily if the surface proportions are distorted and the body as a form of appearance is divorced from its real form. Confronted with Baroque facades, we always feel impelled to take up our stand to the side. Meanwhile, we must here again refer to the fact that every epoch bears its standard within itself, and that not all views are possible at all times. We are always prone to take things in a still more painterly way than they are meant to be taken, even to force the definitely linear, if it is at all possible, into the painterly. . . .

With the idea of foreshortening, we have attacked the problem of the perspective view. In painterly architecture, as has been pointed out, it plays an essential part. For what has been said up to now, we refer to the example of S. Agnese in Rome [Fig. 4], a church with a central dome and two front towers. The rich array of forms predisposes to a painterly effect, but is not in itself painterly. S. Biagio in Montepulciano is composed of the same elements without being akin in style. What makes the painterly character of the design here is the fact that into the artistic calculation there enters that variation of the aspect which, of course, is never entirely absent, but is, in a handling of form aiming from the outset at visual effects, much more strongly

Figure 4
S. Agnese Church, Rome.

justified than in architecture of pure being. Every reproduction remains inadequate, because even the most startling picture in perspective represents only *one* possibility, and the interest lies just in the inexhaustibility of the possible pictures. While Classic architecture seeks its significance in corporeal reality, and only allows the beauty of the aspect to proceed from the architectural organism as its natural result, the visual appearance, in the Baroque, plays a determining part in the conception from the beginning: the aspects, not the aspect. The building assumes very different forms, and this variation in the mode of appearance is enjoyed as the interest of movement. The views strive toward each other, and the picture with the foreshortening and overlapping of single parts is as little criticized as an improper by-product as, for instance, the asymmetrical appearance in perspective of two symmetrical towers. This type of art takes care to set up the building in

97

pictorially fruitful sites for the spectator. That always means a limitation of the points of view. It does not lie in the interests of painterly architecture to set up the building so that the spectator may move all round it, that is, as a tangible object, as was the ideal of Classic architecture.

—⁓—

CONCLUSION

§3. The Why of the Development

The development from the linear to the painterly, comprehending all the rest, means the progress from a tactile apprehension of things in space to a type of contemplation which has learned to surrender itself to the mere visual impression, in other words, the relinquishment of the physically tangible for the sake of the mere visual appearance.

The point of departure must, of course, be given. We spoke only of the transformation of a Classic art into the Baroque. But that a Classic art comes into being at all, that the striving for a picture of the world, plastically tectonic, clear, and thought out in all its aspects, exists—that is by no means a matter of course, and only happened at definite times and at certain places in the history of mankind. And though we feel the course of things to be intelligible, that, of course, still does not explain why it takes place at all. For what reasons does this development come about?

Here we encounter the great problem—is the change in the forms of apprehension the result of an inward development, of a development of the apparatus of apprehension fulfilling itself to a certain extent of itself, or is it an impulse from outside, the other interest, the other attitude to the world, which determines the change? The problem leads far beyond the domain of descriptive art history, and we will only indicate what we imagine the solution to be.

Both ways of regarding the problem are admissible; i.e., each regarded for itself alone. Certainly we must not imagine that an internal mechanism runs automatically and produces, in any conditions, the said series of forms of apprehension. For that to happen, life must be experienced in a certain way. But the human imaginative faculty will always make its organization and possibilities of development felt in the history of art. It is true, we only see what we look for, but we only look for what we can see. Doubtless certain forms of beholding preexist as possibilities; whether and how they come to development depends on outward circumstances.

The history of generations does not proceed differently from the history of the individual. If a great individual like Titian incorporates perfectly

new possibilities in his ultimate style, we can certainly say a new feeling demanded this new style. But these new possibilities of style first appeared for him because he had already left so many old possibilities behind him. No human personality, however mighty, would have sufficed to enable him to conceive these forms if he had not previously been over the ground which contained the necessary preliminary stages. The continuity of the life feeling was as necessary here as in the generations which combine to form a unit in history.

The history of forms never stands still. There are times of accelerated impulse and times of slow imaginative activity, but even then an ornament continually repeated will gradually alter its physiognomy. Nothing retains its effect. What seems living today is not quite completely living tomorrow. This process is not only to be explained negatively by the theory of the palling of interest and a consequent necessity of a stimulation of interest, but positively also by the fact that every form lives on, begetting, and every style calls to a new one. We see that clearly in the history of decoration and architecture. But even in the history of representative art, the effect of picture on picture as a factor in style is much more important than what comes directly from the imitation of nature. Pictorial imitation developed from decoration—the design as representation once arose from the ornament—and the aftereffects of this relation have affected the whole of art history.

It is a dilettantist notion that an artist could ever take up his stand before nature without any preconceived ideas. But what he has taken over as concept of representation, and how this concept goes on working in him, is much more important than anything he takes from direct observation. (At least as long as art is creative and decorative and not scientifically analytic.) The observation of nature is an empty notion as long as we do not know in what forms the observation took place. The whole progress of the "imitation of nature" is anchored in decorative feeling. Ability only plays a secondary part. While we must not allow our right to pronounce qualitative judgments on the epochs of the past to atrophy, yet it is certainly right that art has always been able to do what it wanted and that it dreaded no theme because "it could not do it," but that only that was omitted which was not felt to be pictorially interesting. Hence the history of art is not secondarily but absolutely primarily a history of decoration.

All artistic beholding is bound to certain decorative schemas or—to repeat the expression—the visible world is crystallized for the eye in certain forms. In each new crystal form, however, a new facet of the content of the world will come to light.

Italian Painters of the Renaissance

BERNARD BERENSON

Psychology has ascertained that sight alone gives us no accurate sense of the third dimension. In our infancy long before we are conscious of the process, the sense of touch, helped on by muscular sensations of movement, teaches us to appreciate depth, the third dimension, both in objects and in space.

In the same unconscious years we learn to make of touch, of the third dimension, the test of reality. The child is still dimly aware of the intimate connection between touch and the third dimension. He cannot persuade himself of the unreality of Looking-Glass Land until he has touched the back of the mirror. Later, we entirely forget the connection, although it remains true that every time our eyes recognize reality, we are, as a matter of fact, giving tactile values to retinal impressions.

Now, painting is an art which aims at giving an abiding impression of artistic reality with only two dimensions. The painter must, therefore, do consciously what we all do unconsciously—construct his third dimension. And he can accomplish his task only as we accomplish ours, by giving tactile values to retinal impressions. His first business, therefore, is to rouse the tactile sense, for I must have the illusion of being able to touch a figure, I must have the illusion of varying muscular sensations inside my palm and fingers corresponding to the various projections of this figure, before I shall take it for granted as real, and let it affect me lastingly.

From BERNARD BERENSON, *The Florentine Painters of the Renaissance* (New York: G. P. Putnam's Sons, 1896) and *The Central Italian Painters of the Renaissance* (New York: G. P. Putnam's Sons, 1897); reprint under the title *The Italian Painters of the Renaissance* (London: Phaidon, 1952), 40–43, 93–95 (page citations are to the reprint edition). Reproduced with permission of Phaidon Press Ltd, London.

It follows that the essential in the art of painting—as distinguished from the art of coloring, I beg the reader to observe—is somehow to stimulate our consciousness of tactile values, so that the picture shall have at least as much power as the object represented, to appeal to our tactile imagination.

Well, it was of the power to stimulate the tactile consciousness—of the essential, as I have ventured to call it, in the art of painting—that Giotto was supreme master. This is his everlasting claim to greatness, and it is this which will make him a source of highest aesthetic delight for a period at least as long as decipherable traces of his handiwork remain on moldering panel or crumbling wall. For great though he was as a poet, enthralling as a story-teller, splendid and majestic as a composer, he was in these qualities superior in degree only, to many of the masters who painted in various parts of Europe during the thousand years that intervened between the decline of antique, and the birth, in his own person, of modern painting. But none of these masters had the power to stimulate the tactile imagination, and, consequently, they never painted a figure which has artistic existence. Their works have value, if at all, as highly elaborate, very intelligible symbols, capable, indeed, of communicating something, but losing all higher value the moment the message is delivered.

Giotto's paintings, on the contrary, have not only as much power of appealing to the tactile imagination as is possessed by the objects represented—human figures in particular—but actually more; with the necessary result that to his contemporaries they conveyed a *keener* sense of reality, of lifelikeness than the objects themselves! We whose current knowledge of anatomy is greater, who expect more articulation and suppleness in the human figure, who, in short, see much less naively now than Giotto's contemporaries, no longer find his paintings more than lifelike; but we still feel them to be intensely real in the sense that they powerfully appeal to our tactile imagination, thereby compelling us, as do all things that stimulate our sense of touch while they present themselves to our eyes, to take their existence for granted. And it is only when we can take for granted the existence of the object painted that it can begin to give us pleasure that is genuinely artistic, as separated from the interest we feel in symbols.

At the risk of seeming to wander off into the boundless domain of aesthetics, we must stop at this point for a moment to make sure that we are of one mind regarding the meaning of the phrase "artistic pleasure," in so far at least as it is used in connection with painting.

What is the point at which ordinary pleasures pass over into the specific pleasures derived from each one of the arts? Our judgment about the merits of any given work of art depends to a large extent upon our answer to this question. Those who have not yet differentiated the specific pleasures of

the art of painting from the pleasures they derive from the art of literature, will be likely to fall into the error of judging a picture by its dramatic presentation of a situation or its rendering of character; will, in short, demand of a painting that it shall be in the first place a good *illustration*. Others who seek in painting what is usually sought in music, the communication of a pleasurable state of emotion, will prefer pictures which suggest pleasant associations, nice people, refined amusements, agreeable landscapes. In many cases this lack of clearness is of comparatively slight importance, the given picture containing all these pleasure-giving elements in addition to the qualities peculiar to the art of painting. But in the case of the Florentines, the distinction is of vital consequence, for they have been the artists in Europe who have most resolutely set themselves to work upon the specific problems of the art of figure painting, and have neglected, more than any other school, to call to their aid the secondary pleasures of association. With them the issue is clear. If we wish to appreciate their merit, we are forced to disregard the desire for pretty or agreeable types, dramatically interpreted situations, and, in fact, "suggestiveness" of any kind. Worse still, we must even forgo our pleasure in color, often a genuinely artistic pleasure, for they never systematically exploited this element, and in some of their best works the color is actually harsh and unpleasant. It was in fact upon form, and form alone, that the great Florentine masters concentrated their efforts, and we are consequently forced to the belief that, in their pictures at least, form is the principal source of our aesthetic enjoyment.

Now in what way, we ask, can form in painting give me a sensation of pleasure which differs from the ordinary sensations I receive from form? How is it that an object whose recognition in nature may have given me no pleasure, becomes, when recognized in a picture, a source of aesthetic enjoyment, or that recognition pleasurable in nature becomes an enhanced pleasure the moment it is transferred to art? The answer, I believe, depends upon the fact that art stimulates to an unwonted activity psychical processes which are in themselves the source of most (if not all) of our pleasures, and which here, free from disturbing physical sensations, never tend to pass over into pain. For instance: I am in the habit of realizing a given object with an intensity that we shall value as 2. If I suddenly realize this familiar object with an intensity of 4, I receive the immediate pleasure which accompanies a doubling of my mental activity. But the pleasure rarely stops here. Those who are capable of receiving direct pleasure from a work of art, are generally led on to the further pleasures of self-consciousness. The fact that the psychical process of recognition goes forward with the unusual intensity of 4 to 2 overwhelms them with the sense of having twice the capacity they had credited themselves with: their whole personality is enhanced, and, being aware that this enhancement is connected with the object in question, they for some

time after take not only an increased interest in it, but continue to realize it with the new intensity. Precisely this is what form does in painting: it lends a higher coefficient of reality to the object represented, with the consequent enjoyment of accelerated psychical processes, and the exhilarating sense of increased capacity in the observer. (Hence, by the way, the greater pleasure we take in the object painted than in itself.)

And it happens thus. We remember that to realize form we must give tactile values to retinal sensations. Ordinarily we have considerable difficulty in skimming off these tactile values, and by the time they have reached our consciousness, they have lost much of their strength. Obviously, the artist who gives us these values more rapidly than the object itself gives them, gives us the pleasures consequent upon a more vivid realization of the object, and the further pleasures that come from the sense of greater psychical capacity.

Furthermore, the stimulation of our tactile imagination awakens our consciousness of the importance of the tactile sense in our physical and mental functioning, and thus, again, by making us feel better provided for life than we were aware of being, gives us a heightened sense of capacity. And this brings us back once more to the statement that the chief business of the figure painter, as an artist, is to stimulate the tactile imagination.

The proportions of this book forbid me to develop further a theme, the adequate treatment of which would require more than the entire space at my command. I must be satisfied with the crude and unillumined exposition given already, allowing myself this further word only, that I do not mean to imply that we get no pleasure from a picture except the tactile satisfaction. On the contrary, we get much pleasure from composition, more from color, and perhaps more still from movement, to say nothing of all the possible associative pleasures for which every work of art is the occasion. What I do wish to say is that *unless* it satisfies our tactile imagination, a picture will not exert the fascination of an ever-heightened reality; first we shall exhaust its ideas, and then its power of appealing to our emotions, and its "beauty" will not seem more significant at the thousandth look than at the first.

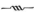

If Duccio was so sublime in his conceptions, so deep in feeling, so skillful in transcribing them in adequate forms; if, in addition to all these merits as an Illustrator, he can win us with the material splendor of his surfaces; if he composes as few but Raphael, and can even make us realize space, why have we heard of him so seldom? Why is he not as renowned as Giotto? Why is he not ranked with the greatest painters? Giotto was but little younger, and there could have been a scarcely perceptible difference between the public of the one and the public of the other. Most of Giotto's paintings now existing were, in fact, executed rather earlier than Duccio's reredos. Is the illustrative part of Giotto's work greater? On the whole, it

certainly is not; at times it is decidedly inferior, seldom having Duccio's manifold expressiveness and delicately shaded feeling. If Giotto, then, was no greater an Illustrator than Duccio, and if his illustrations, as illustrations, correspond no more than Duccio's to topics we crave nowadays to see interpreted in visual form, and if, as interpretation, they are equally remote from our own conception and feeling; if, in short, one is no more than the other a writer of pictorial leaders on the entrancing interests of the hour, why is the one still a living force, while the other has faded to the shadow of a name? There must exist surely a *viaticum* which bears its possessor to our own hearts, across the wastes of time—some secret that Giotto possessed and Duccio had never learned.

What is this mysterious life-conserving virtue—in what does it consist? The answer is brief—*in life itself.* If the artist can cunningly seize upon the spirit of life and imprison it in his paintings, his works, barring material accidents, will live for ever. If he contrives to give range to this spirit, to make it leap out, to mingle with and increase the life in our veins, then, for as long as we remain humanized beings, he will hold us in his thrall.

I have attempted elsewhere in this volume [*The Central Italian Painters of the Renaissance,* 1897] to explain what is this *viaticum,* this quality so essential to the figure arts that, for want of it, when scarcely born, they dwindle away; and to Book II, *Florentine Painters* ([1896,] pp. 40–43), wherein the question is discussed, I must refer the reader. Here I shall limit myself to saying that, by means of their more subtle Decorative elements, the arts must be life-enhancing—not by their material charm alone, still less by their attractiveness as Illustrations. This particular life-communicating quality is in the figure arts to be attained by the rendering of form and movement. I prefer to the word "form" to use the expression "tactile values," for form in the figure arts gives us pleasure because it has extracted and presented to us the corporeal and structural significance of objects more quickly and more completely than we—unless, indeed, we also be great artists, or see as they see—could have grasped them by ourselves. This intimate realization of an object comes to us only when we unconsciously translate our retinal impressions of it into ideated sensations of touch, pressure, and grasp—hence the phrase "tactile values." Correct drawing, fine modeling, subtle light and shade, are not final goods. In themselves they have no value whatever, and it does not in the least explain the excellence of a picture to say it is well modeled, well lighted, and well drawn. We esteem these qualities because with them the artist succeeds in conveying tactile values and movement; but to suppose that we love pictures merely because they are well painted, is as if we said that we like a dinner because it is well cooked, whereas, in fact, we like it only because it *tastes* good. To speak of the drawing, the modeling, the chiaroscuro, as to speak of cookery in the instance of a dinner, is the busi-

ness of the persons who paint and cook; but we whose privilege it is to enjoy what has been cooked or painted for us—we, I say, must either talk of it in terms of enjoyment and the psychology thereof, or—talk nonsense!

Tactile values and movement, then, are the essential qualities in the figure arts, and no figure painting is real—has a value of its own apart from the story it has to tell, the ideal it has to present—unless it conveys ideated sensations of touch and movement. If I may be pardoned a very childish parable, it is like someone who comes to us with a message. He tells us something we are very eager to know. No matter how we have been rejoiced by his news, no matter how attractive he seems, if he is merely a messenger, it is only of his message that we think. But let him be a man of character and a gentleman, let him be sympathetic, and his message will have been but the happy accident that has initiated a lifelong friendship. And so with a picture; long after, years after we have exhausted its message, if it have tactile values and movement, we are more in love with it than ever, because these qualities, like the attractions in a friend, have the power of directly enhancing life.

And now to return to Duccio. His paintings do not possess these virtues, and therefore have been nearly forgotten, while Giotto's works contain them to a degree so remarkable that even today the real lover of art prefers them to all but a very few masterpieces. For Duccio, the human figure was in the first place important as a person in a drama, then as a member in a composition, and only at the last, if at all, as an object whereby to stimulate our ideated feelings of touch and movement. The result is that we admire him profoundly as a pictorial dramatist, as a Christian Sophocles, somewhat astray in the realm of painting; we enjoy his material splendor and his exquisite composition, but rarely if ever do we find him directly life-communicating.

Conversations with Berenson

UMBERTO MORRA

20 *June 1937*

The desire to touch is instinctive, from children to the common man, almost as though experimenting with the resistance of objects were the only guarantee of their existence. With art objects, with masterpieces, the same thing occurs: whoever is most intellectually motivated, most expert, will seek to "touch" through his imagination and ideas, to convince himself of the corporeality of objects by some other means than pure touch. For the most proven admirers, "ideated sensations" substitute for the touch of the hand.

Nevertheless I feel sympathetic with anyone who does touch, with anyone who does not keep himself from seeking that immediate and "material" (if you wish to say it that way) communication, because its materialness does have a meaning, even if only embryonic, which so many abstruse metaphysics and so many ideal assertions completely fail to have. Contact is a desire for joining, love for the "thing in itself," of "itness" as I call it. And a work of art is, above all, an irreplaceable, individual thing which knows nothing "beyond" itself, which is alone and essential in itself. Thus one makes contact with art not theorizing or reading theories, but looking, being in direct relationship. But since the work of art is, from another standpoint, the living stone of the structure in which we live, the most vivid incarnation of time, it is also necessary to know this house where we live: our civilization, our history. And thus all the history which has already been explained, all historical works, help our knowledge of art, as does that other manifestation of life which is literature. My precept, better to say my admonition, is not to

From UMBERTO MORRA, *Conversations with Berenson* (Boston: Houghton Mifflin, 1965), 240–41. Used by permission of Brunetto Vincioni for the Estate of Umberto Morra.

read works about the figurative arts, but to look, and then, with the greatest possible intelligence, comparative faculty, instinct, and education, to read (never enough) works of history and literature in order to always be putting the work of art into a more conscious relation with time, that is with the human element, and thus to be more successful in identifying, in deepening, the work of art in oneself.

Fundamental Laws
of Sculpture

JOHN RUSKIN

§137

Fundamental Laws of Sculpture

Sculpture is essentially the production of a pleasant bossiness or roundness of surface.

If you look from some distance at these two engravings of Greek coins,[1] you will find the relief on each of them simplifies itself into a pearl like portion of a sphere, with exquisitely gradated light on its surface. When you look at them nearer, you will see that each smaller portion into which they are divided—cheek, or brow, or leaf, or tress of hair—resolves itself also into a rounded or undulated surface, pleasant by gradation of light. Every several surface is delightful in itself, as a shell, or a tuft of rounded moss, or the bossy masses of distant forest would be. That these intricately modulated masses present some resemblance to a girl's face, such as the Syracusans imagined that of the water goddess Arethusa, is entirely a secondary matter; the primary condition is that the masses shall be beautifully rounded, and disposed with due discretion and order.

It is difficult for you, at first, to feel this order and beauty of surface, apart from the imitation. But you can see there is a pretty disposition of, and relation between, the projections of a fir cone, though the studded spiral imi-

From KENNETH CLARK, *Ruskin Today,* chosen and annotated by Kenneth Clark (London: John Murray, 1964), 151–54; originally published in JOHN RUSKIN, *Aratra Pentelici: Six Lectures on the Elements of Sculpture, Given before the University of Oxford in Michaelmas Term, 1870* (London: Smith, Elder, 1872), lecture 1, nos. 21–25. Used by permission of John Murray (Publishers) Ltd.

tates nothing. Order exactly the same in kind, only much more complex; and an abstract beauty of surface rendered definite by increase and decline of light—(for every curve of surface has its own luminous law, and the light and shade on a parabolic solid differs, specifically, from that on an elliptical or spherical one)—it is the essential business of the sculptor to obtain; as it is the essential business of a painter to get good color, whether he imitates anything or not. At a distance from the picture, or carving, where the things represented become absolutely unintelligible, we must yet be able to say, at a glance, "That is good painting, or good carving."

And you will be surprised to find, when you try the experiment, how much the eye must instinctively judge in this manner. Take the front of San Zenone, for instance. You will find it impossible without a lens, to distinguish in the bronze gates, and in great part of the wall, anything that their bosses represent. You cannot tell whether the sculpture is of men, animals, or trees; only you feel it to be composed of pleasant projecting masses; you acknowledge that both gates and wall are, somehow, delightfully roughened; and only afterwards, by slow degrees, can you make out what this roughness means; nay, though here I magnify one of the bronze plates of the gate to a scale, which gives you the same advantage as if you saw it quite close, in the reality—you may still be obliged to me for the information, that this boss represents the Madonna asleep in her little bed, and this smaller boss, the Infant Christ in His; and this at the top, a cloud with an angel coming out of it, and these jagged bosses, two of the Three Kings, with their crowns on, looking up to the star (which is intelligible enough, I admit); but what this straggling, three-legged boss beneath signifies, I suppose neither you nor I can tell, unless it be the shepherd's dog, who had come suddenly upon the Kings with their crowns on, and is greatly startled at them.

Farther, and much more definitely, the pleasantness of the surface decoration is independent of structure; that is to say, of any architectural requirement of stability. The greater part of the sculpture here is exclusively ornamentation of a flat wall, or of door-paneling; only a small portion of the church front is thus treated, and the sculpture has no more to do with the form of the building than a piece of lace veil would have, suspended beside its gates on a festal day; the proportions of shaft and arch might be altered in a hundred different ways, without diminishing their stability; and the pillars would stand more safely on the ground than on the backs of these carved animals.

Note

1. [Not reproduced in Clark 1964.]

From Light into Paint

E. H. GOMBRICH

*Painting is the most astounding sorceress. She can persuade us
through the most evident falsehoods that she is pure Truth.*

—Jean Etienne Liotard, *Traité des principes et des règles de la peinture* [1]

§1

Among the treasures of the National Gallery of Art in Washington hangs a
painting of Wivenhoe Park in Essex by John Constable [Fig. 1]. No historical
knowledge is needed to see its beauty. Anyone can enjoy the rural charm of
the scene, the artist's skill and sensitivity in rendering the play of sunlight on
the green pastures, the gentle ripples on the lake with its swans, and the
beautiful cloudscape that encloses it all. The picture looks so effortless and
natural that we accept it as an unquestioning and unproblematic response to
the beauty of the English countryside.

But for the historian there is an added attraction in this painting. He
knows that this freshness of vision was won in a hard struggle. The year 1816,
in which Constable painted this country seat of one of his first patrons,
marks a turning point in his artistic career.[2] He was moving toward that con-
ception of painting which he was later to sum up in his lectures at Hamp-
stead. "Painting is a science," Constable said, "and should be pursued as an
inquiry into the laws of nature. Why, then, may not landscape painting be
considered as a branch of natural philosophy, of which pictures are but the
experiments?"[3]

From E. H. GOMBRICH, *Art and Illusion: A Study in the Psychology of Pictorial
Representation* (London: Phaidon, 1960; reprint 1977), 29–30, 33, 37–38, 40, 42–44,
46–47, 49–54 (page numbers are to the reprint edition). Reproduced with permission of
Phaidon Press Ltd, London.

Figure 1
John Constable, *Wivenhoe Park,
Essex,* 1816. After treatment (1982).
Oil on canvas, 22⅛ × 39⅞ in.

What Constable called "natural philosophy" we today call "physics"; the assertion that the quiet and unassuming painting of Wivenhoe Park should be classed with the abstruse experiments of physicists in their laboratories must sound puzzling at first. . . .

. . . Wivenhoe Park looks so natural and obvious that we are inclined to overlook its daring and its success. We accept it as simply a faithful record of what the artist saw in front of him—"a mere transcript of nature," as paintings of this kind are sometimes described, an approximation at least to that photographic accuracy against which modern artists have rebelled. Let us admit there is something in this description. Constable's painting is surely much more like a photograph than the works of either a Cubist or a medieval artist. . . .

[T]he artist . . . cannot transcribe what he sees; he can only translate it into the terms of his medium. He, too, is strictly tied to the range of tones which his medium will yield. Where the artist works in black and white this transposition is easily seen. We happen to have two drawings made by Constable on almost the same spot. In one [Fig. 2] he seems to have used a rather hard-pointed pencil. He had therefore to adjust all his gradations to what is objectively a very narrow range of tones, from the black horse in the foreground to the distant trees through which the light of the sky appears to shine, as represented by the grayish paper. . . . Does it therefore reproduce what the artist had in front of his eyes?

Figure 2
John Constable, *Dedham Vale,*
ca. 1811. Pencil drawing.

. . . When we say that an image looks exactly like its prototype we usually mean that the two would be indistinguishable when seen side by side in the same light. Place them in different lights and the similarity will disappear. If the difference is small we can still restore the match by brightening the colors of the object in the dimmer light, but not if the one is in the shade and the other in sunlight. It was not for nothing that painters were advised since ancient times to have their studios facing north. For if the painter of a portrait or a still life hopes to copy the color of his motif area by area, he must not allow a ray of sunlight to play havoc with his procedure. Imagine him matching a white tablecloth with his whitest white—how could his palette then still yield the extra brightness of a sunlit patch or the brilliance of a sparkling reflection? The landscape painter has even less use for literal imitation.

—◊◊◊—

The artist cannot copy a sunlit lawn, but he can suggest it. Exactly how he does it in any particular instance is his secret, but the word of power which makes this magic possible is known to all artists—it is "relationships."

No professional critic saw the nature of this problem more clearly than a famous amateur artist who had taken up painting as a pastime. But then this was no ordinary amateur but Sir Winston Churchill:

> It would be interesting if some real authority investigated carefully the part which memory plays in painting. We look at the object with an intent regard, then at the palette, and thirdly at the canvas. The canvas receives a message dispatched usually a few seconds before from the natural object. But it has come through a post office en route. It has been

112

transmitted in code. It has been turned from light into paint. It reaches the canvas a cryptogram. Not until it has been placed in its correct relation to everything else that is on the canvas can it be deciphered, is its meaning apparent, is it translated once again from mere pigment into light. And the light this time is not of Nature but of Art.[4]

I am not that "real authority" on memory to whom Sir Winston appealed for an explanation of this mystery, but it seems to me that we will be able to tackle this aspect only after we have learned more about that "transmission in code" which he discusses.

§II

No medium illustrates the code character of this gradation more clearly than that of the mosaic. Four graded tones of tesserae will suffice for the mosaicists of classical antiquity to suggest the basic relationships of form in space. I confess to being naive enough to admire these simple tricks of the craftsmen who laid down the floor mosaics for villas and baths throughout the Roman Empire [Fig. 3]. They exemplify the relational cryptograms which remained in use throughout Western art, the contrast of figure and ground on the one hand and, within the figure, the modifications of the "local color" through the simple "more" or "less" of light.

Figure 3
Floor mosaic from house near Antioch, second century C.E.

As a matter of fact, we have become so obedient to the artist's suggestions that we respond with perfect ease to the notation in which black lines indicate both the distinction between ground and figure and the gradations of shading that have become traditional in all graphic techniques. Baldung Grien's woodcut of the Fall [Fig. 4] looks perfectly complete and legible to us

LAPSVS HVMA·
NI GENERIS ∵

Figure 4
Baldung Grien, *The Fall of Man,*
1511. Woodcut.

in its notation of black and white. It is all the more interesting to study the
additional effect of the second plate [Fig. 5]—one of the earliest examples of
the chiaroscuro woodcut technique. By lowering the tone of the ground the
artist can now use the white of the paper to indicate light. The gain from this
modest extension of range is dramatic, for these indications of light not only
increase the sense of modeling but also convey to us what we call "texture"—
the way, that is, in which light behaves when it strikes a particular surface. It
is only in the chiaroscuro version of the woodcut, therefore, that we get the
"feel" of the scaly body of the serpent [Fig. 6].[5]

The task of the painter with his many colors seems so much simpler
than that of the graphic artist with his limited cryptograms. It is in fact more
complex. His aim of "imitation" may cut across the need for that basic infor-
mation about relationships which we need for our decoding. I must plead

Figure 5
Baldung Grien, *The Fall of Man,*
1511. Chiaroscuro woodcut.

guilty to sharing this confusion in my *Story of Art* when I quoted a well-known anecdote about Constable and his patron, Sir George Beaumont: "The story goes that a friend remonstrated with him for not giving his foreground the requisite mellow brown of an old violin, and that Constable thereupon took a violin and put it before him on the grass to show the friend the difference between the fresh green as we see it and the warm tones demanded by convention."[6]

It was an amusing gesture, but obviously we must not infer that Sir George had never noticed that grass was green and violins brown, or that Constable made that momentous discovery. Both of them knew, of course, that such matching will never do. The point at issue was a much more subtle one—how to reconcile what we call "local color" with the range of tonal gradations which the landscape painter needs to suggest depth.

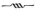

Figure 6
Detail of *The Fall of Man,*
shown in Fig. 5.

Figure 7
Sir Joshua Reynolds, *Lady Elizabeth Delmé and Her Children*, 1777–79. Oil on canvas, 94⅛ × 58⅛ in.

[E]xperiments with gradations from a pale blue to a mellow brown by seventeenth- and eighteenth-century artists taught Sir George Beaumont how to suggest light and distance in a landscape. . . .

Looking at Reynolds's *Lady Elizabeth Delmé and Her Children* in the National Gallery in Washington [Fig. 7] or, for that matter, at Gainsborough's *Landscape with a Bridge* [Fig. 8], we realize the value of an even gradation based on the brown of the foreground. Indeed, a glance at Constable's *View of Salisbury Cathedral* [Fig. 9] convinces us that he, too, achieved the impression of light and depth by modulating tone. The difference is one of degree. Constable questioned the need to remain within the compass of one scale. He wanted to try out the effect of respecting the local color of grass somewhat more—and, indeed, in his *Wivenhoe Park* he is seen pushing the range more in the direction of bright greens. Only in the direction of—for, needless to say, if we would match fresh green grass against the canvas it would still be nearer to the Cremona fiddle. It is a transposition, not a copy.

Once we realize this basic fact, the master's contention that all paintings should be viewed as experiments in natural science loses much of its

Figure 8
Thomas Gainsborough, *Mountain Landscape with Bridge*, 1783–84. Oil on canvas, 44 ½ × 52 ½ in.

Figure 9
John Constable, *Salisbury Cathedral from Lower Marsh Close*, 1820. Oil on canvas, 28 ¾ × 35 ⅞ in.

Figure 10
Jean-Baptiste-Camille Corot, *View near Epernon*, 1850–60. Oil on canvas, 12¾ × 21 in.

puzzling character. He is trying to produce what he called the "evanescent effects of nature's chiaroscuro" on canvas, within a medium which excludes matching. Indeed his experiments resulted in discoveries.[7] . . . We need only walk through any major gallery to see that in the end Constable's method found acceptance. Green is no longer considered "nasty."[8] We can read much brighter pictures, such as the landscapes by Corot [Fig. 10] and, what is more, enjoy the suggestion of light without missing the tonal contrasts which were thought indispensable. We have learned a new notation and expanded the range of our awareness.

This is the main lesson the historian should learn from the measurements of the physicists. The truth of a landscape painting is relative and the more so the more the artist dares to accept the challenge of light. . . .

. . . What a painter inquires into is not the nature of the physical world but the nature of our reactions to it. He is not concerned with causes but with the mechanisms of certain effects. His is a psychological problem—that of conjuring up a convincing image despite the fact that not one individual shade corresponds to what we call "reality." In order to understand this puzzle—as far as we can claim to understand it as yet—science had to explore the capacity of our minds to register relationships rather than individual elements.[9]

§III

We were not endowed with this capacity by nature in order to produce art: it appears that we could never find our way about in this world if we were not thus attuned to relationships. Just as a tune remains the same whatever the key it is played in, so we respond to light intervals, to what have been called

"gradients," rather than to the measurable quantity of light reflected from any given object. And when I say "we," I include newly hatched chickens and other fellow creatures who so obligingly answer the questions psychologists put to them. According to a classic experiment by Wolfgang Köhler,[10] you can take two gray pieces of paper—one dark, one bright—and teach the chickens to expect food on the brighter of the two. If you then remove the darker piece and replace it by one brighter than the other one, the deluded creatures will look for their dinner, not on the identical gray paper where they have always found it, but on the paper where they would expect it in terms of relationships—that is, on the brighter of the two. Their little brains are attuned to gradients rather than to individual stimuli. Things could not go well with them if nature had willed it otherwise. For would a memory of the exact stimulus have helped them to recognize the identical paper? Hardly ever! A cloud passing over the sun would change its brightness, and so might even a tilt of the head, or an approach from a different angle. If what we call "identity" were not anchored in a constant relationship with environment, it would be lost in the chaos of swirling impressions that never repeat themselves.

What we get on the retina, whether we are chickens or human beings, is a welter of dancing light points stimulating the sensitive rods and cones that fire their messages into the brain.[11] What we see is a stable world. It takes an effort of the imagination and a fairly complex apparatus to realize the tremendous gulf that exists between the two. Consider any object, such as a book or a piece of paper. When we scan it with our eyes it projects upon our two retinas a restless, flitting pattern of light of various wave lengths and intensities. This pattern will hardly ever repeat itself exactly—the angle at which we look, the light, the size of our pupils, all these will have changed. The white light a piece of paper reflects when turned toward the window is a multiple of what it reflects when turned away. It is not that we do not notice some change; indeed, we must if we want to form an estimate of the illumination. But we are never conscious of the objective degree of all these changes unless we use what psychologists call a "reduction screen," in essence a peephole that makes us see a speck of color but masks off its relationships.[12] Those who have used this magic instrument report the most striking discoveries. A white handkerchief in the shade may be objectively darker than a lump of coal in the sunshine. We rarely confuse the one with the other because the coal will on the whole be the blackest patch in our field of vision, the handkerchief the whitest, and it is relative brightness that matters and that we are aware of. The coding process of which Sir Winston Churchill speaks begins while en route between the retina and our conscious mind. The term which psychology has coined for our relative imperviousness to the dizzy variations that go on in the world around us is "constancy."[13] The color, shape, and brightness of things remain to us relatively constant, even

though we may notice some variation with the change of distance, illumination, angle of vision, and so on. Our room remains the same room from dawn through midday to dusk, and the objects in it retain their shape and color. Only when we are faced with special tasks involving attention to these matters do we become aware of uncertainties. We would not judge the color of an unfamiliar fabric in artificial light, and we step into the middle of the room if we are asked whether a picture hangs straight on the wall. Otherwise our capacity to make allowances, to infer from relationships alone, is astounding. We all know the experience at the moving pictures when we are ushered to a seat very far off center. At first the screen and what is on it look so distorted and unreal we feel like leaving. But in a few minutes we have learned to take our position into account, and the proportions right themselves. And as with shapes, so with colors. A faint light is disturbing at first, but with the aid of the physiological adaptation of the eye we soon get the feel of relationships, and the world assumes its familiar face.[14]

Without this faculty of man and beast alike to recognize identities across the variations of difference, to make allowance for changed conditions, and to preserve the frame work of a stable world, art could not exist. When we open our eyes under water we recognize objects, shapes, and colors although through an unfamiliar medium. When we first see pictures we see them in an unfamiliar medium. This is more than a mere pun. The two capacities are interrelated. Every time we meet with an unfamiliar type of transposition, there is a brief moment of shock and a period of adjustment—but it is an adjustment for which the mechanism exists in us.

§IV

The brighter palette, the strong and even loud colors to which first Impressionism and then twentieth-century paintings (not to mention posters and neon lights) have inured us may have made it difficult for us to accept the quiet tonal gradations of earlier styles. The National Gallery in London has now become the focus of discussion about the degree of adjustment we should be prepared to make when we look at old paintings.

I venture to think this issue is too frequently described as a conflict between the objective methods of science and the subjective impressions of artists and critics. The objective validity of the methods used in the laboratories of our great galleries is as little in doubt as the good faith of those who apply them. But it may well be argued that restorers, in their difficult and responsible work, should take account not only of the chemistry of pigments, but also of the psychology of perception—ours and that of the chicken. What we want of them is not to restore individual pigments to their pristine color, but something infinitely more tricky and delicate—to preserve rela-

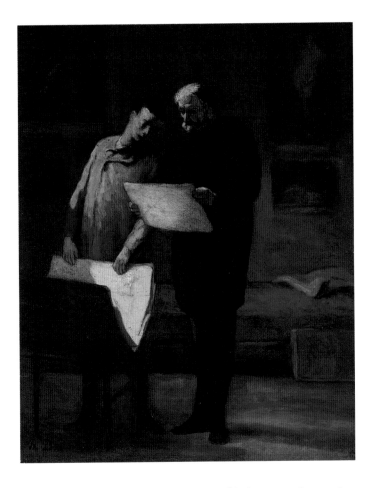

Figure 11
Honoré Daumier, *Advice to a Young Artist,* probably after 1860. Oil on canvas, 16⅛ × 12⅞ in.

tionships.[15] It is particularly the impression of light, as we know, that rests exclusively on gradients and not, as one might expect, on the objective brightness of the colors. Wherever we observe a sudden steep rise in the brightness of a tone we accept it as a token of light. A typical tonal picture such as Daumier's *Advice to a Young Artist* [Fig. 11] reminds us of this basic fact. The abrupt change of tone brings the sunlight into the gloomy nineteenth-century interior. Study the clever effect of the daylight streaming through the eye of the Pantheon in Pannini's attractive picture [Fig. 12]. Once more it is the sharp edge of the patch of light that creates the illusion. Mask it off and the impression of light will largely disappear. I am told that this fact presents a problem of which the restorer must learn to be aware. Whenever he starts the process of cleaning, he will produce a similar difference in brightness, an unexpected gradient which will look as if light were streaming into the picture. It is a psychological effect cleverly exploited by an amusing poster of the National Clean-up Paint-up Fix-up Bureau [Fig. 13]. But I would not send

Figure 12
Giovanni Paolo Pannini, *Interior of the Pantheon, Rome,* ca. 1734. Oil on canvas, 50½ × 39 in.

my pictures to that admirable institution for treatment. This seductive impression of daylight dispelling the gloom is created within the picture; the gradient which causes it will disappear when the cleaning is finished. As soon as we are then attuned to the new key of brightness, the constancies come into their own and the mind returns to its proper business of assessing gradients and relationships. We adapt ourselves to different varnishes as we adapt ourselves to different conditions of light in the gallery, provided, of course, that visibility is not completely obscured. The added brilliance, I feel, often sinks back as soon as the shock wears off. It is an effect which resembles, to me at any rate, that of turning the knob of the radio from bass to treble. At first the music seems to acquire a new, sharp edge, but here, too, I adjust my expectations and return to the constancies with the added worry whether all gradients have been respected and preserved by those invisible ghosts, the tone engineers.

I fear it is in the nature of things that the historian will always be distrustful of the man of action in these difficult and delicate matters. We are as appalled as any to see our documents fading and our pictures dirty, but we also know how little we know about the past. About one thing we are quite certain: our reactions and our taste must of necessity differ from that of past generations. If it is true that the Victorians erred so frequently, it is all the more likely that we, too, will often be mistaken despite the improvement in our techniques. We know, moreover, that there were other periods besides the nineteenth century that looked upon brilliance of color as a disturbing element. To Cicero, for instance, it seemed obvious that a cultivated taste grew tired of such brilliance no less than of a surfeit of sweetness. "How strongly," he writes, "do new paintings usually appeal to us at first for the beauty and variety of their colors, and yet it is the old and rough picture that will hold our attention."[16] Even more telling is a passage in Pliny where we read of Apelles's inimitable way of toning down his pigments with a dark glazing "so that the brightness of colors should not hurt the eyes."[17] We do not know what degree of brightness offended the sensitive taste of a fourth-century Greek or a first-century Roman. But is it conceivable that such famous testimonies would never have induced a master of the sixteenth or seventeenth century to emulate Apelles and apply a darkening varnish to

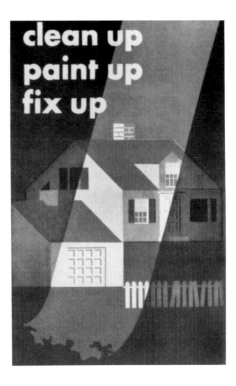

Figure 13
Joseph Beider, poster for
National Clean-up Paint-up
Fix-up Bureau, 1953.

Figure 14
Rembrandt van Rijn, *Jacob Haaringh* (*Young Haaringh*) (*Pieter Haaringh*), 1655. Etching, drypoint, and burin on European paper.

achieve a more subtle tonal unity? I do not think it is even claimed that our "safe" cleaning methods could detect such a varnish, let alone that they could preserve it. Admittedly, the man of action confronted with a deteriorating canvas may have to take the risk—but need he deny its existence?

The question of what paintings looked like when they were made is more easily asked than answered. Luckily we have additional evidence in images that neither fade nor change—I mean particularly the works of graphic art. Some of Rembrandt's prints [Fig. 14], I believe, provide an astounding object lesson in reliance on dark tones and subdued contrasts. Is it an accident that there are fewer print lovers now than they ever were? Those who got used to the sound of the concert grand find it difficult to adjust their ears to the harpsichord.

We do well to remember that relationships matter in art not only within any given painting but also between paintings as they are hung or as they are seen. If we look, in the Frick Collection, from Hobbema's *Village with Watermill among Trees* [Fig. 15] to Constable's *White Horse* [Fig. 16], the latter painting will look as full of light and atmosphere as Constable meant us to see it. Should we choose another route in the gallery and come to it with our eye adjusted to the palette of the school of Barbizon, of Corot [Fig. 10], for instance, Constable's painting will seem to be eclipsed. It

Figure 15
Meindert Hobbema, *Village with Watermill among Trees,* ca. 1670.

Figure 16
John Constable, *The White Horse,* 1819.

recedes behind the ridge which separates, for us, the contemporary vision from that of the past.

The reason, I believe, lies precisely in the role which our own expectations play in the deciphering of the artists' cryptograms. We come to their works with our receivers already attuned. We expect to be presented with a certain notation, a certain sign situation, and make ready to cope with it. . . .

Psychologists call such levels of expectation "mental set." . . . All culture and all communication depend on the interplay between expectation and observation, the waves of fulfillment, disappointment, right guesses, and wrong moves that make up our daily life. . . . The point to remember is that here, as elsewhere, it is the "more" or "less" that counts, the relationship between the expected and the experienced.

The experience of art is not exempt from this general rule. A style, like a culture or climate of opinion, sets up a horizon of expectation,[18] a mental set, which registers deviations and modifications with exaggerated sensitivity. In noticing relationships the mind registers tendencies. The history of art is full of reactions that can only be understood in this way. . . .

To us historians these simple psychological facts present some difficulties when we discuss the relation between art and what we call reality. We cannot but look at the art of the past through the wrong end of the telescope. We come to Giotto on the long road which leads from the Impressionists backward via Michelangelo and Masaccio, and what we see first in him is therefore not lifelikeness but rigid restraint and majestic aloofness. Some critics, notably André Malraux, have concluded from this that the art of the past is closed to us altogether, that it survives only as what he calls "myth," transformed and transfigured as it is seen in the ever-changing contexts of the historical kaleidoscope.[19] I am a little less pessimistic. I believe the historical imagination can overstep these barriers, that we can attune ourselves to different styles no less than we can adjust our mental set to different media and different notations. Of course some effort is needed. But this effort seems to me eminently worthwhile. . . .

Notes

[Notes are organized by chapter and page number (not shown here) in the 1977 edition, pages 339–40. The author's descriptive references to the text are shown in small caps after the note number.]

1. MOTTO: "La peinture est la plus étonnante magicienne; elle sait persuader, par les plus évidentes faussetés, qu'elle est la vérité pure." JEAN ETIENNE LIOTARD, *Traité des principes et des règles de la peinture*, vol. 2 of Collection Ecrits de peintres (Geneva: n.p., 1781; reprint, Geneva: P. Cailler, 1945), chap. 1.

2. CONSTABLE IN 1816: MICHAEL KITSON, "John Constable, 1810–1816: A Chronological Study," *Journal of the Warburg and Courtauld Institutes* 20 (July–December 1957): 338–57.

3. PAINTING A SCIENCE: Constable's fourth lecture at the Royal Institution (1836), in CHARLES ROBERT LESLIE, *Memoirs of the Life of John Constable,* ed. Jonathan Mayne, Phaidon Pocket Series (London: Phaidon Press, 1951), 323.

4. WINSTON S. CHURCHILL, *Painting as a Pastime* (1932; reprint, New York: McGraw-Hill, 1950), 28–29.

5. GRAPHIC NOTATIONS: Masterly discussions in ERWIN PANOFSKY, *Albrecht Dürer* (Princeton, N.J.: Princeton University Press, 1943), 47–48, 63–68, 133–35; and WILLIAM MILLS IVINS JR., *Prints and Visual Communication* (Cambridge, Mass.: Harvard University Press, 1953), 66.

6. CREMONA FIDDLE: See my *The Story of Art* (London and New York: Phaidon Press, 1950), 374–75; after LESLIE, *Memoirs,* 114.

7. EVANESCENCE: e.g., LESLIE, *Memoirs,* 100.

8. "NASTY GREEN THING": SIDNEY J. KEY, *John Constable, His Life and Work,* British Painters Series (London: Phoenix House, 1948), 88.

9. RELATIONSHIPS: For the history of this discovery see EDWIN GARRIGUES BORING, *Sensation and Perception in the History of Experimental Psychology,* Century Psychology Series (New York and London: D. Appleton-Century Company, Inc., 1942), especially 255.

10. WOLFGANG KÖHLER, *Gestalt Psychology* (New York: H. Liveright, 1929), 167–68; for related experiments, see CHARLES EGERTON OSGOOD, *Method and Theory in Experimental Psychology* (New York: Oxford University Press, 1953), 279; for a critical view, see D. W. HAMLYN, *The Psychology of Perception: A Philosophical Examination of Gestalt Theory and Derivative Theories of Perception,* Studies in Philosophical Psychology (London: Routledge and K. Paul, 1957), 61.

11. WHAT WE GET ON THE RETINA: See OSGOOD, *Method and Theory,* 197.

12. THE STABLE WORLD: JAMES JEROME GIBSON, *The Perception of the Visual World* (Boston: Houghton Mifflin, 1950), especially chap. 3.

13. THE CONSTANCIES: OSGOOD, *Method and Theory,* 271 ff.; MAGDALEN DOROTHEA VERNON, *A Further Study of Visual Perception* (Cambridge: Cambridge University Press, 1952), chap. 6; GIBSON, *Perception,* chap. 9; R. S. WOODWORTH and HAROLD SCHLOSBERG, *Experimental Psychology* (New York: Holt, 1954; London: Methuen, 1955), chap. 15; WOLFGANG METZGER, *Gesetze des Sehen* (Frankfurt am Main: W. Kramer and Co., Inc., 1936), chap. 9; all with bibliographies.

14. PICTURES SEEN FROM THE SIDE: DAVID KATZ, "Zwei Beiträge zur Theorie der Wahrnehmung," *Theoria* 17 (1951): 89–102.

15. PICTURE CLEANING: For the chemical aspect, see ETIENNE GILSON, *Painting and Reality,* Bollingen Series 35, A. W. Mellon Lectures in the Fine Arts 4, 1955 (New York: Pantheon Books, 1957), chap. 3, part 3 (with bibliography). See also *An Exhibition of Cleaned Pictures 1936–1947,* (London: National Gallery, 1947).

16. CICERO, *De oratore* 3.98 (Amsterdam: A. M. Hakkert, 1962).

17. APELLES'S DARK VARNISH: "Unum imitari nemo potuit, quod absoluta opera atramento inlinebat ... ne claritas colorum aciem offenderet veluti per lapidem specularem intuentibus et e longinquo eadem res nimis floridis coloribus austeritatem occulte daret [but there was one which nobody was able to

imitate ... so that the brilliance of the colours should not offend the sight when people looked at them as if through muscovy-glass and so that the same device from a distance might invisibly give sombreness to colours that were too brilliant]," PLINY THE ELDER, *Histoire naturelle de Pline* 35.97 (Guillaume Bowyer, 1725; reprint, London: William Heinemannn Ltd.; Cambridge, Mass.: Harvard University Press, 1968), 332–33 (page citations are to the reprint edition). I have previously drawn attention to this passage in a letter to *Burlington Magazine* 92, 571 (1950): 297–98.

18. HORIZON OF EXPECTATIONS: I owe this phrase to K. R. Popper.

19. ANDRÉ MALRAUX, *The Voices of Silence,* trans. Stuart Gilbert and Francis Price. (Garden City, N.Y.: Doubleday, 1967); and my review, "André Malraux and the Crisis of Expressionism," *Burlington Magazine* 96, no. 621 (1954): 374–78.

Of Turnerian Mystery:
Secondly, Willful

JOHN RUSKIN

§5

And going down from this great truth to the lower truths which are types of
it in smaller matters, we shall find, that as soon as people try honestly to see
all they can of anything, they come to a point where a noble dimness begins.
They see more than others; but the consequence of their seeing more is, that
they feel they cannot see all; and the more intense their perception, the more
the crowd of things which they *partly* see will multiply upon them; and their
delight may at last principally consist in dwelling on this cloudy part of their
prospect, somewhat casting away or aside what to them has become compar-
atively common, but is perhaps the sum and substance of all that other
people see in the thing, for the utmost subtleties and shadows and glancings
of it cannot be caught but by the most practiced vision. And as a delicate ear
rejoices in the slighter and more modulated passages of sound which to a
blunt ear are utterly monotonous in their quietness, or unintelligible in their
complication, so, when the eye is exquisitely keen and clear, it is fain to rest
on gray films of shade, and wandering rays of light, and intricacies of tender
form, passing over hastily, as unworthy or commonplace, what to a less edu-
cated sense appears the whole of the subject.[1] In painting, this progress of
the eye is marked always by one consistent sign—its sensibility, namely, to
effects of *gradation* in light and color, and habit of looking for them, rather
even than for the signs of the essence of the subject. It will, indeed, see more

From JOHN RUSKIN, *Modern Painters: Their Superiority in the Art of Landscape Painting
to All the Ancient Masters, Proved by Examples of the True, the Beautiful, and the
Intellectual, from the Works of Modern Artists, Especially Those of J. M. W. Turner,
by a Graduate of Oxford* (London: Smith, Elder, 1843), part 5, chap. 5, nos. 5, 6.

of that essence than is seen by other eyes; and its choice of the points to be seized upon will be always regulated by that special sympathy which we have above examined as the motive of the Turnerian picturesque; but yet, the more it is cultivated, the more of light and color it will perceive, the less of substance.

§6

Thus, when the eye is quite uncultivated, it sees that a man is a man, and a face is a face, but has no idea what shadows or lights fall upon the form or features. Cultivate it to some degree of artistic power, and it will then see shadows distinctly, but only the more vigorous of them. Cultivate it still farther, and it will see light within light, and shadow within shadow, and will continually refuse to rest in what it had already discovered, that it may pursue what is more removed and more subtle, until at last it comes to give its chief attention and display its chief power on gradations which to an untrained faculty are partly matters of indifference, and partly imperceptible. That these subtle gradations have indeed become matters of primal importance to it, may be ascertained by observing that they are the things it will last part with, as the object retires into distance; and that, though this distance may become so great as to render the real nature of the object quite indiscernible, the gradations of light upon it will not be lost.

Note

1. And yet, all these intricacies will produce for it another whole; as simple and natural as the child's first conception of the thing; only more comprehensive.

Rudiments of Connoisseurship

B E R N A R D B E R E N S O N

§III. The Works of Art

We have already mentioned the deductions of the connoisseur as being of more value in every way than mere tradition. This point will be discussed while considering the works of art themselves as information, and evidence, in a word, as material in the study of art.

In a sense, the works of art themselves are the only materials of the student of the history of art. All that remains of an event in general history is the account of it in document or tradition; but in art, the work of art itself is the event, and the only adequate source of information about the event, any other information, particularly if of the merely literary kind, being utterly incapable of conveying an idea of the precise nature and value of the event in art.[1] An art that has failed to transmit its masterpieces to us is, as far as we are concerned, dead, or at the best a mere ghost of itself. Let us take Greek painting, for instance. We have considerable literary information concerning it, and a student acquainted with the texts, and at the same time with the practice of the art as a living thing, can make them yield many conclusions of a general kind as to the methods and skill of the Greek painters. But insofar as we have a definite idea at all, a visual image, let us say, of Greek painting, it is based not on texts, although helped out by them, but on our acquaintance with Greek marbles, bronzes, coins, vases, and scanty fragments of paintings, such as those of Pompeii, that have come down to us. It is the composite visual image derived from all these concrete examples that keeps us within the vague bounds of the Greek image-world, and prevents us from

From Bernard Berenson, *The Study and Criticism of Italian Art* (London: George Bell and Sons, 1902), 119–25, 129–31, 144–48.

supplying with our own modern imagery the descriptions of Greek pictures that we read in Pliny, Lucian, or Pausanias. In that way we get a vague notion of what the great Greek pictures were like, and, vague as this notion is, yet, as we have seen, it never could have been supplied by texts alone. We have derived it mainly from those kindred arts which happen to have come down to us, and without these we should not know even the very little about Greek painting that we know at present.

The text, therefore, or its equivalent in our studies, the document or tradition, is of value only in connection with the work of art; in other words, is not itself material for the art student, but material of great value in helping to prepare the real materials, the works of art themselves. The works of art themselves being the only adequate source of information in the study of art, everything depends on the choice made at the start of those which we consider necessary to the study of a given subject. Our problem, let us say, is the Venetian school: we wish to know how it originated, how it ripened to maturity, how it decayed, and what were its characteristics in all these phases. Our conclusions will obviously depend to a great extent on the pictures we have chosen to regard as belonging to the Venetian school. If we allow to slip into the number a quantity of Flemish, or Tuscan, or purely Byzantine works; if we pass unnoticed a quantity of masterpieces by the Bellini, Titian, and Tintoretto; if we disregard Crivelli and Lotto, and yet proceed deductively in our studies, our final idea of the life and character of the Venetian school is bound to be very different from the real one to be obtained by considering all the relevant factors concerned in the problem. As the factors in the problem given are pictures, it is of radical importance that each picture be submitted to the severest criticism before it is accepted.

Hitherto we have spoken of art in general, because what we have had to say applies equally to all the figurative arts. Henceforth we will confine ourselves more strictly to painting. Granting, then, the importance of testing each picture before we accept it as a factor in our problem, what is the nature of the test to be applied to it? We have seen that the document furnishes no adequate test, and mere tradition is of course even more powerless. We have already concluded that the adequate test is to be supplied by connoisseurship, which we have defined as the comparison of works of art with a view to determining their reciprocal relationships. It is now time to elaborate the definition, and to discuss the methods of the science.

Connoisseurship is based on the assumption that perfect identity of characteristics indicates identity of origin—an assumption, in its turn, based on the definition of characteristics as those features that distinguish one artist from another. A picture without signature or label of any sort is presented to us, and we are asked to determine its author. As a rule, the mere types of the faces, the compositions, the groupings, and the general tone,

classify the picture at once as belonging to such and such a school. Closer examination of these features discovers a larger number of affinities with one particular following of the school than with any other, and the spirit and quality of the work reveal whether we have before us a great master or second- or third-rate painter. Our field of research is by this time reduced to very small compass, but the difficulties begin only here. Those striking resemblances which have guided us hitherto, become at this point not only valueless, but positively misleading. Types, general tone, and compositions a master has in common with his closest predecessors, his most kindred fellow-pupils, and his nearest followers, and they consequently cannot help us in distinguishing his work from theirs. We must leave them out of consideration in determining the precise authorship of a picture, and base our comparison on data affording a more intimate revelation of personality. We must begin by reversing the process we have been pursuing. Hitherto we have been eager to discover the closest affinities of the unknown picture we started with as an example, but having found these affinities, and having decided that the author of our picture must be one of a certain group of painters, we proceed to examine the differences between the work in question and the works of the different members of this group. Our attention this time drawn to the differences, we easily discover a number which lay unsuspected while we were searching for resemblances, and large enough to exclude as candidates for the authorship all but two or three of the group we had just now fixed upon. We then return to the search of resemblances between our unknown work and the works of the two or three candidates for its authorship, he to be adjudged the author with whose works ours has in common the greatest number of characteristics affording an intimate revelation of personality.

Obviously what distinguishes one artist from another are the characteristics he does not share with others. If, therefore, we isolate the precise characteristics distinguishing each artist, they must furnish a perfect test of the fitness or unfitness of the attribution of a given work to a certain master; identity of characteristics always indicating identity of authorship. Connoisseurship, then, proceeds, as scientific research always does, by the isolation of the characteristics of the known and their confrontation with the unknown. To isolate the characteristics of an artist, we take all his works of undoubted authenticity, and we proceed to discover those traits that invariably recur in them, but not in the works of other masters. Let us consider some of the questions we ask in searching for characteristics, and what answers we may be able to give them.

Of types, general tone, and composition we have already disposed, but very close examination of even these factors often reveals in the precise oval of the face, the precise cut of the features, the precise nuances of tone, the precise grouping and packing of the composition, characteristics of an

individual kind, occurring in one painter, but not in another even close to him. These characteristics, are, however, so delicate, when of value, that the profit to be derived from their consideration is largely dependent on the personal equation, particularly as they may all, or nearly all, occur in a clever contemporary copy, itself distinguishable from an original only by inferiority of quality. The vehicle or medium rarely yields results, for two reasons. In the first place, in a school, and more particularly in a set or clique, these were practically identical; in the second place, most of the Italian pictures that have come down to us from the Renaissance have suffered from bad treatment of all sorts, and restorations. The very slight difference that there may once have been between one Italian painter's medium and another of the same close following are by this time as a rule obliterated. Insofar, then, as considerations of vehicle yield results at all, they are not of the kind to help us distinguish painter from painter, but to place the painter in his precise school, and particular following.

Having disposed of types, general tone, composition, and technique, we are ready for the study of morphology, with the view of discovering what characteristics this study will yield. By morphology, by the way, we understand all that in a picture which can be distinguished from the feeling, or, as it is sometimes called, the spirit. The legitimacy of such a division is sufficiently questionable to suggest a fuller discussion of it than I can permit myself here; but adopting it for the present as a matter of convenience, we must bear in mind that morphology includes not only the figures, and all that happens to be upon them in the way of clothing and ornaments, but the surroundings as well, furniture, buildings, and landscape. As it is impossible to put one's finger on certain morphological details, the execution of which is invariably different in every painter, we must have the patience to examine all the important details separately, with a view to discovering how likely each is to become a characteristic, bearing in mind, to start with, that the less necessary the detail in question is for purposes of obvious expression, the less consciously will it be executed, the more by rote, the more likely to become stereotyped, and therefore characteristic. We will begin with the human figure, considering important details from top to toe.

—⚬—

The ears, although never alike in two individuals, do not, by their variety, except in cases of gross peculiarity, change the character of the face; and as they are incapable of variation for purposes of expression they attract little attention. It must be remembered, furthermore, that European man was very much less observant in the fifteenth and sixteenth centuries than he is now of things not immediately concerning his interests: of character and expression he was a keen observer, because they revealed to him how he must act to attain his ends; he was, as we know, sensitive to beauty of face and figure; but

he was as good as blind to minute peculiarities that neither touched his feelings for beauty, nor concerned his interests. The ear seems never to have been noticed. What poet of the Renaissance indited a sonnet to his mistress's ear? The merest mention of the ear as a beautiful feature is so rare in Renaissance writers that it is hard to think of one instance, while, in our own times, the novelist rarely fails to tell us what sort of an ear his heroine had. This slight digression has been necessitated by the fact that, unobservant of the ear as most of us still are, we are yet startled when told that our ancestors as good as never noticed it. But just because they never noticed its character, nobody ever protested against the painter's giving it any shape, not grotesque, that he pleased. Having no inducement for resisting a habit, we do not resist it, and the Italian painter kept on through a lifetime painting the same ear, because there was absolutely no call for changing it. The ear is, therefore, necessarily very characteristic of the painter, more characteristic, indeed, than any other detail of the human figure. This arises not only from the fact that he always painted it in the same way, but that this way must necessarily have been a way of his own; the precise combinations of lines, curves, points of light and shadow in an ear being, to all intents and purposes, infinite, it is practically impossible for two painters to hit upon the same combination.

But excellent a test of authenticity as the ear is, its application is by no means easy, nor as proof is it absolutely coercive. In the first place, we must be able to distinguish precisely what is characteristic in a given ear. If the ear were always an unchanging outline nothing would be easier than to trace the outline of one in a known picture by a master and see whether it precisely corresponded to the outline of an ear in a work of which we are trying to find the author. But the number of cases in which the outline of the ear remains unchanging are too few to permit this rough test. In most instances it is only a part of the ear which is characteristic. In Botticelli, for example, it is the bulb-shaped upper curve; in Perugino, the bony lobe; in the Bellini, the cavity; in Lotto, the distinct notching of the line joining the ear to the cheek; in Moroni, the *chiaroscuro*. Only training in the isolation of characteristics and careful study of all the known works of a master can make the employment of this test profitable. Even then, we must not accept its evidence unless the mere trick also has the quality of the master, as, for instance, the quality of line in Botticelli or Mantegna, or the quality of light in Moroni; although, as a matter of fact, the old copyist was apt to put some characteristic of his own into an ear he copied, or not to copy it at all, but give his own ear, and this for the same reasons that he would not have copied the ears of his living model. The ear, therefore, when we have found its precise characteristics, furnishes a more valuable test than any we have yet discussed; but it is conceivable that a master would have executed all that he thought important in a head, and let an assistant put on the ears. Rare though this practice may have been, the

mere consideration of its possibility should prevent us from taking the ear *alone* as sufficient evidence of authorship.

<div align="center">—⁂—</div>

Having now discussed for their value as tests the more important formal elements of a picture,[2] we are ready to look back and see what results we have obtained. We note that all the elements are easily divisible into three classes, in view of their immediate application as tests.

> The most applicable: The ears, the hands, the folds, the landscape.
> The less applicable: The hair, the eyes, the nose, the mouth.
> The least applicable: The cranium, the chin, the structure and the movement in the human figure, the architecture, the color, and the chiaroscuro.

Although we have found that the quality can never be left out of consideration—indeed, that it is always the highest consideration—yet we note in the classification just made that on the whole the ratio of immediate applicability of a test is inversely as the importance of allowing for the question of quality: the more important the question, the less applicable; the less important, the more applicable the test. But we have also found that even in the most applicable test it is the qualitative rather than the formal element that gives them their value. The ears, the hands, the folds, the landscape are never to be applied mechanically, as if machine-made, and capable of being induced to coincide by superposition. If two leaves on the same tree are not absolutely identical, we need not expect absolute identity in two ears, two hands, or even less in two landscapes. The identity, it must be remembered, is in the visualization and habits of the artists, and it is there we ultimately must look for it. Rather than ask, "Is this Leonardo's ear or hand?" we should ask, "Is this the ear or hand Leonardo, with his habits of visualization and execution, would have painted?"

The forms employed as tests being themselves the resultants of habits of visualization and execution, the forms must inevitably change as the habits change. Habits, as we know, cannot remain stationary. Unless they encounter a resistance proportioned to their force, they tend by the inevitable necessity of mechanical laws to dig deeper and easier channels for themselves. The subject really demands a separate and exhaustive discussion, but at this point it is enough to indicate it as the cause of the inevitable though almost imperceptible change that constantly takes place in the forms of a given artist.

In the case of a long-lived artist, the forms in the works of his old age will scarcely bear a resemblance to those in his early pictures. It would never do to apply a test mechanically, even if a mechanical test were possible, with-

out reference to the different periods of a master's career. A hand, an ear, a fold, a landscape background, that would be perfect tests of an early Titian, would, for example, furnish no tests whatever for a late Titian. As a matter of fact, every test has its time limit, and its application regardless of this limit, far from advancing the study of art, can lead only to a confusion which, in one respect, is even a degeneration from the chaos which reigned at the beginning of this century, when the connoisseur in the presence of a work of art rarely was satisfied with saying "This is a certain master," but always added "in his first, or second, or third manner." He at least took cognizance of the inevitable changes in style, and although we are amused at his sharp divisions into manners, as at the old historian's divisions of history into ancient, medieval, and modern, yet his method was fundamentally more scientific than that of those students of today who apply tests regardless of time limits. Although the forms are, as I have already said, in a state of constant change, this change becomes distinctly noticeable only after a certain lapse of time. The length of this period varies greatly in different artists: in some it is five, in some it is ten, in others fifteen, twenty, or even twenty-five years. As, in order to ascertain accurately the authorship of a given unknown work of art, we have hitherto felt obliged to isolate its characteristics, and to see with what known works it has them in common, so, to make perfectly certain of the authenticity of a work, we must be able to say with which one in particular of the known works there is the closest community of characteristics.

Every test we have thus far discussed has, when satisfactory, a tendency to determine the authorship of a work of art. The question may, therefore, be asked: at what point shall we have a number of tests, each one tending to determine the authorship of a work of art, sufficient to make us feel that we have determined it? This point, it can be answered, must vary with the presumable author. If he be one with a definite character subject to no violent change, if he be at the same time a master with a distinct quality, we can scarcely be justified in identifying a picture as his, unless we find in it practically all the characteristics of some one period of his career. If the author, on the other hand, have no distinct quality of his own, no distinct character, but be one of those secondary or even third-rate artists whose career is chiefly parasitical or retailing, we may be satisfied with comparatively few tests, and be all the more satisfied with these, as such artists rarely invite imitation, and as qualitative considerations need scarcely be applied to their works. Thus one, or two, or at the utmost three, very peculiar tricks suffice to make it almost certain that a picture of a Venetian or Lombardo-Venetian character of a certain epoch is by Bartolommeo Veneto: this artist having no definite character, no organic development, not even a type of his own; changing with every wind, and never of more than mediocre quality; but possessed of a few tricks and mannerisms sufficiently constant to enable us

to identify him. On the contrary, no quantity of tricks, mannerisms, and mechanical tests suffice to persuade us that a certain picture is by Titian, because all of these might conceivably exist in a forgery—all ready tests in such a case being merely aids to the more essential consideration of the question of quality, which question increases, of course, in importance with the importance of the artist. Indeed, it may be laid down as a principle, that *the value of those tests which come nearest to being mechanical is inversely as the greatness of the artist. The greater the artist, the more weight falls on the question of quality in the consideration of a work attributed to him.* The Sense of Quality is indubitably the most essential equipment of a would-be connoisseur. It is the touchstone of all his laboriously collected documentary and historical evidences of all the possible morphological tests he may be able to bring to bear upon the work of art. But the discussion of Quality belongs to another region than that of science. It is not concerned with the tests of authenticity which have been the object of our present study; it does not fall under the category of demonstrable things. Our task, for the present, has limited itself to the consideration of the formal and more or less measurable elements in pictures with which the Science of connoisseurship must reckon. We have not touched upon the Art of connoisseurship.

Notes

1. [p. 120 n. 1] This arises from the fact that words are incapable of arousing in the reader's mind the precise visual image in the writer's.
2. [p. 144 n. 1] As a matter of fact, there is *no* detail, however slight, that may not be valuable as a test, but it is scarcely necessary to do more than indicate them, as I have done, in a summary way.

On Art and Connoisseurship

MAX J. FRIEDLÄNDER

§XXI. Art and Erudition

Erudition has turned to art late, has perhaps hesitated to do so from an expectation that this union would not be productive of many blessings. The scholar, who concerns himself with art, generally clasps emptiness. He woos the capricious beauty, now in this fashion, now in that, and as a result succeeds in seizing the garment rather than the body. He experiments as historian, as philologist or as a scientist. He is a philologist inasmuch as he examines literary accounts critically, an epigraphist when he investigates inscriptions, a scientist when he examines works of art with a view to deriving chemical and physical information from them. Naturally he is compelled, by such many-sided activity, to seek help from others and to read a tremendous lot. The excessive black-and-white diet is not wholesome to his eyes. Since we live in the age of the scientific disciplines, whose methods enjoy an almost superstitious veneration, he is particularly fond of keeping company with the scientists. He lives in a continuous fear of losing dignity through his contact with something as slight as art, and of not being admitted to the circle of the serious and respected University dons.

History, whatever its subject, is in a difficult position among the scholarly disciplines. Frequently enough people have refused to acknowledge its true scientific character. Art history has apparently an advantage over other branches of history; it claims superiority with some justification, especially

From MAX J. FRIEDLÄNDER, *On Art and Connoisseurship,* trans. Tancred Borenius (London: B. Cassirer, 1942; reprint, 1944), 143–54, 163–71, 172–78 (page numbers are to the reprint edition). Used by permission of E. M. Hill for Bruno Cassirer (Publishers) Ltd (closed 1990).

over political history. The works of art are there before our eyes, as it were, as a preserved "spirit of the times." Only, let us not forget the words of Goethe:

> *What Spirit of the Times you call*
> *Good Sirs, is but your spirit after all*
> *In which the times are seen reflected.*

Nevertheless, something survives that mirrors itself, while the historian, so far as politics are concerned, is thrown back exclusively upon literary tradition, and distills his truth—mostly, not entirely without a political tendency—out of a hundred inaccurate, if not definitely mendacious, and mutually contradictory reports. The deeds of the artists we can perceive for ourselves; of the deeds of the kings an echo reaches us—we hear mostly what the victors have let their scribes put down.

The image is older than writing, and for long stretches of time the sole provider of information and evidence.

Now it should be remembered that works of art do not speak—they sing, and can therefore only be understood by listeners upon whom the Muses have bestowed their gifts.

Grillparzer expresses himself somewhere approximately thus: "Whoever writes a history of chemistry, must be a chemist, and can only as a chemist become a historian." I wonder if this does not apply to art history? And Schiller says: "There exists only one vessel for the reception of works of imagination, namely, imagination."

Since artistic activity, whatever else it may be, is in every case a process of emotionally spiritual nature, the science of art is bound to be psychology. It may also be something else, but it is psychology in all circumstances. Since, however, all psychology depends upon experience of what has happened to oneself spiritually and emotionally, it follows that only an artistically gifted spectator can penetrate into the nature of artistic production. We approach thereby the deduction that only the practicing artist is entitled to judge. This deduction is erroneous.

The productive artist is incapable of assuming, with regard to his own work and the work of others, the receptive, observing attitude from which enlightenment may be expected. He produces naively and unconsciously; his experiences lie too deep for it to be possible for him to bring them to the light. Accordingly, his confessions in letters, autobiographies or theoretical expositions are valuable only as indirect evidence—as such they possess, however, great value: but they must be subjected to interpretation. The producing artist cannot be accepted as a judge, since he cannot free himself from his own artistic formula, which is tied from the point of view of time, place and individuality; and he is the less capable of doing this, in the measure that his own gifts are original, fertile and thirsting for expression. And,

after all, he has other and better things to do than to indulge in philosophizing; and he may even have a presentiment that knowledge does away with ability to produce, or at any rate weakens it—something that is noticeable in the individual development of many artists in civilized ages. And yet there is more to be learned from the stammering utterances of artists than from the well-constructed, systematic treatises of the aestheticians.

In front of art the thinkers are mostly blind, and the practicing artists mostly dumb. There only remains the artistically gifted, but nonproductive, spectator as the one who is capable of insight and deeper understanding, and called upon to provide enlightenment.

Artistic production and contemplation of art are activities which have more in common with one another than is usually assumed. The creative imagination stands in the same relationship to the receptive as the cogwheel to the cograil. The lover of art shares with the creative artist an abnormally sensitive receptiveness. His emotional life reacts quickly and violently to optical signals. The ability to produce, the capacity to realize vision are absent in him, whether it be that his interior images are not distinct enough, or that his hand lacks skill. His is a platonic talent, so to speak, even a "Raphael without hands." He possesses a reliable memory for visual experiences, and indeed not because he has, shall we say, eagerly learned things by heart, but because—extending his emotional sympathy, and living in a state of excitement which softens the wax of the tablets of memory—he has experienced delight in contemplation. Form and color are retained in his memory for decades; not in the sense, it is true, that he would be able to produce, reproduce or even describe them, but certainly in the sense that an appearance, presenting itself once again, is recognized by him and greeted as something familiar. Emotion and the senses have a much better memory than the intellect.

It can be contested that there exists a science of art; at least the concept "science" can be defined so narrowly that art as a subject accessible to her is eliminated.

Every scientific effort presupposes a terminology which covers the field of knowledge concerned, and through which the scholar can convey to other scholars his reasons, deductions and conclusions in an unambiguous manner. Even the greatest optimist will not maintain that art criticism can comply with this demand. If I judge a work of art, and employ words in order to give reasons for my opinion, I am far removed from thinking that I have expressed with those words that which has caused my judgment. The modifications, blendings and shades in emotional life, which truly determined my opinion, are not to be seized with verbal pincers.

An honest striving after knowledge may be recognized as science, even here, where the results remain questionable, and do not make themselves plain to reason.

Science, in conformity with its nature, is striving for the goal of establishing necessity; it hates accident. It must not rest content with establishing, "this is the case"; rather, it must prove, "this is the case for such and such a reason." The historian comes, however, everywhere upon accident, while he does not notice necessity—which yet is his constant concern—but invents and imagines it. That Rubens and Van Dyck both worked in Antwerp at the same time, that Schongauer had died by the time that Dürer went to Colmar in search of him, these are accidents in the sense in which one may at all speak of accident; and that such accidents have had a share in determining the development of artistic production is not to be denied. In order to avoid coming up against accident, one has set up the ideal of a "history of art without names," being moved by the desire to recognize a course of events which is governed by law, and which takes place independently of the intervention of individual artists here and there, now and then.

I will leave undecided the old question, debated by philosophers concerned with history, as to the greater or smaller effect exercised upon the course of events by heroes who "accidentally" have emerged at a given time and in a given place. In any case, even if I aim at a "history of art without names," I am yet bound to have classified the works of art according to time and place, and as far as possible to have brought them into harmony with biographical tradition, before I attempt to say something about the general development of the will for art. To someone who knows nothing about Correggio's life, it might happen that he would assign the works of this master to the seventeenth century, and in no case would he be able to classify them as, in their essence, affording evidence regarding Parma and the time about 1520. When the Monforte altarpiece by Hugo van der Goes arrived at Berlin [Fig. 1], a sensitive art historian—to whom "history of art without names" was a desirable goal—terrified me by his remark that the picture obviously was a work of the sixteenth century, and hence could not possibly be by Hugo van der Goes, who, of course, died in the fifteenth century.

The boundaries of the style of a given period may only be drawn, it is claimed, after all that was produced had been examined. And when would this be?

To the art historian there is available evidence of a twofold kind. On the one hand we have tradition as contained in writings, posthumous fame, records, inventories, biographies; and on the other, the surviving works. The task consists in building bridges from one bank to the other, in bringing the documents into harmony with the surviving examples. Were all the works by Raphael lost, we would nevertheless, thanks to the utterances of his contemporaries, have an idea of his importance, his influence and even of his manner of art. Since we have a considerable part of his life's work before our eyes, we enrich and vary that idea as a result of contemplation. It becomes the task

Figure 1
Hugo van der Goes, *Adoration of
the Magi* (*"The Monforte
Altarpiece"*), ca. 1476.

of style criticism to "attribute" the works, to classify them according to time
and place, and to fit them into the frame of tradition represented by art liter-
ature and records.

The community of art scholars consists of two groups—one may even
say, two parties. The university chairs are mostly occupied by people who like
to call themselves historians, and in the museum offices you meet the
"experts." The historians strive generally from the general to the particular,
from the abstract to the concrete, from the intellectual to the visible. The
experts move in the opposite direction, and both mostly never get further
than halfway—incidentally, without meeting each other.

The ideal set up by the historians is called "history of the spirit."
It seems indeed most desirable that all visible results of artistic activity be
considered as expressions of the continuously changing spiritual forces of
humanity, in connection with other expressions to be found say in politics,
literature, manners and customs, and economics. It seems perfectly possible
that the experts—thus, people who take the individual work of art as their
starting point—through fixing their aim high may approach that exalted goal;
and it is certainly to be desired that they and the historians should join

forces. When one passes from theory to practice there is, however, lack of mutual confidence. The historians look down upon the pettifogging fuss with detail of the "experts," who, for their part, accuse their colleagues at the universities of facing the works of art with prejudiced views. Both reproaches are justified.

On the defects peculiar to connoisseurship—spiritual narrowness, subjectivity questionable from the scientific point of view, an inclination to be guided by sentiment, also uncertainty—I shall yet have to speak, from abundant experience. As regards the performance of the historians, however, I may illustrate straightaway the dangers connected with their activities.

An aspiring scholar, intending to show himself worthy of university honors, plans a book on "Art during the Period of the Counter-Reformation." By assiduous reading he informs himself about the political, religious and philosophical aspects of the movement and acquires an idea of some of the features characteristic of the spiritual life of the period. He then turns to the works of art, and in them finds proof and confirmatory evidence of his conception of the spirit of the period, gained by reading. Thanks to the quantity and variety of the buildings, sculptures and paintings, dating from the time, there is much that can be found. And he who seeks, and knows from the start what he is going to find, cannot possibly go wrong. Moreover it is in the nature of a work of art to speak ambiguously, like an oracle.

The freshness of observation, the capacity for an unprejudiced reception of artistic impressions, may well be endangered through such efforts.

If the scholar takes the concept of "the Baroque" as his starting point he will feel inclined to fit all forces stirring in the seventeenth century into a scheme, and this cannot be done without applying violence. Even Rembrandt is forced into the bed of Procrustes. To be sure the searching eye, guided by a knowledge of history, can bring hidden things to light, but the mobility, receptiveness and lack of prejudice of the contemplation of art are as a result narrowed down and suffer grievously. Blindness to everything that slips through the wide meshes of the hunting net of expectations, is inevitable.

The expert is at pains to complete and differentiate the materials for study; the historian has little interest in the increase of the works of art which he has to consider, particularly as he draws his conclusions much more easily from ten than from a hundred pieces of evidence. One can perfectly well write an excellent book on Raphael by exclusively noticing the narrow circle of absolutely certain works, and without attempting to effect additions by means of style criticism, paying more heed to the purity than to the completeness of the entire picture. But the clearer the notion at which the biographer arrives, the more forcibly is it going to act as a magnet, which attracts some examples out of the troubled mass of questionable works. Whoever knows something, does also recognize it, and whoever does not

recognize, reveals thereby that he does not know. The historian becomes, whether he wants it or not, an expert. Throughout the literature of art history it can be traced, how scarcely anyone of the scholars, inclined towards the history of the spirit, has on principle evaded determination of authorship. And, in view of the performance of Carl Justi it is permissible to express the hope that the difference between historian and expert may be bridged over.

A fundamental evil from which art-historical erudition suffers, seems to me to spring from the method which, put to good use in other disciplines, has mistakenly been associated with the contemplation of art. Art history, which is frequently described as young, or even as still in the nursery, appears to the typical university mind as a playful child in need of education, who must first of all learn seriousness from the grown-up branches of learning. I remember a very learned colleague once saying: "Unfortunately I have no time, being busily engaged on other important work; otherwise I would take up the Hubert and Jan van Eyck question and settle it." Such optimistic determination may, in other domains, be conducive to untiring, systematic and fertile performance; with regard to art, it proves a complete failure. The method which we employ—if indeed the word method be here applicable— must be won from the object; that is, irrational art. One should look at works of art without any intention of deriving knowledge, and rejoice if sometimes, as of itself, a confirmation or enrichment of our knowledge comes in a flash; and one should not approach them with the determination to solve a problem. One must let them speak, one must converse with them, but one must not interrogate them. To an inquisitor they refuse any information.

A continuity of knowledge, such as elsewhere fertilizes the whole of scientific discipline, is almost completely unavailing with regard to art. It is true that art historians read a lot, copy or assert the reverse of that which they have read—which is not much more difficult than to copy—but if one inquires by whom and in what manner our knowledge has been enriched, one usually comes upon the lover of art who, independently of predecessors, has naively faced the works of art. Everyone must here start scratch and be able to forget what he has read.

—⁓—

§XXIV. On the Objective Criteria of Authorship

Since the expert, especially when he assumes the part of the didactic writer, experiences the difficulty or impossibility of convincing others of the truth of his verdicts, he attaches great importance to objective characteristics. Just as a tired swimmer breathing a sigh of relief welcomes firm ground under his feet, so does the expert react to inscriptions, documents and objective data of different kinds. Without being able to swim he would, to be sure, not have

been able to reach land: on long distances the water is so deep that it is necessary to swim.

I class among objective criteria:

1. Signatures and monograms, which give or hint at the name of the master.
2. Documentary information, agreements, inventories, catalogues which are approximately coeval with the works of art described in them; also the references to existing works in early writings, for instance the *Lives* of Vasari and Karel van Mander.
3. Measurably similar forms which, familiar to us from authenticated, signed, or recognized works, reappear in those to be attributed, say, in the architecture or ornament. Under this heading is to be introduced the similarity of form of the ear, the hand, the fingernail, so strongly emphasized by Morelli.

As regards the signatures, it is to be noted that their evidence may be misleading. The name may have been added later, bona fide or mala fide, the genuine may have been removed and replaced by a forged one. A test with spirits—which are resisted by the original layer of color—has not infrequently led to the result that the signature vanishes. Graphological tests assist the chemical ones. But even the "genuine" inscription—that is, the one which was added by the master himself immediately on the completion of the work—must not in all circumstances be regarded as valid and binding. A copyist may have taken it over from the archetype. When production was organized in a workshop—a circumstance always to be borne in mind—the master occasionally provided pictures, wholly or in part painted by his assistants, with his signature, as it were with a trademark. "Genuine" Bellini signatures occur on pictures which evidently are the work of other masters. Nobody troubled very much in the past about such a thing as spiritual ownership. Even the most venerable of all inscriptions, the celebrated stanza of four lines on the Ghent altarpiece, has very recently, for powerful reasons, been declared suspect.

The inscription may be false, and its statement nevertheless accurate—so that in this case, a rare one no doubt, the objective criterion is not even decisive in a negative sense.

Reliability is not to be expected from statements in inventories which, incidentally, contain authors' names only in exceptional cases, and from early writings. In the Prado at Madrid there is a Madonna, with the solemn information on the reverse of the panel to the effect that the city of Louvain in 1588 offered this work by Johannes Mabeus (Jan Gossaert, called Mabuse) as a present to King Philip II. I have not let this document prevent me from transferring the Madonna picture to Bernard van Orley. It is true that if it had

been possible to fit this picture in among the works by Gossaert, then I would have welcomed the statement referred to as a valuable piece of evidence.

The inventories of princely galleries—such as those of Margaret of Austria, Vicereine of the Netherlands, or of King Charles I of England, and also, say, the notes made by Marcanton Michiel in North Italian houses— are to be utilized skeptically and to be taken seriously only to the extent that facts derived from style criticism do not contradict them.

Again, as to the measurably similar forms, the objectiveness of this criterion is questionable, and its importance as a clue is being exaggerated.

Enthusiasm is a state of mind natural to the lover of art—indeed, to him almost something normal. But it does produce a confusing effect. Morelli, who called himself Ivan Lermolieff, has written some notable sentences about Otto Mündler, whom he knew personally and valued highly. Mündler, says Morelli, relied upon his memory and his intuition; he made his decisions on the strength of the accidental impression produced by the whole. Enthusiasm sometimes lets down the critic badly. This may be read in the introduction to Ivan Lermolieff's volume *Kunstkritische Studien in den Galerien zu München und Dresden* (1891).[1] The Italian, masquerading as a Russian, emphasizes the shortcomings of his predecessors in order to recommend his analytical and "scientific" method as a progress, an antidote. Again the ominous word "accidental" is being used. I do not know why the impression of the whole of the picture should depend more on accident than the impressions of the individual portions, on the basis of which Morelli claimed and believed to judge.

It could probably be proved statistically that Morelli by applying his method—which he, not exactly logically, described as an "experimental" one—made as many mistakes as Mündler depending on intuition. Nay, he would have made even more mistakes if he had applied his method consistently. The decisive factor is something that he too owes to intuition; and if we look closer, we shall find that he has utilized the much-praised method— the observation of measurably similar forms, notably the ears, the hands, the fingernails—less for the purpose of arriving at a verdict, than in order to provide evidence subsequently. He points to the individual forms in order to convince the reader of the justness of his attributions: but he, like every successful expert, has formed his opinion from the "accidental" impression of the whole picture. He had a presentiment of this, and has even hinted at it, when on one occasion he assesses the value of his method—fairly accurately—as being an ancillary device, a means of checking.

The criterion of similarity of form is completely unavailing, once we are faced with the task of differentiating original from copy—thus to answer a question which, in the practice of connoisseurship, is a particularly frequent and burning one.

The verdict may be accurate, although the reasons, the attempt to present it as a compelling truth, established by analysis, appear misguided. It is noticeable that gifted experts in particular, who make their decisions with inner certainty, have little inclination to provide "proof": they probably feel rather like Nietzsche, who said "Am I then a barrel, carrying my foundations with me?" False attributions are often presented with an excessive display of acuteness, and of arguments which sound irrefutable. False Raphael pictures are accompanied by whole brochures. The weaker the inner certainty, the stronger the need to convince others and oneself by lengthy demonstrations.

Enthusiastic lovers of art—at the same time mere amateurs—have contributed most and in the best fashion towards artistic reconstruction: they were, however, also exposed to the danger of making mistakes. Coldly analytical scholars make fewer mistakes; they perform, however, less in the way of positive perception; they discover less, with weaker flair. Morelli himself was, after all, an amateur in the best sense of the word; as a scholar he was rather affected.

Morelli has ably provided psychological reasons for his method. Above all the painter renders the human figure in pose and movement, as well as the face, more particularly mouth and eyes, under the stress of emotional tension, in order to convey his vision to the spectator. In so doing he penetrates relatively deeply into the complexity of that which is individual; but he lapses into convention and routine when he draws parts of the human body, such as the ear or the hand, which seem to be of secondary importance as bearers of expression. The hand speaks more through its movement than through its shape. Moreover, precisely ear and hand are complicated formations, mastered by the draftsman only with difficulty: so that the artist was tempted, by clinging to a formula, to evade the trouble of studying the given form in each case. Even great portrait painters of the seventeenth century, Van Dyck for example, have paid little attention to the individual shape of the hand.

For other reasons the critic of style may be recommended to observe the drapery folds. The painter steps on to a domain of comparative freedom when, in conformity with his temperament and his condition of spirit, he lets the pliable textile undulate, ripple, break, swell, roll up, swing and flow out.

Costume, more particularly when elaborate and idealistic, made expression by means of sonorous melody possible for the artist. In studying the cast of drapery we almost become graphologists, and can deduce the personal temperament and even the momentary mood of the author from the flow of writing, from the arid, angular, measured, sober or exuberant, rushing, dramatically mobile and extravagant play of line. Evidence of the expressive force which can be breathed into the material of garments is provided by Grünewald and Hugo van der Goes.

The graphologist takes as his starting point the fact that a writer must leave letters as much of their given form as legibility demands, but that he, free from this compulsion, is capable of spreading himself in the flourish, and in so doing expresses character, caprice and mood visibly. Also in the work of art, you can tell the difference between flourish and conventional sign. In the case of materials, costume, cut and sewn in such and such a fashion, resembles the letter; the play of folds, fluttering sashes, ends and ribbons resemble the flourish.

Mr. Berenson, who began as a grateful pupil of Morelli, has in a fragmentary article, published in 1902, under the title "Rudiments of Connoisseurship," arranged the "tests" under three headings, according as they are of use for the determination of authorship:

> First Group: Ear, Hand, Drapery fold, Landscape.
> Second Group: Hair, Eye, Nose, Mouth.
> Third Group: Cranium, Chin, Structure and Movement of the Human
> Figure, Architecture, Color, Chiaroscuro.[2]

This scheme is notable and is based on accurate thought: but it must not be applied as having universal validity. Tested in the practice of a connoisseur who has preeminently concerned himself with the Italian Quattrocento, it will, if used in connection with other periods, other manners of art, be partly unavailing. A Netherlandish painter of the sixteenth century may treat the landscape more variably, may invest it with more expression than architecture, so that, so far as he is concerned, architectural form becomes usable as a piece of evidence rather than landscape.

It must always be nicely calculated in each case whether there is predominance of habit and routine, or of observation of nature, individualizing characterization and expression of emotion. The more tense the will to achieve artistic form, the greater the variation.

The paradoxical idea that the master is recognizable where he has least drawn upon his force of expression, partly holds good. Argumentation providing reasons may successfully refer to the similarity of the ears; the act of intuitive arriving at a verdict springs from the impression of the whole. In the one case a master betrays himself; in the other he reveals himself.

§XXV. On Intuition and the First Impression

Even if attention deservedly goes to all the criteria which, with more or less justification, are described as the "objective," seemingly scientific ones, and occupy a space disproportionately large in writings on art, decision ultimately rests with something which cannot be discussed. To be sure, when we come upon the concepts of intuition and self-evidence—and every statement

based upon style criticism ultimately reaches and is wrecked by these concepts—we resign as scholars and even as writers. A purely emotional sense of conviction comes into play, and pushes itself into the place of terse deduction. Perhaps every verdict, formulated on grounds of style criticism, is nothing but a supposition; perhaps only probability may be arrived at along this path.

Style criticism inevitably reckons with probabilities, builds up hypotheses. In order to make fruitful use of such sensitive and delicate means, it is necessary to possess imagination and sincerity, a quality which is often unavailing. The vain desire for a "certain" result of one's studies is often stronger than the love of truth. The scholar is able to provide reasons possessing a certain amount of probability for a "determination"; proceeding, however, in the next chapter, he treats his supposition as an ascertained fact, and builds upon it further "determinations." We must insist that one should remain conscious of the degree of probability in each case, and proclaim it.

A hypothesis is something different from a supposition: it is an experiment. One may, tentatively, suppose even that which is improbable to be true, and draw deductions therefrom. A supposition gains in security if it can support tests of weight.

One should retain, and steel, one's courage of subjective opinion, but one should also skeptically and coolly put this opinion to the test. As in the case of a woman beloved, one should honor naïveté, but not let oneself be ruled by it.

The way in which an intuitive verdict is reached can, from the nature of things, only be described inadequately. A picture is shown to me. I glance at it, and declare it to be a work by Memling, without having proceeded to an examination of its full complexity of artistic form. This inner certainty can only be gained from the impression of the whole; never from an analysis of the visible forms.

This decision from feeling depends upon comparison, but not so much upon the recollection of such and such an authenticated signed or universally accepted work, as rather on an unconscious comparison of the picture to be ascribed with an ideal picture in my imagination. To gain, retain, refine and revive this ideal picture is the important thing, and hence it is advisable to devote as much time as ever possible to the contemplation, in full enjoyment, of the best and the authenticated works by a master; and on the other hand to devote little time to the problematic examples. Many experts act inversely, to their own detriment: they waste time and strength in examining dubious and insignificant pictures, and run the risk of confusing their taste and distorting their standards.

An ideal must not be fossilized: it must ever be kept capable of enrichment and change. It comprises not only such works as have been seen, but also such concealed possibilities as are contained in the gifts of a master. The idea of a master's capabilities becomes often all too early cut-and-dried: it should never be regarded as unchangeable.

If one has made a mistake—which is something that occasionally happens even to the gifted connoisseur—then one must radically and decisively evacuate the falsely judged work of art from one's memory and submit to a purge in the guise of the contemplation of indubitable works by the master. I remember the tragic case of an excellent and conscientious expert who once made a mistake. He was unable to summon sufficient courage and self-control to confess his mistake to himself; he searched for "proofs" of his false attribution and as a result ended up in a false position with regard to the master, to whom he once by mistake had assigned something. As a result of this one mistake, which in itself was no disaster, he was bereft of pure and clear notion, and his judgment, at least so far as this master was concerned, lost certainty. And that *was* a disaster.

One should avoid as far as possible to link up an attribution based on style criticism with another such attribution—in other words, to forge chains—since, of course, the risk of mistake is always there, and steps must be taken in advance to ensure that error does not produce error. A return to the secure starting point remains imperative, to a center from which attributions issue like rays.

Intuitive judgment may be regarded as a necessary evil. It is to be believed and disbelieved. Every sudden idea, however vague, may serve as basis for a fruitful hypothesis; only one must be ready to drop it as soon as it has proved itself incapable of sustaining weight.

In this mixture of bold initiative and equally determined resignation, of enthusiasm and skepticism, lies the fascination—exciting, keeping the spirit fresh and mobile—of work on the basis of style criticism.

Intuition resembles the magnet needle, which shows us our way while it oscillates and vibrates.

In the case of some masters it is easy to find the place of security, where an idea of full complexity can be gained and the ideal given shape in our imagination. In the Hospital at Bruges we not only see works by Memling, but experience his artistic activity, walk in his footsteps, measure the possibilities and limitations which were contained in his gifts. And it is with a similar profit that we leave the Frans Hals Museum at Haarlem, since there too the growth, the changes, the direction of an individual development, and the scope of a master are confided to us. Somewhat recklessly I venture to claim that *we learn to paint like Memling,* that is, to form the same visions as

he. This imaginary pupilage, which naturally has nothing to do with realization—for, of course, we do not become capable of successful forging—obtains for us the inner certainty with which we decide: this must be by Memling, or that cannot be by him.

If someone tells me that he owns a still life by Frans Hals, signed and dated 1650, I conjure up—without ever having seen a still life by Frans Hals—an idea which serves me as a standard as to whether I accept or reject the picture when it is shown to me.

The work of art which I attribute, and my ideal picture of the master whose name I pronounce, stand to each other in the relationship of lock and key. The expert's weapon and possession are less photographs, books, or a dictionary of characteristics, than concepts of visual imagination, gained in pleasurable contemplation and retained by a vigorous visual memory. The capacity of memory is limited. Even a Wilhelm Bode, whose gifts as a connoisseur were of an unexampled manysidedness, was unavailing in many directions. The reliable and successful experts are specialists. One must summon courage to say "I do not know" and reflect that he who attributes a picture wrongly reveals his ignorance of two masters—of the author, whom he does not recognize, and of the painter whose name he proclaims.

You cannot tell by the look of a verdict, based on style criticism, whether it is correct or not. But with time its healthiness reveals itself by its capability of reproduction. A false verdict shows itself to be sterile. With the true something could be done, it was possible to build on it, and usually it was subsequently confirmed by knowledge gained along other paths, and from a different quarter.

The first impression is deeper than all subsequent ones, of different kind and of decisive importance. The first contact with a work of art leaves a profound imprint, if only because it is connected with excitement. The receptiveness of the eye is heightened by that which is new, strange, unexpected, different. And if the contact be repeated, it is the moment of recognition which produces the strongest effect. It seems therefore advisable to look at a picture periodically for six seconds rather than once for a whole minute. Inexperienced beginners, in order to study a picture thoroughly, stare at it so long that they no longer see anything: that is, no longer receive the impression of something arresting. The eye tires if it stays too long in the same place; that which is peculiar and specific assumes more and more the color of that which is normal and incapable of being otherwise: the grace and advantage of the first impression are lost. Young art historians, who assiduously and intensively busy themselves with one master, without having seen much by others, lose the eye for the outline of their hero. Did not Montaigne in his wisdom think it worthwhile to note, "When we want to judge the

tonality of color of a scarlet cloth, we must let our glance glide over it quickly and repeatedly"?

Every verdict on art is the result of a comparison, mostly made unconsciously. A heightening of the impression is obtained by means of contrasted effect. If I have seen a picture by Gerard Dou and then look at Rembrandt certain qualities of Rembrandt emerge; if, however, from Titian I turn to Rembrandt, I receive a different impression. To experiment in this fashion is advisable as an exercise. The greater the distance—as regards time, place or individual character—between the works of art which we confront with another, the more distinct is the impression of that which pertains to time and place; the closer they are to one another, the easier does it become to observe subtle differences, to draw, say, the dividing line between the master and his skillful imitator.

He who knows but one master knows him insufficiently. This inadequacy is often enough to be noted in works denoting a writer's debut, and particularly in theses for a doctorate.

Notes

1. GIOVANNI MORELLI [Ivan Lermolieff], *Kunstkritische Studien über italienische Malerei,* vol. 2 of *Die Galerien zu München und Dresden* (Leipzig: F. S. Brockhaus, 1890–93).

2. [1] BERNHARD [BERNARD] BERENSON, "Rudiments of Connoisseurship," in *The Study and Criticism of Italian Art,* 2d series (London: George Bell and Sons, 1902), 144 [reprinted here as published in Friedländer; see also Berenson, Reading 13, page 136].

Connoisseurship

JOHN POPE-HENNESSY

[T]he significance of connoisseurship transpires most clearly from areas to which it was applied belatedly or was not applied at all. One of them is the study of Renaissance sculpture. In 1907, when Maud Cruttwell's volume on the Pollaiuoli appeared, Bode attacked it in the *Burlington Magazine*[1] for its Morellian or Berensonian tendencies, adding, with what reads as a sigh of relief, "the Morelli school ignored plastic art." And so it did, for the early study of Italian sculpture was prosecuted principally in Berlin by Bode and his disciples. He was anything but a negligible art historian, but he had a positive aversion to rational analysis. In the 1902 German edition of his celebrated *Italian Sculptors of the Renaissance* there is a section devoted to the Madonna reliefs by Donatello; it reproduced twenty-three reliefs, and they are by eleven different hands.[2] When one comes to think of it, this is a very peculiar phenomenon. A large number of documented Donatellos, after all, were known, but never did Bode take the elementary step of checking the Madonna reliefs ascribed to Donatello against the works for which Donatello could be shown to be responsible.

It must be said at once that the connoisseurship of Italian sculpture presents far greater difficulties than the connoisseurship of Italian painting. Most of them arise simply from the fact that sculpture has a third dimension. It presents the problem of actual, not notional tactility. From the 1880s on, valid results could be obtained with paintings by comparing one flat photographic image with another. But if sculptures are looked at as though they

From JOHN POPE-HENNESSY, *The Study and Criticism of Italian Sculpture* (New York: Metropolitan Museum of Art in association with Princeton University Press, 1980; reprint Princeton, N.J.: Princeton University Press, 1981), 28–30, 35–36. Copyright © 1981 by Princeton University Press. Reprinted by permission of Princeton University Press.

were in two dimensions, the results will almost inescapably be wrong. Not only is a knowledge of their physical properties essential, but it is vital to understand the creative act through which they were produced. The early students of Italian painting, whatever their shortcomings, would never have misdated pictures by a whole century. Yet with sculpture that frequently occurred. In the Bargello, beside the bronze *David* of Donatello, stand two other sculptures ascribed to him, a marble Baptist (the Martelli Baptist), carved about 1460 by Desiderio, and a second marble Baptist, carved shortly before 1530 by Francesco da Sangallo; both, as I say, are given to Donatello. And the putative works of Michelangelo have included a Hellenistic statue, and statues by much later sculptors, like Domenico Pieratti, and a seventeenth-century Roman group, the Palestrina Pietà. Even today, if you go to the Casa Buonarotti in Florence, you will find that Michelangelo's name has been attached to a female figure by Vincenzo Danti, and a so-called Slave by heaven knows whom.[3] You might infer from this that sculptures are especially deceiving, and that in my experience would be correct. They must be apprehended slowly (always in the original, since photographs are almost invariably misleading), and there are no shortcuts. Without an understanding of the artist's mind, as it is revealed in the totality of his surviving works, and of his working procedure and technique—the way in which he made his models and approached the marble block—useful attributions cannot be made. And the difficulty of the study is reflected in the fact that, whereas the connoisseurship of Italian painting was developed in the last quarter of the nineteenth century and reached maturity in 1914, the very first occasion when the principles of style analysis were applied to Italian sculpture was in 1935. The instrument of change was a Hungarian, Jenö Lányi. Inevitably, Lányi made mistakes—he was active as a scholar only for six or seven years— but his hits were more important than his misses, and as Morelli had done sixty-five years before, he opened up the study by proving how vulnerable to rational analysis many of its sacrosanct assumptions were. His significance cannot be measured in terms of his results. He returned to the Morellian principle that every attribution must be questioned and each artistic personality defined.

A good deal of progress has been made since then, but many problems which seem prima facie to be soluble are still unsolved. Problems like that presented by the bronze *Baptist* ascribed to Donatello, formerly in Berlin, which disappeared after the Second World War (Fig. 1). It was quite large (84 centimeters high) and was a work of extraordinary individuality and power. Bode, obsessed like so many historically minded people with literary evidence, reached for the nearest document, linking it to a commission to Donatello of 1423 for a gilt-bronze Baptist for Orvieto, and as late as 1935 this explanation of it was still entertained as a serious possibility. But in the latest

Donatello monograph, it was very properly denied to Donatello and given a considerably later date.[4] I never studied it in the original, but some reasonably accurate modern bronze casts were made from it, one on the font at Barga in the Garfagnana, and another in Florence, in the Ognissanti.[5] They tell one nothing, naturally, about the facture of the bronze original, but when I last looked at them it seemed to me, from the way in which the lost bronze was constructed (it has three supports, the two feet and the cloak resting on the ground behind), that the original must have been by Antonio [del] Pollaiuolo, who habitually constructed his small bronzes in this rather eccentric way. I believe that the attribution can be confirmed from the modeling of the arms and the attenuated, rather mannered forefingers, which have parallels in the reliefs of *Theology* and *Dialectic* on the Sixtus IV tomb; from the treatment of the temples, which are shown as indented planes receding sharply from the forehead in a way that recalls the treatment of the shoulders and shoulder blades of the *Hercules* in the Bargello; and from the heavy drapery which falls free of the spare, ascetic limbs in a way that cannot but remind us of the cloak of Hercules in the *Hercules and Antaeus* bronze. Pollaiuolo's authorship of this beautiful and moving work could, I believe, be demonstrated without difficulty, if the original survived.

Figure 1
Donatello [Antonio del Pollaiuolo?], *Saint John the Baptist,* ca. 1423, bronze. (Statue disappeared after World War II: formerly at the Kaiser-Friedrich Museum, Berlin.)

I rehearse these details not to prove that the findings are correct—to do that it would be necessary to present them at much greater length—but to demonstrate that, over a great part of this field, connoisseurship is not a poor substitute for knowledge, but provides the only means by which our limited stock of documented knowledge can be broadened and brought into conformity with what actually occurred. In the great monographs on Renaissance sculptors printed in the last twenty years, its potential has been all but ignored. There comes a point where strict adherence to historicity, in the form of documented works, is in fact unhistorical. One is reminded of a passage in Morelli's preface, where it is explained that "in Germany and Paris art historians do not acknowledge art connoisseurs and vice versa." Morelli's view was a great deal more extreme than mine. "Art connoisseurs," he declares, "say of art historians that they write about what they do not understand." I believe simply that art history is a looser, more speculative science than some of its practitioners suppose, and that the technique of connoisseurship must be inculcated and encouraged if it is significantly to advance. There are dangers in doing that, of course. Those innocent imitators of Panofsky who mistook mousetraps for wine presses might be succeeded by a generation which commands nothing but the semantic basis of connoisseurship. Teachers everywhere tend very naturally to concentrate on topics that can readily be taught—the interpretation of documents, the transmission of images, the elucidation of literary meaning, the projection of space—areas

which can be successfully attacked by intelligent students gifted with indus-
try and common sense. What as a whole they do not do, though there are
some notable exceptions, is . . . cultivate the gift of sight. But the main task
is, after all, to break down the inhibitions that discourage neophytes from
looking, to assist them to transcend received opinion and study a wide range
of works of art in the original intensively, as though nobody had looked at
them before. There can be no really sound, really constructive historiography
of art which does not proceed from the concept of similitude—how simple
the term sounds, and how complex the process is; from the apprehension of
artistic personalities as once living organisms whose responses and inten-
tions are still reconstructible; and from conscientious application of the
style-analytical techniques that are grouped together under the ugly, ma-
ligned, rather inappropriate word, connoisseurship.

Notes

1. [25] W. VON BODE [letter to the editor], *Burlington Magazine* 11 (1907): 181–82.
2. [26] VON BODE, "Die Madonnenreliefs Donatellos in ihren Originalen und in
 Nachbildungen seiner Mitarbeiter und Nachahmer," in *Florentiner Bildhauer
 der Renaissance* (Berlin: B. Cassirer, 1902), 96–125.
3. [27] CHARLES DE TOLNAY, *Alcune recenti scoperte e risultati negli studi
 michelangioleschi,* Accademia nazionale dei Lincei: Problemi di scienza e di
 cultura, quaderno 153 (Rome: Accademia Nazionale dei Lincei, 1971).
4. [28] HORST WOLDEMAR JANSON, *The Sculpture of Donatello,* vol. 2 (Princeton,
 N.J.: Princeton University Press, 1957), 246–47: "Although the authenticity of
 the statuette as a work of Donatello has never been questioned so far, it seems
 to me impossible to fit into the master's oeuvre." Janson proposes a very
 reasonable dating ca. 1470.
5. [29] A blunt plaster cast exists in the Bargello (Alinari 4784).

The Nature of Gothic

JOHN RUSKIN

[O]ur higher instincts are not deceived. We take no pleasure in the building provided for us, resembling that which we take in a new book or a new picture. We may be proud of its size, complacent in its correctness, and happy in its convenience. We may take the same pleasure in its symmetry and workmanship as in a well-ordered room, or a skillful piece of manufacture. And this we suppose to be all the pleasure that architecture was ever intended to give us. The idea of reading a building as we would read Milton or Dante, and getting the same kind of delight out of the stones as out of the stanzas, never enters our mind for a moment. And for good reason;—There is indeed rhythm in verses, quite as strict as the symmetries or rhythm of the architecture, and a thousand times more beautiful, but there is something else than rhythm. The verses were neither made to order, nor to match, as the capitals were; and we have therefore a kind of pleasure in them other than a sense of propriety. But it requires a strong effort of common sense to shake ourselves quit of all that we have been taught for the last two centuries, and wake to the perception of a truth just as simple and certain as it is new: that great art, whether expressing itself in words, colors, or stones, does *not* say the same thing over and over again; that the merit of architectural, as of every other art, consists in its saying new and different things; that to repeat itself is no more a characteristic of genius in marble than it is of genius in print; and that we may, without offending any laws of good taste, require of an architect, as we do of a novelist, that he should be not only correct, but entertaining.

From JOHN RUSKIN, *The Stones of Venice,* vol. 2 (London: Smith, Elder, 1851; New York: American Publishers Corp., 1851), 190–91 (page numbers are to the American Publishers edition).

Yet all this is true, and self-evident; only hidden from us, as many other self-evident things are, by false teaching. Nothing is a great work of art, for the production of which either rules or models can be given. Exactly so far as architecture works on known rules, and from given models, it is not an art, but a manufacture; and it is, of the two procedures, rather less rational (because more easy) to copy capitals or moldings from Phidias, and call ourselves architects, than to copy heads and hands from Titian and call ourselves painters.

PART II

The Original Intent
of the Artist

Diego Rodríguez de Silva
Velázquez, *Count Duke of
Olivares*, ca. 1633.

The Original Intent
of the Artist

Intent, as any lawyer will inform you, is difficult to prove. This certainly applies to artistic intent: what an artist wants to achieve and what aesthetic effect and/or experience the artist wishes to convey to the viewer. It has become commonplace to assume that artists never completely achieve what they may envision. We suppose that, like the protagonist in T. S. Eliot's "The Love Song of J. Alfred Prufrock," they constantly bemoan, "'That is not what I meant at all. That is not it, at all.'" Undoubtedly, creators do experience frequent discontent with their productions since perfection is given to no one. Although fallibility will always prevent the artist from achieving a totally accurate manifestation of what is pictured in the mind's eye, there can be no doubt that most works of art are produced with a specific intent in mind.

Like Alois Riegl's "values" (see Riegl, Reading 6, pages 69–83), intent can also be multiple. An artist can have a variety of intentions for a single work. For example, a portrait of a ruler is intended to convey strength, grandeur, regality; and the success of the image to impress depends on the talent of the artist. Judging this type of intent, what might be called a creative or *image intent*, depends on the ability to discern and differentiate quality. Velázquez's equestrian portrait (ca. 1633) of the *Count Duke of Olivares* (Fig. 1) exudes masculine power, princely fortitude, and an aristocratic disdain for danger. Were the Count Duke to gallop forward, it would be as important to step aside as it would be to avoid the rails of an oncoming express train. A 1628 portrait of *Charles I* by Daniel Mytens (Fig. 2) shows a well-dressed mannequin with the king's rather plain canine face stuck on for good measure. It took Van Dyck to transform Charles I into the elegant, wistfully distant prince, that ultimate aristocratic image we commonly associate with him as, for example, in the circa 1635 *Charles I Dismounted* (Fig. 3). The success of the image intent is thus in direct proportion to the artist's talent as

Figure 1
Diego Rodríguez de Silva
Velázquez, *Count Duke of
Olivares*, ca. 1633.

creator. Appreciation and evaluation of image intent belong to the realm of art criticism.

Artists also have more specific, technical intentions, such as the optical effect of the surface (smooth paint layer or impasto), surface finish (glossy, matte, tinted, or unvarnished), placement or location of a work, lighting, frames, and the like. Architects and sculptors are as concerned with the surface effects of their materials as are painters. Sir Joshua Reynolds, the dean of eighteenth-century British portrait painters, had an absolute passion for imitating the surface effects of old master paintings, especially those by Titian and Rembrandt. To do so, Reynolds assiduously studied the works of his predecessors and concocted various media, using balsams, resins, drying oils, egg, volatile plant oils, wax, and asphaltum, in order to duplicate the effects he admired so much. Benjamin Robert Haydon (1786–1846), a painter of no great merit, remarked that "the surface Sir Joshua got was exquisite," but warned that his methods were not to be used.[1] In many instances, Reynolds's paintings deteriorated so rapidly that he had to restore or refurbish them in order to keep his customers happy.

Figure 2
Daniel Mytens, *Charles I,* 1628.

Albert Albano: The Conservator's versus the Artist's Intent

Reynolds's intent was clearly to imitate the old masters and not to paint pictures that were doomed to all sorts of physical failures from extensive cracking to fading pigments. His creative intent was at odds with another intent which is often forgotten: the patron's intent. One of Reynolds's sitters, Sir Walter Blackett, left no doubt as to what he thought of the results of the artist's quixotic technique: "Painting of old was surely well designed / To keep the features of the dead in mind, / But this great rascal has reversed the plan, / And made his pictures die before the man."[2] At this stage, another intent can come into play, the conservator's intent. Albert Albano, in "Art in Transition," (see Reading 17, pages 176–84) draws attention to the fact that many modern and contemporary artists are excessively faulted for their lack of or refusal to use technical knowledge that would improve the longevity of their works. He puts the phenomenon into proper historical perspective by referring to J. M. W. Turner, among others, who was notoriously experimental with technique. Paintings by Turner and by Reynolds are among the most difficult to clean with any relative safety, and many of them have suffered at

Figure 3
Sir Anthony Van Dyck, *Charles I
Dismounted*, ca. 1635.
Oil on canvas.

the hands of restorers who were not aware of the means used by these artists
to achieve their optical effects and consequently their artistic intent.

Albano raises the important issue of the conservator's role, or intent,
when dealing with contemporary paintings that quickly show the exaggerated
effects of time, assumably due to poor technique. According to Albano, con-
servators have begun to insinuate their concern for preservation—for lon-
gevity with a minimum of physical change—in other words, imposing a
preference for newness value on the creative process. "[W]e now seem to
resent what is considered to be a lack of material and technical knowledge on
the part of artists," Albano writes, "and thus feel justified in imposing our

own concepts of timelessness on them. This has even been carried to the extreme of the artist being prohibited from touching his or her own work ever again, as such interventions are considered better left to the conservator" (Reading 17, page 183). This attitude clearly contradicts both the inexorable reality of time and the fact that many contemporary artists have developed a philosophical view toward, if not a total acceptance of, change and aging. Despite the trend for minimal intervention, conservators apparently have problems accepting the visual effects of what Alois Riegl calls *age value* (see Reading 6, pages 72–75). At issue here is which intent—the artist's or the conservator's (in other words, creative intent versus longevity)—is of greater importance. Artists naturally give preference, and rightly so, to creative intent and the effects they wish to achieve, and serious collectors probably will, as well. When Sir George Beaumont was asked by the parents of Miss Bowles (whose portrait was painted by Reynolds circa 1775) whether or not they should employ Reynolds because his colors faded, Beaumont assured them, "'No matter, take the chance; even a faded picture from Reynolds will be the finest thing you can have.'" [3] Preference was, in this instance, clearly given to the artist's intent.

Surface finish, whether on paintings, statues, furniture, objects, or buildings, has always been and will continue to be a concern for artists, sculptors, craftspeople, and architects. As suggested here, such concern can be called *optical intent*. How can we discover then, if at all, what the optical intent of a work of art originally was? Berenson's dictum that a work of art "is the event, and the only adequate source of information about the event" (Berenson, Reading 13, page 131) is, regrettably, not always sufficient to help ascertain what the original optical intent was. Unfortunately, very few, if any, old master paintings exist with their original layers of varnish still intact, and if they did, they would hardly provide, in their yellowed and dull state, any relevant visual information on original condition or intent. Chemical analysis of such a layer, however, could provide valuable data regarding the composition of a varnish. In turn, this could be compared to information from the sources, such as treatises on painting materials and methods. As important and helpful as original sources are, they are often unclear, contradictory, and require careful interpretation to be of relevant assistance when one is attempting to reconstruct past practice. Innumerable treatises, notebooks, and artists' letters from the seventeenth and eighteenth centuries contain much information on the production of varnishes. [4]

On the basis of these sources, one may reasonably assume that preference was generally given to untinted, glossy varnishes. How glossy they actually were will forever remain a mystery since it is possible to thin down any varnish, thereby diffusing the extent of the gloss. Undoubtedly, this was common practice. A furor was caused by Ernst Gombrich in the 1960s when he

published an article on the use of dark varnishes (see Reading 11, page 123). Gombrich based his theory on a slight passage in Pliny's *Natural History*, written before 79 C.E., that describes Apelles as having used a tinted varnish:

> When his works were finished he used to cover them over with a black varnish of such thinness that its very presence, while its reflexion threw up the brilliance of all the colours and preserved them from dust and dirt, was only visible to anyone who looked at it close up, but also employing great calculation of lights, so that the brilliance of the colours should not offend the sight when people looked at them as if through muscovy-glass and so that the same device from a distance might invisibly give sombreness to colours that were too brilliant.[5]

Undeniably a fascinating passage, it remains too exceptional and too slim for anyone to extrapolate, as Gombrich did, that from the Renaissance on, artists based their practice of varnishing on Apelles's supposed use of a "black varnish."[6] Approximately four centuries separate Apelles and Pliny; therefore, a serious question mark must be placed against the accuracy of this passage. Who or what Pliny's source might have been remains unknown. Gombrich forgot Morelli's, Berenson's, and Friedländer's caution about depending too much on the accuracy of written sources.

Common sense would tend to indicate that artists were basically concerned with the freshness of their paintings and colors rather than obscuring them with tinted varnishes. Dürer, for example, was very specific on the matter. In a letter of 26 August 1509 to Jacob Heller, a patron, he assures him that a painting of a *Virgin and Child*

> will last 500 years clean and fresh if you keep it clean. . . . And when in about one, two or three years time I come to see you, the panel will have to be taken down. If it is then well dried, I would again varnish it with a special varnish which one cannot make anywhere else! Thus it will last another hundred years longer than before. But do not let anybody else varnish it again, for all other varnishes are yellow, and one would spoil your panel.[7]

Obviously, Dürer had no interest in any golden glow. Exactly what he means by other varnishes being yellow is ambiguous. It could indicate varnishes were, after all, generally tinted, but the more logical explanation is that they were simply yellow in the bottle, as mastic and sandarac, for example, would be without any tinting additives. Dürer seems to be touting his own "special" varnish, a very human thing to do when trying to impress a patron. What is of importance is the artist's obvious concern for a non-yellow varnish.

Rubens, too, was very specific on the matter of optical intent. In a letter to his friend, Peiresc, dated 9 August 1629, he mentions:

> If I knew that my portrait were still in Antwerp, I should have it kept there
> in order to open the case and see if it had spoiled at all after being packed
> so long without any light and air, and if, as often happens to fresh colors,
> it had taken on a yellow tone, very different from what it was. If it arrives
> in such a bad state, the remedy will be to expose it several times to the
> sun, whose rays will dry out the surplus oil which caused this change.
> And, if, from time to time, it begins to turn brown, you must expose it
> once more to the sun, the only antidote for this grave malady.[8]

Rubens's concern here is not with varnish but with oil coming to the
surface of a new paint layer, thus turning it brown. Considering his preoccu-
pation with fresh color, it would be mildly ridiculous to suppose he would
have subsequently used a tinted varnish. However, even common sense can
offer no more than a reasonable assumption as to former practice. Much
more work needs to be done in the sources regarding the optical intent of old
master paintings.[9]

John Richardson: The Duty to Respect Original Intent

When we come to modern works of art, we are more fortunate in being able
to go to the best source of all—the works themselves—to find examples that
are still in their original condition, with the optical intent still intact. John
Richardson's "Crimes against the Cubists" addresses a conflict between the
artist's optical intent and the intents of both conservators and collectors.
Regrettably, with increasing frequency—at least at the time Richardson was
writing in 1983—more and more Cubist paintings were being both wax
relined and varnished. Wax, as we know, penetrates the canvas and saturates
the paint layer, radically altering the subtle values of matte colors. What a
layer of varnish will do to an eggshell-matte paint surface hardly needs men-
tion. Richardson notes that "it cannot be . . . too often emphasized that both
Picasso and Braque were adamant that the surface of Cubist paintings be left
matte and *never* in any circumstances varnished. In the case of Braque this
interdiction applied not merely to his Cubist paintings but also to all his sub-
sequent work" (Richardson, Reading 18, page 186).

According to Richardson, both Braque and Picasso accepted the
inevitable signs of age in their paintings. Picasso even relished the effects of
deterioration. Reynolds, too, was phlegmatic about the problem and once
retorted to Sir George Beaumont, who complained that a wax vehicle recom-
mended by Sir Joshua had cracked, "'All good pictures crack.'"[10] Along with
Braque and Picasso, Richardson comes down firmly on the side of age value
and states that, as far as restoration is concerned, he is a minimalist. Going
a bit further, Braque and Picasso "would rather have had a painting disinte-
grate than see it undergo plastic surgery" (Richardson, Reading 18, page 187).

Death with dignity is the logical consequence of an exclusive emphasis on age value.

While age value accepts the signs of age and respects the artist's intention by keeping interventions to a minimum, it can at the same time contradict optical intent by, for example, allowing a badly yellowed layer of varnish to stay in place as a clear indication of age—and thus age value. In restoration, a balance has to be struck between the different values and intents, with preference usually being given to the artist's intent when known or surmised. Richardson's article, published in the *New York Review of Books*, prompted Caroline Keck to write a letter to the editor, Robert Silvers. Keck remarks that "no conservator wants to increase alteration of appearance from the original concept of its artist" and stresses that the "non-material content . . . is the single potent factor in determining our basic standard for the practice of professional conservation: every method must be reversible, do nothing which cannot be undone."[11] This view shows great respect for art value, age value, historical value, creative or image intent, and optical intent.

In her forthright response to Richardson, Keck places greater emphasis on physical condition in terms of longevity than on aesthetic considerations. Her position seems to recall the question posed by Albano when he asks, "Should our function as conservators . . . be to impose our own perspective concerning durability onto the creative process of the artist? The odd result would be the ideals of the conservator taking precedence over those of the artist, as an attempt is made to permanently lock a work of art into a single moment in time" (Albano, Reading 17, page 183). What is of utmost concern to Keck is the prevention of what she perceives as decay. She recommends the use of varnishes as "barricades against air-borne dirt and pollutants" and unequivocally states that "they may be applied by brush or spray, matte or glossy finish, and are reversible without risk to painted surfaces."[12]

While varnish does not physically damage the surface of a painting, the removal of any varnish is always an operation of risk. The real problem, however, is that once any varnish layer—no matter how matte, no matter how thinly applied—is put onto an unvarnished painted surface, it can never be completely removed to reveal again the pristine, virgin surface. Varnish permanently changes the optical intent, as well as the optical effect, of any picture meant to be left unvarnished. Removal of varnish is certainly possible, but the changed optical effect of the painted surface can never be completely reversed. Many treatments better left undone are carried out in the name of "reversibility," which to a large degree is simply a conservator's myth.

Richardson blames the acquired taste for glossy surfaces on the "publishers of art books [who] have corrupted the public's eye by accustoming it to ultra-glossy reproductions" (Richardson, Reading 18, page 191; a similar

point is made by Philippot, Reading 26, pages 268–74). This is certainly true to a great extent, but many collectors seem to prefer glitter and shine, for what Riegl terms the work's *newness value*. Such collectors want their possessions to be in optimum condition, with the presumable intent to impress, to preserve their investment, and to purchase a little bit of immortality. To such thinking, immortality can be better guaranteed by objects in what is commonly considered to be good rather than poor condition. There are also collectors who revel in the sheer delight of being surrounded by rich objects. Their intent is not so much aesthetic reverie as actual sensual enjoyment of their possessions.

Perhaps the collector with the most unabashed epicurean joy in his possessions was Abbot Suger of Saint-Denis (1081–1151). He remodeled and redecorated the abbey church of Saint-Denis and left a record of this work, which bubbles with his delight in luxury. "To me, I confess, one thing has always seemed preeminently fitting: that every costlier or costliest thing should serve, first and foremost, for the administration of the Holy Eucharist."[13] During the restoration, he "also caused the ancient pulpit, which—admirable for the most delicate and nowadays irreplaceable sculpture of its ivory tablets—surpassed human evaluation also by the depiction of antique subjects, to be repaired after we had reassembled those tablets which were moldering all too long in, and even under, the repository of the money chest." Suger recognized the historical value of these ivory reliefs, but dealt with them strictly from the point of view of use value. With no qualms whatsoever he "had . . . put out of the way a certain obstruction which cut as a dark wall through the central nave of the church, lest the beauty of the church's magnitude be obscured by such barriers." Here again emphasis is on use value, but Suger was also concerned with the optical intent of the nave of the abbey. Church furnishings were meant to impress, to instill awe; this was their use value, and Suger "had regilded the Eagle in the middle of the choir which had become rubbed bare through the frequent touch of admirers."[14]

When such "creations" as that achieved by the Abbot Suger—if they should still exist—are restored, more thought must be given to the collector/patron's intent. Out of diverse elements, he succeeded in creating, as any artist, a single "object"—a restored and redecorated abbey in this instance, a compilation of works from many hands, which nonetheless, thanks to Suger's taste and vision, gelled into a unified work of art.[15] The Barnes Collection in Philadelphia is another example of a collector turning his varied possessions into one single great work of art through his personal arrangement of them. It is one of the most important examples of the collector's intent to create a sympathetic, unified, and singular setting, which complements, enhances, and relates works of art one to another.

Ernst van de Wetering: Original Intent, an Absolute or Relative Value?

It was stated earlier that a balance has to be sought between the different values and intents when a conservation intervention takes place. This implies that the conservator, after carefully considering the problems involved, will make a decision that fully recognizes the relative importance of various values and intents that may be in conflict with one another. The conservator's decision will therefore obviously reflect another intent, that of the intervention. As Ernst van de Wetering noted in "The Autonomy of Restoration: Ethical Considerations in Relation to Artistic Concepts" (see Reading 19, pages 193–99), "one is inclined to conclude that restoration has a certain autonomy independent, to some extent, from the artist's intentions" (Reading 19, page 196). At first sight, this seems to be in direct opposition to Albano's stance that the artist's intent should take precedence over the conservator's. This, however, is not what van de Wetering is saying; he simply raises the important issue of the relationship between these intents, without categorically giving preference to one over the other. "Knowing the artist's wishes and intention, however, does not automatically mean that the restorer's interventions should be in line with them" (Reading 19, pages 195–96).

To prove the relevance of his position, van de Wetering draws upon the well-recorded intentions of Vincent van Gogh with regard to the impasto of his paint. In a letter to his brother Theo, van Gogh stated that he painted thickly to guarantee the "solidity of color," not to produce the surface effect, which we have come to value, and which van de Wetering describes as, "the seismographic registration of his artistic temperament" (Reading 19, page 194). Van Gogh even recommended shaving off the impasto, thereby revealing a greater intensity of color. The restorer, whom van de Wetering says was extremely upset about the damage done to van Gogh's impasto by incompetent relining procedures, would obviously be surprised to learn how the artist thought about an optical effect that viewers value but the artist did not. Today's viewers have come to appreciate a visual effect as if it were the artist's intent, which it never was.

Another excellent example given by van de Wetering of an artist's unequivocally expressed intent is Gauguin's advice on relining methods, advice that would be both folly and totally irresponsible for a conservator to follow. Even though, as van de Wetering points out, "[i]t may well be that van Gogh, just as Gauguin, would have preferred the flattened 'très belle surface' of the relined *Bedroom*" (van de Wetering, Reading 19, page 195), today's viewers would not. In the case of van Gogh's impasto, we can perhaps speak of an acquired intent, something the artist did not value but which succeeding generations of spectators have. Our appreciation of his impasto inherently recognizes its historical value as an essential element of his style.

Figure 4
Piero Manzoni, *Achrome*
(*Quadrati bianchi su bianco*), 1960.

An artist's intent can at times be at loggerheads with a collector's intent. The example of Manzoni is used to show that what an artist thinks appropriate for his works is not always what the collector finds appropriate. Manzoni recommended his *Achrome*s be either washed or repainted white to revitalize them for exhibitions (Fig. 4). Collectors, however, preferred his works to show the effects of age. According to van de Wetering, "[t]he appreciation of the 'aura' of authenticity, which in our culture seems so much stronger than in other cultures, has gained priority" (Reading 19, page 197). Richardson would probably not agree that this is actually the case, and Albano would undoubtedly be happy if it were.

What is clear, however, is that more attention is being paid to intention than in the past. A great deal of research has yet to be done in this area, and we must not forget that intent is not only relevant for conservation but also for presentation and what is understood by "original context." Benvenuto Cellini (1500–1571) often makes passing remarks in his *Autobiography* concerning the lighting and placing of his statues. When Cellini was requested to show a silver statue of Jupiter to Francis I in Fontainebleau, he arranged it to be seen at its best advantage. "The Jupiter was raising his thunderbolt with the right hand in the act to hurl it; his left hand held the globe of the world. Among the flames of the thunderbolt I had very cleverly introduced a torch of white wax . . . for when night came, I set fire to the torch, which,

Figure 5
Sir Anthony Van Dyck, *Charles I
on Horseback,* ca. 1638.

standing higher than the head of Jupiter, shed light from above and showed
the statue far better than by daytime."[16] Van Dyck's immense (3.67 × 2.92 m)
Charles I on Horseback, circa 1638 (Fig. 5), now in the National Gallery, Lon-
don, was originally conceived, as were other enormous paintings of the king,
"as *coups de théâtre* at the end of great galleries in the various royal resi-
dences. All are illusionistic paintings on the scale of scene painting meant to
remove the wall from the viewer's eye in the same way as a Baroque ceiling
painting."[17] Background or setting, placement, and lighting are all consider-
ations that belong to original intent.

As far as conservation and original intent are concerned, van de Wetering cautions that "[e]thics in restoration have found their origin in the growing awareness that we will never understand the artist's intentions to their full extent and that consequently our interpretations, which in restoration are expressed on the very object, never entirely cover the truth" (van de Wetering, Reading 19, page 196). Interpretations, especially those dependent on individual aesthetic judgment, also invariably contain a subjective element. This is all the more reason to proceed with the utmost caution and to check, whenever possible, one's conceptions and conclusions against original intent.

—MKT

Notes

1. M. Kirby Talley Jr., "All Good Pictures Crack: Sir Joshua Reynolds's Practice and Studio," in *Reynolds,* exhibition catalogue (London: Royal Academy of Arts, 1986), 63.

2. Ibid., 55

3. Ibid., 69

4. See M. Kirby Talley Jr., *Portrait Painting in England: Studies in the Technical Literature before 1700* (London: The Paul Mellon Centre for Studies in British Art, 1981) for an extensive selection of recipes for making varnishes in the seventeenth century.

5. Pliny, *Natural History,* vol. 9 (London: William Heinemann Ltd, 1968), 333. On the Apelles "affair" see E. H. Gombrich, "Dark Varnishes: Variations on a Theme of Pliny," *Burlington Magazine* 104 (1962): 51–55; Otto Kurz, "Varnishes, Tinted Varnishes and Patina," *Burlington Magazine* 104 (1962): 56–59; Denis Mahon, "Miscellanea for the Cleaning Controversy," *Burlington Magazine* 104 (1962): 460–70; and Joyce Plesters, "Dark Varnishes—Some Further Comments," *Burlington Magazine* 104 (1962): 452–60.

6. For a different interpretation of this controversial passage, see the introduction to Part 7, page 368; on Apelles, see Keck, Reading 28, pages 282–83.

7. Quoted in Helmut Ruhemann, *The Cleaning of Paintings* (London: Faber and Faber, 1968), 234. For the entire text of this letter, see Albrecht Dürer, *Lettres et écrits théoriques: Traité des proportions,* trans. Pierre Vaisse (Paris: Hermann, 1964), 95–97.

8. Ruth Saunders Magurn, trans. and ed., *The Letters of Peter Paul Rubens* (Cambridge, Mass.: Harvard University Press, 1971), 323. And, in the same volume, page 409, see the letter to Justus Sustermans, 12 March 1638.

9. Rob Ruurs, "Matt oder glänzend?" *Maltechnik/Restauro* 29, no. 3 (1983): 169–74.

10. Talley, *Reynolds,* 64.

11. Caroline K. Keck, Letter to Robert Silvers, editor, *New York Review of Books,* 24 June 1983, 4.

12. Ibid., 3

13. Elizabeth Gilmore Holt, ed., *A Documentary History of Art,* vol. 1 (Garden City, N.Y.: Doubleday Anchor Books, 1957), 31.

14. Ibid., 31–32

15. For some indication of the splendor of Saint-Denis under Abbot Suger, see *The Mass of St. Giles* by the Master of St. Giles, ca. 1480, National Gallery, London, and reproduced in color in JOAN EVANS, *Life in Medieval France* (London: Phaidon, 1969), opposite 104.

16. BENVENUTO CELLINI, *The Autobiography of Benvenuto Cellini,* trans. John Addington Symonds (New York: The Modern Library [1927]): 356.

17. ROY STRONG, *Van Dyck: Charles I on Horseback* (London: Allen Lane, Penguin Press, 1972), 20–22. See 22, illustration 6, a photomontage on a detail of Daniel Myten's *Charles I and Henrietta Maria at Theobald Palace,* showing how this picture might have been hung.

Art in Transition

ALBERT ALBANO

In recent years, the conservation of modern and contemporary art has become a subject of substantial interest and frequently heated debate among those engaged in the varied activities associated with art stewardship. Of specific concern here is the increasingly vocal criticism directed at what some people consider to be imprudent experimentation in the fabrication of twentieth-century art, often accompanied by warnings about its premature deterioration. The present discussion is intended to encourage the formation of a broader perspective that will hopefully be more sympathetic toward the nature of some of this deterioration both related and unrelated to materials and technique.

The interested circle of participants in the debate over the conservation of twentieth-century art has expanded at an increasing pace, clearly stimulated by a wide range of economic ingredients. These factors are not insignificant, although they are, unfortunately, too broad and complex to allow for an adequate analysis here. One can affirm without reservation, however, that the widespread interest in and recognition of the importance of contemporary art conservation to growing audiences outside the art world has been catalyzed by the economic climate of recent years. The investment value of art has increased to staggering proportions; and, as the availability of older works of art has decreased, an ever-growing commitment to the acquisition of modern and contemporary art has taken place. The pace and vigor

of this buying may be unprecedented. As Robert Hughes has stated, "There is no historical precedent for the price structure of art in the late twentieth century. Never before have the visual arts been the subject—beneficiary or victim, depending on your view of the matter—of such extreme inflation and fetishization." [1]

Press attention devoted to the subject of the physical vulnerability of contemporary art is also apparently unsurpassed. This increased attention to and concern about deterioration and preservation may be only a temporary phenomenon and therefore somewhat analogous to various past controversies concerning art conservation in general. It may also, however, be similar to the periodic interest in specific issues, such as the debate over picture-cleaning methodology and its results, most recently discussed by Hedley [2] and Keck. [3]

Characteristic of many journalistic critiques is the tendency to incorporate cynical polemics and undocumented anecdotes. These tales are chosen deliberately to favor those opinions that conform to an a priori theme of the author, which usually highlights the ephemeral physical qualities of an artwork. In a typical example, one conservator is quoted as saying, "A couple recently tried to enlist her refurbishing services for a large, disintegrating sculpture made out of bread and blood-soaked rags. She declined the job. 'In a way it's fortunate,' she says of the art's delicacy. 'There's so much art produced you hope some of it will go away.'" [4] As this quote illustrates, much of the commentary concerning the preservation of twentieth-century art, regardless of the respective quality or thoroughness of the analysis, essentially emphasizes the premise that "modern art won't last." This theme is often supported by professional opinion, including statements by conservators who are frequently named but sometimes prefer to remain anonymous, to lend credibility to the writer's premise.

Routinely, critics of contemporary practice make the inevitable and thus predictable comparisons to art produced in previous centuries. Art of the past, they contend, complied more rigorously with accepted, time-tested materials and techniques, reflecting the strict influence of well-established art academies. According to this argument, the decline of the academic system in the mid-nineteenth century inevitably led to a sense of total abandon and wild technical and material experimentation by twentieth-century artists. Another common theme revolves around the accusation that "the artist is no longer a craftsman," as one conservator complained. "They don't have time; they say it would inhibit their creativity." [5] This premise is further supported by describing works of art created with so-called faulty materials, jaunty technique, or both. Most unjustifiable and, therefore, misleading is the sweeping assumption that because an anecdotal reference is made to a conservation problem associated with a particular work of art, the artist's

entire oeuvre is assumed to have been produced with faulty techniques and materials. For example, in a 1988 *New York Times* article titled "Flaky Art," the writer states, "Pollock paintings have as many problems as they have bottle caps, cigarette butts, and coins."[6] In fact, relatively few Pollock paintings contain such accidental inclusions, which in themselves present no conservation problems whatsoever. More important to recognize, however, is that, as a rule, Jackson Pollock's paintings do not present any ongoing conservation problems.

Usually it is the more notable artists—such as Willem de Kooning, Mark Rothko, and Robert Rauschenberg—who are cited as flagrant experimenters. Often mentioned is de Kooning's use of an emulsion medium containing safflower oil, which is described as a paint that does not fully polymerize; therefore, it is implied, his work is critically unstable. Experience has shown, however, that this paint will not disastrously creep down the picture, despite the fact that it remains unpolymerized. Although this aspect of the paint may create unusual problems in cleaning, these problems are no more complex than those posed by the works of an unorthodox painter from a previous era, such as J. M. W. Turner, for example. De Kooning is also accused of using cheap house paints which change in color over time, making the pictures look "shabby." The writer adds that "these are not exceptions to de Kooning's work. It's really rather common."[7]

Younger artists—such as Anselm Kiefer, Julian Schnabel, and Donald Sultan—are new additions to the list of painters accused of using poor technique and consequently of being disinterested in the long-term survival of their work. The implication, if not always directly stated, is that work by these artists may not survive for long, or at least not remain in an acceptable state of preservation. The underlying leitmotiv is that their work is a bad economic investment for collectors or museums purchasing for perpetuity. The contribution of conservators to this intensifying barrage is of particular concern, as these professionals often provide the core of the criticism.

The growing tendency to attack contemporary art on these various grounds has reached a point that warrants some review and response. First we must ask why a different set of conservation criteria has come to be applied to the evaluation and judgment of twentieth-century art compared to the criteria used to evaluate the art of previous centuries. The result is that these criteria segregate twentieth-century art from its logical continuity with earlier art. Second, what is the relevance of the work's deterioration, if assessed as such, in relation to the artist's intent? Why is technical and material experimentation in the twentieth century given such unsparing criticism when its motivations are in many ways similar to the spirit of artistic and technical experimentation of previous periods? This historical double standard seems unduly harsh to our own century.

Finally, why have we, as conservation professionals, not come to accept the physical changes in twentieth-century art with the same objectivity we use in the evaluation of art from earlier periods, and why do we not apply the same ethical standards and responses to contemporary art when conservation is warranted?

Through nearly all periods, the evolution of painting styles has been accompanied by developments in materials and technique. There is evidence to suggest that each technical innovation associated with changing painting styles has been met with doubts and skepticism about its future stability and survival. In the sixteenth century, for example, Giovanni Battista Armenini's obsession with the decline in the arts of his own period was not unique.[8] Hilaire Hiler writing in the 1930s on the subject of materials and techniques describes the age of the Renaissance as "a great period of experiment, and technically the rush of revolutionary ideas, crying for expression, made painters search for new techniques fitted to express them."[9] This sounds remarkably similar to Adolph Gottlieb insisting in 1956 that "all artists have to solve their problems in the context of their own civilization, painting what their time permits them to paint, extending the boundaries a little further."[10]

The experimental trend commonly associated with degeneration of materials and technical facility continued through the sixteenth and seventeenth centuries, as chronicled by contemporaries or near contemporaries of that period. Goethe, for example, in the final chapter of his *Italian Journey, 1786–1788,* in which he discusses Venetian painters of the seventeenth century, claims that those pictures painted with transparent glazes on a dark ground laid over white priming had become lighter rather than darker over time. Whether Goethe's reasons for the alterations are technically accurate is of less consequence than his assessment of the deterioration and thus his perception of the picture's changes. In describing the *alla prima* painting technique on red bolus grounds used by Luca Giordano, for example, he observes that the whites had been drastically darkened by oils which had destroyed the thin, veil-like underpaintings in the transition and shadow tones. But, he adds, "Originally, no doubt, they were quite effective."[11] Only slightly more than a hundred years after their execution, Goethe laments the irreversible alteration of pictures that we, more than three hundred years later, have come to accept and uphold as masterpieces.

What degree of corruption would have occurred to these pictures by the time Max Doerner saw them? Writing in the 1930s, he describes the same faulty techniques and materials when he details the compromises devised by the Venetian school to expedite work (*Fa presto!*) "often by painters who aimed straight at the final effect. ... Gradually, the painters' craft lost in esteem and was relegated to a position of inferiority," with the result that "the artist did not need to concern himself with the menial tasks of his high

profession."[12] G. B. Volpato of the late eighteenth century expressed much the same concern for the decline of technique and its inevitable consequences for the durability of the picture.[13]

Doerner and Jacques Maroger offer many examples from previous eras. Both cite de Mayerne's observations that Rubens's rivals decried his technique. Despite the brilliant effects Rubens obtained, his work was denounced for being far removed from the technical traditions of his period; his critics predicted that his works would "perish with him."[14] How different are all of these predictions from a late-twentieth-century writer's remark that "if you want to have an Anselm Kiefer in twenty-five years, buy it and put it horizontally under glass. You'll have the only one left. Never before has the work of an artist of high value and high interest been so self-destructive."[15]

The parallels that unite these portentous predictions by writers of all periods are obvious. All of them are equally short-sighted, founded as they are on the limited perspective of seeing one's own time outside of historical context. It would be appropriate to speculate, for example, on the amount of technical experimentation carried out in France during the nineteenth century in an attempt to rediscover the lost techniques of the old masters. The irony, of course, is that the very effects these painters were trying to emulate may, to a large degree, have been unintended by the masters. Maroger claims that "the effect of this loss of the old technique was particularly disastrous to the otherwise brilliant 19th century French painting. Without such a catastrophe it would unquestionably have shown with an undiminished glory, and we should not be witnessing today the slow destruction of such admirable works as those of Delacroix, Manet, Renoir and many others which are seriously menaced."[16] Hiler supported this point of view indirectly when he confidently stated in the 1930s that "writers on the subject seem all agreed that the material side of painting reached its lowest ebb sometime between 1830 and 1900."[17] Even Delacroix, commenting on his own time, states, "With our moderns, profundity of intentions and sincerity shine forth, even in their faults. Unfortunately, our material processes are not on the high level of those used by our predecessors. All those pictures will perish before a very long time."[18]

Admittedly, there may be vast difference in the materials and techniques used by the artists mentioned in these examples. Their very differences may have given rise to the kinds of predictions about deterioration that were proportionately as disturbing to each writer. One might argue that the alterations perceived in pictures chronicled by Goethe, de Mayerne, and others of their time—and Doerner, Hiler, and Maroger in this century—were as disheartening and profound to them as the changes we perceive in artwork of our own time.

The question may be asked now as always: What relevance does the deterioration and perceived alterations have to the intent and impact of a particular work of art? Do we believe that work by Tintoretto, Rubens, Delacroix, and so on, does not retain to a large degree the original spirit and intent of the artist in spite of the dire predictions of their contemporaries? Many earlier artists of our own century were directly or indirectly aware of changes occurring in their work as a result of their painting methodology. To a large extent, many of these changes were tolerated. Picasso, speaking to Roland Penrose about traction cracking having occurred in *The Dancers,* said "The paint is solid enough and will not flake off. Some people might want to touch them out but I think they add to the painting. On the face you see how they reveal the eye that was painted underneath."[19]

The willingness to accept such changes, and even to anticipate them to some degree, became more commonplace among artists after World War II. An appreciation of the process of painting itself became a necessary component to the full comprehension of a work of art, as process became aesthetically inseparable from the object. This aspect of painting became such a popular fascination that from 1950 to the late 1960s *Art News* published a series of articles on the painting of a picture by a current artist. In December 1952, Robert Goodnough wrote of Franz Kline:

> He uses a black oil paint that can be purchased in cans (it is used commercially for tinting house paints) so that he will not have to be continually squeezing paint from tubes. Since he usually uses turpentine as a thinner, the black has a matte effect, though in areas that are worked over the paint may not soak in as much and within the blacks there may be spots that are slightly glossy. Such things happen as a result of Kline's way of working and he feels they should be left that way, for to change them merely out of technical consideration would be inconsistent—the emotional results count and not intellectual afterthoughts.[20]

Kline is not an exception. Many painters had begun to understand that there were consequences to their choice and use of materials and had come to accept or tolerate the resulting artifacts of their creative process as inevitable. The alternative was, and is, either to change one's technique, materials, or both. Any of these changes means risking the elimination of a particular result and, possibly, a divergence from the artist's aesthetic intent. Style and technique are to a large extent inseparable.

Artists have responded in a variety of ways to the attacks on their methods and choices of materials. Painter and printmaker Richard Bosman[21] told me, "I'm not going to read Ralph Mayer[22] and drive myself up a wall." Another contemporary artist, Gregory Amenoff,[23] who admits to seeking some balance between technique and aesthetic objectives, said, "I will adjust

materials and technique to the extent that the potency of the image is not compromised or loses dominance."[24] Robert Motherwell responded to a question on *Nightline* about this point in another way: "I certainly don't paint pictures that are going to disintegrate on purpose, but if I have the impulse to paint a picture, say on a piece of cardboard, that is a beautiful picture, or not paint that picture at all because I couldn't paint it on any other surface, then I'll paint it. So then it's a question, do you want a thing that is more beautiful or one that's going to last longer? And given the choice, most of the time I would choose more beautiful."[25] It certainly seems preferable to have a somewhat altered work of art that retains the essential spirit of the artist's intent than one that has been over-restored in an attempt to deny the inevitable and acceptable changes inherent in the materials and techniques chosen by the artist. The conservation profession accepts this interpretive role in the context of old master paintings yet blanches at the prospect of making essentially similar decisions about "acceptable" deterioration in contemporary and modern pictures.

How significant is the shedding of pieces of paint or straw from a painting by Anselm Kiefer, for example? Kiefer, who receives an inordinate amount of abuse concerning his technique, inherited from his mentor, Joseph Beuys, a profound sense of the inherent quality of materials and the possibilities they possess as raw, malleable substances for his use. This concept is one of the core elements of his work. Kiefer told me, "I choose materials which contain and will give off energy when they are used." He first began to use lead when he discovered that it could be turned from one physical state to another. He said that in the process of heating and melting the lead, many different colors emerged during its transformation. He could see the color gold during the process—not ordinary gold but the symbolic gold of the alchemists. He likes the white oxidation of lead and tries to induce it selectively with acid. He also likes straw, as it is golden in color and gives off energy and heat when it is transformed through burning. By using these materials, Kiefer hopes to reinvest them with a spiritual meaning that had been lost to them during the nineteenth and twentieth centuries. His feeling about shellac is similar; he has ten or more different tones of yellow and selects the one he intuitively feels is the most appropriate for the painting at hand. He admires its warmth and glow, its hard, brittle quality, and even the cracks that occur as the material transforms.

Kiefer thinks it is ridiculous for people to worry about his paintings changing. "If something lifted or fell off you could just stick it down," he said. In his view, change is all part of the process, and those who are concerned about his work deteriorating simply do not understand the meaning of his work. Beuys helped instill in Kiefer the perspective that the element of change was a natural and inevitable process and perfectly valid as an aspect

of a work of art. Beuys thought this was obvious, and it was amusing to him that some people did not understand it.[26]

Should our function as conservators, then, be to impose our own perspective concerning durability onto the creative process of the artist? The odd result would be the ideals of the conservator taking precedence over those of the artist, as an attempt is made to permanently lock a work of art into a single moment in time. It is somewhat alarming to realize that the quest for preservation has progressed to the point that we can convincingly justify to our colleagues the removal of an artist's own retouchings in an effort to return a picture to an earlier state. Would we as easily justify the removal of retouchings carried out by Rembrandt, Manet, or any great artist of an earlier period, because they were executed years after the artist had originally begun the picture? We, as conservation professionals, have in many ways begun to isolate the artist from our work. This trend is clearly ironic. It recalls previous periods when restorers were often artists and it was commonplace during restoration for them to impose their own aesthetic on another artist's works. In the same vein, we now seem to resent what is considered to be a lack of material and technical knowledge on the part of artists, and thus feel justified in imposing our own concepts of timelessness on them. This has even been carried to the extreme of the artist being prohibited from touching his or her work ever again, as such interventions are considered better left to the conservator.

Artists of the late twentieth century often consider change to be part of their work. Others have learned to accept—some reluctantly, some painfully—the effects of age and deterioration in their work. Many conservators and interested observers, however, have not demonstrated the same degree of tolerance. In effect, they have often failed to show an appropriate historical perspective in assessing the creative processes of their own century compared to those of earlier eras. As Doerner has said, "Every period requires its peculiar means of expression, and a one-sided admiration of the old masters is of no help to progress."[27] Conservators and critics alike, however, can begin to reassess their narrow position and establish a more broad-minded one. Given our collective training and knowledge of the history of art, materials, and techniques, we should come to know what Rauschenberg took for granted when he said, "The profession that is built on honesty and integrity can't afford to indulge themselves with a myth of eternity."[28]

Notes

1. ROBERT HUGHES, "On Art and Money," *New York Review of Books* 21, no. 19 (1984): 23.
2. GERRY HEDLEY, "On Humanism, Aesthetics, and the Cleaning of Paintings." Reprint of a two-lecture series presented 26 February and 5 March 1985 at the

Canadian Conservation Institute, during Hedley's year of research at the Institute.

3. SHELDON KECK, "Some Picture Cleaning Controversies Past and Present," *Journal of the American Institute for Conservation* 23, no. 2 (1984): 73–87.

4. TIM CARRINGTON, "Why Modern Art May Never Become Old Masterpieces," *Wall Street Journal,* 14 January 1985, 1.

5. Ibid., 9.

6. E. BINGO WYER, "Flaky Art," *New York Times Magazine* (25 January 1988): 44.

7. Ibid., 46.

8. GIOVANNI BATTISTA ARMENINI, *On the True Precepts of the Art of Painting.* Renaissance Sources in Translation series (New York: Burt Franklin and Inc., 1977).

9. HILAIRE HILER, *Notes on the Technique of Painting* (London: Faber and Faber Limited, 1934), 19.

10. SELDEN RODMAN, *Conversations with Artists* (New York: Capricorn Books, 1961), 91.

11. MAX DOERNER, *The Materials of the Artist and Their Use in Painting, with Notes on the Techniques of the Old Masters,* trans. Eugen Neuhaus (New York: Harcourt Brace and Company, 1934), 349–50.

12. Ibid., 350.

13. GIOVANNI BATTISTA VOLPATO, "Moda da tener nel depingere, ca. 1680–1710," in *Original Treatises on the Arts of Painting,* vol. 2, comp. Mary P. Merrifield (1849; reprint, New York: Dover, 1967), 721–55.

14. DOERNER, *The Materials of the Artist,* 355–56; and JACQUES MAROGER, *The Secret Formulas and Techniques of the Master,* trans. Eleanor Beckham (New York: The Studio Publications, Inc., 1948), 96.

15. WYER, *New York Times Magazine,* 48.

16. MAROGER, *The Secret Formulas,* 144.

17. HILER, *Notes on the Technique of Painting,* 12.

18. EUGÈNE DELACROIX, *The Journal of Eugène Delacroix,* trans. Walter Pach (New York: Covici-Friede Publishers, 1937), 600.

19. ROY PERRY, "Pablo Picasso, 'The Three Dancers,'" in *Completing the Picture* (London: The Tate Gallery, 1982), 86.

20. ROBERT GOODNOUGH, "Kline Paints a Picture," *Art News* 51, 8 (December 1952): 36–39, 63–64.

21. RICHARD BOSMAN (b. 1944), painter and printmaker.

22. RALPH MAYER, author of *The Artists' Handbook of Materials and Techniques* (London: Faber and Faber, 1951).

23. GREGORY AMENOFF (b. 1948), painter and printmaker.

24. AMENOFF, conversation with the author, New York, N.Y., February 1987.

25. ROBERT MOTHERWELL, "Disintegrating Works of Art," *Nightline Show* no. 1100 (New York: ABC News, 9 August 1985), 2.

26. ANSELM KIEFER, conversation with the author, Buchen, West Germany, 5 October 1985.

27. DOERNER, *The Materials of the Artist,* 373.

28. MOTHERWELL, "Disintegrating Works of Art."

Crimes against the Cubists

JOHN RICHARDSON

In an article on the great Picasso retrospective at the Museum of Modern Art (*The New York Review,* 17 July 1980),[1] I complained about the way restorers have unwittingly ruined the surfaces of Cubist paintings. Since these objections are apparently shared by others in the field, I would like to investigate the matter more fully in the hope that familiarity with the artists' expressed intentions will prevent restorers and their clients from committing further abuses, and not just of Cubist works.

When I complimented William Rubin of the Museum of Modern Art on the brilliant choice of Cubist works in the Picasso show and praised his museum for possessing the most comprehensive collection of Cubist art in the world, I felt obliged to hint that pride in these great holdings should be tinged with shame, for MOMA was killing its Cubist paintings with the wrong sort of kindness. The varnished surface of one masterpiece after another testified more to a desire to embellish than to any understanding of what Picasso intended. Not that MOMA was the only offender. Many other paintings belonging to American museums and private collectors had had their surfaces irreparably jazzed up by well-intentioned but historically ignorant restoration. True, a number of paintings from European sources showed similar signs of *maquillage* [make-up], but they were in a minority, for Europeans are apt to leave well alone, especially if this involves saving money. "To subject these delicate grounds to wax relining and, worse, a shine," I concluded, "is as much of a solecism as frying a peach."

From JOHN RICHARDSON, "Crimes against the Cubists," *New York Review of Books* 30, no. 10 (1983): 32–34. Used by permission of the author.

Much to my relief, William Rubin agreed with these strictures. Many of MOMA's paintings, he readily admitted, had suffered from overzealous restoration, but this had taken place before his time, and before his eyes had been opened to these abuses by no less an authority than Picasso. Interestingly enough, Rubin said that this revelation had come about apropos the varnish on a Cézanne—which MOMA contemplated exchanging with Picasso—and not on a Cubist work. After pointing out the error of varnishing a Cézanne, Picasso took the opportunity of insisting that Cubist paintings were even more vulnerable in this respect. Indeed the artist maintained—not altogether truthfully—that he refused to sign any canvas that had been polished up with varnish. Rubin, who has always shown the greatest concern for this problem, says that he is doing everything in his power to redress the—irreversible?—damage that has been done in the past, and that nothing of the kind can ever recur under his auspices.

The other institution that I cited in my article was the National Gallery in Washington, which had just purchased Picasso's historic *Nude Woman,* painted in Cadaques in 1910. I singled out this painting for special comment on the grounds that it had acquired a meretricious sheen. The gallery's twentieth-century curator, E. A. Carmean, disclaimed all responsibility for this. The varnish, he said, had been applied before the painting arrived in Washington. Since the work in question came from a dealer, Ernst Beyeler of Basel, whose solicitude for the surface of paintings distinguishes him from many of his competitors (indeed the rumor that Beyeler pays a premium for unvarnished works is thought to have saved many a painting's face), one can only conclude that the refurbishing occurred at some previous stop-off in the market place. Reassuring as it is that the National Gallery is blameless in this case, is it not sad that a great institution in search of twentieth-century landmarks is obliged to purchase a painting whose surface is the reverse of what the artist intended?

For it cannot be too strongly and too often emphasized that both Picasso and Braque were adamant that the surface of Cubist paintings be left matte and *never* in any circumstances varnished. In the case of Braque this interdiction applied not merely to his Cubist paintings but also to all his subsequent work. If a shiny passage was required—and it often was—the artist could always use a lacquer or a glossy house paint like Ripolin, or add varnish to his pigment to point up that specific passage. In this way the artist could differentiate, through texture as well as through the use of color, between surfaces that were intended to be shiny—for instance, a china jug—and surfaces intended to be matte—for instance, a newspaper.

Later in his career, when Braque became more "metaphysical" (his word) in his attitude toward reality, he carried this process a stage further and played arbitrary games with the identities of objects by deliberately send-

ing out confusing signals: making something shiny that should be matte, something opaque that should be transparent, and vice versa. All this he did with a view to invoking mystery and establishing those equivocal pictorial rapports that he identified with "poésie." It goes without saying that these subtle but crucial contrasts count for nothing if an ignorant collector or a dealer out to dress up his wares has a painting defiled with varnish.

Given the extent to which these contrasts are being obliterated in the name of bogus science, the artists in question would have more reason than most to be appalled, since for them the two-dimensional surface of a painting and its finish were sacrosanct. The illusory depths which varnish enabled traditionally trained artists to amplify were anathema to the Cubists, indeed to most other progressive artists from the 1880s onward. For instead of using eye-fooling devices to make things recede as far as possible from the onlooker, the Cubists were out to bring things as far as possible back within reach: they wanted to make the picture surface the equivalent of reality, not a representation of it. Thus the surface of a Cubist painting *is* the subject—all the more reason to respect every detail of that surface. In the circumstances it helps to think of Cubist paintings as objects rather than illusionistic images; only then will people realize that slapping varnish on a Cubist still life is as crass as French-polishing not just the veneer but the leather top and ormolu mounts of a *bureau plat* [flat desk].

However, varnish is not the only danger to Cubist paintings. Wax relining—a process that most restorers have at one time or another used and far too many still consider mandatory—has done even greater harm. By impregnating the canvas from the back with what amounts to an embalming agent, the restorer effects a complete transformation not only of the paint surface but of the entire painting structure. The intention is to preserve the painting from present or future disintegration, but the result is a waxwork, a dead thing. The tragedy is that wax relining, like varnishing, is a virtually irreversible process. Complete removal of wax from infused material is technically impossible, and catastrophic changes often result from heating, infusing, and pressing the paint, ground, and canvas. (Paintings with a lot of impasto are especially vulnerable. More than one rugose van Gogh has ended up as sleek as a Formica tabletop.)

What then should be done to protect Cubist paintings (and for that matter any other paintings) from deterioration, or to minimize damage that has already taken place? My own somewhat extremist view—one, incidentally, that was shared by Picasso and Braque, who would rather have had a painting disintegrate than see it undergo plastic surgery—is the absolute minimum. In view of the pollution problem, paintings of this delicacy should ideally be exhibited in a controlled environment, or, if that is impossible,

under glass. (I know this makes for a shine but at least it is easily removable and, unlike varnish, protective.) Relining should be limited to cases of dire necessity, and then only if one of the new alternatives to wax relining is used.[2]

Here I should perhaps emphasize that my strictures had the blessing of the artists in question with whom I occasionally discussed these matters. Braque was especially forthcoming: all his life he remained passionately interested in problems of paint, and he continued to stretch and prime most of his own canvases and grind some of his own pigment. Picasso, on the other hand, took less and less interest in paint per se. He had little patience with the artisanal chores in which Braque took such pride, and would simply have his Parisian color merchant make regular deliveries of already primed, standard-sized canvases by the hundred as well as tubes of standard-colored paints in industrial quantities.

However, for all their divergences in later years, the two artists continued to share a healthy horror of varnish and virtually all forms of restoration. If an early painting developed a *craquelure,* Braque would be resigned and philosophical, as was his nature, whereas Picasso would relish it: wasn't this proof that he had endowed his work with a volition of its own? If more serious damage developed: "Tant pis." Likewise if he discovered an ink or paint that was liable to deteriorate, Picasso would appreciate the defect for the malicious fun it afforded. He could then present tiresome admirers with graphic *dédicaces* [dedications], secure in the knowledge that they would ultimately fade and with luck—what a tease on future restorers—even vanish.

Braque's obsession with pigment partly derived from his being the son of a house painter. Apprenticed at the age of seventeen to a confrère of his father's, he was subsequently packed off to Paris to study for a craftsman's diploma under a master decorator. Hence his skill at wood graining and marbling, lettering and stenciling—vital factors in the development of Cubism. Hence, too, Braque's ability to do highly unconventional things to the hitherto sacrosanct medium of oil paint. By adding sand, tobacco, sawdust, coffee grounds, metal filings, and plaster, he came up with a new range of textural effects. In this respect Braque probably had a greater understanding of his materials than any other major artist of this century. I will always remember the pride he took in solving a problem that had baffled restorers: one of his paintings had turned black from being walled up during the war. "Don't let anyone touch it," Braque told the owner. "Just leave it out in the sun." And sure enough the painting regained its original color. Nor will I forget how he inveighed against the institution of the *vernissage* [varnishing]: "a redundant process, a redundant rite," he called it. Odd that almost no attention has been paid to the reaction against varnish and the significance of the matte surface in the history of modern painting.

Without a working knowledge of the history of the movement, a restorer would be unwise to tackle a Cubist painting. For instance, it is crucial to understand the Cubists' idiosyncratic approach to color: why they fought shy of it during the early years of "Analytical Cubism," in the belief (to quote Braque) "it could give rise to sensations that would interfere with their new conception of space"; and how they subsequently managed to reconcile it with their work when Braque saw how to use texture to represent local color by varying his paint surfaces with foreign substances and exploiting his repertory of decorators' effects (wood graining, etc.). Lastly the restorer should understand how the invention of *papier collé* [pasted paper] resolved the Cubists' coloristic problems once and for all by making it possible to depict the form of an object and its local color "simultaneously and independently of one another" without offending against the two-dimensionality of the picture surface.

Picasso's genius subsequently led him in many different directions, but for Braque the equation of color with texture remained a lifelong obsession. And he would illustrate his theories by dropping a piece of velvet and a piece of calico into the same pot of color in order to show how different the results could be. He would also demonstrate how the same color could vary in value according to whether it was opaque or translucent, a lacquer or an earth color. "These are differences that every painter should learn to respect," he would say. And every restorer, one might add. It follows that anything a restorer does to blur his or any other artist's carefully contrived distinctions—Cubist or post-Cubist—is tantamount to altering the color and tonality of a painting; as much of a betrayal of an artist's work as the substitution by a conductor of a fortissimo for a pianissimo.[3]

The danger of all this was brought home to me on a visit to Braque's studio, when a painting of a guitar that had formerly been signed on the back—as was the Cubists' habit—arrived from America to be signed all over again on the front, now that wax relining had obliterated the original signature. The artist's horror at the condition of his recently restored painting was painful to observe. "Look how the blacks jump out at you," he gasped. And indeed the black lines that had formerly served as a discreet scaffolding stood out—thanks to glossy varnish—like newly painted iron railings. Jarringly out of tone! No less upsetting to the artist was the awful tautness caused by an aluminum support that stretched the canvas tight as a drum. "Why subject it to this racklike torture?" he asked. Why indeed, since it was quite redundant, and the canvas—of almost linenlike fineness, as is usual with Cubist works—looked as if it were about to pop.

"Restorers are amazing," said Braque. "They have transformed my guitar into a tambourine," and he gave the taut oval a disconsolate tap with his paintbrush as he re-signed it.

This incident took place some thirty years ago, but disfiguration of Braque's Cubist work has not abated. In recent months one of the finest untouched Braques—the property of an illustrious institution—has fallen victim to a restorer's irrepressible urge to varnish, despite a specific request from a leading expert in the field to do no such thing. "The varnish is invisible," the restorer said by way of justification. But these new so-called invisible varnishes, made from synthetic resins, inevitably form a membrane between one's eye and the picture, and their application seals the fate of a painting by establishing the eventual need for their removal and replacement. Furthermore, their long-term effect is totally unpredictable.

To return to the Picasso retrospective that was my starting point: by confronting so many overpolished works with what I can only describe as virgin paintings—paintings whose surfaces had never been subjected to the restorer's improving hand—the exhibition unwittingly drew attention to the evils of ignorant and insensitive restoration. For instance, how tawdry the victims of American beauty parlors looked compared to the paintings from the Kramar bequest in Prague's National Gallery, or the two great compositions with fresh, frescolike surfaces that recently came to light in Picasso's private collection. What testimony to the value of benign—or malign?—neglect! Seventy years after they were painted, these works still looked as pristine as they must have done on the artist's easel; and just as Picasso intended, they made one long to reach out in imagination and caress their peachlike bloom.

Benign neglect also explained why paintings in that other great repository of Cubist art—the Russian state collections—shared in the pristine freshness of the Prague pictures. Alas, no longer. Russian restorers seem to be aping some of their Western counterparts in that they have recently subjected a few of their Picassos to drastic varnishing. Unfortunately Russian loans to the MOMA show were canceled at the last moment—thanks to international *froideur* [coldness]—so it was impossible to judge how bad Russian methods differed from bad Western ones.

The MOMA show did, however, include a group of paintings that exemplified in a highly ironical way the points I have been making. I mean the group of paintings that had been acquired en bloc from the heirs of Gertrude Stein by MOMA, acting on behalf of a group of private collectors who were either trustees or benefactors of the museum. The writer's relatives, it will be remembered, had removed the collection from the custody of Alice B. Toklas (who had inherited a life interest in them) on the grounds that the old lady was not sufficiently solicitous of the Stein family treasures. True, the Stein dogs had never been great respecters of Picasso's work, some of which hung much nearer the floor than the ceiling; true again, Miss Toklas's health and sight were failing. Still I can testify that, with the exception of a dilapidated

Juan Gris collage, the Stein pictures looked in far better shape—a bit dusty perhaps, but otherwise wonderfully fresh—when they hung in Miss Toklas's apartment than when they reappeared on the walls of some of New York's more prestigious collectors, enhanced in some cases with the specious glow of a transparency held up to the light.

Yet, when all is said and done, what can one expect when publishers of art books have corrupted the public's eye by accustoming it to ultra-glossy reproductions—reproductions that bear the same relationship to the originals that magazine advertisements of Technicolor desserts do to the real thing? The fault is to some extent Albert Skira's. In 1948 this enterprising Swiss publisher brought out an album devoted to Picasso's pottery, and in order to simulate the sheen of ceramics he had the bright idea of giving the plates a high glossy finish. Such was the success of this album that Skira used a similar look—now more or less standard, I fear—for the plates of his three-volume *History of Modern Painting*, a history that helped to form the taste of a generation of students. Since many of the plates in Skira's *History* reproduced paintings that hung in a house where I once lived, I was in a position to register the effect that the originals had on eyes queered by reproductions. Face after face would cloud over with disappointment. Where were those gorgeous coach work colors, those plastic blacks in which you could not quite see your face? A silly student even asked whether these really *were* the originals.

Eyes jaded by shiny reproductions have a parallel in ears jaded by souped-up recordings. At a concert a few weeks ago, I overheard two people complaining about the performance. The sound, they agreed, had been a bit thin: it lacked the resonance of a recent record—a record that I had found resonant to the point of schmaltziness. The excesses committed in the mendacious name of hi-fi, I concluded, were not limited to music. Like record companies and art-book publishers, restorers should stop tampering with our perceptions and betraying the works entrusted to their care.

Notes

1. JOHN RICHARDSON, "Pablo Picasso: A Retrospective," *New York Review of Books* 27, no. 12 (1980): 16–24.
2. [1] Some of the alternatives to wax relining are still in the experimental stage. As of now cold lining with adhesives that are sensitive to pressure and do not penetrate is the only gentle and reversible method of relining a canvas in order to hold the paint more firmly in place. Fabri-Sil, a Teflon-coated fiberglass prepared with a silicone adhesive, has been employed with considerable success, because it does not alter the appearance of a painting and can be removed from the back without leaving telltale traces. Poly (vinyl acetate) heat-seal mixtures and BEVA have likewise been used as nap-bond lining

adhesives, but although no impregnation is involved, they require excessive heat and pressure. A number of products (such as Plextol) are also being investigated with a view to achieving a nap-bond lining with the use of minimal heat. These resins can be used with a suction table, which creates contact through a gentle air flow and eliminates the distorting effects of vacuum pressure. Meanwhile new synthetic fabrics are being developed— ones that make minimal demands on the structure of a painting.

3. [2] For the purposes of this article I have restricted myself to the Cubist paintings of Braque and Picasso. However, my strictures equally apply to the insensitive way many other twentieth-century artists' work has been treated. Among contemporary painters one of the most avowed enemies of varnish is Francis Bacon, who has publicly denounced restorers for giving a ghastly sheen to the matte surfaces of his unprimed canvases.

The Autonomy of Restoration: Ethical Considerations in Relation to Artistic Concepts

ERNST VAN DE WETERING

In restoration studios and museum laboratories, a new sensitivity is grow-
ing as to the care of works of art. The consciousness of the authenticity
of objects as material sources is constantly growing; conservation is the
key word.

Such a new attitude is a relief after the rather ruthless glamorizing of
museum objects, often with harmful, irreversible methods which prevailed in
the past but which are to some extent still practiced, in particular when the
object is prepared for the art market. Ethics in restoration is more frequently
discussed.[1] In the wake of this tendency, traditional restoration methods are
being questioned and less drastic, often very sophisticated techniques are
being developed.[2]

With such a laudable reserve and so much technological progress, one
tends to forget that each treatment, or even nontreatment, nevertheless
involves an interpretation of the object. It is not hard to be aware of the inter-
pretative nature of restoration in times when, enthusiastically or naively,
artworks were molded to the taste of the moment. Benvenuto Cellini, for
example, when he was confronted with an antique torso, exclaimed: "The
excellence of this great artist calls me to serve him!" and subsequently he
created a new Cellini, a Ganymede, out of the poor (or lucky) old torso.[3]
But even in the most reserved approach, preconceptions of aesthetic or art-
theoretical nature might unconsciously sneak into the considerations. It is at

From ERNST VAN DE WETERING, "The Autonomy of Restoration: Ethical Considerations in
Relation to Artistic Concepts," in World Art: Themes of Unity in Diversity, ed. Irving
Lavin, vol. 3 (University Park: The Pennsylvania State University Press, 1989), 849–53.
Copyright 1989 by The Pennsylvania State University. Reproduced by permission of the
publisher.

this point that a task for the art historian seems to emerge. Although he is himself subject to hidden preconceptions and anachronisms, his profession provides him with the equipment to uncover these to some extent.

To give an example: At the ICOM Conservation Committee Conference in Copenhagen in 1984, a distinguished restorer stated that nearly all van Goghs have been ruined, as the impasto of most of these paintings has suffered from relining sessions. No one in the audience was inclined to contradict him and some may have, in fact, left the meeting with the conviction that no van Gogh is worth looking at anymore.

It is common knowledge that Vincent van Gogh used to send paintings to his brother Theo. Close inspection of a great number of his paintings proves that he apparently parceled them while the paintings still were more or less wet. On the back of unrelined paintings, one can find the remnants of wet paint, while on the paint surface the imprint of a canvas structure in the impasto can frequently be seen as well as the consequent flattening of the impasto. This observation illustrates that van Gogh himself was the first to impair the impasto of his paintings. One can of course attribute this kind of maltreatment to van Gogh's poverty; unlike Monet, for instance, he could not afford to have his canvases, each on a stretcher, transported in safe boxes. This in itself, however, may give an indication that van Gogh was less sensitive about the surface of his paintings than we tend to be. There is a confirmation for this assumption. The art historian may recall passages from letters by van Gogh and Gauguin which throw quite a different light on the matter. In one of his letters to Theo, Vincent wrote from Arles:

> Do not be troubled if, in my studies, I just leave minor or major protrusions of paint in the brushwork. It is of no significance. If one waits for a year (half a year would suffice) and swiftly passes a razor blade over the surface, a lot more solidity of color is obtained than would be the case if the work has been painted thinly. For the sake of the painting staying well and keeping its colors, it is a good thing that the light passages in particular are thickly applied. And this scraping off the surface has been done by painters from the past as well as by present-day French painters.[4]

It may come as a surprise that, in the first place, van Gogh's ideas about his impasto apparently have to do with his need to create a paint film in which the lasting strength of the color is guaranteed. We, in our time, can hardly help looking through the distorting filter of Expressionism when appreciating van Gogh's impasto as the seismographic registration of his artistic temperament. Seen from that angle, the restorer's remark just mentioned is perfectly understandable, but it seems to be dictated by an anachronistic view of van Gogh's intention. No doubt one has the right to live with

one's personal interpretations, which do not necessarily have to be in line
with the artist's intention. But in this case it goes a bit far to impose one's
personal sensitivity on others, suggesting that a somewhat pressed van Gogh
is not worth looking at anymore. If one reads a letter on this subject by Gau-
guin to van Gogh, one would almost be inclined to think that the contrary is
true: Not only a shaven but even a pressed van Gogh is actually more beauti-
ful. Those fearing the slightest pressure during lining will shudder from Gau-
guin's advice in the following quotation of a letter to van Gogh:

> The *Vendanges* has flaked all over because of the white coming off. I have
> completely glued back the flakes by applying a procedure indicated by
> the reliner (*reentoileur*). I mention this because it can easily be done and
> may be a good thing for your canvases which need retouching. You just
> glue newspapers onto your canvas with a pasty glue (*colle de pâte*). Once
> dry, you put your canvas on a smooth board and forcefully pass very hot
> irons over it. All your paint flakes will remain but they will be flattened,
> and you will obtain a very beautiful surface (*une surface très belle*). After
> that, you thoroughly soak the paper covering and remove it. This is,
> largely, the whole secret of relining.[5]

Remnants of newspapers have been found incrustated in the paint sur-
face of some van Goghs, which may indicate that he followed the recipe of
Gauguin's "reentoileur" faithfully.[6] In the case of his famous Arles *Bedroom*
(the Amsterdam version), we know that Vincent asked Theo to have it lined
since the paint was flaking.[7] X-radiographs of the painting show the serious
degree of *craquelure* and loss of paint which must have occurred soon after
the painting had been finished. If one compares the impasto of this painting
with that of the few van Goghs that were never relined, the difference is dra-
matic. In the *Bedroom* the impasto consists of rounded bulges in the paint
surface. In the unrelined paintings the paint surface is crisp, the impasto has
sharp edges, and in some of the paintings the protruding pinnacles of paint
van Gogh wanted his brother to "shave" off are well preserved.[8] It may well be
that van Gogh, just as Gauguin, would have preferred the flattened "très
belle surface" of the relined *Bedroom*.

Introducing this information into the restoration world is equal to the
sinful breaking of a taboo. And rightly so, as nobody in his right mind would
draw the conclusion from these sources that the preservation of van Gogh's
impasto deserves less care than before—or, absurdly, that paintings by van
Gogh or Gauguin should undergo a relining procedure involving great heat
and heavy pressure.

The lesson we learn from this case is a dual one: The concepts on
which our sensitivity is based may be mistaken and anachronistic. Knowing
the artist's wishes and intention, however, does not automatically mean that

the restorer's interventions should be in line with them. Consequently, one is inclined to conclude that restoration has a certain autonomy independent, to some extent, from the artist's intentions.

Ethics in restoration have found their origin in the growing awareness that we will never understand the artist's intentions to their full extent and that consequently our interpretations, which in restoration are expressed on the very object, never entirely cover the truth. A short look at the history of restoration may confirm this. No wonder that the trend of minimalism and the demand for complete reversibility with each treatment is growing in the restoration world. The van Gogh example shows that even when we seem to be well informed about the artist's preferences, there is an understandable reluctance to follow his wishes. Usually too little information is available to get a grip on this problem. In the case of the restoration of works of recent origin, the nature of this dilemma may reveal itself more acutely.

In the institute where I work[9] there was such a case: the restoration of an *Achrome* by the Group Zero artist Piero Manzoni (1933–63).[10] This *Achrome* was a rectangular piece of white cotton fabric, stitched into squares. There were stains on it and it was somewhat grubby. The museum collection from which it came wanted the stains to be removed selectively but preferred to leave the dirt, which was seen as a patina. As it was technically difficult to remove the stains without affecting the patina, it was considered necessary to gain an understanding of Manzoni's intention with his object and, if possible, to find statements as to the aging of his work. Manzoni considered the *Achrome*s to be manifests proclaiming the end of art and documents of his ideas about the fusion of art and reality. Whether time and the traces of time were part of this reality could not be found in the written sources. Where time was considered in his art theory, it was a cosmic time rather than the trivial daily flow of time which leaves its traces the way it had done on this *Achrome*. As a manifest, or even as a neo-Dadaistic provocation, an empty canvas, the *Achrome* is a disposable message rather than a freshly made classic at the beginning of its way through an eternal museum life. Nonetheless Manzoni's *Achrome*s now perform this rather tragic function.

To find a solution for our cleaning dilemma, we interviewed people who had known Manzoni and had dealt with this work in one way or another when he was still alive. It turned out that there was a sharp division in the opinions of his artist friends and those who, from early on, had collected his works. The artist friends, who had in fact more than once prepared Manzoni's works for exhibitions, recalled how they, on request of Manzoni, had thoroughly washed or completely overpainted the *Achrome*s in order to restore their whiteness. In this case, too, they were in favor of such treatment. The collectors deplored that the works they owned had gone through

such a treatment and rather preferred the appearance of their unrestored *Achromes*, quite remote from Manzoni's original intention.[11]

This example illustrates how the concept of historicity—keyed in connection with the theory of restoration by Cesare Brandi[12]—apparently blends with the concept of authenticity in such a way that the collector prefers no restoration over authentic appearance. The myth of the artist, in which his works partly play the role of relics, gains supremacy over the vitality of the artist's message. The irreversibility of time is accepted. The appreciation of the "aura" of authenticity, which in our culture seems so much stronger than in other cultures, has gained priority. This may partly explain the autonomy of restoration ethics in relation to artistic intention.

The first part of this argument may have suggested that the art historian's engagement in restoration is redundant, due to the seemingly inevitable autonomy in restoration. On the other hand, the growing awareness of the significance of the object as a source of information, which may produce a range of unexploited data for art-historical research, intimately links the fields of art history and restoration. If only for that reason, art historians should keep the restoration world informed about the questions that live with them, while restorers—from their intimate knowledge of the material aspects of the objects—should not hesitate to point out possibilities for research.

But there is more that links the disciplines: Despite the trend of minimalism, interventions of some sort are often inevitable and usually, by implication, involve a statement, realized on the object through the actual treatment. Such concrete manifestation of an interpretation, often made unconsciously, should be keenly evaluated by art historians, whatever the factual consequences of such evaluations may be. Our knowledge of Vincent's ideas of his impasto will have no consequences. Knowledge about the ideas of the Cubists on varnishing, or rather not varnishing, their objects, on the other hand, could have far-reaching consequences for the care and presentation of their works. Recently, the varnishing of some Picassos and Braques in American collections was, on the basis of sound art-historical arguments, heavily attacked.[13] On the other hand, the tendency to apply matte varnishes on old paintings could be argued against on the basis of historical sources testifying that Dutch and Flemish seventeenth-century painters preferred an extremely glossy varnish, as Rob Ruurs recently demonstrated.[14] Günter Bandmann has shown that our nineteenth- and twentieth-century appreciation of materials is quite different from that in earlier times and has demonstrated how, in the history of restoration, this modern appreciation left its traces in the treatment of objects.[15] Peeters showed how the concepts that lie at the basis of the approach to restoration of monuments of some restoration architects are heavily impregnated by Bauhaus ideas on space and light in architecture.[16] As to the frequent "de-restoration" of

antique sculpture, apparently under the influence of archaeological purism, it has been pointed out that this trend is also determined by aesthetic ideas influenced by a torso aestheticism in twentieth-century sculpture since Rodin.[17] These are some examples which may demonstrate how important the contribution of art-historical research can be when it comes to preventing the intrusion of anachronisms in the restoration world. These remarks should therefore be taken as an encouragement for art historians to do research in the no-man's-land that may grow around the restoration world if one takes its autonomy for granted.

Notes

1. See the American Institute for Conservation of Historic and Artistic Works (AIC) *Code of Ethics and Standards of Practice* [now the AIC *Code of Ethics and Guidelines for Practice*, revised 1994; published annually in *Directory, The American Institute for Conservation of Historic and Artistic Works*, Washington, D.C.] and the *Guidance for Conservation Practice* issued by the United Kingdom Institute for Conservation of Historic and Artistic Works, London, 1983.

2. See periodicals such as *Studies in Conservation*, the journal of the International Institute for Conservation of Historic and Artistic Works (IIC); *Maltechnik/Restauro*, International Zeitschrift für Farb- und Maltechniken, Restaurierung and Museumfragen, including *Mitteilungen der* IADA (Internationale Arbeitsgemeinschaft der Archiv-, Bibliotheks-, und Graphikrestauratoren); the *Journal of the American Institute for Conservation*; and conference papers of IIC meetings and of the triennial meetings of the ICOM Committee for Conservation.

3. BENVENUTO CELLINI, *Opere: Vita, trattati, rime, lettere*, I Classici Rizzoli, ed. Bruno Maier (Milan: Rizzoli, 1968), 527: "L'eccellenza di questo gran maestro mi chiama a servirlo."

4. *Verzamelde Brieven van Vincent van Gogh*, uitgegeven en toegelicht door Jo van Gogh-Bonger, verzorgd door Ir. V. W. van Gogh (Amsterdam/Antwerp: Wereld Bibliotheek, 1953), letter 430. I thank Mrs. Brigitte Blauwhoff for drawing my attention to this text and to the ones mentioned in notes 5 and 8.

5. DOUGLAS COOPER, *Paul Gauguin: 45 lettres à Vincent, Théo et Jo van Gogh*, Collection Rijksmuseum Vincent van Gogh, Amsterdam (The Hague: Staatsuitverij, 1983), 251.

6. H. SUZIJN, chief conservator of the Mauritshuis, the Museum Kröller-Müller, conversation with the author. The version of the Arles *Bedroom* in the Louvre, where the flattened tops of the impasto show black characters in reverse, serves as an example.

7. VAN GOGH 1953, *Verzamelde Brieven*, letters 592, 595, and 604.

8. This is, for instance, the case with F. 511 and F. 555.

9. The Central Research Laboratory of Art and Science, Amsterdam.

10. STEDELIJK MUSEUM, Amsterdam, Inv. A−286585.

11. E. VAN DE WETERING, "Het wit bij Piero Manzoni: een conserveringsvraagstuk," *Museumjournaal* 18 (1973): 56−63; reprinted in *Kunstschrift* (Openbaar Kunstbezit) (1986): 14−19.

12. CESARE BRANDI, *Teoria del restauro* (Rome: Edizioni di Storia e Letteratura, 1963), 31–36.

13. JOHN RICHARDSON, "Crimes against the Cubists," *New York Review of Books* 30, no. 10 (1983): 32–34 [see Reading 18, pages 185–92]; reprinted in *Maltechnik/Restauro* 90, 1 (1984): 9–13, under the title "Verbechen an den Kubisten."

14. ROB RUURS, "Matt oder glänzend?" *Maltechnik/Restauro* 89, no. 3 (1983): 169–74; reprinted in ICA *Newsletter* (Oberlin, Ohio: Intermuseum Conservation Association) 16, no. 1 (November 1985): 1–6.

15. GÜNTER BANDMANN, "Der Wandel der Materialbewertung in der Kunst-theorie des 19. Jahrhunderts," *Beiträge zur Theorie der Künste im 19. Jahrhundert* 1 (1971): 129–57.

16. CEES PEETERS, lecture, History of Architecture Dept., Katholieke Universiteit Nijmegen, Art Historical Institute of the University of Amsterdam, 1983.

17. JÜRGEN PAUL, ed., "Antikenergänzung und Ent-restaurrierung, Bericht über die am 13 and 14 Oktober 1971 im Zentralinstitut für Kunstgeschichte abgehaltene Arbeitstagung," *Kunstchronik* 24 (April 1972): 85–112, especially 102.

PART III

The Emergence of Modern Conservation Theory

. Archer, *The Elgin Room,* 1819.
 Oil on canvas.

The Emergence of
Modern Conservation Theory

Conservation is another way of looking at art and cultural heritage. The difficulties encountered in establishing a method of treatment for the works of modern painters are great, as John Richardson points out (Reading 18, pages 185–92), though their intentions may still be intelligible to some extent through their writings and known views. The difficulties, and thus the necessary precautions, are even greater when considering works of art or finds from a context and time far removed from the violent and technologically sophisticated period in which we live, on the threshold of the third millennium.

A knowledge of the humanities, which has been invoked several times in the preceding pages, is indispensable for an understanding of the old masters of painting. Now that the cultural heritage considered worthy of conservation includes a variety of objects besides paintings—from archaeological ruins to underwater finds to Native American canoes—the role of the connoisseur (see Kirby Talley's introduction to Part I, pages 2–41) has been taken over by the historian who, ideally, is able to situate the work of art, the monument, and the archaeological find, in their original contexts.

It is perhaps for this reason that in several European countries, responsibility for the care and restoration of artistic and historical objects to be handed down to future generations is entrusted to the historian (including the archaeologist, the historian of art or architecture, the anthropologist) and not to the conservator. However, such objects rarely come to light in the state in which they left the hands of their creators; they have usually been tampered with, altered, restored, reused, and adapted (see Fig. 1).

Translated by Alexandra Trone.

Change and reuse are processes associated with time and with the concept of value; thus an object that survives from the past and comes down to the present, and that escapes the laws of destruction and annihilation, must always have had a demonstrable value. Various times, fashions, and cultural climates are reflected in it, have taken possession of it to reexperience and reexamine it, have transformed either its appearance or its significance, and have changed it. But in so doing, they have also ensured the object's survival for future generations.

Whatever loses its meaning with social and cultural change, and whatever is forgotten with the passage of time and the changing of context, disappears from general or daily use; a building, an object, even an entire city is finally lost and ends up in the earth. The archaeologists who rediscover it give it a new purpose and a new context, and they also cause the interrupted cycle of transformation and change to resume.

In Western European culture, Classical antiquity is in the unique position of being the touchstone for the very concepts of civilization and art, the constantly revisited source. It has, therefore, undergone continual interference and alteration through periodic renascences.[1]

Between the end of the nineteenth and the beginning of the twentieth centuries, a theoretical base was established that gave rise, especially through the efforts of Cesare Brandi, to the modern concept of restoration. Before that time, however, reuse, alterations, completions "in style," and conservation were not clearly distinguished from one another.

The conservator who needs to handle an object—to repair damage caused by human beings or by time—should be able to review the entire history of the object and distinguish its original function and appearance (insofar as these can still be surmised) from later modifications; the conservator should not only study the relevant texts but also read the object itself to recognize the traces of its history.

The more famous a work of art, the more tortuous its history. The continual attention to which it has been subjected is never a passive process, and it frequently leads to changes in function and symbolic value. These changes, in turn, cause changes in the material condition of the work of art, with portions of it being lost or violently removed and new, extraneous material being superimposed on it.

The distinguished, contemporary French writer Marguerite Yourcenar describes the fascination and the torment of time and history (see Reading 20, pages 212–15). She expresses with great lyricism the indelible mark of history left on a work of art: the various ways in which it was regarded at different times and the varying intentions of its users, owners, and even past restorers.

In the past the aim was, above all, to destroy the traces of time, to make good the signs of damage, to reconstruct or recreate, to pursue in vain an

Figure 1
Giuditta in the Piazza della Signoria, Florence. Copy (1988) of the bronze original by Donatello.

unattainable "original condition." This aspect of the problem is considered at length in Rossi Pinelli's text, with examples taken from the history of restoration (see Reading 29, Rossi Pinelli, pages 288–305).

Today, new concerns have arisen for which there appear to be no remedies: concern for *anastylosis* (the excessive reconstruction of old buildings) carried out to satisfy the demands of mass tourism; concern for the effects of technological advances; concern for the vandalism and urban decay that attack even the best known and most beautiful historic cities; concern for bombs and terrorism; and concern for the pollution that has reached worrisome levels in recent decades.

No theory of conservation or attempt at conservation can be effective unless it takes into consideration the sustainable uses to which an object is put and the quality of its environment. As Brandi writes, an intervention that does not remove the cause of the deterioration is useless and ineffective. Nevertheless, these contemporary difficulties pose a warning that many causes of damage are not easily eliminated and that their elimination may not be within the province of conservation authorities.

There are also priorities to consider: before asking *how* to conserve, one must ask *what* to conserve and *for whom*. Current theories must face the problems of the new context in which the cultural heritage exists today.

The texts in this section were written more recently than those in Parts I and II. Nonetheless, they have already acquired the status of classics. They lead one to observe how quick and dangerous the processes used in the last fifty years are, and to reflect on what it is that separates us from the last of the connoisseurs. The roots of today's most compelling problems, doubts, and debates may often be found on these pages. This may help us regain the perspective that the urgency of immediate events threatens to obscure.

One of the authors here, Paul Philippot, is a distinguished member of the international conservation community. The former director of the International Centre for the Study of the Preservation and the Restoration of Cultural Property (ICCROM) in Rome, he provides an important introduction to the problems faced by conservators. His broad vision is not confined by technical considerations such as individual recipes or methods of treatment; he regards the essence of the problems and emphasizes those topics of general significance on which particular choices depend. A scholar in close touch with the leading conservators, restorers, and theorists of this century, he has disseminated their precepts throughout Europe and the world.

Glancing through Philippot's articles, one becomes aware of how significant the 1950s were for conservation. The idea of conservation as a specialization and an independent field of study had already been formed by this time, and it was no longer regarded as a mere appendix to art criticism or

as the artist's awareness of age value. It was during the 1950s that the components of the contemporary concept of conservation were first discussed and examined.

Philippot considers one of the main innovations to be the weight given to science and laboratory work, making them no longer ancillary aids but the main reference points for conservation. He saw a clear example of this change in the notorious controversy over the cleaning of several paintings in the National Gallery in London (see Reading 21, pages 217–18). The conflict, which took place around 1950, represented a clash between different trends in conservation practice. Moreover, it was waged between professionals of different backgrounds, pitting the point of view of the greatest theoretician of restoration against that of a generation of conservators for whom the humanistic tradition (exemplified by Berenson, Friedländer, and Bell) was no longer held to be the essential core of a useful body of knowledge.

A no less important change was the extension of the field to countries other than those in Europe and North America; awareness of the problem of conservation was now growing in various countries and cultures in the developing world. They approached the debate with their own sensibilities, starting from traditions completely unlike those of the West and with an altogether different conservation history.

As if that were not enough, problems equally difficult arise when whole groups of objects or entire historic city centers fall into disuse. One no longer wonders only how to conserve paintings, art, and archaeological objects in the great traditional museums, but also how to prevent the destruction of those monuments, urban contexts, craft items, and ethnographic objects in danger of being either destroyed or dispersed by the tide of modernization that is engulfing the planet at the end of the twentieth century. The fear is that, with the disappearance of their cultural heritage, peoples and nations are losing their identities. Those who conserve the cultural heritage are, in short, now charged with a new task. To accomplish it, one must negotiate a very narrow path with destruction on one side and mummification on the other. Maintaining a middle ground is very difficult.

The greatest interpreter of Brandi's *Teoria del restauro*—which he has made accessible to many outside Italy by means of his eloquent French prose—Philippot is very careful to record the resistance and hostility to Brandi's stance, which most architects oppose. Several excerpts that illustrate this opposition appear in the texts by Carbonara (see Reading 23, pages 236–37).

Philippot makes abundantly clear that conservation intervention cannot be honorably undertaken unless the relationship between context and use is considered from the very beginning from both theoretical and practical standpoints (see Reading 21, pages 218–19). If the ritual value of a work of

art, determined and consolidated by tradition, is to be preserved, then this value must be respected when making a decision about conservation procedure. If, for instance, a reliquary or a pectoral will continue to be carried in procession, any structural restoration of it should provide for this eventuality.

Providing examples from around the world—from New Delhi to the Vatican, from Philadelphia to Munich—Philippot discusses a range of situations with variations on the theme (see Reading 21, pages 219–25). He returns to the idea of context from a new vantage point, looking at a work of art in order to recover its original features and also to understand the significance it may have acquired in its new context, even if this new meaning is far removed from the artist's original intention.

His reflections conclude with a final, very topical argument: the relationship of the object to the public, the last constituent of the new context in which ancient works of art are often placed, and the one that imposes conditions on all the others. Preservation and use are closely connected; as scientific surveys of environmental factors have shown, some of the worst cases of damage have been due to an excess of visitors.

Carbon dioxide, unacceptable levels of relative humidity, and dust— even vandalism and graffiti on walls and pavements—are the destructive results of mass tourism in great historic cities and in major museums. However, if the work of art is a form of communication—if the monument conveys a message, for example, or serves as a memorial—excluding the audience cannot be a general solution for ensuring its preservation. Striking a new balance between the demands of conservation and the rights of the public is one of the most difficult challenges, but it is also the most urgent to undertake in order to secure the future of the past.

In addition to his own original and influential contributions to the study of art history and restoration, Philippot must be considered the leading interpreter and popularizer of Brandi. Nevertheless, a firsthand appreciation of the writings of Brandi himself, as a contemporary scholar who built up a general theory of restoration, is essential. His thoughts are collected and his philosophy summarized in his *Teoria del restauro* (1963). Born in Siena, Brandi was a university teacher, art critic, and musicologist of sophistication, as well as the first director of the Istituto Centrale del Restauro, the first institution of its kind, founded in Rome in 1939. Brandi expresses his ideas in very dense and difficult language, which, until now, has deterred both direct familiarity with his work and its adequate dissemination. Included here is a new English translation of a few significant excerpts to provide an example of the only complete and organic system of thought on the subject of restoration. The purpose of these selections is to stress how many terms, expressions, and established principles are derived from Brandi and how many have meanwhile become ephemeral, how perspectives and approaches have

altered, and how many topics that were not then taken into consideration have now become of paramount importance and urgency.

Brandi's *Teoria del restauro* is inspired by the idealist philosophy of Benedetto Croce; from historicism it derived a fundamental concept that remains fully valid: the relative, partial, and transient character of any restoration, even the most skillful, as it is always marked by the cultural climate in which it is carried out.

Today, as conservators, we are driven to emphasize the destructive potential of conservation, as revealed by such recent mistakes as are often made in the name of presumed technological breakthroughs. We are inheriting the burdensome and destructive legacy of many recent "conservation" treatments in which materials and procedures developed for industrial purposes or for the maintenance of modern buildings were used on works of art and on fragile objects that are witnesses to human history. We are thus in no position to indulge in an easy sense of triumphalism.

It follows that one should work according to Brandi's criterion of the "minimum of needed intervention." This is neither a minimalist nor an unthinking position; on the contrary, it is respectful of the object. Another debt we owe to Brandi is the systematization of the concept of reversibility in restoration. We now know—and this will be mentioned in passages referring to the so-called cleaning controversy—that absolute reversibility is a useful myth; a consolidation or anticorrosion treatment leaves the treated material changed forever. This alteration may be acceptable if it is not disfiguring, if it does not destroy historic or artistic features, and if it effectively increases the chances of the object's survival. But, above all, a treatment is acceptable—as Brandi recommends—if it does not hinder future treatments.

Such prudence has not yet been sufficiently put into practice, although the history of restoration is strewn with episodes that should encourage it. Toward the end of the eighteenth century, when the restorer was already recognized as professionally distinct from the artist, a famous controversy set two French restorers and their descendants against one another. Robert Picault and Jean-Louis Hacquin both treated famous paintings with spectacular results: Picault treated paintings in the Collections du Roi, and Hacquin worked on paintings requisitioned in Italy for the Musée Napoléon.

The bone of contention concerned the technique of transferring the paintings to new panels. Two of the paintings in question were Andrea del Sarto's *Charity* and Raphael's *Madonna di Foligno*. It is precisely because of the accolades that greeted this last effort that the Hacquins went so far as to formulate the theory that "restoration improves the work of art."[2]

On the contrary, we must always view contemporary restoration in relative terms, conceiving of it not as final and definitive, but as no more than a moment in the life of the object, with the aim of ensuring its survival. Other

treatments ought to follow; they will become more viable as the history and the complex stratigraphy of the object are more carefully evaluated and as the heavy hand of the restorer becomes lighter.

Brandi's definition of restoration is still valid: "any operation aimed at reviving the function of a product of human endeavor." It is true that houses are restored, refrigerators are repaired. He warns, however, that where the historic and artistic heritage is concerned, it is the very cultural and aesthetic function that needs to be recovered. In the case of an ancient ceramic vase from a tomb, the conservator should ensure not that it can hold liquids or solids again, but that it may be contemplated as a document of an ancient ritual for the dead and/or as an object of aesthetic value, if that is appropriate.

Returning to the original thought, to which Yourcenar's text adds the ambiguous and terrible fascination of the transience of things, it is important to consider the problem of interference implied by any restoration. It may be possible to go a step beyond Brandi to offer a tentative definition of the theory of restoration as: the theory defining the degree of acceptable interference on a work of art that is consistent with the goal of conservation and compatible with the historic character and aesthetic value of the object.[3]

Another valuable aspect of Brandi's theory is the humanist view underlying his conception of restoration, a view that inspired many of the texts discussed here. It is evident, as noted earlier, that restoration is not an ancillary technical activity but a moment of critical appreciation of the work of art—in other words, it is an aspect of philological and aesthetic research toward an understanding of art.

Other aspects of Brandi's thinking, especially concerning the relationship between material and image, seem further from contemporary sensibilities. Brandi admitted that the image is also coincident with the material, but he immediately instituted a hierarchy between the material directly connected with the image and that confined to a supporting, or structural, role. This distinction may appear to be justified when applied to a painting and its structure (support, ground, paint layer), but it has no possible application to three-dimensional objects—sculpture or architecture, for example—unless one accepts the simplification that appearance equals surface.

Brandi argued that alterations could be allowed only if they left no visible traces. From here, the idea originated that the surface alone had a special function: that of bearing the image of the work as well as testifying to its authenticity and its history. From this conception of the surface, there have developed—though surely without any such intention on Brandi's part—the various practices of intervention on the unseen part of the object in whatever way seems expedient (and that includes some extremely violent, heavy-handed methods). The conviction is that since the intervention affected only the structure, it in no way alters the image.

This same contrast between material and image appears in other formulations of Brandi's theory, namely those that relate directly to the methods and results of restoration. Restoration is called upon to re-create the unity that the object has lost through the effects of time or through previous restorations or alterations. To achieve this goal, restoration should agree with historical principles (not to destroy the traces of the passage of time and of human intervention) as well as aesthetic ones (to remove erroneous completions and disfiguring or inappropriate alterations). Aesthetic requirements, however, often tend to prevail in Brandi's thinking.

Brandi's theory has been most successful in the field for which it was intended: the restoration of paintings. On the other hand, many architects have repudiated his thinking in whole or in part. In Italy, especially, there has been a lively and prolonged discussion, demonstrating the difficulty of applying to architecture principles conceived for two-dimensional paintings.

Some of the objections raised against Brandi are discussed by Carbonara, a scholar at the University of Rome (see Reading 23, pages 236–43). Although, like his mentor Renato Bonelli, Carbonara is close to the idealist and historicist tendencies of Brandi, he finds the *Teoria* too limiting when it restricts the creativity of the architect-restorer.

According to Carbonara, it is possible to recover the unity and re-create the lost image of a monument or building only by means of completions, fully recognizable as such and carried out in the style current at that time. Alterations and additions would be justified by the goal of recovering and conserving the value that the ancient building represents.

Even greater difficulties arise in the full application of Brandi's theory to archaeology. This discipline has undergone profound changes in the present century and, above all, in the period after World War II. It has also been the subject of a very wide debate, to which the English-speaking world has contributed significantly.[4] The dichotomy inherent in the nature of archaeology's origins has been much in evidence, with antiquarians and art historians on one side, and scientists and prehistorians on the other.

The theory of stratigraphic excavation sees archaeology as a branch of historical science that uses sites, materials, and objects themselves as sources of evidence and investigates them through its own methods of excavation and data processing. Despite their attention to material evidence, even field archaeologists of this persuasion were late in considering the problems of conservation and restoration.

It was the art historians who first began to consider the importance of conservation for recovering the aesthetic and historical values of paintings. Meanwhile, the problems of conserving great ruins were tackled almost exclusively by architects. For this reason, it is not easy to find "fundamental" texts on archaeological conservation to place beside the others in these readings.

Marie Berducou belongs to a much younger generation; some of her recent writings, however, will stand the test of time for the clarity of their argument and for the synthesis they achieve (see Reading 25, pages 248–59).

The central themes of the definition of restoration and its relation to art criticism and historical research, as defined by Brandi in his *Teoria*, appear to be fully valid. However, profound changes in the field of archaeology have brought new themes to light, ones that require an approach other than the idealist philosophy of Brandi. Some basic reflections on these themes have recently begun to appear.

In archaeology, as Berducou makes clear, a find is important less as a work of art than as a document with an information potential and a semantic content; it is a document that does not communicate aesthetic values alone. Moreover, it is now possible, thanks to the refinement of excavation techniques, to recover more information and more finds on site than was possible in the past.

The task of responding to such new demands on conservation has, therefore, now become much greater and more complex, requiring a new approach and new priorities. The reading from Berducou clarifies, far better than a long discussion, the distance in time and in sensibility that separates the archaeology of today from Brandi's outlook. To better measure this distance, one may refer to the pages of Brandi's *Teoria* dedicated to the problem of ruins and reexamine his original proposals (Reading 22, pages 233–34).

According to Brandi's definition, a "ruin" is a number of fragments that have lost all trace of their original function and aesthetic qualities. A ruin cannot be restored, because it is impossible to recover its lost unity; however, it might be possible to ensure, through maintenance, its status quo. The field of archaeology is concerned with ruins and remains. No principles of restoration should therefore apply, he asserts, and no treatment or reconstruction should be considered except for the maintenance of the status quo.

Brandi thus appears not to allow enough latitude. According to the *Teoria*, restoration ought to retard decay processes without interfering with the image, often identified restrictively with the surface alone. Some of the readings in this section examine this question in depth and move significantly in the direction of clarifying it.

—AMV

Notes

1. E. PANOFSKY, *Renaissance and Renascences in Western Art* (London: Paladin, 1970).

2. A. CONTI, "Vicende e cultura del restauro," *Storia dell'arte italiana,* vol. 3, no. 10 (Turin: Einaudi, 1981), 50–53.

3. A. MELUCCO VACCARO, "Archeologia e restauro," chap. 7 in *Teoria del restauro e archeologia* (Milan: Mondadori, 1989).

4. D. L. CLARKE, *Analytical Archaeology,* ed. B. Chapman, 2d ed. (London: Methuen, 1978); E. C. Harris, *Principles of Archaeological Stratigraphy,* 2d ed. (London, New York: Academic Press, 1979); R. PARKER, *Miasma: Pollution and Purification in Early Greek Religion* (Oxford: Clarendon Press, 1983), especially 27 ff.

That Mighty Sculptor, Time

MARGUERITE YOURCENAR

On the day when a statue is finished, its life, in a certain sense, begins. The first phase, in which it has been brought, by means of the sculptor's efforts, out of the block of stone into human shape, is over; a second phase, stretching across the course of centuries, through alternations of adoration, admiration, love, hatred, and indifference, and successive degrees of erosion and attrition, will bit by bit return it to the state of unformed mineral mass out of which its sculptor had taken it.

It goes without saying that we do not possess a single Greek statue in the state in which its contemporaries knew it: we can barely discern, here and there on the hair of a kore or a kouros of the sixth century, the traces of reddish color, like palest henna, which attest to their pristine character of painted statues alive with the intense, almost terrifying life of mannequins and idols which also happen to be masterpieces of art. Those hard objects fashioned in imitation of the forms of organic life have, in their own way, undergone the equivalent of fatigue, age, and unhappiness. They have changed in the way time changes us. Their maltreatment by Christians or barbarians, the conditions under which they have spent their centuries of abandonment underground until discovery has given them back to us, the sagacious or ill-advised restorations from which they have benefited or suffered, the accumulation of dirt and the true or false patina—everything,

From MARGUERITE YOURCENAR, "That Mighty Sculptor, Time," in *That Mighty Sculptor, Time,* trans. Walter Kaiser, translation copyright © 1992 by Walter Kaiser (New York: Farrar, Straus and Giroux; Oxford: Aidan Ellis, 1992), 87–89; originally published as *Le temps, ce grand sculpteur: Essais* (Paris: Gallimard, 1983). Reprinted by permission of Farrar, Straus and Giroux (USA) and Aidan Ellis Publishing (UK).

including the atmospheric conditions of the museums in which they are today imprisoned, leaves its mark on their bodies of metal or stone.

Some of these alterations are sublime. To that beauty imposed by the human brain, by an epoch, or by a particular form of society, they add an involuntary beauty, associated with the hazards of history, which is the result of natural causes and of time. Statues so thoroughly shattered that out of the debris a new work of art is born: a naked foot unforgettably resting on a stone; a candid hand; a bent knee which contains all the speed of the foot race; a torso which has no face to prevent us from loving it; a breast or genitals in which we recognize more fully than ever the form of a fruit or a flower; a profile in which beauty survives with a complete absence of human or divine anecdote; a bust with eroded features, halfway between a portrait and a death's head. This blurred body is like a block of stone rough-hewn by the waves; that mutilated fragment hardly differs from a stone or a pebble washed up on some Aegean beach. Yet the expert does not hesitate: a line which is worn away, a curve which is lost here and reemerges there can only result from a human hand, a Greek hand, which labored in one specific spot during one specific century. The entire man is there—his intelligent collaboration with the universe, his struggle against it, and that final defeat in which the mind and the matter which supported him perish almost at the same time. What he intended affirms itself forever in the ruin of things.

Those statues which have been exposed to the sea wind have the whiteness and porosity of a crumbling block of salt; others, like the lions of Delos, have ceased to be animal effigies and have become blanched fossils, bones in the sunlight at the edge of the sea. The gods of the Parthenon, affected by the atmosphere of London, little by little are turning into cadavers and ghosts. The statues reconstituted and repatinated by eighteenth-century restorers, made to harmonize with the shimmering parquets and polished mirrors of papal or princely palaces, have an air of pomp and elegance which is not antique but evocative, rather, of the festivities at which they were present, marble gods retouched according to the taste of the period standing side by side with ephemeral gods of flesh. Even their fig leaves clothe them like the dress of that time. Lesser works which people have not taken the trouble to shelter in galleries or in pavilions made for them, quietly abandoned beneath a plane tree or beside a fountain, ultimately acquire the majesty or the languor of a tree or plant: that shaggy faun is a moss-covered tree trunk; this bending nymph is indistinguishable from the woodbine that embraces her.

Still others owe their beauty to human violence: the push toppling them from their pedestals or the iconoclast's hammer has made them what they are. The classical work of art is thus infused with pathos; the mutilated

gods have the air of martyrs. Sometimes, the erosion of the elements and the brutality of man unite to create an unwonted appearance which belongs to no school or time: headless and armless, separated from her recently discovered hand, worn away by all the squalls of the Sporades, the Victory of Samothrace has become not so much woman as pure sea wind and sky. One bogus aspect of modern art comes from these involuntary transformations of ancient art: the Psyche in the Museo Nazionale of Naples with her skull cut cleanly off, horizontally cloven, has the appearance of a Rodin; a decapitated torso turning on its base recalls a Despiau or a Maillol. What our sculptors today imitate by willful abstraction and, moreover, with the help of cunning artifice, is there intimately bound to the fate of the statue itself. Each wound helps us to reconstruct a crime and sometimes even to discover its causes.

That emperor's face received a hammer-blow on a certain day of revolt or was rechiseled to serve for his successor. A rock thrown by a Christian castrated that god or broke his nose. Out of greed, someone extracted the eyes of precious stone from this divine head, thus leaving it with the cast of a blind man. A German mercenary boasted that he had tumbled that colossus with one shove of his shoulders during a night of pillage. Sometimes the Barbarians are responsible, sometimes the Crusaders, sometimes the Turks; sometimes the lansquenets of Charles V and sometimes the soldiers of Napoléon; and Stendhal was later moved to tears at the sight of the Hermaphrodite with a broken foot. A world of violence turns about these calm forms.

Our ancestors restored statues; we remove from them their false noses and prosthetic devices; our descendants will, in turn, no doubt do something else. Our present attitude represents both a gain and a loss. The need to refashion a complete statue with artificial members resulted in part from the naive desire to possess and exhibit an object in perfect condition, which is inherent to all ages because of the simple vanity of the owners. But that taste for excessive restoration which all great collectors from the time of the Renaissance down to our own day have possessed surely arises from profounder causes than ignorance, convention, and the vulgar bias in favor of a fair copy. Our forebears—perhaps more human than we and with different sensibilities at least in the domain of art, from which they hardly demanded more than pleasurable sensations—found it hard to put up with mutilated masterpieces and with marks of violence and death on gods of stone. The great lovers of antiquities restored out of piety. Out of piety, we undo what they did. But possibly we are more accustomed to ruins and wounds. We are suspicious of any continuity of taste or of human spirit which would permit Thorvaldsen to repair Praxiteles. We more easily accept that this beauty, so remote from us and lodged in museums rather than in our homes, should be a dead beauty or a beauty made of fragments. And finally, our sense of the pathetic is gratified by these bruises; our predilection for abstract art causes

us to like those lacunae and fractures which tend to neutralize the forceful human element in this statuary. Of all the changes caused by time, none affects statues more than the shifts of taste in their admirers.

A form of transformation more striking than any other is that undergone by statues which have fallen to the bottom of the sea. The vessels which carried work commissioned from a sculptor from one port to another, the galleys into which the Roman conquerors crammed their Greek loot to transport it to Rome, or else to take it along with them to Constantinople when Rome became less sure, sometimes went down with all hands. Some of those shipwrecked bronzes, fished up in good condition like a drowned man revived in time, have acquired from their subaqueous sojourn nothing more than a beautiful greenish patina—as, for example, the Ephebe of Marathon or those two powerful athletes from Erice found recently. Fragile marble statues, on the other hand, emerge gnawed or eaten away, corroded, decorated with baroque volutes sculpted by the caprice of the tides, or encrusted with shells like those boxes we bought at the seaside in our childhood. The forms and gestures the sculptor gave them proved to be only a brief episode between their incalculable duration as rock in the bosom of the mountain and their long existence as stone lying at the bottom of the sea. They have passed through this decomposition without pain, through this loss without death, through this survival without resurrection, as does all matter freed to obey its own laws. They no longer belong to us. Like that corpse in the most beautiful and haunting of Shakespeare's songs, they have suffered a sea change into something rich and strange. That Neptune, a good workshop copy intended to decorate the quay of a small town whose fishermen would offer him their first catch, has descended now to the realm of Neptune. This Celestial Venus, or Venus of the Crossways, has become the Aphrodite of the Sea.

Restoration from the Perspective of the Humanities

PAUL PHILIPPOT

When one examines the evolution of the concept of restoration in the professional literature and colloquia, one sees that interest in this type of question has grown in recent years. Simultaneously, the nature of these concerns has been clarified appreciably, to the point that today we may speak unequivocally of conservation as a discipline that is based on method, whereas formerly it was a profession resting on no more than empirical knowledge. In the context of such a change, the relationships that have arisen between the two components of modern conservation—that which is relevant to the humanities and that which is relevant to technique and the exact sciences—merit very special attention.

One may place the developmental origins of the first of these components—conservation as a historical discipline—at the beginning of the nineteenth century, when Canova refused to complete the fragments missing from the sculptures of the Parthenon, while Thorvaldsen consented to restore the Aegina Marbles. To restore in that era meant to reconstitute works of the past according to a system of rules considered Classical, and this is what Thorvaldsen did.[1] To be sure, when we look at the final result, the differences between the Neoclassical style, belonging to the restorer's era, and the original style of the sculptures are not immediately apparent, but the distance

From PAUL PHILIPPOT, "La restauration dans la perspective des sciences humaines," in *Pénétrer l'art, Restaurer l'oeuvre: Une vision humaniste: Hommage en forme de florilège,* ed. C. Périer-D'Ieteren (Kortrijk: Groeninghe, 1989), 491–500; an extended version of a lecture presented 9 June 1982 at the Académie des Beaux-Arts, Vienna, originally published as "Restaurierung aus geisteswissenschaftlicher Sicht," *Österreichische Zeitschrift für Kunst und Denkmalpflege* 37, no. 1–2 (1983): 1–9. Used by permission of Bundesdenkmalamt, Vienna. Translated by Garrett White.

widened by the archaeological conscience between creation and reconstitution is tangible nevertheless.

This situation slowly became clear in the course of the nineteenth century thanks to "revivals," to the extent that the different styles of the past were each progressively recognized as formal systems with their own characteristic dignity. One now set out to make restorations "in the style of," following in this regard the principles of Viollet-le-Duc. Such an upheaval had been unthinkable without historicism; this was incontestably its great merit—to have taken into consideration the specifically critical dimension of restoration and in the same moment to have separated the latter from the sphere of creation. It must be noted, however, that the very spirit in which these revivals took place prevented for some time the systematic implementation of such a program; for purely aesthetic reasons of order, certain phases of various past styles were exalted to the detriment of others. We are not able to say today that this kind of thinking has been completely surmounted in all quarters. Nevertheless, on a theoretical level it has been questioned since the nineteenth century by such authors as Ruskin, Morris, Riegl, and Boito, who criticized many restorations undertaken "in the style of." This line of thought, which affirms the fundamentally individual character of every work of art, emphasizing the historical and aesthetic dimension of restoration and aspiring to make of it a veritable critical activity, found its highest expression in the twentieth century in the classic formulations of Cesare Brandi's *Teoria del restauro*.[2]

The second component of modern conservation has a more recent origin, since it only really developed after World War II. The expanding role of technological studies of works of art brought the practice of restoration and conservation from the level of traditional working-class artisanship to that of an exact science.

The meeting of these two evolving components would inevitably give rise to conflicts. We became quickly aware of this when, shortly after 1945, the newly restored paintings of the National Gallery were presented to the English and international public. The controversy created by these restorations undoubtedly represents the oldest example of a direct confrontation between the techno-scientific and historico-humanist approaches to the problem. The arguments that were then advanced by the two camps can be found again today in the theoretical literature and, excepting certain details, have lost none of their immediacy.[3] Indeed, the separate positions remain entrenched: Is it not possible to recognize the museum, or at least the country, from which a painting in an exhibition originated by the manner in which the painting was treated? Certainly, in a good many areas a dialogue was opened, and to the benefit of both parties. However, the problem of the cleaning of paintings remained a taboo subject, undoubtedly for reasons of

international courtesy but perhaps also because for many years the number of art historians participating in conservation conferences has declined (this, at least, is the case at the ICOM [International Council of Museums] Committee for Conservation).

Conversely, theoretical issues were hotly debated in the domain of architectural conservation, which, it must be admitted, could take some pride in a unique immediacy since the beginning of the 1960s due to problems posed by the preservation of historic centers. It is almost as though human beings take no notice of the importance of historical objects until the moment they perceive that the material existence of these objects is threatened. This feeling would indeed have a catalyzing effect.

A certain shift could be observed in the relationship between the disciplines concerned with architectural conservation: the architect seemed increasingly to take precedence over the historian or the archaeologist. This phenomenon could be explained by the growing necessity to find new, creative solutions. It carried an obvious danger, which was the exploitation of the historical monument to the extent that the architect considered it above all from the perspective of a developing whole—that is to say, of an environmental totality that could not survive without creative intervention.

In recent years, intense discussion of these problems, particularly in a politically favorable milieu, such as that found in Bologna, has permitted a rethinking of certain established principles. Notably, we have seen that the ideas implicitly embodied in various "cultural heritage charters" are all derived from the "superior" categories of the works of art, according to the way in which these categories have been established by traditional discourse on the history of art. But this restrictive conception of heritage is incompatible with the desire to save the totality of the living cultural environment of a population, an environment threatened not only by modern development, and especially by land speculation, but also by an abstract and far too narrow conception of the work of art.

A concern for the conservation of the particular values of a historically transmitted and still living milieu, considered as a problem regarding the whole community, indeed requires a new definition of the object to be restored; this definition will have to be broader and more comprehensive than the traditional one.

This is particularly crucial for problems posed by heritage inventories. In Emilia-Romagna, the compilation of a catalogue of cultural property was made on the basis of a new method of description, taking into consideration the fabric of the historic and current relations existing between these objects and the life of the community.[4]

A negative example from Mexico shows how important this problem is once we take into account the anthropology of modern life. When I visited

the church of Cata near Guanajuato in 1972, the interior was still covered with hundreds of ex-votos. I learned recently that all of them were removed during a restoration. These images were thus sacrificed on the altar of "architectural purity."

Certainly, concern for redefining the monument from a larger perspective is not a new idea. To place emphasis on the social dimension of a building is to recapture, by systematizing it, a conception that was already demonstrated in the scope of restorations directed by art historians. They often wished to conserve not simply an object pulled from its context but also the history of its life and its present environment. In so doing they helped free the protection of cultural heritage from a museum-oriented definition of the monument and from the tendency to transform it into an exhibition piece.

From the moment we pose the question of what it is advisable to restore (a fundamental question that ought to be posed before any intervention), the same problem of method also exists to a certain degree for art objects. We will begin with an extreme case, that of an object as foreign as could be to a museum setting: the *Volto Santo* at Lucca.[5] For the art historian, the object is a Romanesque crucifix in wood that through the course of time has been clothed in various attire. And yet, for the religious pilgrim who venerates the image today, it is the actual appearance of the image, and this alone, that is the deciding factor. It is this superimposition of different historical strata that illuminates the particular importance of the work for the faithful as well as for the modern anthropologist. Here, the definition of the object to be conserved can only be the result of careful observation, implying both a gathering of information and a choice of values.

Practically speaking, problems of this kind are infinitely complex, to the extent that the status conferred upon the work can vary considerably according to the system and the cultural context in which it is inscribed. Thus, for example, effigies of Buddha in the temples of Nepal are in many respects comparable to the *Volto Santo*. There is, in fact, a custom in that country of covering sculptures installed in the open air with red clay and decorating them with cut flowers. In this way, these images form an integral part of the local liturgical life. We can imagine the misunderstanding when a figure from the fifth century is found "renovated" in modern colors!

On the other hand, the Ethnographic Museum of New Delhi has made an attempt to reconcile traditional methods and the situation of objects in the museum by turning over the maintenance of popular artifacts to local artisans. Ultimately, the third world presents us with problems not unlike our own in this regard, even if, in our country, these problems have been multiplied tenfold by the extremely rapid character of technological change in the nineteenth century. The work of restoration is neither acceptable nor

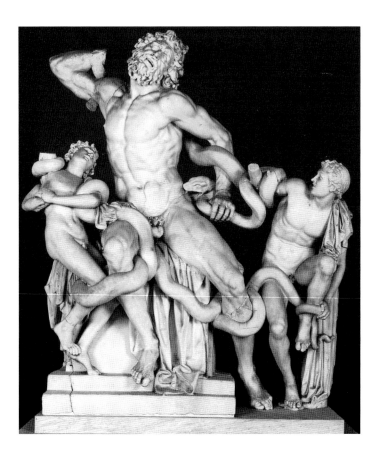

defensible except insofar as it takes into account the living traditions maintained in relation to a monument still in use.

Our attitude with regard to objects conceals problems of a comparable nature. The tiny Romanesque Reliquary of Agnani in silver repoussé over a wooden structure was covered through the course of time with many fragments of old cloth. These completely hid the ancient metalwork, giving the reliquary the appearance of a fetish. An intervention was necessary to preserve the metal and textile fragments, and the question was posed as to whether it was appropriate to replace the pieces of cloth after restoration. Put another way, ought one to be restoring the fetish (now become a historical object) or the Romanesque work of art? Dr. Plenderleith solved the problem by producing a copy of the wooden case, over which the restored textile fragments were applied. The copy was displayed next to the original in silver.

Figure 2
The *Laocoön*, the Hellenistic work
with the reintegration of the
original arm.

This was a museum-oriented solution, to be sure, but one that tried to take into consideration the history of the object. The principle of reversibility was respected, but, at the same time, a historical judgment had to be made: not everything that has happened to the object can be considered equally significant. What makes history is the meaning of the event, the meaning that we recognize in a particular context.

The situation was exactly the opposite with the celebrated *Laocoön*. The facts are well known. After having been unearthed at the beginning of the sixteenth century in the Via delle Sette Sale, this Hellenistic masterpiece, uncovered as a fragment but universally admired, was the subject of many restorations. The earliest one was that of Montorsoli (Fig. 1), which gave to the work the look that established its fame in art history. But Montorsoli did not restore the work in the modern sense of the term; he did not endeavor to

return the group to its original state. Rather, he reformulated its theme on the basis of Classical aesthetic concepts, relying on his own understanding of the principles of Classicism. That is how the ancient fragment was transformed into a Mannerist work. One might say the same of restorations of antiquities undertaken by Algardi, Duquesnoy, or Bernini.

The rediscovery of the original arm of the *Laocoön* posed a problem: Should it be integrated into the original, and so destroy the work of Montorsoli, or should the rediscovered fragment be shown on a cast of only the antique portions, which would have preserved the Mannerist creation as well as a visualization of the archaeological reconstruction? In the end, the first solution was chosen (Fig. 2), thus giving priority to the ancient work, though it remains incomplete even after the reintegration of the arm. This effaced the later reformulation of the group, the memory of which was nonetheless preserved in a cast.[6]

The case of the Aegina marbles (Figs. 3, 4), which belong to the Glyptotek in Munich and were restored in a flawed manner by Thorvaldsen in 1816, may appear comparable to that of the *Laocoön*. The judgment we make of this intervention depends in large measure upon our critical evaluation of Neoclassicism. Must we see in it only a sterile academicism devoid of sensitivity, as has long been held, or, rather, does this style in fact constitute the very origin of the modern aesthetic problem, as Giulio Carlo Argan stated in 1970[7] and as more and more historians acknowledge today? Be that as it may, one cannot underestimate the exceptional historical importance of the Thorvaldsen intervention: it constitutes the oldest example of a restoration "in the style of," and thus of something entirely other than that undertaken by Montorsoli. This episode demonstrates once again how essential a historical and critical judgment is in determining the outcome of the intervention by defining in advance the object to be treated.[8]

We wish now, after having examined two examples of restorations of ancient objects, to turn to that of a *Gesamtkunstwerk* [artistic synthesis] from a more recent period: the Nördlingen retable, attributed to Friedrich Herlin. This altar, broken in pieces by the Iconoclasts of the sixteenth century, was repaired in 1683 according to its Protestant use (without wings) and fitted with a Baroque frame. Under the influence of the growing general fervor for conservation, which has reached an ever larger public over the past twenty years, the parish (though still Protestant) considered returning the celebrated altar to its original 1462 state (the casing of the altarpiece had remained in place, while the painted wings, slightly shortened at the top, were conserved in the city museum). Following a colloquium organized to examine and discuss the problem, the decision was made to preserve the 1683 repair, not only for its historical interest, but also because the preservation

of the Baroque frame would have been compromised if it were to lose its raison d'être.[9]

The reference we make here to the denominational background is not solely anecdotal, even if we in no way claim that the contradictory doctrines regarding restoration may originate in differing religious positions. The fact is, we know that neither the Vatican nor Catholic Munich have hesitated to eliminate earlier restorations, even if these embodied the historical identity of the work, while, at the expense of its original appearance, the Protestant town of Nördlingen preferred to give precedence to the aspect of the work passed down by history. Our allusion to the denominational dimension aims to show that the problem we are considering arises from a conflict between two fundamental attitudes vis-à-vis history, two attitudes which, in Christian Europe of the sixteenth century, were without a doubt expressed most clearly through the schism in the Church at the time of the Reformation. The Protestant movement in fact affirmed the necessity of a return to origins of archaeological purity, while the Catholic Church underscored the value of historical continuity, of tradition. These attitudes constitute the twin poles of the hermeneutical problem posed each time we attempt to understand the past, even if today it becomes clearer and clearer that we can in no way reconstruct this past except on the basis of inquiries suggested to us by our own situation, the cultural situation of humanity in the twentieth century.

Even if today the great currents of conservation theory—European in origin—can be considered widely disseminated, their relative importance continues to vary from sector to sector. We are referring here not only to the different approaches to these problems by the art historian and the archaeologist, but above all to the particular historical situations of the diverse nations of the world and the tensions caused by the rift between industrial societies and those that have retained their traditional lifestyles. The more radical the rupture with the past, the stronger the tendency to turn to a "scientific" approach to these problems, to see the past from an anthropological perspective and transform it into a purely archaeological museum object.

The profound nature of this phenomenon stands out in sharp relief as soon as museum status is conferred not upon an isolated object, but upon a living ensemble such as a town, for example. The example of colonial Williamsburg is well known (Fig. 5). Here, the aspect presented by a city at a given moment in its history has been "frozen" by a total museumification. But affective attachment to the past is not satisfied by an objectifying distance appropriate to the progression of historical knowledge, and takes vengeance by demanding that it materialize in a complete reconstruction that restores a currently existing presence to the past. Yet no matter how brilliant this presence may be in its archaeological rigor, it is nevertheless unable

Figures 3, 4
Sculpture from the pediments of the Temple of the Aphaia in Aegina. Even after eliminating the restorations carried out by Thorvaldsen, it was impossible to present to the public the pure archaeological state of the sculptures. In the central group of the west pediment (Fig. 3, right), the shields have been to a large extent restored. The shield, the chest, and the knee of the recumbant statue from the east pediment (Fig. 4, below) are modern restorations.

to reestablish the continuity of lived history. Its authenticity thus impaired, it takes revenge in turn by conferring upon the reconstructed town—which has become, in the disguise of its historical costumes, an open-air museum of a particular genre—the ambiguous character of a Disneyland, bordering perhaps on kitsch.

As demonstrated also by the case of Philadelphia's Independence Hall, the "frozen" monument shows a tendency to be transformed into its own

Figure 5
A street in Williamsburg, Virginia.

image, to the extent that the historical distance from which the process of museumification arises finds itself in a way denied by the manner in which exhaustive reconstruction brings it up to date. Past and present are thus brought together on the same level with no depth of field whatsoever. This is certainly not to say that these images lack all power of suggestion—quite the opposite—or that they may be scientifically questionable. Rather, we would say that they are unacceptable to the historical conscience because they have been created upon the monument itself and that such a restitution can conceal or even falsify certain original formal values. The reconstruction of Independence Hall's historic room is therefore justified by how it permits the conscious visualization of a historical event but not by its restoration of an architectural creation. This is why the approach that has been adopted here cannot be applied to monuments such as the Stoa of Attalus or Greek theaters.

We are now at the heart of the problem of restoration: An authentic relationship with the past must not only recognize the unbridgeable gap that has formed, after historicism, between us and the past; it must also integrate this distance into the actualization of the work produced by the intervention. By treating a monument as a simple historical document, the integration of the object into our era takes place at the cost of a reduction of our relationship to the object to the level of mere knowledge. For a work of art, such a reduction signifies nothing less than the refusal to recognize its very specificity. Appropriate forms of presentation have therefore been developed that, while keeping to the requirements of historical criticism, comply also with those of the work of art as actual aesthetic presence. It is in the light of these considerations that the well-known problem of lacunae and their integration must be considered.[10]

Before the advent of museums, a work of art was not limited solely to its aesthetic dimension; it also performed a whole series of other functions—liturgical, ritual, social, decorative. Through the agency of the museum, the work was integrated into contemporary culture. The entrance of the work into the museum entails the loss of these functions, which are bound up nevertheless with its meaning (nonaesthetic), reducing it solely to its historical and documentary dimensions.

Awareness of this situation provoked a reaction. While the nineteenth century had favored the isolation of the object, developing an encyclopedic museology, today we seek to reconstitute collections and to evoke the historical contexts into which they fit. And while the object is no longer able to fulfill its original function—functions are also transformed or fade away—we occasionally try to simulate it in order to keep the original meaning of the work alive.

More and more, for art historians at any rate, an emphasis is placed on the original viewing conditions of works of the past, and especially upon the role of the surrounding space and lighting factors. We may cite here the example of the *Kefermarkt* retable studied by Eva Frodl-Kraft. She demonstrated that the piece was conceived to operate with back lighting and with sources of lateral light. This environment is necessary if the details are to be correctly integrated into the whole. On the other hand, frontal light with the use of "spots" destroys this original unity and transforms the work into a simple sum of details.[11]

The original viewing conditions were completely different for Spanish and Mexican *retablos,* as we have seen notably at Tepotzotlan. Here, there is no backlighting but rather a *decrescendo* of light emanating from openings in the drum of the cupola or from others, smaller and lower, in the transept. The multiplication of patterns presents a strong relief and simultaneously suggests a kind of golden rain that dissolves slowly in the shadowy light of the sanctuary. Grilles that prevent one from seeing the whole retable in one view serve a similar purpose: to enhance the quality of transcendence and unreality. Our wish to contemplate the image is, in effect, reinforced by the fact that we never quite see anything but details, and because of this it appears to the viewer as a kind of holy mystery. The Church has always been cognizant of the metaphysical suggestions that lie in the partial concealment of the object of worship and has occasionally exploited them with a great deal of psychological expertise. That, for example, is the case at Varallo, where the Mystery of the Redemption is conjured in a series of chapels in which one may only catch sight of the representations they shelter, fragment by fragment, through grilles (Fig. 6).

These considerations have apparently taken us a long way from the practical and technical substratum without which we would have but a simple critical discourse in place of restoration. And yet, in more than one

Figure 6
The Sacro Monte de Varallo, near Milan. A series of screened chapels containing representations of the Mystery of the Redemption. These can be contemplated only through grilles, thereby stimulating the perception of contemplating a sacred mystery.

respect, our knowledge of the object and its history directly depends on the study of its state of conservation and its material structure. This is why laboratory examinations, which precede any restoration, are essential at this point for both the object and its critical interpretation.

The dominant role played by conservators in the rediscovery of polychromy in both sculpture and architecture has been well established. In these last two cases, technological and laboratory studies depend upon a true field archaeology directed toward the object, and they can assist in establishing its history as well as different phases of its genesis. The permanent enrichment—thanks to restorations—of our technical knowledge of the plastic arts and the growing consideration of them on the part of art historians makes apparent the necessity of integrating the technological approach with the general methodology of art history. In other words, art history would no longer be able to consider a representation independent of its material support. Certain recent investigations concerning the copying and attribution of early Flemish painting constitute a good example of this new approach.[12]

However, the technological study and critical definition of the object constitute only the point of departure for conservation. For if historians can revise their diagnoses and value judgments at any moment, the formulations of which remain entirely discursive, the conservator, on the contrary, has always to carry out his decisions on the object itself. The conservator's decisions determine the appearance of a monument, for the artistic creation as much as for the historical document, thus suggesting a certain reading of the

work to the viewer. Out of this particular situation comes the responsibility of the conservator, who is, in effect, forced to concretize a critical judgment on the work itself. The conservator provides in the same moment a given direction for the imaginary contemporary museum.

Awareness of this state of affairs requires limiting interventions as much as possible and searching for the greatest possible degree of reversibility. This is why integration of lacunae can be nothing other than an attempt to reconcile the historical with the aesthetic; it is a matter of reducing damage without slipping into falsification.

Finally, the reaction of the modern viewer is an important aspect of the problem of restoration. Even though it constitutes a specialized discipline, it is clear that its progress depends upon the response its achievements elicit from the public at large and therefore upon the level of aesthetic and historical culture of that public. In the future, museums and administrations in charge of heritage must devote more attention to this arena, despite the additional labor and expense this implies. For if restoration is today considered one of the rare domains within which humanist culture and technology (the human sciences and the exact sciences) can merge, it is clear that it will not be able truly to develop except to the extent that the range of its cultural function is understood and sustained by society.

Notes

1. RANUCCIO BIANCHI-BANDINELLI, *Introduzione all'archeologia classica come storia dell'arte antica*, Universale Laterza 334 (Rome-Bari: Laterza, 1976), 75.

2. CARLO CESCHI, *Teoria e storia del restauro* (Rome: Mario Bulzoni, 1970); ALFREDO BARBACCI, *Il restauro dei monumenti in Italia* (Rome: Istituto Poligrafico dello Stato, Libreria dello Stato, 1956); CESARE BRANDI, *Teoria del restauro* (Rome: Edizioni di Storia e Letteratura, 1963) [see also Readings 22, 35, and 40].

3. See in particular CESARE BRANDI, "The Cleaning of Pictures in Relation to Patina, Varnishes, and Glazes," *Burlington Magazine* 91, no. 556 (1949): 183–88 [see Reading 41, pages 380–93]; N. MACLAREN and A. WERNER, "Some Factual Observations about Varnishes and Glazes," *Burlington Magazine* 92, no. 568 (1950), 189–92; CESARE BRANDI, "Some Factual Observations about Varnishes and Glazes," *Bollettino dell'Istituto Centrale del Restauro* 3–4 (1950): 183–88; reprinted in his *Teoria del restauro*, 127–47.

4. ANDREA EMILIANI, *Una politica dei beni culturali*, Piccola Biblioteca Einaudi 236 (Turin: G. Einaudi, 1974).

5. [4bis] [Note added to 1983 reprint] Since this article first appeared, the *Volto Santo* in Lucca has been the object of a radical restoration that has involved the elimination of post-Romanesque additions.

6. [5] W. OECHSLIN, "Il Laocoonte o del restauro delle statue antichi," *Paragone* 287 (January, 1974): 3–29. [For additional discussion of the *Laocoön*, see PINELLI, Reading 29, pages 288–94.]

7. [6] G. C. ARGAN, "Studi sul neoclassico," *Storia dell'arte* 7–8 (1970): 249–60.

8. [7] On the "de-restoration" of the Aegina Marbles, see J. PAUL, "Antikenergänzung und Ent-Restaurierung, Bericht über die am 13 und 14 Okt. 1971 in Zentralinstitut für Kunstgeschichte abgehaltene Arbeitstagung," *Kunstchronik* 25, no. 4 (1972): 85–112; and CH. DELVOYE, "La nouvelle présentation des frontons d'Egine à la Glyptothèque de Munich," *Annales d'histoire de l'art et d'archéologie de l'Université Libre de Bruxelles* (1979): 6–15.

9. [8] JOHANNES TAUBERT, "Der Hochaltar von St. Georg in Nördlingen und seine Restaurierung," *Restauratorenblätter* 2, Österreichisches Sektion der IIC (Vienna: A. Schroll, 1974), 189–98; and his "Friedrich Herlin, Nördlinger Hochaltar von 1462," in *Farbige Skulpturen: Bedeutung, Fassung, Restaurierung* (Munich: Callwey, 1978), 150–66.

10. [9] In this context see BRANDI, *Teoria del restauro*.

11. [10] E. FRODL-KRAFT, "Die Beleuchtung spätgotischer Flügealtäre," *Österreichische Zeitschrift für Kunst und Denkmalpflege* (1962), 83ff.

12. [11] See, for example, B. R. GROSSHANS, "Rogier van der Weyden, Der Marienaltar aus der Kartaus Miraflores," *Jahrbuch der Berliner Museen* N.F. 23 (1981), 48–112; P. KLEIN, "Dendrochronologische Untersuchungen an Eichenholztafeln von Rogier van der Weyden," *Jahrbuch der Berliner Museen* N.F. 23 (1981), 113–25; and C. PÉRIER-D'IETEREN, "L'Annonciation du Louvre et la Vièrge de Houston sont-elles des oeuvres autographes de Rogier van der Weyden?" *Annales d'histoire de l'art et d'archéologie de l'Université Libre de Bruxelles* 4 (1982): 7–26.

Theory of Restoration, I

CESARE BRANDI

§1. The Concept of Restoration

Restoration is generally understood as any kind of intervention that permits a product of human activity to recover its function. . . . [L]et us consider the variety of products of human activity to which the particular intervention we call restoration should be applied. There will be restoration relevant to industrial products and restoration relevant to works of art. . . . As long as one is, in fact, dealing with industrial products, defined on the widest scale starting from the smallest craft item, the purpose of restoration will obviously be to reestablish the functional properties of the product. Consequently, the nature of the restoration will be exclusively tied to the accomplishment of this goal.

Yet for works of art, even if there are some that structurally possess a functional purpose (such as architecture, and, in general, objects of the so-called applied arts), the reestablishment of the functional properties will ultimately represent only a secondary or accompanying aspect of the restoration, never the primary or fundamental aspect that respects a work of art as a work of art.

. . . The human product that deserves this recognition is there, before our eyes. But it can be generically classified among the products of human activity only so long as the conscious appreciation of it as a work of art does not definitely exclude it from the community of other products.

—⟋⟍—

From CESARE BRANDI, *Teoria del restauro* (Rome: Edizioni di Storia e Letteratura, 1963; reprint, Turin: G. Einaudi, 1977), chaps. 1–2, 4–5. Used by permission of Giulio Einaudi editore s.p.a. Translated by Gianni Ponti with Alessandra Melucco Vaccaro.

Thus we have come to recognize the inseparable link between restoration and the work of art, in that the work of art conditions the restoration and not vice versa.

—∿—

Now that we have reestablished the direct relationship between restoration and the appreciation of a work of art as such, we can define restoration: *Restoration is the methodological moment in which the work of art is appreciated in its material form and in its historical and aesthetic duality, with a view to transmitting it to the future.*

Naturally, the principles that guide the restoration during its operational phase will have to derive from this fundamental structure of the work of art in the reception the individual consciousness gives it.

—∿—

The material form of the work must necessarily take precedence because it represents the very realm of the image's manifestation; it ensures the transmission of the image to the future, and thus guarantees its perception within human consciousness. . . .

[E]ven though the imperatives of conservation are generally directed at the complex structure of a work of art, conservation pertains especially to the material form in which the image is manifested. Every effort and all research should be directed at ensuring that the material form lasts as long as possible.

—∿—

From this we clarify the first axiom: *Only the material form of the work of art is restored.*

But the physical medium to which the transmission of the image is entrusted does not accompany it; on the contrary, it is coextensive with it. It is not a question of the material form on the one hand, and the image on the other.

—∿—

Thus we can state the second principle of restoration: *Restoration must aim to reestablish the potential unity of the work of art, as long as this is possible without producing an artistic or historical forgery and without erasing every trace of the passage of time left on the work of art.*

§2. The Material of the Work of Art

The first axiom, by which the material form of the work of art is the only object of restoration, requires an in-depth examination of the relationship between matter and the work of art. . . . To begin with, and above all in relation to restoration, we must define matter, in that it represents contemporaneously both the "time" and the "place" of a restoration. To do so, we can

only make use of a phenomenological approach by which matter becomes ostensibly the "vehicle for the epiphany of the image." . . .

[This concept] provides the key to understanding the duality, already hinted at, of "structure" and "appearance."

—∽—

Let us take the most obvious example of a painting on a wooden panel where the wood has become so porous that it no longer provides adequate support. In this case, the painting is the material appearance while the wood is the material structure. Such a distinction might not always be so clear-cut: the fact that the painting is on wood gives it special characteristics that could, in fact, be altered if the panel were removed. It is therefore important to keep in mind that the distinction between "structure" and "appearance" is more subtle than it may seem at first and, in practice, is not always possible to determine. Let us consider another example: a collapsed building, partially destroyed by an earthquake, that lends itself to reconstruction or anastylosis. In this case, appearance cannot be defined as being merely the outer surface of the building blocks; they have to remain blocks, not only on the surface. Nonetheless, the interior wall structure can be altered to guarantee the building against further earthquake damage. Even the interior structure of columns, if there are any, can be changed, assuming that this will not alter the appearance of the material. Here also a delicate approach will be necessary to ensure that the altered structure does not influence appearance.

—∽—

§4. Time in Relation to the Work of Art and Restoration

—∽—

We should recall at this point that so-called archaeological restoration, however praiseworthy it may be for its respect of the work of art, does not achieve the fundamental aspiration of human consciousness in relation to the work of art by restoring its potential unity. It only represents the first phase of reconstruction, which will necessarily end only when the surviving relics of what used to be a work of art no longer allow plausible integrations. . . .

It will not be necessary to press the point any further, then, in order to state that the only legitimate moment for the act of restoration is the actual moment of the consciousness contemplating the work of art. At this time, the work of art exists in the moment and is historically present; yet it is also part of the past and, at the cost of not being part of human consciousness, is thus part of history. For restoration to be a legitimate operation it cannot presume that time is reversible or that history can be abolished. Furthermore, the act of restoration, in order to respect the complex historical nature

of the work of art, cannot develop secretively or in a manner unrelated to time. It must allow itself to be emphasized as a true historical event—for it is a human action—and to be made a part of the process by which the work of art is transmitted to the future. From a practical point of view, this historical requirement should translate not only into a differentiation of the integrated areas, something already made explicit when the potential unity is reestablished, but also into a respect for the patina, which we can think of as the buildup of time on the work of art. Furthermore, it should allow for saving sample areas that show the state of the work of art before restoration and also of noncontemporaneous parts of the work that represent the same passage of time. Naturally, for this last requirement, we can only provide a general guideline, for each case has to be evaluated individually and never at the expense of the aesthetic requirement, which always takes precedence.

—⟋⟍—

§5. Restoration According to Historicism

—⟋⟍—

[I]f a work of art is the result of human activity and, as such, its appreciation does not depend on fluctuations in taste or fashion, its historical significance has priority over its aesthetic value. Since the work of art is a historical monument, we must consider it as such from the extreme point when the formal arrangement that shaped matter into a work of art has almost vanished, and the monument is reduced to little more than a residue of the material that made it up. We must then examine the ways we can conserve a ruin.

—⟋⟍—

A ruin is anything that is a witness to human history. Its appearance, however, is so different from the one it originally had that it becomes almost unrecognizable. . . . Consequently, the preservation of a work of art that is reduced to a state of ruin depends to a great extent on the historical significance that is assigned to it. . . . When dealing with ruins, restoration can only be a consolidation and preservation of the status quo. Otherwise, the ruin was not a ruin, but a work of art that still maintained an implicit vitality that would allow the reestablishment of the original potential unity. The identification of a ruin therefore goes hand in hand with that initial phase of restoration know as preventive restoration, meaning merely conservation and protection of the status quo. This recognizes that any direct intervention is explicitly excluded if it goes beyond conservation monitoring and consolidation of materials.

—⟋⟍—

Therefore, with the concept of ruin, the analysis of a work of art in terms of its restoration begins from the very first stage, beyond which the materials that constituted the work of art reverted back to raw materials. This is consequently the very first level of restoration. Having to present the work of art not in its transition from internal creation to extrinsic form but as already having a worldly existence, restoration must start from precisely where the work of art ends, that is, at that limiting moment (a limit in both time and space) when the work of art, reduced to a few traces of itself, is about to fall back into an amorphous state.

—☙—

If we continue the analysis in terms of the historical point of view, we are faced with a double problem regarding works of art: the conservation or removal of additions, and the conservation or removal of reconstructions. In going from a work of art that has been reduced to a ruin to a work of art that has undergone additions and reconstructions, it might seem impossible to approach the problem from a strictly historical point of view. Yet we want to emphasize that we do not wish to solve the same problem using two distinct approaches. We only want to examine if conservation or removal of additions and reconstructions is, in fact, legitimate from the historical point of view. We also want to determine the limitations of both historical and aesthetic requirements, and to try to find at least a way of reconciling any discrepancies.

By presenting the problem of the legitimacy of conservation or removal, we have already overcome the obstacle posed by those who believe that the legitimacy of conservation is based exclusively on the historical significance of the work of art. If this were so, we should have to respect unconditionally both the barbaric vandalisms and the integrations carried out on artistic, not restoration, grounds that a work of art may have been subjected to over the centuries. Nor should we exclude the possibility that both can be respected together. Yet, since a work of art is endowed with both historical and aesthetic requirements, conservation and removal cannot occur at the expense of the one and the disregard of the other.

. . . From a historical point of view, an addition to a work of art is nothing more than new testimony to human activity and, thus, is part of history. In this context, an addition is not different from the original stock and has the same right to conservation. On the other hand, removal, although also the result of human action and thus also part of history, in reality destroys a document and does not document itself. It would thus lead to the negation and destruction of a historical process and would falsify evidence. Therefore, from a historical point of view, only the conservation of an addition is unconditionally legitimate, while its removal always needs justification, or should at least be done in a manner that will leave a trace both of itself and on the work of art.

Consequently, the conservation of an addition is the norm, removal the exception. This is the exact opposite of what nineteenth-century empiricism recommended for restorations.

—∿—

One might think that the problem is not very different as far as reconstructions are concerned. Even reconstruction is evidence of human action and represents a historical moment, but it is not the same as an addition. An addition can *complete* a work or can function, particularly in architecture, differently than was originally intended. With an addition there is no imitation; there is, rather, a development or an insertion. A reconstruction, on the other hand, seeks to reshape the work, intervening in the creative process in a manner that is similar to how the original creative process developed. It merges the old and the new so that they cannot be distinguished, abolishing or reducing to a minimum the time interval between the two creative moments. The difference is therefore striking.

—∿—

If we thus come back to the alternatives of conservation or removal from a visual, historical perspective, we will consider it appropriate, whenever possible, to return a monument to that state of imperfection in which it had been left by the historical process, and which ill-considered restorations have instead completed. However, we should always respect the *new* unity that, independently of the foolishness of restorations, was established within the work of art through a new fusion; the more this fusion affects the work of art, the more it is also a real source of historical material and testimony.

Thus an addition will be worse, the closer it comes to being a reconstruction; while the reconstruction will be all the more acceptable, the more it differs from an addition and tries to form a new unity in place of the old one.

One can point out, nonetheless, that even the worst reconstruction does, in fact, document human activity, albeit an erroneous one, and that it is still part of human history. Thus it should not be removed—at the most it can be isolated. This position would seem to be historically unassailable if it did not, in fact, lead to a conviction of nonauthenticity or falsification for the entire work of art. Such a conviction would lead us to question the very veracity of the monument as a historical monument: this cannot be allowed at the level of philological critique. Furthermore, a similar requirement to completely conserve all phases through which the work of art has passed must not contradict the aesthetic requirement.

The Integration of the Image: Problems in the Restoration of Monuments

GIOVANNI CARBONARA

Restoration between Theory and Empiricism

From antiquity to the present, the historical fickleness of the very concept of conservation and the emphasis on either practical craftsmanship or subtle theoretical interpretation of principles have not been able to exclude an issue that is always present in restoration: the more-or-less conscious link between restoration and aesthetics; between restoration and how each time period conceptualizes art.[1] . . .

The link between restoration and the related concept of art and, by extension, of architecture, is thus a constant issue that prompts one to carefully investigate this relationship from a philosophical or, if you wish, an empirical point of view: philosophically, in the sense that from the very concept of art one rigorously deduces the concept of restoration,[2] thereby systematically developing a theory and methodology of intervention; and empirically, which is outside any concept or ontological conception of art, by identifying each time, within the framework of specific works of art, the artistic and historical qualities that one wishes to keep or recover, thereby establishing the extent and the nature of the restoration.

Yet the different approaches, far from being considered academic differences that can always be reconciled in the name of a common interest for conservation, derive instead from "major discrepancies,"[3] as shown by the fierce controversy in 1950 between the British and the Italians over the cleaning of early paintings in the National Gallery of London. The particular

From Giovanni Carbonara, *La reintegrazione dell'imagine: Problemi di restauro dei monumenti*, chap. 1 (Rome: Bulzoni, 1976), 31–89. Used by permission of Bulzoni editore s.r.l. Translated by Gianni Ponti with Alessandra Melucco Vaccaro.

British concept of the historical significance of a work of art was seen as respect for the artist's original intent and perceived as an attempt to "return the work to the state in which the artist wanted it to be seen."[4] This concept clashed with a broader perspective, supported by Brandi, which considered the work of art in its original form, but also included the historical values stratified upon it by time from the moment it was completed by the artist to the moment it impacted the conscience of the modern viewer. These stratifications were manifest in the *irreversible,* physical transformation of the materials; in changes in viewing conditions, in figurative culture, and in the viewers' perceptive sensitivity. All of this explained how the attempt to reestablish "the original state" was a purely mythical endeavor that could never be obtained; one could only have a "present state of the material."[5]

—⚏—

In an attempt to underline the anything-but-empirical concept of a strong link between restoration and aesthetics, we sought to emphasize how the "major discrepancies" mentioned above were not due to a contrast in technical methods, but rather to "unshakable aesthetic positions: British empiricism and Italian idealism."[6]

—⚏—

Yet the issue unexpectedly changes scale and becomes problematic when, particularly in architecture, one moves from theoretical premises to practical intervention. The danger of betraying guiding principles is always present when faced with the difficulties of individual concrete cases. They seem to justify setting aside the development of principles as useless, academic baggage, in favor of direct and active contact with the monument. The objection to a systematic view—with all the effort that a thorough critical and historical approach implies, and the limitations that it imposes on an impartial planning process—comes from professionals who now and then deal with these problems. But even more violent objections come from certain officials who are overwhelmed by the excessive workload caused by the disastrous condition of our conservation services and by all kinds of administrative obstacles. At the same time, these civil servants, protected by official sanction, too often believe that they can do the work, and do it well, without a healthy debate and constant verification of the conservation criteria used in such a sensitive field, which is neither bureaucratic nor professional but strictly cultural.[7]

Finally then, having reaffirmed the need for a clear theoretical framework to be used as a philosophical and scientific basis for dealing with the problem, the most urgent need is to transform the framework into "practical principles that cannot be considered empirical" [see Reading 35, Brandi, page 341], and above all to initiate controlled experimentation. All of this should be enlivened by an open debate, by the exchange of ideas, opinions,

and results among all of those who are interested in these issues for cultural or official reasons.

—∿—

Scientific Restoration: Observations

Interest in the *monument as a document* "of art and history" is the main characteristic of this concept of restoration, which in Italy, at least on a theoretical level, had a hold on the field throughout the entire first half of the twentieth century. Already defined in its essential terms by Camillo Boito since the last quarter of the nineteenth century,[8] it then received more complete elaboration thanks to the steadfast work of Gustavo Giovannoni.[9] For decades it has been treated as an absolutely rigorous enunciation. For the perfection and consistency of its principles, it has been considered the last word in the field of restoration. Yet, as with all historical concepts, even the precepts of scientific restoration have been shaken and weakened, both by the dramatic events of the war, which have shown that they are not applicable universally, and by new developments in thinking about art and, therefore, architecture, that have demonstrated the concept's limitations and outdated character. Its "scientific" principles have not necessarily lost their validity, nor have they been disproved. Rather, they have been viewed justifiably as being limiting, incapable of encompassing the complete artistic and documentary reality of monuments, and thus have been considered insufficient for guiding intervention methods.

Careful analysis has shown that this concept of restoration is more "philological" than scientific, in the full sense of the term. It is tied to a way of understanding art, and particularly architecture, that is essentially positivistic and classificatory with attention to evolutionary and stylistic aspects, but that is insufficient for reaching a historical understanding of the monument.[10] A historical understanding requires "further work" (Croce) in overall critical reevaluation and in aesthetic appreciation. In terms of the two "requirements" raised by Brandi, around which the whole problem of restoration revolves, the philological method tended to take into consideration only the historical one, as if there were "no difference in importance between a ruin[11] and the most beautiful and admired monument,"[12] with the result that restoration was deprived of most of its meaning.

—∿—

Restoration as a critical act and restoration as a creative act are the two conceptual issues reconsidered and clarified by Renato Bonelli. In numerous writings,[13] he sought, on one hand, to underline the limitations of Brandi's formulation and, on the other hand, to emphasize the vast operational influence of the method, an ideal reference point valid also for a

broader application: from monuments to the urban environment, from simple maintenance problems to the integration of the most badly damaged images.

Bonelli's criticism of philologism is stinging: "The idea of attributing the character of authentic testimony of a historical past to a monument or to a building is no longer current. First of all, this is equivalent to working on an arbitrary section in the real unity of the work, trying to select elements that cannot be isolated. ... [T]he philological criterion requiring that structural bodies must be authentic in order to obtain reliable 'information' from them, is a point of view that marks a certain era and culture,"[14] one imbued by positivism that witnessed the birth of scientific theories of restoration and that is by now obsolete.

The pure interest in authentic testimony is declared unacceptable because "an architectural work is not only a document but is, above all, an act whose form is the total expression of a spiritual world. ... For our culture, because of its artistic significance, it represents the highest form."[15]

—◊◊◊—

Recent Contributions: Restoration as Conservation

The concept of restoration as pure "conservation" is generically connected to the crisis of the aesthetic philosophies and, specifically for Italy, to the breakup of the legacy of Croce and the development of new critical interests.[16] Renewed interest in philological research, enlivened and reinforced by the modern contributions of the natural sciences and a mature historical sensitivity, calling for the respect of the work of art in its totality and thus also in terms of its most minute documentary value, prompted Argan to say: "In the field of art everything has meaning, everything is artistic ... even materials, techniques, supports, typological or iconographic schemes, even the state of conservation,"[17] and, finally, narrowly conservative ideas borrowed from urbanistic and sociological debate on the subject.[18]

—◊◊◊—

The basic dilemma—conservation or intervention, historical or aesthetic approaches in restoration—is nonetheless always present and cannot be solved by denying one of the issues; by acting either as unconstrained innovators or as stubborn, noncritical conservators. The dilemma can and should be dealt with each time by critical actions and choices that, as such, are necessarily subjective, but not necessarily unfounded or arbitrary.[19]

—◊◊◊—

If it is absolutely impossible to "go back to the monument," meaning the original one, would it not be possible and desirable, by working and reusing the ancient fragments as incentives and starting points, to go back to

a new, original creation that would also respect the needs of conservation? The result would certainly be a different image, and not a substitute for the lost original. It would be a redesigned image with the existing remains used and reinserted next to new elements, creating a figurative "circuit." We would not have *the monument* of old but *a monument* that emerges anew—an independent architectural expression, even if fragmentary, that respects the basic integrity of what the past has handed down to us.

In other words, the problem can be posed in the following ways: In order to meet the historical and aesthetic requirements of the ancient monument,[20] is it absolutely necessary to restore the monument according to procedures that are formally "indifferent" or "neutral," albeit "scientifically" reliable? Or can the monument, if only for the absolute respect it is owed, be introduced in a new visual equilibrium (or deliberate disequilibrium or dissonance, but this is another problem)?[21] It is a matter of giving back to the object or to the architectural element to be restored not only a worthy physical context, but a figurative context—no longer the original one that is lost or irrecoverable, nor the atrophied and incomprehensible one of a too-badly damaged image. The new context has to derive from placing the object in a new "artistic work," so the object becomes part of the structure into which it is inserted, by maintaining an independent legibility and by joining with other new elements. The process is not too different from what one sees in a well-planned and scientifically conceived museum, in which the items on display (down to the last detail, such as the showcases, lighting, colors, supports, and reinforcements) interact with the architecture that contains and protects them (Fig. 1). In this way, the objects are presented in a whole series of planned views and, at the same time, in a manner that displays the individual object in the most congenial way.

Notes

1. [30] CESARE BRANDI, "Il fondamento teorico del restauro," *Bollettino dell'Istituto Centrale del Restauro* 1 (1950): 5–12; GIUSEPPE LA MONICA, introduction to *Ideologie e prassi del restauro con Antologia di testi* (Palermo: Libreria Nuova Presenza, 1974); CESARE CHIRICI, *Il problema del restauro: Dal Rinascimento all'età contemporanea* (Milan: Ceschina, 1971), with the permission of E. Garboni, passim.
2. [35] This is the intention expressed by BRANDI in "Il fondamento," 6.
3. [36] Ibid.
4. [37] CHIRICI, *Il problema,* 198, and CESARE BRANDI, "Some Factual Observations about Varnishes and Glazes," appendix 6 in *Teoria del restauro* (Rome: Edizioni di Storia e Letteratura, 1963), 129 (originally published in *Bollettino dell'Istituto Centrale del Restauro* 3–4 [1950]: 183–88) [see Reading 35, pages 339–42].

Figure 1
New wing of the Vatican Museums.

5. [38] PAUL PHILIPPOT, "Historic Preservation: Philosophy, Criteria, Guidelines," *Preservation and Conservation: Principles and Practices,* ed. Sharon Timmons, proceedings of the North American International Regional Conference, Williamsburg, Virginia, and Philadelphia, Pennsylvania, 10–16 September 1972. On the problem of recovering the "original state," see also the reflections of E. H. GOMBRICH, *Art and Illusion: A Study in the Psychology of Pictorial Representation,* Bollingen Series 35, A. W. Mellon Lectures in the Fine Arts 5, Washington, 1956 (London: Phaidon, 1960) [see Reading 11, pages 110–28]; and those of BENEDETTO CROCE, *Estetica come scienza dell'espressione e linguistica generale: Teoria e storia,* vol. 1 of *Filosofia come scienza dello spirito* (Bari: G. Laterza & Figli, 1945), 136–40, on the capacity of historical interpretation, more than the actual restoration of the "physical object," to reinstate the conditions for our appreciating an ancient work of art.

6. [41] BRANDI, "Il fondamento," 6.

7. [69] "The conviction that the truth of culture is one thing and the strategy appropriate to pursue to protect the property of that same culture is quite another" (Roberto Pane, "Il monumento per l'uomo: Atti del II Congresso internazionale del restauro," introductory lecture at the Second International Congress of Restoration, Venice, 25–31 May 1964, published in French in *Il monumento* [Marseilles: ICOMOS, 1972], 10–11) reappears in the writings of several *soprintendenti* [superintendents] to justify their diffidence, not only toward "theoretical and abstract principles, which would perhaps be entirely praiseworthy insofar as theory and abstraction are concerned but which must, through the force of circumstances, yield to the evidence of particular cases," but also toward people "nourished on abstract theories." In this respect, cf. the polemic launched by GIUSEPPE FIENGO in *Restauro* 2, no. 9 (1973): 79–92.

8. [77] CAMILLO BOITO, "Ordine del giorno sul restauro" at the Convenzione nazionale degli ingegneri e architetti italiani [National Convention of Italian

Engineers and Architects], Rome, 1883; *I restauratori: Conferenza tenuta all'esposizione di Torino il 7 giugno 1884* (Florence: G. Barbera, 1884); "I nostri vecchi monumenti: Conservare o restaurare?" *Nuova Antologia* 87 (June 1886): 480–506; *Questioni pratiche di belle arti: Restauri, concorsi, legislazione, professione, insegnamento* (Milan: U. Hoepli, 1893).

9. [78] Of Gustavo Giovannoni's writings, other than those quoted elsewhere, we mention only: *Questioni di architettura nella storia e nella vita: Edilizia, estetica architettonica, restauri, ambiente dei monumenti* (Rome: Biblioteca d'Arte, 1929); *Vecchie città ed edilizia nuova,* Collana di urbanistica 1 (Turin, Unione Tipografica-editrice Torinese, 1931); his entry "Restauro dei monumenti," *Enciclopedia italiana di scienza, lettere ed arti* 29 (Rome: Istituto Giovanni Treccani, 1936): 127–130; *Il restauro dei monumenti* (Rome: Cremonese, 1945), besides other documents directly inspired by him: *Atti della Conferenza internazionale di Atene pel restauro dei monumenti* (Athens: n.p., 1931); Ministero per l'Educazione Nazionale, Consiglio Superiore AA.BB.AA., *La carta del restauro* (Rome: n.p., 1931).

10. [79] On the "truth of dating" and these matters, cf. Renato Bonelli, *Architettura e restauro,* Raccolta pisana di saggi e studi 3 (Venice: N. Pozzi, 1959), 30–35, and, indirectly, Brandi, "Il fondamento," 114.

11. [80] Which, as we know, is for Brandi the borderline case of the transformation of a work of art that, having almost completely lost its form, is reduced to a purely historic document; cf. *Teoria del restauro,* 58–60, and his entry "Restauro" in "Concetto del restauro: Problemi generali," in *Enciclopedia universale dell'arte,* vol. 11 (Venice-Rome: Istituto per la Collaborazione Culturale, 1963), cols. 328–29.

12. [81] Bonelli, *Architettura,* 31.

13. [96] See note 22 [in original edition] and particularly Bonelli, *Architettura,* the first chapters, of a theoretical and methodological nature, 13–58; and, as an interesting proposal with practical application according to new criteria, "Il pavimento del Duomo di Orvieto e il suo rinnovamento," *Bollettino dell'Istituto Storico Artistico Orvietano* 5 (1949): 1–7.

14. [97] Bonelli, *Architettura,* 19–20.

15. [98] Bonelli, his entry "Restauro architettonico," *Enciclopedia universale dell'arte,* vol. 11 (Venice-Rome: Istituto per la Collaborazione Culturale, 1963), col. 347.

16. [156] Manfredo Tafuri, *Teorie e storia dell'architettura,* Biblioteca di cultura moderna 649 (Bari: Laterza, 1968), 13. "Né è più possibile rifugiarsi in quella che, per tradizione, è stata la valvola di sicurezza della critica: il giudizio assolutorio o di condanna sull'opera in sé" [Nor is it any longer possible to take refuge in what has traditionally been the safety valve for the critic: the judgment that either absolves or condemns the work of art in itself], notwithstanding that "non vorremmo si equivocasse: non intendiamo affato dire che il giudizio debba essere eliminato in una sorta di limbo relativistico ove *tout se tient*" [we would not want to be misunderstood: we do not mean at all that judgment must be eliminated in a sort of relativistic limbo where *tout se tient* (everything holds together)]. Rather, we are contesting the dogmatic attitudes of critics that are considered absurd, faced with the present disconcerting panorama that leads, rather, to a kind of "provisional suspension of judgment" and to a rethinking of the intrinsic meaning of criticism itself.

See also Maurizio Calvesi, "Riscoprire il ruolo del museo," *Corriere della sera,* 6 April 1975. "[Il] 'critico' [deve poter] dire la sua non già emettendo verdetti di qualità o pronunciamenti di fede ... ma estraendo ... il senso di un discorso, di un tema, di un assunto" [The 'critic' (must be able to) say what he has to say without already pronouncing verdicts on quality or statements of belief ... but extracting ... the sense of a discourse, theme, or issue].

17. [157] Giulio Carlo Argan, *Conoscere per poter conservare* (n.p., n.d.).

18. [158] Compare the declarations of the Gubbio Convention, "Salvaguardia e risanamento dei centri storico-artistici: Dichiarazione finale," *Urbanistica* 32 (December 1960), and the bibliography quoted in La Monica, *Ideologie e prassi del restauro,* and, especially, in Ado Giuliani, *Monumenti, centri storici, ambienti: Sviluppo del concetto di ambiente, teoria ed attuazione in Italia* (Milan: Tamburini, 1966).

19. [169] As, on the contrary, Armando Dillon would seem to have us understand in *Interpretazione di Taormina: Saggio sull'architettura e notizie di restauri* (Catania: Società Editrice Internationale, 1948), cited in Carlo Ceschi, *Teoria e storia del restauro* (Rome: M. Bulzoni, 1970), 199: "Nella valutazione del maggiore interesse di una struttura rispetto ad un'altra, l'opera del restauratore diventa soggettiva e talvolta arbitraria" [In evaluating the greater importance of one structure with respect to another, the work of the restorer becomes subjective and sometimes arbitrary]. Subjective undoubtedly, but not arbitrary if carried out with historical-critical intent. The thinking of Paul Philippot ("La notion de patine et le nettoyage des peintures," in *Bulletin de l'Institut Royal du Patrimoine Artistique* 9 [1966]: 138–43) is, by the way, very clear: When does one fall into the "pure subjectivité du goût personnel? Ce sera le cas, sans doute, chaque fois que le problème critique sera éludé parce que le restaurateur n'en aura pas pris conscience, et se laissera guider par ses seules préférences personnelles" [pure subjectivity of personal taste? That will undoubtedly be the case each time the critical problem is evaded because the conservator did not take note of it and allowed himself to be guided by his own personal preferences], 139–40 [see Reading 39, page 374].

20. [187] Which, besides its conservation, requires that the monument not be reduced to a "caricature" of itself, through absurd changes in its function, fortuitous choices of color, or insertions into inappropriate urban fabrics; as, for example, the Sedia del Diavolo and San Giovanni Conca in Milan.

21. [188] See, in this respect, the interesting observations by L. Grassi, "Monumenti e problemi di storia del restauro," in *Restauro architettonico* (Milan: Cesare Tamburini, 1961), especially 24–28.

Knowing How to "Question" the Object before Restoring It

ALBERT FRANCE-LANORD

I have often noticed that the development of the use of scientific research methods has a tendency to modify our behavior when we are faced with an object, and in particular an art object. The concepts resulting from physico-chemical examination appear more accessible, more precise, more certain than the traditional ideas of historians and critics of art, ending in a tendency to consider as worthy of interest only those conclusions drawn from interpretations of analyses. And however difficult these risky and provisional conclusions may be to establish, we can guess the danger that exists in not first defining limits for the use of these methods and their margins of error.

This tendency is not without its repercussions for the conservation of works of art. This is why it is advisable to remind not only restorers and museum conservators but also all members of the public interested in art and archaeology of a particular and somewhat ignored aspect of the conservation of antiquities.

A fictional situation will assist the reader in entering a part of the museum generally closed to him: If tomorrow some especially happy archaeologist were to bring me the miraculously rediscovered pieces of the Soissons vase, what kind of work would I undertake? Must one, as was the case with the Vix krater, reshape the deformed fragments, put them back together in a solid and undetectable fashion in order to return the work of art to its former glory and enhance the beautiful colors of the mineralized layer of metal, evidence of its long burial? I would be content, after a delicate cleaning, to

From Albert France-Lanord, "Savoir 'interroger' l'objet avant de le restaurer," *Archeologia* 6 (September–October 1965): 8–13. © 1965 *Archeologia*. Originally excerpted from a conference presentation by the author and Nicole Bichaton at Spoleto, Italy, 1964. Used by permission of Editions Faton s.a. Translated by Garrett White.

examine how this celebrated vase was made, to determine whether or not, as legend has it, it was shattered by a battle-ax, and I would return the fragments of this object to the museum, which ought to display them as they are, for its meaning, the message it brings to us, is that of having been intentionally broken.

—⁓—

The work of art, the weapon, the piece of jewelry, oxidizes, corrodes, and little by little returns to its mineral state. This alteration affects their form and matter as a consequence of a practically irreversible process of destruction.

The treatments and care we administer in the laboratory ought to return to the object, as much as possible, its significance. In addition, they must slow the processes of destruction and ensure the survival of the object. This is possible by means of treatments entrusted more and more frequently to scientists, or to individuals who, struck by the apparent rigor of scientific operations, have a tendency to consider only this aspect of conservation. As the sound principles of scientific conservation spread, it must be remembered that the work of art is not composed solely of matter, and that what is "left over" must also be taken into consideration.

The first question that arises when confronted with an object is: Why and how should it be conserved? We are guided by demands such as its form and composition, its rarity or integration into a particular archaeological context. But the object is not just inert physical matter, the restoration of which has the goal of repair; restoration means to renew not only a material but a product of human activity. Whether it is a matter of works of art or simple objects, they are important not only because they are old or composed of matter but also because of all they hold that is still alive in them, which, after the work of the excavator, we must again bring to light.

—⁓—

We have seen that matter is found to be modified over the course of time by a series of irreversible processes. The activity of conservation cannot therefore aim to bring back the material from which the object was made; it must instead restore to the object all of its meaning as an embodiment of the imagination. In addition to the meaning it may have had in the time it was created, this object is also a message for us, charged with very diverse meanings. We now see appear all of the importance of its human aspect and the repercussions it may have for the data of conservation.

The meaning of this message varies considerably in each case. It may be exclusively documentary in nature, carry a purely aesthetic or historical sense, or it may present many aspects at once.

—⁓—

Each of these objects has been affected in the course of time by many different kinds of deterioration—corrosion, deformation, recent or ancient damage—and also by unskilled or ill-timed restorations. The object will have been modified in terms of its material, its form, and its decoration. These alterations may be progressive, and the object may soon enough disappear. We have seen that metals, because of their surrounding environment, suffer extremely profound structural changes. In the ground, after a certain amount of time, they may reach a state of equilibrium and cease to change; they are stable. In removing them from the ground, this equilibrium is broken, subjecting them to new rapid and dangerous changes if certain precautions are not taken. We know how much the air in cities has become polluted over many decades. Statues that were stable for centuries are "tormented," like the gilded bronze horses of San Marco in Venice, posing delicate problems for conservation.

We are thus confronted with a metallic object, an organized, individualized "personage" hit by a progressive disease, corrosion, which calls for a treatment appropriate to its nature. The moment of restoration has arrived, and we now enter the laboratory or atelier, steadfastly determined to proceed to the many necessary treatments—cleaning, repair-restoration, stabilization, exhibition-preservation—while respecting all of the scientific data of the problem so as not to alter the object-material that has been examined, analyzed, and X-rayed for the purpose of defining its physical condition. But now the imperatives just expressed must take into consideration respect for the human context of the object-message.

—⚏—

Questions arise as soon as one begins the first operation, which is cleaning. It consists of removing elements and matter foreign to the object, which adhere to it and have become more or less one with it. This may be simple—as in the case of pottery or gold objects—if the metal has not altered to the point of losing a substantial part of its mass, which has formed, with certain elements in the environment in which the object was found, foreign matter such as rust or oxides that one must sometimes remove or, sometimes on the contrary, preserve.

In the course of cleaning or stripping operations, the restorer is guided by the notion of the epidermis of the object. All that is exterior to what was the original surface of the object must be removed, everything below it must be maintained. The rule is simple, and gives meaning to the confusing notion of "patina." This word, banished from the vocabulary of specialists, has been and continues to be employed to mean just about anything. It ought not to refer to anything other than artificial alterations made to the surface of a metal to accentuate its relief, and by extension, to the mineralized layer of carbonates and sulfates that form on bronzes exposed to the air. It should

never be applied to mineralized objects uncovered in the ground. The notion of conserving the patina of these objects signifies nothing precise. On the contrary, we look for an epidermis that is on occasion admirably conserved under a crust of mineral products. Color itself means nothing; an ancient bronze is not necessarily green, the mineral components of copper possess extremely variable colors: malachite greens, azurite blues, and red cuprite, to name only a few.

In the case of iron objects completely transformed into magnetite, one will have to undertake a veritable work of sculpture to rediscover the original surface, often difficult to detect.

The appearance we must search for at the end of this stripping process clearly depends upon the purpose of the object. If the metallic core of an iron weapon is satisfactory, it is enough to reveal the appearance of the material.

(a)

Figure 1a, b
Halstattian urn from the Saint-
André coast, bronze (a) in
fragments, and (b) reconstructed,
650 mm in height.

The surface of a bronze statue, upon which light should play, must regain its smoothness and polish. A piece of silverwork blackened by sulfates and brown with chlorides is inconceivable unless polished and brilliant. Dirt cannot be maintained on the pretext of proof of authenticity, which can be established with certainty using other much more serious physical criteria. Nevertheless, oxides can preserve certain traces that are messages in themselves, as, for example, in the case of a Halstattian urn [Fig. 1a, b] that has been uncovered enveloped in a wonderfully mineralized cloth. In order for this object to remain "meaningful," it is obvious that this remnant of textile would have to be conserved. On the contrary, traces of the leather that covered the Vix krater have been removed, for they harmed the beauty of the object.

(b)

We can see how much the choice of working methods is determined by essentially human considerations.

Introduction to Archaeological Conservation

MARIE BERDUCOU

Part 1: Concerning the Conservation of Cultural Property
The Idea of "Cultural Property"

This expression, for not having been often defined, is today one of the terms most frequently used to cover, for better or worse, the immensely diverse mass of documents of all types upon which our societies confer a particular artistic, historical, or ethnological interest. According to what criteria do they assign this kind of "spiritual supplement" to the strict materiality of these objects? The answer is not always easy. A glance at national legislation that seeks to establish legal regulations for this special category[1] clearly shows the difficulty: attempts at definition often quickly become a drawn-out cataloguing process. Readily applicable criteria are undoubtedly symbolic of the capacity of the society under consideration to understand and represent its present and its past, as well as those of others; their fluctuation according to place and era is obvious to anyone.

The extremely broad and hazy concept of cultural property appeared only in recent decades. Immediately employed by numerous international organizations working in the cultural domain,[2] it seems little by little to have encompassed and supplanted established categories—works of art, antiquities, curiosities, specimens—all of which came to be confused, not long afterward, with the very notion of culture. The extraordinary outmoding and

From MARIE BERDUCOU, "Introduction à la conservation archéologique," chap. 1 in *La conservation en archéologie: Méthodes et pratique de la conservation-restauration des vestiges archéologiques*, ed. Marie Cl. Berducou (Paris: Masson, 1990), 3–15, 24–26. © Masson, Paris, 1990. Translated by Garrett White.

relativization of these classes of objects, as witnessed, for example, by the heterogeneous character of the collections in the better part of our museums, certainly points toward a multitude of processes, constituting for the historian or sociologist a field worthy of research and reflection. Of these processes, perhaps not all depend solely on the evolution of ideas. The role of various "cultural markets," notably the art market, and the successive trends that feed them, suggest, for example, other analyses. But for what is essential to our interests here, we think first of the rise of the social sciences, especially archaeology. These disciplines, in their search for knowledge about man and his individual as well as collective methods of operation, are today channels for tracking down information in ever larger fields of exploration. Thus, in a few decades, the objects of archaeological study—beginning with prehistoric archaeology—have multiplied, and the documents in its purview are of such diversity that it would be impossible for us to give an exhaustive presentation in this text. At the same time, the majority of these objects lend themselves to more and more complex studies, as if each were a potential carrier of multiple meanings, each of these accessible only through specifically relevant research. In short: more and more objects, more and more questions to ask of them!

In this way, archaeology provides a good example of the ways in which a growing number of widely divergent documents have acquired a cultural nature, in this instance as sources of information about the history of man and his environment. Are all of these documents cultural property?

To pose this problem is to inquire less into their nature than into their status and the fate we reserve for them. Indeed, whatever their nature and related functions (to make known, educate, contemplate, invest), cultural property is not found to be decisively clarified except through its implicitly "patrimonial" character, even to the point of frequently observing a certain confusion between the notions of cultural property and cultural heritage, the latter embracing a still more vast domain (oral traditions, patronymics, choreographies, rituals and ceremonies, et cetera) not entirely embodied in a succession of cultural "things." In this light, the word *property* says as much as the word *cultural,* speaking to us above all of appropriation and heritage, the "common heritage,"[3] the material expression of which is as much to collect as to transmit, which is to say, *conserve.* It is hardly oversimplifying to say that a cultural property is not plainly recognized until the moment we become concerned with its conservation. And if specialists in conservation are not privileged officials—neither more nor less than other social actors, which is as it should be—responsible for the choices that go into conferring upon this or that object the status of cultural property, their discipline is certainly the tool that assures the practical realization of this vast corpus.

The Conservation of Cultural Property

Cultural property ... Did you say *cultural property*? How strange ... I heard *conservation!*

It is true that the expression *cultural property* arose only to conveniently designate a series of things, difficult to define in a restrictive or precise manner, but which we take the trouble to conserve. There are no texts that speak of cultural properties in the absolute. Wherever we encounter them—even when their definition varies—it is a question of their conservation.

What does it mean to conserve?

Conservation is the ensemble of means that, in carrying out an intervention on an object or its environment, seek to prolong its existence as long as possible. The first goal of conservation is to ensure the *durability* of cultural property. The means implemented for this goal must in no way affect the nature of this property, neither its material constituents nor the meaning or meanings those materials convey; conservation respects the *integrity* of the object. Operating in this way, conservation brings its technical assistance to a global project: the formation of a useful heritage, a heritage capable, in other words, of being studied, displayed, or archivally preserved, as the case may be, but always offering a certain *accessibility*.

The act of reserving special treatment for certain human productions of the past or present—with the goal of bestowing upon them a form of permanence—goes back a long way. In a recent article,[4] Alain Schnapp cites a very beautiful text concerning Nabonidus, king of Babylon in the sixth century B.C.E., who quasi-archaeologically researched and reconstructed in its original state the temple of Ebabbar, founded by one of his distant, illustrious predecessors, King Hammurabi, some twelve centuries earlier. But to maintain the permanence of a function (useful, symbolic, or otherwise) is not conservation in the current sense of the word. Conservation supposes an awareness of the materiality of the objects in which we are interested, and of the twofold consequence of that materiality: their irreplaceable nature and their physical vulnerability to the test of time. The most modern feature of this conception can be found in the notion of integrity. To respect the integrity of an object is to recognize in it a kind of inviolability; to avoid bringing harm to the original material from which it is made; to devote oneself to as wide a perception as possible of each of its parts, features, and possible interpretations; to leave it untouched by any intervention that would definitively limit alternative treatments or subsequent ways of comprehending it. What formidable requirements! The ruin, in the not too distant past, to which we have been led by methods of "conservation" that did not subscribe to this principle of integrity (massive repairs and reconstructions undertaken

to the detriment of original parts, occasionally sacrificed or irremediably altered) is without doubt responsible for this new state of mind. Two of the great texts that well illustrate this progressive state of mind, the Charter of Athens (1931) and the Charter of Venice (1964), were drafted mostly by architects concerned with the principles to be applied to the care of historic monuments, clearly the objects (and occasionally the victims) in the previous century of harsh polemics and extreme appraisals.[5] But the developments mentioned above, such as in archaeological research, are no longer strangers to the current vigor of the concept of the *integrity* of cultural property. We know that today an archaeological object yields a great deal more information than in the past, and it is in probing its material composition that some of that information, until quite recently hidden and unsuspected, has become accessible. The cultural character of these objects has changed and become more complex; it has gone beyond their apparent form and value as evidence. Even their material composition is no longer a simple expression of their authenticity. Their authenticity is in their structure, their physicochemical makeup, the potential source of new learning.

Certainly, to try to ensure both the durability and integrity of an object may pose an impossible challenge. In order to stabilize it, to slow the processes involved in its alteration, modifying its material constituents is sometimes unavoidable. This is what is implied, for example, in nearly all of the treatments of consolidation by impregnation treatments that we nevertheless already know will frustrate certain kinds of analysis or dating. A fortiori, how do we guarantee that our interventions, which are necessarily based on our current state of knowledge, will not compromise a future investigation that we are as yet incapable of imagining!

That is clearly impossible. But the reply is altogether simple: What will we be able to study tomorrow of an object that has disappeared?! Matter ages, ineluctably, and transforms. We can only slow these phenomena by acting upon the conditions in which that matter is placed (preventive conservation) and upon the matter itself when necessary (treatments of consolidation and stabilization), *all while sacrificing as little as possible of its integrity.* That is an initial compromise.

There are others. The majority of the objects we have taken upon ourselves to conserve have already aged; they are altered and may be at times unrecognizable or unintelligible. A mural painting may be partially hidden by concretions, a stained-glass window partly obscured by the products of its corrosion, a metal object practically without an identifiable form. Where is their "integrity"?

Their current state amalgamates (unfortunately, sometimes without much distinction) paint, stained glass, a metal object; namely, whatever

remains of them or attests to their existence and the products of their transformation over the course of time, products resulting from interactions established in the milieu in which they have survived until now.

To decipher this amalgam and simply recognize an extremely altered object, as archaeology is often able to do for us, meticulous research of what remains of the initial object—which must be differentiated from what masks it—is necessary. It is through this research, at times difficult, that the object becomes truly *accessible*. It ends in a commonplace—but never banal—operation generally referred to as cleaning: the elimination of all or part of the products of alteration. During cleaning, we excavate—almost in the archaeological sense of the word—what is to be conserved; the understanding of the object elaborated at this stage of the work becomes established more or less definitively and determines the reading of it that will henceforth be possible. One must constantly evaluate what has been eliminated, which is nevertheless always a testimony, if not to the initial object, then at least to a part of its history: its aging.

The problem may become even more complicated when a cultural property comes down to us transformed by earlier interventions that have degraded, damaged, or misrepresented it, thereby imposing upon us a reading considered debatable today. One must then make a judgment concerning an eventual "de-restoration."

Thus, we can appreciate the immense degree of difficulty involved, in actual practice, in rigorously respecting the integrity of an object, even when that object is at times discovered or rediscovered *not in its original state (which has disappeared) but through the interpretation of the present state of what remains of it, and this often at the price of abandoning part of the trail of its material history.* This sacrifice is also a compromise between the necessity of reaching the object to be conserved and the desire to lose nothing that concerns it nor information conveyed by it, even indirectly.

We can easily deduce from the foregoing that the conservation of cultural property requires both a multidisciplinary approach and the opposite of a spirit of dogmatism. Every intervention is a special case that must be preceded by as complete a study as possible of the object at hand: the nature of its material constituents; the information, messages, or values it carries; the context in which it would be appropriate to situate it; an appraisal of its state of alteration; the probable causes of that alteration; and a prognosis of its possible evolution. . . . Before manifesting as a series of technical gestures performed on the material, conservation is first a critical research into the object and its characteristics[6] The sum of the transformations it has undergone throughout its history certainly influences what can be understood of it; there is, then, a dialectical relationship between the preliminary study that

guides conservational interventions and the elements of identification and interpretation in turn provided by it. In the end, technical intervention itself (what is removed, what is found to be modified, what is eventually added) is *the concrete expression of a critical judgment* thus formed in the course of this process.

To Conserve and/or to Restore ...

Is the work of conservation we have just set forth—consolidation, stabilization, cleaning, de-restoration—a matter of what we currently call restoration and the sphere of activity of those whom we call "restorers"?

Customarily, conservation and restoration are presented as two alternative choices. "It is essential to differentiate between conservation and restoration. ... Fundamentally, conservation may be defined as an operation aiming above all to prolong the life of an object by preventing, for a more or less long period of time, its natural or accidental deterioration. Restoration, on the other hand, may rather be considered a surgical operation comprising in particular the elimination of later additions and their replacement with superior materials, going on occasion as far as to reconstitute what is called— incidentally, in a somewhat incorrect manner—its original state."[7]

This definition has no unanimous support; in reality, the meaning given to the words *conservation* and *restoration* varies considerably according to author and country.[8] We could cite here as proof page after page of contradictory quotations. These contradictions, upon closer inspection, point less to opposing behaviors regarding treatments applied to cultural property than to a common difficulty, resolved differently by each: how to reconcile the word *restoration*, ancient and charged with history, with the new exigencies we have spoken of and that are undoubtedly better served by the more modern word *conservation*. Indeed, we know that the desire to embellish, at times to rejuvenate, or at the very least rehabilitate cultural property according to the expectations of contemporaries has long overshadowed other considerations.[9] These are the various attempts to "repair" that restoration has historically signified. How do we come to terms with this past?

We may be tempted to rid ourselves of the word *restoration* altogether, "or—as we say more readily today in order to distance ourselves from the practice of abusive restitutions—*conservation*," say the authors of a comprehensive work on the treatment of mural paintings.[10]

This is not always the attitude that prevails in the Latin countries, which are more inclined to keep the term and redefine it. One of the major texts on which the current conception of the restoration of works of art is based, *Teoria del restauro*, by Cesare Brandi,[11] defines it this way: "Restoration

is the methodological moment in which the work of art is appreciated in its material form and in its historical and aesthetic duality, *with a view to transmitting it to the future*" (our emphasis). Restoration can therefore no longer be considered separately from the notion of durability. Brandi's work closes with a chapter titled "Preventive Restoration." Restoration, updated in this way, encompasses the very content of the modern idea of conservation and remains the dominant word and concept.

In the Anglo-Saxon countries we see an opposite evolution. *Conservation* is almost always a generic term designating all of the technical actions carried out on an object and its environment, from research into the original material of which it is composed to preventive conservation, including, along the way, consolidation, stabilization, and so on. The word *restoration* is employed in a restricted manner to designate operations in strict alignment with the improvement of what subsists of an object, constituting, as it were, a specific and optional moment in conservation as a whole. The *conservator* is generally the person who ensures the execution of each of these interventions; the word *restorer* is becoming rare (above all in writing), employed occasionally in regard to easel painting or to signify a person specialized in the retouching and reintegration of lacunae.

In France, the fact that the words *conservation* and *conservator* are reserved for the designation of services and persons responsible overall for our museum collections clearly hinders a plain and simple transfer of the Anglo-Saxon terminology.

When, moreover, it is a matter of exhibiting the concrete works of conservation and/or restoration, it is occasionally impossible to make a theoretical distinction between that which falls under one and the other. A good many cleaning operations, for example, answer a twofold necessity: the elimination of certain products of alteration in order to improve the appearance of an object (an aesthetic or pedagogical goal), but also because these products present a danger to the original material. The corrosion of metal or stained glass often provides such examples. In many cases, the cleaning of textiles is also a measure that is as conservational as it is aesthetic. Likewise, we know today that certain materials used in the past as protective coatings, adhesives, consolidants, or to fill in possible lacunae, can generate substances while aging that are capable of degrading the original material of the object with which they are in contact; it is therefore not solely because an older restoration may be unsuitable on an aesthetic or historical level that the question of its removal is posed but perhaps also for reasons of conservation.

There are thus numerous situations in which the *same intervention pertains to both the improvement and the safeguarding of an object*. Indeed, it is self-evident that a treatment of consolidation, for example—strictly neces-

sary for conservation (this is what justifies it)—can by no means be con-
ducted without constant attention to its impact on the final appearance of
the object. In the same way, an intervention with a purely aesthetic aim, as
in the cleaning of superficial or inoffensive products of alteration or the
return of missing parts (reintegrations, restitutions . . .), cannot be under-
taken without assurance of its absolute harmlessness, now and for the long
term, to what remains of the object. The imperatives of conservation always
take precedence.

Conservation and restoration are, then, in terms of treatment, closely
linked. The first revolves around research, the understanding and long-term
preservation of the materials of which an object is made, and the sec-
ond relates to their enhancement.[12] In practice, the two procedures are not
easily separable.

This is undoubtedly the reason for the appearance somewhat recently
of the expression *conservation-restoration* as a reference to the ensemble of
technical interventions we have been discussing. These two terms placed
side by side imply, on the whole, conservation in the larger sense and restora-
tion in the restricted sense, conforming to the Anglo-Saxon vision. They have
the advantage of clearing up certain ambiguities and can be translated with-
out much misunderstanding from one language to another (contrary to their
use separately) to indicate the comprehensiveness and modernity of the sub-
ject: It is first and foremost a matter of ensuring the durability and integrity
of cultural property, of allowing for its study and preservation—conservation.
But it is also a question of striking a balance between the social usefulness of
this property, transmitted by the revelation and enhancement of its "mes-
sage"—aesthetic, historical, or other—and the constraints imposed by its
conservation.

Conceived in this way, the term *conservation-restoration* is a useful
tool—temporarily, in any case—for avoiding the pitfalls of a vocabulary
inherited from the past, as witnessed by its increasing use in texts with inter-
national scope.[13] In our estimation, the most important aspect of this link is
to have done away with exclusive definitions and to be moving toward a shared
system of procedures and requirements. Of what importance, finally, is an
absence of consensus on the terminology if there is agreement on the task?

Conservation, restoration, conservation-restoration—in the current
sense of these expressions, each pursues the triple objective set forth earlier:
the durability, integrity, and accessibility of cultural property. The only pos-
sible conduct when intervening concretely upon this property is one that is
based on a critical, well-researched appreciation of the object and that strives
to organize these objectives hierarchically and adopt a solution that offers the
greatest possible conciliation between them.

It is worth noting that to guide this endeavor, a number of principles have gradually formed that apply to cultural property of all genres (from paintings, posters, and photographs to archaeological objects, regional costumes, and African masks). These principles are not meant to be disciplinary. They are a series of signposts, theoretical reminders, and ethical markers largely elaborated and disseminated by and for those who "take action" on the objects, for which they bear the unavoidable ultimate responsibility, a fact, moreover, of which they are acutely aware.[14]

—⚹—

Part 2: Conservation in Archaeology

—⚹—

The Archaeological Specificity of the Object

Objects and structures do not become "classified antiquities," ruins or historic monuments, intangible evidence of the past or obvious fragments of the collective heritage the moment they are unearthed. Their "discovery"— which in a way is an extension of excavation—is often, to a degree, yet to be accomplished; and, at least for a while, they remain pieces of an overshadowing puzzle.

The first difficulty brought up by the intrusion of the archaeological perspective into conservation is the shattering arrival of *context* in a universe ruled habitually by *the object in itself* and the one-on-one relationship with it. Ah, context! When he works in archaeology, the conservator-restorer must quickly learn to take it into account.

There is first of all the immediate archaeological context, the surroundings of the object (what we may also call the associative context): certain aspects of the object's appearance, its function, its significance are not comprehensible unless the object is reinserted into the setting of its discovery. Otherwise it can easily be misinterpreted. One can fill in a deliberately perforated ceramic object, reconstitute or straighten a weapon intentionally broken or twisted, mistake wear for an alteration, a significant deposit for soil pollution, something unfinished for damage (or vice versa), or undertake a reconstruction of a group of fragments when half of the pit has yet to be excavated. Archaeological objects frequently do not speak for themselves, unequivocally at any rate; *their immediate archaeological context sheds light on them in a decisive manner.*

There is also the general archaeological context: what we already know of an object even before it is studied. The recognition of some traits rests in

part on preexisting hypotheses. We look for a given characteristic in a partic-
ular extremely altered object (a method of assembly, possible decoration, the
traces of a missing part) because its presence is attested to by others of the
same or similar type. The exploration of a group of glass or ceramic frag-
ments mingled indistinctly is infinitely faster if work is aided by a given idea
of the forms likely to appear. Thus, examination of the objects themselves is
guided (but not constrained) by signs furnished by known series or parallels;
the general archaeological context situates them in an ensemble of references.

Finally, there is the variable relevance of the object according to its
particular context, and here for the first time factors intervene that are, prop-
erly speaking, extrinsic to it and yet control to a large extent the treatment
applied to it: Two related objects—one found in a context of abundance; the
other a unique, even unexpected, specimen in its context of discovery—
do not receive the same attention. A structure is moved or dismantled to
allow for the excavation of the subjacent level and not because its conserva-
tion requires it. An object may be restored because it is a typological example,
among many other comparable specimens that will be disregarded; another,
on the contrary, will be restored because of interest in its variant features. *In
this sense, context relativizes the importance of archaeological objects.*

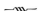

Toward a Personal Conclusion

In some countries more than in others, particularly more than in ours,
archaeological conservation already has a history.[15] And this history should
not be confused with that of archaeometry, for example, even if it is closely
aligned with what we might call the science of archaeological material. The
first methods for treating waterlogged wood appeared in Denmark in the
middle of the nineteenth century. The work conducted in that country after
1890 by Georg Rosenberg on environmental control, the conservation of
organic materials, and above all the conservation of metal resulted in critical
knowledge. In Berlin in 1888 and in London at the beginning of this century,
chemists were sought by archaeologists to study and combat the causes of
alteration in objects found in Egypt. The first general works on the conserva-
tion of antiquities were published before World War II.[16] It was under the
direction of a great archaeologist, Sir Mortimer Wheeler, that London's Insti-
tute of Archaeology introduced education in conservation, intended first for
students of archaeology, and later for future specialists in archaeological
conservation.[17]

. . . The contribution of archaeological conservation to the knowledge,
notably technical knowledge, of vestiges of the past is indisputable. Alas,
because we cannot conserve them, we may find materials that are of interest

today (leathers and skins, for example) that in the past we came to know only through exceptionally well-preserved finds. Conservation-restoration is also becoming the indispensable companion of archaeology in all of its media-related developments.

Notes

[Note numbers are not given in the original text. The following citations were prepared from the bibliographic material in the French edition and completed as information was available.]

1. B. Burnham, comp., *The Protection of Cultural Property: Handbook of National Legislations* (Paris: International Council of Museums [ICOM], 1974).
2. Unesco, *The Conservation of Cultural Property, with Special Reference to Tropical Conditions* 11 (Paris: Unesco, 1968); and *Convention on the Means of Prohibiting and Preventing the Illicit Import, Export, and Transfer of Ownership of Cultural Property* (Paris: Unesco, 1970).
3. Bernard M. Feilden, *An Introduction to Conservation of Cultural Property* (Paris: Unesco, 1979).
4. Alain Schnapp, "L'archéologie apparente," *Préface* 7 (1987): 59–60.
5. "Les restaurations françaises et la Charte de Venise," *Monuments Historiques*, éditions de la Caisse Nationale des Monuments Historiques et des Sites, 1977.
6. Paolo Mora, Laura Mora, and Paul Philippot, *The Conservation of Wall Paintings* (Bologne: Ed. Compositori, ICCROM, 1977), 1.
7. P. Coremans, "The Training of Restorers," in *Problems of Conservation in Museums*, Travaux et Publications de l'ICOM 8 (Paris: Editions Eyrolles, 1969): 15.
8. M. Berducou, "La Conservation archéologique," in A. Schnapp, ed., *L'Archéologie aujourd'hui* (Paris: Hachette, 1980), 163.
9. A. Conti, *Storia del restauro e della conservazione delle opere d'arte* (Milan: Electa Editrice, 1968; reprint 1973).
10. Mora, Mora, and Philippot, *The Conservation of Wall Paintings*.
11. Cesare Brandi, *Teoria del restauro* (Rome: Edizioni di Storia e Letteratura, 1963), 34 [see also Brandi, Reading 22, page 231].
12. C. Di Matteo, "Restauration des œuvres d'art," *Encyclopaedia Universalis* 15 (1985): 1035–43.
13. Icom Committee for Conservation, *Eighth Triennial Meeting, Sydney, Australia, 6–11 September, 1987*, 3 vols., preprints (Los Angeles: The Getty Conservation Institute, 1987).
14. American Institute for Conservation of Historic and Artistic Works [AIC], Committee on Ethics and Standards, *Code of Ethics and Standards of Practice* (Washington, D.C.: AIC, 1979).
15. M. Corfield, "Towards a Conservation Profession," *Conservation Today* (1988): 4–7.
16. A. Lucas, *Antiquities, Their Restoration and Preservation* (London: Edward Arnold, 1924); H. J. Plenderleith, *The Preservation of Antiquities* (London: The Museum Association, 1934).

17. H. GEDYE, "Forty Years of Conservation at the Institute," *Recent Advances in the Conservation and Analysis of Artifacts,* ed. J. Black, University of London, Institute of Archaeology, Jubilee Conservation Conference (London: Summer Schools Press, 1987), 16–19; H. HODGES, "From Technical Certificate to Diploma in Conservation, 1957 to 1974," *Recent Advances in the Conservation and Analysis of Artifacts* (1987): 20–23.

Historical Perspective

Temple of Juno, Agrigento, Sicily,
Doric architecture, fifth century
B.C.E. Detail with scaffolding
in background.

Historical Perspective

In a well-known passage included in these readings, Max Friedländer proclaims that restoration is a necessary evil (see Reading 33, page 332). It is relatively easy to demonstrate that it is an evil; the difficulty lies in proving it is necessary. That, in short, is the alarming conclusion to which one arrives when examining the problem from a long historical perspective.

Camillo Boito (1836–1914), considered to be the first theoretician of architectural restoration, remarked ironically in one of his lectures, "With rare exceptions, only one wise course of action remains: to leave them [the works of art] alone or, where necessary, to free them of restorations, whether old or recent, bad or not too bad."[1] He continues:

> How many mistakes restorations have caused! Not forgetting the dispute occasioned by the violin that Bernini placed in the hand of an Apollo. Perhaps you are familiar with the important question of whether the Greeks and Romans shod their horses—it seems they did not. But then a bas-relief turns up in which the horseshoes are visible, plain as the nose on one's face, complete with nails; a celebrated, cautious, and discerning archaeologist of our time sees them and exclaims triumphantly: "they shod them!" Unfortunately, the hooves were reconstructions. The *Knife-Grinder* becomes a *Flayer of Marsyas*; . . . the *Jason* in the Munich Glyptothek was once believed to be a *Cincinnatus*.

He concludes: "In short, is there really any need for these blessed restorations? ... Are not the torso of the *Farnese Hercules*, known as the Belvedere torso, and the torso of *Bacchus* admirable, broken and mutilated as they are?"

Translated by Alexandra Trone.

That question marks the end of the epoch of imitative restoration "in the style of the original," which was dealt an even more forcible blow earlier by Ruskin's irrevocable condemnation: "[Restoration] means the most total destruction which a building can suffer: a destruction out of which no remnants can be gathered: a destruction accompanied with false description of the thing destroyed" (see Reading 32, page 322).

Thus, the sensibility of the second half of the nineteenth century emerges as the expression of an entirely new approach toward cultural heritage, one that is marked by progress in scientific thinking. This approach decrees the impossibility of imitating the styles and works of the past; sanctions, for the first time, the removal of alterations and later additions from a work of art; and makes a clean break between the past and the present. It is in these decades that archaeology, history of art, and history of architecture were defined. This new view disrupts continuity, eliminating the possibility of reinserting oneself into the creative process to open it up once more in competition with the great artists of the past.

Since that time, it has not been considered permissible to transform and reuse an object, thereby exploiting its prestige and the history it conveys. This had been a common practice in the past. In Rome in 1538, for example, Pope Paul III Farnese compelled Michelangelo to move and restore the equestrian statue of Marcus Aurelius (Fig. 1). It was removed from the Piazza di San Giovanni, where for centuries people believed it to be a statue of

Figure 1
Bronze equestrian monument of
Marcus Aurelius, after restoration,
Rome, 1989.

Constantine, identified accurately with its original name, and placed in the center of the newly renovated Piazza del Campidoglio. There it served to represent the sixteenth-century view that papal power had been inherited from imperial Rome but was superior to it.[2]

An equally violent transformation had been perpetrated even earlier in the name of the Emperor Augustus by Caius Sosius (consul in 32 B.C.E.), a member of the emperor's family. When the Temple of Apollo near the Theater of Marcellus in Rome was being reconstructed, the emperor ordered the splendid sculptures of a *Battle of the Amazons*, a work that had been removed from a Greek temple of the fifth century B.C.E., to be installed there. In its new location it symbolized the fact that Rome was now the New Greece.[3] The examples could continue ad infinitum.

Unfortunately, the new sort of removal that was initiated at the end of the nineteenth century led to another and more grievous type of mistake implied by the passage from Boito quoted previously. It was believed then that all the restorations of the past, seen as ridiculous and uncivilized pastiches, could simply be canceled or wiped out. Work was thus started—to the particular detriment of collections of ancient sculpture and the complex stratigraphy of many churches and buildings—to reverse these previous interventions.

These efforts to recover an original state that is forever lost, or to select the earliest from the various phases of a building and thus to "free" it from the "inappropriate" alterations to which it had been subjected and return it to its original "purity" are now known by the German term *Ent-Restaurierungen* (de-restoration) to emphasize their destructive effect. Because of the attempt to return to origins, this trend was known as Purism. The harmful effects of Purism are not confined to the nineteenth century; as the examples quoted by Orietta Rossi Pinelli demonstrate (see Reading 29, pages 288–305), this attitude continued until a few decades ago; for example, in the controversial restorations at the Munich Glyptothek in the 1970s.[4]

The folly of Purism, which has devastated so many museums and buildings, is an entirely new type of absurdity, without precedent in the history of restoration. However far into the past one probes, the prevailing attitude—with different emphases and many variations on the theme in ancient, medieval, and modern times, in the East and in the West—is that of continuity of maintenance and regular replacement of damaged or altered parts, of reuse, and of changes in function as may be suitable to various cultural or political changes.

Conservators have the enviable but onerous responsibility of ensuring a future for many antiquities, monuments, and works of art that have survived until now, thanks to a continuous tradition. They must confront their responsibility from a historical perspective, realizing that they are, by and

large, not the first to carry out an intervention on a given work of art, and hopefully they will not be the last.

The study of the history of conservation is based on treatises, where they exist; but, as the methods of archaeology demonstrate, it is also essential to thoroughly examine the object itself. How long has conservation existed? The question is central to the debate. The answer is "always," if by conservation one means uninterrupted continuous care, as described above; and the answer is "not until this century," if one means the conscious care that begins with a new scientific detachment, coupled with a renunciation of the destruction perpetrated in the name of Purism, and completions "in style."

Roger Marijnissen (Reading 27, pages 275–80), who refers to the importance of history as a part of the training of restorers, rightly refutes an unfounded assertion by Alois Riegl (Reading 6, pages 69–83) attributing the beginning of *Denkmalpflege* (literally, the preservation of monuments) to the Renaissance. No epoch has been more ambiguous than the Renaissance in the alternate practices of destruction and conservation. It suffices to recall that in 1515 Pope Leo X issued a papal brief that empowered Raphael to intercede in the destruction of ancient marbles, usually aimed at obtaining lime and recovering precious building materials, largely for the new workshops of St. Peter's Basilica. The destruction was particularly intense at that time, especially in the Roman Forum. Raphael had the power to choose outstanding fragments, to apportion those to be destroyed and those to be reused.

As has been emphasized, restoration is a corollary of the fame and fortune of a monument as well as an aspect of the "imitation of the antique." This is demonstrated by the vicissitudes of the *Laocoön* group (see Rossi Pinelli, Reading 29, pages 288–94), still magnificent in the Belvedere Pavilion of the Vatican Museums. It was discovered on 14 January 1506 in the very Baths of Titus where Pliny the Elder had described seeing it. The subject was recognized at once, on the basis of some verses of Virgil, as that of the unfortunate priest who had dared to warn the Trojans against the deception of the wooden horse and was punished for it by being dragged away, together with his sons, by an enormous sea serpent.

This outstanding sculpture has been the object of a series of restorations that serve as excellent examples, as they manifest various changes in taste that succeeded one another; each is the expression of a different perception of Classical sculpture. Within the climate of Mannerism in which the sculpture was found, the resplendent modeling of the Baroque marble group, a product of the school of Rhodes in the Hellenistic period, fell on fertile ground and enjoyed immediate and enthusiastic success. The pope and other notables vied for possession of the group and the pope won. It was immediately examined by Michelangelo, who inspired the first restoration in 1532 by Giovanni Angelo Montorsoli (circa 1507–63). In the Mannerist style

of the time, Montorsoli reconstructed the father's missing arm in an emphatically raised gesture to complete the composition.

The sculpture remained in this state from the early sixteenth century until the beginning of the twentieth. Then, while rummaging in a shop near the Colosseum, Ludwig Pollak, an illustrious representative of the fraternity of connoisseurs then living in Rome, found the original lost fragment of Laocoön's raised arm.[5] Here was proof of what the scholars, and Michelangelo himself, had always maintained: the reconstruction of the *Laocoön*'s arm was incorrect, and it distorted the rhythm of the composition.

The mistaken reconstruction was not, however, immediately dismantled. This was not done until 1955–57, when the apparently still thriving Purist spirit of several archaeologists overcame all resistance. Several eighteenth-century reconstructions, also considered to be completely misguided, were removed along with the incriminated arm. The restorers did not have the courage, however, to reduce the masterpiece to fragments; thus the course of action they had undertaken was not followed to its conclusion. The de-restoration, with some parts removed and others retained, has, in essence, left the *Laocoön* incomplete, with its stumps now exposed. It has thus become a sad monument to the conceit of those who believed they could eradicate the marks of history from the piece.

The archaeologists who treated the *Laocoön* so heavy-handedly were unable either to understand or to emulate the far wiser example of Antonio Canova who had been called to London around 1815 to examine the marbles that Lord Elgin had so eventfully removed from the Acropolis in Athens not long before. Elgin had offered the sculptures for sale to the British Museum, and Canova ruled out the feasibility of any attempt at restoration.

Rossi Pinelli cites the *Laocoön* group, *inter alia*, to illustrate past attitudes that have left profound and indelible marks on ancient sculptures, whatever the Purists past and present may say. Reading the catalogue of gruesome disasters Rossi Pinelli describes, one can only hope that all temptation to do anything similar will be resisted in the future.

Some passages by Paul Philippot (Reading 26, pages 268–74) are a good introduction to the arguments for considering the entire history of a work of art. The author compares present attitudes toward objects made in the past with attitudes in earlier times: today, he says, ancient or historical objects are looked at as one looks at a distant landscape; whereas in previous periods, even as late as the end of the nineteenth century and the beginning of the twentieth, restorers believed they could reinsert themselves into the creative process in order to complete it. Philippot helps evaluate the significance of these arguments and the importance, for the art historian and the archaeologist as well as the conservator, of acquiring a deeper knowledge of earlier restoration methods.

Marijnissen (Reading 27, pages 275–80) and Sheldon Keck (Reading 28, pages 281–87) add historical depth to the picture and, with the help of written sources, examine the triumphs and disasters of early restorers, venturing as far back as Classical antiquity. This historical knowledge enriches the theoretical side of training. It helps develop a sense of detachment and a sense of "relativity" that, according to Brandi, ought to be the foundation of any intervention (see Reading 22, pages 230–35); it induces caution and the use of minimal treatments that do not impede further measures in the future.

This knowledge is even more necessary from the technical point of view. It forms an integral part of the material and critical appreciation of the object to be conserved. Earlier alterations and additions, including those with results that have proved beneficial, will have modified the original intentions of the artist, and it is incumbent on the conservator to discriminate between these modifications with discernment.

—AMV

Notes

1. C. Boito, *I restauratori* (Florence: Barbera, 1884).
2. A. Melucco Vaccaro, "The Equestrian Statue of Marcus Aurelius," in *The Art of the Conservator,* ed. A. Oddy (London: British Museum Press, 1992), 45–75.
3. A. Melucco Vaccaro, "Il riuso in età classica," chap. 2 in *Archeologia e restauro: Tradizione e attualità* (Milan: Mondadori, 1989), 45–75.
4. D. Ohly, *Die Aegineten: Die Marmorskulpturen des Tempels der Aphaia auf Aegina,* catalogue (Munich: Beck, 1976).
5. On Pollak's find, see Margarete Merkel Guldan, *Die Tagebücher von Ludwig Pollak: Kennerschaft und Kunsthandel in Rom 1893–1934* (Vienna: Verlag, 1988); and Ludwig Pollak, *Römischer Memorien* (Rome: "L'Erma" di Bretschneider, 1994).

Historic Preservation: Philosophy, Criteria, Guidelines, I

PAUL PHILIPPOT

The origins of historic preservation are linked with those of the modern historical consciousness, which matured toward the end of the eighteenth century.[1] The word *preservation*—in the broadest sense, being equivalent in some cultures to *conservation* or *restoration*—can be considered, from this point of view, as expressing the modern way of maintaining living contact with cultural works of the past. This way of maintaining contact evolved after the outburst of the Industrial Revolution and the development of a historical conscience brought an end to the traditional link with the past, which may be said to have lasted, in various forms, from the origin of civilization to the end of the eighteenth century.

Indeed, since this rupture, the past has been considered by Western man as a completed development, which he now looks at from a distance, much as one looks at a panorama. On one hand, this new historical distance has produced the conditions necessary for a more objective, scientific approach to the past in the form of historical knowledge. But purely scientific knowledge cannot in itself insure the continuity that was guaranteed by tradition. To bridge the gap that the historical conscience opened between the past and the present, a new kind of contact developed, based on the feeling that the past has indeed been lost, but continues to live through nostalgia.

From Paul Philippot, "Historic Preservation: Philosophy, Criteria, Guidelines," in *Preservation and Conservation: Principles and Practices,* Proceedings of the North American International Regional Conference, Williamsburg, Virginia, and Philadelphia, Pennsylvania, 1972 (Washington, D.C.: Preservation Press, 1976), 367–74. Copyright 1976 National Trust for Historic Preservation in the United States, Washington, D.C.

This romantic nostalgia of the past, which replaced the traditional continuity between the past and the present, combines historicism and nationalism and has led, since the end of the eighteenth century, not only to various revivals of past styles of art and architecture but also to an unfortunate confusion of preservation and reconstruction.

A scientific archaeological approach to the past and nationalistic revival are closely interwoven in Eugène Viollet-le-Duc's theory[2] [see Reading 30, pages 314–18] and in all nineteenth-century restoration work in Europe, where these ideas have not yet died out completely. Modern nationalism also seems to foster revivals and reconstructions in most young countries that have recently become independent.

In the meantime, however, the scientific approach to the past has surpassed national borders and now considers products of all cultures as part of one cultural patrimony of mankind. Living contact with this patrimony can no longer be achieved in revivals—nor, consequently, in reconstructions based on the symbolic value given to a style of the past by romantic nationalism. It can be achieved only through a new approach that will acknowledge simultaneously the uniqueness of every creation of the past and the distance from which it is appreciated in the present.

John Ruskin was the first to express a full awareness of the consequences of this break in the continuity of tradition introduced by the development of the modern historical consciousness:

> Neither by the public, nor by those who have the care of public monuments, is the true meaning of the word restoration [meaning the reconstruction, whether total or partial, suggested by revivalism] understood. It means the most total destruction which a building can suffer: a destruction out of which no remnants can be gathered: a destruction accompanied with false description of the thing destroyed. Do not let us deceive ourselves in this important matter; it is impossible, as impossible as to raise the dead, to restore [meaning reconstruct] anything that has ever been great or beautiful in architecture. That which I have above insisted upon as the life of the whole, that spirit which is given only by the hand and eye of the workman, can never be recalled. Another spirit may be given by another time, and it is then a new building; but the spirit of the dead workman cannot be summoned up, and commanded to direct other hands, and other thoughts.[3]

Modern developments of aesthetics and principles of historical criticism and philology can only confirm the truth expressed by Ruskin[4] (see also Ruskin, Reading 32, pages 322–23]. Each work of art, each piece of decoration, each historic document is unique and cannot be repeated without

faking. It is like a dead language: One can know and understand Latin or Sanskrit, but one cannot speak these languages anymore because such speech could not be genuine expression. The genuine voice of the past is exactly what must be safeguarded by preservation/conservation. The survival of traditional crafts should not mislead one here. What survives of the craftsman's tradition in the new industrial world is its practical skill, and while this skill can certainly be of great use in conservation, it is no longer a genuine expression either of the past or of the present. To ignore this would mean to close one's eyes to the fact that the modern historical consciousness has irreversibly broken the traditional continuity and, therefore, would lead to a faked expression. If the conservation of an object or building requires an intervention or substitution, the intervention should be recognized as a modern, critical action. How to integrate the modern intervention without faking the original object is an essential question of conservation, and the way in which the modern intervention is handled makes the difference between the restorer or conservator and the traditional craftsman.

What to Preserve and Inventory: Criteria

Every object (or complex of objects) that is recognized to be of artistic or historical significance is entitled to be safeguarded as an item of cultural value and as a legacy of the past to the present and the future. The recognition of such significance, however, does not depend upon the fulfillment of preestablished criteria, but rather upon the progress of the development of the historical consciousness and the culture of the people involved. This progress is expressed by the work of historians and the sensitiveness of cultivated people.[5] As a matter of fact, the range of interest in this connection has been continuously expanding since the beginning of the nineteenth century, progressively including all cultures of the world and all kinds of folklore and reaching up to the threshold of the present, which in turn will deserve protection whenever its objects qualify as items with artistic or social value. The universality of this modern viewpoint, as compared to the classicistic or nationalistic one, does not prevent some fluctuation of values from one nation to the other. In fact, this fluctuation is quite justified inasmuch as the significance of the past is indeed relative to the peoples who recognize it as their past. Any other view of universal values would be a purely abstract one.

Since the first step toward conservation is to establish an inventory of what should be conserved, criteria that recognize the creative quality, documentary significance and impact of the object on human consciousness must be established. Such criteria will, of course, never crystallize in fixed rules but will reflect the development of each country's culture.

Methodology

The Approach to the Object

The first operation in any conservation process is to assess accurately the substance of the object to be safeguarded. This may seem obvious but, alas, is not, and ignoring this operation by considering it to be obvious may result in irreparable mistakes. The problem's main aspects may be summarized in three questions: (1) What is to be considered the whole of the object, to which all operations must be referred? (2) What is the context of the object? and (3) What has been the history of the object?

The Whole of the Object

The importance of the whole must be stressed because positivistic habits of classification have accustomed us to divide various arts according to technique and to split the whole of a monument into various pieces scattered throughout various sections of museums and galleries. What was once a Gothic altarpiece may be dismantled into isolated sculptures, easel paintings and decorative carvings, the result being that the experience of the altarpiece as a whole has to be rediscovered. This rediscovery includes, for example, defining the artistic relationships that existed among sculptures, reliefs and paintings.

The same situation applies to architecture, which today is often reduced to that part of the building that can be expressed in architectural drawings, thereby arbitrarily separating structure and decoration. One especially vivid example of this kind of separation concerns the plasterwork within a structure and its color. The result of this separation is that today original plasterwork is becoming so rare that it is difficult to know its genuine character in various periods and styles.

Germans have a convenient word to stress this importance of the whole of the monument. By *Gesamtkunstwerk,* they mean the unity resulting from the cooperation of the various arts and crafts that combine to make a monument and cannot be divided from it.

It is obvious that what is a whole must be treated consistently as a whole, and this implies that close cooperation among various specialists in preservation—architects, conservators, artisans—under one consistent policy is necessary. On the other hand, each fragment will have to be treated as such, keeping in mind the whole to which it once belonged.

Context

Context refers to an object's immediate surroundings, inasmuch as these determine the approach and, thus, the correct interpretation of the

object; that is, the frame of a picture, traditional surroundings of a monument that are essential to its scale and significance and social circumstances in which the object is or was used, this consideration being especially important for liturgic or ethnographic objects.

In some cases, the context may be an object, as is the case, for instance, of minor architecture in historic centers, when no individual building is a work of art but the whole becomes a monument in itself (e.g., the Campo dei Fiori in Rome). An object should never be deprived of its context, if the object is to avoid becoming isolated and "museumized," that is, segregated from life.

The recognition of the value of the whole and the object's context leads logically to the principle that every object should, whenever possible, be conserved in situ if one wants to save the full value of the whole and of the parts. This applies to wall paintings, altarpieces and sculptured decoration. It also applies to architecture and to its architectural or natural surroundings. Exceptions to this principle must be made, however (e.g., in situations where a fresco or building can be preserved only by disassembling and moving it, even though the movement will produce unavoidable and irreparable damage). The open-air museum is an emergency solution and is almost a contradiction in itself, since vernacular architecture is existentially linked to its surroundings, even more so than major monuments that can impose themselves on their surroundings. Hence, there is the almost inherent tendency of the open-air museum to evolve into a Disneyland: No longer is it a preservation of history in the present, but rather a projection of fantasy into objects of the past, which is a special variety of faking.

The Object's History

A monument of the past, be it architecture, sculpture, painting or any combination of these forms of art, has come to man through time and history. During this period, it usually undergoes changes of various kinds—additions, reductions or modifications in shape, use or sense due to man's interventions and material alterations due to physical and chemical processes.[6] Furthermore, the way the object is perceived is continuously evolving as the result of the historic development of a culture, especially aesthetic sensitiveness. Each new experience in art changes one's view of the history of all art in the way that one's vision of colors is no longer the same after experiencing Impressionism.

All this history must be taken into consideration when establishing what is the whole to be safeguarded. Indeed, history and time cannot be undone; they are irreversible. However, those additions that are recognized to be of no historical or artistic significance and that distort or obliterate the

object can rightly be removed. But removal always requires a justified decision, thus showing the inescapable freedom and cultural responsibility of the restorer in making history.

It is an illusion to believe that an object can be brought back to its original state by stripping it of all later additions. The original state is a mythical, unhistorical idea, apt to sacrifice works of art to an abstract concept and present them in a state that never existed. Tendencies, much supported by archaeologists, to strip medieval churches of their Baroque or even nineteenth-century decoration in order to discover naked walls without their original plaster or furnishing and to undo old restorations of Classical sculpture have led to a great deal of destruction without ever succeeding in reestablishing the appearance of the work at a real historic moment (Figs. 1, 2 [see Reading 21, pages 222–23]).[7]

The patina resulting from material alterations of an object has been the subject of much controversy, especially in the field of easel paintings[8] [see Philippot, Reading 39, pages 372–76]. This, however, should be considered as only a particular case of a more general problem. Physical and/or chemical alterations of original materials are unavoidable and usually irreversible. They may, however, up to a point, be anticipated by the artist or accepted as an additional aesthetic value, like the traditional acceptance of the patina of bronzes, sometimes called "noble" patina. The point when such alterations are felt to be distortions of the object's value and not enhancements of its aesthetic quality cannot be defined objectively and is, therefore, a matter of critical interpretation and cultural responsibility. It should be clear, in any case, that simple removal of the patina on a bronze or a painting will not recover the object's original appearance, but only uncover the present state of the original material. Furthermore, what is the original appearance? At what moment can it be fixed? Obviously, the original state is an abstract idea and not a historical reality. Bear in mind also that any attempt at removing a patina, which is, of course, a modification of the original material, will necessarily result in a further alteration of the material. It should be admitted, therefore, that the patina is a part of the object's original substance as transmitted to man through history and that any attempt to eliminate it will damage the original substance and introduce a historical contradiction, inasmuch as removal will show an old object in fresh, or new-looking, material. For example, the drastic cleaning of pictures or bronzes is in no way an objective approach to the object, and it would be easy to show that the decision in recent times to so treat an object being "restored" has been greatly determined by a definite aesthetic approach, influenced by the new sensitivity to materials developed by Expressionism and the Bauhaus.

The cleaning of facades, inaugurated in Paris as a matter of political prestige, brings to the fore the complicated nature of this problem. Assuming

that cleaning will not harm the original material, it remains that the appearance of each building will look "correct" only when all the surrounding buildings are equally clean, but the patina, or dirt, forms again so quickly on the freshly cleaned facades that such a general unity is never reached. What results is that cleaned buildings look like white ghosts in their darkened context. Even regular maintenance is hardly a solution as long as the causes of pollution are not eliminated.

Notes

1. On the history of restoration, see CARLO CESCHI, *Teoria e storia del restauro* (Rome: Mario Bulzoni, 1970).
2. EUGÈNE VIOLLET-LE-DUC, *Dictionnaire raisonné d'architecture française du XIe au XVIe siècle* (Paris: F. de Nobele, 1967), s.v. "restauration."
3. JOHN RUSKIN, *The Seven Lamps of Architecture* (London: George Allen and Unwin, Ltd., 1925), chap. 6, aphorism 31, 353–54.
4. See CESARE BRANDI, *Teoria del restauro* (Rome: Edizioni di Storia e Letteratura, 1963).
5. See GIULIO CARLO ARGAN, "La storia dell'arte," *Storia dell'arte* 1–2 (1969): 5–36. See also ROLAND GÜNTER, "Glanz und Elend der Inventarisation," *Deutsche Kunst und Denkmalpflege* 28, 1–2 (1970): 109–17.
6. BRANDI, *Teoria del restauro*, 99–103.
7. On the unjustified removal of Baroque decoration in medieval churches, see BENEDIKT NICOLSON, "Restoration of Monuments in Tuscany," *Burlington Magazine* 113, no. 813 (1970): 789–92; on the equally unjustified removal of Renaissance, Baroque and classicistic restoration of antique sculptures, see J. PAUL, "Antikenergänzung und Ent-Restaurierung," *Kunst-Chronik* 4 (April 1972): 85–112.
8. See PAUL PHILIPPOT, "Le notion de patine et le nettoyage des peintures," *Bulletin de l'Institut royal du patrimoine artistique* 1, 9 (1966): 138–43.

Degradation, Conservation, and Restoration of Works of Art: Historical Overview

R . H . M A R I J N I S S E N

The Need for a History of Restoration

An overall history of the restoration of deteriorated works of art has yet to be written. The field, for that matter, has barely been explored. It was a full thirty years ago that Moritz Stübel argued that historical research into restoration would constitute a major contribution to all areas related to art in general.[1] He was addressing art historians in particular, since he was convinced that such research could be carried out only by them. He even suggested that a *Corpus Restaurationum* be published, but his appeal bore no fruit. . . .

Existing literature deals with the concepts behind restoration and with formerly used techniques only occasionally, or else treats them as a side issue. Information on the subject is sometimes found in reports published on the occasion of a given treatment or, more frequently, as part of a polemic arising from the endless controversy surrounding the cleaning of paintings.

Historians seem to be of the opinion that such historical research would encounter insurmountable difficulties. Stübel himself stressed the main obstacle, namely that archives do not have much to offer in this area.

The relative rarity of archival data may be explained in a number of ways. In the past, it was not considered necessary to write a detailed report on treatments carried out on a damaged work, and restorers were little inclined to allow their interventions to be officially recorded. They even

From R. H. Marijnissen, "Aperçu historique," chap. 1 in *Dégradation, conservation, et restauration de l'oeuvre d'art*, vol. 1 (Brussels: Editions Arcade, 1967), 21–29; originally produced as a Ph.D. dissertation under the title "Het beschadigde Kunstwerk," Hoger Instituut voor Kunstgeschiedenis en Oudheidkunde der Rijksuniversiteit Gent, 1966. Used by permission of the author. Translated by Garrett White.

seemed hostile to the idea, because the profession was traditionally thought to be a highly skilled craft. Their ambition essentially focused on the realization of a completely integrated restoration, that is to say, unapparent or even invisible. They sought to restore a work to its original state, and firmly believed they could do so. No one asked them to reconstruct a preliminary "material history" of the work in question, nor were they in any way prepared to carry out that sort of research. . . .

In professional circles, historical investigation has always been viewed with skepticism and is given little credence. One nevertheless has the impression that archives contain no lack of interesting records and lists that have probably been neglected or overlooked by researchers due to a simple lack of curiosity. Public institutions have massive collections of art. Almost all the finest paintings and sculptures are now in museums or churches or other public buildings. Some of these works were commissioned by the institutions that still own them today; others were acquired long ago. Their conservation was therefore the object of written reports. True, such documents are sometimes basically administrative in nature, but often enough they also contain valuable information on successive treatments carried out on the work in question.

—⚋—

The earliest manuals for restorers of works of art date back to the eighteenth century, and were usually no more than a chapter or an appendix to a publication of a more general nature. Treatises, strictly speaking, did not appear until the nineteenth century. A systematic, comparative study of such publications should be undertaken. . . . One by Secco Suardo,[2] written partly in 1866 and partly in [1873, reprinted in] 1894, has just been adapted and republished.[3] I can do no more than mention the existence of these manuals here, in order to stress their importance as primary sources for a history of the restoration of works of art. Obviously, the research project suggested above should be conducted simultaneously on two fronts—that of historical criticism on the one hand, and that of artisanal techniques on the other.

—⚋—

Historical data on restoration treatments carried out on a work would enable a laboratory to date certain phenomena, contributing to a better understanding of the behavior of materials used for retouching and alterations, as well as the aging and decaying processes of these materials. Laboratories study the deterioration of materials by submitting samples to artificial—that is to say, accelerated—aging. Laboratory technicians would benefit highly from chronologically precise points of comparison. . . . It is obvious that historical data on the behavior of traditional materials could serve as an argument when assessing the desirability and attendant risk of employing a synthetic product in the place of a tried-and-tested natural one.

. . . Art history reflects mankind's great intellectual and spiritual quest. It is more than likely that the history of the restoration of art objects will also, in its own way, mirror this very quest. Such a history may even reveal the way humanity behaves toward a cultural heritage now disseminated throughout the world.

—⁓—

The "scientific" approach to the conservation and restoration of works of art is a relatively recent phenomenon. Rigorous laboratory methods contrast sharply with the empirical and sometimes hazy methods employed by traditional craftspeople. The incompatibility is such that it overshadows, in a way, everything that remains relevant or valid in artisanal methods.

The Origins of Conservation and Restoration

—⁓—

At what precise moment did people start to conserve and restore works of art? Posed thus, the question seems to be largely irrelevant. The simple maintenance of a work of art already constitutes in itself an operation of conservation. It goes without saying that the regular maintenance of historic buildings and works of art has been carried out since time immemorial. The few passages by ancient authors on the subject are in no way extraordinary,[4] for what could be more normal than the repair of a decaying or damaged object? But the attitude that reigned in those days concerning the care or treatment accorded an object is a far cry from the meaning that is given today to the term *conservation*. Riegl feels that the origin of *Denkmalpflege* (the conservation or protection of monuments) dates back to the Italian Renaissance, when people began protecting vestiges of the Classical period.[5] If the Renaissance represented both the end of a period of abandonment of ancient monuments and the beginning of a taste for collections of rare works, does this new behavior in itself constitute proof of the emergence of a new attitude dictated by a spirit of conservation? Riegl himself admits that *Denkmalpflege* as understood by the Renaissance did not yet correspond to today's meaning of the term. It is worth recalling that the Iconoclast movement occurred at a time when the Renaissance spirit had well and truly penetrated the southern Netherlands. It might be argued that a period of conflict should not be cited as a counterexample, since disorder reigned at every level in 1566. One need merely consider another example, then, and point to the decrees that ordered the destruction of works of art in the mid-seventeenth century.[6]

All those familiar with art history know that Renaissance sculptors worked on fragments of ancient statues.[7] Could this really be described as restoration? . . . The sculptor made no concessions to the original object.[8]

Classical sculpture merely supplied him with an example or ideal to follow—his interest in things antique was essentially one of admiration. The attitude of the restorer-artist toward the crumbling work was like that of a conqueror. Despite his admiration, he lacked the fundamental respect that dictates, above all, preservation of evidence of the past. He did not yet have the attitude of a historian, a paleographer, an archaeologist, a Bollandist, or even a learned person. He had not yet realized that a work of art is *also* a historical document.[9]

Riegl is right to claim that the distinction between the artistic value of an early work of art and its historical value began to emerge during the Renaissance, yet one should be careful of taking an overly narrow view of the period when this new idea first appeared. Other circumstances, furthermore, confirm that this interest in classical antiquity was in no way determined by a real need to preserve cultural testimony of the past. As proof, one need only study the attitude taken toward an enormous artistic heritage of more recent times. The fourth provincial Council of Milan, for instance, urged bishops to renovate (*renovari*) pious images. Those that were too badly damaged were to be burned and the ashes buried under the church floor to avoid profaning them.[10] This demonstrates that, in the second half of the sixteenth century, the clergy considered pious images primarily—indeed, exclusively—as objects of worship. It is worth stressing again that this attitude was prevalent in the middle of the sixteenth century, at a time when the Renaissance spirit flourished throughout Europe, and in Italy in particular.

It is impossible to calculate the number of works of art lost or destroyed in the seventeenth and eighteenth centuries. Works of the highest order were treated with casual contempt. Style and taste were changing, and old-fashioned works of art no longer held any interest. Numerous masterpieces underwent scandalous tribulations. . . .

. . . Many masterpieces escaped destruction only because they had been forgotten. Others were, in certain cases, treated with a lack of respect bordering on vandalism. A panel by Joos van Ghent, *A Humanist's Lesson,* was used as a tabletop in Florence.[11] The trials suffered by Jean Baudolf and Nicolas Bataille's famous *Apocalypse* tapestries in Angers can only be described as unbelievable.[12] That no one in 1782 wanted to buy 792 square meters of tapestry is hardly surprising. But the indifference that allowed these magnificent tapestries to be used for the most utilitarian and prosaic purposes defies comprehension. Some sections were used to mask cracks in a wall; others hung in the greenhouse of Saint Serge Abbey to protect orange trees from the cold; some were used as packing cloth and bedside rugs; and pieces were even put up in the bishop's stables to prevent horses from scraping themselves on the swinging bail. Still other fragments served to protect the floor when ceilings were being repainted. Whatever the case, this appears

to be a highly significant example. It immediately demonstrates that historical consciousness had not yet been completely awakened at that point, and it also reveals that fourteenth-century style was not at all appreciated in the eighteenth century. It could even be said that eighteenth-century taste was incompatible with the austere aesthetic of these medieval tapestries. Nevertheless, it can hardly be ignored that this series immediately presents itself as a monumental achievement of the Gothic period, if only by its scope. Now, the eighteenth century was a highly cultivated period, particularly in France, so how can one explain the fact that the tapestries did not even spark sufficient interest to be conserved in proper conditions? Such negligence cannot be blamed on a single person, because the destitution lasted for more than fifty years! Under the circumstances, there is only one valid explanation: total indifference, both in terms of past heritage and of future generations. No one seems to have thought that there might possibly be future interest in this magnificent series.

Proper historical criticism precludes a judgment on eighteenth-century civilization based on the fate it reserved for the *Apocalypse* of Angers. Historians must be very careful of generalizations when drawing conclusions. It might be pointed out that similar cases occurred in the nineteenth century.[13] Some might add that countless medieval monuments survived the seventeenth and eighteenth centuries. Cathedrals, for instance, come to mind. I think it would be highly rewarding to conduct an in-depth study on this question, for it would seem that many Romanesque and Gothic buildings survived mainly for practical and financial reasons, and not at all because they represented the cultural heritage of a remarkable past.

By way of conclusion, I shall just say that there are good reasons for believing that a sense of responsibility toward artistic heritage emerged only very slowly.

Notes

1. M. STÜBEL, "Gemälderestaurationen im 18. Jahrhundert," *Der Cicerone* 18 (1926): 122–135; and "Gemälderestaurationen und ihre Geschichte," *Museumskunde* 9, no. 2–3 (1937): 51–60.

2. [3] GIOVANNI SECCO SUARDO, *Manuale ragionato per la parte meccanica dell'arte del ristauratore dei dipinti*, 2 vols. (Milan: Tipografia di P. Agnelli, 1866–1873).

3. [4] GINO PIVA, ed., *L'arte del restauro: Il restauro dei dipinti nel sistema antico e moderno, secondo le opere de Secco-Suardo e del Prof. R. Mancia* (Milan: U. Hoepli, 1961).

4. [8] M. CAGIANO DE AZEVEDO, "Conservazione e restauro presso i Greci e i Romani," *Bollettino d'Arte* 1, no. 9–10 (1952): 53–60; and his "Restaurierung und Konservierung von Kunstwerken," *Das Atlantisbuch der Kunst: Eine Enzyklopädie der Bildenden Künste* (Zurich: Atlantis-Verlag, 1952): 708–34.

5. [9] ALOIS RIEGL, "Der moderne Denkmalkultus," 1903; reprinted in *Gesammelte Aufsätze* (Augsburg-Vienna: B. Filser, 1929), 144–93 [see also Riegl, Reading 6, pages 69–83].

6. [10] ORDERS OF PARLIAMENT, 1645, cf. RICHARD REDGRAVE and SAMUEL REDGRAVE, *A Century of British Painters* (London: Phaidon, 1947), 9; C. PHILIPS, *The Picture Gallery of Charles I,* The Portfolio Artistic Monographs 25 (London: Seeley Macmillan, 1906), 47.

7. [11] M. NEUSSER, "Die Antikenergänzungen der Florentiner Manieristen," *Wiener Jahrbuch für Kunstgeschichte* 6 (20): 27–42; HEINZ LADENDORF, *Antikenstudium und Antikenkopie: Vorarbeiten zu einer Darstellung ihrer,* especially appendix B (Leipzig: Akademie-Verlag, 1953), 55–61; CAGIANO DE AZEVEDO, "Restaurierung und Konservierung von Kunstwerken," 711–12.

8. [13] I quote a very judicious comment by M. NEUSSER, "Die Antikenergänzungen der Florentiner Manieristen," on the restoration by Benvenuto Cellini in 1546 of a "Ganymede" in the Bargello collection: "Der Künstler benutzt den antiken Torso in erster Linie als Schaustück um daran sein raffiniertes und vielseitiges Können zu demonstrieren" [The artist uses the antique torso in the first place as a *schaustück* with which to demonstrate his refined and many-sided talents].

9. [14] As far as the restoration of works of art is concerned, the Renaissance has nothing to offer to compare with the critical-philological editions of texts by humanist scholars.

10. [15] Cf. JACQUES GUILLERME, *L'atelier du temps: Essai sur l'altération des peintures* (Paris: Hermann, 1964), 127, note 2.

11. [16] WINDSOR CASTLE, ROYAL COLLECTIONS. Cf. Musée de Beaux-Arts, Ghent, *Juste de Gand, Berruguete et la cour d'Urbino,* exhibition catalogue 20 (1957).

12. [17] ANDRE LEJARD, *Les tapisseries de l'Apocalypse de la cathédrale d'Angers, accompagnées du texte de l'Apocalypse de St.-Jean dans la traduction de Le Maistre de Sacy* (Paris: A. Michel, 1942).

13. [18] A coppersmith bought five Gobelins in Paris, in 1852, to be burnt to recover the gold thread. See A. JOUBIN, *Journal de Eugène Delacroix* 1 (1936–1938): 447.

Further Materials for a History of Conservation

SHELDON KECK

A history of conservation is valuable to us as conservators, not just to establish the antiquity of our vocation, but to give us insight into what we may encounter on examination and treatment of the same works today, as well as to give us an understanding of past philosophical approaches to the subject of restoration.

Although we know that methods of preservation, particularly in the funerary arts, were of profound importance to the ancient Egyptians, so far as artifacts are concerned, we know only that the Egyptians attempted to provide a favorable environment for the contents of their tombs as well as protection against damage or theft. The governing motive was religious. The incidental result was the preservation for millennia of arts and crafts sealed, hopefully for eternity, not only from the grasp of humanity but also from its sight. Objects, repaired before burial, have been reported excavated from Egyptian tombs. Inscriptions, reliefs and sculptures on earlier monuments were often obliterated to make way for new ones celebrating a succeeding royal personage. This circumstance permitted some monuments to survive. One could hardly call this conservation or restoration. Historical integrity was a matter of minimal concern.

In Greece, and later in Rome, individual artists were revered for their unique skills and creativity. Works of painting, sculpture and architecture were celebrated long after their creators had died. The desire existed to preserve

From SHELDON KECK, "Further Materials for a History of Conservation," in AIC *Preprints of Papers Presented at the Fourth Annual Meeting, Dearborn, Michigan, 1976* (Washington, D.C.: American Institute for Conservation of Historic and Artistic Works, 1976), 11–19. Copyright 1976. Reprinted with the permission of the American Institute for Conservation of Historic and Artistic Works, Washington, D.C.

works of art for their aesthetic significance as well as their monetary worth. Large collections were assembled first in Greece and then in Rome, in temples, public buildings and in the dwellings of the affluent. Because of the great renown in which the works of art were held, we have in Greece relevant mentions as well as implications of restorations from Classical writers. Both Pliny and Vitruvius indicate that, during their time at least, the ancients were well aware of deterioration, damage and disfigurement caused by dampness, smoke, fire and ignorance.

In the second century A.D. the Greek traveler Pausanias[1] wrote that in the temple of Hera at Olympia there remained one ancient column of oak while all other columns were of stone. Archaeological excavations of the temple reveal that the stone columns were of different styles belonging to different periods.[2] As each original wooden column in the temple deteriorated it was replaced by a new column of stone according to the prevailing style over a span of some eight centuries. In this earliest of recorded architectural restorations the religious form of the temple remained inviolate, but the substance of its architectural members was transformed without regard to original material or style. Rosi points out that the Greeks preserved in situ the last remaining vestige of the temple's original construction suggesting an interest in preserving contact with the cultural past.[3]

For his sources on the history of painting and sculpture the Roman encyclopedist Pliny the Elder drew extensively on now long lost writings of Greek historians and essayists. Paintings which he describes by renowned fourth century B.C. Greek artists like Apelles, Protogenes, Pausias and Polygnotos [sic] were on exhibition at Rome, and were seen by him in the first century A.D. Restorations when required were performed by artists, a tradition already established in Greece. This tradition prevailed for centuries since the artist knew from long apprenticeship and experience, certainly better than anyone else, the nature of the materials and construction of the works of art he was called upon to restore.

Pliny records the Greek legend that Pausias of Sikyon learned the new encaustic technique from Pamphilos, and became the first well known master in this medium.[4] On being called upon to restore certain wall paintings by Polygnotos at Thespiae, Pliny explains that the restoration by Pausias suffered by comparison because, in order to conform to the style of Polygnotos, he had to work in an aqueous technique of which he was by no means a master.

Also of interest is the record by Pliny that Apelles' friend, Protogenes of Kaunos on the island of Rhodes, painted a picture of "Ialysos bearing a Palm" with four coats of color to preserve it from injury and age, so that if the last upper coat peeled off, the lower one would take its place.[5] This painting hung in the Temple of Peace at Rome in the first century A.D. The story of the painting by Protogenes recalls the letter which Albrecht Dürer wrote to

Herr Jacob-Heller, dated 26 August 1509, for whom he had just completed a painting. The letter describes a procedure very similar to that of Protogenes, "I have painted it with great care, as you will see, using none but the best colors I could get. It is painted with good ultramarine under, and over, and over that again, some five or six times; and then after it was finished I painted it again twice over so that it may last a long time. If it is kept clean I know it will remain bright and fresh 500 years, for it is not done as men are wont to paint. So have it kept clean and don't let it be touched or sprinkled with holy water."[6]

Other paintings of Greek origin apparently were not so thoroughly painted and suffered as a result. For instance a picture by another contemporary of Apelles, Aristiedes of Thebes, representing a "Tragic Actor and Boy" which hung in the Temple of Apollo at Rome "was ruined through the ignorance of the painter to whom Marcus Junius as praetor (c. 25 B.C.) entrusted it to be cleaned before the games of Apollo."[7]

A masterpiece by Apelles portraying "Aphrodite Rising from the Sea" had been brought to Rome and was dedicated by the Emperor Augustus in the temple of his father, Caesar. "When the lower portion was damaged no artist could be found with the ability to restore it and thus the very injury redounded to the glory of the artist whose skills were inimitable. In the course of time the panel of the picture fell into decay and the Emperor Nero substituted for it another picture by the hand of Dorotheos." According to Sellers, the commentator on Jex-Blake's translation of Pliny, the term "substituted" may be an exaggeration and probably the painting was only restored by Dorotheos, since the picture by Apelles seems to have continued in existence under Vespasian when Suetonius speaks of it being again restored.[8]

Three of the paintings mentioned above were easel paintings on wooden panels as were innumerable other works transported to Rome as spoils of war. Vitruvius confirms that wall paintings were transported there as well. "In Sparta paintings have been taken out of certain walls by cutting through the bricks, then have been placed in wooden frames, and so brought to the Comitium to adorn the aedileship of Varro and Murena."[9]

Boasting of the antiquity as well as the durability of wall paintings in Italy, Pliny further states that "To this day there are extant in the temples of Ardea paintings older than the city of Rome, which I admire beyond any others for though unprotected by a roof they remain fresh after all these years. At Lanuvium again there are two nude figures by the same artist, of Atalanta and Helen, painted side by side. Both are of great beauty, and the one is painted as a virgin; they have sustained no injury though the temple is in ruins. The Emperor Caligula from lustful motives attempted to remove them but the consistency of the plaster would not allow this to be done."[10]

Vitruvius warns against painting walls or ceilings of winter dining rooms with grand subjects or delicate decorations because they will be

spoiled by the smoke from the fire and the constant soot from the lamps. Further he gives precautions on avoiding continuous dampness which will cause injury to plaster and stuccowork.[11]

. . . The artist craftsman directed and exploited by the early Christian Church furnished a utilitarian product. Its edifices required sacred images for worship and pictorial decorations to educate and impress the masses. I have seen only one example from this early period which was probably restored within a century or two of its time of origin. At the Istituto Centrale del Restauro in Rome in 1958 I was shown a large encaustic painting of the Madonna, on panel, dating from the sixth or seventh century from one of the Roman basilica churches. It showed extensive early repainting as well as some that was obviously much later. All during the Middle Ages it appears to have been customary to repaint completely panels, icons and polychrome sculpture when they became worn, darkened or damaged. The consecrated object retained its sacred nature in spite of repeated repaintings, whereas replacement with a new rendition could have meant sacrifice of miraculous spiritual properties inherent in the original object. Wall paintings, the primary purpose of which was public education, were also renewed by overpaint or frequently covered with fresh plaster upon which new subjects were painted.

An example of medieval restoration was elegantly brought to light some years ago in Florence, Italy, by the skilled hand of Leonetto Tintori.[12] His preliminary examination, including X-ray photography of an obviously repainted Tuscan crucifix, revealed that under the paint seen on the surface, consisting largely of restorations dating from the fifteenth to nineteenth centuries, were indeed two earlier layers each in reasonably good state of preservation. Tintori first removed the top layer of crude provincial restorations to uncover the upper of the two early layers. The surface revealed could be dated stylistically about the last decade of the thirteenth century. Still covered by this restoration was the original painting of about 1250. Between the tempera paint of 1250 and the tempera overpaint of the 1290s was a continuous and fairly thick layer of oil resin varnish. By attaching a protective facing to the entire upper layer of paint and employing a solvent which dissolved only the oil resin varnish, Tintori succeeded in separating both paint films. He removed as a complete and continuous unit the restoration of the 1290s and revealed the original painted panel of 1250. The two paintings, the artist's concept and the work of the first restorer mounted on a new support may now be viewed side by side. While this method of separating and preserving two contiguous paint films is extremely rare, not at all unusual is the example it provides of medieval restoration procedures. Numerous other specimens of that era which were completely overpainted have been uncovered in recent times. In fact, the medieval concept of restoration by complete overpainting

has continued in provincial churches even up to the middle of the nine-teenth century.

—⁂—

By the time of the Renaissance in Italy, paintings were venerated as works of art and their conservation became a matter of serious concern. Nevertheless, much art and architecture was destroyed to make way for contemporary interpretations of the classical past. Vasari describes efforts both to preserve paintings faced with destruction and to restore those that had deteriorated. Giotto's frescoes which decorated the Old St. Peter's in Rome with scenes from the old and new testaments, were restored by artists of Vasari's day. During the building of the new walls of St. Peter's, some paintings on the old walls were carried away and set under the organ, others were destroyed. Among those saved "was a representation of Our Lady on a wall. In order that it might not be destroyed with the rest it was cut out, supported by beams and iron and so taken away. On account of its great beauty, it was afterwards built into a place selected by the devotion of M. Niccolo Acciaiuoli, a Florentine doctor enthusiastic over the excellent things of art, who adorned this work of art with stucco." [13]

Vasari himself restored Pietro Lorenzetti's frescoes in the Pieve at Arezzo together with the altarpiece in tempera of which he says: "I have entirely restored this altar at my own expense and with my own hands." [14]

—⁂—

Interesting, too, are the diagnoses of causes of deterioration recognized during the Renaissance. Of the frescoes by Pietro Cavallini in the vaulting of the church of Araceli sul Campidoglio in Rome, Vasari states that "the figures in this work as has been said elsewhere are much better preserved than the others because the vaulting suffers less from *dust* than the walls." [15]

The destructive effects of humidity are mentioned often by Vasari. He describes for example the last work of Giovanni Tossicani in the chapel of the Vescovado of Arezzo, "a fine Annunciation with St. James and St. Phillip. As this work was on the north wall, it was all but destroyed by the damp, when Master Agnolo di Lorenzo of Arezzo restored the Annunciation, and soon after Giorgio Vasari then quite a youth, restored Sts. James and Phillip to his great advantage as he learnt a great deal." [16]

—⁂—

Restorations in Vasari's time were not always considered successful as we may observe from his account of what happened to the four battle scenes on panel painted by Uccello which were at Gualfonda on a terrace in the garden once belonging to the Bartolini. "These pictures being damaged, and having suffered a good deal, were restored in our day by Giuliano Bugiardini who has done them more harm than good." [17]

—⁂—

A Pietà by Giovanni Bellini dating from about 1460, which hangs in the Ducal Palace in Venice, bears on its face the inscription "MDLXXI Renovatum" at which time it was enlarged and restored.[18] One wonders if the canvas on which it was painted was not also lined at the time.

Only one example is cited from the Renaissance in Northern Europe, a portrait by Holbein of Sir William Butts, the Younger. Painted in 1533–37, it depicts Butts as a young man in the style typical of Holbein. The portrait, hanging now in the Museum of Fine Arts, Boston, was said to have been restored for Butts years later on the occasion of a visit to his estate by Queen Elizabeth Ist. The restoration, by an unrecorded hand, brought the sitter's likeness up to date showing him as an elderly man, but bearing no relation to Holbein's style. Although the altered portrait was probably a reasonable likeness of Butts in his later years, as a recorded Holbein it was a complete falsification. The overpainting was removed in the twentieth century bringing to light the "lost" work by Holbein.

In 1603, letters by Peter Paul Rubens, written while he was an envoy in Spain, relate his restoration of a collection of paintings extensively damaged by damp and mold during their transportation from Italy.[19] In 1618, an artist, J. Fisher, was employed to restore Dürer's "Paumgartner Altarpiece." His restorations transformed the wings of the altar painted by Dürer in 1498 into flamboyant specimens of the baroque style.

A conversation in the Volpato manuscript between painting apprentices gives insight into the cleaning of pictures in the seventeenth century. The elder apprentice warns of the dangers involved and the damage which may result. A solution of potash in pure water is advised, gently applied by sponge and washed off quickly with pure water. Rinsing is done a second time followed by drying with a linen cloth. The painting is then varnished with white of egg. Oiling is not recommended because it is not good for pictures except when applied to the back of a canvas from which the paint is "scaling." And as proof of this, remarks the apprentice, "see the St. Peter Martyr, at Venice, who having been oiled so many times by sacrilegious blockheads who have copied him, is so spoiled and blackened that there is no telling what sort of face he has, and yet I recollect when he was beautiful."[20]

We have no certainty when, in order to reconsolidate a torn or embrittled painting on canvas, a new fabric was first applied to cover completely the reverse of the original one. It is probable that the process was an outgrowth of the simpler expedient of locally patching a torn area with a piece of cloth or paper and an adhesive. As the size of the rupture increased, the thought eventually must have occurred to someone that a fabric which covered the entire reverse would not only disguise the fact that the painting had been torn, but would strengthen a canvas which had become fragile around its edges. Painting on canvas first became popular in Venice in the sixteenth

century and spread quickly from there. It seems likely that the technique of "lining" an original canvas with a second fabric using water soluble adhesive of paste or glue was an established process well before the end of the seventeenth century.[21]

Notes

1. [3] PAUSANIAS, *Description of Greece*, vol. 2, trans. W. H. S. Jones and H. A. Omerod (Cambridge: Harvard University Press, 1926), 471.

2. [4] G. ROSI, "Safeguarding Our Artistic Heritage," *Unesco Chronicle* (May, 1959): 160.

3. [5] Ibid., 159.

4. [6] K. JEX-BLAKE, *The Elder Pliny's Chapters on the History of Art* (Chicago: Argonaut Inc. Publishers, 1968), 151.

5. [7] Ibid., 137–39.

6. [8] W. M. CONWAY, *Dürer's Literary Remains* (England: Cambridge University Press, 1889), 69.

7. [9] JEX-BLAKE, *The Elder Pliny's Chapters*, 135.

8. [10] Ibid., 127–29.

9. [11] VITRUVIUS, *The Ten Books on Architecture*, trans. M. H. Morgan (New York: Dover Publications Inc., 1960), 53.

10. [12] JEX-BLAKE, *The Elder Pliny's Chapters*, 87; and PLINY, *Natural History*, trans. H. Rackham, vol. 9 (Cambridge, Mass.: Harvard University Press, 1961), 27.

11. [13] VITRUVIUS, *The Ten Books on Architecture*, 208–9.

12. [14] U. PROCACCI, "Distacco di tempere ducentesche sovrapposte" *Bollettino d'Arte* 1 (1953): 31–37.

13. [16] G. VASARI, *The Lives of the Painters, Sculptors, and Architects*, vol. 1 (New York: E. P. Dutton and Company, 1927), 70–71. See also 71 n. 1.

14. [17] Ibid., 100.

15. [19] Ibid., 126.

16. [20] Ibid., 155.

17. [22] Ibid., 237–38.

18. [26] R. LONGHI, "The Giovanni Bellini Exhibition," *Burlington Magazine* 91 (1949): 274–80.

19. [27] R. S. MAGURN, *The Letters of Peter Paul Rubens* (Cambridge, Mass.: Harvard University Press, 1955), 32 ff.

20. [28] M. P. MERRIFIELD, *Original Treatises on the Arts of Painting*, vol. 2 (New York: Dover Publications Inc., 1967), 750–52.

21. [29] R. H. MARIJNISSEN, *Dégradation, conservation, et restauration de l'oeuvre d'art*, vol. 1 (Brussels: Editions Arcade, 1967), 33–34, places the first mention of "relining" in 1660 followed by other references in 1680 and 1698.

The Surgery of Memory: Ancient Sculpture and Historical Restorations

ORIETTA ROSSI PINELLI

§I. Restoration, or about Subjectivity: A Journey through the *Laocoön*

Let us try for a moment to imagine all the representations of the *Laocoön*, from the early engravings to the more recent plaster casts. Let us reduce them to schematic images and gather them one on top of the other like those children's books that give the illusion of movement when you flip the pages quickly. We would see the dramatic figure of the Trojan priest and his two dying sons bid us farewell with their hands, awkwardly gesticulating with their arms. Even the snake's coils would undulate as if the sea monster were again committing the horrible crime right before our eyes.

In this hypothetical, dynamic reconstruction, the work would certainly lose its aura. Yet we would have the opportunity to perceive simultaneously the extraordinary variety and the contradictory quality of the restorations that have been devised to resolve the problem posed by the mutilated state in which the prestigious sculptural group was found. From time to time, these restorations were subject to changing aesthetic models and to changes in antiquarian culture that developed within a specific cultural area and within a precise time frame.

Through the sequence of restorations on the *Laocoön*, one can in fact trace the restoration history of the ancient sculpture as if through a mirror. There are numerous general indications by virtue of the extraordinary uniqueness of this work. For centuries it has dominated the collective imagi-

From ORIETTA ROSSI PINELLI, "Chirurgia della memoria: scultura antica e restauri storici," in *Memoria dell'antico nell'arte italiana*, ed. Salvatore Settis (Turin: G. Einaudi, 1986), 183–91, 239–44, 245–47. Used by permission of Giulio Einaudi editore s.p.a. Translated by Gianni Ponti with Alessandra Melucco Vaccaro.

nation, and has, therefore, been the focus of unusual attention and controversies. Elevated to the status of *exemplum doloris* since the sixteenth century, the sculpture has borne witness to the terrible nature of the human condition subjected to the injustice of the gods, who do not hesitate to strike down an honorable man and his two innocent sons.[1]

Are we then faced with submission or rebellion in the *Laocoön?* Chance has allowed the group to be found in substantially good condition,[2] with only a few fragments missing. Unfortunately, the missing parts are decisive ones for interpreting the spirit of the protagonists and the unfolding tragedy: the right arm of the father and the younger son, the older son's right hand, as well as some of the snake's coils. The father's gesture, in particular, could significantly alter the interpretation of the pain portrayed on his face. Over that missing gesture many artists, as well as antiquarians, have been at odds, often oblivious to clues that can be observed directly on the sculpture: the difference in the carving of the marble around the right ear and at the nape of the neck, and the treatment of the muscles on the broken shoulder and neck. These clues would have suggested from the start that the missing right arm was more likely to have been bent backwards with the hand resting behind the head.

Nonetheless, in handling "live" material from antiquity, emotional considerations often overcome rational ones, even when restorations have assumed a semblance of philological rigor.

Even though the *Laocoön* has been the subject of many recent and often accurate studies,[3] the vicissitudes surrounding its actual or proposed restorations and de-restorations still leave several difficult issues unresolved. These events are in fact "contaminated" by elements that cannot be inserted into strictly consequential schemes. It is, first of all, no small surprise to register the discrepancy, already apparent in antiquity, between literary and iconographic sources. Pliny exalts the Rhodian work as one of the most beautiful in the ancient world; he is also responsible for the interesting legend that the three figures were carved out of a single block of marble.[4] On the other hand, copies of the work have never been found,[5] a fact that seems to contradict Pliny's observations indirectly. Furthermore, the few ancient paintings[6] that have survived seem to ignore the model altogether. After the discovery of the work, it was precisely the complete lack of any other comparable references that strongly influenced the outcome of the restorations and the related controversies.

The *Laocoön* immediately became the subject of analysis and hypotheses. No artist passing through or living in Rome to study antiquities omitted the Belvedere group from his itinerary. Alongside the many drawings, still surfacing from the collections of great museums,[7] a whole series of casts and copies[8] in plaster, bronze, and marble demonstrate the fame and appreciation

with which the work was received after its discovery. The work was endowed with the renown that Pliny had subjectively attributed to it in his own time, and that, perhaps, had not been recognized then.

As far as the restorations are concerned, the first and most authoritative source continues to be Vasari;[9] a precise and valuable source who, although failing to clarify the issues that led to later restorations, has nonetheless left room for a variety of conjectures.

In the life of Jacopo Sansovino, Vasari[10] provides the earliest chronological reference to the statue. In 1510, it was the object of a competition among artists living in Rome to reproduce the Rhodian work in wax. Sansovino's work turned out to be the best, and was subsequently used to make a bronze copy for Cardinal Domenico Grimani.[11]

The first clear reference to a restoration of the *Laocoön*'s right arm is in the life of Bandinelli: "[H]e restored . . . the right arm of the ancient *Laocoön* that had broken off and was lost. Baccio made a large one in wax that matched the muscles and the delicacy of the original. It bonded well, showing how Baccio really understood the work of art, and he used the model to make the whole arm for his own [statue]."[12] These were the years 1520 to 1525, and Bandinelli was in Rome carving a marble copy of the whole group. All traces of his wax arm were soon lost, but the marble copy in the Uffizi Gallery bears witness to the choice used by Bandinelli to restore the missing arm. The gesture imposed by the sculptor on the Rhodian group met a criterion that was more compositional than interpretative: the arm bent at the elbow, with the forearm reaching upward and the serpent twisting its coils, emphasizes neither a rebelliousness nor submission by the priest. Rather, it recomposes the distribution of the arms and legs in a chiastic image. If the compositional element seems to prevail, Bandinelli nonetheless also paid attention to the "story": it looks as if he went back to read the verses of the Aeneid[13] that describe the tragedy of the priest and his two sons, for he emphasizes both the entangled coils of the serpent around the arm and the muscular force of Laocoön to free himself from them.

We do not know what happened to the *Laocoön* between 1525 and 1532, the year in which Montorsoli completed his own restoration. If we are to believe Vasari,[14] Montorsoli was called in to integrate the "broken statues" of the Belvedere, among them the *Apollo* and the *Laocoön*. Perhaps Bandinelli's wax arm had fallen off or had been intentionally removed; possibly it had been vandalized during the sack of 1527, or perhaps—another possibility—it was still in place when Montorsoli was appointed. Moreover, why did Pope Clement VII—the same pope who had so appreciated Bandinelli's copy that he wanted it kept in the Medici House in Florence—not require that the restoration be executed on Bandinelli's wax model in a more durable material?

Michelangelo, who had recommended Montorsoli to the Pope, probably did not appreciate the solution of the Florentine artist to the same extent, and might have suggested a completely different remodeling.[15] It is a mere hypothesis, but it is not unlikely that Michelangelo had a more important role in the affair than the sources lead us to believe, especially if we consider the influence that Buonarotti had on the young Montorsoli.[16] The fact remains that Montorsoli took no account of the previous model and chose to substitute the half-folded arm with one that would express a great emphatic gesture, more apt to show nonsubmissive pain—an attempt at rebellion against the undeserved punishment. The gesture chosen by Montorsoli does not appear in any of the previous studies. It even challenges the chiastic equilibrium proposed by Bandinelli in favor of a formal tension that is both centrifugal and asymmetric and that implies a search for a pathetic emphasis. The arm of the younger son has no relation whatsoever to the father's arm—as it does in the eighteenth-century restoration, which has survived up to the most recent de-restoration. By folding back onto itself, this arm underlines both the formal isolation between the two figures and the complexity of the spatial directions. Ever since its first appearance, Montorsoli's invented gesture, along with the priest's suffering features, became the expressive hallmark of the entire group and, consequently, was an extraordinary penetrating force in contemporary and later figurative culture. The great theatrical gesture of the *Laocoön,* though arousing not a few misgivings in terms of its archaeological accuracy, was generally liked and remained associated with the image of the statue until the years following World War II. How then do we explain the bronze cast completed by Primaticcio around 1540 for the cast collection commissioned by Francesco I? Why are the Montorsoli integrations missing in this bronze? Had the terracotta arm been temporarily removed, as Brummer suggests,[17] or are we faced with Primaticcio's deliberate choice? I would have great doubts about the possibility of a temporary removal. However, one could advance two hypotheses for Primaticcio's decision: either the artist did not agree with the recent integrations, but, if so, he himself could have seized the opportunity of the bronze cast to propose a variation; or—and this seems to me the more likely hypothesis—the decision to reproduce the *Laocoön* with its original lacunae was a tribute to the taste, still strong north of the Alps in the 1540s, for the ruin and the fragment.

Until 1725–27, however, the *Laocoön* maintained the restorations of 1532. Once again it is not clear why at that time Agostino Cornacchini, branded by Cicognara[18] as "one of the saddest sculptors ever to work with a chisel," was assigned to carry out new interventions on the group. Evidently there was a desire to substitute the poor materials of the sixteenth-century integrations with marble. Yet what remains obscure is with what authority

Cornacchini was able to intervene to modify the Montorsoli gesture of the younger son by extending the right arm upwards, clearly recalling the father's gesture. This certainly seems to be a choice that derives from a strictly compositional interest, and one that contradicts the standard interpretation of the figure as the one closest to death.[19]

A cast dating to the mid-eighteenth century that seems to have belonged to the Mengs cast collection, and which today is in the Academy of Fine Arts in Florence, shows the traditional gesture of the dying son. It is not an ordinary cast, but an accurate archaeological study of the group. Beyond reinstating the partially extended arm of the young victim, the cast, for the first time in the history of studies of the Rhodian group, challenges the very relationship of the three figures to each other. We should recall at this point that when the *Laocoön* was found in the 1506 excavation, the figure of the older son certainly must have been detached from the other two. Some prints dating to soon after the excavation confirm the separation of the figures at the time of their discovery.[20] The frontal arrangement of the group is thus a sixteenth-century reconstruction that perhaps has nothing to do with the original composition of the Rhodian work. This at least appears to be the conviction of the author of the cast; in fact, the figure of the older son is turned with its back to the father, establishing a more vivid and decipherable relationship in the exchange of glances among the three protagonists and inspiring a new compositional arrangement that is highly suggestive. A few decades ago, Seymour Howard, ignoring this precedent, developed a solution based on extremely accurate measurements and philological reconstructions of the work[21] that would fully confirm the reconstruction hypothesis of the Florentine cast. Yet the cast's surprises do not end here: it is, in fact, impossible to explain why the author did not modify the position of the father's arm, which at the time was universally recognized as incorrect. At this point it is worth recalling Winckelmann's judgment: "This arm, entangled by the snake, must have been folded over the head of the statue, ... yet it looks as if the arm folded above the head would have in some way made the work wrong."[22] Winckelmann's judgment probably weighed on the fate of the statue for some decades later. When the *Laocoön* arrived in Paris in 1799 as a spoil of war, and was the subject of a public competition for a new restoration (the modern arms had been removed and left in Rome), nobody entered the contest. And yet an intervention on the group could well have been a historical opportunity for the winner of the competition.[23] Furthermore, when the statue returned to Rome in 1816 with the other masterpieces that had been appropriated from Italy by the Napoleonic government, the arms and hands, which had been removed and carefully conserved, were returned to Laocoön and his two sons. Why did Canova not arrange to remodel at least

the arm of the dying son? The one modeled by Cornacchini was universally considered dreadful. Yet, most of all, why—with all his authority—did he not remodel the father's arm as well? Canova had no doubts about the incorrect position of the gesture imposed on the statue in the sixteenth century. He perfectly understood how the arm should be bent behind the head; yet he also confessed to Gherardo De Rossi that the removal of the old restoration "would have caused disputes and litigation among antiquarians and artists, and worry for himself without gaining any merit."[24] Therefore, "reasons" of the heart prevailed over "reasons" of archaeology, that is, the awareness of a philological error was sacrificed to the seduction of a gesture, highly suggestive as it was.

For the modifications to be able to be realized, the emotional tensions that surrounded the Rhodian group first needed to subside. This began to occur only around the middle of the nineteenth century, when that very same gesture, once considered sublime, became hardly tolerated because it was now considered rhetorical. Furthermore, integrative restorations in general were beginning to be strongly criticized.[25] Among the many peculiarities that have distinguished the history of the *Laocoön* since the time of its discovery, there is also the unexpected rediscovery of the original arm. It was found in Rome in 1905, in the workshop of a stone carver, thanks to Pollack [sic], a German scholar who had spent considerable energies studying the problems of the group. Yet the arm was not replaced immediately. We had to wait until 1960 for the substitution to take place, in a manner that, fortunately, saved the arm sanctioned by tradition. This has since been incorporated on a plaster cast of the group.[26]

Nonetheless, instead of subsiding, conjectures about the *Laocoön* have multiplied. Archaeologists, who now consider the group their exclusive domain, driven by their desire to rediscover, once and for all, the precise identity of the work, have competed in developing reconstructions that are more or less correct and more or less fanciful. By favoring strictly formal issues over those related to the needs of the story, scholars have too often reached results that betray a latent aesthetic subjectivity beneath the apparent rigor of scientific research.

In support of this it will suffice to recall a statement by Vergara Caffarelli, one of the authors of these reconstructions-on-a-cast, who thus comments on his own work: "It is a new work of art [the one he reconstructed] that appears in place of the one known for more than four centuries. It requires a reconsideration of the severe judgments that archaeologists and, especially, art critics have heaped on it in recent decades. The rhetorical emphasis of which it was accused, and which derived from the restoration—from whose effect not even scholars aware of its falsity could free

themselves—completely disappears, giving way to an intense drama reached through a most learned composition. The divine voice of poetry replaces Academia."[27]

—⁓—

§XIII. Integrate or Conserve the Fragment? The Contributions of Canova, Thorvaldsen, and Quatremère de Quincy

The occasion for Gherardo De Rossi's brief essay was the integration of a statue of *Antinous* found at Ostia by Antonio d'Este, who had begun to work on his own after Canova's death. According to De Rossi, the result confirmed the accuracy of the theoretical premises to which the restorer had remained faithful. "The feet are beautiful, and for the head the restorer has followed the advice expressed by Canova when he was alive, mainly that the head be a complete imitation of the antique, combining the two heads of *Antinous* from Villa Albani and from Braschi."[28] The small interventions on the drapery were masterly as much for their stylistic quality as for their disguising perfection "so that they almost hide the restoration." Such were the informative principles that guided the restorations, which were meant to satisfy the needs of antiquarians and artists before the needs of collectors: a restoration that, to use modern terminology, now had a scientific intent. There was thus no hesitation, at least on a theoretical level, about the legitimacy of integrating the fragment, as long as the insertion perfectly mirrored the style, character, and proportions of the original fragment, and was perfectly camouflaged in the new unified image. Canova showed himself to be absolutely convinced by this approach, which for its most consistent work was centered in Rome. Canova himself never actually restored, but followed the most important restorations, especially those for the Vatican Museums. It was he who suggested the de-restoration and a new integration of the so-called *Filosofo Giustiniani,* acquired for the Pio-Clementino. The sculptor was certain that the work represented an ancient author of tragedies and not a philosopher; he thus ordered the substitution of the head (the result of a modern restoration) with a head of Euripides. De Rossi, who unconditionally supported these interventions, judged the final result as "a truly rare Greek figure."[29] Nonetheless, Canova is credited with being the first to hint at a crisis in the theory of integrative restoration or, at least, to raise a loud alarm against the abuses that continued, despite warnings of caution being expressed from many directions.

Around 1815–16, Canova, prompted by two important events, developed the first doubts and proposed new guidelines on the subject of restoration. The first, most important episode was the impact of the Phidian sculptures of the Parthenon, transferred from Athens to London by Lord

Elgin. The second episode was the recovery of most of the works of art car-
ried off by the French and the consequent ease in reintroducing selection
criteria for the acquisition of works of art for the public museums in Rome.

Canova reached London in 1815 to express the pope's gratitude to the
English government for the significant financial help offered in the diffi-
cult recovery of the Italian works of art that had been taken to France by
Napoléon.[30] The visit gave him the opportunity to study firsthand the famous
Elgin marbles,[31] by then celebrated all over Europe. Canova was confounded
by a reality that was considerably superior to his expectations. The Parthenon
marbles were clearly of superior quality to the *Apollo Belvedere.* Canova was
convinced that "had the Roman artists seen [the sculptures], they would
have changed the style of their own works."[32] The Parthenon marbles had
been displayed in the British Museum in the fragmented condition brought
about by time and by the troubled affairs of Greek politics; as for all other
ancient monuments, there was debate about who should restore them and
how. But how could one be certain of not running the risk of counterfeiting
inimitable works of art, when even the best restorers had worked only on
Roman marbles, with a style that was so much more familiar and so much
easier to reproduce? This is what Canova wondered, and the answer was
simply: the sculptures should not be touched.[33] The year 1816 certainly was
one to remember in the history of restoration. While the world contemplated
the Parthenon marbles in wonder or even, on occasion, in controversy, and
while the important decision to avoid any attempts at integration of the
sculptures was being made, Thorvaldsen completed an integration in Rome
on a group of Greek statues from Aegina that Ludwig I of Bavaria had pur-
posely routed through Rome so that the Danish sculptor could restore them.
Thorvaldsen's work received no less of a consensus than the apparently oppo-
site decision of not restoring the Elgin marbles. One could suspect that in
1816 opinions on issues of restoration were quite uncertain. On the contrary,
we are faced, probably for the first time, with a definite and basically homo-
geneous approach of an international character. Canova and Thorvaldsen
both had elaborated and defined opinions that had already been formulated
by Winckelmann and Ennio Quirino Visconti: the only purpose of restora-
tion was to improve our knowledge and understanding of a work of art. The
choice between intervening and not had to be subordinate to the *possibility*
of intervening. If no artist could match Phidias's style (one should keep in
mind that at that time interventions on works of art were beginning to be
influenced more by aesthetic than by iconographic considerations), Phidias's
works should be left in their fragmentary state. Yet if Thorvaldsen was
capable of imitating perfectly the Aegina style, the whole group of statues
would certainly have gained from the integrations. "I therefore think that
we will owe to the restoration of the pediments of the Temple of Aegina our

better understanding of how they were, of the taste in the composition of pedimental sculpture, and of the style of this ancient school."[34] Quatremère de Quincy, tutelar name of European *intelligencia,* believed in the didactic use of restoration, most of all because it prevented imagination from superseding the reality of the works of art. "I am convinced that the antique would not have affected public taste the way that it has in the last fifty years if all ancient sculptures had been left in a state of mutilation." And, providing us with unexpected information, he adds, "... as the artists often like to see them."[35] An appreciation of the fragment was beginning to develop: first among artists, who were, naturally, more sensitive to formal issues, then among collectors. Yet a theoretician of Quatremère's repute feared the inherent individualism of such a tendency and further understood that "people in general, ... foreign to the essence, science and practice of art, want to be captured through the eye, and are often put off by incomplete works."[36] Thorvaldsen, according to Quatremère, did an excellent job; he understood how to confer on the integrated parts the same "rigid, methodical and not so expressive" style that was typical of "that school."[37] The sculptor, even though making astonishing mistakes (like placing a warrior lying on the ground rather than standing as he certainly was), had in fact worked to bestow a stylistic unity on the group of statues. He had proceeded with great care, first by joining all fragments found in the excavation; then by studying and preparing in plaster the necessary integrations; and finally by having executed in marble all the necessary parts. Furthermore, he was careful not to polish the completed parts, a widely accepted practice, and even tried to imitate the roughness of the ancient marble on the modern parts. Thus his work fit perfectly into a climate of archaeological respect and philological passion for the work of art. Quatremère's judgment is still the most straightforward evidence for the complexity, but also for the consistency, of general thinking about restoration at the time. The Aegina restoration added new elements for a better understanding of the works, but with respect to the Elgin marbles, Quatremère did not hesitate to side with Canova. "I think they do very wisely in London to leave the works in the state in which time and destruction have left them for us."[38]

The other event that confirms a qualitative advance in the theory of restoration, which was caused, as we have seen, by the impact of the Elgin marbles, was the return of works of art from France and thus the need to establish extremely selective criteria for acquisitions by museums. These criteria had been considerably expanded out of necessity to compensate for the many *absences* caused by the French looting. Canova thus advised Cardinal Pacca, the Camerlengo, to form a special advisory committee to determine the guidelines for acquisitions. "The advice was appreciated by the Cardinal, who, by means of an official order, instructed Canova, as Inspector General

of Public Arts, to propose the names of qualified persons to form said com-
mittee."[39] The committee was formed by Antonio d'Este (secretary general of
the Papal Museums), Carlo Fea (director of antiquities and author of the
1802 law that protected the artistic heritage),[40] Filippo Aurelio Visconti, and
the sculptor Thorvaldsen, who was nominated for the esteem bestowed upon
him as artist and restorer and for the fact that "he had nothing to sell" and
thus would not have profited from the appointment.[41] The basic principle to
which the committee agreed to adhere in deciding the acquisition of works of
art was truly unusual: the number of integrative restorations that had been
performed on the works. "Only those monuments that are preserved unal-
tered in their original, ancient form, without restoration, will be bought."[42]
The suspicion that a restoration could constitute forgery was thus consid-
ered, for the first time, within an institutional context. Nonetheless, it was
not a challenge to the legitimacy of integrative restoration. It was, rather, a
challenge to its abuse and to the common practice of not meeting scientific
requirements in order to satisfy the needs of an inflated market for antiqui-
ties. Furthermore, the substantial doubts posed by the Elgin marbles cer-
tainly influenced the issue.

 To understand the true novelty of that decision, it is important to ana-
lyze the offers for sale by those who owned works of art. Vincenzo Pacetti, for
example, well known for his elegant restorations in the school of Cavaceppi,
presented a list of sculptures that he wished to sell to the museum, indicat-
ing prices that—as usual—gave more value to statues he had restored than
to fragmented pieces. The committee, on the other hand, gave a completely
opposite evaluation: faced with a total request for 20,810 scudi, it offered the
modest sum of 570 scudi because of the excessive integrations.[43] It was the
first time that such an upheaval in the judgment of value had occurred. For
the material offered by Ignazio Vescovali, a merchant who had a shop in San
Carlo at Corso n. 129, an even more severe criterion was applied, stating that
"the many ancient art objects [were] more apt to please the fancy of cultured
foreigners," but were "unsuitable for the Papal Museums." Such a statement
decreed the particular character of public museums and their scientific and
didactic function, as opposed to the "taste" and choices that inspired pri-
vate collectors.

 At the same time as the work of the committee, a legal proposal[44]
was also presented by Canova's studio with the aim of permanently sanction-
ing the criteria that had been adopted on that occasion. The document,
dated 1816, addressed several problems related to the regulations that gov-
erned the sale of antiquities and, most of all, defined limitations on the
subject of restorations. It established that since "[a restorer] is capable of
creating a statue from a fragment, often reworking the original to liken it to
the modern work, he should give a note before each restoration made, on

penalty of confiscation." It was therefore forbidden "for any sculptor to perform any restoration on any ancient monument without the required authorization from the Office of the Camerlengo, from the Camerlengo himself, or from the owner of the object that he wishes to restore."

The code was to be reprinted every three months and was to be posted, fully visible, in every antique shop or sculptor's studio to "prevent pleading on grounds of ignorance." In 1820 the code was finally added to the new protection law promulgated by Cardinal Pacca, which gave definitive and lasting form to the slow, controversial process of theoretical and practical research that had marked the last thirty years in the history of the protection and restoration of the artistic heritage.

§XIV. Conclusions

If 1816 had been the year for defining a theoretical model for restoration (whose origins went far back in time, but which had been defined only because of the coincidence of particular situations), then 1830 can be considered the year, without anything in particular happening, in which a general consensus of opinion emerged. It revealed a significant change in the taste of intellectuals and in public opinion with regard to ancient works of art as well as to integrations.

In the very city of Berlin, during the inauguration of the great Schinkel Museum, which was full of prestigious, carefully restored sculptures, Wilhem von Humboldt, a figure of great cultural influence, showed the first signs of intolerance. Humboldt had elaborated a poetic philosophy on antiquity and Rome that inevitably condemned any integration of works of art. "Rome is a desert ... but the most sublime, the most fascinating one I have ever seen. Rome is made only for a few, only for the best ... here, for the first time, in ripe solitude the shapes of the world unfold clearly and calmly ... sadness and joy pass quietly from one to the other, and on the border between life and death it is easier to move in life, it is sweeter to resign to death."[45]

This kind of philosophy of life and memory emphasized the significance of ancient remains, rather than the philological reconstruction of their original appearance. "When we excavate a half-buried ruin, we always feel a certain resentment. It is, at most, a gain in erudition at the cost of fantasy." With such a premise it is not difficult to understand the motive that moved Humboldt, in 1830, to write a memorandum on the ancient restorations in the Berlin Museum, arguing that the integrations were no longer justifiable. This was because, at the moment of intervention on a fragment, its character was altered; the work of art, shaped by time, nonetheless maintained a unity of its own.[46] The poetry of the fragment was developing; an

aesthetic interest dominated the cognitive one, and iconographic passion had become a dead issue.

In England too, in the same year, Allan Cunningham, an eccentric figure in Anglo-Saxon culture, was finding ample reasons, among the greedy English collectors, to tease or condemn their enthusiasm for works of art that had little or nothing to do with their original appearance.[47] These works of art were an assemblage of fragments of different statues to which some manual skill, good glue, and a shrewd application of patina gave an unlikely, yet suggestive, ancient flavor; the casual insertion of distinctive attributes gave the statues even more unlikely identities.

The proliferation of public museums, based on the French model, and their administration by specialists posed the problem of restoration in a new light. We have already seen how in 1816 Canova established unusual criteria for the acquisition of works of art for the Vatican Museums. The works were no longer furnishings, but rather evidence of a past history that needed to be reconstructed and made known. At least in terms of their strictly educational function, public museums had been an idea of the Enlightenment. The choice of the works of art implied that they had to be known and understood. Research became necessarily more rigorous. The methodologies that were sought had to provide certainties.

Germany quickly found itself in the lead both in terms of the proliferation of qualified museums and, most of all, in the formation of an extremely valuable archaeological discipline.[48]

Around the 1830s and throughout the century, the German philological school of Overbeck, Müller, Brunn, Friederichs, and all the way to Furtwängler produced extremely interesting material by comparing the many Roman copies to the relevant literary sources in order to arrive at an image of the Greek originals. For these scholars the restorations of previous centuries were completely irrelevant to the purpose of their studies, so they began to remove them and to recommend their destruction, finding support in more than one man of culture, even beyond the German border. In 1884, the Italian Camillo Boito, an authority in the field of restoration, stated: "General theory for sculpture: no restorations; and throw away immediately, without exception, all those done up to now, whether recent or old," confirming that a consensus had been reached on the relevant objectives.[49]

Philology had somehow done away with a myth; it had interrupted the magic relationship between sculpture and the public. Museums played a major part in isolating and estranging works of art from an everyday context that, in the past, had made them familiar presences. Above all, the interests of collectors were also changing. "We have not left a mark on our houses, gardens or anything else," wrote de Musset. "Even the apartments of wealthy people are a bazaar of curiosities: the ancient, the gothic, the taste

for the Renaissance and for Louis XIII, are all mixed in confusion."[50] Classical sculpture was at best one of the many furnishings that cluttered houses: romantic culture preferred other models. To give new meaning and appeal to ancient statues it will be necessary to attribute to them a disturbing sense of the perverse. The *Vénus d'Ille,* from Mérimée's short story of the same name,[51] is an outstanding bronze sculpture, excavated in the quiet French countryside, that becomes a terrifying, murderous demon. The beautiful Juno in a story by Henry James[52] leads a young Roman aristocrat to the verge of insanity; he is saved only when the evil image is again buried. But these are only sporadic revivals. Only mythology will find new energy in psychoanalysis: the *images* of myths, in the form of sculpture, will instead live ever more removed from the world, confined to museum rooms or university classrooms. The identification of the subjects and the reconstruction of the original images will become more and more the focus of learned arguments among experts, who will challenge each other with plaster casts integrated on the basis of subtle and sophisticated reconstruction hypotheses. A kind of iconoclastic rage will sweep away ancient restorations, forever scattering works of art that were the result of interventions by artists who had lived at quite different times.

The new cult of the fragment recovered images that had very little to do with the original, however, because of the alterations that were performed during the ancient restorations. This is how we have come to possess fragments that often have almost nothing left that is authentic.[53]

Notes

1. L. D. Ettlinger, "*Exemplum doloris:* Reflection on the *Laocoön* Group," *De artibus opuscula 40: Essays in Honour of Erwin Panofsky,* vols. 1–2, ed. Millard Meiss (New York: New York University Press, 1961), 121–26.

2. The *Laocoön* was found in January of 1506, on the Oppian Hill, under the remains of the Baths of Titus at a site called "Le Capocce," in a vineyard worked by a certain Felice Freddi. It was immediately identified as the group cited by Pliny in *Natural History* 36.37. In March, Pope Julius II bought the statue to place it in the Vatican Belvedere. The names of the three sculptors were known from Pliny: Agesander, Polydorus, and Athenodorus of Rhodes; the date for the group is still a matter of debate among specialists; see most recently Bernard Andreae, *L'immagine di Ulisse: Mito e archeologia* (Turin: G. Einaudi, 1983), 190–96.

3. The bibliography on the *Laocoön* is truly immense. For this reason I will cite only the most significant works and those that pertain to the history of its restorations: Margarete Bieber, *Laocoön: The Influence of the Group since Its Rediscovery* (New York: Columbia University Press, 1942; edition used Detroit: Wayne State University Press, 1967); G. R. Ansaldi, "Il Laocoönte

cinquecentesco e quello di oggi," *Emporium* 101 (1945): 55ff; E. VERGARA
CAFFARELLI, "Studio per la restituzione del Laocoonte," *Rivista dell'Istituto
Nazionale di Archeologia e Storia dell'Arte* 3 (1954): 28–69; A. PRANDI, *La
fortuna del Laocoonte dalla sua scoperta alle Terme di Tito* (n.p., n.d.), ivi, 78ff;
HANS HENRIK BRUMMER, *The Statue Court in Vatican Belvedere,* Acta
Universitatis Stockholmiensis, Stockholm Studies in the History of Art, vol. 20
(Stockholm: Almqvist and Wiksell, 1970), 75ff; J. PAUL, "Antikenergänzung und
Ent-Restaurierung," *Kunstkronik* 25, no. 4 (1972): 85–112; W. OECHSLIN, "Il
Laocoönte o del restauro delle statue antiche," *Paragone* 25, no. 287 (1974):
1–29; M. WINNER, "Zum Nachleben des Laokoon in der Renaissance,"
Jahrbuch der Berliner Museen 16 (1974): 83–121; G. DALTROP, *Die
Laokoongruppe im Vatikan: Ein Kapitel aus der Römischen,* Xenia 5 (Konstanz:
Universitätsverlag Konstanz, 1982); H. W. KRUFT, "Metamorphosen des
Laokoon: Ein Beitrag zur Geschichte des Geschmacks," *Pantheon* 42, no. 1
(1984): 3–11; and E. SIMON, "Laokoon und die Geschichte der antiken Kunst,"
Archäologischer Anzeiger 4 (1984): 641–72.

4. There is actually no agreement, even on the total number of marble blocks
 that compose the statue; see CAFFARELLI, "Studio per la restituzione del
 Laocoonte."

5. After the discovery of the great sculptural groups in the Sperlonga cave, which
 carry the signatures of the same Rhodian artists, there is still debate as to
 whether the *Laocoön* can be considered a Hellenistic original or a Tiberian
 copy of a model from about two centuries earlier. The discoveries were made
 in 1963. See BALDASSARE CONTICELLO and BERNARD ANDREAE, *Die Skulpturen
 von Sperlonga* (Berlin: G. Mann, 1974).

6. Compare the Pompeii frescoes in the House of Menander and in the House of
 the *Laocoön;* also the miniature in the Codice Virgiliano (Vat. Lat. 3225, fol. 18v),
 which belonged to Pontano in the sixteenth century. In both iconographic
 representations, Laocoön's arms are far from the body. In particular, the
 Laocoön in the House of Menander raises the right arm in a way that is very
 similar to that imposed on the statue by Montorsoli. At the time, Montorsoli
 obviously could not have known of the fresco. For the iconography of the
 Laocoön before the discovery of the Rhodian group, see the fundamental essay
 by WINNER, "Zum Nachleben des Laokoon in der Renaissance."

7. M. WINNER, "Il Laocoonte nel cortile del Belvedere e un progetto di restauro
 anteriore a quello di Montorsoli," (paper presented at the conference Roma
 centro ideale della cultura dell'antico nei secoli 15 e 16, 25–30 November 1985).

8. FRANCIS HASKELL and NICHOLAS PENNY, *Taste and the Antique: The Lure of
 Classical Sculpture, 1500–1900* (New Haven and London: Yale University Press,
 1981); and their exhibition catalogue, *The Most Beautiful Statues: The Taste for
 Antique Sculpture, 1500–1900* (Oxford: Ashmolean Museum, 1981).

9. *Le Vite de' più eccellenti architetti, pittori et scultori italiani, da Cimabue
 insino a' tempi nostri* (Florence: n.p., 1550; reprint, Florence: Appresso
 i Giunti, 1568); edition used: Gaetano Milanesi, ed., vol. 6 (Florence:
 G. C. Sansoni, 1878–85), 146, 632.

10. Ibid., vol. 7, 489.

11. For the complex events related to the copies and drawings of these early years
 and for the related extensive bibliography, see BIEBER, *The Influence of the
 Group since its Rediscovery,* and BRUMMER, *The Statue Court in Vatican*

Belvedere. Prandi believes that it is possible to infer from Vasari that the first integration of the arm can be attributed to Sansovino; there is no basis for this hypothesis, which has caused many subsequent misunderstandings.

12. Vasari, *Le Vite,* 146, 683.

13. Virgil, *Aeneid* 2, The Alpha Classics, Latin authors (London: G. Bell, 1961), 220: "Ille simul manibus tendit nodos." Winner has identified the correspondence between Virgil's verses and Bandinelli's solution in "Il Laocoönte nel cortile del Belvedere."

14. Vasari, *Le Vite,* 632. At the beginning of the nineteenth century, on the basis of a vague reference by Michelangelo, it was believed that Montorsoli's arm was the work of Bernini. See G. G. De Rossi, "Lettera sopra il restauro di una antica Statua di Antinoo, e sopra il restauro degli antichi marmi nei tre secoli precedenti al nostro," *Nuovo Giornale dei Letterati* 13 (1826): 23–38.

15. F. Magi, "Il ripristino del Laocoönte," *Memorie (Pontificia Accademia Romana di Archeologia)* 9 (1960). Magi found in the Vatican a marble arm destined for the *Laocoön.* He presumes that it could be an attempted restoration, never completed, by Michelangelo. Bieber, *The Influence of the Group since Its Rediscovery,* considers this a valid hypothesis. Brummer, on the other hand, notices a similarity between the Vatican arm and a terracotta of the *Laocoön* that he found in the Princeton Art Museum and that he attributes to Sansovino. He assumes that the arm is an unfinished intervention by Sansovino. The arm was already known at the end of the eighteenth century and is discussed explicitly by E. Q. Visconti (*Musée Pio-Clementin II* [Milan: I. P. Geigler, 1819], 274), who mentions an unfinished marble arm, traditionally attributed to Buonarroti. Visconti believes that the arm is instead an early project by Montorsoli. This hypothesis is also unfounded because Montorsoli never made a marble arm for the statue.

16. Winner, "Il Laocoonte nel cortile del Belvedere," in reconstructing the placing of the group in the Cortile Belvedere in the sixteenth century, presumes that the Montorsoli transformation was conditioned by the need to charge Laocoön's gesture with a certain emphasis so as to make the group more visible. The group was half hidden by the two large statues of Nile and Tiber, which at the time were placed in the middle of the courtyard. This is a convincing hypothesis, even though it is likely that Montorsoli's choice was the result of more than one factor.

17. Brummer, *The Statue Court in Vatican Belvedere;* for the Primaticcio cast, see Baucher (n.p., n.d.).

18. Leopoldo Cicognara, *Storia della scultura dal suo risorgimento in Italia* 6 (Venice: Fratelli Giachetti, 1813–18), 236; on Cornacchini see also G. Faccioli and D. Agostino, "Cornacchini da Pescia scultore a Roma," *Studi Romani* 16 (1968), 439ff., and related entry in *Dizionario biografico degli Italiani* (Rome: Istituto della Enciclopedia Italiana, 1960), cited henceforth [in author's text] as *DbI,* 29 (1983), 100–4.

19. Ulisse Aldrovandi, *Le statue antiche che in Roma in diversi luoghi e case particolari si veggono, raccolte e descritte* (Venice: G. Olms, 1562).

20. Winner, "Zum Nachleben des Laokoon in der Renaissance," fig. 14; Düsseldorf, Kupferstichkabinett, inv. Mr. F.P. 7032: it is the oldest print of the group found on the Oppian Hill, ca. 1506–8.

21. S. HOWARD, "On the Reconstruction of the Vatican Laocoön Group,"
 American Journal of Archaeology 63 (1959): 365–69.

22. JOHANN JOACHIM WINCKELMANN, *Storia delle arti del disegno presso gli antichi,*
 ed. Carlo Fea, vol. 2 (Rome: Dalla stamperia Pagliarini, 1783–84), 242. Even
 Winckelmann believed that the unfinished marble arm was Michelangelo's
 and that Bernini was the author of the Montorsoli restoration of the arm. In
 the footnote to the Italian edition of 1830 (477 n. 42; this is still the edition by
 Fea), we read that Heyne and Winckelmann disagreed on both author and
 date of the restoration. Heyne refutes the attribution to Bernini and mentions
 Montorsoli. He also states that the first restoration was performed by
 Bandinelli before 1525. Heyne also notes how damaged the copy in the Uffizi
 was after the fire of 1762. The writer of the footnote assumes that the author of
 the unfinished arm is Montorsoli. VISCONTI dedicates a long and exquisite
 passage to the *Laocoön* in his *Musée Pio-Clementin II,* praising the expressive
 quality of the Montorsoli restoration ("une des meilleures restaurations que
 l'on voye adaptées à d'antiques sculptures" [one of the best restorations one
 has seen applied to ancient sculpture], so that if the ancient arm was to really
 bend back toward the head, "elle n'aurait pas paru avec tant d'avantage" [it
 would not have looked so good with so much advantage]). Visconti harshly
 criticizes Cornacchini's restoration of the younger son's right arm, "qui par-là
 lui donne une action insignifiante" [which in this way makes the restoration
 look insignificant] (275 n. 1).

23. In Paris, the *Laocoön* acquired the plaster arms that the sculptor Girardon had
 made on returning from his journey to Rome at the end of the seventeenth
 century. E. MICHON, *Monuments et mémoires,* Fondation Eugène Piot 21
 (Paris: E. Leroux, 1913), 13; his "La Restauration du Laocoon et le modèle de
 Girardon," *Bulletin de la Société Nationale des Antiquaires de France* (1906);
 PAUL REINHOLD WESCHER, *Kunstraub unter Napoleon* (Berlin: Mann, 1976);
 E. MICHON, "La Vénus d'Arles et sa restauration par Girardon," *Monuments et
 mémoires publiés par l'Académie des inscriptions et Belles-Lettres* 21 (1913): 13 ff.

24. DE ROSSI, "Lettera sopra il restauro."

25. J. BURCKHARDT, *Il cicerone* (Florence: Sansoni, 1952), 450–52; C. BOITO,
 I restauratori (Florence: G. Barbera, 1884), 13.

26. The 1960 restoration was completed by F. Magi, who has published a report on
 the intervention, "Il ripristino del Laocoonte."

27. CAFFARELLI, "Studio per la restituzione del Laocoonte."

28. [p. 239 n. 1] DE ROSSI, "Lettera sopra il restauro," 23–24; this observation, like
 others by De Rossi, contradicts the thesis that considers Canova a forerunner
 in radically opposing integrations, as suggested, for example, by M. CAGIANO
 DE AZEVEDO (*Il gusto nel restauro delle opere d'arte antiche* [Rome: Olympus,
 1948], 60). When Canova opposed the reintegration of the Parthenon marbles,
 he did so mostly because he was convinced that there were no sculptors who
 could imitate that style.

29. [p. 240 n. 2] DE ROSSI, "Lettera sopra il restauro," 37.

30. [p. 240 n. 3] The British government had given 200,000 francs to Pius VII for
 the recovery. Canova went to London to thank the government, and brought as
 gifts numerous plaster casts of Greek and Roman masterpieces that were in
 the stores of the Vatican Museums, as well as mosaics and modern cameos.

See A. D'ESTE, *Memorie della Vita di Antonio Canova* (Florence: Felia le Monnier, 1864), 245ff.

31. [p. 241 n. 4] The vicissitudes of the Elgin marbles have been amply recounted by ADOLF THEODOR FRIEDRICH MICHAELIS, *Ancient Marbles in Great Britain* (Cambridge: University Press, 1882); by MASSIMILIANO PAVAN, "Antonio Canova e la discussione sugli 'Elgin Marbles,'" *Rivista dell'Istituto Nazionale di Architettura e Storia dell'Arte* 21–22 (1974): 219–344; and his "La visita a Londra del Canova nel 'Diary' del pittore J. Farington," *Atti dell'Istituto Veneto di Scienze, Lettere ed Arti* 130 (1976–77); by WILLIAM ST. CLAIR, *Lord Elgin and the Marbles* (Oxford: Oxford University Press, 1967); and by M. PAVAN, *L'avventura del Partenone: Un monumento nella storia* (Florence: Sansoni, 1983).

32. [p. 241 n. 5] D'ESTE, *Memorie della Vita di Antonio Canova*, 220.

33. [p. 241 n. 6] A. MICHAELIS, "Storia della collezione capitolina di antichità fino alla inaugurazione del Museo nel 1734," *Bollettino dell'Imperiale Istituto Archeologico Germanico* 5 (1981): 145.

34. [p. 242 n. 7] A. C. QUATREMÈRE DE QUINCY, *Lettres escrites de Londres à Rome et adressées à M. Canova sur les Marbres d'Elgin à Athènes,* letter 4 (Paris: n.p., 1818), 82. The restorations were violently criticized by A. FURTWÄNGLER, *Aegina das Heiligtum der Aphaia, unter Mitwirkung von Ernst R. Fiechter* (Munich: Verlag der K. B. Akademie der Wissenschaften in Kommission des G., 1906); CAGIANO DE AZEVEDO, *Il gusto nel restauro delle opere antiche,* 66–67, is shocked outright: "Le povere sculture di Egina ... ligio alla sua prassi e al suo gusto per la grecità neoattica e manieristica, si impossessa [Thorvaldsen] vigorosamente dei marmi di Egina e lima, congiunge, integra, leviga, e pulisce fino a dare un aspetto antipatico e repellente anche alle meravigliose parti antiche" [The poor Aegina sculptures. ... (Thorvaldsen), faithful to his practice and taste for neo-Attic and Mannerist Greek, vigorously takes over the Aegina marbles by filing, joining, integrating, polishing, and cleaning so that he gives an unpleasant, repulsive appearance to even the beautiful ancient fragments]. This kind of judgment, shared by an entire tradition devoted to the poetry of the fragment, favored the serious undertaking of de-restoration in the early 1970s to the detriment of the entire collection of antiquities in the Munich Glyptotek.

35. [p. 242 n. 8] DE QUINCY, *Lettres escrites de Londres à Rome,* 81. On the Thorvaldsen restoration see also L. O. LARSSON, "Thorvaldsen Restaurierung der Aegina," *Kunsthstarijk Tidskrist* 38, no. 1–2 (1969): 23–46; and the exhibition catalogue *Bertel Thorvaldsen, Skulpturen, Modelle, Bozzetti, Handzeichnungen* (Cologne: Museen der Stadt Köln, 1977), 243–60.

36. [p. 242 n. 9] DE QUINCY, *Lettres escrites de Londres à Rome,* 87.

37. [p. 242 n. 10] Ibid., 82.

38. [p. 243 n. 11] Ibid., 83.

39. [p. 243 n. 12] D'ESTE, *Memorie della Vita di Antonio Canova.*

40. [p. 243 n. 13] O. ROSSI PINELLI, "Carlo Fea e il chirografo del 1802: Cronaca giudiziaria e non, delle prime battaglie per la tutela delle 'Belle Arti,'" *Ricerche di Storia dell'arte* 8 (1979): 27–41.

41. [p. 243 n. 14] D'ESTE, *Memorie della Vita di Antonio Canova*, 247.

42. [p. 243 n. 15] Ibid.

43. [p. 244 n. 16] All the records of the committee's work are in A.S.R., Camerlengato Antichità e Belle Arti 1, title 4, envelope 38.

44. [p. 244 n. 17] O. Rossi Pinelli, "Artisti, falsari, o filologi? Da Cavaceppi a Canova, il restauro della scultura tra arte e scienza," *Richerche di Storia dell'arte* 13–14 (1981), 52.

45. [p. 245 n. 1] W. von Humboldt, *Briefe, 1802–1805,* ed. W. Rössle (Munich: C. Hanser, 1952), 241, 262, 270. See also E. Garms and J. Garms, "Mito e realtà di Roma nella cultura europea," *Storia d'Italia: Annali* 5, Il Paesaggio (Turin: G. Einaudi, 1984), 646.

46. [p. 245 n. 2] Paul, "Antikenergänzung und Ent-Restaurierung," 93–99, in which one finds an elaborate analysis of the issue of de-restorations in museums.

47. [p. 246 n. 3] A. Cunningham, *Lives of the Most Eminent British Painters, Sculptors and Architects,* Family Library Series (London: J. Murray, 1830).

48. [p. 246 n. 4] In Munich the sculpture museum was built on a design by Leo von Klenze between 1816 and 1830. In Berlin it was designed by Schinkel between 1825 and 1831.

49. [p. 246 n. 5] C. Boito, "I restauratori," lecture held at the Turin Exhibition in 1884 [published in Florence in 1884]. Unfortunately, extensive de-restorations continue in many European and American museums. F. Haskell, enraged, has pointed out to me the ones that were being done in the Copenhagen Glyptotek; F. Zeri has brought to my attention the ones in the J. Paul Getty Museum, Malibu. Fortunately, the recent restorations in Rome of the *Ara Pacis Augustae* panels (see the exhibition catalogue, edited by Bruno Zanardi, who was also responsible for the restorations, Rome, 1983) and of the statues in the Ludovisi Collection can be considered exemplary. The historical restorations have been carefully studied and maintained as a now-integral part of the sculptures. Furthermore, they have been slightly emphasized by lowering the level of the adjacent stucco.

50. [p. 247 n. 6] Alfred de Musset, *Non si scherza con l'amore: Le confessioni di un figlio del secolo,* I grande della letteratura 59 (Milan: Fratelli Fabbri, 1969), 28.

51. [p. 247 n. 7] P. Mérimée, "La Vénère d'Ille," in *Racconti e novelle* (Florence: n.p., 1966), 207–34.

52. [p. 247 n. 8] H. James, "L'ultimo dei Valeri," in *Le ombre del salotto* (Rome: n.p., 1983), 81–112.

53. [p. 247 n. 9] On the difficult problem of de-restorations there is also an article by A. Chastel, "La dérestauration des statues et ses problèmes," *Le Monde,* 8 August 1975.

PART V

Restoration
and Anti-Restoration

San Pablo's Church, facade.
Valladolid, Spain, 1993.

Restoration
and Anti-Restoration

The nineteenth century is a complex period from which many current trends in conservation are directly descended. All the readings in Part V, which often start from the same premises, stress the essential dichotomy that runs through the century. This applies not only to the relationship between Classicism and Romanticism, but also within the Romantic movement itself, in which opposing sensibilities and standpoints confront one another above and beyond the predilection for the medieval and reassessment of the Gothic.

The ethics of restoration also exemplify and reflect this conflict, which is particularly severe in the field of architecture. One need only think of Eugène-Emmanuel Viollet-le-Duc on the one hand, and William Morris and John Ruskin on the other.

Viollet-le-Duc is considered to be the greatest exponent of the movement whose adherents thought of restoration as imitation and as reconstruction "in the style of the original" (see Reading 30, pages 314–18). This group believed that by studying the monuments of the past, especially the great Gothic cathedrals, and with meticulously accurate and detailed documentation of the characteristics of style as well as of the details of the buildings and the methods of construction, they could make possible the complete and accurate rebuilding of entire parts or phases of these buildings.

In the *Teoria del restauro,* Brandi, like all the idealist philosophers of this century, railed against the pretense that one could reinsert oneself into the process of creating a work of art—an attempt at canceling the passage of time—and condemned this school of restoration as falsification pure and simple.

Translated by Alexandra Trone.

Even earlier, Morris and Ruskin, who were among the contemporaries of Viollet-le-Duc, violently opposed Viollet-le-Duc's work. They took a firm stand against all restoration, a stand that Camillo Boito took up again in Italy at the end of the century (see the introduction to Part IV, pages 262–63).

In *The Stones of Venice* (1853), above all, Ruskin gave free expression to his decadent rather than purely Romantic tendencies. Thanks to the success of his prophetic prose, illustrated by splendid watercolors painted from life, he immortalized the disfigured but incomparable beauty of the City on the Lagoon, already in full decline. This contributed decisively to the dissemination throughout the British Empire of the Gothic style (considered by Ruskin to be the apex of human creative endeavor) and to a celebration throughout Victorian England of the ogives (pointed arches) and carved marble.

Ruskin is the prophet of a radical way of perceiving age value (see Riegl, Reading 6, pages 72–75). Together with Morris, he initiated the Anti-Restoration movement, whose aims were declared in the *Manifesto of the Society for the Protection of Ancient Buildings* (see Morris, Reading 31, pages 319–21).

The only intervention apparently intended to reconcile the real necessity for structural treatment with the Romantic concepts of the "beautiful ruin" and of the "picturesque"—and which, curiously, anticipates Ruskin's violent, nihilistic creed by half a century—is to be found at the Colosseum in Rome (Figs. 1–3). This took the form of a buttress built against the side toward the Basilica of San Giovanni and was emphasized by an epigraph of Pope Pius VII (1807) on the monument. There is nothing imitative or decorative about this enormous prop built to support the external arcades of the amphitheater; it is placed there without concealment, simply to reinforce the damaged part of the building. The dislocated stones of the arches appear to be frozen, as in the still frame of a movie, only an instant before their final collapse. Precarious in appearance only, they have, in fact, been in this position for nearly two centuries.

This extremely elegant intervention is unique and without sequel. To appreciate it, one has only to look at the opposite side of the Colosseum, toward the Arch of Constantine. The present entrance to the amphitheater forms one part of the restoration completed in 1826 by Giuseppe Valadier, a distinguished architect in papal Rome. Here, in an accurate reconstruction "in the style of the original," the ruined arches have been rebuilt in brickwork perfectly imitating the ancient travertine blocks (Fig. 3).

The Romantic movement has left no visible traces on extant buildings; yet the sensibility that inspired Ruskin is anything but spent. Today this sensibility is represented by all those who, confronted with the increasing decay of the cultural heritage caused by pollution and overpopulation, reject the idea of restoration of any kind, which always appears disfiguring to them.

Figure 1
Colosseum, Rome. Buttress of the
Stern restoration (1807).

This tendency is particularly prevalent among members of the environmental movement. Many people are opposed to moving monuments and sculptures into museums for the sake of preservation; they fight substituting copies for the originals. They advocate allowing the great artistic centers to slowly waste away in preference to having their historic appearances deliberately altered. Consciously or unconsciously, they take their inspiration from the Anti-Restoration movement.

In a lecture he gave in Manchester, Ruskin said: "I do not mean, however, that copies should never be made. A certain number of dull persons should always be employed by Government in making the most accurate copies possible of all good pictures; these copies, though artistically valueless, would be historically and documentarily valuable, in the event of the destruction of the original picture."[1]

Even the nihilistic Ruskin could see the remote possibility of a rational use for a copy in the event of the original being destroyed. The present situation, with masterpieces exposed in the open in many historic cities, with no protection from either pollution or urban vandalism, is clearly far worse than what the most pessimistic of theorists could have predicted.

Figure 2
Colosseum, Rome. Scaffolding for
the Valadier restoration (1822–26).

Figure 3
Colosseum, Rome, restored by
G. Valadier in 1826. Detail.

The Anti-Restoration movement is intrinsically in a losing position. It
certainly was in the last century, when it lost its battle against the restorers of
the Purist movement. The followers of Viollet-le-Duc, usually with neither
his education nor his profound knowledge of styles, removed Baroque porti-
coes, stuccowork, and carved wooden choir stalls in an attempt to bring to
light the earliest phase of construction of many Byzantine, Romanesque, or

Gothic buildings. Churches, most of all, fell victim to this whirlwind of destruction. Of course, after "alterations and superfluous additions" had been removed, it was necessary to reconstruct, "in the style of the original," those parts of the building that had been removed.

"To restore an edifice means . . . to reestablish it in a finished state, which may in fact never have existed," Viollet-le-Duc affirms (Reading 30, page 314). The presumption of not only re-creating the altered building but of completing it, even if it had originally remained incomplete, signifies a position as extreme as that of the Romantic nihilists. The followers of Viollet-le-Duc took up a still more extreme position, negating the master's prudent warning that "the adoption of absolute principles for restoration could quickly lead to the absurd" (Reading 30, page 316).

It should be recognized that the more moderate and cautious of nineteenth-century reconstructions deserve merit for having preserved many buildings and monuments that, if left in ruins, would have decayed to a point at which they would probably have succumbed to the increasingly aggressive effects of environmental pollution. The parts completed "in the style of the original," which irritated advocates of the Anti-Restoration movement at the time, are today covered with a patina that makes them more acceptable; time is still the mighty sculptor (see Yourcenar, Reading 20, pages 212–15).

On the other hand, we are indebted to the Anti-Restorationists for the sense of danger that ought to accompany any conservation project: the criterion of the "minimum needed intervention" and the appeal to "stave off decay by daily care" are derived from the precepts of their *Manifesto*.

Some passages from Viollet-le-Duc convey more than the principles and guidelines alluded to earlier. They also make one realize just how many contradictions and difficulties a Purist reconstruction would entail for anyone actually planning and carrying out an on-site project that appears straightforward in principle but is, in fact, quite complex. The strongest contradiction that emerges is the one between ancient materials and building techniques on one hand and modern materials that came into use in the middle of the nineteenth century—precisely when Viollet-le-Duc was working—on the other.

Another source of doubt may be found in the contrast between the restoration of a building—a church, for example—to its supposed condition in the twilight of the Middle Ages and the needs of contemporary use, including heating and lighting systems that involve the devastating introduction of piping. The excerpt from Viollet-le-Duc thus touches on many contemporary concerns.

In the writings of those opposed to the movement represented by Viollet-le-Duc, the words false, falsification, lie, and destruction recur more

frequently than any others in connection with restoration. These selections should be read in the context of the violent antagonism that raged between the two opposing schools of thought in the nineteenth century. It should be kept in mind that much of this fury could be justified by the Purists' excesses, which must have seemed both offensive and truly destructive, although the "patina of time" now makes them appear more acceptable.

—AMV

Note

1. JOHN RUSKIN, *The Lamp of Beauty: Writings on Art by John Ruskin,* ed. Joan Evans (Oxford: Phaidon, 1925; reprint, 1980), 312.

Restoration

EUGÈNE-EMMANUEL VIOLLET-LE-DUC

Restoration . . . Both the word and the thing are modern. To restore an edifice means neither to maintain it, nor to repair it, nor to rebuild it; it means to reestablish it in a finished state, which may in fact never have actually existed at any given time.

—⚏—

There are few buildings, especially those constructed during the Middle Ages, that were built overnight, though; or which, even if they did go up rapidly, did not undergo notable modifications later, by either additions, conversions, or partial changes of one type or another. It is therefore essential, before any repair work actually begins, to ascertain exactly the age and character of each part of the building, and then to write up an official report on all these things based on solid documentation, a report that may include written notes as well as drawings and illustrations. More than that, in France each province had its own style; each had a particular school of architecture whose practices and principles it is always necessary to understand. . . . The architect in charge of restoration must have exact knowledge not only of the styles assignable to each period of art, but also of the styles belonging to each school. . . .

. . . Often buildings or parts of buildings dating from a certain era have been repaired, sometimes more than once, and sometimes by workers who

From Eugène-Emmanuel Viollet-le-Duc, "Restoration," in *The Foundations of Architecture: Selections from the Dictionnaire Raisonné,* trans. Kenneth D. Whitehead (New York: George Braziller, Inc., 1990), 195, 209–12, 214–15, 216, 222–23; originally published as "Restoration," in *Dictionnaire raisonné de l'architecture française du XIe au XVIe siècle,* vol. 8 (Paris: B. Bance, 1854), 14–34. Copyright © 1990 by George Braziller, Inc. Reprinted by permission of George Braziller, Inc.

were not native to the province where the buildings were constructed. Many difficulties can arise from this kind of situation. Both the earliest parts and the modified parts of the edifice need to be restored. Should the unity of style simply be restored without taking into account the later modifications? Or should the edifice be restored exactly as it was, that is, with an original style and later modifications? It is in cases like this that opting absolutely for one or the other of these restoration solutions could be perilous. It is in fact imperative not to adopt either of these two courses of action in any absolute fashion; the action taken should depend instead upon the particular circumstances. What would these particular circumstances be? We cannot list them all. It will suffice if we identify a few of the most important of them in order to bring out the element of the critical analysis always required in work of this kind. Ahead of everything else—ahead of any specific archaeological knowledge, for example—the architect responsible for any work of restoration must be an able and experienced builder, not in general but in particular. He must be knowledgeable about the methods and procedures of the art of construction employed at different times and by different schools. These various methods and procedures of construction have only a relative value, of course; not all of them are equally good. Many of them had to be abandoned, in fact, because they were not very good. Thus, for example, let us take a building constructed in the twelfth century without gutters for its roof drains, which had to be restored in the thirteenth century and at that time was equipped with gutters producing combined drainage. The crowning is now in bad condition and has to be completely rebuilt. Should the thirteenth-century gutters be abandoned in order to restore the cornice of the twelfth century (of which the elements are all still present)? Certainly not. The cornice with gutters from the thirteenth century needs to be reestablished and its form retained—for it would be impossible to find a twelfth-century model with gutters that could be used. To construct an imaginary twelfth-century model with the idea of preserving the integral architecture of that particular epoch would be to construct an anachronism in stone. Let us take another example: the vaults of a twelfth-century nave were destroyed as a result of some kind of accident and were then rebuilt later, not in their original form but in the typical form of the time of the rebuilding. But now these later vaults, too, are threatening to collapse; they need to be rebuilt. Should they be reconstructed in their later, remodeled form, or should the earlier, original vaults be reestablished? The latter. Why? Because there is no particular advantage in proceeding in any other way. Yet there is a distinct advantage in giving back to the structure its original unity. In this second case, it is not a question, as it was in our earlier example, of maintaining or preserving a rebuilt feature that was a necessary improvement on an earlier but defective model; it is rather a question of reminding ourselves

315

that the earlier restoration or rebuilding was carried out in accordance with the practice of that time; all rebuilding was done in accordance with the style and practice then current. However, we want to follow a contrary principle; we hold that an edifice ought to be restored in a manner suitable to its own integrity. Let us, however, go on to consider yet another important point: suppose the rebuilt vaults, even though they are alien to the original structure, happen to be of remarkable beauty, and, at the time they were installed, they also made it possible to construct glasswork employing stained glass that is of equally remarkable beauty; moreover, when the modified vaults were added they were fashioned in such a way that the exterior construction of the building now also has great intrinsic value. Should all of these valued features now be done away with merely in order to restore the construction of the nave to its primitive simplicity? Should the beautiful stained-glass windows go into storage? And should exterior buttresses and flying buttresses be left in place if, the building having been restored to its original condition, they now no longer have anything to support? Our answer on all three counts in this modified example must be: Certainly not. It is easy to see from these kinds of examples that the adoption of absolute principles for restoration could quickly lead to the absurd.

—❧—

There is another overriding condition that must always be kept in mind in restoration work. It is this: both the methods and the materials of construction employed by the restorer must always be of superior quality. The restored building needs to be given a longer lease on life than the one that is near expiration. No one can deny that the scaffolding, struts, and supports employed in construction, like any necessary clearing or removing of parts of the masonry, just might possibly have disturbed the fundamental structure in such a way as to provide a potential for possible accidents that could be highly unfortunate. It is therefore prudent simply to assume that any building that has been in place over time has lost some part of its strength as a result of such possible disturbances in the past as those we have indicated. It is necessary, therefore, as a matter of principle to compensate for this probable weakening that has occurred, by the use of new building materials of maximum strength, by devising improvements in the structural system where possible, by the use of chain bond or other ironwork to strengthen the structure, and, in general, by providing greater resistance to the construction by every possible means. It ought to be superfluous to have to mention that the choice of building materials is one of the most important of all factors in restoration. Many buildings threaten to fall into ruin only because of the mediocre quality of the materials out of which they were originally constructed. . . .

It is clear that the architect responsible for restoration needs to know the style and forms of the building he is working on, as well as the school of architecture to which it belongs. Even more, the architect needs to know the structure, anatomy, and temperament of the building. He needs to know these things because, before everything else, his task is to make the building *live*. He needs to develop a feel for it and for all of its parts almost as if he himself had been the original architect. Once he has acquired this kind of knowledge of his building, he must then have at his disposition several alternative methods of carrying out the work of restoration. If one method fails, he needs to be able to fall back upon another, and even upon a third, if necessary.

— ∞ —

We have been able to give only some slight indication, and that in a very general way, of the difficulties that face the architect responsible for doing restorations. As we said earlier, we could describe only the broad lines of the kind of overall restoration program called for as a result of all the critical analysis of the problems of restoration. The real difficulties, though are in no way merely material difficulties. Since all the edifices whose restorations have been undertaken actually have a purpose and in some way continue to be used, it is impossible to be merely a restorer of ancient dispositions that are no longer of any practical use to anybody. Once it leaves the hands of the architect, a building has to continue to be as suitable for its assigned purpose as it was before its restoration was undertaken. Too often, archaeologists of a speculative bent fail to take such practical questions as these into account; they are therefore capable of blaming an architect rather harshly for what they consider his caving in to present exigencies—as if the building he was responsible for restoring somehow belonged to him personally, or as if he was never under any obligation to carry out the program of restoration that was given him.

These, then, are the kinds of circumstances that usually present themselves to the restorer; the sagacity of the architect must show up, precisely, in how he works in the circumstance given to him. He is always under the obligation to reconcile his role as a restorer with his duty as an artist to deal creatively with unforeseen circumstances and necessities. The fact is that the best of all ways of preserving a building is to find a use for it, and then to satisfy so well the needs dictated by that use that there will never be any further need to make any further changes in the building. It is clear, for example, that the architect responsible for transforming the beautiful refectory of Saint-Martin-des-Champs into a library for the Ecole des Arts et Métiers [sic], if he was going to respect the construction at the same time as he was restoring it, had to organize the bookshelves and compartments in

such a way that there would never again be any necessity to alter the dispositions of the room.

In such circumstances, the best thing to do is to try to put oneself in the place of the original architect and try to imagine what he would do if he returned to earth and was handed the same kind of programs as have been given to us. Now, this sort of proceeding requires that the restorer be in possession of all the same resources as the original master—and that he proceeds as the original master did.

Manifesto of the Society for the Protection of Ancient Buildings

WILLIAM MORRIS

A Society coming before the public with such a name as that above written must needs explain how, and why, it proposes to protect those ancient buildings which, to most people doubtless, seems to have so many and such excellent protectors. This, then, is the explanation we offer.

No doubt within the last fifty years a new interest, almost like another sense, has arisen in these ancient monuments of art; and they have become the subject of one of the most interesting of studies, and of an enthusiasm, religious, historical, artistic, which is one of the undoubted gains of our time; yet we think that if the present treatment of them be continued, our descendants will find them useless for study and chilling to enthusiasm. We think that those last fifty years of knowledge and attention have done more for their destruction than all the foregoing centuries of revolution, violence, and contempt.

For Architecture, long decaying, died out, as a popular art at least, just as the knowledge of mediaeval art was born. So that the civilized world of the nineteenth century has no style of its own amidst its wide knowledge of the styles of other centuries. From this lack and this gain arose in men's minds the strange idea of the Restoration of ancient buildings; and a strange and most fatal idea, which by its very name implies that it is possible to strip from a building this, that, and the other part of its history—of its life that is—and

From WILLIAM MORRIS, "The Principles of the Society [for the Protection of Ancient Buildings] As Set Forth upon Its Foundation," *Builder* 35 (25 August 1877). Reprinted without alteration from the original (as it has been reprinted in every annual report of the Society since its inception) by permission of the Society for the Protection of Ancient Buildings.

then to stay the hand at some arbitrary point, and leave it still historical, living, and even as it once was.

In early times this kind of forgery was impossible, because knowledge failed the builders, or perhaps because instinct held them back. If repairs were needed, if ambition or piety pricked on to change, that change was of necessity wrought in the unmistakable fashion of the time; a church of the eleventh century might be added to or altered in the twelfth, thirteenth, fourteenth, fifteenth, sixteenth, or even the seventeenth or eighteenth centuries; but every change, whatever history it destroyed, left history in the gap, and was alive with the spirit of the deeds done midst its fashioning. The result of all this was often a building in which the many changes, though harsh and visible enough, were, by their very contrast, interesting and instructive and could by no possibility mislead. But those who make the changes wrought in our day under the name of Restoration, while professing to bring back a building to the best time of its history, have no guide but each his own individual whim to point out to them what is admirable and what contemptible; while the very nature of their task compels them to destroy something and to supply the gap by imagining what the earlier builders should or might have done. Moreover, in the course of this double process of destruction and addition the whole surface of the building is necessarily tampered with; so that the appearance of antiquity is taken away from such old parts of the fabric as are left, and there is no laying to rest in the spectator the suspicion of what may have been lost; and in short, a feeble and lifeless forgery is the final result of all the wasted labour.

It is sad to say, that in this manner most of the bigger Minsters, and a vast number of more humble buildings, both in England and on the Continent, have been dealt with by men of talent often, and worthy of better employment, but deaf to the claims of poetry and history in the highest sense of the words.

For what is left we plead before our architects themselves, before the official guardians of buildings, and before the public generally, and we pray them to remember how much is gone of the religion, thought and manners of time past, never by almost universal consent, to be Restored; and to consider whether it be possible to Restore those buildings, the living spirit of which, it cannot be too often repeated, was an inseparable part of that religion and thought, and those past manners. For our part we assure them fearlessly, that of all the Restorations yet undertaken the worst have meant the reckless stripping a building of some of its most interesting material features; while the best have their exact analogy in the Restoration of an old picture, where the partly-perished work of the ancient craftsmaster has been made neat and smooth by the tricky hand of some unoriginal and thoughtless hack of today. If, for the rest, it be asked us to specify what kind of amount of art, style, or

other interest in a building, makes it worth protecting, we answer, anything which can be looked on as artistic, picturesque, historical, antique, or substantial: any work in short, over which educated, artistic people would think it worthwhile to argue at all.

It is for all these buildings, therefore, of all times and styles, that we plead, and call upon those who have to deal with them to put Protection in the place of Restoration, to stave off decay by daily care, to prop a perilous wall or mend a leaky roof by such means as are obviously meant for support or covering, and show no pretence of other art, and otherwise to resist all tampering with either the fabric or ornament of the building as it stands; if it has become inconvenient for its present use, to raise another building rather than alter or enlarge the old one; in fine to treat our ancient buildings as monuments of a bygone art, created by bygone manners, that modern art cannot meddle with without destroying.

Thus, and thus only, shall we escape the reproach of our learning being turned into a snare to us; thus, and thus only can we protect our ancient buildings, and hand them down instructive and venerable to those that come after us.

The Lamp of Memory, II

JOHN RUSKIN

§18

. . . Neither by the public, nor by those who have the care of public monuments, is the true meaning of the word *restoration* understood. It means the most total destruction which a building can suffer: a destruction out of which no remnants can be gathered: a destruction accompanied with false description of the thing destroyed. . . . [I]t is *impossible*, as impossible as to raise the dead, to restore anything that has ever been great or beautiful in architecture. That which I have above insisted upon as the life of the whole, that spirit which is given only by the hand and eye of the workman, can never be recalled. Another spirit may be given by another time, and it is then a new building; but the spirit of the dead workman cannot be summoned up, and commanded to direct other hands, and other thoughts. . . . There was yet in the old *some* life, some mysterious suggestion of what it had been, and of what it had lost; some sweetness in the gentle lines which rain and sun had wrought. . . .

§19

Do not let us talk then of restoration. The thing is a Lie from beginning to end. . . . But, it is said, there may come a necessity for restoration! Granted. Look the necessity full in the face, and understand it on its own terms. It is a necessity for destruction. Accept it as such, pull the building down, throw its stones into neglected corners, make a ballast of them, or mortar, if you will;

From JOHN RUSKIN, "The Lamp of Memory," chap. 6 in *The Seven Lamps of Architecture* (London: Smith, Elder, 1849), nos. 18–20.

but do it honestly, and do not set up a Lie in their place. And look that neces-
sity in the face before it comes, and you may prevent it. . . . Take proper
care of your monuments, and you will not need to restore them. . . . Count
its stones as you would jewels of a crown; set watches about it as if at the
gates of a besieged city; bind it together with iron where it loosens; stay it
with timber where it declines; do not care about the unsightliness of the
aid; better a crutch than a lost limb; and do this tenderly, and reverently, and
continually, and many a generation will still be born and pass away beneath
its shadow. Its evil day must come at last; but let it come declaredly and
openly, and let no dishonoring and false substitute deprive it of the funeral
offices of memory.

§20

. . . *We have no right whatever to touch* [the buildings of past times]. They are
not ours. They belong partly to those who built them, and partly to all the
generations of mankind who are to follow us. The dead have still their right
in them: that which they labored for, the praise of achievement or the expres-
sion of religious feeling, or whatsoever else it might be which in those build-
ings they intended to be permanent, we have no right to obliterate. What we
have ourselves built, we are at liberty to throw down; but what other men
gave their strength, and wealth, and life to accomplish, their right over does
not pass away with their death; still less is the right to the use of what they
have left vested in us only. It belongs to all their successors. . . . For a mob it
is, and must be always; it matters not whether enraged, or in deliberate folly;
whether countless, or sitting in committees; the people who destroy anything
causelessly are a mob, and Architecture is always destroyed causelessly. . . .
The very quietness of nature is gradually withdrawn from us; thousands who
once in their necessarily prolonged travel were subjected to an influence,
from the silent sky and slumbering fields, more effectual than known or con-
fessed, now bear with them even there the ceaseless fever of their life; and
along the iron veins that traverse the frame of our country, beat and flow the
fiery pulses of its exertions, hotter and faster every hour.

PART VI

Reintegration of Losses

. Paul Getty Museum conservator
retouching a fifteenth-century
Italian cassone panel.

Reintegration of Losses

It is very difficult to move from general principles to the criteria and precepts that ought to ensure that these principles are put into practice. Many apparent points of agreement fail to make this transition. It appears to be just as difficult to clarify the relationship between the terms *conservation* and *restoration*. These terms sometimes occur in the specialized literature in the form of "conservation-restoration," for instance, as used by Marie Berducou (see Reading 25, pages 253–56). This conjunction also recurs idiomatically and in journalistic usage. When the term restoration is used alternately or together with the term conservation, the distinction between the two is not always clear.

According to some attempts at definition,[1] *conservation* signifies treatments, including preventative, environmental measures, designed mainly to prolong the life of an object; the object of *restoration* should refer to all procedures aimed at improving the object's aesthetic character and appearance, while taking into consideration its final presentation to the public. This distinction, however, appears to be unsatisfactory; the boundary between the two fields and the two types of procedures is not at all clear, given their close interdependence and the fact that they impose conditions on one another. To evaluate the first (conservation) as truly necessary and all others (restoration) as secondary or superfluous does not seem to be acceptable, if we keep in mind Brandi's definition of restoration. According to Brandi, restoration is essential to the reconstitution or preservation of the cultural value and quality of the image of an object with cultural significance, even more so for a work of art. It is not even acceptable to contrast conservation and restoration

Translated by Alexandra Trone.

as though the first were guided by objective criteria and the second by judgment and "taste." Juxtaposing the two terms is an attempt to recover the sense of a historic tradition, at gathering together the best from the two movements that were so ferociously opposed to one another in the nineteenth century.

Max Friedländer interprets the best of the late-nineteenth-century tradition of connoisseurship (see Reading 33, pages 332–34). In a passage written in 1944, before the publication of Brandi's *Teoria del restauro*, he expresses a different point of view, in considering restoration a "necessary evil." And yet, even though Brandi would never have admitted to being in any sense in agreement with Friedländer, it is worth comparing this excerpt with those excerpts from Brandi (see Reading 35, pages 339–42) regarding lacunae and their completion. This convergence may well diminish the impression of abstract distance and isolation that Brandi's tone seems at times to generate.

The excerpts selected for inclusion here emphasize the modernity of Friedländer's outlook in his references to various points of view and to opposing opinions on how a restoration ought to be conducted.

It could be said that neither the approach of Ruskin (who obsessively repeats "conserve, don't restore") nor those of Viollet-le-Duc and Friedländer can be made absolute. There comes a point when daily care and attentive and regular maintenance are no longer sufficient, just as on-site treatment during an excavation (Berducou touches on this in Reading 25, pages 256–57) must be followed by thorough conservation so that the finds may be exhibited in museum showcases.

In short, it is proposed here that with the juxtaposition of the two terms it should be possible to overcome the nineteenth-century confrontation and show that a single process can ensure the survival of cultural heritage. Conservation-restoration is a process that removes the causes of deterioration, takes care of the environment of the exhibition space or setting, respects history, and ensures a presentation worthy of an object of aesthetic and cultural significance. It then provides for maintenance, environmental control, and so on, in a complete and, if possible, programmed continuum of procedures. These phases of treatment are all connected and are all indispensable; the sequence should never be interrupted unless limited resources mean resorting to partial and incomplete procedures.

Considerable difficulty arises when it becomes necessary to coherently apply even more principles and terms. Most people in the field would very likely agree with each one of the following principles: Brandi's definition of restoration, rejection of imitative restoration, respect for the traces of time and the impossibility of erasing them from an object, using restoration to give back to an object the unity it has lost through interference and alterations, taking the original context into consideration, respect for the present

context, and filling lacunae so the intervention is recognizable at close range but not from a distance.

Disagreement is just as likely to arise when all the principles listed above, or even two or three of them, are to be applied simultaneously. That is the trouble with programmatic documents known as conservation charters, the first of which was that of Athens in 1931. Almost all similar documents are derived from this one, including those published by international agencies such as Unesco. All are restricted by a common problem: declarations of principle that are too general, sometimes generic; and treatment formulas that are tied to the products and realities of the marketplace, making them outdated in a very short time.

We have therefore included some readings that discuss, in concrete terms, one of the issues just mentioned—one in which the problems of methodology and their technical solutions are connected in a particularly obvious way: at issue is the reintegration of lacunae, long considered to be the fundamental problem of restoration. That was in the days when no one looked beyond museums and paintings. Today conservators realize that it is impossible to discuss the reintegration of a lacuna in a mosaic if it is not known whether the mosaic is to be kept in a museum or on site, whether the public will walk on it, and so on.

In any case, the guiding principle of these readings is the search for the roots of contemporary problems and the rereading of texts that have become classics but that are still rich in suggestions and useful for putting our everyday problems into perspective. It therefore seemed useful to start from the central subject, which goes back to the *Teoria* and to the precepts of Brandi, to whom nearly all contemporary methods can be traced more or less consistently and more or less consciously.

It should be obvious that the problem of lacunae was first raised in relation to paintings, and it follows that its solutions have more weight and authority in this field. On the other hand, these solutions seem totally inadequate in relation to three-dimensional objects, from sculpture to architecture. It is precisely in these last fields that Brandi's *Teoria* seems most inadequate.

Filling a lacuna, reestablishing the unity of the image, means intervening in the image itself. This ought to be done, therefore, by means that take into account the visual processes and mechanisms of the human eye. Brandi started from this basic insight when formulating his theory. He observes that a lacuna introduces an interruption into the figurative pattern that is not only local, and does not relate merely to the spot where it is situated, but disturbs the entire field of vision. It causes an inversion of perception in which the lacuna places itself aggressively in the foreground while the image slides into the background.

If the lacuna is filled correctly, it should achieve another inversion in which the lacuna recedes into the background. The method of retouching known as *a tratteggio* or *a rigatino* is based on this theoretical foundation taken from Brandi's *Teoria del restauro*. This method is used more or less strictly in many schools of European restoration; it is discussed by Paolo Mora, Laura Mora, and Paul Philippot, in excerpts included here (see Reading 36, pages 351–53).

Others have offered different approaches to the problem.[2] Umberto Baldini, for example, discusses restoration as "an act of abstraction" (see Reading 37, pages 355–57). Although these other conservators may want to distance themselves from Brandi, they are all chips off the same block.

It is necessary to turn once more to Philippot to gain a broad view of the problems of recovering and re-creating the image in a painting, with examples that relate the theoretical foundations of the problem directly to the experience and the practice of every conservator. Following this reading from Albert Philippot and Paul Philippot (Reading 34, pages 335–38) are the theoretical texts by Brandi that inspired it (Reading 35, pages 339–42). The intention is to make the relationship between theory and practice more comprehensible by going back to the origins of precedents and precepts that are still fully valid.

In turn, there follows a very well-known section from the fundamental chapter of the manual on the conservation of wall paintings by Mora, Mora, and Philippot (Reading 36, pages 343–54); it is a text of unsurpassable profundity and clarity. With extreme precision, the authors confront the subject of lacunae and the methods of their reintegration: lacunae are divided into different types according to their location with respect to the image and to the support; namely the patina, the ground, and the paint layer. They find ways of integrating each type of loss. This is an excellent and classic example of the way in which the solution of technical problems benefits from a close association with the cultural and theoretical approach.

As mentioned earlier, Baldini, former director of the Opificio delle Pietre Dure in Florence, has evolved a set of principles that he categorizes as "abstractions" or "chromatic selections." Baldini's position is a very personal one that has not had a wide following outside Florence. In the excerpt chosen here, he provides a survey of the various positions taken up in the international debate on the question of lacunae in paintings (see Reading 37, pages 355–57).

Compared to the accumulated knowledge and experience available for integrating losses in paintings, for archaeological material and architecture there are no valid points of reference. Examination of the fundamentals of Brandi's *Teoria*, as discussed earlier, reveals his inadequacy in confronting the relationship between the image and the material, and the impossibility of

Figure 1
Attic red-figured krater depicting
the myth of Talos (425–400 B.C.E.),
after restoration in 1993.

applying his distinction between materials as structure and "materials . . . as image" (see Reading 40, page 378) to three-dimensional objects. This showed that his point of departure was restricted to the character and stratigraphy of the painting (support, ground, pigment layer).

There is an enormous variety in the typology of pottery, for example, and in the fundamental problems associated with it; yet the retouching methods used in paintings can be applied—with adaptations to take into account their three-dimensionality—to red- and black-figured vases from Attica[3] (Fig. 1).

Architectural reconstruction, has also been much discussed, especially in relation to the rebuilding of archaeological ruins, or *anastylosis*. Brandi, judging from the visual point of view, disapproved of anastylosis. Today it is understood that it is possible to raise and reassemble the collapsed elements of an archaeological ruin only in rare cases. Often the traumatic events that cause the collapse also destroy and alter the dispersed elements of the building.

In order to put a fragment back into its original position and to support and integrate it, it is often necessary to introduce a great many new elements. The process is nothing but the reverse of the de-restoration of sculpture and is based on the same Purist misunderstanding: the belief that time and its ineradicable marks can be eliminated. At the end of the process, an enormous part of the building consists of new elements, and these are likely to be regarded as the good part—the original—whereas the few damaged and eclipsed original fragments appear to be valueless, disturbing lacunae.

Unfortunately, the unpleasant fashion for anastylosis has been justified for the good of tourism and communication. It would be far better for the buildings and much more educational for tourists if a greater commitment were made to conserving the original parts while entrusting to the multimedia (posters, videos, and computer techniques such as virtual reality) the task of explaining and showing what the buildings might have looked like originally.

It is necessary to recall Philippot's broad view of the problems of reintegrating losses when the object is three-dimensional (see Reading 38, pages 358–63). He alludes to the fact that objects from the past often have many lacunae since, like a sumptuous mantle now unfortunately in tatters, these objects have been able to convey through time only a few scraps from their original context.

—AMV

Notes

1. P. COREMANS, "The Training of Restorers," in *Problems of Conservation in Museums,* Travaux et Publications de l'ICOM 8 (Paris: Editions Eyrolles, 1969), 7 ff.
2. M. KOLLER, "Probleme und Methoden der Retusche polychromer Skulptur," *Maltechnik/Restauro* 85 (1979): 8 ff.
3. A. MELUCCO VACCARO, "La reintegrazione della ceramica da scavo: I termini del problema," *Faenza* 75 (1989): 8–16.

On Restorations

MAX J. FRIEDLÄNDER

Restoration is a necessary evil; necessary, inasmuch as threatening decay can be stopped by the laying down of blisters, stabilization of the pigments, strengthening of the ground that carries everything. Moreover artistic value can be increased through cleaning, through the removal of later disfigurements, of retouches and of varnish, darkened or even ruined and gone opaque. Thirdly—and here the intervention begins to become of doubtful value—the restorer supplements, fills in holes, from a delusion of being able to reestablish the original condition.

Even the purely preserving action is accompanied by risk. The old canvas has, say, decayed; so new material is glued to the reverse of the old one. This entails ironing, not infrequently to the detriment of the impasto of the pigments.

The removal of the old layer of varnish, be it by the dry method through rubbing with the hand, or by means of spirits, is not always effected with the necessary circumspection. Something of the original color can easily be attacked. If the original layer of color is grainy and rough, the darkened varnish has settled in the depths and can hardly be rubbed off without injury to the original paint. Incidentally in many cases the endeavor to remove the old varnish radically, down to the last vestige, appears by no means so desirable as to justify running the risk which I have indicated.

We can remember many sensational incidents over which the newspapers busied themselves. A restorer had put right a picture—that is he had

From MAX J. FRIEDLÄNDER, "On Restorations," chap. 37 in *On Art and Connoisseurship*, trans. Tancred Borenius (London: B. Cassirer, 1942; reprint, 1944), 267–72 (page citations are to the reprint edition). Used by permission of E. M. Hill for Bruno Cassirer (Publishers) Ltd (closed 1990).

removed the old varnish and perhaps also some repaint. At once accusations were heard that he had "overcleaned" the picture, rubbed down its genuine glazes and reduced its artistic value. Such an indignation—usually expressed by people who never had paid any attention to the picture before it was "damaged"—is mostly unjustified, if only for the reason that the picture may have been overcleaned already before it was last cleaned, and that, strictly speaking, only someone who was present at the restoration ought to have a right to judge. Moreover the hard, cool, and naked appearance shown by the picture immediately after being cleaned proves in itself nothing against the restorer. Our taste depends on convention. We are not accustomed to perceive the original condition, more particularly so, for example, in a gallery like the Louvre, where almost every picture, under many layers of dull varnish, disproportionately warm and dark, shows the cheapest form of harmony. A cleaned picture, among such as are not cleaned, looks overcleaned. Our eyes are enervated and spoiled. The aspect worn by the pictures, when they originally left the workshops, would shock us as being crude and motley. The earlier restorers knew this well and, after cleaning the pictures, used to make them "old"—that is warm and "harmonious"—once more, by means of colored varnish. A continuous change in the demands, in the prejudices, is to be expected. Especially in German museums one has [become] accustomed to the appearance of cleaned, and occasionally over-cleaned, pictures.

The activity of the restorer becomes highly problematical the moment there presents itself the question of making up for deficiencies—that is, of filling gaps or revivifying passages which have been rubbed. Here the various wishes, demands and aims part company. The historian, to whom the work of art is a record, opposes, from his standpoint, with full justification, that kind of restoration which goes beyond preserving and exposing. He demands to see clearly what is left of the original, but wishes it also not to be concealed from him that something of the original is missing. It is precisely the successful reintegration that is distasteful to him: the unsuccessful one he, of course, detects easily and can make allowance for. The picture-owners, in whose service and in conformity with whose wishes the restorer works—collectors or dealers—take up a different standpoint from that of the scholar. What they demand is not so much the document which has been cleaned and gives reliable information as, rather, the maximum of value—and, indeed, not only artistic value but also market value. Every damage, as long as it remains visible, lowers the market value. The restorer must conceal such damage. The serious lover of art and the museum official, who supervises and directs the work of the restorer, are inclined to side with the scholar. And, as a matter of fact, the purist faction has lately gained adherents. Now and then you find in public galleries carefully cleaned pictures whose defective portions have been left open—say, have been filled in with a neutral tint.

There is this to be submitted in favor of such a procedure, that the best restorer is ineffectual when it is a question of filling gaps, especially if it is a question of parts which are of fundamental importance for the total impression of the picture.

The decision—apparently unavoidable—against every reintegrating restoration is, however, beset with practical difficulties. If part of the original pigments are missing in a panel of the fourteenth century, it is still possible to derive some enjoyment from what is left, and in one's imagination to fill the gaps which have remained open. The position changes, however, if gaps are visible in the midst of a picture of the seventeenth century. They do away with the illusion of a spatial whole, and destroy the effect. In every case it must be carefully considered whether a more or less questionable addition, made by a restorer, is not to be regarded as the lesser evil; just as a surgeon always should ask himself whether the success to be expected from an operation is so great and so certain that it outweighs the danger entailed by the operation. It is, no doubt, possible to choose a middle course, namely, to fill in the hole in such a fashion that the defective passage does not strike the eye as something that disturbs the general effect, but yet becomes obvious if you look closely. Such a procedure has the defect of all half-measures.

As long as works of art in private ownership are regarded as representing financial values, so long will the restorer again and again find himself forced into the part of the forger.

There exist underground connections between the workshops of the restorers and of the forgers. Years ago I saw in the possession of a London dealer a pretty Bruges picture of about 1480 which was greatly rubbed, a full-length figure of the Madonna with two female saints. A Belgian restorer then got hold of it. I do not know whether he restored it: in any case I have not seen it again. But a forgery, based on it, did turn up, considerably larger and more imposing than the archetype. A small misfortune had, incidentally, befallen the forger. St. Catherine, receiving the ring from the Infant Christ, was depicted; the ring was, however, no longer recognizable in the poorly preserved original. In the copy, the Infant Christ busies himself quite unaccountably with the finger of the saint, since He has no ring to bestow.

The Problem of the Integration of Lacunae in the Restoration of Paintings

ALBERT PHILIPPOT AND PAUL PHILIPPOT

A work of art as such is not composed of individual parts but constitutes, as an image, a whole endowed with its own unity, realized in the continuity of the form—a unity therefore essentially different from that of the things represented. Any discontinuity, any interruption inevitably disturbs the reading of this rhythm. But conversely, since the unity of the form is not divisible, each remaining fragment continues to participate in the broken unity, suggesting it to the extent that each fragment still contains the potentiality of it.[1] The unity exists in the manner of a text where certain words are either missing or difficult to decipher. While impossible to resume the original creative process, reconstitution remains conceivable, even fully justified, if we understand it as an act of critical interpretation intended to reestablish a broken formal continuity, to the extent that this continuity remains latent in the damaged work and reconstruction brings to the aesthetic structure the clarity of reading that it has lost.

—⁊⁊⁊—

 Seeking to reestablish the continuity of the formal structure, a reconstitution must above all rely on as deep an understanding of it as possible. Only this understanding can provide the standard that will open the way to an appraisal of the meaning of lacunae and the elaboration of solutions. Indeed, the trouble caused by a lacuna does not only vary according to its

From ALBERT PHILIPPOT and PAUL PHILIPPOT, "Le problème de l'intégration des lacunes dans la restauration des peintures," *Bulletin de l'Institut Royal du Patrimoine Artistique* 2 (1959): 5–19; reprinted in *Pénétrer l'art: Restaurer l'oeuvre: Une vision humaniste: Hommage en forme de florilège,* ed. C. Périer-D'Ieteren (Kortrijk: Gooeninghe Eds., 1989), 413–15, 418. Used by permission of the Institut Royal du Patrimoine Artistique, Brussels. Translated by Garrett White.

location and extent but also according to the nature of the style it has inter-
rupted. It is not always the largest lacunae that provoke the most serious rup-
tures. A very light "dandruffing" can bring confusion to "sfumato" modeling,
a tiny loss can violently shatter the luminous atmosphere of a Dutch interior,
while a much larger gap may leave the constructive force of a great structural
plane almost intact. . . .

Developed along these lines, critical interpretation clearly cannot be
limited to a verbal judgment; it must take shape *in actuality* in the execution
of the retouching, and to that end must be realized at the imaginary level in
which the form is intuitively brought back to life. This is where restoration is
essentially an art, requiring practical cultivation of the visual imagination.
Despite its critical nature, it cannot, as a last resort, divide itself between
pure intellectual decision and pure technical execution. But this is also
where the peril, even tragedy, of the restorer is revealed. This intuitive recon-
stitution remains essentially critical; that is to say, it suppresses as much as
possible the practitioner's own personality, something all the more difficult,
the more acute the sensitivity—as it needs to be for this task.

—⁓—

This methodological problem is in no way limited to painting; we find it
in the polychromy of sculpture and architecture as well. A long-standing
practice of neoclassical and academic descent has accustomed minds here to
consider the plastic or architectural form separate from color, often to the
point of losing the indissoluble sense of formal unity they formed in the past.
Form is not an abstract volume dressed up in color at the whim of the ama-
teur; it was conceived with its own material and coloring, and to break this
unity is to betray the plastic form as seriously as a repainting or lacuna can
distort the pictorial form. Each period, each style, is expressed in a proper
accord between polychromy and plastic form. Likewise, when a sculpture—
covered, as it so often happens, with numerous layers of polychromy in vary-
ing states of deterioration—must be subjected to treatment, no rational
restoration is conceivable without as clear as possible a preliminary descrip-
tion of the condition of existing polychromies. This alone will determine on
which plane—that is to say, at which technological and thus chronological
level of successive layers of polychromy—a real historical unity can be estab-
lished. For it is not a matter of removing history out of a naive purism. The
obsession with returning to the original, to the initial state of the poly-
chromy, is as dangerous here as it was for architecture in the time of Viollet-
le-Duc: we will not destroy a Gothic polychromy unless this operation would
bring to light an original Romanesque polychromy in a state of conservation
that justifies the sacrifice. How many "restorations" based on the strength of
this conception, which today we must rightly call primitive, have irretrievably

lost precious evidence, already so rare, that could have helped us understand the development of these essential connections between color and form! But no less rare or regrettable are those empirical treatments that—scraping here, retouching there; without a rational plan, since they are without a critical effort—have made of other works definitively illegible palimpsests.

Posing an identical problem, architecture exhibits the same dangers. Apparently "prudent" solutions occur to us that resort, often with unquestionable taste, to broken, ocherous hues, delicate mattes, applied so as to create an impalpable background effect but that, precisely in this way, dissolve the constructive solidity of the wall planes and the incisive rigor of sculpted decorations, Gothic ribs, or Baroque stuccos. This is to confuse subjective taste, a reflection of a pictorial experience—which here undoubtedly brings to mind Carrà, Braque, or Karl Hofer—with the critical work of reconstituting a damaged formal unity.

One must not confuse the reestablishment of the formal structure with the "finish" of the retouching. It is indeed not a question of the degree of imitation or illusionism, but of the *nature* of the reconstruction, the spirit that drives it. The degree of finish shown in the retouching will be a function of the critical interpretation of the case at hand. It will depend not only on the location and extent of the lacunae and the suggestions included in what exists but also on the varying importance the lacuna will assume according to the style. If the rupture caused in a medieval fresco can often be filled in by a simple hue—as long as its value and density places it at the proper constructive level— the importance of detail, finish, and enamel-like appearance to create the atmosphere proper to a Flemish primitive painting will demand, for the realization of an equivalent integration, an infinitely more elaborate retouching.

—⁂—

A retouching pushed until it is almost invisible, illusionist, has at times been condemned in principle, since it would constitute a fake. Even if there is in this a healthy reaction against obvious excesses—which are, however, largely a thing of the past—this scruple nevertheless seems to us excessive. Once the function of the retouching is established, as well as the limits dictated by the potential unity of the damaged work, it is sufficient to limit the retouching strictly to the lacunae—something that must be a sacred principle in every retouching—and to a scientific documentation allowing the immediate identification of the intervention: in this the retouching is, in fact, entirely comparable to a restitution proposed in an edition of a text, which does not interrupt the flow of the phrase but establishes its exact nature in a critical note. Plainly delimited, inserted into the work like a mosaic tile among its neighbors, the retouching remains essentially a critical hypothesis,

a proposition always modifiable, without alteration of the original, when a clearer critique judges it necessary.

—⁊⁊—

If we acknowledge that retouching must reestablish the unity potentially contained in the damaged work, and can because of this, if the need arises, push integration to the maximum, we will be led from time to time to take into consideration an important factor in the condition of the surface: the network of *craquelure*. It may well be, in effect, that a perfect integration can only take place by extending the *craquelure* throughout the retouching. But at times there may also be technical considerations that plead in favor of a *craquelure*-style retouching. Indeed, when a lacuna runs in a narrow strip through to the ground, even to the support, and when there is reason to insert a new support or apply a new ground, contact between these and the original materials poses a delicate problem. Reacting differently than the older materials, the new materials, before stabilizing, can cause a fissure where the retouching and the original meet, risking cleavage and bright surface effects. Properly calculated, the artificial, preliminary *craquelure* of the ground and pictorial layers of the retouching will ensure the optical integration of the surface condition and will constitute a pattern of expansion joints that will respond to the pull of the support, reducing the risk of rupture with the original, thus ensuring greater stability for the retouching.

Note

1. [2] As shown, in a close analysis, by CESARE BRANDI, "Il ristabilimento dell'unità potenziale dell'opera d'arte," *Bollettino dell'Istituto Centrale del Restauro* 2 (1950): 3–9.

Theory of Restoration, II

CESARE BRANDI

§3. The Potential Unity of the Work of Art

Having clarified the significance and limitations of the role of the material in the manifestation of a work of art, we can now investigate the concept of "unity," which must be defined in order to establish the boundaries of restoration.

—∽—

. . . Let us consider a work of art that is effectively made up of several components. Taken individually, the components do not have any particular aesthetic significance; they might only possess a generic value in terms of the beauty of the material, the purity of craftsmanship, and so on. Let us use mosaics as an example of painting, and likewise structural elements, bricks and stone blocks, for architecture. We need not dwell now on the problem, which is a side issue for us here, of the value of the rhythm an artist can achieve when composing the individual parts into the image he is creating. The fact remains that, once mosaic tesserae and stone blocks have been dismantled from the formal arrangement imposed upon them by the artist, they remain inert and do not preserve any effective record of the unity of which the artist has made them a part. It is like reading words in a dictionary; those same words that a poet has arranged in a verse, and that once separated from the verse, become again nothing more than a group of semantic sounds.

—∽—

From CESARE BRANDI, *Teoria del restauro* (Rome: Edizioni di Storia e Letteratura, 1963; reprint, Turin: G. Einaudi, 1977), chap. 3, 13–20, and appendix, 71, 75–76. Used by permission of Giulio Einaudi editore s.p.a. Translated by Gianni Ponti with Alessandra Melucco Vaccaro.

Once we accept the "unity of the whole" for a work of art, we must ask if this *unity* tries to reproduce the organic unity or the functional unity that is continually founded on experience. Here the things that make up the natural world do not exist as independent elements: a leaf recalls a branch; a branch recalls a tree; the cut-up limbs and heads we see in a butcher's shop are still part of an animal. Clothing, too, so far as it is represented in the stereotypical designs of ready-made clothes, refers inevitably to man. . . .

Yet, in the image that is presented through a work of art, this world of human experience seems reduced to only a cognitive function within the figurative nature of the image: any concept of organic integrity is dissolved. *The image is truly and only what it represents.* . . . Thus the image of a man seen in a painting as having only one arm, has one arm only. The image cannot be considered mutilated because in reality the image does not have any arms at all; assuming that the "arm-that-we-see-painted" is not an arm but only a semantic device within the figurative context that the image develops. The assumption of the *other* arm (the one that is not painted) is not related anymore to the process of looking at the work of art, but to the opposite operation through which the work of art is born; and to the reduction of the work of art to a reproduction of a natural object for which the natural object represented there, man in this case, is supposed to have another arm.

─ᴍ─

. . . Thus we derive two corollaries.

In the first we deduce that if a work of art, which is not composed of parts, is physically fragmented, it will continue to exist as a *potential whole* in each of its fragments. This *potential* will be present and can be expressed in a form that is directly related to what has survived of the original artistic features on each fragment of the material that has been disintegrated.

For the second corollary, we infer that if the "form" of each work of art is indivisible, where the work of art is materially split up, we will have to attempt to develop the original potential unity contained within each fragment. This is proportional to the extent that the original form is still preserved within the fragments themselves.

With these two corollaries we have to deny the possibility of intervening on a mutilated, fragmented work of art by *analogy*. This is because a procedure by *analogy* would require, as a starting point, an equivalence between the intuitive unity of a work of art and the logical unity with which we conceive existential reality. This has been refuted.

We can furthermore derive that an intervention that seeks to recover the original unity by developing the potential unity of the fragments of that *whole,* which is the work of art, should limit itself to the indications that are implicit within the fragments themselves, or that can be recovered from reliable sources about the original.

—⚭—

From here we can derive some practical principles that cannot be considered empirical. The first one is that any integration must always be easily recognizable, but without interfering with the unity that one is trying to reestablish. Thus, at the distance from which the work of art will be viewed, the integration should be invisible. From a closer viewpoint it should be immediately recognizable, without the aid of special equipment. In this sense we are contradicting many axioms of so-called archaeological restoration, because we are asserting the need to reach a chromatic and luminous unity of the fragments with the integrations. Furthermore, if the distinction between added parts and original fragments can be achieved with particular and lasting techniques, the use of identical materials and artificial patina is also acceptable, so long as it remains restoration and not reconstruction.

The second principle pertains to materials and related image. Materials cannot be substituted only if they directly contribute to the figurative aspect of the image and not to the structure. From this comes, but always in harmony with the historic context, the greatest freedom of action with regard to principal supports, load-bearing structures, and so on.

The third principle concerns the future: that every restoration should not prevent but, rather, facilitate possible future restorations.

—⚭—

A lacuna in regard to a work of art is an interruption of the figurative pattern. Contrary to general belief, the most serious aspect in regard to a work of art is not what is missing but what is inserted inappropriately. The lacuna, in fact, will have a shape and color that are not relevant to the figurative aspect of the represented image; it is inserted into the work of art as a foreign body. The studies and experiences of Gestalt psychology greatly help us to interpret the sense of a lacuna and to find ways to neutralize it.

A lacuna, even though it has a fortuitous structure, is a *figure* in relation to a *background* that then comes to be represented in the painting. In the spontaneous organization of human perception, which demands symmetry and the simplest forms to interpret a complex image immediately, there is a structured relationship between figure and background. It is, in short, a spontaneous pattern of perception with which we establish a relationship between figure and background in a visual image. . . . When there is a lacuna in the structure of a painting, this unexpected "figure" is perceived as a real figure to which the painting provides a background. The image is more than just mutilated, it is also *devalued*, in the sense that what was born as a figure is now reduced to mere background. Out of the first attempts to establish a methodology for restoration that avoided integrations based on fantasy came the first empirical solution of a *neutral tint*. It was an attempt to reduce the front-row prominence of the lacuna by trying to push it back with a tint as

free of tone as possible. It was an honest but insufficient method. Furthermore, it became clear that a neutral tint really does not exist, that any supposed neutral tint in reality influenced the chromatic distribution of the painting. The proximity of the colors to the tint dimmed the colors of the image, resulting in the emphasis of the intrusiveness of the color of the lacuna. . . . To reach more satisfactory results, it was enough to introduce (where the statics of the color allowed) a difference in level between the painted image and the lacuna. From being a *figure* to which the painting provides a background, the lacuna functions as a background on which the painting is the figure. . . . In most cases, it is enough to expose the wood or the canvas of the support to obtain a clean, pleasant effect, above all because all ambiguity resulting from the dramatic appearance of the lacuna as a figure is removed. . . .

This solution, albeit an intuitive one, has received support and explanation from Gestalt psychology for it takes advantage of a natural mechanism of perception.

Appendix

What is a lacuna that appears in the context of a painted, sculpted, or even architectural image? If we go back to the essence of a work of art, we will readily feel that a lacuna is a formal, unjustified interruption that we could even perceive as painful. . . . If we remain in the realm of immediate perception, through the spontaneous patterns of perception we will interpret the lacuna in terms of a background figure. We will sense the lacuna as a *figure* to which the painted, sculpted, or architectural image is reduced to background while the same figure is foremost. From this recession of the figure to the background and from this violent intrusion of the lacuna as a figure in a context that tries to expel it, comes the disturbance that produces the lacuna, more so than from the formal interruption that the lacuna produces within the image.

Thus the problem is well defined. It is necessary to reduce the prominent figurative value taken on by the lacuna with respect to the real figure, which is of course the work of art. That said, it is clear that the solutions on a case-by-case basis, as the lacuna demands, will not stray from the guiding principle, which is to reduce the perceived prominence of the lacuna as a figure. . . .

We have established some firm points: the complete, easy recognition of all integrations that bring about the potential unity of the image, and the reduction of the prominence of the lacuna as a figure. These points allow for a great variety of specific solutions, which still will be consistent with the principle from which they derive.

342

Problems of Presentation

PAOLO MORA, LAURA MORA,
AND PAUL PHILIPPOT

Treatment of Losses
General Principles

—w—

Historical conscience today demands that the authenticity of the documents of the past be respected. Modern aesthetics, on the other hand, in its emphasis on the unique character of the work of art as the creation of an individual consciousness at a given historical moment, has in turn proved that it cannot be reproduced, not even by the artist himself who in attempting to do so would either make a replica—or even a fake—or else create a new work.

. . . Aesthetic reality lies entirely in the appearance of the work of art and its understanding cannot be dissociated from the presentation of the work. . . .

There are two levels of disturbance caused by losses in a painting. On one hand, the loss makes it difficult to perceive the image because, to follow Brandi's use of the terminology of Gestalt psychology, it has a tendency to become the *pattern* while the painting as a whole then becomes the *ground* [Figs. 1, 2].[1] On the other hand, the loss seems, from the formal point of view, to be an interruption of the continuity of the form.[2] The minimization of this disturbance in order to restore to the image the maximum presence

From PAOLO MORA, LAURA MORA, and PAUL PHILIPPOT, "Problems of Presentation," in *Conservation of Wall Paintings,* chap. 13 (London: Butterworths, 1984), 301–10; originally published as "Die Behandlung von Fehlstellen in der Wandmalerei," in *Beiträge zur Kunstgeschichte und Denkmalpflege, Walter Frodl, zum 65 Geburtstag gewidmet* (Vienna-Stuttgart: W. Braumüller, 1975), 204–18. Used by permission of Butterworth-Heinemann, Stoneham, Mass.

Figure 1
Roman Forum, *Oratory of the Forty Martyrs.* Reinforcement of the edges of the losses, executed in bands that are too wide and too light in color, completely obliterates the ensemble by reducing it to the status of "ground" on which the reinforcing borders stand out as "figures."

Figure 2
Ajanta. The composition of the painting has been rendered illegible by the manner in which the losses have been treated, so that the losses appear as the foreground and disrupt the unity of the image. The image would reestablish itself naturally if the losses were treated as fragments of a single ground plane situated optically *behind* the image.

possible, while respecting its authenticity as a creation and as a historical document is the real critical problem of the reintegration of lost areas.

Conceived in this way, and not as an intervention which aims to complete the work, it is obvious that the reconstruction of the missing parts is justified within well-defined limits and practical means. This has been proved by Cesare Brandi, who based his argument on the notion of the potential

344

unity of the mutilated work. From an aesthetic viewpoint, the work of art is characterized by the unity of the form as a whole. The image created by the artist differs from the object which is its physical support in that it is not equal to the sum of its parts and is therefore not divisible. Consequently, even when the work is mutilated or reduced to fragments something of its original totality always remains. This continues to exist in the remaining fragments, in varying degrees of potentiality according to the extent and nature of the mutilations. Reconstruction as a critical interpretation is thus aesthetically justifiable as long as it aims only at making it easier to see the potential formal unity of the work which exists within the fragments. *This last restriction implies that the operation should stop where hypothesis begins.* At that moment, since the loss can no longer be reintegrated by reconstruction, it will have to be considered only insofar as it disturbs the legibility of the image. Reintegration should then be limited to treating the loss in such a way that instead of coming forward in space as a *pattern* it will on the contrary become part of the *ground,* thereby restoring the image's preeminence as a figure [Fig. 3].[3]

Moreover, from the historical point of view, respect for the authenticity of the work imposes a second limitation on reconstruction. This must always be distinguished, as a critical interpretation, from the original work.[4] A comparison may be drawn with the restitution of a word in an incompletely preserved text, although in the case of a text, transmission of the word is ensured by the published edition, which is physically different from the

Figure 3
Tarquinia, *Tomb of the Lionesses.* The losses, filled with cement without any effort to integrate them, stand out as a pattern in front of the original composition, which is thereby fragmented and reduced to the status of "ground."

original document. This means that the critical restitution never takes place
on the manuscript itself but only on the published text, where it is indicated
by a footnote. In a work of art, on the other hand, the reconstruction of
the image is only possible on the original. Consequently, reconstructed
parts must be intrinsically distinguishable from the original and also inte-
grated with the formal totality of the work. The technical procedures recom-
mended for reconciling these apparently contradictory requirements will be
described later.

Based on the potential unity of the mutilated work, reintegration
must therefore treat each loss in consideration of the totality of the work
[Figs. 4–6]. This is exactly where mural painting presents a particular prob-
lem, distinct from an altarpiece or an easel painting. Indeed, insofar as the
mural painting is an integral part of the architecture, it is subordinate to a
larger totality in which the losses may sometimes affect more than the paint-
ing alone. . . .

Of course, the problem reaches its height when, as in the Late Baroque
in central Europe, pictorial space and architectural space, both based on
perspective, tend to merge, the privileged viewpoints of the architecture

coinciding with those of the pictorial perspectives. The preservation of the illusion indispensable to the unity of the whole will surely justify the reconstruction of the extensive losses. However, a complete reconstruction, as has sometimes been carried out after war damage, will never be anything else but a stylistic falsification and will soon be outdated, whatever the quality of the documentation on which it is based and no matter how perfect it may be. We must resign ourselves, here, not only to the loss of the painting, but also the irremediable mutilation of the architecture.

Figure 5
Annunciation. After a general treatment of the losses, worn areas have been integrated with a watercolor wash, small losses with *tratteggio;* large losses and those situated in areas that could not be reconstructed have been treated so they recede behind the image and serve as a uniform ground.

Figure 6

Assisi, lower church. Simone Martini, chapel of St. Martin. Details of the vaults, before and after restoration. The losses, limited to the paint layer and due to the action of efflorescences of salts, have been integrated by lowering the tone of the losses and reestablishing formal continuity in worn areas, but without reconstructing the missing areas.

Practical Procedures

Various Types of Losses

The losses which damage a painting can be distinguished by their location and their size and by how deeply they penetrate the paint layer or the underlying rendering. When considering the problem of reintegration, losses may be divided into five different types [Fig. 7]:

1. Wear of the patina.
2. Wear of the pigment layer.
 The term "wear" refers to the superficial alteration of the patina or of the actual pigment layer, due either to abrasion or to the loss of minute flakes of paint beneath which a part of the pigment layer or at least the original rendering remains.
3. Complete losses of the pigment layer or the rendering, limited in surface area and capable of being reconstructed.
4. Complete losses of the pigment layer or of the rendering which, because of their extent and/or localization, should not be reconstructed.
5. Losses of considerable extent, which should nevertheless be reconstructed because of their architectural significance.

—m—

348

Figure 7
Types of losses according to the depth of the damage: (1) wear of the patina, (2) wear of the paint layer, (3) loss of the paint layer, (4) loss of the *intonaco*.

Reintegration of Losses

Since the painting to be restored normally presents losses of different types, it is important that the reintegration be adapted to them while respecting the above-mentioned principles [Figs. 4, 5]. These differences, however, should be considered within a coherent system, in order to restore the maximum presence and unity to the image without resorting to hypotheses. Indeed, the clarity of the restored image will depend just as much on the coherence and the critical logic of the system adopted as on the quality of the execution.

To attain this purpose it is generally advisable to proceed progressively, treating first the damage due to wear, which causes only a minor disturbance but which is easily reintegrated, thus clarifying the image so that the larger losses may be better assessed. Then one can decide which losses can be reconstructed and which cannot. The latter will consequently have to be treated in such a way that the restored image is disturbed as little as possible.

In theory, various different systems of reintegration can be considered. However, the range of practical possibilities is, in fact, very limited, owing to the great number of requirements which must be satisfied simultaneously. The method described here is based on very long experience, and although it may not be the only valid method, it seems to us the one that solves the problem in the most satisfactory manner. It will be described under the different types of losses established earlier.

Reintegration of the Patina

Wear of the patina causes a discontinuity of the surface which alters the luster of the painting and, consequently, the depth of the tones and the spatial unity of the image. When the losses are very small and superficial they can be reintegrated by a light watercolor glaze, which reestablishes the uniformity of the surface without the risk of altering the remaining paint layer which it covers. The tint must be matched to the particular tone of the patina in each case. This patina, grayish in frescoes, should be reintegrated in a similar cool tint.

Reintegration of Wear in the Pigment Layer

When wear due to abrasion or to flaking reaches the actual pigment layer, it affects the image, not only because it alters the state of the surface, but also because it causes small light spots (sometimes even white spots when the rendering is exposed) to appear optically *in front of* the original pictorial plane. These spots must be made to recede in space and thus the image will recover its continuity and its depth [Figs. 6, 8]. This can be achieved by lowering the tone of the losses by means of watercolor glazes. In order that the intervention may be distinguished, a tone of the exact value but very slightly lighter and cooler than the original should be used. . . .

Figure 8
Detail of Fig. 4, *Annunciation*, illustrating the integration of worn areas using a watercolor wash. (The areas inside the rectangle have not yet been integrated.)

Reconstruction of Losses: Filling and *Tratteggio*

The reconstruction of limited losses is justified by the potential unity of the surrounding painting. . . . The method which we consider has given the best results, and whose systematic character is probably best suited to the critical approach which is proposed here, is that of *tratteggio*. It was developed at the Istituto Centrale del Restauro during 1945–50 and inspired by Cesare Brandi's theory of restoration. . . .

The filling of losses in the rendering should not be undertaken until the adherence of the paint, especially along the edges of the losses, has been verified and until the necessary consolidation has been undertaken in order to avoid the risk of crumbling when ensuring a perfect bond at the edges. The essential purpose of such a filling is to serve as preparation for the pictorial reintegration; it must therefore reestablish, as exactly as possible, the level and the texture of the original rendering. Normally, materials identical or at least similar to those of the original rendering should be used.

—∾—

Whatever formula is chosen, the wall must be soaked with water before applying the filling. Moreover, great care should be taken to avoid soiling the surrounding painted areas as this could produce stains after drying. In order to avoid such a risk and to facilitate the application of the filling, it is recommended to fix the paint around the loss with a 10% solution of Paraloid B72. In this way, the filling which might have spread beyond the edge of the loss during application can easily be eliminated without any damage to the painting. After the filling has dried, the fixative can be removed by means of an appropriate solvent.

Reconstruction in tratteggio consists in transposing the modeling and drawing of a painting into a system of hatchings based on the principle of the division of tones [Fig. 9]. This system, by its very nature, works like a kind of screen between the restorer and the original. Its purpose is firstly to differentiate the retouching from the original, in the same way as the use of a different typeface in a printed text can be distinguished; and secondly, to prevent or to filter, through the mechanical nature of the system, any personal expression of the restorer in the spontaneous continuity of the modeling, the brush stroke or the line, so that the intervention is structurally unmistakable as a critical interpretation. It is of course essential that the restorer should do his utmost, through that screen, to obtain the most complete and most rigorous reintegration of the loss by means of reconstruction. Otherwise the barrier would be meaningless and would only cause confusion and haziness of the image, which is exactly the opposite of the objective.

Normally, *tratteggio* is applied with watercolor, which helps to distinguish it materially from the original painting and makes it easier to be

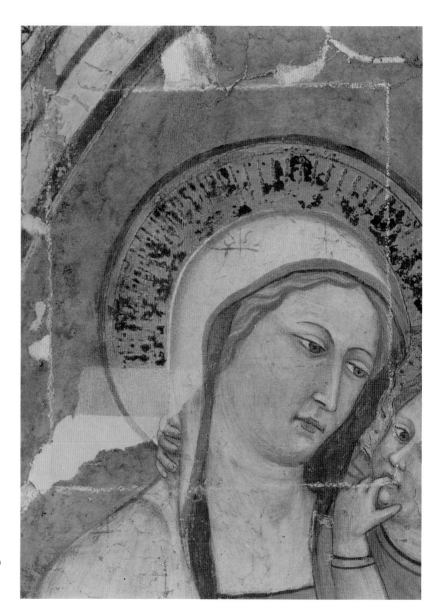

Figure 9
Figure of the Virgin from a church
at Tuscania. Example of the
integration of a loss in *tratteggio*
during execution.

removed, should this prove desirable. The technique of execution is determined by this method, since watercolor does not allow the use of impasto and all the light must therefore derive from the ground through transparent layers.

Tratteggio is a system of small vertical lines averaging one centimeter in length. The first lines, which indicate the basic tone of the retouching, are placed at regular intervals equal to the width of one line. Next, these intervals are filled with a different color, and then again with a third color, in

order to reconstitute the required tone and modeling by means of the juxta-position and superposition of colors which are as pure as possible. Each line in itself should be weak in intensity, the desired intensity of the whole being obtained by the superposition of glazes of transparent lines rather than by strength of color, which would cause the retouching to lack the vibration indispensable for a good integration.

In order to obtain neat hatchings, without discontinuity and with-out the formation of drops at the bottom, the following procedure is recommended:

1. The brush must be sufficiently loaded to trace a full line without let-ting any paint run. To achieve this, as soon as the color has been taken, the brush should be wiped over an absorbent material such as slightly wet cotton wool, which has been fixed to the bottom right-hand corner of the palette. This operation controls the load of the brush by dis-charging it if necessary and, by its spiral movement, gives the brush the perfect point it had lost while preparing the tone on the palette.

2. It must be pointed out that the use of a maulstick (hand support) is essential. It allows the correct movement of the hand which, while the upper part of the forearm remains still, must cause the point of the brush to trace an arc intercepting the picture plane along the length of the line, so that the line begins at the top and ends at the bottom in a very sharp point.

The tone peculiar to frescoes, characterized by the light veil of super-ficial dust incorporated in the patina, can be easily reconstituted by starting the retouching with very low, slightly bluish tones produced by adding to the mixture the necessary quantity of blue.

Limitations of tratteggio. The advantages of *tratteggio* naturally diminish as the surfaces to be reintegrated become larger and the forms less articulated for the vibration of the hatchings then contributes to a certain imprecision of the planes. In such cases other methods of identifiable retouching may be preferable. But *tratteggio* should not be combined with other methods because two methods of reconstructing losses applied in the same painting would certainly affect the visual unity of the image.

Moreover, it is essential that the reconstruction in *tratteggio* remain limited to losses with a neatly defined outline and not overlap the worn parts of the original. . . .

Losses That Should Not Be Reconstructed

The reconstruction of missing parts ceases to be justified when it becomes hypothetical and, generally speaking, when the loss exceeds a certain size.

In this case, the problem is to reduce the disturbance caused by the loss by preventing it from interfering with the image. The loss, instead of being a pattern detaching itself in front of the image which has become a ground, must be transformed into a ground behind the image now restored to its role of figure.

The ground of a mural painting must be interpreted here as being the wall that lies behind the painting. In relation to the painting and to the architecture, the wall constitutes a plane of reference and the best way to treat nonreconstructable losses is to act as if they were due to the fall of a layer of surface rendering which has laid bare the underlying *arriccio*.

Notes

1. [4] CESARE BRANDI, "Il trattamento delle lacune e la Gestalt-psychology," *Studies in Western Art: Acts of the Twentieth International Congress of the History of Art,* ed. Millard Meiss et al., *Problems of the Nineteenth and Twentieth Centuries,* vol. 4 (Princeton, N.J.: Princeton University Press, 1963), 146–51.
2. [5] CESARE BRANDI, "Il ristabilmento dell'unità potenziale dell'opera d'arte," *Bollettino dell'Istituto Centrale del Restauro* 2 (1959): 3–9.
3. [6] BRANDI, "Il trattamento delle lacune."
4. [7] CESARE BRANDI, "Il restauro dell'opera d'arte secondo l'istanza della storicità," *Bollettino dell'Istituto Centrale del Restauro* 11–12 (1952): 115–19; and his *Struttura e architettura* (Turin: Einaudi, 1967), 225–32.

Theory of Restoration and Methodological Unity

UMBERTO BALDINI

During its lifetime a work of art can undergo its "destruction" (thanatos), which can occur because of our complete inaction (from negligence and abandonment to decay) or because of traumatic external events (earthquake, war, collapse, fire, et cetera); it can undergo the extension of its "life" (bios), exemplified by the physical act of treating the work's ailment or material loss (maintenance and conservation); it can undergo the "restitution" of its reality as an existing work of art (eros), exemplified in the final act of philological critique (act of restoration).

At the same time we can identify in each work of art at least three other acts. The first pertains to its realization by the "artist"; the second is the action of "time" on the work itself; the third is the action of "man."

This last one, in which we are the protagonists, can express itself through two primary actions:

1. repairing the damaging, or otherwise altering, the action of time.
2. altering the reality of the first act, and sometimes even the reality of the second, by presenting it in a new context.

—〰—

When starting an act of restoration, maintenance, or conservation, we first complete, by means of a precise philological analysis, what we call the identification of the reality of the object in the form that it has come down to us, or is still recognizable.

From UMBERTO BALDINI, *Teoria del restauro e unità di metodologia,* vol. 1 (Florence: Nardini Editore-Centro Internazionale del Libro, 1978), 9–14, 27–29. Used by permission of Nardini Editore. Translated by Gianni Ponti with Alessandra Melucco Vaccaro.

This is the most important operation because through it we obtain knowledge and, therefore, knowledge of the object. The conservation intervention must start from here. If, in theory, conservation can technically and aesthetically develop in a variety of ways, it must adhere to one undeniable condition: it cannot, in any way, alter the value and the reality of that acquired knowledge and awareness.

If such a law must be the basis for all operations comprehensively defined as "cleaning," then all the more reason to apply it to all operations defined as "definitive restoration or pictorial restoration."

Such operations can easily modify and therefore influence appearance whenever they become competitive or imitative. To avoid this it will be necessary to analyze restoration carefully in terms of quantity, weight, and method.

—⁂—

The action of man (the third action) should not alter in any way the work of art, but instead emphasize and clarify it. This should be a critical intervention that derives from the reality of the object and is unaffected by taste or personal inclinations. Most of all, the intervention should happen! It is absolutely necessary and cannot be neglected or avoided by appealing to that kind of alibi that a convenient interpretation of the "charter of restoration" allows those who do not wish to face issues or formulate problems with no easy solutions. As a result, there would be the certain risk of an unacceptable alteration of the object, too often reduced to the state of a cheated fragment in the name of "honesty" or so-called "scientific rigor." . . .

Down this road we go quickly and without hope toward that fetishism for the fragment that is the unhappy result of the refusal (especially for masonry and in architecture) of "maintenance." This action, as we have said, is essential to the "lifetime" of the work of art and alone has permitted the survival of so many objects that have thus come down to us. That action, precisely because it is an act of intentional maintenance and conservation, "must" occur if we do not want the passage of time to reduce the already worn object to an arbitrary reality worse than any forgery. Why wait for an object to waste away and then panic about trying to stop forever its decay?

—⁂—

An intervention is thus necessary for the object to continue living and existing. But we have said that an intervention cannot in any way be competitive or imitative. Thus in restoration we cannot accept as legitimate the application of gilding in areas where it has fallen off by itself, or because the priming layer has fallen off, taking with it the bole. Nor can we even accept or uphold as valid the introduction of a material that, on the basis of a misunderstanding of pictorial restoration, seeks to imitate the priming layer or the bole. Such an act, though it does not result in the direct application of

gilding as a reconstruction, is an invention that conveys a fraudulent and artificial idea of how the work of art is presumed to have deteriorated.

Both of them, the artificial priming layer and the bole, would be in contact with the original priming layer and bole to the point of blending into an obvious falsification. Our third act would thus be visually deceiving, and the intervention would become part of the second act without any right and with artificial values. The object would therefore have a false and arbitrary "lifetime."

To avoid all of this and to prevent us from making the same mistake as the restorer who reconstructs, we will do well to focus our attention precisely on this third act, which is an act of restoration. Such an act, which is the result of a critical approach, not an assertion of taste, has to clarify and emphasize the reality without changing it. To conclude and solve the problem, we can only trust a methodological act that excludes both imitation and competition. We will have to trust an act that we could define as being an act of abstraction of the existing materials that we wish to emphasize.

Historic Preservation: Philosophy, Criteria, Guidelines, II

PAUL PHILIPPOT

The Fragmented Object; Lacunae and Their Integration; Archaeology and Museum Objects

The problem of lacunae (i.e., missing parts of objects) and the object in fragments may best be approached from the viewpoint used in dealing with museum objects and archaeological remains which, being free from the requirements of practical functions, allow for the strictest interpretation of basic principles.

The lacuna, be it in a picture, sculpture or monument of architecture, appears to be an interruption of the continuity of the object's artistic form and its rhythm. Since the object's completeness is no longer a necessity (and often, the fragmented object has acquired a value in its fragmented state, as is the case for a ruin or a torso), the only aim of restoration should be to reduce or eliminate the disturbance caused by lacunae in such a way that the intervention can be unmistakably identified as such (i.e., as a critical interpretation).

Philology has shown the way to achieve that aim in a long tradition of the editing of old manuscripts. In the editing, the missing word or words are never added by the editor unless they can be safely reconstructed, and this interpretation is then clearly indicated as a reconstruction by the use of special printing devices and footnotes. Missing words are never written on the

From PAUL PHILIPPOT, "Historic Preservation: Philosophy, Criteria, Guidelines," in *Preservation and Conservation: Principles and Practices,* Proceedings of the North American International Regional Conference, Williamsburg, Virginia, and Philadelphia, Pennsylvania, 1972 (Washington, D.C.: Preservation Press, 1976), 374–82. Copyright 1976 National Trust for Historic Preservation in the United States, Washington, D.C.

original manuscript. Since in the case of a work of art editing has to be done on the object itself, the same principles require that special practical devices be applied to a painting, sculpture or monument of architecture, while the basic philosophy is fundamentally the same as that applied in philology. Therefore, in each case, it is necessary to make a distinction between lacunae that may and lacunae that should not be reintegrated.

Reintegration will be justified only when lacunae are relatively small and so situated that there can be no doubt about what was lost and when the new work is sufficiently limited so as to avoid the reconstruction's appearing to quantitatively overwhelm the original parts and making the whole seem to be a fake or a copy. The reintegration (used in preference to the terms "retouching" and "inpainting") should then aim to reestablish the continuity under normal conditions, while being easily identified on closer inspection. There are various technical solutions to this problem, and the restorer will have to use his artistic feeling, as well as his knowledge of materials, to find the best answer, one essential point being the consistency of the reintegration system. Hatchings in paintings and changes of material or of surface treatment (akin to but different from the original) in sculpture and architecture have given satisfactory results (Figs. 1–5).

Figure 1
Detail of the Arch of Titus in the Roman Forum as restored by Valadier, using travertine instead of marble and leaving the modern parts unfinished.

Figure 2
West sidewall of the Arch of Constantine. Lacunae in the middle show more respect for the original and are better integrated than those at the base of the wall, where white patches are disturbing.

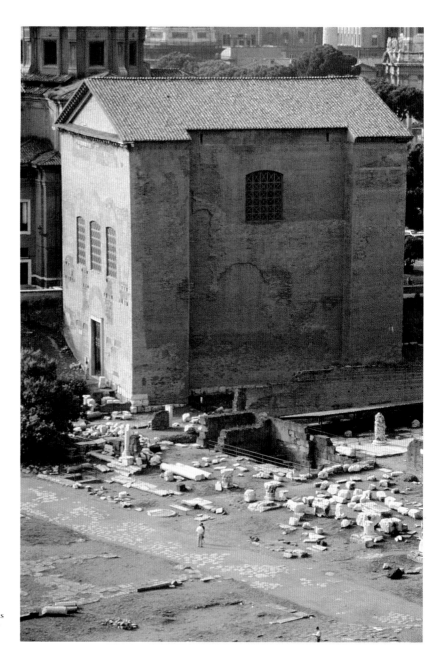

Figure 3
Wall of the Curia in the Roman
Forum showing good restoration
technique. Restoration was
completed with bricks placed
slightly below the level of old bricks
and a hammered surface to allow
easy distinction of old and new.

Figure 4
Detail of the Curia wall, showing
the surface treatment of bricks
used for filling holes.

When lacunae cannot be reintegrated because this process would be too hypothetical or because there would be more lacunae reintegrated than there would be remains of the original, restoration should consist of treating lacunae in such a way that their disturbance is reduced to a minimum. As Cesare Brandi has shown in a penetrating study where he refers to the structures of perception according to Gestalt psychology,[1] the treatment should consist of preventing lacunae from becoming so patterned over the work that the original image recedes into the background. Lacunae should, on the contrary, be made to appear as the background before which the work is perceived. The disturbance due to lacunae will then be reduced to a minimum. . . .

A special problem arises in the archaeological field. A ruin is normally considered the object to be preserved, not as a fragment of the object, since ruins themselves are cultural objects with their own specific emotional values and appeals to the imagination, which would be completely destroyed by an attempt to restore the ruin to its original state.

There is one case, however, where such an intervention may be contemplated. When all fragments of a part or the whole of a building have been preserved and can be reassembled with the certainty that in so doing the original shape is restored, then one may be justified in performing an *anastylosis* (i.e., the reconstruction of the object from its scattered fragments), with modern additions being strictly limited to what is required for static safety and justified as reintegration. Obviously, anastylosis can be contemplated only

Figure 5
Piero della Francesca, *The Flagellation.* Detail with retouching in hatching technique (*tratteggio*).

when the building is of dry masonry (i.e., joints allow for an exact restitution of the original shape) and pieces have not suffered deformation by erosion.

When joints are made with mortar, as in brick structures, disassembling and reassembling even a complete building will result in faking, as the old mason's peculiar rhythm in laying the bricks is replaced by a mechanical dryness and hardness of line due to the modern way of working.

As is stated in the Venice Charter of 1964, anastylosis is the only justified form of archaeological reconstruction, because it is the only one that can reestablish the genuine object. Any other kind of reconstruction that the archaeologist may be able to achieve on the basis of fragments, iconographic documents or descriptions can refer only to a knowledge of the lost object. Such a knowledge cannot be identified with the real object without faking; it should, therefore, be materialized in drawings or models, but never in actual reconstruction of the object.

The Object Still in Use and Its Context

Once the guidelines for safeguarding an object's value have been defined in the "pure" situation of archaeological and museum objects, one may consider what special adjustments may be necessary for objects that have retained a practical social function; this refers in particular to architecture and to ethnographic objects in traditional societies.

As regards architecture, it is obvious that lacunae may have to be supplied to a much larger extent than may be justified on aesthetic grounds for

archaeological remains. However, the two basic requirements for reintegration and easy identification of the intervention are still valid in this instance, their validity extending up to the point where the intervention would become hypothetical or so extended that only a modern creation would avoid faking. When an entirely contemporary intervention is called for, original parts of the structure (or group of structures) will constitute the basic elements of the design problem, the aim being to achieve a harmony within the larger unity of a contemporary environment.

Such creative integration requires a study of the old building, its context and perhaps the whole historic center where it is located in order to establish the peculiar rhythm of the old complex and to adjust the scheme of the modern creation to the basic modules and materials that already exist. Since control of social and economic factors will also be essential in achieving a harmonious development, a new, dynamic and multisided systematic study of historic complexes in the larger, town-planning frame of reference will have to be developed in order to bridge the gap between the classical conservation approach to the structure and the need to maintain a living, human environment.[2] One point ought to be stressed in this regard: A detailed evaluation, through a thorough study of the structure or complex of buildings, must always precede any study of adaptation to new functions. Otherwise, restoration will unavoidably give way to exercises in modern architecture made at the expense of old buildings.

Notes

1. [9] CESARE BRANDI, "Il trattamento delle lacune e la Gestaltpsychologie," *Studies in Western Art: Acts of the Twentieth International Congress of History of Art,* ed. Millard Meiss et al., *Problems of the Nineteenth and Twentieth Centuries,* vol. 4 (Princeton, N.J.: Princeton University Press, 1963), 146–51.
2. [10] Compare, in this regard, INGRID BROCK, ROBERTO GIULIANI, and CRISTIAN MOISESCU, *Il centro antico di Capua: Metodi di analisi per la pianificazione architectonico-urbanistica* (Padua: Marsilio Editori, 1972); and D. STEPHEN PEPPER, "Conservation and Its Social Context," *Paragone* 22 (1971): 77–85.

The Idea of Patina

Rome, Trajan's Column, scene
ɔ. 146 depicting Dacian prisoners.
Detail with ancient intentional
oxalate patina.

The Idea of Patina

The nature of the past as "both intriguing and deceptive," in the words of Talley (introduction to Part I, page 8) and the "deep sense of voicefulness" evoked by Ruskin (Reading 1, page 42) are qualities most particularly evident on the surface of an object. Time pervades and changes all the material that constitutes an object; it acts especially on the surface where its effect is partly to change and destroy the original features and appearance of the object, and partly to increase its appeal (Fig. 1).

This aspect of the surface, which bears traces of the time that the object has endured, is defined with a term that is both ambiguous and complex: *patina*. As Philippot states, "This is not a physical or chemical, but a *critical* concept" (Reading 39, page 373).

The origin of the word patina, which is Italian, is also controversial; it first appears in a text printed in 1681 in the *Vocabolario toscano dell'Arte del Disegno* by Filippo Baldinucci and, appearances to the contrary, has no obvious parallels in Latin. In the *Vocabolario* it is mentioned as a term used by painters to indicate the dark tone that appears on paintings as an effect of time and that sometimes embellishes them (see Reading 42, Weil, pages 394–414). It is thus a natural phenomenon, which, nonetheless, has an aesthetic effect. That is the crux of the problem, which, as has been suggested, finds its perfect figurative expression in Hogarth's well-known painting *Time Smoking a Picture*.

All debates on the subject, past or recent, suffer from a confusion that has never been resolved between the natural aspects of patina and the inten-

Translated by Alexandra Trone.

Figure 1
Michelangelo's frescoes, Sistine Chapel. Detail.

tional ones. The history of the problem will therefore be examined from its beginnings to set this out clearly.

From the *Natural History* of Pliny the Elder, and from allusions by other authors of the ancient world, it is known that in Classical times people were well aware of the effects of the environment on works of art, especially on bronze statuary exposed in the open air. Plutarch, in his *De Pythiae Oraculis,* recounts that a group of visitors to the sanctuary at Delphi paused to consider the appearance of a bronze with a surface that looked "as though it had been immersed in a bath of brilliant blue varnish."[1] The visitors wondered whether they were looking at a natural phenomenon or at a finish intentionally applied by the artist. In the currents of Classical aesthetics taken up by Pliny in his treatise, however, art was conceived as an imitation of nature, and it was not considered possible that a work of art could be produced from a poor raw material.

This powerful two-way bond between material and creation is emphasized by the fact that the Greeks had no specific term for art but used the word *techne* indifferently for art and technique. In the view of the Classical world, therefore, the material and the ways in which it should be worked concerned the creative process directly as well as the durability of the work of art.

There are many indications and ample proof that selection of appropriate materials, extremely accurate techniques of workmanship, and constant

subsequent maintenance were employed to ensure that a work would last. Much is known about the measures taken to maintain the works of art in the major sanctuaries of ancient Greece,[2] in particular, and then of Rome. These included periodic washing and coating with protective substances: probably transparent oils, waxes, and resins for metal objects and marble sculptures; waxes for wall paintings and renderings; and mostly plaster with glue additives for buildings.

The difficulty in interpretation—which affects works of art from both the ancient world and post-Classical periods—arises because the artists themselves, conscious of the effects of time on their work, applied protective finishes. Their intention was to improve the final appearance as well as to protect the surface so this appearance would be long lasting.

Bronze in Classical antiquity was covered with a varnish based on bitumen, a mixture—so it is argued—of pitch and turpentine. Pliny wrote: "Bitumine antiqui tinguebant eas, quo magis mirum est placuisse auro integere" (In early days people used to stain statues with bitumen).[3] This remark, often misinterpreted, indicates a transparent treatment intended to make the surface of bronze look as if it had been gilded.

E. H. Gombrich (see Reading 11, pages 123–24) and Talley's commentary (introduction to Part I, pages 27–28) brought up the question of the dark varnishes known as *atramentum* that the ancient painters are said to have used. This should not be considered a common practice. Apelles, Alexander the Great's official artist and the most illustrious of ancient painters, referred to the term as an "invention." This can be understood well enough within the limits of the artist's own aesthetic investigation into luminous effects, which consisted of strong contrasts between light and shade.[4]

The recipe remains a secret, but Pliny refers to the reasons why the artist produced it, saying that when he had completed a painting, he would apply a coat of *atramentum* so thin that, forming a transparent layer, it produced a white color attributable to its brilliance [alone] and at the same time it "preserved [the painting] from dust and dirt."[5] The *atramentum* was visible at close range only, but even then, Pliny tells us, Apelles very wisely lowered the light to prevent the brilliance of the colors from striking the eye as though through a looking glass. Seen from a distance, the effect of the process was to soften the brilliant colors without the *atramentum* itself being visible.

Similar aims and procedures to produce finishes and protective layers have recurred often. Successive restorers repeated these or similar treatments, creating a sequence of layers that are no longer easily distinguishable. The unintentional alterations occurring with time, especially those having a considerable visual impact, were periodically removed and a new finishing-protective layer was added.

It is therefore incumbent on conservators and historians to ask themselves—even though a correct answer may not always be possible—what finish might originally have characterized the work (the question formulated by Talley, on page 28, as to "What was considered to be a painting's proper look?") and to what successive surface treatments it may have been subjected over the course of time.

To pay attention to intentional treatments that might be present is a necessary counterweight to the approach of the scientific laboratories. Scientists are inclined to investigate the work of art from the material point of view. They too often forget that the work is an artifact, and that its passage through time is not marked by natural processes only but also by early restoration treatments. These may not always have been valid and effective, but they have often ensured the object's survival.

Thus the traces of time, and human interventions designed to counteract the more disfiguring effects of time, are concentrated in the material of the work of art, especially on its surface. It should be clear that recognizing whether or not a material or a layer has been intentionally applied has immediate consequences for the strategies to be used in the course of conservation.

Scientific analysis and critical interpretation are often in conflict over the few microns of a layer under discussion. In the past, however, art historians and curators of major museums were the very ones responsible for destroying traces of treatments, color, patination, and toning layers, especially on ancient marbles.

In keeping with the taste of Classicists from the time of Winckelmann onward, architecture and sculpture that survived from Greek and Roman times were wrongly considered to have always been devoid of all applied color. It is now believed, on the basis of treatises and other written sources, philological arguments, and archaeological evidence, that the opposite is the case. Unfortunately, the ravages of time and pollution have been nothing compared to the damage done by restorers: removal of the surface and violent cleaning with hot water and ashes, or washing with sponges soaked in nitric acid, have almost completely destroyed any traces of polychrome finish spared by the effects of time.[6]

Philippot clarifies the aspects of the problem that concern the cleaning of paintings (see Reading 39, pages 372–76). He elucidates the way in which material and aesthetic factors are intertwined with the concept of patina. He also disentangles the ensuing debate with particular reference to the episode known as the "cleaning controversy," which is mentioned several times in the following selections.

Once again, the passages by Philippot will provide a good introduction to help understand the excerpts dedicated to the problem of patina from

Brandi's *Teoria del restauro* (Reading 40, pages 377–79). The position Brandi took up in opposition to the English conservators responsible for the cleaning of paintings in the National Gallery in London (see Carbonara, Reading 23, pages 236–37) follows from the arguments presented here.

The confusion between natural, unintentional processes and intentional patination is real and is not helped by Brandi's difficult prose. The idealist conflict between material and image typical of his thoughts leads him to define patina in general, and especially in relation to its visual effect, as an element that attenuates (he uses the musical term "mutes") the excessive prominence of the material. From this and from his aesthetic—even more than from his historical—values, he deduces the necessity of conserving patina.

Other excerpts from Brandi's writings on this question (Reading 41, pages 380–93) are far less theoretical and abstract, partly because they are intended to respond to a specific problem and to explain his outright disagreement with the cleaning, or rather overcleaning, of important paintings that the National Gallery in London had completed at about the time he was writing.

He explains clearly, citing good examples, why it is wrong to clean a painting by eliminating all the layers that overlie the paint layer, as though they were all, without distinction, dirt layers; and why, on the other hand, it is necessary to distinguish between unintentional layers, or alterations, and intentional layers—coatings, varnishes, and successive and repeated protective treatments of the paint layer. The clarity of this text proves that Brandi's teaching was much more concrete than most of his writings. In his capacity as director of the Istituto Centrale del Restauro, he was responsible for the treatment of very well-known paintings and founded a school of conservation whose most acclaimed proponents are Paolo Mora and Laura Mora (Reading 36, pages 343–54).

The problem of cleaning, the completion of lacunae (discussed in Philippot and Philippot, Reading 34, pages 335–38), and the final presentation of a painting constitute the beginning, middle, and end of a continuum of procedures that should be followed with absolute unity of method. The recent and prestigious conservation of the *Pesaro Coronation* by Giovanni Bellini[7] provided an opportunity to reexamine a painting that had previously been restored in 1954 at the Istituto Centrale del Restauro following Brandi's precepts. Examination of the painting's surfaces during the recent intervention showed that the precautionary layer (a layer intentionally and prudently left by the previous restorer) was easily distinguishable—a clear example of the practical application of Brandi's directives in relation to patina.

This layer had been left in place over the original layers so that the restorer could be quite certain they would not be damaged. Today, specific

solvents are available that permit us to dissolve the overlying materials without attacking the original ones. It is, therefore, possible to clean more profoundly, in effect eliminating or greatly reducing the precautionary layer (left in place by the previous restorer) without causing the kind of overcleaning that was discussed earlier.[8]

To emphasize the significance and function of the surface of a work of art, we have included a final passage on patina by Ernst van de Wetering (Reading 43, pages 415–21). The author illustrates, with sharp paradoxes, the complex and intriguing relationships between form and illusion in art, between material and surface effects, and between original intentions and present practices (possibly ill conceived) in the treatment of the surface as an essential element of the final appearance of an object; in other words, as the ultimate and conclusive act in a conservation intervention.

This article emphasizes the danger and arbitrary nature of many apparently commonplace treatments carried out in laboratories and museums, pointing out that these procedures are, in fact, capable of destroying significant traces of the original finish of the object or altering entire periods of its history.

<div align="right">—AMV</div>

Notes

1. PLUTARCH, *De Pythiae Oraculis* (Naples: M. D'Auria, 1992), fol. 393BF.
2. R. PARKER, *Miasma: Pollution and Purification in Early Greek Religion* (Oxford: Clarendon Press, 1983), 22 ff.
3. PLINY, *Natural History* 34.15, ed. H. Rackham, vol. 9 (London: William Heineman Ltd., 1952; reprint, 1968), 138–39.
4. J. GAGE, "A locus classicus of colour theory: the fortunes of Apelles," *Journal of the Warburg and Courtauld Institutes* 44 (1981): 1–26.
5. PLINY, *Natural History* 35.97, 333.
6. P. REUTERSWAERD, *Studien zur Polychromie der Plastik, Griechenland und Rom* (Stockholm: Almquist F. Wiskell, 1960); and A. MELUCCO VACCARO, "La policromia nell'architettura e nella plastica antica: Stato della questione," in *Ricerche di storia dell'arte* 24 (Rome: Bulzoni, 1984): 19 ff.
7. *La Pala ricostituita: L'Incoronazione della Vergine e la cimasa vaticana di Giovanni Bellini: Indagini e restauri*, ed. M. R. Valazzi (Venice: Cataloghi Marsilio, 1988).
8. See also A. CONTI, "La patina della pittura a vent'anni dalle controversie storiche: Teoria e practica della conservazione," in *Ricerche di Storia dell'arte* 16 (Florence: La Nuova Italia, 1982), 23 ff, for other examples of sharp conflicts about the cleaning of pictures.

The Idea of Patina and the Cleaning of Paintings

PAUL PHILIPPOT

With regard to its restoration, every work of art presents a twofold historical character. On the one hand, it is historical in the sense that it is a human creation realized at a fixed point in time. On the other, it comes to us across a span of time that has elapsed since its creation and can never be erased. This span of time acts upon the materials used in creating the image; in the case of painting, with which we are concerned here, certain transformations occur naturally over time that are totally irreversible.

The strain of the support and the drying of the paint, for example, naturally cause a network of *craquelure,* which plays a considerable role in the appearance and texture of the work. The drying of the binding medium tends to increase the transparency of the pictorial layers, especially in areas where it was used in abundance (as in earth-colored glazes); this effect may heighten the contrast between these transparent areas and the relative opacity of less developed areas. Certain of [Adriaen] Brouwer's works provide notable examples of this phenomenon. The transformation of certain other colors is also well known. Often, it is a question of darkening, as with some reds and umbers; copper resinate has a tendency to brown; blues are sometimes subject to a particular instability; varnishes yellow and appear to lose their transparency. Finally, a normal consequence of drying is the exudation of the binding medium toward the surface. Such migration determines to a great extent the particular luster of the "stabilized" pictorial surface, affecting not only the surface condition but the transparency and depth of the tones.

From PAUL PHILIPPOT, "La notion de patine et le nettoyage des peintures," *Bulletin de l'Institut Royal du Patrimoine Artistique* 9 (1966): 138–43. Used by permission of the Institute Royal du Patrimoine Artistique, Brussels. Translated by Garrett White.

All of these changes can be considered normal. Except in extreme cases, we do not even perceive them as deterioration, but as the simple mark of time—even if, from a strictly material point of view, they are clearly the result of processes of deterioration.

Nevertheless, to the extent that these modifications are irreversible and resist precise measurement, it must be admitted that the original state of the work—that is, the state in which the artist left it when the creative process was complete—is impossible to reestablish or even to determine objectively. No restoration could ever hope to reestablish the original state of a painting. It can only reveal *the present state of the original materials.* Even if restoration could determine the original state, it would still be impossible to abolish the second historicity of the work, the span of time it has crossed to appear before us.

This conception permits us to address in a more rigorous manner the critical problem of connecting its historical and aesthetic aspect with the material factors in which it now appears. And it is here that the notion of patina becomes pertinent. Indeed, patina is precisely the "normal" effect that time has on material. This is not a physical or chemical, but a *critical* concept. Patina is nothing more than the combination of these "normal" alterations as they affect the appearance of the work without disfiguring it— precisely because it is the result of "normal" alterations. Resorting to this notion of "normality" does not negate the concept of patina; it merely reveals that the concept does not concern material but rises from the critical domain and always implies an aesthetic judgment.

It would be a grave error to believe that such a judgment could be eliminated, and that this elimination would restore a "scientific" objectivity to the problem. To eliminate the problem of patina would mean, quite simply, to reduce the question to its material data and, consequently, to ignore the *fact* of the evolution of the material—this would be a scientific error—or to refuse to consider the problem that is posed by the concept of patina: the relationship between the original state and the present state of the original materials—in other words, to refuse to consider the aesthetic reality of the work.

The importance of the notion of patina for the cleaning of paintings derives from the particular role played by the varnish. It is the brilliance of the varnish that fades with time, and this alteration, provided it does not pass certain limits, combines with alterations in the subjacent layers to create what we call patina. Particularly when these layers have suffered, the fading of the varnish can attenuate the effects of damage or increased contrast. This necessarily raises the question of evaluating the ways in which alterations of the varnish may affect the present appearance of the work. As the present state of the pictorial surface can in no way be identified with the

original state of the work, it is necessary, when cleaning a picture, to appreciate the role varnish plays, or may play, as an element of patina. But it is clear that this appreciation, as well as that of patina in general, is based upon a mental comparison of the present appearance of the work—or, more exactly, of several possible appearances according to the degree of cleaning—with the idea that the conservator forms (for he cannot help doing so!) of the original image. Such a comparison is largely, and necessarily, hypothetical, but the conservator cannot avoid it without abandoning his mission. Is this to say that we have fallen back upon the pure subjectivity of personal taste? That will undoubtedly be the case each time the critical problem is evaded because the conservator did not take note of it, allowing himself to be guided by his own personal preferences. In this sense, a complete removal of varnish, no less than a partial devarnishing, may very well be nothing more than a manifestation of taste. The conservator's objectivity is, in effect, illusory, since it is bought at the price of substituting a merely material criterion for critical judgment.

A strict critical methodology, on the contrary, must proceed with a thorough awareness of every aspect of the problem. It will therefore be necessary, to assess the alterations suffered—whether or not they are a simple matter of patina or of actual damage or defacement. This diagnosis must be based both on an objective knowledge of the *evolution of the materials* and upon the idea we form about their *original appearance,* which in turn rests upon experience of works of art in their material and aesthetic reality. The conservator must also form the most precise idea possible of the *original unity of the work,* which is a function of specific values. This intuition, which is fundamental, is nothing more than the identification of the formal reality of the work: this perception, having its own coherence, is therefore the only criterion by which alterations can be measured, inasmuch as they affect form. It would seem, then, that we are reduced to a vicious circle, the idea of the original unity of the work of art being formed on the basis of the altered work of art itself, and the appraisal of the alterations being based on its original unity. But this would be to overlook two factors that fall outside of the circle and thus ensure the validity of critical endeavor: the objective assessment of alterations, though at a purely material level, and the experience of the work of art as something that, by reason of the formal coherence that is always implied, exposes the damage it bears—exactly as the experience of a musical performance reveals, with regard to the work performed, any eventual errors in the performance.

A comparison between the present state and the living representation of the original image is therefore not only possible, it is the definition of the experience of the work of art as such, to the extent that it has appeared before us across the span of time that separates us from its creation. It is on

the basis of this continual to-and-fro from material to image and vice versa, in the course of which the critical diagnosis becomes more and more precise, that the conservator will be able to appreciate the role played by the more or less altered layers of varnish. From a critical point of view, cleaning then becomes the search for an achievable equilibrium that will be most faithful to the original unity. And it is clear that the solution must be arrived at on a case-by-case basis. The cleaning of a painting can thus never be conceived of as a purely material operation and as such, "objective": the elimination of varnish—and eventually of overpainting—that recovers the original layer. To clean a painting is to proceed, on the basis of as exact as possible a preliminary knowledge of its present condition, toward a condition that, without violating the original material, more faithfully restores the original image. This progression ultimately implies the capacity to foresee the final result, for without this it is impossible to know when to stop, and cleaning then becomes a blind hunt for a treasure that will only end with the original material (and not always at that!).

In fact, the veil that an ancient varnish carries will generally be quite valuable when there is a question of offsetting heightened contrasts or balancing worn areas with those that are intact, yet cleaning can usually be taken much further when alteration due to patina is minimal. In this case, however, one must also take into account the fact that radical exposure of the original pictorial layer almost always accentuates its materiality to the detriment of the image, and that bestowing a new appearance on an ancient object can create discord within the work of art that is a kind of falsification. It emphasizes the material to the detriment of form, and indicates the predominance of a hygienic interest in the object over an aesthetic interest in the image.

To the extent that cleaning approaches complete removal of varnish, the condition of the surface of the pictorial layer requires that much more attention. The criterion of the absence of pigment on the solvent pads, a purely material security, has no value whatsoever in this case. This is true not only because such control can only be made *a posteriori*, and is not therefore a guarantee, but above all because the surface can be materially altered without the loss of pigment. In effect, the migration of the binding medium toward the surface in the course of drying determines the luster of the surface, giving the tones their depth and transparency. Consequently, the luster may very well be altered by excessive cleaning long before this is revealed by a loss of pigment. In fact, we all too frequently find paintings ravaged by drastic cleaning that, by changing the surface luster created by migration of the binding medium, has "pierced the skin" of the painting. A wound is thus opened through which color appears with the same materiality it has on the palette, interfering with its own formal transfiguration in the image. The

material reaches the surface of the image as an island emerges from a lake and breaks the stillness of the water. Effects of lighting and bright areas fall most quickly to the ravages caused by the "treasure hunt" for the original material, and certain masters are, consequently, particularly exposed to this danger. The luminous brushwork of Joos de Momper has long been marked as a privileged victim, and precious few of his works have escaped the massacre. We must add—for it cannot be repeated enough—that the crime rarely ends at this stage. The material thus exposed, how many times have we not sought to exalt it further with a revarnishing as thick and brilliant as fine coachwork! It is, then, the exact opposite of a patina, for if patina calms the materiality of a painting in order to emphasize the transposition of textures in the image, a rich and dense varnish that coats the painting interposes on the contrary the new and aggressive materiality of its own tinsel. A contrast is then created between the real texture of the painting and its surface condition, which tends to transform the work into its reproduction This tendency is all the more dangerous as the influence on the "mental museum" of the public of color reproductions, with their high gloss paper, grows to a point that requires the work of art to conform to the reproduction.

The aesthetic problem of the cleaning of paintings does not reside therefore in the abstract terms of the two alternatives: total or partial removal of varnish. It consists in a measured interpretation of the case in point, which, having taken into account the present state of the material of the work, seeks to reestablish not an illusory original state but the state most faithful to the aesthetic unity of the original image. Concrete solutions will, therefore, be elaborated, according to the situation, from the full range of cleaning possibilities, up to complete removal of varnish. In practice, however, it is clear that this last option is only justified in exceptional cases, for it nearly always sacrifices patina in glorifying the material to the detriment of its formal transfiguration in the image.

Theory of Restoration, III

CESARE BRANDI

§6. Restoration According to Aesthetics

—ɯ—

Leaving aside innumerable other examples, we can only reiterate the concept that the *ruin*, also for aesthetic requirements, must be treated as a *ruin*, and the action to be undertaken must be *conservation* rather than *integration*.

—ɯ—

We now need to reconsider the problem of conserving or removing additions. We must keep in mind at this point that we are not only dealing with a ruin but—as is most often the case—with additions to works of art that, if the additions could be removed, would in fact rediscover not only their potential unity but even their original unity. Seeing the problem this way, and from the point of view of Aesthetics, we thus realize that the importance of the historical requirements, which dictated the primary need to conserve additions, is reversed. Because of the requirements arising from the artistic nature of the work of art, the addition calls for removal. Thus there could be a potential conflict with the principles of conservation established by the historical requirements. Such a conflict can only be outlined at a theoretical level, for it is the most individual and unique problem that could arise. Yet we cannot reach a solution by *authority*; the requirement that

From CESARE BRANDI, *Teoria del restauro* (Rome: Edizioni di Storia e Letteratura, 1963; reprint, Turin: G. Einaudi, 1977), chap. 6; originally published as "Il restauro dell'opera d'arte secondo l'istanza estetica o dell'artisticità," *Bollettino dell'Istituto Centrale del Restauro* 13 (1953): 1–8. Used by permission of Giulio Einaudi editore s.p.a. Translated by Gianni Ponti with Alessandra Melucco Vaccaro.

carries more weight has to suggest it. Since the essence of the work of art is in the fact that it is a work of art, and the historical event that the work represents is only a secondary aspect, then, whenever the work of art is spoiled, unnaturally altered, overshadowed, or partially hidden from view by the addition, the addition has to be removed. It will only be necessary, so far as possible, to undertake separately the conservation, the documentation, and the recording of the historical passage that, by so doing, is removed and canceled from the live body of the work of art. . . .

—⁂—

But we have not fully exhausted the problem of conserving additions, for again we have to examine the legitimacy of the conservation of the *patina* from the aesthetic point of view. Historically we have seen that the *patina* documents the passage through time of the work of art and thus needs to be preserved. Yet, for Aesthetics, is such a conservation just as legitimate? . . . The key to the problem will be provided by the materials that form the work of art. Assuming that the transmission of the formulated image actually occurs through the materials, and assuming that the role of the materials is to be that of a *transmitting agent,* then the materials should never take precedence over the image. This means that the materials have to disappear as materials in order to be valued only as image. If the materials impose themselves with a freshness and boldness that overshadows the image, the pure reality of the image will consequently be disturbed. Thus, from an aesthetic point of view, the patina is that imperceptible muting placed on the materials that are compelled to remain subdued within the image. It is this role that then provides the practical measure for the *point* to which the *patina* has to be brought and for the equilibrium that it *must* regain. . . .

We are thus left with examining the problem of conservation of reconstructions. Here also, from an aesthetic point of view, it is clear that the solution depends primarily on our evaluation of the reconstruction. If the reconstruction indicates the accomplishment of a new artistic unity, it will have to be preserved. Yet it is possible that a reconstruction—whether a deplorable restoration or a new adaptation—cannot be removed for having caused the partial destruction of specific aspects of the monument, which would not have happened had the monument been preserved as a ruin or integrated in its potential unity. In this case, the reconstruction has to be preserved, even if prejudicial to the monument.

The reconstruction of the bell tower of St. Mark's, which is more a *copy* than a reconstruction, although it functions as a reconstruction in the urban environment that it completed, raises again the problem of whether or not it is legitimate to put a copy in place of an original that has been either moved for a better conservation or lost. From both historical and aesthetic points of

view, the substitution of a copy cannot be justified, unless the substituted work of art has a merely integrative function and no value of its own. A copy is a historical and aesthetic forgery; it can only be justified as a purely didactic or commemorative object, and cannot be substituted without causing historical and aesthetic damage to the original.

The Cleaning of Pictures in Relation to Patina, Varnish, and Glazes

CESARE BRANDI

The recent acrimonious controversies on the cleaning of pictures has done nothing more than paralyze the positions taken up by the upholders of radical cleaning and the partisans of patina. Unfortunately, once a picture has been totally cleaned, when nothing survives but the layer of paint in full impasto, it is impossible to judge whether glazes have really been removed, whether there still existed at least patches of old varnish, and finally whether the patina, even if dark, was not preferable to the raw, brutal surface of paint laid bare by the cleaning [Fig. 1].

The upholders of total cleaning proceed from a criticism of the concept of patina: they accuse it of being a romantic concept, that is to say, of falsifying the picture by emotional overtones, which, according to them, correspond to the romantic predilections of sentimentalism, ruins, mystery, twilight, and so forth.

It is as well to refute from the outset this too-hasty assumption about patina. Patina, even if it were worked up artificially and exaggerated in the romantic epoch, was by no means a romantic invention. In 1681, in the heyday of High Baroque, Baldinucci defined *patena* (patina) in the following way in his *Vocabolario toscano dell'Arte del Disegno:*

> Voce usata da' Pittori, e diconla altrimenti pelle, ed è quella universale scurità che il tempo fa apparire sopra le pitture, che anche talvolta le favorisce [Term employed by painters, which they otherwise call skin, it

From CESARE BRANDI, "The Cleaning of Pictures in Relation to Patina, Varnish, and Glazes," *Burlington Magazine* 91, no. 556 (1949): 183–89. Reprinted by permission of *Burlington Magazine*. Excerpts translated by Brent Sverdloff.

Figure 1
Frans Hals, *Portrait of a Man.*
Oil on canvas, 31⅝ × 26¼ in.,
after cleaning.

being that general darkness which time causes to appear on paintings
and which often enhances them as well].[1]

The definition is so precise that it can still be substantially accepted
today. And let this be borne in mind: it proceeds from a Tuscan writer who
had at his disposal the practice and theory of painting as it had developed
in Tuscany, in Florence, where draftsmanship and intellectualism were so
highly prized. It does not come from a Venetian, or from a Tuscan like
Aretino, who was steeped in the pictorial tradition of Venice and preferred it
to that of Florence.

Thus, Tuscan Baroque painting is famous even today for the uncom-
promising violence of colors which, one might have supposed, would have
made the painters of the day all the more predisposed toward patina. The
concept of patina might be said to go back even further than the Baroque era.

Already Vasari, in his *Trattato della scultura*,[2] repeats recipes for artificial patinas applied in his day to bronze. This gives cause for reflection. If the sensibility of Renaissance artists induced them to tone down the brightness, and soften the overpowering impact, of newly fashioned bronze, is it not conceivable that they should also have sought to temper the crudity of their coloring, of the too-ostentatious display of earth colors, lacquers, and ultramarines?

The triumph of the materials over the form is all to the detriment of the form: the materials in a work of art must be induced to serve, in a subordinate capacity, the image itself.[3] To reach such a conclusion it is not necessary to depart from a theory of aesthetics. All that is needed is the watchful sensibility of the artist who well knows that he cannot and must not sink to the level of the artisan. The work of art in which the materials triumph we call handicraft: the jewel, the vase, the plate, not the picture or the statue. The function of patina, therefore, is to conceal the materials used in a work of art, to arrest the work of art on the threshold of the image, to prevent it from relying for its appeal on irrelevant qualities.

It is as well to emphasize that the arguments put forward above would equally well hold water in those cases where it was possible to demonstrate that the colors of old paintings were preserved exactly in the way that they were applied by the artists, and that above all they maintained, beneath the patina, the equilibrium they held originally. This proposition, which the upholders of radical cleaning are bound to assume as a self-evident truth, is an absolutely arbitrary presumption. It is not self-evident, it just cannot be proved.

The last refuge of the upholders of total cleaning is the hypothesis that dirt, varnishes accumulated over centuries and so forth, are being palmed off as patina. It is precisely in order to dispel doubts and reassure waverers that we are happy to be able to bring forward three important witnesses, from which it can be proved that what we call patina can more often than not be shown to consist either of glazes or of tinted varnishes. Our examples will be chosen from widely divergent periods, so as not to imply that these methods are restricted to any particular school or artist. They are cases which have come to the attention of the Istituto Centrale del Restauro in Rome where the practice of cleaning *à l'outrance* [to excess] has never been followed and where, by way of recompense, the author of this article has at least been able to find indubitable proof of the validity of the methods he employed.

When examining the surface of Giovanni Bellini's *Pesaro Coronation,* which an earlier and ill-omened restoration had skinned in an attempt, fortunately checked halfway, at total cleaning, I noticed that around the head of St. Peter the previous incautious restorer had carried away, in an attempt at cleaning, the gold laid on to the already completed painting with delicate brush strokes. Now it was possible to observe that, precisely where the gold

was erased, a layer of dark varnish still appeared over the sky—a layer which, if it had been applied at a later date, would necessarily have disappeared with the gold. This observation persuaded me quite confidently to forbid the removal of the varnish in spite of the fact that this course was recommended in the literature on the subject[4] and by experts visiting the Institute.

But the final confirmation of my reasoning came when I turned my attention to the compartment of the predella representing St. Terence [Fig. 2]. Here too, the earlier restorer had tried to clean off the varnish where it has been gilded at one point, on the steps below the Saint, and this is what happened [Fig. 3]: Bellini had painted in *directly* on the guiding lines of the perspective but had instead added *by glazing* the subdivisions of the stones and the bronze clamps—in the Roman manner—between one block of stone and the next. All this had been secured by a fairly thick varnish which was impossible to remove without carrying away with it the parts added by glazing. When the varnish was examined, it was found to be composed of hard resin with traces of yellow lacquer.[5] In other words, Bellini had used a tinted varnish to lay a tone over the whole painting.

This disconcerting discovery was sufficient to cause the whole problem of glazing and of the cleaning of pictures to be reexamined.

What is "glazing"? It is clearly a stage in the completion of a picture, a layer of color aimed at correcting or modifying the local, as well as the prevailing, tonality. It is, if you like, a last-minute device, a secret remedy, and,

Figure 2
Giovanni Bellini, St. Terence, detail of the Coronation altarpiece. Panel, before cleaning.

Figure 3
Enlarged detail of the steps shown in Fig. 2, demonstrating the removal of marks in glazing, together with the old varnish, after cleaning (1988).

as such, unlikely to be readily acknowledged. It lies outside the official practice of painting. Although we cannot claim that the researches we have undertaken in the relevant literature are complete, we believe that the method is hinted at for the first time by Armenini,[6] a fact of great significance, since Armenini reflects Tuscan and Roman, not Venetian, taste. Baldinucci subsequently provided the definition:

> Velare. Coprire con velo. Appresso i nostri artefici, velare val tignere con poco colore e molta tempera (o come volgarmente si dice acquidoso o lungo) il colorito in una tela o tavola, in modo che questo non si perda di veduta, ma rimanga alquanto mortificato e piacevolmente oscurato, quasi che avesse sopra di sé un sottilissimo velo [To glaze. To coat with glaze. Among our craftsmen, glazing means tinting with a small amount of color and a good deal of tempera (or, in layman's words, watery or long) the coloring on a canvas or board, not so as to obscure the painted surface completely, but rather to render it muted and pleasantly darkened, almost as if delicately shrouded by a gossamer veil].[7]

To come across this text written in 1681, one wonders which is greater, the lack of conscience or of erudition of those who have so far ignored the existence of glazing, if not as a general rule, at least in the case of Venetian paintings of the sixteenth century. It is nevertheless true that, although explicitly mentioned by Baldinucci, glazing maintained an almost illegitimate and underground existence in painting. It is no mere chance that the *Vocabolario della Crusca* does not cite the term, and that it is only just mentioned in Tommaseo's Dictionary. But some time before Tommaseo it is to be found in Milizia's Dictionary of 1827, with an abundance of recipes and other particulars which show convincingly that glazing played a flourishing, if clandestine, part in the studios of painters:

> Velatura. È uno strato di colore leggero, che si applica specialmente alla pittura ad olio, per velare e fare trasparire la tinta che vi è sotto.
>
> Alcuni pittori velano al primo colpo; così practicò il Rubens e la sua scuola. In questo modo le velature, impiegate sopra un fondo bene asciutto, sono durevoli, leggere e spingono la tinta.
>
> Altri ad esempio dell'antica scuola veneziana danno sul primo strato la velatura con tinte diverse per accordare l'opera, e rimediare ai difetti scappati nel primo strato.
>
> Questo metodo è funesto al quadro, perchè la velatura impedisce l'evaporazione degli olii del primo strato ancora fresco, e vi si fa una crosta d'un giallo nero. Etc.
>
> [Glazing. A light layer of color applied especially to oil paintings for the purpose of tempering the color underneath and causing it to shine through.

Some painters glaze all at one stroke; such was the practice of
Rubens and his school. In this method the glazes, when applied to a
thoroughly dry surface, are durable, light and stimulate the colors.

Others, for instance those belonging to the old Venetian school, apply
glaze to the first layer with different hues befitting the work, and to make
up for defects present in the first layer.

This method harms the painting, inasmuch as the glazing hinders the
evaporation of the oils from the still fresh initial layer, and a darkish yel-
low crust forms. Etc.] [8]

As can be seen, in the early nineteenth century—and at earlier peri-
ods, as we have shown—the meaning of the term "glazing" was still well
understood,[9] and the use that the Venetians and Rubens had made of it.
Whoever, therefore, on cleaning a Rubens, succeeds in bringing to light the
bare, crude color underneath, has no right to be certain that he has not
ruined it for ever.

As far as the Venetian school is concerned, the lesson that we learn
from the cleaning of the Bellini—an early painting, incidentally, in parts still
Mantegnesque—accords perfectly with the idea of color that the Venetian
theoreticians themselves developed. "Tone" is not an invention of modern
criticism, but reflects in terms of present-day criticism the vision of Titian's
contemporaries. This is what Pino has to say:

> Ciascun colore o da sé, o composto può fare più effetti, e niun colore
> vale per sua proprietà a fare un minimo dell'effetto del naturale ... [Every
> color, whether alone or blended, can produce more striking effects; and
> no color, relying on its own properties, can produce a minimum of the
> effect of its occurence in nature ...].[10]

from which it is evident that Pino wished to differentiate between *physical
color* and *pictorial image*. With so precise a distinction, how can anyone be
justified in emphasizing the materials used at the expense of their blending
in the image, leaving no residue behind? But in Pino we find another, even
more characteristic, passage:

> ... avvertire sopra il tutto d'unire, ed accompagnare la diversità delle tinte
> in un corpo solo [... take care overall to unify and to meld the distinc-
> tiveness of the hues into one harmonious body].[11]

Here we have an eloquent plea for glazing, and a definition, *avant la
lettre* [literally], of "tone."

But this distinction between physical color and the color of the
image is not to be found only in Pino: shortly afterwards it reappears explic-
itly in Dolce:

Nè creda alcuno che la forza del colorito consista nella scelta di bei colori; come belle lache, bei azuri, bei verdi e simili; percioché questi sono belli parimente, senza che e' si mettano in opera: ma nel sapergli maneggiare convenevolmente [Let no one believe that the power of the coloring depends upon choosing beautiful colors, whether they be beautiful lacquers, lovely blues or greens, or the like, since these are in and of themselves handsome without ever being applied to the work: the secret lies in knowing how to manipulate them properly].[12]

There can be no doubt about the interpretation of this passage. The materials must disappear, and so that they may disappear in such a manner that the color is merged in the image, the secret, obliging and almost invisible process of glazing came to the artist's rescue. Besides this, the composition of ancient varnishes, which nearly always contained stone oil, that is to say naphtha, clearly reveals that it was expected of the varnish, not only as Baldinucci says that those parts of the painting, "per qualità e natura del colore fossero prosciugate, ripiglino il lustro, e scuoprano la profundità degli scuri" [which, owing to the quality and nature of the color, could dry up, should recover their sheen and reveal the depths of the dark areas],[13] but also that it should act as a general unification of tone, since it was certainly not possible at that time to obtain stone oil as transparent as water, and the varnishes obtained in this way provided by themselves a uniform covering.

The question of painting before the sixteenth century remains to be discussed.

We were in process of cleaning at the Istituto del Restauro, the *Madonna* by Coppo di Marcovaldo [Fig. 4], traditionally dated 1261. The signature and date, recorded in the so-called *Guida di Alessandro VII* in 1625, subsequently disappeared without leaving a trace, to the effect that in 1784 Faluschi attributed the panel to Diotisalvi Petroni. Recently, when the eighteenth-century frame was removed, the old frame was found underneath, in almost perfect state, with the date and the signature, and with a thick layer of varnish. It was obvious that this varnish antedated the eighteenth-century restoration of the panel; but since the panel bore no trace of restoration between the Ducciesque repainting and the eighteenth century, everything seemed to point to the fact that we were in the presence of the original varnish. Cennini describes in detail the varnishing of panels—indeed, so explicitly that, in cases where we encounter varnish on the gold ground of Primitives, we can at once exclude the possibility of the varnish being original, since varnish was never spread over the gold ground. In fact in the eighteenth century a new layer of varnish[14] had been spread over the whole painting, including the gold ground, and this layer was removed—by the *dry* process of cleaning—without interfering in any way with the old layer of varnish uniformly covering the painting beneath. The objection might be

Figure 4
Coppo di Marcovaldo, *La Madonna del Bordone,* signed and dated 1261. Panel, after cleaning.

raised that this varnish had now grown yellow and so had falsified the tones, and for this reason should be removed. It was therefore necessary to demonstrate that Coppo di Marcovaldo had had no intention of retaining the harsh brilliance of the pure colors, and had in fact intended that they should be concealed. The painting offered abundant evidence to prove this hypothesis.

The Madonna's veil, patterned with eagles enclosed in circles, emerged the color of canary yellow, once the eighteenth-century smearing had been removed, so that an expert might have been led to suppose that it was simply white which had turned yellow. But a close examination of a few abrasions (which in the restoration remained visible) showed that Coppo had indeed painted the dark shadows on the white preparation, but had covered the whole surface with a transparent, colored varnish, on top of which, afterwards, he had painted the tondos of eagles [Fig. 5]. We repeat: "transparent, colored varnish." Here too there was ample evidence that the veil was originally colored, since, when the follower of Duccio (perhaps Niccolò di Segna) repainted the face of the Madonna and of the Child, he added a white underveil for the Madonna, which would have been senseless had the earlier veil been white also. Subsequently, the painting revealed further surprises. The

Figure 5
Detail of the veil of Coppo's *Madonna* (Fig. 4), demonstrating the removal of the circular ornamentation painted with transparent varnish.

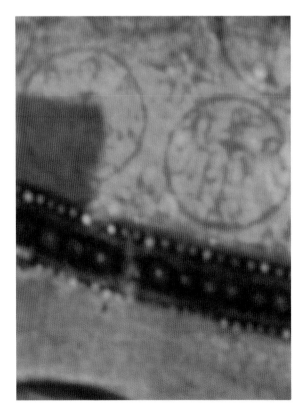

Madonna's cloak as well as her robe proved to have been painted on a silver ground, which did not represent a pentiment but a substratum for colors intended equally to be transparent, as in translucent enamels of a later age. Painted in the same way as the veil was the cloth held by the Madonna under the Child, with transparent shadows, colored varnish, and embroidery superimposed on the varnish. An even more astonishing case was the cushion used as a footstool, which, patterned in the first place with regular and extremely lively checks, was afterwards covered in the middle part—the part, that is, which caught the light—with a yellow varnish, and in the parts designed to suggest relief and shadow, it was covered with a ruby-red transparent varnish, achieving the characteristic effect of shot silk. In this way it was proved, *lippis et tonsoribus* [to anyone's plain sight],[15] that Coppo had made use of pure colors only in the early phase, for the preparation of the painting, and had later completed the painting by applying glazes and colored varnishes. We discovered explicit confirmation of this extraordinary process in the *Schedula* of Theophilus, a text well-known and widely disseminated throughout Europe in the Middle Ages. In Chapter 29, *De Pictura translucida,* Theophilus explains the process, of which Coppo's painting is the clearest and fullest application:

> Fit etiam pictura in ligno, quæ dicitur translucida, et apud quosdam vocatur aureola, quam hoc modo compones. Tolle petulam stagni non linitam glutine nec coloratam croco sed ita simplicem et diligenter politam, et inde cooperies locum, quem ita pingere volueris. Deinde tere colores imponendos diligentissime oleo lini, ac valde tenues trahe eos cuon pincello, sicque permitte siccari [To prepare a painting on wood, also called translucent, and among certain men is referred to as "golden," you do as follows: Take a fine sheet of tin, neither smeared with glue nor yellowed, but essentially pure and polished with care. Next, you cover over the place that you intend to paint. Afterward, thoroughly smooth out the colors to be applied, using linseed oil, and, with painstaking care, spread them lightly with a brush. Allow to dry].[16]

The only difference between Theophilus and Coppo lies in the fact that Coppo used silver instead of tin, and extended the process to include every layer of color.

From what has gone before, it follows that even in the case of the Primitives it is necessary to bear in mind the possibility of the existence of colored varnishes functioning as glazes, and to assume that the process was common.

It must not be supposed that this is true only in the case of thick varnishes strongly colored, as in the example cited above.[17] A third example, the painting by Benozzo Gozzoli of 1456, in the Pinacoteca at Perugia [Fig. 6], is a case of glazing applied without varnish, not uniformly over the whole painting,

Figure 6
Madonna with Saints, by Benozzo
Gozzoli, 1456. Panel, before the
recent restoration.

but differing from place to place in order to obtain a softening or variation in
the local color. The interest of the Benozzo, from the point of view of restora-
tion, resides in the first place in the fact that it was never varnished, or at
most very thinly. The case is not unusual in Tuscan and Umbrian painting:
several pictures by Neroccio, Francesco di Giorgio, and Boccati are still in
this condition, which may not have been deliberate, but due to the practice
of waiting at least a year before a picture was varnished. Pictures delivered at
once to the clients might thus remain unvarnished. In any case, on the pic-
ture in question by Gozzoli, there remained only the suggestion of a varnish
of a misty opaqueness, due, as far as it was possible to tell, to a coat of
paraffin wax which at some uncertain period must have been applied to the
picture to "revive" it. There were besides several drops of wax which, when
removed, disclosed the original surface—not, however, the surface of the
paint itself, but of the glazing with which Gozzoli had achieved his final col-
oring. St. Paul's mantle was revealed to be originally rose-colored and subse-
quently glazed in blue tending to violet; St. Peter's mantle, originally yellow,
was glazed in a deeper yellow [Fig. 7]. The Virgin's blue mantle was glazed in
green, while beneath could still be seen a pure lapis lazuli. In short, there
were no draperies in this picture which had not been treated with a very light
glazing. For this reason, cleaning was a very delicate operation, in which the

opaque resin had to be removed without disturbing the very delicate glazing, quite unprotected by any layer of varnish. But the result, it may be said in passing, was excellent.

We can now briefly conclude: given the proof, in every age and in every school, in practice as well as in theory, of the existence of glazes and colored varnishes, it necessarily follows that the accepted system of cleaning must be reconsidered, and the presence of glazes and old varnishes must be assumed, unless the opposite can be definitely proved. Even in those cases where the absence of old varnishes and glazes can be proved, it is always possible that these were removed in earlier restorations; and it must be borne in mind that we may often find ourselves in closer touch with the mind of the artist by leaving the picture with its patina than by removing it.[18]

Figure 7
Detail of the cloak of St. Peter in Gozzoli's *Madonna with Saints* (Fig. 6). The arrow indicates the place where the removal of a drop of wax discloses original glazing.

Notes

1. FILIPPO BALDINUCCI, *Vocabolario toscano dell'Arte del Disegno* (Florence: Santi Franchi, 1681), 119.

2. GIORGIO VASARI, *Le opere di Giorgio Vasari: Con nuove annotazioni e commenti di Gaetano Milanesi,* vol. 1 (Florence: G. C. Sansoni, 1906), 163.

3. This argumentation follows the lines set out in my *Carmine o della pittura con due saggi su Duccio e Picasso* (Florence: Vallecchi, 1947).

4. For instance, CARLO GAMBA, *Giovanni Bellini,* Collection "Le Musée de la Pléiade" (Milan: Librairie Gallimard, 1937), 76 ff.

5. The analysis was undertaken by Dr. Liberti, head of the laboratory of the Istituto Centrale del Restauro.

6. GIOVANNI BATTISTA ARMENINI, *De' veri precetti della pittura* (Bologna: F. Tebaldini, 1587; Pisa: Tipographia di V. Ferrario, 1823), 140: "Ma nelle bozze dei panni, che sono da *velarsi* ..." [yet in the rough sketches (made) with the cloths, which are to be *fogged*], and 141: "... ma ritorno ai panni, che a *velare* si usano ... con tutte le spiegazioni tecniche che seguono" [but once again on the subject of the cloths, which are employed for *fogging* ... and all the technical explanations that follow].

7. ARMENINI, *De' veri precetti,* 174.

8. FRANCESCO MILIZIA, *Dizionario delle belle arti del disegno,* vol. 2 (Bologna: Cardinali e Frulli, 1827): 514.

9. In English there are two terms for *velatura:* "glaze" (a dark layer on light ground) and "scumble" (light on dark). The French word which comes nearest is *glacis,* and the German equivalent is *glasur.* All these terms do naturally not correspond exactly with *velatura,* a term long in use in Italy, both in practice and in recipes.

10. PAOLO PINO, *Dialogo di pittura* (1548); ed. Pallucchini, Edizione D. Guarnati (Venice: P. Gherardo, 1946), 108, 109.

11. [7] Ibid.

12. [11] LODOVICO DOLCE, *Dialogo della pittura* (Vinegia: Gabriel Giolito de' Ferrari, 1557; reprint, Florence: n.p., 1735), 222.

13. [12] DOLCE, *Dialogo,* 180. See also 110 [in Dolce] where stone oil is defined as "l'olio di sasso ... detto altrimenti nafta (Plinio, libro 2, chap. 18) o pure olio petroleo ... Trovasi quest'olio nello Stato di Modana ... " [stone oil ... otherwise referred to as naphtha (Pliny, *Natural History* 2.18) or also, in fact, as petroleum oil ... This oil is found in the State of Modena ...]."

14. [13] DR. LIBERTI's analysis showed that the varnish found on the original frame consisted of not very hard resin of the *Dammar* type; the tenth-century varnish on the whole painting was copal varnish.

15. [Literally, "with the bleary-eyed and hairdressers." From HORACE, *Satires* 17.2–3.]

16. [14] This quotation is taken from the 1843 Leipzig edition, PRESBYTER THEOPHILUS, *Theophili presbyteri et monachi 3; seu (Diversarum Artium Schedula) Essai sur divers arts,* chaps. 39, 48.

17. [15] Also in Coppo's painting one can clearly observe glazes applied in transparent paint, as for instance in the folds of the material which form the back of the throne of the Virgin.

18. [16] The thesis elaborated in this essay formed the basis of a series of illustrated lectures that I held in March 1948 at the Museum in Brussels, at the Louvre, at Strasbourg University, at the Museumsgesellschaft in Bâle, and, again, at the ICOM Congress in Paris in June 1948. For the relevant facts relating to the restorations mentioned in the text, I refer to the catalogue of the fifth *Mostra di restauri,* held in March 1948 at the Istituto Centrale del Restauro.

After this essay had already gone to press, Dr. Cagiano de Azevedo drew my attention to the following recipe for colored varnish which dates from the fifteenth century: "A fare vernice liquida per altro modo—Recipe libre 1 de semi de lino e metilo in una pignata nuova invitriata. Poi tolli mezo quarto de alumi de rocho spolverizato e altratanto minio e cinabro subtili macinati e meza oncia de incenso ben trito, poi mista omne cosa insiemi e ponile in lo dito olio e bolire" [Another method for making colored varnish—take 1 lb. of flaxseed and place into a new glazed receptacle. Then take a half quart of powdered alum and similar quantities of finely ground minium (red lead) and cinnabar and one half ounce of minced incense. Once all ingredients have been mixed together, place them into the aforesaid oil and boil] (See OLINDO GUERRINI and C. RICCI, *Il libro dei colori: Segreti del secolo 15* [Bologna: Romagnoli Dall'Acqua, 1887], 164.)

This proves not only that colored varnish was used in Italy in the fifteenth century, but that the recipe was well known.

A Review of the History
and Practice of Patination

PHOEBE DENT WEIL

The word *patina* today is most commonly associated with the handsome green corrosion products found on certain ancient bronzes recovered after long burial in the soil, or with colors intentionally produced on bronze using various chemicals either with or without heat. My discussion will focus on the latter sort, commonly termed artificial patination. For a proper study of the history of artificial patination of metallic artifacts, particularly bronzes, one must consider as well the larger question of historical attitudes toward the interaction of color and form. Such a study serves several useful purposes: first and most important, it serves as a step toward achieving the objective that is the basis for all aesthetic decisions for connoisseur, curator, and conservator alike, namely that of attempting to see the object through the eyes of its maker or makers—of discovering the artist's original intent. What evidence do we have to call upon that will enable us to see antique bronzes through the eyes of the ancient artisans of the Berlin Foundry vase (Fig. 1), here shown putting the final polish and burnish on a colossal bronze sculpture; or the sculptor Foggini, here seen (Fig. 2) in his studio around the year 1700, beginning the first clay sketch-model or *bozzetto* that will later be perfected, enlarged, and translated into bronze? Further, such an inquiry will assist us in distinguishing, as the ancients did, between *aerugo nobilis* or "noble patina" and *virue aerugo* or patina that is destructive either visually or physically or both; and will provide a basis for deciding what, if any,

From Phoebe Dent Weil, "A Review of the History and Practice of Patination," in *National Bureau of Standards Special Publication* 479, proceedings of a Seminar on Corrosion and Metal Artifacts: A Dialogue between Conservators and Archaeologists and Corrosion Scientists held at the National Bureau of Standards, 1976 (Gaithersburg, Md.: National Bureau of Standards, 1977), 77–92. Reprinted by permission of the author.

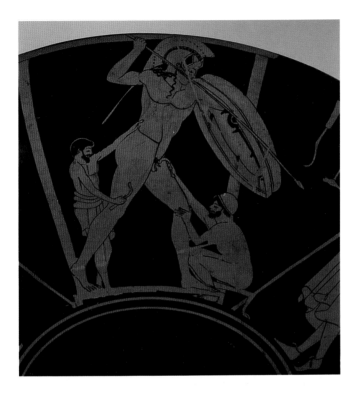

Figure 1
Berlin Foundry Cup. Detail
showing polishing and burnishing
of a bronze statue.

treatment will most appropriately bring the object closest to its originally intended appearance.

The problem of treating metallic objects is complicated by the fact that patina, i.e., corrosion, is formed at the expense of the substance of the object itself, even occasionally to the point of complete mineralization, and once severe alteration or corrosion has occurred it is impossible to determine original coloration or finish from physical evidence. Further, these corrosion products and accretions can in themselves contain highly important historical information, whether they be the corrosion products and layers of soot and dust on an urban bronze that can perhaps reveal valuable information about past environmental history, or, in buried artifacts, a bit of soil that can help to identify provenance and establish authenticity.

This dilemma, the problems of determining original appearance, of identifying changes that have occurred during the course of time, and of judgment in distinguishing disfiguring foreign material from authentic substance of the artifact or work of art are among the most keenly debated problems in Art Conservation. The most publicized articulation of this dilemma that we might call "The Patina Dilemma" came about as a result of the so-called "Cleaning Controversy" in London, with articles published in the *Burlington Magazine* between 1949 and 1962.[1] The Cleaning Controversy

Figure 2
G. B. Foggini at work. In Klaus
Lankheit, *Florentinischer
Barockplastik* (Munich:
F. Bruckmann, 1962), fig. 4.
Caricature by A. D. Gabbiani,
Florence, Uffizi.

related not to metallic artifacts but to paintings, for which the changes
wrought by time have been summarily identified as *patina*. The arguments
begin with rather polarized points of view of the Aesthetician versus the
Scientist, the former speaking against "the raw and brutal surface laid bare
by cleaning" and presenting a definition of *patina* for painting in terms
of glazes or tinted varnishes claimed to have been purposely added by art-
ists throughout the centuries to "tone down brightness."[2] The Scientists held
that treatment could be based on a purely scientific distinction between *gen-
uine patina* or the alterations wrought by time on the authentic substance
of the painting and *other* disfigurements wrought by discoloration of once
water-clear varnishes, overpaint and restoration and accretions of various
sorts.[3] These thesis-antithesis viewpoints were brought to rather elegantly
stated synthesis in the articles by Stephen Rees Jones and Denis Mahon,
who stressed the absolute necessity, to quote Mahon, of "the genuine
pooling, without distrust and *arrière-pensée* of the most diverse forms of
knowledge."[4] Rees Jones stressed the *necessity* for interplay between the
methods of the laboratory and aesthetic and historic criteria on the question
of patina, and quotes Paul Coremans in emphasizing the fact that chemi-

cal analysis and physical method "should be viewed in relation to one another, and in the light of historical, aesthetic, stylistic and technical data to be derived from the curator's, aesthetician's, and restorer's examination of a picture."[5]

It is surely this total-view that we must ideally bring to bear on our approach to the consideration of patina on metallic objects as well. Perhaps in no other area of connoisseurship is one's judgment of beauty so dependent upon scientific understanding, for, as we often see, one man's "handsome patina" can be another man's "ugly corrosion products." The aesthetician will find that an acquaintance with the intellectual processes necessary to understand structure and cause and effect, instead of interfering with his sensory reaction, will rather enhance it; and the scientist will become more acutely aware of the demands made by historic and aesthetic criteria.

Turning now more specifically to our concern with the coloration of bronze, let us begin with a consideration of the material itself. Most of us are familiar with the bright, salmon-colored appearance of the highly-polished metal, as well as with the dark, red-brown of the oxidized surface of the metal. It is precisely the difference between the appearance of a new penny and that of an old penny. Now something different happens when bronze is exposed to increased amounts of moisture and various chemical substances, either gaseous or solid, that will react with the metal. Chemical reactions will occur that will tend to bring the metal into equilibrium with its ambient condition whether above or below ground, inside or out. Moisture is the essential ingredient for further change to take place, and if moisture could be excluded no further chemical changes other than the formation of the thin coating of red-brown oxide would occur. Once moisture becomes accessible to the bronze artifact, what happens is far from simple and still not entirely understood. Lewin and Alexander, in the introduction to their annotated bibliography on the composition and structure of natural patinas, published in *Art and Archaeology Technical Abstracts,*[6] point out the considerable complexity of the chemical systems, as an example of which they mention that there are at least eight sulfate-containing copper compounds that can form when copper alloys corrode in the presence of sulfur compounds, and that some twenty-five copper-containing minerals have been identified in natural patinas. Furthermore, ambient conditions can change, as it must be remembered that prior to the Industrial Revolution in the nineteenth century, outdoor bronzes developed natural patinas described as attractive, thin, compact, translucent, generally red-brown and more or less tinged with green depending upon accessibility of moisture.[7] This stands in contrast to the mottled green and black appearance of modern urban bronzes (Fig. 3) whose surfaces have been attacked by various components of urban air, particularly sulfur compounds.

Figure 3
George Washington, LaFayette
Square, St. Louis. A typically
disfigured outdoor bronze.

Thus, when we read Webster's current definition of *patina* as: "1. a fine crust or film on bronze or copper, usually green or greenish blue, formed by natural oxidation and often valued as being ornamental," and "2. any thin coating or color change resulting from age, as on old wood or silver,"[8] we have a definition that, rather than being definitive, contains all of the elements that contribute toward present confusion on the subject:

1. "Natural oxidation" is an imprecise way to describe the extraordinarily complex variety of chemical reactions, of which oxidation is only one, that can occur on a metallic bronze surface as it works its way toward equilibrium with its environment.

2. The results are only rarely a "fine crust or film," but more often range from thin to thick, warty, and multi-layered; from compact to porous; from finely crystalline to containing crystals of large size; smooth and enamel-like or rough and varied in texture; containing one or two simple compounds to a large number; and in colors spanning the entire spectrum: reds, grays, blacks, greens, blues, browns, purples, yellows, and oranges.

If patina is valued as an indicator of age, when, if ever, should it be removed?

What are the criteria for the ornamental qualities of patina?

A revealing way to begin a study of historical attitudes toward patination is by having a look at the origins and use of the word itself. Most dictionaries give the origin of the word as deriving from the Latin word for *plate* or *pan* (*patena*),[9] though it is often mentioned that the connection is uncertain. The key is perhaps to be found in the first known printed use of the word which occurs in Filippo Baldinucci's *Art Dictionary* of 1681 where *patena* is defined, without reference to corrosion products of metals, as "a term used by painters, called by others a skin, namely that general dark tone which time

causes to appear on paintings, that can occasionally be flattering to them."[10] William Hogarth's depiction of *Time Smoking a Picture* provides a good illustration of Baldinucci's definition (Fig. 4).

The most likely origin of the word *patina* is the old Italian word *patena* used to refer to a shiny dark varnish applied to shoes.[11] Baldinucci's use of the term indicates that it came to refer generally to the effects of time and only later was applied to such effects on metallic objects. The first appearance of the word in a dictionary with the definition referring to green corrosion products on bronze occurs in the French *Encyclopédie* of 1751, where *patine* is defined as follows: "There is no French word to express that beautiful and brilliant color of verdigris that copper does not always assume; the attractiveness of this color to the eye and the difficulty in describing it (because all coppers do not uniformly develop it) is highly valued by the Italians who call it *patina* as one dares to do here after their example and by the example of M. le Comte de Caylus who states correctly that one should be allowed to adopt a foreign word at least in the language of the arts of which this Encyclopedia is the Dictionary."[12] Webster would have done well to emulate French caution.

Figure 4
William Hogarth, *Time Smoking a Picture,* 1761. In M. Dorothy George, *Hogarth to Cruikshank: Social Change in Graphic Satire* (London: Allen Lane, Penguin; New York: Walker, 1967), fig. 10.

The term *patina* used to refer to green corrosion products on bronzes was most likely stimulated by the expanding and heightened interest in archaeology in the eighteenth century. According to the *Oxford English Dictionary,* the earliest recorded English usage of *patina* to describe green corrosion products on bronze is as late as 1797. According to the Italian etymological dictionaries, the Italian verbs meaning *to give a patina, patinated,* and *patinator* are all nineteenth century in origin.[13]

The philological aspects of the word appear to reflect the historical situation: while coloristic effects were achieved in bronze sculpture and other metallic artifacts by a variety of means from earliest times, it was not until the nineteenth century that artificial patination of bronzes by chemical means, with or without heat, was generally and widely practiced.

Observation of, indeed a fascination with the colored corrosion products of copper and copper alloys dates back to ancient times. Experimental artificial production of these substances from copper and other metals was perhaps even fundamental to the development of alchemy and thereby of chemistry itself.[14] The most convincing studies regarding the problem of patination of bronzes in ancient art have been made by Erich Pernice in 1910,[15] followed by the discussion by Gisela Richter in the 1915 catalogue of the ancient bronzes in the Metropolitan Museum,[16] and a more recent study by H. Otto in 1959[17] based on X-ray diffraction analysis of patinas. Both Pernice and Richter provide rich documentation from ancient literature and inscriptions as well as from the objects themselves, and Pernice goes a further step in having himself re-created the ancient method of finishing bronze. Both Pernice and Richter's work have been frequently overlooked in recent studies.

The most important of the ancient literary sources on the subject of patination are to be found in Plutarch, the Greek biographer and historian, and the Roman, Pliny the Elder (Gaius Plinius Secundus), both of whose writings date from the first century C.E. Richter's account of the passage from Plutarch's *De Pythiae Oraculis* is worth quoting here: "A number of visitors to the sanctuary of Apollo at Delphi are made to discuss the question whether the patina on the bronze group in front of which they are standing is natural or artificial. One of them is admiring the beautiful surface of the bronze, which resembles neither dirt nor rust, but looks as if it had been dipped in a bath of brilliant blue color. 'I wonder,' he adds, 'whether the ancient masters used a certain mixture or preparation on their bronzes?' In the discussion that follows, various suggestions are made to explain the presence of the patina by physical conditions, for instance, that it is due to the action of the atmosphere which enters the bronze and forces out the rust (or rather corrosion); or that the bronze itself when it gets old exhales the rust." Miss Richter goes on to point out the great importance that Plutarch "had no

reason to believe in an artificial patina, but clearly decides in favor of a patina acquired by natural causes."[18]

To answer the question, "How did the ancients normally finish their statues?" both Pernice and Miss Richter marshal an impressive array of evidence supporting the thesis that the ancients finished their objects in bronze by giving them a painstakingly careful, high, lustrous polish. All seams and welds of the separately cast pieces were ingeniously and carefully hidden so that all exposed surfaces could be polished to perfection by specialists in the foundry. When one considers the great value of bronze metal in ancient times, it is not so surprising that the high luster of the smoothed and polished metal itself was admired and judged the most desirable and normal method for finishing bronze artifacts of all kinds. This is not to say that sculpture and other bronze artifacts were not without a variety of coloristic and textural effects; they were, but these were achieved by using alloys of contrasting colors and other materials, such as ivory, stone, or glass, as inlay or in juxtaposition, in combinations such as niello, silver and copper. Such contrasting effects were entirely dependent on a bright and untarnished appearance of the whole. The Delphi *Charioteer* has, for example, inset glass paste eyes and separately inserted bronze plate eyelids with eyelashes. This is consistent with the evidence we have for the appearance of Greek marble sculpture that was not only painted in bright colors, but often was fitted with accessories of different materials such as glass, ivory, or metals of various sorts such as necklaces and earrings or diadems. And as the marble sculpture was provided with a protective coating of what was probably a wax-resin mixture (Vitruvius' Punic wax),[19] so was the bronze sculpture provided with a coating designed to exclude moisture and preserve the bright polish of the metal.[20] For both marbles and bronzes it was considered normal to remove and renew these coatings in order to maintain the original dazzling splendor of the sculptures. As Miss Richter pointed out in the passage from Plutarch, it "follows indirectly that in his own time bronzes were kept in their natural finish; otherwise, why should the Delphic visitors be surprised at the presence of a patina on Greek bronzes?"[21]

Several inscriptions survive from ancient times documenting provision for maintenance of bronzes. Pernice mentions an inscription from Chios of the fourth century B.C.E. in which the clerks of the market are told to see to it that a bronze statue of a tyrannicide be kept free from corrosion, and further the clerk is instructed to see that the statue be provided with a garland and kept bright.[22]

The writings of Pliny[23] relevant to the finishing of bronze have been variously interpreted, but in the light of preceding remarks he is found to be entirely consistent. The Latin term he uses to describe the green corrosion

products of copper is *aerugo, aeruginis,* that is to say the rust (*robigi*) of bronze (*aes*). Pliny speaks of a method of producing it artificially, by hanging copper metal in casks over strong vinegar.[24] The uses and purpose of producing this *aerugo* are primarily medicinal and cosmetic, such as for annointing eyes and the healing of sores and ulcers, and not in any way related to the finishing of statuary. When Pliny speaks of bronze and the varieties of bronze alloys he consistently speaks of the color of the metal itself, for example the addition of lead to Cyprus copper "produces the purple color seen in the bordered robes of statues,"[25] and that certain bronzes had special value because of their color.[26] A particularly good case in point is Pliny's account of the statue of Athamas by Aristonidas: "When the artist Aristonidas desired to represent the madness of Athamas subsiding in repentance after he had hurled his son Learchus from the rock, he made a blend of copper and iron, in order that the blush of shame should be represented by rust of the iron shining through the brilliant surface of the bronze (*aeris relucente*)."[27]

As to bronze treatments, Pliny mentions the use of vinegar and the urine of a child (*urina pueri*) for cleaning bronze.[28] For copper and bronze utensils he recommends frequent polishing and rubbing with oil or coating with vegetable pitch to preserve them from corrosion.[29] Perhaps the most frequently misinterpreted passage has to do with Pliny's statement about providing a protective coating for bronze statuary, the key words of which are: "bitumine antiqui tinguebant eas," which has frequently been interpreted to mean that the ancients painted their statues with a dark black coating of bitumen.[30] Considering the care taken in inlay work and in contrasting colors of metals this would be unthinkably inappropriate. Pernice has demonstrated the correct interpretation of this passage based on experiments using pitch diluted with turpentine to brushing consistency which was then painted in a thin coating onto a piece of brightly polished bronze. "The wash," he claims, "increased rather than diminished the brightness of the bronze, and at the same time protected the surface from atmospheric effects."[31] The entire passage in Pliny runs: "The ancients painted their statues with bitumen, which makes it more surprising that they afterward became fond of covering them with gold,"[32] because, as Pernice has demonstrated, the bitumen coating gave the same appearance to the bronze as gilding, and therefore made gilding unnecessary. This is reminiscent of the discussion of ancient picture varnishes and the varnish of Apelles as described by Pliny that occurred during the London Cleaning Controversy. Those who supported the idea that the ancients applied a tinted varnish to obscure their bright colors pointed to the descriptions of the dark resin solutions apparently used.[33] Those arguing in favor of the ancients not having veiled their colors pointed to the fact that such natural resins most likely to have been used by the ancients, while appearing murky brown in a container,

had the appearance of a shiny, essentially water-clear, transparent coating when applied to the painting.[34]

We have even an inscription as late as 1076 C.E. on the bronze doors of the church of S. Michele at Monte S. Angelo in which the sponsor of the doors, Pantaleone d'Amalfi, instructs those in charge to clean the doors once a year so that they will always be shiny and bright.[35]

So all evidence points to the fact that bronzes of all kinds, from artifacts to sculpture, normally received a high polish in the ancient Western world, and apparently in the East as well, and effort was made to maintain this polish. Those that were not maintained turned the familiar reddish-brown, and the old bituminous coating (if present) turned to a darkish color. Those statues exposed to damp outdoor or underground conditions later became tinged with greenish corrosion products. Above and below ground, and apparently beneath the ocean as well, the original high polish itself afforded a certain degree of corrosion resistance, for the smoother the metallic surface, the less well it can retain water, and the rubbing and burnishing process removes the softer constituents from the metallic surface to produce an exposed surface that is both enriched in the harder constituents and, most important, has greater structural and compositional uniformity. Gettens has, for example, pointed out this phenomenon in explaining the thicker, reddish corrosion products found in the unpolished recesses of relief patterns on certain bronze Chinese vessels, compared with the smooth green formed on the polished areas of relief.[36]

With the rebirth of bronze casting during the Renaissance a new element of value entered the picture, namely "antiqueness" of a bronze object. There is even some evidence that this concept was valued in Roman times by collectors of Greek bronzes. During the Renaissance, however, it becomes clear that corrosion products had acquired a value, not only because occasionally the color effects of excavated antique bronzes could be quite alluring in themselves, but also because they testified to the age and therefore genuineness of an ancient bronze. And once this value was established, the imitators and forgers were not far behind.

Coloristic effects were still primarily achieved through gilding or the use of contrasting alloys on small objects, and by far the most popular and most common finish for bronzes large and small was the application of a dark lacquer, as can be seen in Donatello's *David* of circa 1430, which was the first free-standing, full-length bronze figure cast since Antiquity. The use of this dark lacquer may have been a misinterpretation of Pliny or an imitation of an ancient, discolored, bituminous coating, or, more likely, such a coating served the important purpose of providing visual uniformity to conceal numerous casting flaws and repairs that are reportedly characteristic of Florentine fifteenth-century bronzes. When, for example, the dark coating plus

accretions and corrosion products were cleaned from the bronze doors exe-
cuted by Filarete between 1433–45 for St. Peter's basilica in Rome, they were
found to be not only full of numerous original repairs but also made of a
patchwork variety of alloy compositions clearly not intended to be seen.[37] In
Donatello's earlier *St. Louis of Toulouse* of 1423, the statue was ingeniously
cast in pieces small enough so that each could be gilded separately and the
whole then put together much as a tailor constructs a suit.[38] The variety and
experimental qualities of Donatello's approach to coloration of sculpture is
exemplified as well by the wooden statue of the *Magdalen* which was covered
for many years with a uniform brown paint to resemble bronze until the
cleaning after the Florence flood revealed Donatello's bright polychromy.[39]

The first modern account of the subject of the coloration of bronze
occurs with the *De Sculptura* published in 1504 by Pomponius Gauricus, an
amateur who made observations in the bronze foundries at Padua: "All
beauty," he says, "appears perfect in the polishing and coloration. In the pol-
ishing we remove all harshness of the filing by means of a scraper, and we add
the shine with pumice or with a point or with a burnisher. For coloration we
give the color to each part whether in the cast itself (i.e., by alloying)," and he
goes on to describe the following colors: "white is achieved by the application
of silver leaf, yellow, i.e., gold, with gold leaf; green by wetting with salted
vinegar, and black by a varnish of liquid pitch or smoke of wet straw. These
colors will do for now, in waiting for the time that we will learn others."[40]

Our other principal literary source for Renaissance practice comes
from the writings of the painter Vasari whose preface to his *Vite,* or *Lives of
the Great Artists,* published in 1550 and revised in 1568, describes various
artistic techniques. Vasari simply states that bronze "assumes through time
and by natural change a color that draws toward black ... Some turn it black
with oil, and others with vinegar make it green, and others with varnish give
it the color of black so that everyone makes it come as he likes best."[41]

Though Vasari mentions green formed by exposure to vinegar, artificial
green patinas are rarely found until well into the nineteenth century, at least
one reason for which is the lack of stability of artificially formed greens, par-
ticularly under outdoor conditions.

The dark, shiny lacquer was most typical during the Renaissance with
certain exceptions, for example in the coloristic effects, particularly in small
bronzes, achieved through combinations of metals and other materials seen
in the work of such artists as Benvenuto Cellini and Antico and in the exquis-
ite translucent, reddish-brown lacquers typical of the work of Gian Bologna
and his followers in the late sixteenth century.[42]

As to stone and marble sculpture, it appears that in Roman times
where carved representations were little derived from Greek originals from

which the polychromy had disappeared, a dichotomy developed for the first time between high-class, unpolychromed sculpture and more popular and conservative works that were polychromed in the old tradition. This tendency was followed, by and large, through the Renaissance onward, and marble carvers adhered to the progressive Classical tendency following the Roman traditions and never used color. For coloristic effects it was necessary to rely upon textural variation.

Rudolf Wittkower's discussion of the problem of the polychromy of sculpture, in an article about Bernini's bust of Louis XIV, points out the problem of the eye as having always presented sculptors with one of their greatest problems in representing a head, for "of all parts of the human body, the eye alone has a design in it which exists only in terms of color and not of shape—(that is) the iris and pupil. The problem is to translate this colored design into colorless sculptural form ... Not until the Hellenistic period was a way found of representing the eye by purely sculptural means. Sculptors then depicted the iris by a circle cut out of the eyeball and the pupil either as one or two small holes in the center. While the shadow of the two holes gives the effect of the dark pupil, the ridge between them stands out clearly and produces an effect similar to the dash of light which enlivens the human eye. Since in real life this spot of light shifts with a person's angle of vision, the ridge enabled the sculptor to fix the direction of the look. The Romans accepted at certain periods the Hellenistic sculptured eye, while at others they preferred the simple Greek eyeball; but since they had abandoned poly-chromy, they left the eyeball unpainted ... (During the Renaissance) one and the same sculptor would revert to the simple convex as well as to the sculp-tured eye ... Michelangelo used the sculptured eye for his *David*, where he wanted the stare in the eyes to be fixed and determined. The same applies to his *Moses*. But in his Madonnas and statues in the Medici chapel he left the eyeball unworked."[43]

Few sculptors have expressed the general problem of polychromy in sculpture as well as has Gian Lorenzo Bernini in the seventeenth century, who was, to quote Wittkower, "always meditating upon the central question of portraiture in stone, namely how to translate the colors and the complex-ion of a face into uncolored marble," or we might add, into monochromatic bronze. Bernini stated that "If a man whitens his hair, his beard, his lips, and his eyebrows and were it possible, his eyes, even those who see him daily would have difficulty recognizing him." He explained that, for instance, "in order to represent the bluish color which people have round their eyes, the place where it is to be seen has to be hollowed out, so as to achieve the effect of this color and to compensate in this way for the weakness of sculpture which can only give one color to matter. Adherence to the living model

therefore is not identical to imitation,"[44] presaging Picasso's famous state-
ment that, "We all know that Art is not truth. Art is a lie that makes us real-
ize truth."[45]

A document referring to a bronze portrait bust by Bernini states
specifically that he wished to reserve the final chasing of the face, hair and
beard for himself, and that he preferred the bust without any type of color-
ing, "since time will give the metal a true and natural color."[46] He was refer-
ring in this case to indoor bronze. In Bernini's immense bronze decorations
for St. Peter's basilica in Rome, the *Baldacchino,* the *Cathedra Petri,* and the
Cappella del Sacramento, the bronzes were either all or partially gilt or highly
polished and allowed to darken naturally to a rich red-brown. Coloristic
effects were achieved by gilding and the contrasts with other richly colored
materials such as marbles and lapis lazuli.

It is not until the nineteenth century and particularly in France that we
find the development of what can be called true artificial patination practiced
on a large scale. As late as 1802, Francesco Carradori's book on sculpture
technique written in Florence describes only filing and polishing the bronze
surface.[47] By midcentury, in Paris, it has been estimated that about six thou-
sand men were continuously employed in bronze casting;[48] among them
were the Master Patineurs, artistic specialists in their own right, who devel-
oped the art of coloring bronzes by application of heat and chemicals, and
who, for the most part, carefully guarded their secrets. It was the exception
for the artist himself to apply his own patinas. The Limet brothers, shown
here (Fig. 5) in their Paris studio, did much of the patination of Rodin's
bronzes. An exceptionally fine example of artificial patination is seen in this
small horse by Degas (Fig. 6) cast by the founder Hébrard after Degas's death
in 1917. Degas's use of polychromy in sculpture is exceptional but explainable
by the fact that he was primarily a painter. Many of the small sculptures he
left after his death were in multicolored waxes. The bronze caster Hébrard
stated that particular efforts were made to duplicate the colors of the waxes
in the coloration of the bronze. The horse is a particularly beautiful example
of color variation by chemical means, with the horse colored a rich chestnut
brown and the base tinged with green. Degas's interest in the coloration of
form is perhaps best exemplified in *Little Dancer, Fourteen Years Old* from
1880 to 1881, exhibited in wax form during Degas's lifetime. The dancer's
shoes and bodice were real objects covered with colored wax and the sculp-
ture was fitted with a real cloth ribbon and *tutu.* Such innovative effects were
received with a certain amount of shock during Degas's lifetime.[49]

While the Master Patineurs delighted in creating artistic effects on a
small scale, large works were normally given the simplest of treatments, nor-
mally uniform and depending, it seems, largely on the quality of the cast. For
example, at the von Müller foundry in Munich, the bronzes were left uncol-

Figure 5
*Père et Jean Limet in Their Paris
Studio.* In Malvina Hoffman,
Sculpture Inside and Out (New
York: W. W. Norton and Co., 1939).

ored and probably simply waxed. Harriet Hosmer's statue of Senator Thomas
Benton, cast by von Müller in the 1860s was described as being a bright
golden color at its unveiling.[50] Otherwise, large-scale sculpture was normally
chemically treated to turn a dark brown or black.

Efforts to study the change in appearance of outdoor bronzes wrought
by atmospheric pollution at the dawn of the Industrial Age and to provide a
more scientific base for the chemical coloration of bronze appear to have
begun in Berlin in the 1860s. The various milestones can be found for the
most part in the Lewin-Alexander "Patina Bibliography."[51] Alongside this tra-
dition is that of the sculptor's or craftsperson's handbooks that present the
various methods handed down in the workshops or, more often, simply lifted
without acknowledgment from previously published handbooks. I have col-
lected some eighteen or so books and articles by sculptors or metalworkers,
the earliest dating from 1873, and there must be many more.[52] Malvina Hoff-
man's book, *Sculpture Inside and Out,* first published in 1939, is among the
most comprehensive accounts drawing on her experience as a student of
Rodin and work with Master Patineurs in the Rudier foundry in Paris. For the
most part these are simply recipe collections with ingredients often described

Figure 6
Horse by Degas. A small indoor bronze with patina in good condition.

in obscure, arcane or imprecise fashion, for example: salt of sorrel, sulphydrate of ammonia, uric acid (for urine), wine vinegar, and the like. Explanations of the chemistry involved, when provided, are usually incorrect. It is no wonder that the various sculptor-authors often speak of the element of chance or luck in achieving desired results. Occasionally these handbooks provide a statement regarding desirable aesthetic qualities of artificial patination, all of which agree with that of Slobodkin who states that artificial patinas should (1) appear natural, and (2) be very thin and transparent and emphasize the metallic qualities of the medium.[53] Uniformly absent is any discussion or even concern with maintenance other than the usual suggestion that bronzes should receive an occasional application of beeswax or commercial paste wax. One author, J. Rood, goes so far as to state: "If a sculpture is of sufficient importance that subsequent generations would like to preserve it indefinitely, a way can certainly be found."[54] To this we should certainly exclaim, "Such faith!"

Most modern sculptors in bronze believe in the romantic myth of a benevolent Nature that will in time provide their sculptures with a handsome patina. For example, Henry Moore has stated that "bronze, naturally in the open air (particularly near the sea) will turn with time and the action of the atmosphere to a beautiful green. But sometimes one can't wait for nature to have its go at the bronze, and you can speed it up by treating the bronze with different acids which will produce different effects. Some will turn the bronze black, others will turn it green, others will turn it red. I usually have an idea, as I make a plaster, whether I intend it to be a dark or a light bronze, and what color it is going to be. When it comes back from the foundry I do the patination and this sometimes comes off happily, though sometimes you can't repeat what you have done other times ... It is a very exciting but tricky and uncertain thing, this patination of bronze."[55]

Those of us who must be concerned with the preservation of bronzes and therefore with the problems of patina have a difficult task indeed,

demanding the broadest use of scientific, historical, and aesthetic tools available. For sculpture the problem of patination is particularly subtle and acute, for when one considers the traditional way in which the sculptor has worked since the Renaissance in monochromatic wax or clay translated to plaster, translated to bronze or marble, his coloristic effects, as Bernini has stated so well, are dependent upon textural variation. For the eye to see these variations in texture and form requires a reasonable uniformity of coloration. By comparing the appearance of sculpture before and after conservation treatment, the camouflaging effect of a deteriorated patina is plainly apparent (Figs. 7, 8).

Figure 7
Bronze statue of Thomas Hart Benton, LaFayette Square, St. Louis, before conservation treatment.

Figure 8
The statue shown in Fig. 7, after conservation treatment.

Notes

1. CESARE BRANDI, "The Cleaning of Pictures in Relation to Patina, Varnish, and Glazes," *Burlington Magazine* 91, no. 556 (1949), 183–88 [see Reading 41, pages 380–93]; NEIL MACLAREN and ANTHONY WERNER, "Some Factual Observations about Varnishes and Glazes," *Burlington Magazine* 92, no. 568 (1950): 189–92; E. H. GOMBRICH, "Dark Varnishes: Variations on a Theme by Pliny," *Burlington Magazine* 104, no. 707 (1962), 51–56; OTTO KURZ, "Varnishes, Tinted Varnishes and Patina," *Burlington Magazine* 104, no. 707 (1962): 56–60; S. REES JONES, "Science and the Art of Picture Cleaning,"

Burlington Magazine 104, no. 707 (February 1962): 60–62; J. PLESTERS, "Dark Varnishes—Some Further Comments," *Burlington Magazine* 104, no. 716 (November 1962): 452–60; D. MAHON, "Miscellanea for the Cleaning Controversy," *Burlington Magazine* 104, no. 716 (November 1962), 460–70; J. A. VAN DE GRAAF, "The Interpretation of Old Painting Recipes," *Burlington Magazine* 104, no. 716 (1962): 471–75; M. MURARO, "Notes on the Traditional Methods of Cleaning Pictures in Venice and Florence," *Burlington Magazine* 104, no. 716 (1962): 475–77.

2. BRANDI, "The Cleaning of Pictures."

3. MACLAREN and WERNER, "Some Factual Observations."

4. MAHON, "Miscellanea," 461.

5. REES JONES, "Picture Cleaning," 60.

6. S. LEWIN and S. ALEXANDER, "The Composition and Structure of Natural Patinas," part 1, "Copper and Copper Alloys," section A, "Antiquity to 1929," and section B, "1930 to 1967," *Art and Archaeology Technical Abstracts* 6, no. 4 (1967), and 7, no. 1 (1968).

7. G. MAGNUS, "Über die Einfluss der Bronzezusammensetzung auf die Erzeugung der schönen grünen Patina," *Dinglers Polytechnisches Journal* 172 (1864): 370–76; J. RIEDERER, "Corrosion Damage on Bronze Sculptures," (preprint of paper presented to ICOM Committee for Conservation, Madrid, 1972), 4; J. LEHMANN, "Corrosion of Monuments and Antiquities Made of Copper and Copper Alloy in Outdoor Exhibits," (preprint of paper presented to ICOM Committee for Conservation, Madrid, 1972), 3–4.

8. *Webster's New World Dictionary,* 2d College Edition.

9. See, e.g., *Webster's New World Dictionary.*

10. FILIPPO BALDINUCCI, *Vocabolario toscano dell'Arte del Disegno* (Florence: Santi Franchi, 1681): "*patena,* voce usata da' Pittori, e diconla altrimenti pelle, ed è quella universale scurità che il tempo fa apparire sopra le pitture, che anche talvolta le favorisce."

11. CARLO BATTISTI and GIOVANNI ALESSIO, *Dizionario etimologico italiano* (Florence: G. Barbera, 1954), s.v. "patina"; *The Cambridge Italian Dictionary,* vol. 1, ed. B. Reynolds (Cambridge: Cambridge University Press, 1962), s.v. "patina."

12. DENIS DIDEROT and D'ALEMBERT, *Encyclopédie, ou Dictionnaire raisonné des sciences, des arts et des métiers, par une société de gens de lettres,* 36 vols. (Neufchastel: Société Typographique, 1779; Lausanne: Sociétés Typographiques, 1780–82): "*Patine:* Il n'y a point de mot francois pour exprimer cette belle & brillante couleur de vert-de-gris que le cuivre ne prend pas toujours; l'agrément de cette couleur pour l'oeil & la difficulté de la rencontrer (car tous les cuivres ne s'en chargent pas également), la rendent très recommandable aux Italiens, qui la nomment *patina,* comme on ose ici le faire d'après eux, & par l'exemple de M. le comte de Caylus. 'Il doit être permis, dit-il avec raison, d'adopter un mot étranger au moins dans la langue des arts.' Or l'Encyclopédie en est le dictionnaire."

13. BATTISTI and ALESSIO, *Dizionario etimologico italiano.*

14. See, e.g., CYRIL STANLEY SMITH, *A History of Metallography,* 2d ed. (Chicago: University of Chicago Press, 1965), 2; JAMES RIDDICK PARTINGTON, *Origins and Development of Applied Chemistry* (London: Longmans, Green & Co., 1935);

A. J. Hopkins, *Alchemy: Child of Greek Philosophy* (New York: Columbia University Press, 1934).

15. Erich Pernice, "Untersuchungen zur antiken Toreutik, V. Natürliche und künstliche Patina im Altertum," *Jahreshefte des Österreichischen Archäologischen Institutes in Wien* 13 (1910): 102–7; and his "Bronze Patina und Bronzetechnik im Altertum," *Zeitschrift für Bildende Kunst* 21 (Leipzig: E. A. Seemann, 1910): 219–24.

16. G. M. A. Richter, *The Metropolitan Museum of Art: Greek, Etruscan, and Roman Bronzes* (New York: The Gilliss Press, 1915).

17. H. Otto, "X-Ray Fine Structure Investigation of Patina Samples," *Freiberger Forschungshefte,* B37 (1959), 66–77. For further discussion of ancient practices see, e.g., Jean Charbonneaux, *Greek Bronzes* (London: Elek Books, 1962), 36 ff., who mentions that as early as 1896, Villenoisy wrote in the *Révue Archéologique* against the supporters of artificial patination, pointing out how many Greek and Roman kitchen utensils with the humblest functions have a splendid patina.

18. Richter, *The Metropolitan Museum Bronzes,* xxix–xxx.

19. Vitruvius Pollio, *On Architecture* 7.9.3, trans. and ed. Frank Granger, vol. 2 The Loeb Classical Library (Cambridge, Mass.: Harvard University Press, 1970), 119; Patrik Reuterswärd, *Studien zur Polychromie der Plastik Griechenland und Rom,* Stockholm Studies in the History of Art (Stockholm: Almqvist and Wiksell, 1960); M. Cagiano de Azevedo, "Conservazione e restauro presso i greci e i romani," *Bollettino dell'Istituto Centrale del Restauro* 9–10 (1952): 53–60.

20. Pliny the Elder, *Natural History* 34.21, trans. H. Rackham, vol. 9 The Loeb Classical Library (London: W. Heinemann, 1967); Pernice, *Österreichischen Archäologischen Institutes;* Richter, *The Metropolitan Museum Bronzes,* xxx.

21. Richter, *The Metropolitan Museum Bronzes.*

22. Pernice, *Österreichischen Archäologischen Institutes,* quoted in Richter, *The Metropolitan Museum Bronzes,* xxxi.

23. Pliny, *Natural History* 34.

24. Ibid., 34.26.

25. Ibid., 34.20.

26. Ibid., 34.3.

27. Ibid., 34.40.

28. Ibid., 34.25; used also for the same purpose by Benvenuto Cellini, *I trattati dell'oreficeria e della scultura* (1568), ed. Carlo Milanesi (1857), trans. C. R. Ashbee, *The Treatises of Benvenuto Cellini on Goldsmithing and Sculpture* (New York: Dover Publications, 1967); and by Pomponius Gauricus, *De Sculptura* (1504), ed. André Chastel and Robert Klein, *Hautes Etudes Medievales et Modernes* 5 (Geneva: Droz, 1969), 232, 232–33 n. 47.

29. Pliny, *Natural History* 34.21.

30. Ibid., 34.9. The passage reads: "bitumine antiqui tinguebant eas, quo magis mirum est placuisse auro integere." At least part of the problem is the translation of *tinguebant,* which the Loeb Classical Library edition, for example, translates as "used to stain." In this case, it apparently means "coated," as Pernice convincingly demonstrates (see note 15 herein).

31. Richter, *Metropolitan Museum Bronzes,* xxx.

32. PLINY, *Natural History* 34.9.

33. GOMBRICH, "Dark Varnishes"; and KURZ, "Varnishes."

34. MAHON, "Miscellanea," 461.

35. VITTORIO FEDERICI, in *Le porte bizantine di San Marco*, a cura della Procuratoria di S. Marco, edizioni dello Stadium Cattolico Veneziano, Venice, 25 April 1969). The inscription reads: "Rogo et adiuro vos, rectores S. Angeli Michaelis, ut semel in anno detergere faciatis has portas, sicut nos ostendere fecimus ut sint semper lucidae et clarae."

36. R. J. GETTENS, *The Freer Chinese Bronzes*, vol. 2 of *Technical Studies*, Freer Gallery of Art, Oriental Studies 7 (Washington: Smithsonian Institution, 1969), 182.

37. JOHN SPENCER, conversation with the author.

38. BRUNO BEARZI, "Considerazioni di tecnica sul S. Ludovico e la Giuditta de Donatello," *Bollettino d'Arte* 36 (1951): 119–23.

39. See, e.g., the photograph of the *Magdalen* in DORA JANE HAMBLIN, "Science Finds Way to Restore the Art Damage in Florence," *Smithsonian* 4, no. 11 (1974): 29.

40. POMPONIUS GAURICUS, *De Sculptura*, 230.

41. *Le Vite de' più eccellenti architetti, pittori et scultori italiani, da Cimabue insino a' tempi nostri* (Florence: n.p., 1550; reprint, Florence: Appresso i Giunti, 1568), edited in nine volumes by Gaetano Milanesi (Florence: G. C. Sansoni, 1878–85); "Prefix" to the *Vite*, trans. Louisa S. Maclehose, ed. G. Baldwin Brown, *Vasari on Technique: Being the Introduction to the Three Arts of Design, Architecture, Sculpture, and Painting, Prefixed to the Lives of the Most Excellent Painters, Sculptors, and Architects* (New York: Dover, 1960), 165–66; and vol. 1, ed. R. Bettarini and P. Baroucchi (Florence: G. C. Sansoni, 1966), 103: "Questo bronzo piglia col tempo per se medesimo un colore che trae in nero e non in rosso come quando si lavora. Alcuni con olio lo fanno venire nero, altri con l'aceto lo fanno verde, et altri con la vernice li dànno il colore di nero, tale che ognuno lo conduce come più gli piace. Nel che si vede questa arte essere in maggior eccellenza che non era al tempo degli antichi."

42. Further on Renaissance bronzes, see WILHELM VON BODE with M. MARKS, *The Italian Bronze Statuettes of the Renaissance* (London: H. Grevel and Co., 1908); H. LÜER, *Technik der Bronzeplastik*, Monographien des Kunstgewerbes 4, ed. J. L. SPONSEL (Leipzig: H. Seemann, 1902), "patina," 16ff; JENNIFER MONTAGU, *Bronzes* (London: Wiedenfeld and Nicolson, 1963); HANS R. WEIHRAUCH, *Europäische Bronzestatuetten* (Braunschweig: Klinkhardt and Biermann, 1967); GIOVANNI MARIACHER, *Venetian Bronzes from the Collections of the Correr Museum* (Washington, D.C.: Smithsonian Institution, 1968), bibliography.

43. RUDOLF WITTKOWER, *Bernini's Bust of Louis XIV*, Charlton Lectures on Art 33 (London: Oxford University Press, 1951), 9–11.

44. Ibid., 9.

45. ALFRED HAMILTON BARR JR. *Picasso: Fifty Years of His Art* (New York: The Museum of Modern Art, 1946; reprint, New York: Arno Press, 1966), 270.

46. GISELA RUBSAMEN, "Bernini and the Orsini Portrait Busts," lecture, College Art Association, Washington, D.C., 22–25 January 1975. The only other source for patination in the seventeenth century that I know of is ANDRÉ FÉLIBIEN, *Des principes de l'architecture, de la sculpture, de la peinture, et des autres arts*

qui en dépendent (Paris: J. B. Coignard, 1699; Farnborough, Hants., England: Gregg, 1966), 239: "Après qu'elles sont bien nettoyées & réparées, on leur donne si l'on veut une couleur. Il y en a qui prennent pour cela de l'Huile & de la Sanguine: d'autres les font devenir vertes avec du Vinaigre. Mais avec le temps le bronze prend un vernis qui tire sur le noir" [After they have been cleaned and repaired, one may color them, if desired. Some use oil or sanguine for this purpose, and others turn them green with vinegar. But with time, bronze takes on a varnish that tends toward black]. The French *Encyclopédie* of Diderot states under "sculpture": "Quant à la poix dont les anciens couvroient leurs bronzes, nous n'avons rien à desirer; les fumées & les préparations de nos artistes sont d'autant préférables, qu'elles ont moins d'épaisseur" [As for the pitch with which the ancients covered their bronzes, we have nothing to envy; we prefer the smoke and preparations of our artists, since they are less thick].

47. Francesco Carradori, *Istruzione elementare per gli studiosi della scultura* (Florence: Società Letteraria, 1802), xxxiii: "Finalmente ripurgasi il lavoro, e conducesi alla dovuta perfezione, prima con lime diverse, più o meno fini, e capaci di entrare in tutte le parti; indi con acqua e pomici di varie grossezze; e per ultimo con dell'istessa pomice pesta, e stecche di legno, e con tripolo" [In the end, one cleans up the work again and brings it to the necessary perfection through finishing touches, first using files of varying grains and sizes to get into all the parts; then using water and pumice of different sizes; and finally using the crushed pumice, with wood sticks, and with tripoli].

48. G. Savage, *A Concise History of Bronzes* (New York: Praeger, 1968), 227.

49. On Degas sculpture, see John Rewald, ed., *Degas, Works in Sculpture: A Complete Catalogue* (New York: Kegan Paul, 1944).

50. C. Carr, *Harriet Hosmer: Letters and Memoirs* (New York: Moffat, Yard and Co., 1912), 260.

51. Lewin and Alexander, "Natural Patinas," see, e.g., Magnus, "Schönen grünen Patina"; C. Puscher, "Artificial Patinas," *Polytechnisches Notizblatt für Gewerbtreibende, Fabrikanten und Künstler* 38 (1883), 90; E. Donath, "Artificial Patination," *Dinglers Polytechnisches Journal* 253 (1884), 376–80; L. Vanino and E. Seitter, *Patina: Its Natural and Artificial Formation on Copper and Its Alloys* (in German) (Vienna: A. Hartleben, 1903); Arthur Horseman Hiorns, *Metal-Colouring and Bronzing*, 2d ed. (New York: Macmillan, 1892); Samuel Field and S. R. Bonney, *The Chemical Coloring of Metals and Allied Processes* (New York: Chapman and Hall, Ltd., 1925), 137–52; Colin Garfield Fink and C. H. Eldridge, *The Restoration of Ancient Bronzes and Other Alloys* (New York: Metropolitan Museum of Art, 1925); J. R. Freeman and P. H. Kirby, "The Rapid Development of Patina on Copper," *Metals and Alloys* 3 (1932), 190–94; W. H. J. Vernon, "Open-Air Corrosion of Copper, part 3: Artificial production of a green patina," *Journal of the Institute of Metals* 49 (1932): 153–61; D. Fishlock, *Metal Colouring* (Teddington: R. Draper, 1962), 192ff.; Deutsches Kupfer-Institut, *Chemische Färbungen von Kupfer und Kupferlegierungen* (Berlin: Beuth in Komm., 1974).

52. Ernest Spon, *Workshop Receipts, for the Use of Manufacturers, Mechanics, and Scientific Amateurs* (London: E. and F. N. Spon, 1873; reissued 1875 and 1890; 2d ed. 1895); Georg Buchner, *Die Metallfärbung und deren Ausführung,*

mit besonderer Berücksichtigung der chemischen Metallfärbung (Berlin: S. Fischer, 1891; rev. ed. 1920); WILLIAM O. PARTRIDGE, *The Technique of Sculpture* (Boston: Ginn and Co., 1895), "patina on bronze," 90 ff.; HERBERT MARYON, *Metalwork and Enamelling* (London: Chapman and Hall, Ltd., 1912; 5th rev. ed., New York: Dover Publications, 1971), "the colouring of copper and brass," 264–66; HUGO KRAUSE, *Metal Coloring and Finishing* (New York: Chemical Publishing Co. of New York, Inc., 1938); MALVINA HOFFMAN, *Sculpture Inside and Out* (New York: W. W. Norton and Co., 1939), "bronze patining," 302–4; RALPH MAYER, *The Artist's Handbook of Materials and Techniques* (New York: Viking Press, 1940; 3d ed. 1970), "patina on bronze," 618–20; JACK C. RICH, *Materials and Methods of Sculpture* (New York: Oxford University Press, 1947; reprint, 1970), "the patination of metals," 199–209; WILLIAM ZORACH, *Zorach Explains Sculpture: What It Means and How It Is Made* (New York: American Artists Group, 1947), "patination," 161 ff.; LOUIS SLOBODKIN, *Sculpture: Principles and Practice* (Cleveland: World Publishing Co., 1949), "patining bronze," 166 ff.; JULES STRUPPEK, *The Creation of Sculpture* (New York: Holt, 1952), "patinas," 232 ff.; BERNARD CHAET, *Artists at Work* (Cambridge, Mass.: Webb Books, 1960); JOHN ROOD, *Sculpture with a Torch* (Minneapolis: University of Minnesota Press, 1963), "patinas," 36 ff.; JOHN MILLS, *The Technique of Sculpture* (London: B. T. Batsford, 1965; 3d ed. New York: Reinhold, 1967), "finishes," 106 ff.; JOHN BRZOSTOSKI, "Patination of Bronzes," *Craft Horizons* (November–December 1965): 26–28; DONA Z. MEILACH and D. SEIDEN, *Direct Metal Sculpture* (New York: Crown, 1966), "color and patina," 35 ff.; JOHN BALDWIN, *Contemporary Sculpture Techniques: Welded Metal and Fiberglass* (New York: Reinhold Publishing Corporation, 1967), "patinas," 60 ff.; NATHAN CABOT HALE, *Welded Sculpture* (New York: Watson-Guptill Publications, 1968), "patinas," 126 ff.; DONALD J. IRVING, *Sculpture: Materials and Process* (New York: Van Nostrand, 1970), "finishing," 127 ff., "patination," 136 ff.; JEAN DE MARCO, "Bronzes and Their Patinas," *National Sculpture Review* 21, no. 1 (Spring 1972), 23–25 and 21, no. 2 (Summer 1972), 25–26.

53. SLOBODKIN, *Sculpture*, 166.

54. ROOD, *Sculpture with a Torch*, 39.

55. HENRY MOORE, *Henry Moore on Sculpture*, ed. Philip James (New York: Viking Press, 1967), 140.

The Surface of Objects and Museum Style

ERNST VAN DE WETERING

There are negative undertones in describing someone as superficial. A person is more highly valued if his views and feelings are perceived to have depth. We also tend to mistrust our attitudes toward the surfaces of objects; we would rather wait and see whether the surface of an object really corresponds in quality to that which lies beneath. Emphasis on the surface provokes thoughts about appearances being deceptive, about glitter rather than gold.

You may thus imagine that my ears perked up when, in her significant paper at the last seminar in Veszprém, Hanna Jedrzejewska concluded that "the most important and the most representative part of an object is its surface." [1]

Museum objects are—unfortunately—only there to be *seen*. Thousands of people earn their living preventing untold thousands of others from touching the objects. But what, other than the surface, can be seen of an object? Moreover, it is the surface that bears the finishing touches and the finest workmanship of the original artist or craftsman. It is, however, also the surface that is most exposed to environmental influences and rarely resembles its original appearance. And that is the crux of a very complex problem. The term "patina dilemma" has already been used in this connection. In attempting to resolve this dilemma, it is most important to consider the peculiarities of our perception.

The moment one consciously concentrates on surface phenomena, one is overwhelmed—at least I was—by the unbelievable diversity in the

Originally presented in English by ERNST VAN DE WETERING at the Third International Seminar for Restorers, Veszprém, Hungary, 1981; published under the title "Die Oberfläche der Dinge und der museale Stil," *Maltechnik Restauro* 2 (1982): 98–102. Copyright Ernst van de Wetering. Used by permission of the author. Translated by Alexandra Trone.

appearance of the objects all around us. That sensing these surface appearances intensively should cause a near-psychedelic experience without recourse to drugs indicates that we consciously experience relatively few of these impressions in our daily lives. Instead, we generally use them without identifying and assessing an object; we then know whether we are likely to bump into it, whether we will dirty our hands if we touch it, how heavy it might be if we were to try to lift it, et cetera.

Objects are often identified by other means in which the appearance of the surface plays no part. When, as a seventeen-year-old, I went to France for the first time and, after traveling all night, found myself walking through the streets of a typical hilly southern French town, a solitary ball suddenly rolled round the corner in the gutter. Wanting to be helpful by returning the ball to its unseen owner, I kicked it—and then limped for the rest of the day: the ball was made of iron. The fact that it was rolling down the street and that it was round (I had never heard of the game of *boules*) sufficed to prevent me from noticing any of its other properties, such as the appearance of the surface or even the clattering noise it must have made. The only material I could even begin to consider that ball to have been made of was rubber.

The realization that we are able to form an idea of the surface characteristics of an object by indirect means also explains why we easily accept working with countless photographs of the objects that occupy us professionally in museums. It hardly troubles us that the subtleties of the appearance of the surface are lost or falsified in these reproductions. In looking at the photographs we imagine the surface on the basis of our visual memory bank.

In this one kind of "seeing" the image is thus based to a great extent on memories and on the expectations based on these memories. The appearance of the object before us is conveyed to our minds by a quick glance—in daily life also by means of the other senses: hearing, smell, touch. Our readiness to see what we expect to see causes us to overlook a lot. It is for this reason that the museum visitor overlooks damage of all sorts as well as very crude restorations; this could be taken to imply that we need not expend too much effort on restorations.

On the other hand, this same, average museum visitor perceives surfaces very sensitively—not only in the course of intensive examination, but also in daily life while casually glancing at things in passing. We often pass verdicts on our fellow human beings based on the tiniest stains, on minute blemishes, on specks of dust. Entire industries are built on the inclination people have to repair the smallest deficiencies in surfaces of the most varied types: in clothing, furniture, cars, tableware, the human skin, et cetera. Here our perception is apparently very sophisticated—even at the briefest glance.

Oddly enough, it is precisely the small areas of surface damage perceived at speed—either consciously or much more often subconsciously—that do not really disturb us (unless, of course, they affect our own property); on the contrary, we use these surface deficiencies to identify and assess the objects around us. Our sensitivity to these small signposts is great. We are all profoundly knowledgeable about the signs of aging on the outer skins of things. My knowledge of the ways in which a paint layer on a wooden ground forms blisters and *craquelure,* how it separates from the ground, was essentially acquired in childhood, as I sat next to the green-painted coal bunker in my parents' garden, absentmindedly breaking off flakes of paint and squashing blisters that collapsed with a cracking sound. A refined understanding of the nature and appearance of iron corrosion was developed by observing the rusty nail on which the coal shovel hung. The familiar wooden door handles in my grandparents' house are the basis for lovingly acquired impressions of the ways and means by which wood wears and becomes shinier in some spots than in others through constant handling. We could surely all spend hours telling one another about the development of the enormous range of knowledge of the surfaces of things that each of us possesses.

A knowledge of what we now somewhat abstractly call "natural aging" is acquired early in life. We use this knowledge daily in order to find our way around objects. Although we may not be aware of it, it is specifically the signs of natural aging and of wear that often provide us with significant information about the material of which an object is made. These signs also provide instant information about the meaning of an object and about the ways and means in which it is used; they even let us know the extent to which it is valued—or neglected. The early Flemish painters already incorporated small signs of damage in the painted objects in their panel paintings to enable the observer to identify the materials of which these objects were made. An example is the detailed portrayal of the chipped stone on the niches in Gerard David's *Annunciation* (Fig. 1). The painters in Rembrandt's circle were able to represent the relationship between the persons depicted in their paintings and the objects around them, such as books and furniture, by emphasizing signs of the objects' use in their depictions (Fig. 2).

Both the signs of aging and the signs of wear may be disturbed severely in the course of restoration; even if they are consciously respected by the restorers, an alien effect may result. The surface acquires a look that does not occur "in nature": one has the feeling that something has happened to the object although one does not usually get as far as asking oneself consciously just *what* is odd about it. Yet the piece has acquired the characteristics of a museum object. It becomes an intermediate object between a carefully preserved object of daily use—such as a well-polished shoe, its brittle leather

Figure 1
Detail of the *Annunciation* painted in grisaille by Gerard David. The small chips off the corners of the niche were apparently intended to identify the material depicted as stone.

smeared with shoe cream, a process we take for granted as a sign of diligence and cleanliness—and an object that has aged at its own pace, and carries an air of having been left untouched for a long time. By its untouched condition it spans, amazingly, the gap between us and the distant past, and unexpectedly gives us the feeling the Dutch historian Huizinga called *de historische sensatie:* the propulsion into a direct experience of the past.

Many carefully conserved objects have had surface treatments that have either interfered with the evidence of the materials of which they are made or have blocked direct access to their past; the objects have thus become, through such treatment, stylized objects of our own time.

Figure 2
Detail of Rembrandt's *Portrait of the Preacher Cornelisz Anslo and His Wife.* The book lying on the table has lost its binding, suggesting its intensive use and thus the great learning of the preacher.

418

A frequently occurring example of this kind of alienating condition is the nearly invisible protective layer that is applied to many objects. As we accept this in the case of the above mentioned shoe, so we also accept the pleasing domestic layer of wax on the polished surface of furniture, the obligatory varnish layer on a painting. With many other sorts of objects, however—archaeological objects, tools, utensils, et cetera, but above all with objects that to some extent convey the sense of decay as a process—such a layer can have a very disturbing effect. This layer often reveals minor surface damage or defects in the outer layer of engravings as well as in pits of corrosion on metal objects. At those points where the surface recedes or advances to a different level, these layers tend to create small catchlights that alert the observer to the fact that the object is covered with a thin layer that is meant to be invisible. One begins to get the unpleasant feeling that a momentary state in the movement through time has been indiscretely fixed.

Another example of the alienating effect of interference with the skins of objects is the partial interruption in the continuity of the signs of aging. We have a pronounced sense of the logic of a given form of damage; for example, we have a clear expectation of the way in which a crack will develop in stone, in wood, in terracotta or in porcelain. If such a crack is partly closed in the course of restoration because the surface of the object demands continuity at that point—for example, in connection with the retouching of a painted motif—our expectations of the behavior of this material are confused. It seems as though the entire object has been transformed from its familiar state of brittleness into a viscous mass.

Yet another example is the type of retouching in which the color on the surface is continued by the restorer into the depression of a damaged area of an object that is not apparently massive. This sort of interference profoundly affects the appearance of the object, because it is no longer possible to have confidence in the integrity of the surface layer as an authentic whole.

If only one single aspect of the aging of the surface is obliterated during restoration, while others remain, the results can be most disturbing. The connections between the signs of aging are dissolved, so that the object is partly displaced in time, resulting in a common form of museum stylization.

Although they are perceived only subconsciously, the examples of alienating conservation and restoration treatments described here may cause a slight feeling of revulsion, which can disturb or even eliminate any sympathy with the object.

Patina has long been highly esteemed in the broadest sense and considered to be a part of the identity of the object. In this sense the prevailing significance of patina is as a symbol, as a sign that something is old, worthy of respect, and genuine; and as with all symbols, a general indication suffices

to give the idea. As a result, an industry of patina kitsch has developed whereby these symbolic values are "glued" onto objects in the cheapest way possible. The tin rusk box with printed-on *craquelure* and gradual darkening toward the edges commonly appears on many Dutch breakfast tables. It radiates coziness and seems to have been around since granny's day. But make no mistake: this patina kitsch is to be found in antique shops, and if we are not careful, it will be promoted in museum showcases as well. It is the result of searching for a balance between stability and cleanliness on the one hand, and on the other hand, the emanation of a worthy venerability. The increasingly sophisticated facilities, ingenious showcases and theatrical lighting in museums are leading to the taming and stylization of the often somewhat unintentionally savage air that clings to many objects, hinting at past calamities. Many restoration and conservation treatments have, often unintentionally, a subtle cosmetic effect that leaves the objects imperceptibly well groomed, so that they comply with museum style.

One might ask another question about museum style: How much influence does incessant confrontation with reproductions have on our aesthetic expectations and demands? One might, for instance, ask to what extent our concept of a beautiful surface is influenced by modern color reproductions. Could there be a parallel with a phenomenon known to have affected the early American symphony orchestras? Somewhat tinny tones were discernible in their sound, tones typical of those heard in recordings of the renowned European orchestras of the time: these records represented the ideal sound to contemporary American musicians.[2] It might be thought to follow that the splendid reproductions available today have such an influence. Every shade of each color is saturated, thanks to the glossy paper and the properties of the printer's ink: many, not always necessary, surface treatments in the restoration studio result in similarly saturated colors, and this gives rise to a singular perception of the authentically historical. On the other hand a diffuse refraction of light, which results in a somewhat dusty appearance, is very rarely seen with objects in museum exhibition cases. However, it occurs commonly on the surfaces of old objects in "the natural state" and contributes greatly to the experience of authenticity.

In describing the effect of interventions on the character of the surface—many more examples of which could, of course, be given—the object thus treated was several times compared to a similar object as it occurs in "the natural state." It should be clear what is meant by "the natural state" in this context: those conditions in which objects are left to age, change, and wear out in their own way. Also meant by "the natural state" is the immense picture book of the manifestations of aging that we build up in our visual memories from childhood on; one might almost say a pattern book into which the surface appearance of many restored or conserved objects does

not really fit. And that leads to the alienating effect that occurs more often than one is aware of consciously. It goes without saying that the "naturalism" here being defended has nothing to do with nostalgia. It also is certainly not "capitalist culture-fetishism" as an academic critic has described my efforts. It concerns the ability to recognize the object undistorted, to perceive it unobstructed.

When objects are in need of conservation, it admittedly sometimes seems inevitable that the character of the surface is changed by treatment. The argument may then be that the change was technically unavoidable, that the alteration occurred inadvertently. What makes the work of the restorer so interesting, however, is that he does not limit himself to the technically *possible*; on the contrary, he regards the technically *impossible* as a personal challenge. It was precisely the ethical and aesthetic demands of restoration that caused many traditional solutions to conservation problems to be considered unsatisfactory and made the need for quasi-impossible new solutions unavoidable.

Minimalism in conservation and restoration can be defended in various ways. The most significant argument is surely the need to preserve the many-layered documentary evidence that every historic object bears. No one can foretell what sort of questions will be asked of the object in connection with future attempts at interpretation; in examining (art) historical objects one all too often discovers that essential traces have been made unintelligible or destroyed during treatment because their meaning went unrecognized. The argument against minimalism is that the object ought to be presentable and stable in its present function and should therefore be thoroughly restored. The discussion above is intended to bring some shades of distinction to this objection.

Notes

1. HANNA JEDRZEJEWSKA, "Basic Problems in the Conservation of Stone," *Problems of the Completion of Art Objects: Second International Seminar for Restorers, Veszprém, Hungary, 15–27 July 1978,* ed. Adam Szemere (Budapest: Institute of Conservation and Methodology of Museums, with the support of Unesco, 1979), 36.
2. V. ZUCKERKANDL, *Sound and Symbol,* Bollingen series 44 (New York: Pantheon Books, 1956); G. C. KOP, *Mens en Muziek: Inleiding tot de paedagogische muziekpsychologie* (Amsterdam: J. Muusses, 1958), 155–56.

PART VIII

The Role of Science and Technology

Riace bronze during restoration,
1993. Museo Archeologico
Nazionale, Reggio Calabria, Italy.

The Role of Science and Technology

The last issue discussed here is the most controversial: the relationship between the natural sciences and the humanities, and their roles in conservation. Conservation was once the undisputed domain of the humanist and the technical restorer. In recent years, the scientist has intervened with the intent of showing the rationality and empiricism of the scientific method and making available the growing body of knowledge that chemistry and physics were already accumulating by the middle of the nineteenth century. It has been necessary, in fact, to limit certain excesses and put a brake on the experiments of some restorers who lacked scruples or any sense of measure.

There is no lack of examples. For one, the paintings in the Temple of Isis at Pompeii, detached at the time of their discovery (1764–66) and conserved in the National Museum of Naples, were displayed at an exhibition in 1992. On that occasion, studies and conservation treatments were carried out, and data relevant to the oldest restorations were recovered and closely examined.[1]

The information obtained is of great interest. The question of which techniques to use for detaching and conserving frescoes had been raised from the start of the excavations at Pompeii, some thirty years before the discovery of the Temple of Isis. Documentation of the work of Stefano Moriconi, an artillery officer, goes back to 1740. Introduced to the Bourbon court by Marcello Venuti, an antiquarian from Cortona, Moriconi made his fortune when he was put in charge of applying his own varnish recipe to all the paintings that had been discovered up to that time at Herculaneum and

Translated by Elizabeth Maggio.

424

Pompeii. The mixture, based on resins dissolved in alcohol, had already been applied to more than two thousand finds by 1766 when a dispute arose over the correctness of such treatments. The disagreement showed no signs of being resolved, so the king himself intervened, taking the drastic measure of prohibiting the use of varnish of any kind.

Consequently, the fragments of the Temple of Isis were not subjected to Moriconi's treatment, but the problem of conservation, which had only been put aside temporarily, was raised again around 1813 when Andrea Celestino, inventor of an encaustic treatment consisting of wax melted in turpentine, attracted the attention of Queen Caroline Murat. In this case, given the obvious damage caused by the preceding interventions, the Academy of Fine Arts and a group of experts from the Academy of Science in Naples were commissioned to study the treatment before the wax was applied to all the finds in the museum (1825). The experts worked in an exemplary manner; they subjected Celestino's mixture and the efflorescence present on the paintings to chemical analysis. On the basis of their findings, they not only approved the treatment but improved the procedures for preparing and applying the wax.

Several years ago, Norman Brommelle published a commentary on the reports from the Commissions of Enquiry that, in 1850 and 1853, were established by the House of Commons to verify the exhibition condition of the paintings at the National Gallery in London, the cleaning methods used, and the composition and efficacy of the protective varnishes that were applied.[2] The gallery was, incidentally, the first museum in which an air conditioning system equipped with a humidifier was installed (1844), the same system used in the Houses of Parliament.

From these documents come observations of great interest and significance about atmospheric pollution and its darkening effects on pictures. As part of his study on the methods used for the restoration and protection of paintings, Brommelle sent a questionnaire to a number of major European museums. He found, among other things, that, "In Rome 'the practice is to do as little as possible. The less restoration, the better.'"[3] This represents the principle of minimal intervention discussed earlier, a principle that has completely retained its validity to this day.

Also interesting to note from the same documents is that when interviewing John Seguier (restorer at the National Gallery during the time that Charles Eastlake was the keeper, 1843–47) about the methods for cleaning and removing old varnish, the commission stated this principle: "It is not desirable to bare the actual surface of the original master's work, but to leave some lower part of the coat of varnish, in order both to protect the surface of the picture, and also to maintain the mellow tone which the public prefers in

an ancient work of art." This is an enlightened principle that corresponds to the one Cesare Brandi proposed a century later and that continues to be followed by the Istituto Centrale del Restauro, the institution Brandi directed.

Conservation's relationship with science is, therefore, an old one. Undeniably, there was an understandable resistance by humanists, connoisseurs, and museum directors to admit the scientist into the decision-making circle. Eastlake (cited in Brommelle's study) was opposed to the continuing and fundamental presence of the renowned chemist Michael Faraday, preferring to use him as an adviser; thus he delayed by about a century the addition of a chemist to the National Gallery staff, something that happened only in 1948.

In reference to a work of art, Bernard Berenson, an undisputed authority, could still say in 1948 that "The technique likewise seems revealed clearly enough on the surface if it is in a fair state—clearly enough for the historian of art, if not for the historian of technique."[4] At this time the only instruments that had begun to infiltrate the uncontested reign of the humanist were the photographic camera and the X-ray machine; today, we could not do without them, but to the art critic of the time they seemed useless intrusions. Clive Bell seems to agree when he declares, "The specialist is never completely civilized."[5]

Despite this resistance, scientific methods and instruments have become an increasing presence. Paul Coremans reviews this in his 1961 article, included here (Reading 44, pages 432–38). He notes the key steps that led to the establishment of investigative laboratories and research centers in the major countries and to the publication of specialized periodicals and manuals. Among the latter is the book by Plenderleith, *The Conservation of Antiquities and Works of Art* (1956), notable for its excellent, clear treatment of the subject and for the vast quantity of material covered, from parchment to bronze.[6] This text reflects the direct experience of the author and is considered a milestone in research as applied to conservation.

But the road has not been as straight as Coremans outlines. After a promising beginning, on balance, the concrete contributions of science, while shedding light on some areas, have left others in obscurity; the judgment is not totally positive, above all regarding the effect of the new technologies applied to conservation during the last fifty years.

Because of technological innovation and the changes it has produced in the scientific community and in the traditional methods of practitioners, even basic conservation treatments have undergone a process of "modernization" that has not always been orderly or rational but often guided by market demands rather than scientific justification. Procedures and materials handed down over the centuries through the practice of artistic craftspeople and through technical treatises on the fine arts have often been abandoned. Their place has been taken by procedures and materials developed for the mainte-

nance of modern buildings or other productive activities without adequate experimentation, or with insufficient laboratory simulation, and with no verification of their compatibility with ancient materials.

Historians, art critics, and archaeologists are not the only ones debating these issues and condemning the damage done; the situation has also started a basic rethinking among architects and engineers.[7] A similar trend is also underway among chemists who have more experience in multidisciplinary work and in research applied to conservation.[8] Many of the predictions made by laboratories have not turned out as planned, especially in relation to the durability of industrial products used in restoration and their subsequent alteration. While diagnostic techniques have been widely practiced (and have been costly), they have made little progress in resolving several dramatic conservation problems.

More thought is being given to the negative impact that disciplines such as engineering and chemistry can have. These are disciplines that lack a sense of history and thus tend to reduce a cultural artifact to its constituent materials, denying its specificity. Engineers have begun a study of their own discipline, of the characteristics and origins of their culture; they have brought to light prejudices from the beginning of this century that were based on the scientific optimism and growing industrialism at the time. These prejudices caused a negative, summary judgment to be pronounced on preindustrial culture and traditional knowledge, considered regressive and obsolete, thus decreeing their demise.

By now the damage caused by this unjustified sense of superiority of technology over the knowledge inherent in the refined artistic techniques of the past is obvious. Many of the problems of degradation now affecting historic monuments are due to recent drastic interventions: the treatment of stone surfaces with unsuitable products, large-scale structural consolidations, the substitution of cement and steel for traditional building materials, and so on.

Movements parallel to environmental ones, as in Ruskin's time (Reading 16, pages 158–59), point to the distorted and indiscriminate use of industrial products and modern technologies as the cause of the progressive deterioration of the environment and cultural heritage, and the loss of identity and historical memory in many parts of the world.

The intervention of science must, perhaps, be looked at more closely. For example, Gael de Guichen maintains that science does not concern itself enough with conservation, especially preventive conservation, but concentrates human resources, tools, equipment, and research primarily on archaeometric studies and on the characterization of materials.[9]

Giorgio Torraca, long-time deputy director of the International Centre for the Study of the Preservation and the Restoration of Cultural Property

(ICCROM), shares this view. "Little by little, scientists learned to keep away from the dangerous domains of practical conservation. Instead they wandered into the safer pastures of the analysis of artifacts, from which a flourishing new branch of science (archaeometry) now grows" (Torraca, Reading 45, pages 439–40).

In Torraca's view, the role of science in the field of conservation is so vast that he is not shocked by how many innovations have come about by chance or from the interaction of scientists with historians and restorers rather than in the laboratory. Innovation has come even more often from technologists who have adapted commercially available products to the specific needs of conservation. Torraca sees the technologist, and not the pure scientist, as the key figure in the future.

Giovanni Urbani, director of the Istituto Centrale del Restauro for ten years, also took time to analyze the crises and difficulties inherent in the collaboration among historians, restorers, and scientists (Urbani, Reading 46, pages 445–50). He feels that the lack of motivation and of commitment that scientists show toward conservation is related to the marginal role assigned to them by historians and restorers; Urbani believes that the situation could improve decidedly if scientists were given the task of describing and measuring "the state of conservation" of objects.

But how does one define this "state of conservation?" There is no threshold or fixed value measurable with laboratory equipment; it depends on the significance attributed to an object and on its use. The evaluation of the state of preservation of an organ, and thus the type of restoration to undertake, changes radically if the organ is to remain mute and on display in a Baroque church or if it must be made to play music.

The problem becomes even more intriguing when we ask ourselves what relationship exists between state of conservation and aesthetic quality. Looking back for a moment to the arguments regarding patina discussed in Part VI, one can see that many times in the artistic literature the question arises of the effect of time on a work of art, and this effect is not always judged negatively.

The Greeks valued certain natural alterations of bronze and tried to imitate them; even before the Romantic concept of "age value," the obfuscating effects produced by varnishes were sought by antiquarians in the eighteenth century. The refined irony with which George Hogarth interpreted this theme in his drawing, *Time Smoking a Picture* has already been noted (see also Weil, Reading 37, page 399).

Urbani was very insistent on this point and turned to a particularly fascinating example. He described the atmosphere of tension and reverential awe displayed in the presence of a large cardboard box containing a painting

by Renoir in the storeroom of the Museum of Modern Art in New York. Having barely escaped destruction in a fire, the painting was nearly carbonized but still perfectly recognizable as a Renoir, made even more fascinating by its extraordinary state.

By using this whimsy of fate—this extreme case—to make his point, perhaps Urbani was trying to explain a motive for the art historian's minimal interest in the problems of conservation, at least as long as a work of art retains some beauty, however faded and disfigured, through the "patina of time."

Urbani himself was not exempt from this type of fascination. Following the restoration of the equestrian statue of Marcus Aurelius, he believed, judging solely on aesthetic grounds, that this great bronze monument was "in a good state of preservation," so much so that it could be displayed once again in the open in the polluted air of Rome (see introduction to Part IV, page 263). Unfortunately, this was not true despite the overall magnificent effect. In addition to the chemical alteration of the metal, the lacunae and the discontinuities of the bronze, from the smallest to the largest, are so numerous that conservation of the statue in the present state of knowledge is possible only in a protected environment.

Art historians can be misled by the aesthetic quality of a work of art and misunderstand its actual soundness and ability to withstand stresses. But this does not mean that the determination of the state of preservation of a work does not concern them, as the value of the work is derived by common consent from various factors, aesthetic ones certainly among them.

How can we get out of this situation, and which roles should be assigned to science and which to history and aesthetics? According to Urbani, monuments today have acquired an anthropological value beyond their aesthetic value; they have become elements of the urban environment. Their increasing decay is disturbing, a further example of the loss of identity for historic centers.

It would be possible, then, to entrust scientists with the task of measuring, apart from aesthetic characteristics, the state of conservation of a work of art; such scientific imagination would be the only form of creativity allowed today, since artistic creativity is precluded from modern concepts of history and restoration.

Unfortunately, Giovanni Urbani is no longer with us, and we cannot ask this art historian if he really meant to remove from his discipline the possibility of defining "the state of conservation" of a work; that is, the formulation of complex value judgments that cannot be measured with chemical and/or physical instruments. If so, the final evaluation of the compatibility between the intervention required for the survival of a work of art and

the conservation of its historical and aesthetic characteristics depends on its physical condition, once this has been established from various points of view and according to different disciplinary approaches; and even this determination is not a simple or an unambiguous matter.

Complex evaluation is, however, the task that in the Italian tradition and in the tradition of other Western countries properly belongs to the critic and historian; that is, those who understood the values of an object's specific nature as a monument, work of art, or document.

In other cultural contexts, such a responsibility is assigned to conservators. Even these professionals must be fully aware that their role is justified not because an object's material exists, but because that material has assumed, by cultural agreement, a function that is symbolic, communicative, and aesthetic.

It must be kept in mind that the provocative statement made by Urbani about ten years ago may not have been based on a serious intention to assign the role of defining the state of conservation of a work of art only to scientists. If anything, it was motivated by his bitterness at so much disinterest in the problems of conservation shown by many of his art historian colleagues.

In tribute to Urbani's teaching, this writer hopes to have contributed to furthering knowledge critically needed to better protect cultural heritage.

— AMV

Notes

1. RENATA CANTILENA, "La conservazione ed il restauro dei dipinti pompeiani, tra Settecento ed Ottocento," in *Alla ricerca di Iside: Analisi, studi, e restari dell'Iseo pompeiano nel Museo di Napoli*, exhibition catalogue (Naples: Arti ed Industria, 1992), 105–10; and PAOLA CINTI, "Intervento di restauro," in *Alla ricerca di Iside*, 115–22.

2. N. BROMMELLE, "Material for a History of Conservation," *Studies in Conservation* 2 (October 1956): 176–88.

3. Ibid., 180.

4. BERNARD BERENSON, *Aesthetics and History in the Visual Arts.* (St. Clair Shores, Mich.: Scholarly Press Inc., 1948; reprint, 1979).

5. CLIVE BELL, *Civilization and Old Friends* (Chicago: University of Chicago Press, 1973), 76.

6. H. J. PLENDERLEITH, *The Conservation of Antiquities and Works of Art* (London and New York: Oxford University Press, 1956).

7. E. BENVENUTO, "L'ingresso della storia nelle discipline strutturali," *Palladio* 1 (June 1988): 7–14; S. D'AGOSTINO and G. FRUNZIO, "Consequences of Small Earthquakes on the Artistic Heritage," in *Structural Preservation of Architectural Heritage* (Zurich: IABSE-AIPC-IVBH, ETH-Honggerberg CH-8093, 1993), 255–56; and S. D'AGOSTINO and G. FRUNZIO, "Structural

Restoration of Archaeological Monuments in Seismic Areas," in *Proceedings of the Tenth European Conference on Earthquake Engineering,* ed. A. A. Balkema (Rotterdam: Uitgevers B. V. Postbus 1675 NS–3000, forthcoming).

8. Robert L. Feller, "Concerning the Place of Science in the Scheme of Things," in *Training in Conservation: A Symposium on the Occasion of the Dedication of the Stephen Chan House,* ed. N. S. Baer (New York: Institute of Fine Arts, New York University Press, 1989), 17–32.

9. Gael de Guichen, "Scientists and the Preservation of Cultural Heritage," in *Science, Technology, and the European Cultural Heritage: Proceedings of the European Symposium, Bologna, Italy, 13–16 June 1989,* ed. N. S. Baer, C. Sabbioni, and A. I. Sors (Guildford, England: Butterworth-Heinemann, 1991), 17–26.

Scientific Research and the Restoration of Paintings[1]

PAUL COREMANS

Manuscripts and treatises on painting from the Middle Ages and the Renaissance have certainly bequeathed us a few recipes concerning the restoration of easel paintings, but it was only in the seventeenth and especially the eighteenth centuries that the earliest specialized studios appeared, first, it seems, in Italy and France;[2] in the nineteenth century, when most of the museums of Western Europe were created, restoration came into its own, and collections of recipes and advice dealing with the care of paintings were published. Up to the end of the eighteenth century, archival documents and literary sources in this area were relatively rare in Belgium; it was not until 1815, when hundreds of paintings returned from France all requiring urgent care at the same time, that restoration too abruptly took off.

Literature gives us ample information about what is meant by restoration almost all through the nineteenth century. In our country, Belgium, this delicate enterprise was the sole responsibility of the regional or national administration: an advisory committee was appointed of members of scholarly societies at times assisted by some professional painter—"a council of sages," if you like—and they laid out a path to follow in a very specialized area they knew nothing about, with only their conscience as their guide. Obviously, the reports do not describe operational details, and since the solvents used are part of the secrets of the studio,[3] they are almost never mentioned;[4] interest is mainly concentrated on the paint layer alone, which is cleaned according to the best principles of aesthetic surgery; and when it is

From PAUL COREMANS, "La recherche scientifique et la restauration des tableaux," *Bulletin de l'Institut Royal du Patrimoine Artistique* 4 (1961): 109–15. Used by permission of the Institut Royal du Patrimoine Artistique. Translated by Barbara Harshav.

the wood support that is in question, there is a tendency to demonstrate know-how by blocks and parquet backing, or else to recommend the disastrous transfer to a new support. These are the same controversies we encounter today, especially when the issue is choosing the restorer, on whom the survival of the work depends.[5] The nineteenth century was the period of glory of empiricism,[6] of secret formulae; it was also the romantic period of restoration that, in line with the aesthetic of the time, favored tinted glazes and compelled the restorer to overpaint even more broadly, since he had to present only those works that were apparently intact, as if time had done nothing but skim over them.[7]

The situation improved somewhat when museums became aware of their responsibilities, including the preservation of the cultural objects that had been entrusted to them; and when university curricula incorporated art history, which gradually substituted teams of professional scholars for enlightened amateurs. With the aid of experience, restorers could diversify and perfect their operational techniques, and by the end of the nineteenth century, restorers worthy of the name were working in several studios in every single Western country.

However, the honor of leading restoration into a brand new direction was due to the natural sciences. That step had to wait until those sciences, particularly physics and chemistry, attained an adequate stage of development.

Let us recall that if well-known chemists and physicists made their contributions to the history of art and archaeology throughout the nineteenth century and even—though very rarely—prior to that, this assistance was only occasional and aimed only at short-term applications.[8] The chemistry of ancient materials could be practiced only on minimal samples; it was only in 1870 that von Pettenkofer introduced the use of the microscope, and in 1905 that Ostwald used the resources of microchemistry; it was not until 1914 that Faber demonstrated the usefulness of the radiography of pictures, at the same time as Kougel revealed the resources of ultraviolet and fluorescence. Then it was necessary to wait until after the war [World War I] for the general application of X rays and ultraviolet; at the same time (1924–32), infrared photography emerged, primarily thanks to Bayle, and Maché made spectrography a useful technique in the examination of paintings.

With one exception—the Staatliche Museum of Berlin, created in 1888—museum laboratories[9] did not emerge until after World War I, as, for instance, the laboratory in the British Museum of London, which has been functioning since 1919. There are now about twenty of them throughout the world, along with, of course, the many technical studios of restoration.

Ever since the interwar period,[10] the activity of these museum laboratories has produced a series of monographs and articles devoted to the

scientific examination and restoration of cultural property, and has led to the appearance of specialized periodicals. The meeting in Rome in 1930 of a group of experts from various countries at the initiative of the International Office of Museums led to the publication of a monograph on the preservation of paintings and placed the problem on an international level.[11] After World War II, contacts multiplied especially thanks to Unesco,[12] the International Council of Museums (ICOM)—notably among the International Committees for the Treatment of Paintings and for Museum Laboratories—and because of the International Institute for Conservation (London); the International Center for the Study of the Preservation and the Restoration of Cultural Property, established in Rome; and the international meetings organized around particular problems by Great Britain (Weaver Committee), Belgium (van Eyck, Bosch, Rubens), France (Leonardo da Vinci) and Italy (Giotto).

Instruction in the scientific examination and preservation of objects of art and archaeology has made its way into the university.[13] There are now specialized courses in various countries, the most recent at the Conservation Center of the Institute of the History of Art at New York University, which grants "an M.A. in Conservation."[14]

Thus, from its initial empiricism, the restoration of old paintings gradually progressed first as a craft, solely through the efforts of the restorer. Then, from its collaboration with the museum chemist and physicist, the science of restoration was born with more solid theoretical bases and a tested experimentation. Far from diminishing the contribution of the practitioner (restoration will never be the work of the laboratory scientist), it offers the support of an experimental and inductive science. At the same time, the restorer and the laboratory scientist have developed an association with the art historian and the connoisseur, each now able to call on a specialized literature constantly enriched by a broad international cooperation that catalyzes teamwork and mitigates the apparent or real contradictions between different schools of training and thought. So we are far from the tightly locked studio, the secret formulae, the subjective vision of a restorer working alone. In our time, everything is done in broad daylight; there is a common doctrine on the subject of restoration, operational techniques familiar to everyone, and general rules applied by those who undertake the preservation of the masterpieces of the past.[15]

We now come to define the preliminary examination in the treatment of every important work.

This examination comprises several aspects requiring constant collaboration between the restorer and specialists in various disciplines. It essentially calls for the identification of the original materials, their composition,

the structure of the various layers, as well as the determination of the painting technique; the distinction between the original and the subsequent coatings, in order to establish the chronology of successive restorations; and hence the knowledge of the material condition of the work before its treatment, the causes and forms of the disorders that afflict it, and their possible consequences for its preservation. All those laboratory data are then collated with the material history of the work (displacements, deteriorations, removals of varnish and revarnishings, cleanings and restorations), which is studied in archival documents and literary sources. The laboratory analyses are thus integrated into their historical and artistic context and acquire their full meaning. Once this result is achieved,[16] the nature and mode of treatment can be specified with much greater chance of success and its phases of execution followed much more rigorously—and without fear of harmful interference in the very delicate operation of the actual restoration, in which only the mastery of the restorer is exercised.[17]

Chemistry and physics are young sciences, and so is art history. Aesthetics has existed much longer, but its criteria have varied over time.[18] If restoration must rely on these diverse disciplines to varying degrees, the technique of restoration[19] will be truly perfected only as a function of the progress of the exact sciences. This progress is constant: microscopy and microchemistry first received the contribution of X rays, ultraviolet and infrared rays—true, for only a few wavelengths—and of emission spectrography; and, especially since World War II, new physics techniques, some of them not requiring any sample of precious material, have invaded the laboratory and offer promising solutions. We can now vary the wavelength in the invisible spectra, transforming it into an image perceptible to the eye; absorption spectrography presents endless possibilities for the determination of the organic structure of materials; chromatography is already applied successfully, as are microradiography, the X-ray diffraction, electronic microscopy, and the method of determining the relative age of ancient organic materials by radiocarbon.[20] We went beyond the simple identification of anions and cations long ago, and attention is now concentrated on the physical structure of the material, which thus reveals its real nature along with the alterations due to age.

Particularly in the area of ancient painting, with some exceptions, we are familiar with the pigments, which are almost always inorganic; yet we are still far from having an adequate knowledge of the binding agents. Only some microreactions, sometimes of dubious value, allow us to determine the presence of gums, resins, gum resins, and drying oils, especially since those substances appear only in very weak proportion and are often found in a compound, and since age has altered their molecules. But if we pursue systematic research for several years, notably using absorption spectrography,

we will certainly have more chance of success in approaching the identification of the binding agent of the easel painting—hence the descriptive study of painting technique—and in following its evolution through time. At that moment, the technical history of painting can finally be written, and the very important chapter of the transition from a water-based binding agent to an oil-based binding agent—a transition that seems to have occurred in our area in the early fifteenth century—will take its rightful place in that history. This is one of the most important and exciting problems, both for the art historian and for the laboratory scientist.

There are many other problems that await a solution, but as in all other areas, to encourage research is to open new paths that someday—it is hard to predict when or how—will allow us to rethink the whole problem of the preservation of our cultural heritage. It is urgent to consider that at a time when, for quite diverse reasons, this heritage is deteriorating more rapidly than ever.

Notes

1. [p. 109 n. 1] "Scientific research" in the sense of research in a physics and chemistry laboratory; "restoration" of paintings in its broadest meaning, or all operations applied to an easel painting.

2. [p. 109 n. 2] Cf. M. CAGIANO DE AZEVEDO, *Bolletino dell'Istituto Centrale del Restauro* 1 (1950): 44–45, and 3–4 (1950): 113–21; L. BORRELLI, *Bollettino dell'Istituto Centrale del Restauro* 1 (1950): 71–84. E. BERGER, *Quellen für Maltechnik während der Renaissance und deren Folgezeit: Beiträge zur Entwickelungs-Geschichte der Maltechnik* (Munich: G. D. W. Callwey, 1901), comments on the history of restoration based on published sources.

3. [p. 110 n. 1] "Secrets artisanaux" [trade secrets], we might say, which were found both in painting studios as well as restoration studios. As early as the fifteenth century, several foreign artists (Antonello of Messina, for example) came to Flanders to fathom the secret of the new binding agent of paintings.

4. [p. 110 n. 2] This is the period when cleaning was apt to be done with a potato or an onion, the cleaning action itself accomplished by soda or caustic potassium.

5. [p. 110 n. 3] A salient passage from the documentation of the Royal Commission of Monuments and Sites (File 2423.8), dated 1 July 1862, seems quite contemporary in this respect: "Le Conseil provincial, en votant la première allocation en faveur des restaurations d'anciennes oeuvres d'art a fait la recommandation formelle à la députation permanente d'employer des artistes appartenant à la province et je crois qu'il est à la fois convenable et prudent de tenir compte de ce voeu dans l'intérêt même de la prompte et facile solution des questions de ce genre qui peuvent se présenter" [The provincial Council, by voting the first allocation for the restoration of ancient works of art has made the formal recommendation to the permanent deputation to employ artists belonging to the province and I think it is both suitable and

prudent to take account of this wish in the interest of the prompt and easy solution of questions of this kind which may arise].

6. [p. 110 n. 4] Inquiries conducted by the National Gallery of London toward the middle of the nineteenth century are quite instructive in this respect. Cf. N. BROMMELLE, "Material for a History of Conservation," *Studies in Conservation* 2 (1956): 176–88. In chemistry, the empiricist period came to an end only at the end of the eighteenth century. Previously, just like the restorer a few decades later, the chemist was devoted to personal experiments, and the resulting conclusions were never worth more than a studio recipe.

7. [p. 110 n. 5] The same was true of the other plastic arts; in architecture, a damaged stone was replaced, a restored ancient monument became a brand new building.

8. [p. 111 n. 1] COREMANS, "L'introduction d'un nouveau critère d'appréciation des oeuvres d'art: Les sciences naturelles," *Alumni* 19 (1950): 292–301.

9. [p. 111 n. 2] Ibid.

10. [p. 112 n. 1] We must pay homage to the Berlin laboratory, whose first director, F. RATHGEN, published a remarkable manual titled *Die Konservierung von Altertumsfunden* in 1905, long before World War I. Several monographs emerged after 1919; the latest, of particular importance, is that of H. J. PLENDERLEITH, *The Conservation of Antiquities and Works of Art* (London and New York: Oxford University Press, 1956). Among the periodicals, we must cite especially *Mouseion,* bulletin of the International Office of Museums (1927–43), succeeded by *Museum,* published by Unesco since 1948; like the organs of various national associations of museums, the oldest being the *Museum Journal* of Great Britain, these devote only occasional articles to the examination and restoration of cultural property. This objective became the essential concern of *Technical Studies in the Field of the Fine Arts,* published by the Fogg Art Museum, Harvard University (1932–42), a role that was taken up in 1952 by *Studies in Conservation,* the journal of the International Institute for the Conservation of Historic and Artistic Works established in London, and by the bulletins of various specialized institutions.

11. [p. 112 n. 2] In 1932–33, H. J. PLENDERLEITH summed up the essence of the exchange of views in Rome in "The Examination and Preservation of Paintings: A Digest," *Museums Journal* 32 (1932–33): 308–10, 349–51, and 388–89. Volumes 41–42 (nos. 1–2, 1938) of *Mouseion* were devoted to the conservation of paintings; in 1939–40, a special volume was published in English and French titled *Manual of the Conservation of Paintings.*

12. [p. 112 n. 3] The missions of experts organized and subsidized by Unesco deserve special mention. They allow us to reach the developing countries, synthesize the major problems they confront, train specialized technicians, and thus gradually reach an autonomous organization for the protection of cultural properties. Belgium participates actively in that endeavor.

13. [p. 112 n. 4] In this respect, Pasteur was a precursor. From 1863 to 1867, despite the opposition of certain authorities who did not accept "the introduction of courses alien to art," he occupied the new chair of geology, physics, and elementary chemistry in l'Ecole des Beaux-Arts of Paris. His course, he said, "a l'application pour but, mais une science exacte pour point d'appui" [has application as a goal, but an exact science as its support]. Cf. D. WROTNOWSKA, "Lettre inédite de Pasteur, professeur à l'Ecole des Beaux-

Arts," *Bulletin de la Société de l'histoire de l'art français* (1954): 134–42; and
"Notes pour des leçons de physique et de chimie appliquées aux beaux-arts,"
in *Mélanges scientifiques et littéraires, Table chronologique, Index analytique et
synthétique de l'oeuvre de Pasteur*, vol. 7 of *Oeuvres de Pasteur*, comp. Pasteur
Vallery-Radot (Paris: Masson, 1939): 223–62.

14. [p. 113 n. 1] The initiative should be pursued. Many of the difficulties will be
ironed out when art historians and archaeologists become familiar with the
basic data that govern the scientific examination and restoration of cultural
property. See in this respect P. PHILIPPOT, "Réflexions sur le problème de
la formation des restaurateurs de peintures et de sculptures," *Studies in
Conservation* 5 (1960): 61–70.

15. [p. 113 n. 2] This evolution is demonstrated by the title given in certain
countries to the technician of restoration. The United States generally speaks
of a "conservator," as in Germany, where the same term "Konservator" is used.
On the other hand, countries that speak Romance languages still retain the
word "restaurateur," reserving the title of "conservateur" for art historians in
museums, who once had sole responsibility for the preservation of the cultural
heritage.

16. [p. 114 n. 1] Unesco and ICOM attach such importance to the preliminary
scientific examination that they have issued a special recommendation on
this subject; they also emphasize the written and graphic documentation that
must accompany every examination and treatment of a work of art. We need
only recall the difficulties of interpretation of the reports of the nineteenth
century to admit the merit of the recommendations of these international
organizations.

17. [p. 114 n. 2] From that moment on, the only valid dialogue is between
the work of art and the restoration craftsperson, and it is only when the
craftsperson is familiar with the work of art both spiritually and materially that
the manual work will begin. It is also at that moment that the scientist and the
art historian realize that the restorer is no longer the agent of execution of the
past but is a full-fledged collaborator.

18. [p. 114 n. 3] Thus presented, aesthetics appears as a dubious criterion. In fact,
the evaluation of artistic beauty is sometimes more difficult than the search for
scientific truth. This is probably why the evolution and progress of aesthetics
find such a weak response among nonspecialists.

19. [p. 114 n. 4] The treatment of an old painting was defined in Brussels in 1950
by an international committee of experts as "an operation of a technical nature
aiming to assure the preservation of the work with a minimum of restoration
(that is, surgical intervention, as opposed to preservation, which seeks above
all the preservation of the work), with the strictest respect for its historical
and aesthetic integrity." Cf. P. COREMANS (director), "L'Agneau Mystique au
laboratoire: Examen et traitement," Les Primitifs flamands 3, *Contributions à
l'étude des Primitifs flamands* 2 (Anvers: De Sikkel, 1953), 9–10.

20. [p. 114 note 5] Cf. I. ELSKENS, "Note sur l'installation à l'Institut d'un
laboratoire de datage par le radiocarbone," in the present volume of this
Bulletin [*Bulletin de l'Institut Royal du Patrimoine Artistique* 4 (1961)].

The Scientist's Role in Historic Preservation with Particular Reference to Stone Conservation

GIORGIO TORRACA

Application of Science to Conservation

In 1818 Sir Humphrey Davy was sent by the king of England to Naples with the task of speeding up the unrolling of charred papyrus scrolls that had been discovered more than sixty years before in a villa near Herculaneum. In the previous years a local friar had devised a complicated contraption with which he was able to separate the papyrus sheets, but with extreme slowness; only a few scrolls were opened in that period. Because it would have taken centuries at that rate to unroll the whole library, all intellectual Europe became impatient. Everybody wished to know the content of the first Classical library ever discovered.

Davy tried rapid chemical means on eleven scrolls, all of which were destroyed in the process before any attempt to decipher them could be made. Some people think he was unlucky in the choice of scrolls he submitted to the experiment, others that he was dealt the wrong ones on purpose. Whatever the case, one of the first recorded attempts of scientists to meddle with the conservation of antiquities was a complete failure.

From a superficial examination of conservation history it appears that the record did not improve very much in ensuing years. Relevant cases include the application of alkali silicates (Kuhlmann ca. 1830) and fluosilicates (Kessler in 1883) to stone conservation. Little by little, scientists learned

to keep away from the dangerous domains of practical conservation. Instead they wandered into the safer pastures of the analysis of artifacts, from which a flourishing new branch of science (archaeometry) now grows. Scientific concepts and modern materials have obviously influenced modern conservation practice, but only insofar as they have been absorbed, more or less correctly, by the conservators who tried to adapt them to their needs.

Science and Technology

Some of the difficulties met in the transformation of scientific ideas into conservation processes are common to any branch of technology. In order to overcome these difficulties and to reduce the number of costly failures, industry relies on a particular class of persons of various (and frequently dubious) extraction who claim to be able to translate laboratory data into efficient processes on the production line. I shall designate them as "technologists" or, not so respectfully but more fondly, as "tinkerers."

A constant characteristic of any job involving complex techniques is that decisions must be made before a given deadline. There is never time enough to obtain all the data required to build up a scientific model of the situation. On the production line, decisions are invariably made on the basis of insufficient information. Errors are frequent, and experience is gained the hard way, by trial and error.

The technologist is accustomed to taking risks, gambling on his innate visionary gift to build models from insufficient data, on the experience obtained from previous failures, and finally on his luck. The technologist on the production line is normally the one who survived, so he is bound to be very good or very lucky.

Progress in technology may arise from the introduction of new scientific ideas from the research laboratory, but frequently it stems from innovation on the production line attempted by a tinkerer of genius who had an urgent problem to solve. It is up to technologists to apply scientific discoveries at least as often as it is up to scientists to explain why something works. In both ways progress is made.

Peculiar Aspects of Conservation Technology

If life is difficult for the technologist on any production line, it is even more so in practical conservation. Many variables are involved in conservation problems, and some of these lie out of the field of competence of any scientist (e.g., historic and aesthetic values). Even within natural science, the disciplines concerned are so varied that the case in which a single scientist may feel competent over the entire field is rather the exception than the rule.

The immediate result of conservation processes is evaluated by a customer (historian, architect, or layman) who has little knowledge of the processes and the risks involved, but has strong views on what the result should not be. Anyway, an objective evaluation is always difficult because there are no standard procedures of quality control and no recognized acceptance tests.

The final results of conservation processes can be judged only after a long time; this means that the outcome of a prototype operation is not known when the production line starts applying a new process. Because it is so difficult to judge the result (criteria of evaluation are nonscientific and the time required is long), it is not surprising that not only the fittest but also the less fit survive among the tinkerers and that the quality of the work produced is quite variable.

As a consequence of the frequent reluctance on the part of scientists to become involved with practical conservation, the conservators seldom enjoy the services of technologists and of laboratories applying sound testing procedures. Thus conservators are frequently tempted to take over the entire sequence of operations: experiment, application, evaluation of results. Occasionally conservators mask the lack of scientific grounding of their efforts by contact with some friendly scientist who offers some amateur collaboration. The scanty and usually irrelevant results of such collaboration are proudly displayed in reports and exhibitions to guarantee the scientific level of the work done, on which they had no influence whatsoever.

Attitudes of the Scientist in Conservation

A scientist who decides to enter the field of practical conservation is, therefore, confronted with a production line whose quality is dubious and difficult to evaluate. The relevant technical literature is of difficult access and, when available, it looks shallow to the scientific eye (few data, no statistics, no reaction rates, no computerizable models).

On the other hand, the scientist is strongly attracted by the domain of conservation. This is partly because the objects to be preserved are fascinating in themselves and partly because, in the multivariable processes that govern deterioration and conservation, the hints for new ideas are innumerable. Even the dumbest scientist can discover new schemes in a short time by application of the most standard concepts of his normal branch of activity.

As soon as the scientist has developed some new ideas, he is emotionally involved. He starts seeing himself as a savior for the endangered antiquities. This is a dangerous attitude, both for the antiquities involved and the scientist himself; just like the conservator, the scientist tends to take over the entire field, getting rid of all the other incompetent people. It is not

infrequent to see research, development, production, and (positive) evalua-
tion of the result carried out by the same person. This practice obviously is
questionable, even if one must admit that the difficulties of collaborating
with people of different backgrounds, who also are emotionally involved, may
be indeed infuriating.

"Interdisciplinarity" is frequently used as a word but is seldom put into
real practice. Nevertheless, effective interdisciplinary work is an absolute
requirement for progress in conservation.

The Conservation Technologist

A consequence of what has been said above is that, in conservation practice,
we frequently meet two anomalous tendencies. On one hand, the conserva-
tor tends to improve his scientific background and to do his own research
and development; on the other, the specialized scientist expands his activity
to cover the whole field down to the production line.

A substantial improvement in conservation practice may be brought
about only by more technological experimentation and more testing, under
the condition that these be carried out by people and laboratories who are
specialized in this kind of activity and are not emotionally involved (that is,
people who have not invented a new process nor executed the job they must
evaluate). In other words the screen of technological tests should be inter-
posed as much as possible between basic research and the actual execution
of conservation work. This is occasionally done in some government labora-
tories, but widespread action will probably require the support of university
engineering departments, which have the right experience and equipment.

To standardize testing procedures, the cooperation of a wide range of
specialists within the scientific community is essential, both at the national
and the international level. Professional organizations like ASTM [American
Society for Testing and Materials] and RILEM [Réunion Internationale des
Laboratoires d'Essais et de Recherches sur les Matériaux de Construction]
have an important role to play here. As the improvement of the professional
level of technologists and of the standardization of testing bring substantial
progress, conservation will probably become far less picturesque than it used
to be, but more reliable. Considering the high value of the property involved,
reliability requirements should become more and more stringent, and much
work will be needed to reach an adequate level in everyday practice.

Much of the trouble in the present situation lies in the insufficient
number (and level of competence) of the technologists available. The ideal
conservation technologist should be a man of solid scientific background, but
with enough versatility and culture to be able to understand the attitudes of
all types of specialists involved in the conservation process. He should have a

feel for accurate measurement, fairness in judgment, and a decision-making capability. Above all, he should never invent a new conservation process.

The ideal technologist would also understand that conservation requirements cover such a wide field that it is almost impossible to find an absence of conflicting requirements in any real problem (e.g., authenticity versus mechanical strength). He knows, therefore, that he is always wrong on some accounts when he performs an actual intervention on a piece of cultural property. On the other hand, he also knows that action may be required quickly to avoid some worse evil.

In such cases the technologist must be able to select the right deadline, one that leaves sufficient time to collect the minimum of data required but is brief enough to keep the chance of a catastrophic development to a minimum. The solutions he will choose for his problems will not pretend to be perfect, but only "least evil" choices; he will be well aware of this and conscious that the case is never closed and that dangers lie ahead.

A kind of walker on a tightrope, the conservation technologist has as a guideline the so-called principle of minimum intervention. The principle requires that he disturb as little as possible the "information" stored in the objects he must deal with, while ensuring that it is possible to preserve them and to use them for the function assigned by the present society (or that will be assigned by a future one).

This attitude is very different from that of conservators (and scientists) of the past, who tended to do too much, either because of an egotistical tendency to show their ability or in the naive hope of ensuring preservation for eternity. Minimum intervention, however, is applicable only if care and maintenance are foreseen.

The advent of the conservation technologist implies, therefore, a general change of conservation policies, shifting the emphasis from spectacular performances in restoration to periodic maintenance routines (survey, documentation, monitoring, repair, environmental protection). If and when this desirable evolution takes place, conservation technology will become as reliable as railroad engineering, probably to the regret of the lovers of adventure who are so abundant in our trade. Luckily for them, the field is so complex and apparently inexhaustible that such a stage is not likely to be reached in a short time.

The Conservator

Do not underrate the conservator. Scientists are frequently tempted to do so when they see him tinkering with "research" ideas and using very peculiar methods. The testing procedures of the conservator are unorthodox. However, by feeling the properties of materials with very accurate instruments

443

(his eyes and hands), he can cut his way through a multivariable problem more efficiently than the scientist, who is accustomed to proceeding by logical steps and may have trouble identifying which variable is the relevant one.

Mixtures concocted by conservators for cleaning or protection purposes have frequently proved surprisingly successful when submitted to comparative tests with other products available on the market or prepared by scientists. In conservation, also, similar materials and processes may perform quite differently in the hands of different people. The difference may be not only aesthetic (which is quite important in this field), but might involve durability.

Good eyes and hands are attributes that are slowly developed in a professional career. They are not improvised. A good scientist is not necessarily a good conservator. A flawless execution with a low-performance material may produce a better overall result than the inept application of a scientifically tested procedure.

The conservator of the future will be a noble artisan educated in scientific and technological principles and humanistic culture. His eyes and hands will be as good as they have ever been, but he will have learned to allow other disciplines to aid his work and to extract from any sort of specialists information that is useful to him. He will be tendentially lazy, basing his actions on the principle of minimum intervention. Perhaps he will lose his natural tendency to overdo because he will be well paid to look upon the objects entrusted to his continuous care and to touch them only occasionally and with the lightest possible touch. He will resemble the family doctor who is paid to keep the patient in good shape, rather than the surgeon who performs spectacular operations in desperate cases.

The Science and Art of Conservation of Cultural Property

G I O V A N N I U R B A N I

I believe that the organizers of this course,[1] by entrusting me with the topic on "Science and the Art of Conservation," wanted to give me the opportunity to reflect, at this particular time in the evolution of conservation activity, on the nature of the relationships among the three roles that are relevant to the particular topic: the scientist, the historian, and the restorer.

I would say that we are dealing with generally positive relationships that, nonetheless, could be significantly improved if each role could be freed from the feeling of being a tool for the others and from the temptation of considering the others in the same way.

For example, I do not believe that archaeology has much to gain from its so-called auxiliary sciences, such as thermoluminescence or carbon 14 dating, which are no more than analytical or measuring techniques that were devised for quite different purposes, and that by chance turned out to be useful to archaeological research. On the other hand, the application of these techniques to archaeology has brought advantages to their inventors, even though we have seen no great progress in the sciences for which the techniques were in fact conceived and developed. We can say just about the same thing for most investigative techniques that are applied today to our own field of interest. Putting aside both the legitimate satisfaction that can come to those researchers who first experiment with new applications and the benefits

From Giovanni Urbani, "La scienza e l'arte della conservazione dei beni culturali," in *La scienza e l'arte della conservazione: Storici dell'arte, tecnici, restauratori a confronto sui temi ancora irrisolti del restauro. Ricerche di Storia dell'arte* 16 (Rome: La Nuova Italia Scientifica, 1982), 7–10; a lecture organized by the Università Cattolica del Sacro Cuore and by the Region of Lombardy, Milan, 7 May 1981. Used by permission of La Nuova Italia Scientifica, s.p.a. Translated by Gianni Ponti with Alessandra Melucco Vaccaro.

that such solutions bring to some of our problems, we are dealing entirely with one-way contributions. Not only do they fail to translate into progress in basic research in chemistry or physics (which might be too much to expect), but they do not define even the necessary conditions for the birth of an independent scientific discipline. This is something we have long dreamed that conservation research could be.

By this we do not mean to shrink from the challenge; we only want to be aware of the fact that, as long as we continue to assign only a technical or auxiliary role to the experimental sciences, we can only expect them to make a limited contribution.

As far as working relationships are concerned, this state of affairs causes a difficulty in the dialogue between scientists and experts in cultural property. Having agreed that the common objective is the *material conservation* of a work of art, scientists are then immediately asked not to concern themselves with the work of art as such, but to focus exclusively on the aggregation of materials that compose it. After the initial, gratifying moment in which the scientist is invited to advise on a famous and, for him, unusual object, he can only return to his lab to verify whether, on that particular aggregation of materials, he can repeat his usual type of experiment.

This time, however, he is aware that the information that can be retrieved will not exhaust the ultimate reality of the object under investigation, as is usually the case in his line of work. This reality instead will be the prerogative of the art historian's considerations and the restorer's manipulations.

Given this situation, one should not be surprised if the scientist, after repeating this kind of experience several times, becomes less inclined to perform a job in which he no longer can expect to bring substantial changes to the way restorers and art historians think about and carry out the conservation of a work of art.

To change this state of affairs and to allow the scientist to fulfill a role that is not merely technical or auxiliary, he should be given responsibility, as much as is given to the restorer and art historian, for the ultimate reality of the work of art as a whole and not simply for its constituent materials.

We certainly do not mean to say that a scientist should become a restorer or an art historian. The examples of this kind of versatility, of which there are fortunately only a few, have so far only produced a pleasant but quite useless dilettantism.

The involvement of the scientist should instead occur at a level that is equal to that of the other two kinds of experts; yet, oddly enough, this kind of concern has not received from any of the parties involved the consideration that it deserves.

I am referring to the concept of "state of conservation," meaning something that should constitute the focal point of a thought process linked to an activity that, by definition, is related to conservation. Yet the examination of such a concept is, at present, so superficial that it can only be translated into judgment criteria that are completely subjective and unverifiable. This is certainly the case when the state of conservation of a work of art is described as being good, mediocre, or bad.

Someone could argue that art historians and restorers are the ones who accept this kind of evaluation, while the scientist, who carries out chemical and physical characterization of samples of the materials making up the work of art, does in fact reach that very precision of judgment that we complain is missing.

Yet we can precisely evaluate the state of conservation of an item or artifact only in terms of the specific function that the item or artifact is meant to have. Such a function is carried out more or less successfully depending on the state of conservation of the materials. If, from our contemporary point of view, we agree that the primary function of the work of art is to stimulate our aesthetic sensitivity, then we should fear that the scientist's evaluation of the state of preservation of the materials that make up the work of art may turn out to be completely unusable, not only for the historian or restorer but also for the scientist himself. Once he has completed the analysis of the samples, the scientist has to return to the work of art to verify whether the more or less advanced state of deterioration of the analyzed materials relates to a greater or lesser capacity of the work of art to fulfill its role of stimulating aesthetic sensitivity.

Not only is there the risk that the condition of the materials, established by laboratory procedures, may not relate in any way to the condition of the work of art established *de visu*, through aesthetic appreciation, there is even the possibility that an extreme state of deterioration of materials may coincide with a maximum display of the work's aesthetic potential.

I will present the example of a painting by Renoir that should still be in the storerooms of the Museum of Modern Art in New York. I saw it almost thirty years ago lying on a flat surface on the bottom of a large cardboard box that was being opened with infinite care, in an atmosphere of utter suspense. The painting triggered in the onlooker an aesthetic feeling that was greater than the already considerable feeling inspired by any other Renoir. This was so because, about ten years before, the house of the painting's owner had been practically destroyed by fire. Though the flames were kind enough not to touch the painting, the immense heat had turned the painting virtually into ashes; yet it remained perfectly recognizable as a Renoir. Given the circumstances, this was certainly a unique Renoir that deserved special admiration.

Question: In a case like this, what is the relationship between the functionality of a work of art and the state of conservation of its materials?

We are dealing not with a paradox, but rather with a rule, if we consider that the same question can be addressed when we are faced with something that is not so rare and unusual, such as a ruin.

Let us consider the Colosseum. Anyone is capable of seeing that its state of conservation is awful; yet no one would know how to tell us if and to what extent our understanding of the Colosseum as historical testimony and as a work of art is compromised by this desperate state of conservation. We can even dare to say that the sudden loss of two or ten of its arches, or even its complete collapse, would not significantly affect our historical and aesthetic understanding of the monument.

Yet, if this is the case, what is the purpose of the ritual that takes place when an archaeologist, realizing that a stone has fallen off the Colosseum, asks the chemist to analyze the agents of deterioration and asks the restorer to somehow reset the stone from where it fell?

Let us presume that the archaeologist is truly determined to take full advantage of the analysis because he wants to entrust the restorer with something a little more demanding than the mere resetting of the one stone. Let us say that he wants to commission the restoration of the entire Colosseum. How will the archaeologist relate the level of sulfate attack of the stone—and all the other research data provided by geologists, structural engineers, et cetera—to a global restoration project, one that does not end up a simple cosmetic intervention, but whose objective is to slow down the natural deterioration process of the monument in a carefully controlled way?

We cannot avoid the problem by saying that because of a lack of funds, administrative inertia, and so on, such a decision on the part of the archaeologist—any archaeologist—is highly unlikely ever to occur. Let us admit, instead, that even if we are not satisfied with the awful state of conservation of the Colosseum, the kind of relationship that we have with monuments from the past—a relationship, as I have just said, based on historical awareness and on aesthetic appreciation—prevents us from planning and completing an efficient conservation of the same. Such a conservation effort would undoubtedly require substantial changes in the present appearance and use of the Colosseum. These modifications would possibly be feared as "unnatural," and are not required by the kind of historical-aesthetic esteem in which we hold ancient art.

And yet why is it that everyone, including archaeologists and art historians, strongly feels with increasing urgency the need to ensure the "material conservation" of ancient art?

We cannot think that this is an absolute imperative, unrelated to what ancient art represents in our concept of human history. Let us say, instead,

that in this concept, at a time when man begins to feel the ominous historical novelty of the destruction of his own environment, certain values, like ancient art, demonstrate how the potential of human activity can integrate rather than destroy the beauty of the world. These values (ancient art)—alongside their acknowledged role as a source for study and aesthetic pleasure—begin to take on the new dimension of human environmental components that are equally important for the well-being of the species and for the ecological equilibrium among natural environmental factors.

If this, as I believe, is the situation, then we can understand how the poor condition of our monuments, though having no relevance to historical understanding and aesthetic appreciation, arouses in us the same apprehension and desire for rescue that we feel before our devastated environment. We can also understand, when faced with the decay of our cities, how unbearable is the fact that the prime victims of the ever increasing deterioration of the urban environment are precisely monuments and those values (ancient art) in which we recognize the fundamental conditions for urban life on a human scale.

This acknowledgment, obviously, can no longer be limited to taking note of the change at a distance, so to speak; that is, as an object of study or aesthetic contemplation. It must attempt to reintroduce it into the realm of an object pertinent to current reality. In other words, reintroduce it into the dimension of an object still open to human intervention; an object with which, through new and different actions, we can recover and repeat the experience of the only activity that has never harmed the world—creativity.

In the past, when creativity pervaded all aspects of community life, and took shape not only in the form of great artistic monuments, but in the whole fabric of the city, the conservation of the creative product could be carried out as a vital process. This occurred by spontaneously replacing time-worn or otherwise obsolete creative products with new ones.

The kind of conservation that we can carry out, unfortunately, cannot rely on this self-generating potential; it cannot unfold by creating new works of art, but only by maintaining indefinitely those existing ones. This is obvious. Yet it should be just as obvious that we are setting ourselves a task that is impossible to fulfill or at least has considerable limitations, given the invincible law of thermodynamics that nothing can remain unchanged indefinitely.

We must then choose between two different patterns of change: change that is in the nature of things, and which sooner or later will have to end with the disappearance of what we would have liked to preserve; or a change that is the product of efficient conservation, that is capable of repeating the creative experience of the past, not in terms of artistic creation, which is definitely precluded, but in terms of scientific imagination and technological innovation.

Let us once again consider the Colosseum. The unlikely decision to attempt its restoration would today be made futile by two insuperable obstacles: by our incapacity to evaluate objectively its state of conservation, and therefore by the incongruity of an intervention of any kind that tried to bring it back to an undefined state of conservation.

Everything seems to indicate that if science can make a contribution to restoration, it is to clarify what is understood by *state of conservation*. If it is possible to measure the speed with which galaxies diverge in millions of light years, and if, at the other end of the spectrum, it is possible to measure the time it takes for a material to halve its radioactivity, why should it not be possible to measure the deterioration rate of the Colosseum?

Whoever succeeds in elaborating a theory for this kind of measurement will certainly solve the problem of conservation, no matter what the implications for restoration. This is so because the demonstrated scientific imagination would be no less impressive than the creativity stamped on the art of the past. Finally then, the work of art will be preserved in the only way that matters: as the matrix of a renewed experience of the creative act, and no longer as a mere object of study or of aesthetic contemplation.

Note

1. Inaugural lecture given at the first refresher course on the problems of protecting the artistic heritage of monuments, organized by the Università Cattolica del Sacro Cuore and by the Region of Lombardy, Milan, 7 May 1981.

Annotated Bibliography

Parts I and II
The Eye's Caress: Looking, Appreciation, and Connoisseurship
The Original Intent of the Artist

Bell, Clive. "Civilization." In *Civilization and Old Friends.* Chicago and London:
The University of Chicago Press, 1973.
Originally published in 1928, *Civilization* discusses the importance of a humanistic
education, a sense of values, and reason in our lives. Our response to art and the level of
our aesthetic ecstasy will be in direct proportion to the extent of our education, the
seriousness of our values, and the acuteness of our reason.

Berenson, Bernard. *Lorenzo Lotto: An Essay in Constructive Art Criticism.* London:
George Bell and Sons, 1901.
Lorenzo Lotto exemplifies Berenson's method of connoisseurship as explained in his essay
"Rudiments of Connoisseurship." It demonstrates the relevance of documentary sources
and the value of the eye in making decisions as to attribution.

———. *Three Essays in Method.* Oxford: Clarendon Press, 1927.
The three essays, "Nine Pictures in Search of an Attribution," "A Neglected Altar-Piece
by Botticelli," and "A Possible and an Impossible 'Antonello da Messina,'" demonstrate
Berenson's method as a connoisseur. They were intended "to canalize guessing" and show
students "all the devices of scholarship" that are used when attributing pictures.

———. *Seeing and Knowing.* London: Chapman and Hall, 1956.
A late work, this book affirms Berenson's conviction that Western art is based on an
artistic convention going back to the Classical tradition and later reaffirmed by the Italian
Renaissance: an artist paints not only what he sees, but also what he knows. Berenson
rejected abstract art since it dispensed with this accepted artistic convention.

———. *The Passionate Sightseer: From the Diaries 1947 to 1956.* New York: Simon and
Schuster and Harry N. Abrams, Inc., 1960.

A joy to read, this book takes the reader along with Berenson as he visits Rome, Venice, Sicily, Tripoli, Leptis Magna, Calabria, the Romagna, and Florence. It is laced with his insights into style, art in context, art and nature, connoisseurship, restorations, et cetera. But, above all, it makes one want to depart immediately for the places Berenson visited, and to look, look, and look again at the sights that enriched his life and perceptions on art.

———. *Sunset and Twilight: From the Diaries of 1947–1958.* New York: Harcourt, Brace and World, Inc., 1963.
Previously unpublished selections from Berenson's diaries reveal the breadth of his insights into art, literature, music, nature, world events, and people. With touching candor, the great connoisseur records his own decline, made all the more tender by his passionate love of life and all its riches.

Bode, Wilhelm von. *Florentine Sculptors of the Renaissance.* New York: Charles Scribner's Sons, 1909.
Bode, the director of the Royal Gallery in Berlin and opponent of Morelli, was a connoisseur of Italian Renaissance sculpture. He was, at times, rather generous in his attributions, as, for example, with Donatello.

Clark, Kenneth. "Bernard Berenson." *Burlington Magazine* 102 (September 1960): 381–86.
An excellent, if not the best, introduction to Berenson, the man, and his work.

———. *Ruskin Today.* Chosen and annotated by Kenneth Clark. London: John Murray, 1964.
This anthology, like the one edited by Joan Evans (see page 453), is an excellent introduction to Ruskin's writings on himself, on nature, on art, on architecture, and on society and economics. Clark's introduction to the volume examines why Ruskin's writings have become neglected.

———. *Civilisation.* London: BBC and John Murray, 1969.
When first aired on television in 1969, *Civilisation* was an immense success with the public, but generally pooh-poohed by the snob contingent among art historians. Clark manages to provide a synthesis of historical events and artistic trends that demonstrates the role great art has played in the long, complicated, and fragile process of becoming civilized. His perceptions encourage us to relook at works of art with renewed openness and a fresh eye. *Civilisation* places appreciation in the context of history and demonstrates the irreplaceable relevance of art to our lives.

———. *What Is a Masterpiece?* London: Thames and Hudson, 1979.
Originally one of the Walter Neurath Memorial Lectures, this brief study examines what makes a masterpiece: the subject, how it moves us emotionally, form and content, and the indefinable quality called "genius."

———. *Moments of Vision.* London: John Murray, 1981.
A wide variety of topics is discussed, ranging from how the aesthetic experience affects the beholder or lover of art to how "divine agitation" stimulates the creative process to essays on Walter Pater and Bernard Berenson. As always, Clark's erudition complements his immense power of observation.

————. *The Art of Humanism*. New York: Harper and Row, 1983.
Clark demonstrates his debt to Berenson in this volume, which deals with the work of five Italian Renaissance artists in the context of humanism. As John Walker comments in his introduction to the book, "While I was living in Italy I was preoccupied with the works of art described and analysed in this book; but to my amazement Kenneth Clark has found marvels I missed. At the end of each chapter I wondered how I could have been so blind, for he has made me see everything afresh."

Crowe, J. A., and G. B. Cavalcaselle. *A History of Painting in Italy: Umbria, Florence, and Siena, from the Second to the Sixteenth Century.* 4 vols. London: John Murray, 1903–1914; ————. *A History of Painting in North Italy: Venice, Padua, Vicenza, Verona, Ferrara, Milan, Friuli, Brescia, from the Fourteenth to the Sixteenth Century.* London: John Murray, 1912.
Perusal of random passages will readily show Crowe and Cavalcaselle's method for attributing pictures. Important to remember is that this monumental work was undertaken without the benefit of photography.

Evans, Joan, ed. *The Lamp of Beauty: Writings on Art by John Ruskin.* Oxford: Phaidon, 1980.
Since Ruskin can be hard going, even to the initiated, a first encounter is perhaps best via an anthology. This volume and the one edited by Kenneth Clark (see page 452) are both excellent introductions to the great writer on art.

Friedländer, Max J. *Genuine and Counterfeit: Experiences of a Connoisseur.* Translated by Carl von Honstett and Lenore Pelham. New York: Albert and Charles Boni, 1930.
This small volume deals with themes later developed in *On Art and Connoisseurship* (see Reading 14, pages 139–53). Chapters are devoted to "Concerning the Opinion of Experts," "On the Restoring of Old Pictures," "The Forgery of Old Pictures," "The Pictorial and the Picturesque," "Form and Color," "Originality," "Style and Manner," and "Development and Influence."

————. *Landscape, Portrait, Still-Life.* Translated by R. F. C. Hull. Oxford: Bruno Cassirer, 1949.
Like Berenson and Clark, Friedländer has the ability to make us look anew at works of art and see them in different ways and different relationships. A book that offers a stimulating and original approach to works of art.

————. *Reminiscences and Reflections.* Translated by Ruth S. Magurn. London: Evelyn, Adams and Mackay, 1969.
This small volume provides many insights into the art world Friedländer grew up in and contains many cogent observations on a wide variety of subjects—from the creation of character in literature to artistic vision.

Fry, Roger. "An Essay in Aesthetics." In *Vision and Design.* New York: Meridian Books, 1957: 12–27.
Fry's theory, dating from 1920, explores the relationship between the maker, via a work of art, and the beholder or art lover: art expresses the imaginative life and as such reveals itself through an expression of emotion. This derives from Tolstoy's theory—as expressed in his book *What is Art?*—that works of art provide communion and aesthetic ecstasy.

Gibson-Wood, Carol. *Studies in the Theory of Connoisseurship from Vasari to Morelli.* New York and London: Garland Publishing, 1988.
This published Ph.D. thesis (1982), prepared for the Warburg Institute, provides a well-researched overview of the main theorists and practitioners. Anyone interested in extensive reading on the subject will find the selected bibliography of great assistance.

Kiel, Hanna, ed. *The Bernard Berenson Treasury: A Selection from the Works, Unpublished Writings, Letters, Diaries, and Journals, 1887–1958.* London: Methuen and Co. Ltd., 1964.
An excellent introduction to Berenson, with selections from both published and unpublished writings spanning his active career as art historian and connoisseur. This book provides an easy overview of the variety and richness of Berenson's thought, covering topics from American culture, Christianity, connoisseurship, Italian Renaissance art, humanism, Japanese painting, marriage, old age, painting, and television to Leo Tolstoy.

Marangoni, Matteo. *The Art of Seeing Art.* London: Shelley Castle Limited, 1951.
This former superintendent for galleries and museums of Florence and professor of art history at Pisa University stresses that subject is secondary to form. For Marangoni, aesthetic contemplation does not lead to, but rather refines, emotion. His chapter "The 'Language' of Architecture" contains many valuable insights on how to look at architecture—an addition to Wölfflin's approach.

McComb, A. K., ed. *The Selected Letters of Bernard Berenson.* Boston: Houghton Mifflin Company, 1964.
McComb, who knew Berenson well, made a representative selection of letters that span Berenson's career from 1887, when he first went abroad and began scouting for pictures for Mrs. Isabella Stewart Gardner, to February 1958, when his health began to deteriorate rapidly. These letters provide insights into his varied activities as art historian, connoisseur, traveler, dealer, collector, and personality.

Morelli, Giovanni. *Italian Painters: Critical Studies of Their Works.* 2 vols. London: John Murray, 1900.
Morelli explains his morphological method for attributing pictures in the chapter "Principles and Method," which appears before "The Borghese Gallery" in volume 1. Throughout both volumes, numerous exercises in attribution are given, which clearly demonstrate how Morelli applied his method to specific problems.

Offner, Richard. "Connoisseurship." *Art News* 50 (March 1951): 24–25, 62–63.
An excellent, brief introduction to the subject, which insists that while emotion is extremely important in our initial response to the visual complexities of an object, we must objectify it by repeated exposure to the object. After the connoisseur has identified an object, the historian can deal with it as part of our spiritual and intellectual culture.

Osborne, Harold, ed. *Aesthetics in the Modern World.* New York: Weybright and Talley, 1968.
For readers wishing an introduction to the varied field of aesthetics, this anthology provides a selection of essays that explores such topics as "Aesthetics as a Branch of Philosophy," "The Quality of Feeling in Art," and "Psychology and Aesthetics."

Panofsky, Erwin. *Studies in Iconology: Humanistic Themes in the Art of the Renaissance.* New York: Harper and Row, 1967.
This is the classic text on iconography and its methodology. It is the quintessential expression of the philological approach to works of art and, like any good detective novel, will be read at one sitting.

Pater, Walter. *The Renaissance: Studies in Art and Poetry.* London: Macmillan and Co., 1894.
Fin de siècle purple prose, art for art's sake aesthetics—call it what you will, but Pater's *Renaissance* remains one of the great books on the appreciation of beauty. It is life enhancing.

Richardson, Jonathan, Jr. *The Works of Mr. Jonathan Richardson Sr., Consisting of I. The Theory of Painting. II. Essay on the Art of Criticism, so far as it relates to Painting. III. The Science of a Connoisseur.* N.p., 1773. Corrected and prepared by Jonathan Richardson Jr. Reprint, Hildesheim: Georg Olms, 1969.
Perhaps the person who wrote most extensively on the principles and methodology of connoisseurship, Richardson anticipates Morelli, Berenson, and Friedländer. His works are always a joy to read and are still relevant today for anyone interested in the methodology of connoisseurship. Richardson's approach is characterized by his dependence upon common sense.

Riegl, Alois. "The Modern Cult of Monuments: Its Character and Its Origin." Translated by Kurt W. Forster and Diane Ghirardo. *Oppositions: A Journal for Ideas and Criticism in Architecture* 25 (Fall 1982): 21–51. (See also Reading 6, pages 69–83.)
Originally published in 1903, Riegl's essay discusses the different values that can attach to monuments, whether they are buildings or other types of art. These different values must be carefully considered when conservation and/or restoration is to be carried out. While many of the values are complementary, some are antagonistic.

Rosenberg, Jakob. *On Quality in Art: Criteria of Excellence, Past and Present.* London: Phaidon, 1967.
The subject of quality—related to connoisseurship—is examined by Rosenberg through a discussion of earlier critics. How judgments on quality are made is demonstrated by analysis of master drawings and the comparison of them to works by followers or minor contemporaries.

Roskill, Mark. *What Is Art History?* London: Thames and Hudson, 1976.
Roskill provides a readable account of how art history has developed into a professional and academic discipline. Connoisseurship and attributions are discussed and illustrated with several interesting case histories, among them the Brancacci Chapel, Piero della Francesca, and Giorgione.

Schwartz, Gary. "Connoisseurship: The Penalty of Ahistoricism." *International Journal of Museum Management and Curatorship* 7 (September 1988): 261–68.
While acknowledging the value of connoisseurship and what art history owes to it, the author points out the problems that can arise when connoisseurs are unable to prove what

their eyes tell them. Schwartz notes the high ratio of attributed works of art in relation to anonymous ones and draws our attention to the large number of documented artists who are just that and nothing else.

Talley, M. Kirby, Jr. "Connoisseurship and the Methodology of the Rembrandt Research Project." *International Journal of Museum Management and Curatorship* 8 (June 1989): 175–214.
The first part of this article provides a survey of the development of connoisseurship from the fifteenth to the twentieth century. Against this historical background, the author examines the methodology of the Rembrandt Research Project, demonstrates how it both follows and neglects the principles of connoisseurship, and offers the results of this indecision.

———. "Under a Full Moon with BB: Building a 'House of Life.'" *International Journal of Museum Management and Curatorship* 11 (December 1992): 347–73.
In this essay, the author explores the importance of a humanistic education and vision (Berenson and Bell among others) to our response to works of art. The increasing lack of such an education and consequent lack of response among art historians, restorers, and conservation scientists are discussed, as are the results of this trend.

Thurston, Carl H. P. *Why We Look at Pictures: A Study in the Evolution of Tastes*. New York: Dodd, Mead and Company, 1926.
Books with titles like this are often passed over in the conviction they contain nothing of value. Thurston's book, however, is filled with sound observations and contains a critique of Bell's theory of significant form.

Venturi, Lionello. *Painting and Painters: How to Look at a Picture from Giotto to Chagall*. New York and London: Charles Scribner's Sons, 1946.
A how-to book from a renowned scholar who brings both scholarship and a good eye to bear upon his subject. The relationship between subjective response and objective criteria is emphasized and made clear throughout the book.

———. *History of Art Criticism*. Translated by Charles Marriott. New York: E. P. Dutton, 1964.
Indispensable reference for anyone who wishes to have a concise, readable, and highly informative book on the history of art criticism from Classical antiquity to the twentieth century. Important bibliography.

Wind, Edgar. "Critique of Connoisseurship." In *Art and Anarchy*. New York: Vintage Books, 1969.
Wind examines Morelli's method and shows that his meticulous morphological approach concentrated on original "fragments" within paintings. Morelli distrusted the finished work, according to Wind, because he had an aversion to artistic conventions. While Morelli's morphological tests will continue to remain a valid and important tool, we must not concentrate solely on details to the exclusion of the entire message.

Wölfflin, Heinrich. *Classic Art: An Introduction to the Italian Renaissance*. Translated by Peter Murray and Linda Murray. London: Phaidon, 1968.

Originally published in 1899, *Classic Art* is one of the seminal texts on how we should look at works of art and analyze their formal characteristics. The themes discussed in this book were later expanded in Wölfflin's *Principles of Art History* (1915) (see Reading 7, pages 84–99).

———. *Renaissance and Baroque*. Translated by Kathrin Simon. London: Fontana/Collins, 1971.
First published in 1888, this book traces the transition of style between Renaissance and Baroque architecture. Wölfflin's acute visual analysis runs throughout his arguments.

Wollheim, Richard. "Giovanni Morelli and the Origins of Scientific Connoisseurship." In *On Art and the Mind: Essays and Lectures*. London: Allen Lane, 1973.
Wollheim's essay is a comprehensive critique of Morelli's method that recognizes both its stronger and weaker points. Morelli's morphological approach concentrated exclusively on details, whereas Wollheim notes that artists also reveal themselves in "larger units" if not in the *tout-ensemble* of a painting.

Part III
The Emergence of Modern Conservation Theory

Bonelli, Renato. "Restoration and Conservation: Principles of Architectural and Urban Restoration and Conservation." In *Encyclopedia of World Art*. Vol. 12, col. 194–97. New York, Toronto, London: McGraw-Hill Book Company, 1966.
The passages in these readings (see Reading 23, pages 236–43) taken from Giovanni Carbonara's *La reintegrazione dell'immagine* go back to positions taken by Renato Bonelli. Bonelli rejects some of Brandi's theories, considering them to be inapplicable to architecture. The article in the encyclopedia consists of the author's summary of his own thinking.

Brandi, Cesare. "Restoration and Conservation: General Problems." In *Encyclopedia of World Art*. Vol. 12, col. 179–84. New York, Toronto, London: McGraw-Hill Book Company, 1966.
In addition to the selection of texts from the *Teoria del restauro* included in English translation expressly for these readings (see Readings 22, 35, and 40, pages 230–35, 339–42, and 377–79, respectively), this summary by Brandi himself is recommended since it expounds his philosophy of restoration very clearly and concisely.

Carbonara, Giovanni. "Restauro fra conservazione e ripristino: Note sui più attuali orientamenti di metodo." *Palladio* 6 (1990): 43–76.
This excellent critical essay synthesizes the current debate in restoration. Carbonara, reviewing the main trends and theoretical orientations, sees them as reflecting an opposition between a conservative approach and one that favors reintegration. Located between these two extremes, Carbonara's own position is defined as critico-conservative: sensitive to documentary values but critical in its antidogmatic stance with regard to the reintegration of losses and the removal of additions. The essay is also notable for a well-argued critique of Brandi's theory.

Corboz, André. "Concerning the Proper Use of Historical Sites." *Vie des Arts* 76 (1974): 106–8. ———. "Esquisse d'une méthodologie de la réanimation: Bâtiments anciens et fonctions actuelles." *Restauro* 36 (1978): 55–73.

These two articles discussing the reuse of historic sites consider questions of intervention criteria, including reversibility, and the problem of irresponsible reconstruction the only justification of which is the benefits yielded by tourism. Corboz's view is that the insertion of a new building in a historic site is not a technical problem but a cultural one. He discusses the risk of uncontrolled rehabilitation of buildings and the difficulty of balancing economic forces and the designation of new functions for old buildings. The issues are illustrated with examples of recycling and rehabilitation practices in Montreal and Quebec City.

Haskell, Francis, and Nicholas Penny. *Taste and the Antique: The Lure of Classical Sculpture, 1500–1900.* New Haven: Yale University Press, 1981.

This study by two Oxford academics further investigates the argument developed by Panofsky in *Renaissance and Renascences in Western Art* (see Panofsky, this section) and clearly states the relations between the dissemination of the taste for Classical antiquity, the habit of collecting, restoration, and the function of copies in this process of diffusion and emulation.

Jedrzejewska, Hanna. *Ethics in Conservation.* Stockholm: Konsthogskolans Institutet för Materialkunskap, 1976.

Hanna Jedrzejewska has contributed over a period of some thirty years a number of fundamental papers on various aspects of ethics in conservation. Several of them, including this booklet of a few pages, have enjoyed less wide dissemination than they deserve. Here she argues a strong case for ethical behavior in conservation from a philosophical and practical point of view. Emphasizing authenticity, she stresses the importance of immaterial values in choosing which objects to conserve and which treatments to use. Ethical considerations apply equally in the teaching of conservation, in the moral responsibility of the administrator, and in the practice of the conservator. The author proposes a kind of decalogue of ethical principles for conservators in which she emphasizes the need for sensitivity in one's approach toward the object.

Lowenthal, David. *The Past Is a Foreign Country.* Cambridge, U.K.: Cambridge University Press, 1985.

Lowenthal's fascinating book explores in an eclectic way human attitudes toward the past and seeks to show how the past has become an even more foreign realm. The author investigates how and why we reshape the past, the effect of such changes on our environs and ourselves, and the links between the sources of past knowledge: memory, history, and relics. Although not easy to read, the book sets out an interesting analysis of the meaning of today's fictitious returns to previous times.

Melucco Vaccaro, Alessandra. *Archeologia e restauro: Tradizione e attualità.* Milan: Mondadori, 1989.

This book, by one of the editors of these readings, confronts many of the themes discussed in them: Cesare Brandi's *Teoria del restauro* and how it may be understood and appreciated today, patina, reuse, the conservation of buildings and archaeological finds, as well as the relationship between the theory of restoration and new problems of reuse in the museum context.

Minissi, Franco. *Conservazione dei beni storico-artistici e ambientali. Restauro e musealizzazione*. Rome: De Luca Editore, 1978; ———, and **Sandro Ranellucci.** *Musealizzazione*. Rome: Bonsignori Editore, 1992.
These two books deal with the relationship between restoration, revitalization, and museumlike presentation for historic buildings and archaeological sites. In Minissi's view, museography and conservation are complementary and coexist within a unique process that he terms "musealisation." His ideas are complemented by Ranellucci's contribution on the reintegration and the recreation of monumental context. Their approach is illustrated by a large number of examples of projects.

Panofsky, Erwin. *Renaissance and Renascences in Western Art*. London: Paladin, 1970.
A key text by an author quoted several times in these readings, this work is particularly useful for the insight it gives into the concept of "reuse," a concept we see as central to the arguments about restoration. It investigates the various "renascences"—that is, the many occasions on which, in Western civilization, the art of a past period considered as "Classical" was reexamined with new eyes and for new purposes. Restoration often follows, indicates, and accompanies the fortunes of an object or a period.

Philippot, Paul. *Pénétrer l'art, restaurer l'oeuvre: Une vision humaniste. Hommage en forme de florilège*. Edited by C. Périer-D'Ieteren. Kortrijk: Groeninghe, 1990.
Several of the papers collected in this book are excerpted in these readings. The volume as a whole is also recommended for the clarity and comprehensiveness of Philippot's writing. The book brings together the most representative of his articles during a long career as art historian and teacher. The essays are divided into two sections: art history and conservation/restoration; each subsection has an introductory essay by a specialist who evaluates Philippot's contribution to the topic. Many of his papers have become obligatory references for their fundamental discussions of the methodology and ethics of restoration.

Torsello, B. Paolo. *La materia del restauro: Techniche e teorie analitiche*. Venice: Marsilio Editori, 1988.
Following Boito's view that restoration and conservation are opposite and irreconcilable concepts, Torsello defines his approach in the spirit of the "new conservation," a current trend that considers architecture a historiographical document. This leads him to refute the ideas of reversibility, critical judgment, and restoration as a creative act in favor of recovering all of the monument's material values. Through Torsello's dialectical confrontation of contrasting philosophies, the reader gains an idea of the current context of Italian thought in conservation.

Zander, Giuseppe. *Scritti sul restauro dei monumenti architettonici*. Rome: Bonsignori Editore, 1993.
Introduced by Renato Bonelli, this volume collects the thoughts of the Italian architectural conservator Giuseppe Zander on the theory and methodology of restoration in the light of his own practical experience. The essays debate most of the current issues—the limits of theory in relation to practice, reuse, critical judgment as an ethical problem, and restoration as a creative act. Regarding the latter, Zander proposes an "architecture-restoration synthesis" in which restoration is absorbed within a unique artistic process of architectural creation.

Part IV
Historical Perspective

Association Suisse de Conservation et Restauration. *Geschichte der Restaurierung in Europa: Histoire de la Restauration en Europe. Akten des internationalen Kongresses Restauriergeschichte.* Vol. 1, *Interlaken.* Worms, Germany: Wernersche Verlagsgesellschaft, 1991.
This volume marks the beginning of a new approach to the history of restoration. It looks at the current state of the topic and also identifies new directions of research. The new perspective is no longer limited to considering the key theoretical and substantial advances as a linear, progressive evolution. Rather, it looks at the totality of restoration practice, which offers a panorama that is less unified and more complex due to the need to consider cultural heritage throughout the world and today's broadened conception of cultural property. The contributions to the volume—covering architecture, painting, and archaeological remains—cast new light on themes already known and raise new questions about current restoration issues.

Boito, Camillo. "I restauratori." Lecture given on 7 June 1884, Turin. In Giuseppe La Monica. *Ideologie e prassi del restauro con Antologia di testi.* Palermo: Libreria Nuova Presenza, 1974: 17–25 (originally published Florence: G. Barbera, 1884).
Considered the founder of the modern approach to restoration, Camillo Boito occupies an important place in any history of the subject. Between the extreme positions of Ruskin and Viollet-le-Duc, Boito takes an intermediate path that was adopted by Giovannoni and by the Vienna School (Riegl, Dvořák) and later codified at the International Congress of Athens (1931). Boito rejects the principle of stylistic unity in restoration, which, by "deceitful falsification," removes all traces of the passage of time. Instead, he proposes an approach to the monument as a *document* of art and of history. Concerned with the problem of authenticity, Boito advocates, in addition to the criterion of minimal intervention, principles that insist on the visibility of nonoriginal elements added during restoration and on scrupulous documentation.

Brommelle, Norman. "Material for a History of Conservation." *Studies in Conservation* 2 (October 1956): 176–86.
To stress the importance of looking at the history of conservation as a means of better appreciating the relevance of current methods, Brommelle examines two reports produced in the middle of the nineteenth century on the conservation of paintings at the National Gallery in London. His careful critical analysis of the reports provides a picture of contemporary practice in administration, preservation, methods and techniques of cleaning, varnishing materials, and restoration. The article also clarifies the institutional status and training background of restorers (or "cleaners") of the time, while also noting an early intervention by "scientists" in paintings conservation.

Cagiano de Azevedo, M. "Conservazione e restauro presso i greci e i romani." *Bollettino dell'Istituto Centrale del Restauro* 9–10 (1952): 53–60.
This study is still the most accurate source of information on the restoration techniques of the ancient Greeks and Romans and on the constant care they took to maintain works of art.

Carbonara, Giovanni. "La philosophie de la restauration en Italie." *Monuments historiques de la France* 149 (January–February 1987), 17–23.
This article is an excellent synthesis of the current debate on conservation in Italy, conveying its intense but stimulating polemical nature. It examines the emergence of "critical restoration" theory that encompasses—along with references to phenomenology and structuralism—the thought of Cesare Brandi. According to this theory, which marks the abandonment of positivism in favor of the aesthetic philosophy of Croce, restoration is applied by definition to a work of art with the aim of recovering and "liberating" its artistic qualities. Carbonara defends this approach in polemical terms, concluding that it is imperative that the "problem" of conservation be approached philosophically—in the sense of a "personal act of conscience and of culture, that is to say a critical comprehension of the concept under examination."

Ceschi, Carlo. *Teoria e storia del restauro.* Rome: Bulzoni, 1970.
Widely considered a classic work, Ceschi's volume deals with architecture in Italy and France from the viewpoint of a close relationship between theory and history. The didactic nature of the book provides an easy introduction to this ever-changing topic by means of a study of its origins, changes in the critical evaluation of works of the past, and the relationships between human beings, works of art, and context. The relative nature of restoration and the responsibility of the restorer are two guiding concepts of the book, which nevertheless leaves the reader free to make independent judgments and choose his or her own approach.

Conti, Alessandro. "Vicende e cultura del restauro." In *Storia dell'arte italiana.* Vols. 3–10, *Conservazione, falso, restauro.* Milan: Electa, 1973. ———. *Storia del restauro e della conservazione delle opere d'arte.* Milan: Electa, 1973.
Two works by the same author give an exhaustive picture of the main events in the history of restoration in Italy and the rest of Europe. Conti is more contentious and less detached when discussing the events and movements of this century.

Dvořák, Max. *Katechismus der Denkmalpflege.* Vienna, J. Bard, 1916. Italian translation published as "Catechismo per la tutela dei monumenti." *Paragone* 22, no. 257 (1971): 30–63; also in Giuseppe La Monica. *Ideologie e prassi del restauro con Antologia di testi.* Palermo: Libreria Nuova Presenza, 1974: 55–74.
Dvořák's essay devoted to the sociocultural aspects of restoration and the duty to protect monuments appeared at a period when the quantitative growth of knowledge contrasted with an insufficient qualitative development of conscience. The "catechism," updated where necessary, remains very relevant in its defense of the unity of the work of art and its sociohistoric context; its refusal of a hierarchy among major and minor arts, styles, and periods; and its denunciation of the dangers facing ancient monuments through either ignorance or mistaken ideas of progress. The essay also provides interesting technical and practical advice on protection and restoration.

Giovannoni, Gustavo. *Il restauro dei monumenti.* Rome: Cremonese, 1945.
Following Boito's line of thought (see entry for Boito, this section), Giovannoni takes up the intermediate position of so-called scientific restoration, synthesized in the phrase "restoration ends where hypothesis begins." With a philological scrupulousness, he stresses the criterion of objectivity and an attitude of absolute respect for the

documentary value of the monument. This positivist approach, however, shows a lack of interest in artistic values and in the recovery of figurative unity. Giovannoni advocates a respect for the context of the work of art but establishes an aesthetic hierarchy between major and minor works and makes a distinction between "dead" and "live" monuments.

Jokilehto, Jukka. "History of Architectural Conservation." In *The Contribution of English, French, German, and Italian Thought towards an International Approach to the Conservation of Cultural Property.* Ph.D. thesis, University of York, Institute of Advanced Architectural Studies, 1986.
This thorough and well-documented study investigates the history and development of major national European philosophies concerning the conservation of historic buildings, monuments, and sites, the cross-fertilization of these ideas and principles, and their contribution toward an international approach in the treatment of historic structures. Five case studies examine the Colosseum in Rome, the Acropolis of Athens, the cathedrals of Durham and Magdeburg, and the church of La Madelaine in Vézelay.

Keck, Sheldon. "Some Picture Cleaning Controversies: Past and Present." *Preprints, Journal of the American Institute for Conservation* 23 (Spring 1984): 73–87.
This review of controversies from the earliest times to the 1970s over the cleaning of oil paintings shows the relative character of restoration and the multiple factors that influence an intervention, beyond the purely scientific ones. The author considers restoration a subjective act influenced by the painting's monetary value, the level of professional expertise employed, and the taste of the period based on a certain concept of the past. Every intervention must be judged within the context that produced it. Accordingly, the author advocates the criterion of minimum intervention and reversibility of the intervention.

Léon, Paul. *La vie des monuments français: Destructions, restaurations.* Paris: Editions A. et J. Picard et Cie, 1951.
In reviewing the vicissitudes of the history of conservation in France, Léon describes the birth and development of a national conscience for the conservation of cultural property and a modern definition of restoration theory. A conscience developed slowly, thanks to the efforts of a few people who resisted contrary currents of thought. Important steps included the emergence of the idea of a national monument, the creation of preservation organizations and inventories, the establishment of an administrative service, and, finally, the definition of a theory of restoration.

Percival-Prescott, Westby. *The Lining Cycle: Fundamental Causes of Deterioration in Painting on Canvas. Materials and Methods of Impregnation and Lining from the Seventeenth Century to the Present Day.* London: National Maritime Museum, 1974: 1–47.
An important historical review of the techniques and materials used for the lining of paintings (the attachment of a support behind a painting to provide structural reinforcement to the canvas). Percival-Prescott emphasizes the repetitive nature of this practice (hence the lining "cycle") and its accumulative effect on the conservation of paintings. With its detailed analysis of the history of the practice and its consequences, this article marks a watershed in a period of less intrusive lining practices.

Picon, Carlos A. *Bartolomeo Cavaceppi: Eighteenth-Century Restoration of Ancient Marble Sculpture from English Private Collections. A Loan Exhibition at the Clarendon Gallery Ltd.* London: The Gallery, 1983.
Many of the readings in the present volume point out the importance of a broad knowledge of the history of restoration. Carlos Picon's work examines this history in relation to one of the best-known restorers of all time, Cavaceppi, the Roman who was Johann Joachim Winckelmann's official restorer. Aside from the technical significance of his treatments, carried out on very important collections such as that of Cardinal Albani, Cavaceppi put Winckelmann's ideas on restoration into practice.

Quatremère de Quincy, Antoine Chrysostome. "Restaurer." In *Dictionnaire historique d'architecture, comprenant dans son plan les notions historiques, descriptives, archéologiques, biographiques, théoriques, didactiques et pratiques de cet art.* Paris: A. Le Clerc, 1832: 375−77.
Under the key heading "Restoration" in this dictionary, Quatremère de Quincy demonstrates a rather modern view of restoration, which comes close to current approaches and which is, on many points, still valid. In his conception, the reintegration of lacunae is motivated by aesthetic considerations and is carried out while rejecting any false notions of historical fakery. The author takes as an example the Arch of Titus in Rome, the temporary solution for its restoration being limited to restoring the mass of the missing elements and reintegrating lacunae according to the contours around them.

Stout, George L. "Changes of Attitude toward Conservation in the Arts." AIC *Preprints, Dearborn, Michigan, 29 May−1 June 1976.* Washington D. C.: The American Institute for Conservation of Historic and Artistic Works, 1976: 20−22.
This short survey of opinions in the United States from 1925 to 1975 could be said to supplement the picture introduced in these readings and to reaffirm Brandi's opinions about the relative value of all restoration—and of any opinion regarding it.

Part V
Restoration and Anti-Restoration

Boito, Camillo. "Restaurare o conservare?" In *Questioni pratiche di Belle Arti.* Milan: Ulrico Hoepli, 1893: 3−67. ———. "I nostri vecchi monumenti: Conservare o restaurare?" *Nuova Antologia* 87, no. 3 (1886).
The fundamental dilemma—to conserve or restore—and the conflictive nature of restoration are well expressed in these two essays of Boito. The texts are written in the form of a dialogue between two people and bring out the dialectic nature of the argument. Posing the issue as a question allows Boito to stress that no a priori position toward deciding between conservation and restoration should be adopted; rather, as he lucidly shows, the two are in fact interconnected.

Choay, Françoise. *L'Allégorie du patrimoine.* Paris: Editions du Seuil, 1992.
This book, which is very widely read in the French-speaking world, discusses the semantic changes undergone by the words and the concepts of "monument" and "historic monument" as the idea of heritage has been extended chronologically, geographically, and

typologically. To understand these concepts in today's context, the author reviews the progressive evolution of the built heritage from its emergence and consecration through the invention of the urban heritage to the age of the heritage industry. Choay stresses the importance of founding figures of the discipline of restoration such as Viollet-le-Duc, Ruskin, and Boito, recognizing also the particular contribution of Alois Riegl.

Corboz, André. "Une analyse de l'article 'Restauration.'" *Restauro* 47–49 (1980): 248–63.
In an issue devoted to Viollet-le-Duc and restoration, Corboz critically rereads his article "Restoration" and emphasizes Viollet-le-Duc's understanding of scientific restoration and even of critical restoration. Certain concepts such as "style," "type," and "school" are reanalyzed. However, Corboz also agrees with a number of criticisms leveled at Viollet-le-Duc over the contradiction between his theory and practice, the lack of a distinction between true and false, and the lack of a historical awareness in his doctrine.

Di Stefano, Anna Maria. *Eugène E. Viollet-le-Duc: Un architetto nuovo per conservare l'antico.* Naples: Edizioni Scientifiche Italiane, 1994.
Viollet-le-Duc's key contribution to the foundation of the discipline of conservation of architectural heritage is brought out in this essay, drawing on wide bibliographic research. In order to appreciate his contribution to a discipline that barely existed at the time, the author describes the context of monument protection in France in the nineteenth century and the influences on Viollet-le-Duc's cultural education through his travel, continuous study, and, above all, his practical work.

Di Stefano, Roberto. *John Ruskin: Interprete dell'architettura e del restauro.* Naples: Edizioni Scientifiche Italiane, 1969 (2d ed. 1983).
Di Stefano uses a dialectical confrontation with the contrasting ideas of Viollet-le-Duc to bring out the continuing value of Ruskin's views on restoration. Some authors have maintained that Ruskin's insistence on regular maintenance (avoiding restoration), on respect for authenticity, and on the dramatic significance implicit in the act of restoration shows a preference for a romantic cult of the ruin. Di Stefano argues that these precepts are, in fact, the basis of modern heritage preservation. The volume includes significant extracts from Ruskin's writings and a rich bibliography both by and about Ruskin.

Pevsner, Nikolaus. "Scrape and Anti-Scrape." In *The Future of the Past: Attitudes to Conservation, 1174–1974.* Edited by J. Fawcett. London: Thames and Hudson, 1976: 34–63.
Pevsner's study of nineteenth-century restoration in England brings out the conflictive nature of the practice. On medieval churches, restoration that aimed at a completion and re-creation of the whole according to the original intent of the architects or according to the most significant period of the building's history led to other approaches in reaction that advocated the preservation of material authenticity. Names associated with this important period include Pugin, Scott, Ruskin, and Morris, and the preservation societies.

Pirazzoli, Nullo. *Le diverse idee di restauro.* Ravenna: Edizioni Essegi, 1988. ———. *Introduzione al restauro.* Santa Croce: Cluva Università, 1986 (2d ed. 1987).
Aimed principally at students of architecture interested in conservation, these two books by Pirazzoli are useful in clarifying the terminology and concepts of different approaches

to conservation and restoration. They do so without advocating one position or the other, while also making clear the contradictory nature of restoration.

Tschudi-Madsen, Stephan. *Restoration and Anti-Restoration: A Study in English Restoration Philosophy*. Oslo: Universitetsforlaget, 1976.
The philosophy of restoration in nineteenth-century England is examined within the context of the Romantic and religious movement of the time. The prevailing critical attitude in England, developed in response to certain forms of restoration, had a considerable impact on ideas about the preservation of monuments on the Continent. The study concentrates on those types of buildings mainly subject to restoration at the time—namely, ecclesiastical architecture and ruined castles.

Viollet-le-Duc, Eugène-Emmanuel. *Catalogue de l'exposition, Paris, février–mai 1980*. Paris: Editions de la Réunion des Musées Nationaux, Ministère de la Culture et de la Communication, 1980.
This catalogue for a huge commemorative exhibition throws a new light on the life and work of Viollet-le-Duc, long the victim of misunderstanding as a result partly of a superficial reading of his writings. Deeply researched and richly illustrated, the catalogue portrays him as restorer of buildings, sculptures, and stained glass windows and as builder, decorator, and draftsman. It also contains a list of work carried out by him and bibliographies both of his own writings and of literature about him.

Part VI
Reintegration of Losses

Carbonara, Giovanni. "Lacune, filologia e restauro." *Materiali e strutture* 2, no. 1 (1992): 23–32.
Carbonara connects two questions—the reintegration of missing parts and the removal of later additions—as central problems in both architectural conservation and philology. Comparisons with restoration theory and practice on, for example, musical scores and literary texts are helpful, but in architecture it is the original itself that is treated and irreversibly modified. The author uses a critical approach to the study of ancient literary texts to argue that conservation can never be considered as pure maintenance, devoid of any theoretical implications, since even the simplest conservative interventions are never "neutral" but always involve historic and aesthetic considerations.

Croce, Benedetto. "The Unity and Indivisibility of the Work of Art." In *The Aesthetic as the Science of Expression and of the Linguistic in General*, translated from the Italian by Colin Lyas, 21–22. New York: Cambridge University Press, 1992.
This brief passage comes from Croce's *Estetica,* published in 1902, and is relevant to the integration of lacunae. Croce argues that every artistic expression is an organic entity in which the elements lose their individual significance and blend into the whole work. The corollary of the indivisibility of the work of art, as formulated by Croce, has played a fundamental role in modern restoration theory. It was taken up by Brandi in his principle of the potential unity of the work of art, thereby providing the basis for principles of the integration of lacunae.

Espagnet, Françoise. "La restauration de la céramique et du verre." *La revue de la céramique et du verre* 9 (March–April 1983), 6–9, and 10 (May–June 1983), 7–11.
The article demonstrates the complexity of problems concerning the restoration of ceramics and glass, with references also to brick, earthen materials, and stained glass restoration. Espagnet surveys the diversity of approaches toward reintegration in use in France, varying between "illusionist" restoration, in which damage to the object and traces of use are concealed, to "museum" restoration, which stresses the importance of visibility of the reintegration. The author argues for the restorer's responsibility with regard to respect for the object's authenticity and for the reversibility and visibility of the intervention.

Gizzi, Stefano. *Le reintegrazioni nel restauro.* Rome: Kappa, 1988.
Gizzi reviews different approaches to the concept of reintegration in architectural restoration, pointing out the methodological discontinuities during the last two centuries of debate on the subject and the diversity of contemporary approaches; for the latter he takes examples from the Italian region of l'Aquila. The meticulous historical synthesis of past debate in Europe is particularly valuable while the case studies in Italy provide concrete examples of different interventions.

Hodges, H. W. M. "Problems and Ethics of the Restoration of Pottery." In *Conservation in Archaeology and the Applied Art.* Preprints of the Stockholm Congress, 2–6 June 1975, 37–38. London: International Institute for Conservation of Historic and Artistic Works, 1975.
In his brief and succinct discussion, Hodges draws attention to the importance of ethical decisions in guiding practical interventions on ceramics and summarizes the reasons for deciding whether to fill the lacunae on incomplete ceramic objects. His cautionary remarks concerning the reversibility of adhesives are worth noting.

Jessel, Bettina. "Helmut Ruhemann's Inpainting Techniques." *Journal of the American Institute for Conservation* 17 (1977): 1–8.
The author considers the philosophy and techniques for retouching practiced by Ruhemann in the restoration of paintings to be still valid. In retouching, Ruhemann advocated imitating the techniques of the original artist. Jessel underlines his conviction that connoisseurship plays a fundamental role in appreciating the quality of a painting and the methods and original intent of the painter. (See also Ruhemann in the bibliography to Part VII.)

Koller, Manfred. "Probleme und Methoden der Retusche polychromer Sculptur." *Maltechnik/Restauro* 1 (1979): 14–39.
In a field he describes as given too little attention, Koller argues that for the restoration of polychrome sculpture, historical and aesthetic values must be considered together for both the sculptural form and the polychrome painting. Integration of lacunae must be the object of a critical interpretation that does not affect the authenticity of the object. Koller provides some interesting examples in six different categories of possible integration, from conservation of a fragment to total reconstruction.

Leavengood, Patricia. "Loss Compensation Theory and Practice: A Brief History."
In *Loss Compensation Symposium Postprints,* 1–5. Seattle: The Western Association for Art Conservation, 1993.

A brief historical overview of changing philosophies and practices with regard to the reintegration of lacunae. Brandi's theory of the potential unity of the work of art is given prominence as the basis of much current thinking.

Melucco Vaccaro, Alessandra. "La reintegrazione della ceramica da scavo." *Faenza* 75, 3 (1989): 8–16.
The author draws attention to the relative neglect of the study of reintegration for excavated pottery, noting the characteristically fragmentary nature of the material and the discontinuity of its use. These particular features require an approach to treatment that satisfies both the purposes for which the ceramic is being restored and its decorative scheme. She then reviews past and current practices of ceramic restoration in this light.

Philippot, Paul. "The Problem of Lacunae in Mosaics." In *Mosaics: Deterioration and Conservation,* vol. 1., 83–87. Rome: ICCROM, 1977.
Philippot applies the general principles established by Brandi's theory and the international charters to the specific case of wall and floor mosaics. He reviews their particular characteristics and considers when lacunae can and cannot be considered appropriate for integration.

van de Wetering, Ernst. "Theoretical Considerations with Respect to the Completion of Works of Art." In *Actes du cours international pour les restaurateurs,* Veszprém, Hungary, 15–27 July 1978, 47–57. Budapest: Institute of Conservation and Methodology of Museums, 1979.
This article casts new light on the question of reintegration of lacunae. Van de Wetering criticizes anachronistic approaches to restoration in which our preconceptions are imposed upon the object and points out the necessary interrelationships between authenticity, historicity, aesthetics, and perception. The last is more important than usually acknowledged since it can help in clarifying concepts and making our decisions consistent. The author discusses the application of Gestalt theory to restoration, recognizing the notable contribution made by Brandi in drawing on the science of perception for treating problems of lacunae in works of art.

Winckelmann, Johann Joachim. *Writings on Art.* Selected and edited by Irwin David. London: Phaidon, 1972.
Winckelmann's approach in the eighteenth century to the reintegration of lacunae in sculpture is still worth restudy. At a time when authentic elements and modern substitutions and completions were indiscriminately combined, he considered that a correct intervention on an antique sculpture was a cognitive operation that required it to be recognizable. Rejecting a recourse to philological analysis, Winkelmann used the Belvedere Torso to illustrate how empirical observation leads to an ideal reconstruction of the missing elements based on solid scholarship.

Part VII
The Idea of Patina

Bergeon, Ségolène. "Conservation-restauration: Le respect du 'vécu.'" In *World Art: Themes of Unity in Diversity. Acts of the Twenty-sixth International Congress of the History*

of Art. Edited by Irving Lavin. Vol. 3, Part 7, 879–88. University Park and London: The Pennsylvania State University Press, 1989.

Bergeon's article considers the reintegration of losses and the idea of patina in works of art in the spirit of a subtle balance between aesthetics and history. She stresses the importance of the "patina of use" of an object and the difficulty of reconciling this aspect of an object's "life" with the idea of aesthetic unity. She also underlines the link between restoration and final presentation of the object, especially in relationship to the public—questions that are often considered in isolation.

Brachert, Thomas. "Restaurierung als Interpretation." *Maltechnik Restauro* 89 (April 1983): 83–95.

In Brachert's view, restoration is a process of interpretation, balanced between two conflicting schools of thought—one aimed at the wholeness of the work of art and the other advocating the retention of authentic fragments and patina. The author asserts that technical questions are only one part of an extremely complex decision-making process and that artistic and art historical considerations are often not adequately taken into account in the restoration process. A range of revealing case studies from the field of paintings and sculpture conservation poses some important questions in relation to patina.

Carbonara, Giovanni. "Il trattamento delle superfici come problema generale di restauro." In *Superfici dell'architettura: Le finiture. Atti di convegno di studi, Bressanone, 26–29 giugno 1990*, 667–78.

This essay is a sensitive appreciation of the significance of patina, explaining the aesthetic values acquired in the course of time by architectural surfaces. Carbonara considers that the treatment of old wall surfaces and coatings should follow the general concepts of restoration of works of art, as if they were paintings (though the techniques used will differ). This view is in marked contrast to the opinion that considers such surfaces merely as a "skin" or as a "locus of deterioration." Carbonara finds this attitude unacceptable because it ignores the importance of these surfaces as loci of documentary history and aesthetic value.

Conti, Alessandro. "La patina della pittura a vent'anni dalle controversie storiche: Teorie e pratica della conservazione." *Ricerche di storia dell'arte* 16 (1982), 23–35.

This essay reviews and updates the problem of the "cleaning controversies," with extensive commentary by the author. What emerges is how closely the problem of interpreting the object is connected to its restoration and how, aside from the episode that gave rise to the conflict between various schools of thought and individuals, cleaning is still a basic problem of restoration.

————, ed. *Sul restauro*. Turin: Piccola Biblioteca Einaudi, 1988.

A collection of essays by E. H. Gombrich, O. Kurz, S. Rees Jones, and J. Plesters, illustrating the problems of cleaning and the related international controversies, including the debate over the Sistine Chapel.

Hedley, Gerry. *Measured Opinions: Collected Papers on the Conservation of Paintings*, edited by Caroline Villers. London: United Kingdom Institute for Conservation, 1993.

This volume collects contributions by Gerry Hedley that set out to establish a theory of the conservation of paintings. His writings reflect an evenhanded approach toward the

relationships between art, scientific research, and practice. The last part of the book ("Varnish Removal") is the most relevant here. The author reviews the cleaning controversies and demonstrates the relativity of the different approaches (total, selective, partial cleaning). Convinced that the different approaches reflect different conceptions of aesthetics, the author concludes that "a restoration policy towards cleaning must embody a system of aesthetics and ultimately, a view of the cultural role of art."

King, Antoinette. "Technical and Esthetic Attitudes about the Cleaning of Works of Art on Paper." *Drawing* 8 (November–December 1986): 79–83.
This article discusses issues raised in the cleaning of drawings by examining some drawings by Matisse and Picasso. Differences between the cleaning of drawings and of paintings stem from the different relationships between the support and the image. The author considers that the choice of a technical solution is simultaneously an aesthetic choice, the two being indissociable.

MacLaren, Neil, and Anthony Werner. "Some Factual Observations about Varnishes and Glazes." *Burlington Magazine* 92, no. 568 (1950): 189–92.
This critique was written as a reply to Brandi's article on "The Cleaning of Pictures in Relation to Patina, Varnish, and Glazes" (see Reading 41, pages 380–93), and continues the controversy of 1946 at the National Gallery, which brought out and accentuated a clear division between "radical cleaners" and "partial cleaners." A terminological confusion over the concepts of patina, glaze, and varnish forms the starting point of the discussion, and the authors question Brandi's interpretation of patina. They emphasize the technical aspects of the problem and see the aim of restoration as the "removal . . . of all accretions which distort the artist's intention."

Philippot, Paul. "La restauration des enduits colorés en architecture: L'exemple de Rome et la question de méthode." *Bulletin de l'Académie Royale de Belgique* 5, no. 10–11 (1988): 259–92.
An excellent analysis of methodological questions, this article adopts a critical approach toward the problem of color on historic buildings. With respect to patina, Philippot remarks on the unsatisfactory results of using synthetic colors, firmly rejecting the practices of imitating old patinas and extending of the *tratteggio* technique to the entire wall surface. A critical analysis of arbitrary restoration and renovation practices on buildings in Rome leads Philippot to argue that to preserve the historic image of a town, a critical approach to restoration must be extended to include the question of color.

———. "La restauration des sculptures polychromes." *Studies in Conservation* 15, no. 4 (1970): 248–52.
The author argues that any conservation intervention on polychrome sculpture, considered until recently among the minor arts, must recognize the individual character of polychrome sculpture. A critical survey of previous practice reveals the use of inappropriate methods, often in total ignorance of aesthetic considerations, or others based upon archaeological and aesthetic principles appropriate to the restoration of paintings. Philippot attempts to identify characteristics that distinguish polychrome sculpture from paintings—as, for example, the heterogeneity of textures, which requires particular precautions when cleaning; and the relative nature of lacunae, which needs to be understood when retouching.

Reuterswaerd, P. *Studien zur Polychromie der Plastik: Griechenland und Rom.*
Stockholm: Svenska Bokförlaget, 1960; **Melucco Vaccaro, Alessandra.** "La policromia
nell'architettura e nella plastica antica: Stato della questione." *Ricerche di Storia dell'arte*
24 (1984): 19–32.
These two essays are cited together since they discuss the problems of patina and surfaces
regarding sculpture and architecture rather than painting. Reuterswaerd was the first
person in this century to collect the archaeological documentation on this "quarrel" that
placed the classicists, who denied the existence of color on antique works, in opposition
to all the rest. Starting from this case of "cultural blindness" dictated by classicist
prejudice, Melucco Vaccaro's essay points out the responsibility of restoration, which has
contributed to the destruction of many of the traces of color spared by time.

Ruhemann, Helmut. *The Cleaning of Paintings: Problems and Potentialities.* New York:
Hacker Art Books, 1982.
This book describes the experience of a paintings restorer of long professional experience
and great influence in the field. Cleaning and understanding being considered inter-
dependent, the cleaning of paintings is defined as a two-stage process: "cleaning to
explore" and "exploring to clean." The author's principles include the removal of all
accretions that have come to obscure the original work of the artist and their replacement
with clear varnishes that do not conceal the character of the original artist's intentions.

Part VIII
The Role of Science and Technology

Baer, N. S., C. Sabbioni, and A. I. Sors, eds. *Science, Technology and European
Cultural Heritage: Proceedings of the European Symposium, Bologna, Italy, 13–16 June
1989.* Oxford: Butterworth-Heinemann Ltd., 1991.
These papers from an international conference show the strong role played by the
scientific community in protecting the European cultural heritage. A reading of the whole
volume conveys an idea of the advances made by science in conservation during the 1980s.
The "overview papers" in Part I are particularly helpful for identifying the principal lines
of research in different areas of science.

Feller, Robert L. "Concerning the Place of Science in the Scheme of Things." In
*Training in Conservation: A Symposium on the Occasion of the Dedication of the Stephen
Chan House,* edited by N. S. Baer, 17–32. New York: Institute of Fine Arts, New York
University Press, 1989.
This paper on the role of the scientist in the conservation of cultural heritage presents a
more optimistic view than that expressed in some of the readings in Part VIII. Feller
reviews thoughtfully the nature of science and the contributions that a conservation
scientist can make, while cautioning against any hopes of instant answers from scientific
research if rigorously conducted.

Philippot, Paul. "Réflexions sur le problème de la formation des restaurateurs de
peinture et de sculptures." *Studies in Conservation* 5 (1960): 61–69.
The author maintains that restoration is a question of critical interpretation, with science
contributing to the technical aspects of conservation work. This broadening of the
discipline requires a close collaboration between the conservator, the art historian, and
the scientist. Philippot explains very clearly how a new definition of the conservator,

together with appropriate education and training, is needed. He then defines the basis of a training system for object conservators in the form of basic training and internships.

Plenderleith, Harold James. *The Conservation of Antiquities and Works of Art: Treatment, Repair and Restoration.* London and New York: Oxford University Press, 1956.
The bible of conservators and restorers for many years, this was the first comprehensive guide to the conservation of a wide variety of materials that was based on scientific information. It drew on the long experience of the author as keeper of the British Museum's Research Laboratory and as one of the field's pioneers in the application of scientific knowledge to what had been largely an artisan tradition. A second, revised edition was published in 1971, coauthored with A. E. Werner, then keeper of the same laboratory. Although much of the advice in the book must now be considered dated, it remains an important landmark in the development of the discipline and deserves selective rereading.

Thomson, G., ed. *Recent Advances in Conservation: Contributions to the IIC Rome Conference, 1961.* London: Butterworths, 1963.
The International Institute for Conservation of Historic and Artistic Works conference in 1960 was a landmark in demonstrating in an international forum the widespread application of science to conservation practice. The movement toward interdisciplinary approaches is reflected in the chapters devoted to training, which describe the need for conservators trained in scientific and technical disciplines. The other chapters describe the application of science to the technical examination and treatment of a wide variety of works of art.

Urbani, Giovanni, ed. *Problemi di conservazione.* Bologna: Editrice Compositori, 1973.
This publication was a landmark in Italy in acknowledging the emergence of a new discipline of science in conservation applied to the protection of cultural heritage in its material aspects. It reflects the situation as it was at the start of the 1970s. Urbani's introduction to the volume notes how the application of science has been enlarged from analytical work on materials to experimental research.

————, ed. *La scienza e l'arte della conservazione: Storici dell'arte, tecnici, restauratori a confronto sui temi ancora irrisolti del restauro.* Rome: La Nuova Italia Scientifica, 1982.
A review by several Italian authors of the double nature of conservation as both art and science requiring the collaboration of the art historian, the scientist, and the conservator. The problems identified as still outstanding are insufficient "creativity" on the part of conservation scientists, poor understanding of theoretical problems in conservation by scientists, and the prevalence of aesthetic criteria over technical criteria. A good bibliography is included.

Ward, Philip. *The Nature of Conservation: A Race against Time.* Marina del Rey, Calif.: The Getty Conservation Institute, 1986.
Short but lively and well-illustrated overview of the conservation field, designed "to stimulate dialogue within the profession and, at the same time, to acquaint the public with the philosophies and efforts of those seeking to preserve the cultural heritage." Chapter 3 considers briefly "The role of science in conservation." Written for the fourteenth general conference of the International Council of Museums (ICOM) in 1986, the book is available in English, French, and Spanish editions.

About the Authors

Albert Albano (b. 1953)

American conservator. Albert Albano is a consultant in art and preservation in Pennsylvania. He was director of conservation at the Winterthur Museum and Garden, Delaware from 1989 to 1994 and has held positions of senior conservator at the Museum of Modern Art and conservator at the Philadelphia Museum of Art. He received a certificate in postgraduate studies (art conservation) from Cooperstown Graduate Programs and an M.A. from New York State University, Oneonta, New York.

Umberto Baldini (b. 1922)

Italian restorer, teacher, and administrator. Umberto Baldini studied art history in Florence and then entered government service as inspector in the Soprintendenza of Galleries in Florence. He became director of the Gabinetto dei Restauri in Florence and, in 1970, was promoted to Soprintendente in charge of the Opificio delle Pietre Dure and Restoration Laboratories of Florence. He has also taught restoration history, theory, and techniques, first at the University of Pisa and then at the University of Florence. From 1983 to 1987 he was director of the Istituto Centrale del Restauro in Rome.

Clive Bell (1881–1964)

British art critic. Clive Bell studied history at Trinity College, Cambridge University, where his contemporaries included Leonard Woolf and Lytton Strachey. Clive Bell, together with his wife, the painter Vanessa Bell; her sister, the novelist Virginia Woolf; and Virginia's husband, Leonard Woolf, formed the nucleus of the Bloomsbury group. Bell's most important literary contribution was *Art* (1914), a book based on previously published essays, in which he formulated his theory of "significant form."

Marie Claude Berducou (b. 1953)

French conservator and university teacher. After studying history, archaeology, and conservation-restoration and earning her master's degree in sciences and technology (M.S.T.) between 1971 and 1977 at the University of Paris I, Panthéon-Sorbonne, Marie Claude Berducou joined the teaching staff there. Since 1980 she has been responsible for developing the M.S.T. conservation-restoration program, the first of its kind in France. Her book, *La conservation en archéologie* (1990), brings together essays written mainly by graduates of the program.

Bernard Berenson (1865–1959)

American art historian and connoisseur. Bernard Berenson (né Bernhard Valvrojenski) immigrated from Lithuania to Boston at the age of ten. Following his graduation from Harvard University with a B.A. in 1887, Berenson traveled to Europe, supported by the Boston collector Isabella Stewart Gardner and other wealthy friends, and thereafter devoted his life to connoisseurship. He became the leading connoisseur of Italian painting and the first to define the schools of Italian painting in a series of fundamental publications. His authority was such that his authentications of works of art brought him substantial commissions from collectors and dealers. On his death, Berenson bequeathed the Villa I Tatti, his home near Florence—as well as his collection, library, and residuary estate—to Harvard University.

Cesare Brandi (1906–88)

Italian art historian and critic. After graduating in law from the University of Siena in 1927 and in humanities from the University of Florence in 1928, Cesare Brandi began his career in the Antiquities and Fine Arts Administration in the Soprintendenza of Museums and Galleries in Siena. During the 1930s he was inspector to the Soprintendenza at Bologna and then at Rome. In 1939 Brandi founded and directed the Istituto Centrale del Restauro (ICR) in Rome, also founding and editing its *Bollettino*. With Giulio Carlo Argan, he was the secretary of the review *Le Arti* and, in 1947, founded the literary and critical review *L'Immagine*. Beginning in 1934, Brandi taught courses at the University of Rome in painting and, after 1955, in the history and theory of restoration. His principal writings on this topic are collected in his *Teoria del restauro*, published in 1963. Beginning in 1948, he undertook a series of missions, lectures, and consultations for various countries and for Unesco. On leaving the ICR in 1960, he accepted the chair in Medieval and Modern Art at the University of Palermo. From the year 1967 he taught at the University of Rome "La Sapienza."

Giovanni Carbonara (b. 1942)

Italian architect and university teacher. After working briefly as an architect for the Amministrazione delle Antichità e Belle Arti, Giovanni Carbonara turned to university teaching and research. He is now professor of architectural restoration at the Scuola di Specializzazione in Restauro dei Monumenti and coordinator of doctoral research studies in conservation of architectural monuments at the University of Rome "La Sapienza." He also lectures at the Istituto Centrale del Restauro, at the International Centre for the Study of the Preservation and the Restoration of Cultural Property (ICCROM) and at the Scuola Archeologica Italiana in Athens.

Sir Kenneth Clark (1903–83)

British connoisseur, museum curator, author, and patron of the arts. Sir Kenneth Clark studied history at Trinity College, Oxford University, where he was introduced to the scholarship and connoisseurship of prints and drawings in the collections of the Ashmolean Museum. From 1925 to 1927, he assisted Bernard Berenson with the revision of his corpus of Florentine drawings. In 1931, Clark was appointed keeper of the Department of Fine Art at the Ashmolean Museum. Soon after, at the age of thirty-one, he became director of the National Gallery in London, a position he held from 1934 to 1945, establishing the museum's scientific department and initiating a program of cleaning paintings. He also served as surveyor of the King's Pictures from 1934 to 1944. After resigning from the National Gallery, Clark devoted himself to lecturing, writing, and broadcasting. His popular television series, *Civilisation* (1966), brought him international renown for making art accessible to a wide audience.

Paul Coremans (1908–65)

Belgian conservation scientist. Paul Coremans studied at Anvers and at the Université Libre de Bruxelles and received his doctorate in Chemical Science there in 1932. In 1934 he was appointed head of the new laboratory attached to the Photographic Service of the Musées Royaux d'Art et d'Histoire in Brussels. In 1947 he began to teach at the University of Ghent and, in 1950, founded the National Centre for Research into Flemish Primitives. With the creation of the Institut Royal du Patrimoine Artistique in 1957, Coremans became the Institute's founding director and created its *Bulletin*. He was one of the co-founders, in 1950, of the International Institute for Conservation of Historic and Artistic Works (IIC) and its journal, *Studies in Conservation*. He was also influential in the founding of ICCROM in 1959 and the International Council on Monuments and Sites (ICOMOS) in 1964. He undertook numerous advisory and training missions for ICCROM and for Unesco. The regional training center established in Mexico City in 1966 was named after him.

Albert France-Lanord (1915–93)

French engineer, curator, archaeologist, conservation scientist. Albert France-Lanord trained as an engineer at the Ecole des Bâtiments et Travaux Publics in Lyons, and eventually became the managing director of a public works firm. Simultaneously, he was an archaeologist studying Merovingian sites in France, curator of archaeology at the Musée Historique Lorrain in Nancy, and founder of the Musée de l'Histoire des Métaux and a center for the study of metallurgy. For over ten years he was a lecturer and consultant for ICCROM. His book, *La conservation des antiquités métalliques* (1965), was ahead of its time in its approach to the conservation of metal objects.

Max J. Friedländer (1867–1958)

German art historian. Educated in Munich, Leipzig, and Florence, Max Friedländer succeeded Wilhelm von Bode as head of the picture gallery and print room at the Kaiser Friedrich Museum in Berlin. Friedländer resigned from that post in 1933, when he left Nazi Germany for Holland and settled in Leiden. Friedländer was among the first to survey early Netherlandish and German paintings, of which he was a leading connoisseur. His fourteen-volume series, *Early Netherlandish Paintings* (1924–1937), written in only ten years, established the basic corpus of fifteenth- and sixteenth-century painting in the Netherlands.

Sir Ernst Gombrich (b. 1909)

Austrian-British art historian and university teacher. Born and educated in Vienna, Ernst Gombrich moved to London where he became a lecturer at the Warburg Institute, University of London. From 1959 to 1976, he was director of the Warburg Institute and professor of the history of the Classical tradition. Gombrich has held the Slade Professorship of Fine Art at both Oxford and Cambridge Universities. Among his many publications, two of the best known are *The Story of Art* (1950; in numerous editions), and *Art and Illusion* (1960).

Sheldon Keck (1910–93)

American art conservator and teacher. Sheldon Keck received his B.A. from Harvard College in 1932, followed by a one-year apprenticeship in art conservation at the Fogg Museum, Harvard University. He was conservator at the Brooklyn Museum from 1934 to 1961, when he became the first director of the Conservation Center and professor of fine arts at the Institute of Fine Arts, New York University. From 1969 until his retirement in 1981, Keck was professor in the Conservation of Historic and Artistic Works at Cooperstown Graduate Programs, State University College at Oneonta, a program he founded and directed with his wife, Caroline Keck.

Roger H. Marijnissen (b. 1923)

Belgian art historian and conservator. Starting to work in 1948 with Paul Coremans, Roger Marijnissen was appointed head of the Conservation Department of the Institut Royal du Patrimoine Artistique (IRPA) in Brussels in 1958, a post he held until 1988. He was awarded his doctorate from the University of Ghent in 1966 for his thesis, published as *Dégradation, conservation et restauration de l'oeuvre d'art* in 1967. He has also published monographs on Bosch (1987) and Pieter Bruegel (1988) and, with L. Kokkaert, *Dialogue avec l'oeuvre ravagée après 250 ans de restauration* (1995).

Alessandra Melucco Vaccaro (b. 1940)

Italian archaeologist. Alessandra Melucco Vaccaro studied classical archaeology at the University of Rome and then joined the Ministry of Cultural Heritage with the Soprintendenza alle Antichità in Florence and in Ostia Antica, followed by a position as curator at the Museo dell'Alto Medioevo in Rome. As director of the Department of Archaeological Conservation at the Istituto Centrale del Restauro, Rome, from 1979 to 1993, she coordinated and/or supervised a number of conservation projects, including the conservation of the equestrian monument of Marcus Aurelius, the Arch of Constantine, Trajan's Column, and the painted Tomb of the Diver at Paestum. She currently serves as soprintendente with the Ministry of Cultural Heritage and as professor of conservation of cultural heritage at the University of Venice.

Laura Mora (b. 1923)

Italian conservator and teacher. After training in the fine arts, Laura Mora joined the staff of the Istituto Centrale del Restauro in Rome in 1945. There she specialized in the conservation of the surfaces of works of art, particularly paint layers, including plaster and colored surfaces in architecture. For many years she coordinated teaching activities in the Istituto's Restoration Department, taught regularly for ICCROM, and carried out numerous conservation projects and advisory missions in Italy and abroad. With her husband, Paolo Mora, she helped pioneer a systematic, interdisciplinary approach to the conservation of works of art. She retired from the Istituto in 1988.

Paolo Mora (b. 1921)

Italian conservator and teacher. Paolo Mora was trained in architecture and joined the staff of the Istituto Centrale del Restauro in Rome in 1944. From 1950 until his retirement in 1986, he was chief conservator there, coordinating projects and teaching conservation techniques for a wide variety of materials. For more than forty years, he has led conservation projects and advisory and teaching missions in Italy and abroad, often on behalf of ICCROM, the International Council of Museums (ICOM), and Unesco. His *Conservation of*

Mural Paintings (with L. Mora and P. Philippot) is the standard reference work in this field.

Umberto Morra (1897–1981)

Italian author and translator. During his career as an author, Umberto Morra contributed to a number of journals on different topics, mostly literary. He translated into Italian the historical works of G. M. Trevelyan and Voltaire's *Le siècle de Louis XIV*, as well as numerous novels by modern American writers. He first met Bernard Berenson in 1925 and was accepted as one of his intimate circle of friends at Villa I Tatti, Berenson's house near Florence. From 1931 to 1940, Morra kept an almost daily record of conversations with Berenson during his visits to the villa.

William Morris (1834–96)

British designer, craftsman, poet, and political thinker. During studies at Exeter College, Oxford, William Morris was influenced by the writings of John Ruskin concerning the social and moral basis of architecture. Working with the Gothic Revivalist architect G. E. Street, Morris indulged his love of medieval art and, influenced by the Pre-Raphaelite D. G. Rossetti, turned to painting. In 1861 Morris established his own firm for the design of stained glass, furniture, textiles, wallpaper, and other decorative arts. He also founded the Society for the Protection of Ancient Buildings in 1877 and the Kelmscott Press in 1891 for the production of fine printed books. His political ideas led him to organize the Socialist League and, later, the Hammersmith Socialist Society, and to the writing of several political tracts, notably *News from Nowhere* (1890).

Erwin Panofsky (1892–1968)

German-American art historian. Erwin Panofsky was born in Hanover, Germany, and received his Ph.D. from the University of Freiburg. From 1921 to 1933 Panofsky taught at the University of Hamburg, first as privatdocent and then, from 1926, as professor of the history of art. He fled Nazi Germany in 1933 and emigrated to the United States. In 1935, after teaching for two years at New York University, he accepted a position as permanent professor at the Center for Advanced Studies at Princeton University. He became professor emeritus at Princeton in 1962 and continued to teach there until his death in 1968. Widely influential as an art historian, Panofsky's collected essays, *Meaning in the Visual Arts* (1955) testify to the breadth of his interests.

Albert Philippot (1899–1974)

Belgian painter and restorer. Albert Philippot, father of Paul Philippot, studied at the Ecole des Arts et Métiers at Etterbeek in Belgium and started to

work as a restorer with the Musées Royaux d'Art et d'Histoire in Brussels in 1948. In 1950 he collaborated with Paul Coremans on the restoration of van Eyck's *Mystic Lamb* in Ghent Cathedral. In 1953 he was officially appointed chief restorer of the Institut Royal du Patrimoine Artistique, a position he had previously been granted by the Musées Royaux des Beaux-Arts of Belgium.

Paul Philippot (b. 1925)

Belgian art historian, administrator, and university teacher. Paul Philippot holds doctorates in both law and the history of art and archaeology. For more than thirty years he has taught at the Université Libre de Bruxelles, teaching courses on the history of painting and architecture, aesthetics, and general conservation theory. He has also taught at conservation centers in France and Belgium, and at the University of Rome and ICCROM. From 1959 to 1971 he was deputy director and, from 1971 to 1977, director of ICCROM and has carried out numerous technical and advisory missions for ICCROM throughout the world.

Sir John Pope-Hennessy (1913–94)

British art historian, curator, and museum administrator. Sir John Pope-Hennessy studied history at Balliol College, Oxford University, where lectures by Kenneth Clark inspired him to become an art historian. He joined the staff of the paintings department of the Victoria and Albert Museum in 1938, transferring later to the department of architecture and sculpture, where he was keeper from 1954 to 1966. He served as director of the Victoria and Albert Museum from 1967 to 1973 and director of the British Museum from 1974 to 1976. In 1977 he moved to New York with a joint appointment as consultative chairman of the Department of European Paintings at the Metropolitan Museum of Art and professor of art history at the Institute of Fine Arts, New York University. He retired from the Metropolitan Museum in 1986 and from the Institute of Fine Arts in 1992.

John Richardson (b. 1924)

British art critic and author. From 1949 to 1962 John Richardson lived in Provence, France, where, with the collector Douglas Cooper, he created a private museum of Cubist painting. Pablo Picasso was a frequent visitor, as were Georges Braque, Fernand Léger, Jean Cocteau, and other artists of the time. After moving to the United States, Richardson organized a major Picasso retrospective and, from 1965 to 1972, directed the American operations of Christie's auction house. He has published books on Edouard Manet and Braque and has been a frequent contributor to the *New York Review of*

Books. Two volumes have been published of his projected four-volume *Life of Picasso.*

Alois Riegl (1858–1905)

Austrian art historian and aesthetician. Alois Riegl first studied law, and then history and philosophy. At a young age he became a curator at the Museum of Decorative Arts in Vienna, 1883–97, and then was appointed professor of art history at the University of Vienna. He contributed significantly to the study of late Roman and Baroque art. He wrote *Der Moderne Denkmalkultus* (The modern cult of monuments) in 1903, shortly after being named president of the Commission of Historic Monuments. His other books include *Problems of Style: Foundations for a History of Ornament* (1893; translated into English in 1992) and *Historische Grammatik der Bildenden Künste* (1966).

Orietta Rossi Pinelli (b. 1943)

Italian historian of art and architecture. Orietta Rossi Pinelli is associate professor of modern art in the Faculty of Letters of the University of Rome "La Sapienza." Her published work since the 1970s has focused on the history of architecture and the city, the restoration of ancient sculpture as an indicator of the vicissitudes of collecting and changes in taste, and on the visual arts in the eighteenth and nineteenth centuries. Her publications on restoration include *Artisti, falsari o filologi? Da Cavaceppi a Canova, il restauro della scultura tra arte e scienza* (1981), and *Il frontone di Aegina e la cultura del restauro dell'antico a Roma intorno al 1816* (1991).

John Ruskin (1819–1900)

British art critic, author, political thinker, and patron of the arts. Introduced early to art and literature, John Ruskin studied at King's College, London, and Christ Church, Oxford. An admirer of J. M. W. Turner, Ruskin published the first volume of *Modern Painters* (1843) in homage to him. Ruskin's writings in art criticism are represented in the five volumes of *Modern Painters* (completed 1860); *The Seven Lamps of Architecture* (1849); *The Stones of Venice* (1851–53); *Lectures on Architecture and Painting* (1853); and *Pre-Raphaelitism* (1851), a movement he defended. Ruskin was the first Slade Professor of Art at Oxford University, a post he held from 1869 to 1878 and again in 1883–84.

Nicholas Stanley Price (b. 1947)

British archaeologist and conservation educator. Nicholas Stanley Price received his B.A. in ancient history and philosophy, and his doctorate in archaeology from Oxford University. His doctoral thesis, completed in 1976, was on

the early settlement of Cyprus. After ten years of archaeological fieldwork and administration in Cyprus, Jerusalem, and Oman, he turned to conservation education, first as a staff member at ICCROM from 1981 to 1986, then at the Getty Conservation Institute, where he served as deputy director of the Training Program from 1987 to 1995. He has worked particularly on the management of archaeological sites and the conservation of rock art.

M. Kirby Talley Jr. (b. 1941)

American art historian. M. Kirby Talley Jr. studied art history at the University of Amsterdam, where he received his M.A. in 1973, and at the Courtauld Institute in London, where he received his Ph.D. in 1977. Under the auspices of the Dutch Ministry of Culture, he established and served as the first director of the State Training School for Restorers in Amsterdam from 1977 to 1984. He then served as director of the Allen Memorial Art Museum in Oberlin, Ohio, before returning to the Netherlands in 1985 to become curator of the State Collections of Old Master Paintings of the Netherlands. Since 1989, Talley has been project coordinator for conservation and restoration for the Dutch Ministry of Culture.

Giorgio Torraca (b. 1927)

Italian conservation scientist. After studying chemistry at the University of Rome and at the Case Institute of Technology in Cleveland, Ohio, Giorgio Torraca worked for the Istituto Centrale del Restauro in Rome from 1953 to 1958 and then in private industry from 1958 to 1965. From 1965 to 1971 he was scientific assistant and, from 1971 to 1986, deputy director of ICCROM, for which he taught regular courses and carried out numerous advisory missions. He is now an associate professor in the science and technology of materials in the Faculty of Engineering, University of Rome "La Sapienza," and works as an independent consultant for materials science applied to conservation.

Giovanni Urbani (1925–94)

Italian art historian, conservator, and administrator. Giovanni Urbani studied art history at the University of Rome and became one of Cesare Brandi's first students at the Istituto Centrale del Restauro in Rome. Working as a paintings conservator on the staff of the Istituto under Brandi and then his successor, P. Rotondi, Urbani eventually became the third director of the Istituto from 1977 to 1983. He promoted the application of advanced scientific techniques to conservation problems, while also advocating maintenance and "programmed conservation" for coping with large-scale preservation needs. In 1991 he co-founded the journal *Materiali e strutture* with Giorgio Torraca and A. Gallo Curcio.

Eugène-Emmanuel Viollet-le-Duc (1814–79)

French architect, restorer, architectural historian, designer, and theorist. Refusing to attend the Académie des Beaux-Arts, Eugène-Emmanuel Viollet-le-Duc gained experience in architects' studios and by visiting monuments in France and Italy during the 1930s. In 1840 Prosper Mérimée, France's chief inspector of Historic Monuments, entrusted him with the restoration of the church of La Madelaine of Vézelay and then the Sainte Chapelle in Paris. In 1844 Viollet-le-Duc undertook, with Jean-Baptiste Lassus, the restoration of Notre Dame in Paris and became head of the Office des Monuments Historiques. Among the many monuments he restored were the cathedrals of Amiens, Chartres, and Reims; the Saint-Denis Basilica in Paris; the fortifications of Carcassonne; and the castles of Coucy and Pierrefonds. His fundamental writings include two *Dictionnaires raisonnés*, one on French architecture (ten volumes, 1854–68), and the other on medieval French furniture (six volumes, 1858–75).

Phoebe Dent Weil (b. 1937)

American conservator. Phoebe Dent Weil received her B.A. from Wellesley College and an M.A. and Certificate in Conservation from the Institute of Fine Arts, New York University. She was conservator at the Washington University Center for Archaeometry, and then became chief conservator in the Sculpture Conservation Laboratory of Washington University Technology Associates in St. Louis, Missouri. She has pioneered new approaches to the preservation of outdoor sculpture and has published several articles, primarily on the technical history of materials.

Ernst van de Wetering (b. 1938)

Dutch art historian. After studying at the Royal Academy of Fine Arts in The Hague, Ernst van de Wetering taught art in secondary schools and then received his doctorate from the University of Amsterdam with a dissertation on the workshop practice of the early Rembrandt. Since 1968 he has been a member, and is now chairman, of the Rembrandt Research Project. He was art historian on the staff of the Central Research Laboratory for Restoration, Amsterdam, from 1969 to 1987 and, since 1987, has been professor of the history of art at the University of Amsterdam.

Heinrich Wölfflin (1864–1945)

Swiss art historian. Heinrich Wölfflin studied art history in Basel, Berlin, and Munich and wrote a doctoral thesis on the psychology of architecture. He was particularly interested in Baroque art and defined its formal values as being in opposition to Classicism rather than an extension of it. Having long studied with Jacob Burckhardt, Wölfflin succeeded him as professor at the

University of Basel in 1893, subsequently moving to Berlin in 1905, Munich in 1914, and Zurich in 1924. His best known publications are *Renaissance and Baroque* (1888); *Classic Art* (1899), an analysis of the Renaissance in its classic phase; and *Principles of Art History* (1915), a synthesis of his theory of art.

Marguerite Yourcenar (1903–87)
French-American novelist and poet. Marguerite Yourcenar (the pen name of Marguerite de Crayencour) was born in Brussels and educated at home. After traveling widely, she emigrated to the United States in 1939 and was eventually granted dual U.S.-French citizenship. She is the author of many plays, poems, essays, and novels, many of the latter being historical reconstructions. *The Memoirs of Hadrian* (1951) and *The Abyss* (1968) are the best known. In 1980 she became the first woman writer to be elected to the Académie Française.

Illustration Credits

Grateful acknowledgment is extended to the following institutions and individuals for permission to reproduce the illustrations in this volume.

Part I

Opening Page: National Portrait Gallery, London.

Introduction to Part I

Figure 1: The British Museum, London; Figure 2: The Rijksmuseum-Stichting, Amsterdam; Figure 3a, b: Museo dell'Opera di Santa Croce, Florence. Photographs courtesy of Scala/Art Resource, New York; Figure 4: Accademia, Venice. Photograph courtesy of Scala/Art Resource, New York; Figure 5: The J. Paul Getty Museum, Malibu, California.

Reading 7 | Wölfflin

Figure 2: The Schwarzenberg Garden, Vienna; Figure 3: Photograph by Vasari, Rome; Figure 4: Photograph by Giancarlo Gasponi, Rome.

Reading 11 | Gombrich

Figures 1, 10: Widener Collection © 1995 Board of Trustees, National Gallery of Art, Washington, D.C.; Figure 2: Department of Prints and Drawings, The Royal Museum of Fine Arts, Copenhagen; Figure 3: Department of Art & Archaeology, Princeton University, Princeton, New Jersey; Figures 4, 5: The Metropolitan Museum of Art, New York. All rights reserved; Figures 7, 8, 9: Andrew W. Mellon Collection © 1995 Board of Trustees, National Gallery of Art, Washington, D.C.; Figure 11: Gift of Duncan Phillips. © 1995 Board of Trustees, National Gallery of Art, Washington, D.C.; Figure 12: Samuel H. Kress Collection © 1995 Board of Trustees, National Gallery of Art, Washington, D.C.; Figure 14: Rosenwald Collection © 1995 Board of Trustees, National Gallery of Art, Washington, D.C.; Figures 15, 16: Copyright The Frick Collection, New York.

Reading 14 | Friedländer
Figure 1: Staatliche Museum, Gemäldegalerie, Berlin. Photograph by Jörg P. Anders.

Reading 15 | Pope-Hennessy
Figure 1: The Getty Center for Art History and the Humanities, Resource Collections, Santa Monica, California.

Part II
Opening Page: The Prado Museum, Madrid.

Introduction to Part II
Figure 1: The Prado Museum, Madrid; Figure 2: The Royal Collection © Her Majesty Queen Elizabeth II; Figure 3: The Louvre, Paris; Figure 4: Stedelijk Museum, Amsterdam; Figure 5: The National Gallery, London.

Part III
Opening Page: Courtesy of the British Museum, London.

Introduction to Part III
Figure 1: Opificio delle Pietre Dure, Florence.

Reading 21 | P. Philippot
Figures 1, 2: The Vatican Museum; Figures 3, 4: Staatliche Antikensammlungen und Glyptothek, Munich; Figure 5: Colonial Williamsburg Foundation, Williamsburg, Virginia; Figure 6: Photograph by Andorno Ghemme, Rome.

Reading 23 | Carbonara
Figure 1: The Vatican Museums.

Reading 24 | France-Lanord
Figure 1a, b: Musée de la Civilisation Gallo-Romaine, Lyon. Photograph courtesy of the Musée de l'Histoire du Fer, Jarville la Malgrange, France.

Part IV
Opening Page: The Getty Conservation Institute. Photograph 1993 by Guillermo Aldana.

Introduction to Part IV
Figure 1: Istituto Centrale del Restauro, Rome. Photograph by Lorenzo De Masi.

Part V
Opening Page: Photograph by Julian Zugazagoitia for the Getty Conservation Institute.

Introduction to Part V
Figure 1: Giulio Einaudi Editore, Turin; Figure 3: Soprintendenza Archeologica, Rome. Photograph by Alessandra Melucco Vaccaro.

Part VI

Opening Page: The J. Paul Getty Museum, Malibu, California.

Introduction to Part VI
Figure 1: Soprintendenza Archeologica della Puglia, Taranto.

Reading 36 | Mora, Mora, and P. Philippot
Figures 1–6, 8, 9: By courtesy of Paolo and Laura Mora, Rome.

Reading 38 | P. Philippot
Figures 1, 2: Photograph by F. Rigamonti, Rome; Figure 3: Photograph by Oliver Radford, Cambridge, Massachusetts; Figure 5: Ministero per i Beni Culturali e Ambientali, Urbino.

Part VII

Opening Page: Soprintendenza Archeologica, Rome. Photograph by E. Monti.

Introduction to Part VII
Figure 1: The Vatican Museums.

Reading 41 | Brandi
Figure 1: Fitzwilliam Museum, Cambridge, England; Figures 2, 3: Musei Civici, Pesaro, Italy; Figures 4, 5: Photograph courtesy of Chiesa dei Servi, Siena, Italy; Figures 6, 7: Photo Archive, Istituto Centrale per il Restauro, Rome.

Reading 42 | Weil
Figure 1: Antikensammlungen Museum, Berlin. Photograph courtesy of Bildarchiv Preußischer Kulturbesitz, Berlin; Figure 2: Soprintendenza per i Beni Artistici e Storici, Florence; Figures 3, 6–8: Phoebe Dent Weil and Objects Conservation Inc., Chesterfield, Missouri; Figure 4: The Huntington Library, San Marino, California; Figure 5: The Getty Center for Art History and the Humanities, Resource Collections, Santa Monica, California. Malvina Hoffman Papers.

Reading 43 | van de Wetering
Figure 1: The Metropolitan Museum of Art, New York. Lehmann Collection. All rights reserved; Figure 2: Staatliche Museum of Berlin, Gemäldegalerie. Photograph by Jörg P. Anders.

Part VIII

Opening Page: Courtesy of Finmeccanica, Rome. Photograph by Paola Teti.

Index

Page numbers in italics indicate texts by the authors listed.